There is only one word to describe this novel, and that word is "authentic." To use the street vernacular, stein has "been there, done that," and he recounts it all. If the author is a fetishist, and he is, it is for exquisite, painstaking detail. Each page is like a dark and mysterious landscape, rendered meticulously, where no stone is left unturned and what scrambles out from underneath is all the stuff we dare to dream if we love the thorns as well as the rose. As a reader, I'd say this book is recommended. As a sadist and a Master, I'd say it is required.

— Thom Magister
author of "One Among Many" in *Leatherfolk*, ed. Mark Thompson, and numerous stories published in *Daddy* magazine

Written with heartfelt emotion and the authority of someone who takes s/m seriously, *Carried Away* takes the reader past the place where pain becomes pleasure and to that ultimately terrifying territory we call intimacy. Many leathermen will read it with longing, others with wonderment, and a lucky few nodding their heads in agreement. This is a novel about adult as well as romantic love, about needs expressed and passions fulfilled. It offers real people in the real world, not the limiting archetypes of pornography. The sex scenes are as moving as they are erotically exciting. Taking us past sex, the author shows us that the world of s/m is fraught with the same emotional pitfalls as any other time and place where two people meet, fall in love, and seek to build a life together. *Carried Away* is sometimes funny, sometimes bittersweet, and ends happily — as one wants a love story to end. It's what we all want to happen after the whipping stops. **— David May**
author of *Madrugada: A Cycle of Erotic Fictions*

Realistic, compassionate, shocking, arousing — one of the best gay male s/m novels I've read. By making the world of gay Masters and slaves more accessible, david stein has opened doors the narrow-minded want to keep closed. *Carried Away* shows that love in an s/m context can be the greatest adventure of all. **— Victor Terry**
author of *WHiPs, Masters, SM/SD,* and *Tying Knots*

CARRIED

AN S/M ROMANCE

AWAY

CARRIED

AN S/M ROMANCE

AWAY

by david stein

Los Angeles
DAEDALUS PUBLISHING COMPANY
2002

Daedalus Publishing Company
2140 Hyperion Avenue
Los Angeles, CA 90027
www.daedaluspublishing.com

You may contact the author via e-mail, gorgik@aol.com.

ISBN 1-8819431-7-8

Carried Away is a work of fiction, and all resemblance to actual persons,
living or dead, is purely coincidental. The Spike and Altar bars actually
existed, though both are now defunct. GMSMA (Gay Male S/M Activists),
the New York Bondage Club, and CHC (Chicago Hellfire Club) are actual
organizations, all still going strong. Florent is a real restaurant, and J's
bar still existed at the first printing of this book, but its days are
numbered. New York City is also an actual place, though some would
contend it's more of a state of mind.

First edition.

9 8 7 6 5 4 3 2 1
Printed on acid-free paper in the United States of America.

Carried Away

*is respectfully dedicated to
Thor Stockman, James Olander, Ted Menten,
Joseph Bean, and Master Steve Sampson,
who encouraged its completion*

*and to the memory of
Richard Hocutt & Randy Sauder,
Tim Steffan,
Michael Sussholtz & Jim Strassburger,
and other good friends and comrades
carried away too soon.*

FOREWORD

Roughly ten years ago I wrote a short story about a horny bottomboy who loves bondage, boots, and cop uniforms, meets the top of his dreams at a bar, and goes off with him. I didn't think of myself as a fiction writer at all, although I'd published numerous nonfiction pieces on bondage safety, s/m politics, and other matters. The story was just a little vignette drawn from my fantasies that I enjoyed getting down on paper. But when I gave copies to friends, the invariable response was, "Hot story! What happens next?"

Being a pig for praise (like most writers!), I did my best to generate more of it by spinning out the tale. I got the characters off to the top's home and put them through a moderately intense scene, then let them get to know each other a little the next day before going at it again even harder than before. And the more I wrote, the more it seemed I *had* to write (in both senses of "had"). The characters seemed to take over and direct the story the way *they* wanted it to go, not how I'd planned it.

While I share a lot of turn-ons and some personality traits with the bottom in the story, whose name echoes my own (my first name is Matthew, though no one's called me that since I was a few days old, and "Stein" in German means stone), even in my younger days I could never match his stamina or piggy eager-

ness. And although the top, who's named after the pseudony-mous author of my favorite s/m novel, *The Story of Harold*, began as a pretty transparent wish-fulfillment fantasy, as the story continued he developed quirks and kinks that I'd never put on my personal wish list.

What had started as a hobby turned into an obsession. I sketched out a novel in six long parts, taking these two characters from their "first date" through the first year of a Master/slave partnership. I imposed two unalterable requirements on myself: First, I would not describe any action or situation that was *impossible*, either physically or psychologically — I'd had enough of erotic writing that casually violated not only the laws of the Bible Belt but also those of physics and biology. The goal I set myself was to write a work of s/m fiction that would be true to life, clearly set in the same world we all live in, if seen from a particular perspective. The characters would deal with the same issues real-world gay leathermen have to face every day — like making a living, staying healthy, reducing risks, juggling partners, friends, and fuck buddies, and deciding how far to come out to family members and co-workers. The challenge, of course, was to write realistically while keeping the story erotically charged and emotionally gripping — you can judge how well I succeeded.

The second requirement was to give my principal characters (whom I'd fallen totally in love with) a happy ending. And that's why it took ten years. The invariable advice to beginning fiction writers is, "Write what you know," and what I knew when I started was mostly what *doesn't* work in a Master/slave context — because I'd done it, or my own partner had. As our relationship unraveled, I lost faith, and the novel lay fallow. How could I write realistically about Mastery/slavery if I no longer believed in it? But about six years ago, I made a concerted effort to connect with men who are serious about this path and to learn from them about both its pitfalls — at least the ones I didn't know all too well firsthand — and its rewards. Above all, I met Master Steve Sampson. He enabled me to find my own slavery again and today is my Guardian Master. He encouraged me to return to the novel and try to complete it, eventually making it an order. And the only proper response to that, in His protocol, is, "Sir, yes, Sir. Thank You, Sir!"

It turned out that the only way I could complete the novel was to round it off at the point where the partnership is well begun, leaving further developments to the reader's imagination —

or an eventual sequel. After all, getting the characters that far takes more than a quarter of a million words! If I tried to continue the story in similar fashion through their first year together, as I'd originally planned, the result would rival Auntie Mame's memoirs "in three volumes, boxed, like Proust!"

Besides Master Steve, I owe thanks to a number of people who encouraged me to go on with this project and see it through: Joseph Bean, who rescued the manuscript from *Drummer*'s slush pile and published the early chapters as a serial back in 1992-93; Bob Wingate of *Bound & Gagged* and the Outbound Press, who read an early draft of the novel and said he'd publish it if I could insert more "dramatic tension" (but later balked at publishing the revised version because it had grown so huge); James Olander, a wonderful erotic writer and good friend who critiqued innumerable versions of the manuscript; Ted Menten, who shared not only his own experience with erotic writing but also lessons from his several long-term Master/slave partnerships; and, finally, my own longtime partner, now my ex, Thor Stockman, who has always supported my work in so many ways. To all of these, my heartfelt thanks.

slave david stein
New York City
February 2002

CHAPTER 1

Boots 'n cuffs

I was horny as hell and wasn't going to take it anymore! I'd just worked through the Labor Day weekend at the bookstore I manage in Manhattan. After dealing with tourists and students for three long days, I needed to be with my own kind. I needed to at least see some other leathermen — and preferably do a lot more than just look!

So I went to the Spike. On Friday and Saturday nights in the early '90s, jammed with preppies and jocks and club kids unfazed by the ear-shattering music, it was barely a leather bar at all anymore. But on a Monday night back then it was the only place in New York likely to have what I wanted: a skilled topman looking for an experienced bottom to tie up and deliciously abuse. I'd given myself the next day off, so if I lucked out and went home with someone equally unencumbered, we wouldn't have to rush.

I got down to the bar from my apartment on the Upper West Side by 10:30 — early by weekend standards but just right for a weeknight — and made the rounds, chatting with the guys I knew, giving high-voltage smiles to those I didn't but would've liked to know, trying not to seem desperate to get laid. I pretended this was only a casual night out with the tribe: Just soakin' in the atmosphere. Just struttin' my stuff with the other kinky boys. Yeah, sure — except it'd been weeks since I'd had any action.

I'm not one of those "high disposable income" type fags who can afford to spend most of August lying on the beach or hiking in the mountains, fucking their brains out every night. Nor am I poor enough or young enough to chuck it all and throw myself on the kindness of strangers. Thanks to the September college rush, August, when the city is at its worst, is my second busiest time of

1

the year (after the month between Thanksgiving and Christmas), and I'd been working late and coming in on weekends, too. Result: I was *sooooo* horny for some good bondage I practically creamed just catching the glint of a subway cop's handcuffs. Cuffing and gagging myself at home and jerking off to a porn video just isn't the same as being under the control of another man. I needed to be brought down all the way, to give it all up. I wanted to follow orders and not have to think about it first! Of course, the trick was finding a man I could trust to give me the *right* orders

I'd dressed with calculated casualness. The night was still muggy, so I wore no visible leather except my vest, belt, old (but spit-shined) combat boots, and a braided bolo tie around my bare neck. A tight gray T-shirt covered my nipple rings (while throwing them into relief for anyone close enough to look). Only a few other signals of my interests were showing, like the triple loop of cotton rope circling my right bicep and the neatly folded gray and black hankies sticking out of the right back pocket of my jeans. You'd have had to get me somewhere a little more private to see the tightly buckled leather cock-and-ball harness that helped maintain my basket. (My cock shrivels when I'm not aroused — or am in pain, even if I'm enjoying it — but it's a respectable six inches hard.) I left my curly reddish-blond hair uncovered. Why hide one of my best assets?

In my first turn around the room I had everyone sized up, measured out, and inventoried: Who was hot, and who was not. Who might be looking for what I had to offer. Who was already taken, and who might be available. Who looked more dangerous than I was prepared to take on. Who was hunting, and who was just window shopping. The advantage of going out on a weeknight is that the bar's not too crowded to circulate easily. The disadvantage is that the pickings can be slim. On the other hand, you only need to snare one — one at a time, anyway! And that night I certainly spotted "the one" right away.

I knew him socially from GMSMA and the New York Bondage Club, and though I'd never played with him, I'd watched him work on others. I could almost hear him whistling as he carefully trussed his partners into delirious immobility. He knew the classic moves, all right, but his specialty seemed to be the off-center variation — like putting a guy in a complicated, full-body rope harness, then suspending him from a dozen rubber bungee cords

hooked into the ropes. Hanging in suspension is one thing, but *bouncing*?

His name is Terry Andrews, and he was wearing a full New York City Highway Patrol uniform — one of my favorite uniform fantasies come to life. If you don't live in the city, or aren't a sucker for cops (pun intended!), you may not know that our Police Department even *has* a Highway Patrol division, let alone that on a halfway decent body its uniform is one of the sexiest outfits ever created — and a total anachronism. Patrol officers wear thigh-hugging Navy-blue serge breeches with a light-blue stripe down the outside seam, usually fitted into knee-high English-style black patent-leather riding boots laced at the instep and top (unlike the CHP's Dehners, which have a back buckle at the top — we uniform buffs care about details like that). In cool weather their shirts (light blue back then, changed to Navy blue a couple years later) are covered by double-breasted black leather coats cinched at the waist by Sam Browne belts complete with shoulder straps. Handcuff cases ride neatly centered in the back of their belts, and leather holster flaps cover their gun butts.

The division cap, worn whenever a helmet is unnecessary, is like the standard eight-sided Navy-blue NYPD cap except that the brim is longer and the wire inside (which holds the crisp angles) is removed, giving it a "crushed" look like a soft chauffeur's cap or a 1920s police cap. What makes all this clearly a matter of style, not function, is that most of these guys ride around in cars, not on motorcycles, so there's no reason they *need* the boots and leather coats. But oh, how they howled when the bean counters tried to take them away! Fortunately, they won that battle.

Terry wore the police gear, including the Sam Browne belt but no gun, with an easy self-assurance. (He also stayed close to the bar's air-conditioning outlets, but hey, it was 83° outside!) Unlike some uniform guys, who look like they'd never in a million years qualify for the service whose gear they're sporting (yeah, I know it's a fantasy, but I can suspend disbelief only so far), nothing about Terry was at odds with the persona he was projecting. Quite the contrary: he was tall (half a head over my 5'9"), broad-shouldered, husky, and clean-cut except for a trim pepper-and-salt moustache. His plain features might not earn him a place in most pinup collections, but his face was full of character. The sensuous lips under the 'stache sometimes curved into a

warm smile, more often into an odd, crooked half grin. His eyes betrayed amusement at the variety of tribal plumage on display.

I'd always admired his style, and he had a good rep — no traumatized tricks or resentful ex-lovers in evidence, just a string of satisfied bottoms eager for return engagements. I guessed he was in his late 30s or early 40s, older than my 33 years but still in my generation. While he'd shown signs of interest in me before, every other time I'd seen him out he already had someone at the end of his leash, either figuratively or literally. Tonight he seemed to be unaccompanied — cruising for someone new? Although he'd been talking with a couple of other men when I came into the bar, by my second turn around the room he was standing alone by the wall near the corner door, working on a soda and eyeing the crowd noncommittally.

I walked over, as casually as possible, and stood next to him, trying not to seem too eager.

"Hi, how ya' doin'?" I said after a decent interval — and could have kicked myself for not coming up with something more imaginative. It didn't seem to matter, though.

"Can't complain," he responded in his rich bass-baritone (I'm a sucker for tops whose voices alone command respect). His eyes raked me over from head to foot, and he turned slightly toward me. My heart thumped.

"You by yourself, Sir?" I asked lightly, giving him my biggest smile. Despite the risk in using the honorific so soon, I felt instinctively that he would appreciate it — and it gave me a buzz using it. "Usually you have someone in tow."

"Not tonight — yet," he said. "How about you . . . uh, Matt, isn't it?"

"Yes, Sir. I'm alone, too, Sir," I said, pleased that he'd remembered my name. "At your service, Sir, if you wish."

"Maybe I'll take you up on that," he said, his eyes twinkling and that suggestive half grin on his face. I hoped he was already thinking about how to restrain and torment me! He finished his soda and set the empty can down.

"Would you like another, Sir?" He smiled and nodded. I was walking on eggs as I went over to the bar to get it. I imagined his eyes following me every step of the way — evaluating me, deciding if I was worth his trouble. After handing him the fresh soda, I ventured a compliment on his uniform.

"You look great, Sir. Not many guys appreciate the Highway Patrol uniform."

"I live in Westchester, so I see them every time I drive into the city," he explained. "It's a lot better than what the street cops have to wear."

"That's for sure." *Go for it* "And have you made your arrest quota yet tonight, Officer?"

"Being arrested is just the first step," he said in a stern voice, setting down the soda and moving a little closer. "Are you ready for what comes afterward?"

"That depends," I told him. "I don't know about the third degree, Sir. Besides, you don't have to torture me to get me to talk — more the reverse! But a spell of close confinement and discipline would go down real easy right now — especially since I don't have to go to work tomorrow."

"How close do you want it, boy?" Not even a half grin now, and his voice had dropped half an octave. Standing in front of me, he leaned into the wall, trapping me between his powerful arms.

"As close as you can make it, Sir," I replied firmly, respectfully lowering my gaze. My cock responded eagerly as we slipped deeper into the time-honored roles.

"Turn around," he growled, stepping away slightly. "Put your hands up on the wall and spread your legs."

I complied, but not fast enough, apparently, for he grabbed me by the back of the neck and pushed my face against the wall — not hard enough to do any damage, but firm, real firm.

"Hold it there," he said, then kicked my legs a little further apart. His gloved hands frisked me thoroughly — *very* thoroughly. My nipples each got a sharp pinch, and he twisted and tugged slightly on my rings, as if gauging their size and weight. When he got to my crotch, he groped hard enough that he must have noticed the cock harness — or at least my hard-on. But he didn't say anything, just finished patting me down.

Then he pulled my right arm down and behind me. I felt cold metal on my wrist and heard the clicking of handcuff ratchets — *magic time!* Terry expertly secured my left wrist as well, keeping my palms out the way cops are trained to do, and set the locks. I shivered a little in excitement, and maybe a tiny edge of fear: I was in custody for sure. I sensed other guys watching us — *probably green with envy.*

Terry twisted me around to face him and pushed me to my knees. *This is going* very *fast*, I thought as my head came level with the buckle of his belt. He quickly slipped a dog chain around my neck and pulled it up snug on the end of a leash, holding the leather loop at the end in his right hand. He seated himself on the low bench under the bulletin board and stretched out his legs.

"Clean 'em," he ordered, pulling down on the leash to bring my head closer to his boots. I shuffled backward and bent into a Z-shape, struggling to keep my balance. My jeans pulled tight over my ass, and my hands strained at the steel cuffs holding them against my back. A twinge of worry — *Are we still in the Spike, or have we somehow time-slipped back to the anything-goes days of the Mineshaft?* — skittered across my mind before bootlust took over. I licked my lips and touched them to each of Terry's boots in turn, tasting them and inhaling the scent before extending my tongue and lapping in earnest.

I really love boots. They're often the first thing I notice about a man. Not just *any* boots, though — they've got to be one of the kinds identified with a traditionally masculine occupation. Military boots, cowboy boots, motorcycle or engineer's boots, and police boots are at the top of my wish list, but loggers' boots, linemens' boots, and just plain shit-kicking work boots also rev my motor. When I'm on my knees with my tongue wrapped around a man's boots, I feel connected to his power source, as much as when I'm sucking his cock or getting fucked — maybe even more, since every guy has a cock, but not everyone can wear boots like he belongs in them.

Terry wore his cop boots with authority, and servicing them was a treat. I don't get off on swallowing dirt from boots — for me that isn't the point, more like an occupational hazard — and his were clean (dirty boots wouldn't have fit his spit-and-polish uniform). I licked them with reverence and relish, running my tongue along their glossy smoothness, straining to feel the slight grain in the leather, occasionally brushing my clean-shaven cheeks across the instep or rubbing my nose along the shafts. I pressed down hard at the toes, trying to make him feel my devotion through the thin layer of leather separating us.

Out of the corner of my eye I noticed that we'd attracted a small audience. One of the onlookers actually challenged Terry about the ritual he was witnessing. I caught the words "humilia-

tion," "degradation," "shameful public display," and others along those lines.

"Why don't we ask him?" I heard Terry say, and he pulled my head up off his boots. I licked my lips and grinned at him. "The man wants to know if you feel humiliated, boy, licking my boots in public," he said sternly, but he looked like he was having trouble suppressing a grin of his own.

"Humiliated, Sir?" I asked, trying to sound bewildered. I'd been asked that question before, by vanilla friends and acquaintances struggling to understand my passion — but to get it here, in a famous leather bar, was irritating. "Why should I be humiliated? It's an honor to lick your boots, Sir."

And I enjoy it, asshole, I added silently, meaning the guy whose question had interrupted us. I couldn't see his reaction, but I heard someone quickly walk away behind me. They didn't sound like bootsteps, either.

"Back to work, then," Terry said, grinning openly now, and let the leash go slack. I returned eagerly to his boots, finishing up in front and twisting myself around to get at their backs. I could see guys still watching us, but it felt as if we were alone again, isolated in a magic circle created by his power and my submission to it.

He seemed to be in no hurry, and though I was so excited I could have shot my load in seconds if I'd been able to stroke my hair-trigger cock, I savored the delayed gratification. Being collared and cuffed, kneeling at his feet, methodically servicing his boots — in fantasy the boots of a cop, in reality the boots of a formidable topman I respected and lusted after — was the most exhilarating experience I'd had in months. I was buoyed by the circle of energy flowing between us, a self-renewing current that seemed to travel from his boots through my tongue to my body. It seemed to energize my nipples, cock, and ass, then flow back up to the chain around my neck and along the leash to his hand, where it re-entered his body only to pour down into his boots and back to me. Despite the aches and pains from my crouching position and the constriction of my arms, I wanted this scene to continue forever exactly as it was. Just lick and lick, sniff and rub, and lick again, world without end, amen. . . .

"That's enough, boy," Terry said finally and stood up. He pulled me to my feet, and when I was steady again — the sudden

change of position left me briefly dazed and shaky — he led me to a darker corner of the bar. Standing against the wall, he turned me so my back was against his chest. That put my cuffed hands very near his crotch, and I tried to feel him up through his leather police coat. As near as I could tell, he had a hard-on, too, and he made no objection to my explorations. He pulled my T-shirt out of my jeans and went exploring on his own, running his hands over my furry chest and down toward my crotch. I sucked in my gut, wishing I had six-pack abs to offer him, regretting each gym session I'd missed during the busy weeks. He didn't seem disappointed, though. The leash chain jingled slightly as the hand holding it moved authoritatively over my body.

He held me tight against his chest as he pinched and pulled my nips more vigorously. I arched my head back and moaned as the pain increased, though it was never too much to bear. When he suddenly licked my neck and ears, rasping his mustache along my skin, I melted.

"Ahhh, shit, Sir! What you're doing to me Please take me home with you, Sir!"

"You need it bad, don't you, boy?" he whispered right next to my ear so it sounded loud and intimate at the same time. His hands continued to play with my nipples while his words played with my head.

"I can do anything I want to you, can't I?" he crooned hypnotically, his normally precise diction slurring as he conjured up one bondage scenario after another. "Twist you up like a pretzel. . . . Plug your butt 'n' mouth. . . . Cuff ya spreadeagle to a cell door and whip y'r ass 'n' back. . . . Stick a catheter up y'r cock 'n' feed ya your own piss. . . . Lock heavy irons on your wrists 'n' ankles and an iron collar 'round y'r neck 'n' chain ya to the wall. . . . Hogtie ya 'n' gag ya with a boot. . . . Strap ya to a post 'n' paddle y'r ass till it's cherry-red. . . . Lace ya into an eyeless, mouthless, padded leather hood, strap ya into a leather straitjacket 'n' leg sack, 'n' let ya stew f'r a few hours — or days."

This erotic litany was accompanied by continual stimulation of my nips and half-painful kneading of my chest and shoulder muscles as well as frequent grabs at my swollen, harnessed cock and balls. My stiff dick and whispers of "Yes, Sir" and "Please, Sir" — in between wordless hisses and moans — didn't leave much ambiguity about my consent to his threats, or promises.

"I could fuck y'r face. . . . Fuck y'r ass. . . . Use ya any way I please, ain't that right? . . . Just as long as you're roped or chained or strapped down. . . . Just as long as ya can't resist. . . . Anything I want — long as there's no damage or unsafe sex."

"Yes, Sir! Thank you, Sir!" I called out to show I noticed, and appreciated, those qualifiers.

"Yeah, that's what you want, isn't it? That's what this boy needs, doesn't he?" These final questions were punctuated by really vicious twists on my nipples.

"*Aiee!* Yes, Sir," I exhaled. "*Aarrggh!* Yes, Sir! *Yessir!*" What else *could* I say? He was offering me exactly what I wanted, and I had good reason to trust him. Should I have called for a time out so we could negotiate calmly before witnesses? Would you?

"Let's go, then," he said and started to walk through the bar toward the front door. The leash chain yanked at my neck before I recovered my wits enough to follow him. I was still cuffed, of course, and struggled to maintain as much dignity as I could as we worked our way through the crowd.

Even though I liked being his prisoner, my eyes dropped and my face flushed with embarrassment whenever we passed someone who knew me. Terry noticed, of course, and seemed to make a point of stopping every few paces to say goodnight to a friend or acquaintance, always making sure they knew who he was dragging off, and why. "Gonna take this cocky Matt Stone fucker home and give 'im some attitude adjustment — isn't that right, boy?" was his usual line. Every time I just blushed and answered, "Sir, yes, Sir, whatever you say, Sir." And my cock stayed rock-hard — maybe I *do* enjoy humiliation!

If he'd been a stranger I'd just met, I don't think I'd have gone with him the same night no matter how horny I was. But he obviously had roots in the community as deep as my own, and I was sure he knew what he was doing. Above all, what was happening *felt* right. As we neared the door I glanced over and saw Billy, my favorite bartender, smiling broadly and giving me a thumb's up sign. I assumed it meant he approved of our pairing, but it could have been merely that our shenanigans were good for business.

The hot, stagnant air outside the bar settled on us like a wet blanket. Fortunately, Terry's car was parked only a block away. Coming on it from behind in dim light, plus my other distrac-

tions, I couldn't even tell the make (a confirmed city boy, I'm not much into cars), just that it was low, curved, and silver colored. Since my hands were still cuffed behind me, I expected him to open the passenger door, but instead he opened the trunk.

"Get in," he said.

Shocked, I looked straight into his face. I don't know what I expected to see, but he looked perfectly normal, with only the faintest twitch at the corner of his mouth betraying his reaction to my reluctance. I dropped my eyes down to the yawning trunk and noticed a pile of blankets and rugs.

"Don't worry, boy," Terry said in a kindly tone. "I'll wedge you in so you won't roll around." I fought my own impulse to surrender. *What kind of a man takes tricks home from a bar in his car trunk?* I wondered, then realized how silly it was to balk at riding in the trunk after being led down the street on a leash!

"Get *in*, boy," he said, more sternly. "Don't keep me waiting — unless you want to stay here and go home alone." *The last thing I want!*

Deciding the uneasiness I felt was all in my head — there was still no warning from my gut — I gave in.

"Okay, Sir. I'm sorry, Sir," I said. The trunk had a low lip, so I tried backing into it. I lowered my ass in first, bracing myself with my cuffed hands on the bottom, and then swung my legs up and in. I glanced at him once I was all the way in, sitting there with my head brushing the raised lid. He was grinning now, but crookedly — one corner of his mouth kept dancing up and down. *What's so funny, copper?* went through my mind, but I didn't dare say it.

Once I'd ducked down under the lid and stretched out, lying on my side, he put a thick, doubled-over blanket under my head and cushioned my arms with a folded rug. When he finished adjusting the padding, I felt both secure and fairly comfortable. He unclipped the leash from the chain around my neck but left the chain, gently brushing my face and hair with his hand. Not thinking why, I licked at his gloved palm. He held it close to my mouth, and I nuzzled it like a pup for half a minute.

"Later, boy," he said as he drew it away finally — but he was smiling, not grinning. "Have a pleasant trip."

The *thunk* as the lid closed seemed very final. *Now I'm really committed,* I thought. *No backing out now.* It wasn't perfectly black

inside the trunk — bits of light from the street showed in several places around the lid. It was hot, but I didn't have any trouble breathing, especially after we started moving, and the faintly musty smell, with just a whiff of gasoline, wasn't unpleasant. As we bumped along the local streets, I was grateful for my padding, but when we smoothly picked up speed on the expressway — there must have been little traffic at that hour — I started to nod off.

I guess this means I trust him, I told myself after I'd yawned for the third or fourth time. Just to be sure, I replayed in my mind every moment of our encounter in the bar, straining to detect a false note or a reasonable cause for concern. All I found was more reason to admire Terry's skill at pushing my erotic buttons. I'd had an aching hard-on for the last hour and was still horny as hell, but that was his concern now — nothing for me to do but follow orders. And as he hadn't given me any to the contrary, I figured a little nap would do me good. *I hope Prince Charming is as gracious when we're alone as he was in public at the ball*, I thought as I fell asleep to the motion of the speeding car.

CHAPTER 2

Heavy metal, home style

I awoke when the car's engine shut off. Nothing else happened for some time, and I lay there in the darkness collecting myself and waiting for Terry to open the trunk. My arms and wrists hurt a bit, but I was otherwise okay. In anticipation, my cock started to get hard again.

When the lid finally opened, I was almost blinded by the sudden light. Terry reached in and rolled me onto my stomach so he could unlock and remove the cuffs. When they were off, he massaged my wrists briefly, then smacked my ass and told me to get out. I turned onto my back, swung my legs over the edge of the trunk, and levered myself to the ground. I was a little unsteady and grabbed the fender of the low-slung car for support.

"You all right, boy?" he asked.

"Yes, Sir," I said. "I'll be fine once my muscles stretch out."

"You can give them a start by stripping off those clothes — except your socks," he ordered. "Put everything else in the trunk, then put your boots back on."

My eyes had adjusted by then, and I saw we were alone in a large, well-lit garage, obviously connected to a house, not an apartment building. Except for a black Jeep and a black-and-silver Harley, both looking immaculately cared for, there were no other road vehicles, just a big, sit-down lawnmower. Garden tools hung along one wall. *Not only a house but lots of grounds to take care of. Is he rich? Or did we drive so far north that land is cheap?*

As I skinned out of my stuff, Terry stood beside the silvery gray car, watching me, still in full uniform. The garage was cooler than the city had been but still warm, so he must have been uncomfortable. I folded my clothes neatly and laid them in the

trunk, finally noticing the car's nameplate in the process. *A Jaguar! Is he a millionaire? Car looks real old, though.*

"Don't dawdle, boy," Terry said, snapping my attention back to more important things. I stuck my feet into my boots and bent over to pull them on.

"Should I lace these up, Sir?" I asked when I straightened up again, and he nodded. I propped one boot on the car's bumper but yanked it off when he shouted.

"Get your fucking foot off my car, asshole! Sit on the floor to do that."

I quickly sank to the concrete — which was cool enough to give me goosebumps — and, still facing the trunk, laced my boots. I heard him walking around as I worked and then loud metallic sounds behind me, but I didn't dare look. When I finished, I stood up and turned to face Terry, who looked down at my boots, as if to inspect my work, then pointed at the pile of gleaming bright steel chains and cuffs on the floor between us.

"Put the leg irons on, over your boots," he said.

They were the heaviest "irons" I'd ever seen (and I've seen plenty). Instead of swing-through bows like modern handcuffs, each leg cuff consisted of two metal half-circles, half an inch thick and a couple of inches wide, joined by an integral hinge. The chain connecting them, almost two feet long, could have lifted his Harley. A longer, only slightly less massive chain ran from its center to a similar short chain linking a pair of matching manacles, smaller but in the same heavy-duty proportions.

All the cuffs were beautifully finished, with smoothly rounded edges, and lying open. When I closed the leg cuffs over my boots, the ends snapped flush together and locked automatically. (*Where'd he get these?* I wondered. *Old-style cuffs usually have a flange for a screw lock or padlock.*) The cuffs were loose enough so I could flex my ankles to walk, but I felt their weight immediately even with my boots cushioning them. As I stood up, my leather-harnessed cock was rock-hard and sticking straight out in front of me. Terry noticed it, too, and smiled.

"I see you appreciate heavy metal," he said drily. "Turn around and put your arms behind you."

The leg chain made a racket on the concrete as I turned, and the thrilling noise continued as he lifted the manacles and fastened the cuffs on my wrists. The heavy steel of the connect-

ing chains was cold against my ass, and the combined weight of chains and cuffs immediately dragged my arms down. Even if the manacles had been fastened in front of me, it would've been a struggle to do anything with my hands.

The next thing I felt was a leather head harness being pulled over my face. A thick, chewy rubber plug gag was pushed into my mouth and a stiff muzzle fitted over my jaw. Soft pads completely covered my eyes, but my ears were left uncovered. Terry took his time adjusting the straps and buckles to his satisfaction, pulling the device tight around my head and jaw and forcing the gag deeper into my mouth. He removed the chain collar he'd put on me in the bar and fastened the wide collar of the harness so it was snug but not too tight.

I moaned softly as his hands moved over me, checking that everything fit as it should. My cock was still hard, if anything harder than before, although I was totally vulnerable and helpless. It was hard *because* I was naked, blindfolded, chained, and muzzled, alone with a man I barely knew — yet trusted — in a place I'd never been before. The inescapable reality of my surrender hit me like a drug rush and left me quivering. But it wasn't danger that was turning me on — it was my lack of control. I had no fear that Terry would harm me. My only fear was that I might disappoint *him*. He stroked my chest and stomach and ass gently, reassuringly.

"You're hot as a pistol, boy," he said softly near my ear. "And so am I. We're going to have a *good* time together."

Deprived of sight, I seized on his voice as a lifeline, feeling his words echo in my brain. He turned me around and roughly stroked my hard, bound cock, then pulled me against his chest and held me tight for a few moments. My cock was squashed against his leather coat, and my nostrils filled with the smell of leather from both the head harness and his uniform. I inhaled deeply, then let it out slowly. He pushed me away slightly and grabbed my cock again, fingering the leather cock ring and ball stretcher I'd put on hours earlier at home.

"I had some ideas for this equipment of yours, boy," he said, "but this'll do for now. You've even got a D-ring here I can use." I felt him attach something to my ball stretcher, then, "Walk where I lead you."

I felt a steady tug at my balls — the leash, presumably. The

chain between the leg shackles rattled on the concrete as I followed him away from the car. The sound only added to my excitement. I was moving pretty slowly — those chains were *heavy* — but he didn't rush me.

After a short walk the tug on my balls slackened, and we stopped. I thought I heard him unlock a door and push it open, and I was sure of it after he led me through and the sound of my chain became louder and higher-pitched, suggesting it was now dragging on ceramic tile (*no cheap linoleum flooring for him!*) instead of concrete. The air was much cooler, and I could feel currents against my skin from the air conditioning. Terry continued to direct me with the leash until we reached a staircase, and then he stood behind me and guided me up with a hand on my back.

Judging by the resonating clatter of the heavy chain, the steps were wooden, but they felt as smooth as glass under my boots. After we reached the top and passed through another door, Terry returned to leading me by the cock leash. The air felt even cooler, and I shivered slightly. (*He probably feels a lot better, though, in that hot uniform.*) The sound again suggested a tile floor, and it seemed to echo in a large room filled with hard surfaces. We passed through yet another doorway, a sliding one it sounded like, and the air became warm again and was scented with flowers. *What the hell . . . ?*

My chain seemed to drag on stone for a few steps, and then it was almost silent as I walked across something soft, yielding. Suddenly I was on stone again. We passed through another sliding doorway into chilled air. The sound of the chain, and the *lack* of sound from our boots, as we crossed the room suggested carpeting over a solid floor. We moved through another doorway onto tile again. Terry stopped me when my shins touched something smooth and hard.

"You probably need to piss," he said as he pushed down on my hard cock, aiming it. "Go ahead. This will be your last chance for a while."

Did I need to piss! The sodas I'd had at the bar were all lined up in my bladder, aching to come out. But I've always been piss-shy, and to take a leak in this situation — excited, erect, in bondage, and with a hot topman holding my hard cock — was almost impossible. I strained. I tried to relax. I thought of canoes on a river, waterfalls . . . eventually my dick softened and a few drib-

bles of pee came out, then a steady flow. *God, that feels good.* When I finished, Terry shook my cock dry — it got hard again instantly — and turned me around, then led me out of the bathroom and partway across the carpet we'd traversed earlier.

"Stand there," he ordered, and I sensed him moving away from me. I listened to the soft sounds of doors and drawers opening and closing, equipment being sorted through, and other, unidentifiable noises. *Are we in his bedroom?* In a few minutes Terry came back and again took hold of the D-ring on my ball harness. He unclipped the leash, then pulled the chain hanging from my manacles through my legs and attached it in the same place. I groaned at the sudden pain as the chain's weight pulled on my balls, but after a few moments it subsided to a dull ache. I took several deep breaths, filling my lungs with oxygen, preparing myself for his next assault. *It hurts so good*, I thought.

I wasn't surprised when he began kneading my nipples and pulling on my nipple rings, but I still moaned loudly when he attached a strong clamp first to one nip and then the other. There was a light chain between the clamps — I could feel its pull and the coldness of its links against my chest. My heart pounded and sweat slicked my body in response to the pain-pleasure in my nips, balls, and arms. Terry stroked my damp chest hair with his gloved hands, then held me against him and stroked and lightly slapped my backside.

"You look good, boy," he growled close to my ear, continuing to stroke me and at times to lick and bite at my shoulders and chest. "I bet you hurt, but it hurts real good, doesn't it, wearing those heavy chains and that tight head harness for me? . . . You like having your tits and balls pulled, don't you? . . . You like being blindfolded and gagged and led around on a leash, don't you? . . . Yeah, sure you do. That's what you need, boy. And I'm gonna give you plenty of it, gonna keep you here, all tied up, for as long as I want. . . . You'd like that, boy, wouldn't you?"

If I'd said no — which I couldn't do in any case, being so well gagged — my stiff cock would've proved me a liar. I moaned through the gag and nodded my head. I figured "tied up for as long as I want" meant until he got his rocks off two or three times — *I'll probably be back home before lunchtime tomorrow, or is that today? Whatever.* I'd lost track of the time because of my nap in the car trunk, but it was probably well after midnight.

Terry pushed me backward a little and adjusted my position from side to side until I was where he wanted, and then I felt a pull at the top of the head harness and more cold metal against my back. I tried to bend my head again but couldn't. *He must've fastened me to a chain from the ceiling.*

He pulled my manacled hands upward behind my back, fixing the chain between them so my wrists hung together over my kidneys. The chain from the manacles down to the leg cuffs, still clipped to my ball harness, pulled tight into the crack of my ass.

"You're anchored, boy. You won't fall," he said, smacking my butt, now a clear target. I swayed a little but couldn't move very far. "You just stand there while I get comfortable. . . . Stand there 'n' suffer. Think about what else I'm gonna do t' you . . . and about what you're gonna do for me."

I wasn't really suffering yet, actually. My balls didn't hurt so much from the weight of the chain hanging from them now that I wasn't swinging it back and forth as I moved, and my nips had gone numb from the clamps. My arms were getting sore, but I could deal with that. The air felt warmer, too, as if he'd noticed my shivering and adjusted the temperature setting. I hawked up some spit to moisten the gag, then tried again to move my head. While I couldn't move it at all off the vertical, I *could* twist a little from side to side. But since I couldn't see anything, there wasn't much point.

My boots were firmly planted on the floor — I was grateful he hadn't pulled me up on tiptoes — and I found I could ease the tension on my head and arms a little by moving my feet closer together. But my legs and thighs felt better with a wider stance, so I soon moved them back.

I imagined Terry watching me and grinning as I made these pathetic attempts to regain a little control. The carpeting muffled his movements around the room.

What did he mean, anyway — "get comfortable"? I hope he's not changing into a bathrobe and slippers! I wriggled my shoulders and tried twisting my torso a bit, just to keep some circulation going. Of course, that made everything that had gone numb start hurting again.

Did he plan all this? Sadistic bastard! Is he lying on his bed watching me twitch? . . . Playing with himself? Getting ready to plunge into my mouth or ass? . . . It's too damn quiet!

I couldn't even be sure he was still in the room with me. *Could he have gone off and left me? Maybe he's watching a movie on TV elsewhere in the house. . . . Aarrggh!*

The waiting more than the pain was getting to me. I twisted violently any way I could, lifting my feet from the floor and kicking out, almost turning all the way around, setting my chains jangling until I was sure he'd have to come see what was the matter. Nothing. Not a sound. I slumped back into the forced parade rest, exhausted by my tantrum. I pulled in great lungfuls of air through my nose, then sighed them out.

Just as I was calming down, concentrating simply on breathing, I felt a leather-gloved hand lightly cup first one asscheek, then the other. I went rigid. Next I felt the sting of an open palm land square on my ass. *Thwaaack!* I jerked at the impact. It was followed by another and another and another, a rain of blistering full-force blows.

At least I have his attention again! I felt warmth spread over my ass and imagined it reddening under his hand. The spanking was mostly pleasurable for a while, but then he changed from his hand to something hard, like a paddle or stiff strap, and I *really* felt it. My whimpers became groans, then muffled screams. Tears were flowing down my cheeks before he finally eased off, going back to medium-force smacks with his hands before changing over to gentle caresses that quickly had me melting again.

"Hard of hearing, boy?" he asked, continuing to stroke and knead my back and shoulders and chest. "Didn't I tell you to stand there quietly and wait for me? . . . Did I say you could dance around and try to pull my ceiling down?"

"Nnrrgh! Mmnnff!" The gag proved very effective.

"You've gotta learn patience, boy," he continued, ignoring my noises. "There's a lot of dead time in confinement, a lot of waiting around with nothing to do, nowhere to go, no way to move. . . . That's where you are, boy, in my custody, just like you asked. Whether I chain you up here in my bedroom or lock you in the cell I've got downstairs, I expect you to behave yourself. A nice, model prisoner, that's what I want."

Although I suspected him of deliberately manipulating me into reacting the way I did, Terry's more-in-sorrow-than-in-anger tone made me feel ashamed, as if I'd let him down. I'd have hung my head like a kid caught raiding the cookie jar if I could move it.

"I told you to get some thinking done while you were waiting, boy. Do you remember?" he asked as his busy fingers stroked and tickled and pinched me everywhere he could reach. I struggled to comprehend his words over the distraction of his manual messages, which had me gyrating frantically.

"Did you do like I said? Did you think about serving me? Did you consider what a favor I'm doing you, bringing you to my house, chaining you up, giving you the discipline you need? . . . I'll bet you didn't. I'll bet all you thought about was how uncomfortable you were and what you wanted me to do about it."

Between the tickling and the pinching and the gentle stroking, I couldn't have said *what* I wanted him to do. Part of me wanted him to stop, part wanted him to continue, and part just wanted to howl like a dog at the moon.

"Well, no matter — for now," he continued. "You don't need to think tonight. I'll do the thinking for both of us. You just do what I tell you." *Sounds good to me!* I was too far gone in heat to think clearly anyway.

"Now that I've got that ass of yours nice and warmed up," he went on, "I'm going to stick something in it. . . . Something to keep it feeling good. . . . I'm going to plug you up nice and tight, boy. . . . Just relax your asshole and let me in easy, 'cause I'm comin' in anyway." *Why am I not surprised?* I couldn't resist the silent gibe, and yet I *wanted* some ass action.

The chain between the manacles and leg irons fell away from my balls and pulled out of my asscrack. I felt the anchor chain jiggling as he reattached it there, and then he turned me slightly to one side so it was out of the way, pulling my arms off-center. In a few moments something cold and greasy poked at my hole. *His finger? Too small for a butt plug.* He shoved it in slowly and moved it around, then pulled it out and paused, probably checking for shit (I'd douched before I left for the bar, so there shouldn't have been any), then stuck it back in, rolling it around, pressing on my prostate. The patient foreplay — more than I was used to getting! — soon had my ass dancing. Terry's exploratory digit was joined by another, and then another, twisting around inside me, opening me up, making me moan from pain turning into pleasure.

"Just so you know, boy," his dark-honey voice told me, "I'm using a latex glove, and I have a condom ready. Nothing to wor-

ry about at all. . . . Just relax. . . . Enjoy yourself. . . . Give your ass to me . . . give it up. . . . Let go. . . . Relax. . . . That's right, you're getting it. . . . I'm goin' to give you what you need. . . ."

I didn't need much convincing. His fingers in my ass felt great, and when he replaced them with his rubbered and lubed cock, I bucked back to take more of it with each thrust. He had a nice-size cock, not small and not too big. He managed to rub my prostate with almost every stroke. While he pumped, he played with the chain hanging off my tit clamps and with my hard dick, pulling and twisting, giving me an overload of intense pleasure-pain sensations. At one point he pulled a rubber over my own cock, but he didn't handle it otherwise.

I gave myself over to pure feeling as he continued to fuck me and play with me. I was moaning and chewing on my gag, struggling to remain steady on my feet as he pumped my ass. *Shit, that feels good!* When Terry finally shouted, "I'm coming!" and pulled off the tit clamps, the pain was like a flash fire in my head that raced down to my nuts and exploded into ecstasy. I screamed into the muzzle, my ass spasmed around his thrusting cock, and I shot my load, too, without a hand on me.

I was happily wasted by the time Terry pulled out. I had to struggle to remain standing and not just hang like wet laundry from the anchor chain holding me at wrists and head. He stood for a while with his arms around me, gently fondling my sore nipples, rubbing something damp and creamy onto them.

"I'm giving you my cum, boy," he said into my ear, running one finger under my nose. I breathed in the spicy smell, intoxicated by it. "You can't swallow it," he continued, "but I can still give it to you, rub it on your nips, your pecs. Feels good, doesn't it?" I moaned assent. "Bet you wish there was more of it. . . . Well, there's plenty more — you'll just have to work harder to get it out of me."

Next he pulled the condom off my cock and held that up to my nose.

"Smell that, fuckass? That's *your* ball juice. Come on, smell it!" I inhaled deeply, obedient but unimpressed. "You shot just from me fucking you." *Well, a few other things helped!* "You shot without permission, but that's okay. I'll overlook that." *Why'd he put a condom on me if he didn't expect me to shoot?*

"It's always a good sign," he said, unaware of my silent

commentary, "if a bottom comes when I fuck him. Shows that we're *simpatico*. Shows he enjoys my using him."

I do enjoy a good fuck, I conceded silently.

Terry unstrapped the muzzle and pulled out the gag.

"I *never* waste cum, boy," he announced while I was flexing my cramped jaw. "What you can't eat gets smeared on you. But *this* you can eat. Open up."

I opened my mouth and stuck out my tongue for what I assumed would be my own cumload. It was cold, viscous, and adulterated with lube from the condom I'd worn.

"Down the hatch now, boy."

I pulled in my tongue and swallowed the glob of semen. *I've tasted better — but that was long ago and far away.*

He surprised me then by putting the gag back in and replacing the muzzle covering it. *Is he afraid I'll say aloud what I've been thinking? Just joking, Sir!*

"Back in a minute," he said. "I have to get something before I let you down." I groaned in disappointment (my arms *hurt*).

He was as good as his word, and soon I felt his fingers probing again at my asshole.

"Just need to slip this plug into you, boy, to keep your hole filled. Don't want you to forget how good it felt."

As if I could! That was a fuck and a half!

"Ummph," I groaned as he worked the plug into me. It was wider than his cock, so I had to stretch, but it was well greased and soon slipped past my assring, which immediately clamped shut around its neck. While it didn't penetrate as deeply as his cock had, it made me feel nice and full. I automatically flexed my ass muscles around it, but it wasn't going anywhere.

While I was adjusting to the butt plug, Terry unclipped me from the chain holding me up and helped me down to the floor. I felt the plug shift in my ass as I folded my legs under me.

"You can rest here for a while," he said. "I'll come get you when I'm ready."

Ready for what? Can't we just go to bed now?

Exhausted, I stretched out on the carpeted floor, still blindfolded and gagged, my arms still chained behind me and heavy irons on my booted feet.

CHAPTER 3

At your service, Sir!

Lying on the floor, I heard water running at a distance, and then soft, spacy music began playing. I must have dozed off again after that, because the next thing I was aware of was Terry's boot nudging me in the balls.

"Wake up, sleepyhead," he said from some height above me. "I'm not finished with you yet. Kneel up."

I struggled to get upright, feeling the plug shift in my ass when I changed position. Terry helped me, and when I was back on my knees, he bent my head down to get at the buckles on the back of the head harness. He pulled it off in one piece — blindfold, gag, muzzle, collar, and all. I blinked in the sudden light, which was actually fairly subdued, and worked my stiff jaw as I looked at him.

He hadn't changed out of his uniform, just taken off the Sam Browne belt, leather coat, and cap. His basket was directly in front of me, and I saw for the first time that the crotch of his breeches was black leather instead of blue serge — the NYPD would hardly approve, but I sure did! *Bet the seat is leather, too*, I speculated, licking my lips in anticipation. His blue uniform shirt, however, was completely regulation in style, including badge, nameplate, and collar tabs. The short sleeves showed off his muscular, hairy forearms, and more dark body hair poked out of the open neck (he'd also taken off the regulation necktie).

On top, his hair was salt and pepper: mostly gray with some black, clipped short in a military brushcut. In place of the police-issue gray leather gloves he'd worn in the bar, however, he now had on a skintight black pair (*the better to pinch me with?*). A plain black leather collar and leash dangled from his left hand.

22

So that's what he meant by "getting comfortable." I felt my face redden in sudden embarrassment at my silent sarcasms.

"Finished staring?" Terry asked. He had that crooked half-grin again, as if he knew just what I'd been thinking — or had a good idea.

"Sorry, Sir, but you look so hot," I said, lowering my head respectfully. On a sudden impulse, totally turned on again, I bent down and kissed his boots. He allowed the gesture but cut short my boot worship, at least for the time being, by buckling the collar around my neck and attaching the leash.

"Follow me," he said as he turned and began walking away. He gave me no chance to stand up, so I shuffled after him on my knees, straining to keep some slack in the leash. We headed across the pewter-shade carpeting past a brilliantly colored area rug toward a reddish-brown leather club chair in the far corner of the large room. Glancing around, I realized that none of the room's "corners" was a right angle.

Behind the club chair was a long wall covered floor to ceiling with burgundy drapes. The ceiling sloped upward from there to the opposite wall behind me. Made entirely of glass, with the same burgundy drapes pulled all the way open, it was noticeably higher. There seemed to be a garden beyond the glass. *Did we walk through there? That would explain the flower scents and the warmer air.* The chain I'd been attached to was hanging from the ceiling between the garden wall and the huge, leather-covered bed jutting out from the middle of a long, slanted wall joining the other two.

When we arrived at the chair, Terry pushed away the matching ottoman and sat down, then pulled me close to him with the leash. He picked up a beer can from a low table next to the chair and put it to my lips.

"Drink," he said. "You're going to need it."

The beer was still cold, and I gratefully drank perhaps a third of the can before he pulled it away.

"Start on the boots again," he said, "but this time you can work all the way up here," indicating my goal with a hand on his ample basket. A firm pull on the leash directed my face down onto his boots.

It wasn't hard to renew my enthusiasm for tongue-worshipping those black-leather columns planted in front of me, and I was eager to follow the trail all the way up to his crotch, from

which rose a heady mix of ball-sweat and leather. My chains rattled as I lapped boot leather, and my ass clenched spasmodically against the butt plug. The tip of it seemed to touch the base of my own cock as I knelt at Terry's feet.

I moved back and forth from one boot to the other, working my way up the shafts. I was neglecting the backs, and the soles, because I was so eager to get to his crotch. I thought he'd let it pass, but just as I was about to move my tongue from the top of one boot to the pant leg emerging from it, he halted me and stretched his legs out, away from the chair.

"Don't be sloppy," he said. "Do it all."

"Yes, Sir," I said, and pulled back to lick the sole. Fortunately, nothing nasty was sticking to it. *Brushed clean by the carpet, I guess.* When I finished, he presented the other bootsole for my tongue, and after that was clean, too, I jackknifed myself under his legs to lick the backs.

When I'd finished both boots to his satisfaction, he pulled my face back to his breeches, to continue licking from where I'd left off, just above his boot tops, inching closer to the bulge of his cock, first on one side and then the other. The blue serge felt rough and dry under my tongue, and though I appreciate authenticity as much as the next uniform fetishist, I didn't linger.

My arms and wrists hurt from the pull of the heavy cuffs and chain, my jaw ached from holding it open so long, my knees were sore, and my tongue was raw. We'd both come already, and my cock was drooping again. *Should I tell him I'm sorry, but I'm tired and want to go to bed — or home?* I didn't think he'd *force* me to continue serving him, or hold me against my will. On the other hand, I hated to give up before tasting his cock. Or at least seeing it!

He gave no sign of noticing any slackening in my efforts, and I realized that despite the discomfort, I found the slow, methodical service I was giving him curiously satisfying. As he'd said, I didn't have to think about anything (not that that ever stopped me!). I needn't make any decisions or plans. All I had to do was lick, breathing in the smells of leather and cloth and male flesh.

From time to time he ran his gloved hand over my head or face, as he'd do for a dog he was petting. Sometimes he put a hand between my mouth and his breeches, and I licked that in-

stead. When he inserted a finger in my mouth, or two or three, I made little noises as I sucked them, between a purr and a moan. The pains I felt receded in my consciousness, and my cock slowly stiffened again.

"Good boy, good bootlicking crotch-sniffer," he said to encourage me as I approached my goal. "That's right, that's the way to make a man feel good. That's what your mouth is for. . . . No talking, no thinking, just licking . . . slobbering over a man's boots and crotch. That's what you're good for. . . . Isn't that right, boy?"

I bobbed my head and mumbled my assent without taking my mouth off his leathered thigh. I didn't really *believe* my only purpose in life was oral service, nor did I think Terry believed it. Yet his words were intensely exciting: they liberated the part of me that *was* just a sensual animal — freeing it, for a time, from the shackles of my workaday life as a responsible adult member of society. It felt damned good to let all of that go for a while, and I licked harder.

Finally, I reached his crotch. I licked furiously up and down the leather fly, feeling the half-hard cock beneath it with my tongue, feeling his fingers in my hair, pressing against my skull. But he was in no hurry to take his cock out. First he slid as low in the chair as he could and shoved my face back between his thighs so I could lick leather all the way from his balls to his asshole. I struggled for air as I buried my face between the leather of his pants and that of the chair.

Eventually he pushed my head away. I sat back on my heels as he got comfortably seated again. Then, slowly, watching me watching him, he unzipped his pants. He'd already fucked me with his cock, but as a connoisseur of manmeat I was eager to *see* it, to memorize its special shape and qualities — and to savor its length and thickness down my throat.

His cut cock sprang to attention in front of me. About seven inches long, it was perfectly proportioned from the mushroom head to its root in his thick pubic bush. The head was a little purplish, and the shaft was all pink and red and white, traced with the faint blue of veins. It was *gorgeous*.

Terry dug into his pants opening and freed his balls as well — big furry eggs hanging low in their sac. I licked my lips, not even thinking about safety issues. Fortunately, he never forgot about them.

"I like you, boy," he said, "and as a special treat I'm going to let you suck my cock. But we're not going to take any chances. You can get the shaft nice and wet and hard, and then I'm going to put on a rubber before you deep-throat me. Now, get your face down here and lick."

I didn't need more urging. I tongued his dick from just below the tip to the root, then back again, up and down and around, slurping along it as if licking a Popsicle. I could smell his precum, tantalizing and luring me, but he wouldn't let me risk tasting it. Probably my own cock was dripping even more, but I didn't have any attention to spare. Terry's cock grew noticeably harder as I tongued it.

"That's enough, boy," he said finally, pulling me off. "Suck my balls while I put on the rubber."

I lowered my head and hunched even closer to him so I could get at his balls without being in his way. I licked each fragrant orb, then sucked it into my mouth and rolled it around. I tried to get both of them in at once but couldn't manage without help. Terry pushed the wayward ball into my mouth and patted my head. My nose was buried in his pubes. My eyes closed.

"Ahhh, that's good, boy. . . . Don't worry too much about your teeth — I like it a little rough, too. Go ahead and chew on the sac."

That made it easier, as I could clamp down with my teeth on the neck of his scrotum to keep the balls in place. I breathed through my nose and held on, rubbing my tongue along the underside of his balls from time to time. I could still smell leather, but the sweat and sex smell was stronger.

"All right, boy, you can let go now," he said. I pulled off his balls and saw his hard cock, a black condom stretched over it.

"Chow down, cocksucker," he said. "Take it all."

I took a deep breath and plunged the full length down my throat. Now, *that* was an all-day sucker! I let my throat muscles ripple around his embedded cock for as long as I could, then pulled off slowly, breathed deep, and went down on him again. Soon Terry decided that *he* wanted to control the rhythm. He held my head and thrust his hips up as he fucked my face, in and out, in and out

He was primed, and it wasn't long before he gave a final thrust and held it in my throat as he shot his second load of the

evening. He didn't shout the way he did the first time, just sighed loudly, "*Aaahh!*"

He held my head down on his cock for at least a minute after he came — I could feel it jerk in my mouth as the last drops spurted into the condom, then slowly soften. It was still semi-hard when he pulled out. A little to my surprise, he bent his head down and gave me a deep kiss.

"That was nice, boy. *Very* nice," he said when our lips unlocked. He leaned back in the chair and looked down at his cock. "You know what to do, boy."

I had a pretty good idea. I bent back down to his crotch, caught the end of the rubber in my teeth, and carefully pulled it off him. I sat up again and faced him, my trophy dangling off my chin, cum starting to drip from the open end onto my chest.

"I never waste cum," he said again, taking the used rubber and methodically squeezing its load onto my face. He spread it around with his thumb until my cheeks and chin and forehead were thinly but thoroughly coated with the fast-drying slime, then wiped the residue from his glove and cock on my chest. I inhaled deeply, letting the sharp smell penetrate to my brain. Instead of an animal now, I felt like one of those "golden noses" who grade coffee or blend whiskey purely by the aroma, without having to taste it. *Ah, yes! I* judged authoritatively. *Grade A, No. 1, gay American cum! . . . Hmm . . . New York City, 1992 vintage, I'd wager.*

"It's bedtime," Terry said, temporarily breaking the sex spell I'd been under, freeing me to respond again to other messages from my body.

"Please, Sir, I need to piss."

"I know, boy," he said. "So do I." He looked at me, frowned, and sighed deeply. *Did I say something wrong?*

"Y'know," he said, getting to his feet, "I'd *love* to give you my piss right now — just shove my dick in your mouth and let you drink it fresh from the tap. I'll bet you'd like taking it, too."

Would I? Yeah, I would, but . . . another sigh from him.

"I can see it worries you, Matt. I'm not infected with anything, but how can you be sure? I can't expect you to trust me that much yet. . . . Wait here while I go to the bathroom. I'll bring back something for you to piss in."

"Thank you, Sir," I said with sincere gratitude. His only answer was a growl.

I stayed on my knees in front of the chair, struggling to keep my own pee from dribbling onto the carpet while I listened to his stream into the toilet. Before I had an accident, he returned with a large, wide-mouth glass jar and set it down between my legs.

"Piss into that, boy, and you'd better not spill any."

As my hands were still chained behind my back, the only way to be sure of my aim was to crouch over the jar and lower my cock into it. The pleasure of letting my bladder empty was mixed with the anxiety that my unguided cock would slip out of position and spray the piss around. And the damned butt plug kept poking different places inside me every time I moved. I was able to complete the job without mishap, but the concentration needed prevented me from sneaking a look at whatever Terry was doing in the meantime. I heard a rustling sound behind me, over on the bed, like leather being unfolded, and a few clinks of chain, but I had no idea what he was preparing.

I sat back on my heels to signal that I'd finished. Terry returned and helped me to my feet. He kept an arm on my elbow to steady me as we walked over to the right side of the king-size bed. My shoulders and arms ached from the weight of the heavy manacles and connecting chains I'd been wearing almost since he took me out of the trunk of his car — *two hours ago at least*, I calculated. When we reached the side of the bed, he halted me and started removing the chains.

I noticed a large, framed photo of a couple of leathermen hanging above the head of the bed, but right then I was more interested in the sleepsack and hood he'd laid out on the near side, along with some rope and other gear. The smooth black leather, silver buckles and rings, lengths of chain, and white rope stood out against the dove-gray bottom sheet (he'd turned down the bedding on that side). Seeing all that, I didn't expect a very long interval of freedom, but I wasn't unhappy about it — in fact, my cock stiffened again at the thought of my whole body being laced into leather. Still, I was eager for a break from the heavy chains.

As soon as the manacles were off, I brought my arms around in front of me and rubbed my wrists. Then I shrugged and rotated my shoulders for relief while Terry knelt to unlock the ankle cuffs. After he unbuckled and removed the leather collar, I ran a hand around my neck, feeling less relief than a strange disappointment.

"Better limber up while you can, boy," he said. "Then take off your boots and socks."

Obediently, I bent and stretched my arms and legs, and rotated my head, until I felt reasonably loose again. I stayed near the bed while Terry carried away the discarded gear and stowed it in a walk-in closet next to the bathroom. After my *faux pas* in the garage, I knew better than to sit on the bed, so I got down on the floor to take off my footgear. Terry hadn't emerged yet, so I took the opportunity to massage my feet and toes, closing my eyes and sighing at how good it felt.

Naturally, Terry returned before I was finished, and when I opened my eyes he was standing over me, his arms crossed on his chest and one boot toe tapping the carpet. He didn't look mad, but the corner of his mouth was twitching, so I stood up again in a hurry. He simply pointed to my boots and socks, then at the wall next to the night table. I stowed them as ordered and came back.

I wondered if he'd remove the butt plug before putting me into the sleepsack, but he just asked if it felt okay (I told him it did) and checked that it was securely in place. Then he picked up the hood and slipped it over my head. It had eyeholes and an open mouth, as well as nose holes, and was luxuriously lined and padded. The detachable blindfold and muzzle were lying on the bed.

The hood hadn't been made to my measure, of course, but by adjusting its laces and straps Terry soon had it comfortably snug all around. An ingenious sort of bellows let me open and close my jaw without altering the fit elsewhere — I'd never worn a hood so well designed for cocksucking or bootlicking. As usual, despite the padding over my ears, sounds were only slightly muffled. When Terry was satisfied with the fit, he ordered me to get on the bed and into the sleepsack.

The sack was lined with smooth leather, too — *first-class all the way!* I eased my naked, tired body into the cool, glove-soft black-leather maw and my feet into the bag at the end. I wriggled around in pleasure, it felt and smelled so good, but Terry soon directed my attention to the arm sleeves. So recently released from restraint, my arms were quickly encased in leather past the elbows and effectively immobilized once again.

"I'm glad you like my sleepsack, boy," he said, grinning,

and tapped my hard-again dick. "You may feel differently after you've spent the night in it, all strapped up."

He's probably right, I thought, but I didn't care — and there wasn't anything I could do to prevent it anyway. I just lay there, smiling broadly and happy as a pig in shit inside my full-leather cocoon.

Terry removed my cock-and-ball harness and instead tied a long strip of soft leather tight around the base of my genitals. He fastened the sleepsack's collar to the hood's collar, inserted pads between my ankles and knees, and zipped the sack shut from both ends, leaving only my hard cock and balls sticking out where the zippers didn't quite meet. The sack fit somewhat loosely with only the zippers closed, but he began lacing a long rope through the rows of small D-rings on both sides, and it gradually snugged up.

It took some time to lace it all the way, and through the eyeholes in the hood I could see him bending over me as he worked. He had a sure economy of movement, as if he was performing an oft-repeated procedure (you don't buy a sleepsack like that and not use it whenever you can!). When he was finished and had tied off the rope, I could barely slide my calves against each other, and my arms were held firmly against my sides. It didn't feel tight, exactly, but my body was completely immobilized.

I could still roll my head around a bit until he put a pillow under it, snapped the end of a chain to the top of the hood, and fastened the chain to the bed frame. The tension at the top of the hood pulled it tight it all around my head and face, and now I couldn't look anywhere but straight up. (Amazingly, I could still move my jaw, and because the hood's collar was fastened to the sleepsack, there wasn't too much pressure on my neck.) When I felt a tug at my feet, I inferred that Terry had chained that end to the bed as well. And *then* he started fastening the heavy straps along the front of the sack!

"You're going to spend the night in this, boy," he explained as he worked, "so I won't pull these real tight. Wouldn't want to cut off your circulation."

When he'd finished, my encasement felt just a little more snug where the straps crossed my body at ankles, knees, thighs, waist, and chest. The thigh strap also held my fingers flat, and the waist strap pulled my elbows in closer. I wasn't in any pain from the constraint, and the feeling of secure immobility was de-

licious. I was quite warm inside the double thickness of leather, of course, but the bedroom was comfortably air-conditioned and I hadn't started to sweat yet. (Terry's face was beaded with sweat, and it struck me, not for the first time, that bottoms outnumber tops because tops have to work harder — the good ones, anyway.) The only oddity was not being blindfolded. Whenever I'd been totally cocooned in the past — more often with plastic wrap and duct tape than leather — I hadn't been allowed to see.

With Terry out of my visual range, I contentedly stared at the ceiling. I heard water run in the bathroom again and later some rustlings and a couple of small thumps on the other side of the bed. The light dimmed even more, and I felt him move over next to me, though there was plenty of room in that bed if he'd wanted to leave me alone. Music was still playing softly, but mellow jazz piano, not the spacy stuff he'd put on earlier.

After a few minutes, Terry propped himself up and looked down into my eyes. He'd undressed, at least as far as I could see. *Now I'm in "full leather" and he's naked. Nice . . . very nice.* My cock, which had never entirely softened since I got into the sleepsack, stood proudly erect, demanding attention I was in no position to give it — and I didn't really expect any more from him.

"Comfy, boy?" he asked. He had his lopsided grin again, which I was quickly learning meant: be ready for anything.

"Yes, Sir, thank you, Sir," I replied, smiling. "It feels great."

"That's good. You *look* great, too, boy, all wrapped and tied and strapped in leather — like a big butterfly larva. But you don't need to see anymore." With that he snapped the blindfold on, then buckled a strap around my hooded head to hold the thick pads tight against my eyes, effectively blocking all light.

"Ahhh," I moaned softly, feeling complete. "Thank you, Sir. That's perfect, Sir." I felt Terry put an arm around me, throw one leg across my body, and rest his head on the pillow next to mine, close enough to nuzzle my hood. I was half dozing when he spoke again, right at my ear.

"I had a good time with you tonight, Matt," he said. "I'm glad you came on to me in the bar the way you did."

"So am I, Sir."

"Well, I think you deserve a reward. I'm going to let you come again before we go to sleep. Open your mouth."

He stuck four fingers of his bare hand into my mouth.

"Wet it good," he warned, "'cause that's the only lube you're gonna get."

When his spit-slimed hand first stroked my hard cock, I almost screamed, it felt so good. He teased me, slowly running his hand up and down the shaft and twirling one finger around the head. I was leaking — I could taste my own precum when he returned to my mouth for more spit.

It's surprising I didn't shoot quicker, but when I'm stimulated for a long time without coming, as I'd been the last hour or so, it takes a while to convince my gonads they can really let go. Terry fondled and stroked my cock lazily while I moaned and did kegels, trying to fuck his hand.

After a few minutes of this pleasurable torture, he used his secret weapon. He reached under my ass, poked into the sleepsack through the back-door opening, which he'd obviously left unzipped on purpose, and fingered something on the end of the butt plug. It started buzzing inside my ass! *The damn thing's a vibrator!* I was a goner, then. He gave my dick maybe half a dozen hard strokes before I went berserk and shot like a cannon.

"*Ahhhggh!*" I screamed, uselessly thrashing against my tight restraints. Terry immediately yanked the end of the leather strip binding my cock and balls, and it unwound, flipping my package every which way in the process. I shot again! He clamped a hand over my mouth and continued to play with my cock. I yelled into his palm twice more until my whole body went limp finally, except for a little twitching, and he switched off the vibrator.

"Oh, God, Sir! . . . Thank you, Sir! . . . That was incredible, Sir! Thank you!"

"You're welcome, boy. Now lick my hand off."

He'd caught my cum — or scraped it off wherever it landed — and was feeding it to me. I licked and swallowed between pants for breath. *When have I ever come like that?* I marveled. *It makes what happened earlier tonight seem like nothing.*

He let me lie undisturbed till my breathing returned to normal, then said I'd better piss again or I'd never make it through the night.

"I don't want any piss stains in my sleepsack, boy."

I wasn't about to argue, but I didn't see how I'd be able to piss strapped up like I was. Terry had everything all planned out, though. I felt him slip something rubbery over the end of my

shrunken cock and work it down to the base, then tighten it there.

"Go ahead and piss into the tube, boy, and it'll drain into the jar."

It was a weird position to piss in, but eventually my plumbing adjusted and the flow started (I guess being blindfolded made me less piss-shy). It felt damn good, too — not as good as coming, but a close second. Terry held the tube tight at the base of my cock and kept it angled properly so the piss didn't leak backward. When I was finished, he pulled away the tube and gently tucked my now thoroughly limp cock and drained balls inside the sleepsack. I heard a small *click* and deduced that he'd padlocked the zipper ends together. *Who's he think I am, Houdini?*

"You don't need your mouth anymore now, either," he informed me, "so I'm shutting it for the night."

Having had bad experiences in the past with sleep gags, I felt we should discuss this first and started to say something, but he cut me off.

"Don't you trust me yet?" he asked with some impatience. "There's nothing to worry about, boy. Nothing is going inside your mouth, and there are air holes in the cover so you'll still be able to breathe if your nose clogs. Besides, I'll be right next to you. *Okay?*"

"Yes, Sir. Thank you, Sir."

I closed my mouth, and he attached a muzzle to the hood that kept it closed, but not so tightly that I couldn't part my lips and pull in air through my teeth. It felt a little like his hand when he'd squelched my screams earlier. *Now, that's a nice thought.*

"Good night, boy. Sleep tight," he said with a chuckle next to my ear.

"Uuu-ni-sr," I mumbled back at him.

I felt him settle into the bed beside me, and soon the music shut itself off and the only sounds were our breathing. After a few minutes his breathing slowed and deepened to soft snores, and shortly after that — sooner than I'd have expected under the circumstances — I felt my own consciousness slip away. Wrapped in safe leathery darkness, I slept, too.

CHAPTER 4

Astral travel

The first time I woke during the night, I floated up to full awareness very slowly rather than waking with a start from a dream. That suggests I was on the high end of a normal sleep cycle, so I'd probably been asleep about four hours.

Despite the slow return to consciousness, I was disoriented and confused at first. It took a few moments before I recalled where I was and why I couldn't move. I felt very strange, almost disembodied. I wasn't actually numb, but the ceaseless, nearly uniform pressure from the leather that wrapped me from head to foot had sent my sense of touch into a dormant state — like being in a flotation tank. *Wake me when something new happens*, my skin seemed to be saying.

Vision, of course, was also absent, and there was nothing to taste, not even a gag, nor any new smells to engage me. All that was left to me was hearing, which in the quiet of the unfamiliar bedroom — far removed from the city noises I was used to at night — seemed hyperacute. My consciousness seemed to fill a sphere defined by the farthest sound that reached my ears, which was the soft whoosh of cool air from vents high on the wall behind me. Nearer was a clock ticking softly, and nearer still was Terry's rhythmic breathing by my side. Nearest of all were my own breathing and heartbeat, which seemed unnaturally loud.

Of course, I soon felt a myriad of small irritations — itches and twitches — and these only grew worse after I was fully awake and had experimentally flexed my limbs inside the sleepsack. But there was nothing I could do about them, and they subsided if I concentrated elsewhere. If I'd been free to move, I'd have gotten up to piss, but for now I was able to suppress the urge easily.

I felt I could direct my awareness freely anywhere within the sphere of sound, from the air vents to the clock to Terry to my own body's unceasing processes. I could focus in on the pulsing of my blood, even seeming to sense its flow through my arteries to the smaller arterioles to the capillaries that fed oxygen and glucose to my tissues, then back to the veins that returned it, now depleted of nourishment, to my heart. My pulse rate was slow and steady, relaxed. I thought I could feel the urine slowly dripping into my bladder, filling and distending it. I felt the flexing of my small intestine as it pushed along the remains of my dinner. I felt sweat beading on my skin and trickling down to pool at the bottom of the sack. But I could barely feel my cock — it was an empty husk after the two shattering orgasms I'd had.

It seemed that I could turn and look down on myself in the bed, or at Terry beside me. I used my limited memory of the room to guide my astral explorations. Certainly the darkness made no difference to the clarity of my mental gaze — it was as if I created my own light for whatever I "looked" at.

Terry lay half on top of the covers, half under them. For a long time I studied him, feeling just the slightest bit guilty about stealing this unguarded view. His body was fit and strong but not gym-toned, and he had the beginnings of a pot belly — I thought about how nice it would be to rest my head on it. I remembered how his hands had felt on me — guiding, restraining, controlling — when I took his cock into my mouth. Much as I'd enjoyed licking his boots and leathered crotch, I'd have been even happier to lick *him*, his whole naked body. *I'd start at his feet, sucking each toe and driving him crazy licking the soles, then work all the way up to his hairy chest and mustached face. Just the dimple in his chin is worth half an hour at least. And his ears! I'd fuck his ears with my tongue!* For a few moments I felt a topman's will to power, imagining how I'd control Terry with my talented tongue, driving him into a distraction of pleasure, helpless to resist my every whim.

He was free to move in his sleep, of course, and I "watched" as he turned and threw an arm over me, which put his face next to my leather-encased shoulder. He breathed in the leather smell and smiled happily. Inspecting his handiwork from the outside, I thought he had every right to smile at the pretty package he'd made of me. No mummy of ancient Egypt was ever more neatly wrapped.

Ahh I must have looked too long on my own form — always a danger for astral travelers! I felt my awareness pulled back down into my body, once again confined, limited by a double thickness of leather and strong ropes and straps. Vainly trying to stare out through the sightless hood, uselessly flexing against unyielding restraints, I gave way to a kind of animal panic. Breathing became hard; the straps around me seemed to be crushing my chest. I imagined the sack becoming tighter and tighter, squeezing me like a trash compactor. A scream started in my throat.

No! This is nonsense, I told myself. *There's nothing to be afraid of. I'm perfectly safe. I can handle this. I* will *handle this.* I had no doubt that if I screamed, Terry would hear me despite the muzzle. But I would have been ashamed to wake him, to confess my inadequacy in the face of the most careful, comfortable, sensuous bondage anyone could want. And I *did* want it. I needed it. *This is why I went home with him. My cock might not be hard now, but this experience is as important as the cocksucking, the fucking, the bootlicking, the spanking, the role-playing, the pain games.* More *important.*

My pulse slowed again, and my breathing eased and slowed. I willed myself to relax and savor my immobility. To treasure it. I wasn't trying to recapture the exciting feeling of bodilessness I'd enjoyed earlier. It was time to move on to a new stage. Instead of trying to replace my unemployed senses with projections, I sought to empty my mind altogether. I used the smattering of meditation discipline I'd learned to still my racing thoughts, to bring my mind down to the same relaxed, instinctive pace as my body. *It's all right if I sleep again. I should sleep again. No need to do anything else.* I focused on the moments after my last orgasm, recalling the sense I'd had of fulfillment, repletion, happy exhaustion. I felt as if my body was rocking slowly back and forth, and then I seemed to begin spinning around . . . slowly at first, ever so slowly, and then faster and faster as I sank deeper and deeper into oblivion.

The rest of the night passed in a confused blur, with no clear demarcations between sleep, trance, and waking. I had vivid dreams that disappeared instantly when my mind moved to a different level. I alternated several times between feelings of soaring liberation, when it seemed as if I could go anywhere and see anything, and claustrophobia, when it seemed as if I *must* cry out for release. My bladder's pressure became more insistent, yet I was still able to hold back the flow.

The hardest challenge was not to cry out when I finally felt Terry stir beside me. I felt his hand lightly brush the leather covering my face, and I'm sure he checked on my breathing, but he said nothing and made no move to release me. Having made it through the night (or however long it'd been), I was stubbornly determined not to beg for release before he offered it. *If he's anything like me in the morning, he'll want some time to get himself together first.*

Soon I heard, through the open door of the bathroom, the noises he made pissing, then showering, shaving, and brushing his teeth. I gritted my teeth and clenched my sphincters, straining to retain the piss in my bloated bladder. Clenching around the butt plug hurt, and I groaned loudly, but if he heard, he decided to ignore it. He seemed to move around the bedroom for a long time, making noises I couldn't easily identify. I began to be annoyed. *Is he getting dressed? Why's it taking so long?* My resolution not to beg for release was crumbling.

I was ready to scream when he finally stroked the face of the hood again, softly calling my name, as though he thought I was still sleeping and didn't want to wake me. After the anguished noise I made in response, he immediately unchained the hood and removed the muzzle and blindfold. I blinked at the strong daylight that filled the room.

"You okay, Matt?"

I'll live, I thought, then, surprising myself, wondered if his use of my name meant that the scene was over. I tried to say, "Yes, but I really need to piss," but my mouth was too dry and it came out garbled.

"I'll get you some water." By the time he returned I'd been able to squeeze out some saliva and flex my stiff jaw.

"I need to piss real bad, Sir," I told him as he bent over me.

"I know. You'll have to hold it a little longer. Drink this first." He held my head up and put a glass to my lips. I sipped slowly at the cool water and felt better for it.

Terry let my head fall back onto the pillow and turned his attention to the sleepsack. The straps and lacing came off a lot faster than they'd gone on, and in a very few minutes I was "unshelled," my sweat-slicked body exposed in the open sack. He made me sit up so he could get on the bed behind me to unlace the hood.

"Sleep well?" he asked with a grin when he had it off and had turned me to face him.

"It was . . . quite a trip. Thanks," I replied, smiling back. The "Sir" seemed to drop away naturally with the last of his restraints.

"You're going to need a little help walking at first," he said, standing up, "so hold onto me."

I felt a brief wave of dizziness as I got to my feet, and my legs had a tendency to buckle at the knees. But Terry held me up and walked me slowly around the room. As soon as I was steady again, he pointed me to the bathroom.

I was finishing at the toilet, sighing in relief and trying to disperse the fog in my brain, when he came to the door. Now I noticed his loose jeans, tan shitkicker boots, and gray uniform shirt with his name embroidered over the pocket. It all looked perfectly natural on him, too, like his real working clothes, not a cruising costume. *What's he do for a living?* I wondered. *This place isn't any mechanic's or truck driver's digs. And there's that Jaguar, too, even if it is an old one.*

"When you take out the butt plug," he briskly instructed me, "strip off the condom and throw it out. Leave the plug on the side of the tub. After you shower, use the gray towel. There's an extra toothbrush laid out for you. When you finish, put on the clothes I left on the bed — they should fit you well enough — and your boots and join me in the kitchen for some brunch. Don't be too long, now. It'll be ready in about 40 minutes."

I nodded, and he left me to go through my cleansing ritu- als alone in the light-flooded, well-equipped, but relatively austere master bathroom. *No gold-plating or fancy marble, nothing showy or gaudy. Just space, light, and comfort.* As in the bedroom, the higher wall was all glass, looking onto the garden I'd glimpsed the night before. It was actually a landscaped courtyard filled with a rain- bow of flowering plants and exotic trees and shrubs, completely surrounded by floor-to-roof glass walls opening into other rooms. *Very nice,* I thought, *and very private. But this is no mansion, unless there's a lot more beyond what I can see.*

I had a really good shit after I pulled out the butt plug. For the first time in Terry's house, I was completely free of restraints, and while I enjoyed the ease of movement — particularly in the oversized tub/shower, where I luxuriated under the hot spray from several strategically placed nozzles — I also wondered if our s/m

encounter was finished. *Will he just feed me and send me on my way? Or are there other kinky treats in store? And which do I want, anyway? After all, I got into this scene because I was horny, and I'm certainly not horny now.... He seems pretty relaxed and laid-back, too, no longer entirely the tough, demanding topman of last night....*

And what kind of a bottom am I this morning?, I asked as I studied my face and body in the bathroom mirror, rubbing my light beard stubble and wishing for a razor — wondering if Terry had a reason for not giving me one. *Maybe he thinks I'd look better with a beard? . . . Anyway, I don't seem to have any marks or damage. No souvenirs? . . . Now where'd that nasty thought come from? Do I want welts and bruises? Well* I flashed myself an evil grin as I felt my cock begin to stiffen — *once a pushy bottom, always a pushy bottom!* — and left the bathroom.

I wandered around the bedroom while I finished toweling off, trying to match things up with my quick glances the night before. Now that the curtains were drawn open on the outer wall, also all glass, light poured into the room from two sides. That wall looked onto a lawn bordered by a tall, thick hedge and large, fully grown trees. *Where the hell are we, anyway?*

There were only a few pieces of furniture, and no knick-knacks or clutter. As in the bathroom, while everything was well designed and well made, there were no extravagant materials, no rare woods or burnished bronze. The nonglass walls and the ceiling were painted a neutral off-white, much as in most New York City apartments. The only thing that drew the eye was the area rug in front of the bed. It looked like a genuine Native American piece, Navajo maybe, in striking shades of brick-red, teal, gray, yellow, and black.

I looked for the hanging chain I'd been attached to. It was gone, but I spotted a hook pulled up close to the ceiling. No hoist mechanism or crank was visible — but on the wall opposite the bed I found a rocker switch. Sure enough, when I pressed it down the ceiling hook began to lower. I quickly returned it to its former position. That same stretch of wall held nine black-steel ring-plates in three rows of three: the top row above my head, the middle one about waist level, and the bottom row in the baseboard. I could just picture myself spreadeagled there, or restrained in an "A" or a "Y" position, my balls tied to the center ring — and the thought was enough to make me hard all the way again.

The oil-finished wood of the four-poster bed was stained black. The massive square posts, taller at the head of the bed than at the foot, all had shiny steel ringplates set into them near the top, at mattress level, and near the bottom (*I'll bet that's not how the bed came from the store!*). The rings at the foot were paired on opposite sides of the posts, the bolts holding them clearly passing all the way through the wood. Four more ringplates were set into the crosspiece at the foot of the bed and the same at the head end. The effect was brutally honest, with no attempt to disguise the hardware as anything but what it was. *Guess his parents don't visit much.*

On both sides of the bed there were night table/bookstands with modern brass-and-glass lamps. The one on the left also held a clock, which read 10:07. *I've probably had only about six hours of sleep*, I estimated, but I felt pretty good anyway. *Nothing like good sex and good bondage to put me right with the world again!*

Speakers for the music system were built into the wall behind the bed along with a control panel for it and the air conditioning, lights, and drapes. The photo centered above the bed, which I'd barely noticed the night before, repaid closer attention. It showed two men in full leather, one bare-headed and chained hand and foot but sitting in a leather wing chair, the other standing beside him, wearing a Muir cap and holding a riding crop and chains leading to the seated man's leather collar. It was an oddly formal portrait, but it wasn't Terry in the photo. I crawled up on the bed to check the signature: Robert Mapplethorpe. *Well, well*

The only other piece of art, besides the museum-quality rug, was a small, faded color drawing on the right side of the bed above the night table. It showed a house set into a sea cliff, just out of reach of a tower of spray from the waves breaking beneath. The building was so artfully married to the rock face, it was hard to tell where one left off and the other began. Its strong horizontal thrust, gripping the earth it emerged from, was balanced by a single tall, slender spire close to the cliff edge. I'd never encountered this image before, but the style was vaguely familiar, so I wasn't surprised to read the signature: Frank Lloyd Wright. *Very impressive*, I thought, *but why these particular pieces? There's plenty more wall space, if he likes art. Does he think they're related somehow? Wright was supposed to be a randy old goat, but I don't think he'd have approved of gay bad boy Mapplethorpe.*

The sleepsack and other gear was nowhere in sight, nor were Terry's uniform and boots from the night before. *So he's compulsively neat. There are worse failings — and why am I suddenly concerned about his domestic habits?* The door next to the bathroom was unlocked, so I looked into his walk-in closet. It proved to be enormous: Two long poles were hung with shirts, sports jackets, suits, and a couple of different uniforms, including the NYPD ensemble. Built-in shelves held underwear and such, and boots lined one wall. I'd have explored further, but my stomach growled, reminding me of the brunch he'd promised. *About 40 minutes, he said!* I went out to check the time, closing the door behind me, which also switched off the lights in the closet. The clock on the night table said 10:18. *Better hurry!*

I chuckled at the clothes Terry had put out for me: ragged cutoff jeans and a gray T-shirt with "Fit To Be Tied" printed in black over the right pec. The shorts fit well enough not to fall down without a belt, which he hadn't left me. The shirt was tight but wearable. *Did he buy this T-shirt for someone special? With that inscription, I doubt he's ever worn it himself.*

The only thing untidy in the room was the bed, so I quickly pulled it back together and smoothed out the leather spread before looking for the exit. It turned out to be a door in the glass wall looking into the courtyard, so I opened it and stepped outside. It was warmer and much more humid than in the house, but not as hot as I expected given yesterday's temperature in the city. Looking up, I saw that the top was glassed in, like a greenhouse, though several panes were propped open for fresh air. *He could grow flowers here year round — it's really a wintergarden.*

From the inside, I could see that the courtyard was enclosed by eight identical glass walls. *Does the outside of the house have the same shape, an octagon? That'd explain those odd angles in the bedroom.* I turned left and walked around the perimeter, looking for Terry. Drapes hid the two segments on either side of the master bedroom, but the rest was open to view. There wasn't always a one-to-one correspondence between the courtyard walls and the rooms beyond them. For instance, the master bedroom and bath shared the same courtyard wall, and the large living area flowed into a dining area and then into the kitchen — where I finally saw Terry. When he turned my way I waved at him. Smiling, he pointed to a door like the one I'd emerged from.

CHAPTER 5

War stories aux fines herbes

Appetizing smells greeted me as soon as I came through the door into the kitchen. "Omelets in five minutes," Terry said without turning away from the three pans he was watching, preempting any comment from me about his remarkable house.

The huge kitchen was as bright as the bedroom. Here, too, not only the wall to the courtyard but the outer wall as well was all glass — it looked onto a vegetable and herb garden, with the same kind of hedge-bordered lawn I'd seen from the bedroom beyond it. The furnishings and appliances looked modern and efficient, neither austere nor grand luxe.

He must spend a lot of time in here, I concluded, eyeing the six-burner range and grill with smoke hood, two ovens, two sinks, and dishwasher ingeniously fitted into the large service island between the kitchen and the formal dining area, which didn't look like it got much use. More pots and pans were hanging overhead than I'd ever seen outside of Macy's Cellar. But in the very center of the kitchen, midway between the courtyard and back garden, was a small oval table set for two. Cool jazz was playing over the ceiling-mounted speakers.

"Sit down and pour yourself some coffee," Terry said. He flipped a switch on a panel near him and the music stopped. I'd taken just a few sips from my cup, however, when a timer *pinged* and he told me to get the muffins out of the top oven and put them in the basket on the table. By the time I'd done so, he was folding sautéed vegetables and diced cheese into the omelets. A couple of minutes later we faced each other over steaming plates.

"It's delicious," I told him after my first bites. "But if I eat all this, I'll be ready to go back to sleep."

"That can be arranged," he said. "I've got some work to do this afternoon. Have you had enough 'close confinement' for one visit, or would you like to spend the day in the cell downstairs? I can give you your own clothes back after brunch and drive you to a train station, or I can lock you up and drive you home this evening after . . . well, after I release you." His crooked grin left all kinds of room for imagination. "You decide."

It didn't take me a second. "That's the best offer I've had in ages," I said, "or at least since last night! I'd love to go on being your prisoner. Sure beats going home and doing laundry."

"Don't think you're going to get off easily," he said, smiling. He seemed pleased at my decision. "I'll expect you to earn your keep, and you can start by cleaning up the kitchen when we finish."

"That's more than fair," I said between bites of the superb omelet.

For the next hour we talked as much as we ate, rounding out our pictures of each other in a way that seemed to promise this wouldn't be our last get-together. I was pretty candid, because I liked and trusted him — and had nothing to hide anyway. But he kept many of his cards face down, just as his house turned inward. *Yet here I am, inside it — he must trust me a* little.

Terry started probing first, asking how old I was, what I did for a living, how long I'd been involved in s/m, what kinds of experiences I'd had, what I liked and didn't like in a scene — beyond what he'd already learned firsthand! — and what kind of relationships I'd had. I answered all his questions and tried to find out much the same about him.

He was surprised when I said I was 33.

"You look a few years younger. Must be the freckles."

"They come with the hair," I explained. "My great-grandfather supposedly had the same red-gold hair and freckles. Everyone else in the family has brown or black hair. I've always wondered if he was gay, too, but he had six kids, so it's not likely."

"Depends what he was thinking about while he was doing his marital duty," Terry said drily.

"I guess I'll never know. Now, how old are you? 42? 46?"

His face clouded over, and he made a big production out of getting more coffee before answering.

"I'm 37," he said. "Apparently I'm not a Peter Pan like you."

"Hey, I'm sorry! I didn't mean it as an insult. I think men are at their best in their 40s. I must have been pegging you at the age I wanted you to be — not that there's anything wrong with 37. . . . Oh, shit. I'm just making it worse. Can we start over?"

"It's okay," he said, laughing. "You just pricked my vanity — I started to go gray early, and it makes me look older. Actually, as a kid I always wanted to be older than I was. Youth is too limiting. I learned early that adults have all the real fun: sex and travel and staying up late and eating whatever you want. Most of all, creative work — making things come into being after a pattern in your mind. So, really, I should be flattered you thought I was older. But now you know: we're just four years apart — we could be brothers. That's fine with me. Are you okay with it, or were you casting me in a Daddy fantasy?"

"Being a Daddy is a state of mind, not age," I reminded him. "And so is being a boy. But no, I'm not shopping for a Daddy. A big brother'll do just fine." We smiled at each other, past *that* little speed-bump. To change the subject, I told him about my job.

"I manage Empire Books, near Lincoln Center. We have one of the best selections of art books in the city," I boasted, recalling the treasures in his bedroom. "Working there may not be very creative, but it lets me rub shoulders with people who are."

"I've been there," he said. "It's a fine bookstore. . . . Don't judge by my bedroom," he added. "I keep most of my books in the study, or my office in town."

"Stop by when I'm on duty, then — 10 to 6 weekdays. . . . *Most* weekdays. I'll give you a discount."

"I'll keep it in mind," he said, smiling. "Now give me the dirt. How'd you get started in s/m?"

"Oh, I've had fantasies about bondage and stuff for a long time, since I was a kid, in fact. But I've only been actively involved in the scene for the last seven years or so. I have a pretty whitebread background," I went on. "I'm the only child of a middleclass Presbyterian couple in Dayton, Ohio. It took me a long time to get over the idea that good little boys didn't suck cock or fuck with men, let alone lick boots or get tied up and whipped. So I kept it all buried in my head and pretended to be 'normal.'

"I came out of the first closet when I went off to Columbia for college, but I didn't actually start *doing* any kinky stuff — except with myself — until after I'd been with my lover Greg for a

few years. We hooked up just a few months after I graduated. I moved into his apartment on the Upper West Side, and it went co-op a year later. We were able to buy, and I stayed on there after he died. . . . I'm sorry — this is probably more than you want to know."

"Not at all," he said. "Go on."

"Anyway, Greg was diagnosed three years after I moved in, and he died a month short of our fifth anniversary. Fortunately for me, we'd practiced safe sex from the start. He must have been infected already, but I tested negative and have been able to stay that way — mainly by acting as though everyone is positive, including me."

"Very sensible," Terry interjected. "I'm negative, too, but can you risk believing that? Even if we're both telling the truth as far as we know it, what if we've been exposed too recently for it to show up? No, unless you're in a 100% monogamous relationship and expect it to stay that way, it's 'Love me, love my rubber.' "

"Too true," I said. "Greg and I weren't officially monogamous — it was an 'open relationship' on principle — so we always played safe. But I was so much in love with him that I never went much beyond flirting or necking with anyone else while we were together. I don't think he did, either."

"So you and Greg started exploring s/m . . . ," Terry probed.

"We didn't get far before he got sick — simple stuff, really. It was like a whole new world opening up for us. Especially because Greg wasn't a hard-core pervert like I am — no childhood fantasies about bondage or police boots. He was a fast learner, though, and whenever he tried something that really turned me on, it turned him on, too."

"But if you'd been repressing your kinks, and he didn't know he had any, how'd you two ever get started?"

I smiled at the memories his question stirred.

"Well, we were living in New York, after all, not some backwater. By the early '80s, s/m was coming out of the closet. References were all over the gay media, and even a bit in the straight media, too, thanks to the cutting-edge fashion makers. Greg realized that I got harder every time he pinched my nipples or slapped my ass during sex, and he was plenty smart enough to put two and two together."

"That couldn't be all of it," Terry said skeptically. "Half the

clones in New York back then were into what they called 'rough sex,' but they'd still flip a wrist or do a Bette Davis impression if you mentioned *real* whips and chains."

"You're right," I admitted, looking down at the table as I continued the story, one I hadn't told for a long time. "There *was* more. . . . One night we were roughhousing, and I was in a very silly mood. I kept squirming and making dumb jokes. Greg was trying to hold me down, and he said something about tying and gagging me if I didn't behave. . . . Talk about revelations. . . . I suddenly stopped squirming and looked straight at him. It must have been his love that gave me the courage, because I looked into his eyes and whispered, 'Please . . . please do it, Sir.' My cock was so hard it hurt. We both realized then what I needed."

"Beautiful," Terry said softly, and I looked up to see him smiling warmly at me across the table. "I'll bet I can guess what happened next. He used neckties to tie your hands and feet, and he stuck a sock in your mouth. And then you two had the hottest sex ever."

"Actually," I grinned back, "he used dress socks for the bondage and bandannas to gag me. But, yeah, it was really hot!"

"And you went on from there . . . ?"

"Not right away. Greg always wanted to research anything new before getting involved with it — did I tell you he was a financial analyst? Anyway, after that first 'scene,' if you can call it that, he checked around. He found out about GMSMA and insisted we attend a few meetings. I didn't want to. I was ready to buy up the back issues of *Drummer* and work our way through the stories, trying everything to see if we liked it. Or just start hanging out downstairs at the Mineshaft and imitating what we saw other guys doing. I didn't want to sit in a room at the Community Center and *talk* about s/m."

"Good thing *one* of you had some sense," Terry said, "or you might not be here telling me about it."

"So I was a dumb kid back then!" His air of superiority suddenly annoyed me. "Try nursing your lover, the guy you've always depended on, through a fatal illness. You grow up in a hurry."

"Of course," he said contritely. "I'm sorry. Please go on."

I smiled to show there were no hard feelings — my moods come and go pretty quickly.

"Now *I'm* the cautious one," I told him. "Most of the time,

anyway," I grinned, remembering how quickly I'd given in to him the night before. He smiled back, his mustache twitching a little above the corner of his mouth. "But back then it was like I'd been starving, and suddenly there's this banquet table in front of us, and he wants to check the FDA nutritional statement first."

"No offense, but I take it patience isn't your strong suit."

"No," I admitted cheerfully. "But Greg was very patient, especially with me. We did it all — the porn, the 'Shaft, the bars, *and* GMSMA. I even got to like the meetings after a while and made some friends there. Greg thought the group was wonderful. He felt comfortable at the meetings and demos because he could ask questions and not have to pretend to be experienced already."

"Doesn't stop some people from pretending anyway," Terry remarked. We exchanged knowing looks.

"That's really the end of the story," I said after a moment. "In less than a year, Greg was so sick that even vanilla sex was a strain. Later on, all we could do was cuddle, and then even that became impossible. Sex was the last thing on his mind, and if I got horny, I'd just go into the bathroom and jerk off, fantasizing. I stopped going anywhere except to work and the hospital. . . . You know how it is."

"We all do by now," Terry said.

"Yeah But a few months after he died I became a real safe-sex slut, trying to make up for lost time. I wasn't much interested in GMSMA events unless I could bottom in a demo — people got sick of seeing me. They called me 'the universal bottom' because I was always available."

"You haven't been so universal in the last couple of years," Terry remarked. *Has he been watching me that long?*

"That's true. I've settled down a lot. After sampling as many topmen as I could, I had a good idea of what I liked and what I didn't. I'm always happy to get together again with a top I really clicked with" — big smile to be sure he got the hint — "but I've avoided getting too involved with anyone. After Greg I didn't want another relationship — playing the field was too much fun. Still is, for that matter." I grinned impudently at him. I didn't want to seem like a pushover, as if any reasonably competent top could make me his love-slave with a twitch of his finger.

"How do the men you play with feel about your love 'em and leave 'em attitude?" Terry asked, frowning slightly.

"I just like variety," I protested. "I never promise anything I don't deliver. And it's a fair exchange. I do what you guys want, and you give me what I need. Isn't that what it's all about?"

"Have you ever considered what tops might need?"

"Near as I can tell," I replied, "what it takes to make a top happy is a humpy bottom he can work over and boss around. Why should I worry about what he wants as long as I do what I'm told? *He* knows what he wants — or should: he's the one giving the orders." *What's eating him?*

"Some things can't be ordered," he said after a pause, and his tone alerted me to listen carefully. "Really important things have to be given freely. Things like respect . . . trust . . . love."

I lowered my eyes and toyed with my food. *This is getting too heavy,* I thought. *If any of the other men I've played with lately said something like that, I'd laugh it off. But I could really fall for this guy.*

He was looking at me when I glanced up again, but his expression was unreadable.

"How 'bout you," I asked, trying to lighten the mood by shifting the subject. "You're pretty experienced, right?"

Though he was cagier than I'd been about the details, he admitted to a somewhat longer s/m career — not only because he was older, but also because he'd started earlier, with fewer hangups. His coming-out story was a hoot.

"I have an uncle who's gay," he said, "and instead of being the black sheep of the family, he was the great success story. He made a fortune selling luxury cars. He had his own agency on the Island, not that far from where I grew up in Queens. Many of his salesmen and even mechanics were gay, too, or bi — not that they called themselves that in the '60s and '70s — and Uncle Max made sure no one put anyone else down. I played there as a kid, and in high school I worked in his repair shop on Saturdays and in the summers. He wasn't 'out' the way people are today, of course, but it was an open secret. He was on good terms with my parents, especially my mother, who's his sister, and as soon as my proclivities were unmistakable — to him anyway, if not yet to me or my folks — he sort of took me under his wing."

"You have a kinky uncle?"

"No," he laughed. "Not at all. By current standards he's an old queen, but he knew what was what, and he helped me accept myself. We never really talked about leather or s/m, but somehow

he sensed what everyone was into. There came a Saturday when Tom, one of the mechanics — a tough, masculine guy I'd always been attracted to but a little in awe of — invited me back to the city with him after work. He had a tiny apartment in a tenement in Chelsea, which hadn't been 'discovered' yet, but it was all he needed. His whole life was work and sex, the kinkier the better. If he couldn't have cock, give him a car to work on, and he was happy. Or vice versa. He admitted later that Uncle Max'd asked him to 'show me the ropes.' Not that he was unwilling, or had to be paid or anything. But he'd never have dared fuck with the boss's nephew without some assurance it was okay."

"So that was your first time?"

"Not for sex, but my first time with . . . ah, embellishments."

"You bottomed for him?" I tried to picture it, but without much success.

"No. It was more a mutual thing. Tom was basically a bottom, and if I hadn't been so raw, he'd have let me take charge. But he showed me some of the possibilities, enough so I knew it was what I wanted. Not so different from your experience with Greg, after all."

"Go on . . . please," I encouraged, but he didn't tell me a lot more. He did confirm that although he was exclusively top nowadays, he'd bottomed a number of times when he was younger, generally with more experienced tops he wanted to learn from. He'd learned most, however, from an experienced bottom he'd played with many times.

"See, pushy bottoms have their uses," I told him.

"He wasn't pushy! He didn't make demands, and he didn't try to escalate the action by provoking me — the way some assholes do." He gave me a hard look.

"I've never deliberately provoked a top," I said, "unless he made it clear he *wanted* an excuse to get heavier. I just try to communicate what I like and what I want. What's wrong with that? The top can always say no."

"That's true," he said with a crooked smile, "but some bottoms make it easier than others. It's hard to abide by your limits if you think the bastard will tell everyone you wimped out. I don't think you're like that, though I've heard stories . . . guess they're exaggerated. Still, why anyone would *want* to be tied up and worked over by an angry, out-of-control top is beyond me."

"Beyond me, too. I'm not suicidal."

"But some guys get off on taking that kind of risk. I wonder if they ever think about how the top feels afterward, especially if he's been pushed into hurting them really bad — or worse."

I squirmed a little under his gaze, realizing how little I usually thought about my play partners' feelings — except when they concerned me.

"Anyway," he went on, "Larry — the bottom I was talking about, a sweet guy, died a couple of years ago. . . . Larry had a real gift for suggesting new things I could do to him — new to me, anyway — without undermining my pride or self-confidence. He didn't push or provoke me. He *seduced* me into exploring more and more of the things that turned him on. And as I learned the craft and was able to stop thinking so much about what I was doing, I found they turned me on, too."

"It didn't turn you on at all being on the bottom? From what you were saying about being sensitive to the other man's feelings, I'd think you'd be enthusiastic about switch-hitting. Sure is one way to learn some empathy."

"Not if you do it for that reason. Playing a role you're not comfortable in only gives you negative reinforcement for whatever you might learn from it. I sometimes envy guys who enjoy going both ways — I'm not old enough to put them down for it, like some do," he grinned, "but I have no desires in that direction, and it's too much against the grain for me to submit to another man anymore. When I need to know how a new piece of equipment or technique feels, I'll try it out on myself, but without witnesses. . . . How about you," he challenged suddenly. "Have you ever topped?"

"Oh, once in a while, if I'm attracted to another bottom and that's the only way to get it on with him. But I don't do head trips, only physical stuff."

"Meaning?"

"Like with my friend Stan — you probably know him: short, chunky, serious body builder, sarcastic as hell." Terry nodded, but I got the impression Stan wasn't one of his favorite people. "Well, every so often Stan and I'll get together and one of us'll top the other, just for fun and to keep our edge. We test each other's limits, mainly with bondage, but we don't get into serious dominance and submission. We tried it once and broke out laughing.

Whoever loses the game has to do his best to give the other a good trip, that's all."

"Loses the game?"

"Oh, we play some game — cards or arm wrestling or something — to determine who has to top. The loser ties the other up and watches over him until he's had enough." Terry was laughing even before I'd finished, and I started to blush.

"Forgive me," he said as the laughter wound down. "I don't mean to make fun of you. But you have to admit it's rather . . . well, unusual! If two tops have the hots for each other and don't want vanilla sex, they'll go out and find a bottom to work over together. The idea of two bottoms playing cards to determine who has to top" He started chuckling again.

"I guess it *is* funny," I conceded reluctantly, "if you look at it that way. But Stan and I *don't* have the hots for each other. We're good friends, we love bondage, and we trust each other. It can be hard to wait for a scene with a good top — you guys are so picky. So in a pinch Stan and I get each other off, without the dangers and compromises of self-bondage. What's wrong with it?"

"Nothing at all," he said, grinning broadly. "Makes perfect sense." *He still thinks it's funny*, I grumbled silently.

We sipped our coffee in silence for a few minutes, glancing at each other and looking away again. I was a little miffed. *If it didn't take two or three years to get on your dance card*, I thought at him, *maybe I wouldn't need to resort to playing games with a buddy*.

He made no sign of receiving my message, but he started up the conversation again, systematically probing my sexual desires and limits. Because of my nipple rings, he was surprised when I said I didn't like piercing.

"I got them to be in fashion," I explained, "and figured they would be fun for bondage. But I really hated getting pierced, and I don't want to repeat it. Needles just aren't my thing. I almost faint when my doctor draws blood." Terry smiled. (*Please don't let him be a needle freak*, I prayed.) I also told him I wasn't into scat. "Aside from any safety issues, it just isn't a turn-on. Maybe I was too well toilet-trained."

"I'm not into it either," he said, "though I've tried it. . . . Ever noticed that sometimes the smell is incredibly sexy? Most of the time, of course, it's anything but — and playing with it makes such a mess!"

"I doubt straight couples would have this kind of conversation over brunch the day after meeting at a singles bar," I said. "Maybe that's their problem — they don't talk enough about what they like and don't like." *Good thing we've finished eating, though!* I added silently.

"You may have something there," Terry agreed, then went right back to cataloging my sexual interests. "How about piss? I was just guessing last night when I said I thought you wanted mine. Safety aside, does it turn you on or gross you out?"

"That depends," I said. "I've done it, and sometimes I liked it, and sometimes I didn't. Getting pissed on is usually pretty hot if it fits the scene, and that's safe enough. But drinking it . . . I think I'm too scared of the plague to consider if it's sexy or not."

"I've researched it," Terry said. "Did you know there've been studies of urine samples from AIDS patients?"

"Really? Why'd they do that?"

"Not because of any concern about odd sex practices! No, it's an obvious thing to check when you think about babies with AIDS. But the studies included adults, too."

"So what'd they find?"

"No live AIDS virus at all, only viral fragments that can't infect anybody. The chances of contracting HIV disease by drinking someone else's piss are probably lower than from kissing him. It's not *impossible* — I wouldn't recommend drinking piss from a guy with a urinary-tract infection, for instance, or being a common urinal at a party. But if your partner is in generally good health, you're probably in more danger crossing the street in midtown Manhattan."

"If that's true, why do they still tell us to avoid exchanging all bodily fluids?"

"Sex phobia, of course. Enlarging the boundaries of safe sex isn't a very high priority for the health establishment — or the government. Same reason there've been so few careful studies of HIV transmission through cocksucking. The health honchos are afraid they'll have to admit it's low risk, and they don't want to be pilloried for 'endorsing' it. But I don't mean to suggest that swallowing another guy's piss is always as safe as, say, licking his sweat. Piss can carry hepatitis, which is no joke, and also CMV, which is *very* bad news if you already have AIDS."

"I knew there'd be a catch."

"It just means you have to be careful and know someone well before getting that intimate. For instance, have you had the hepatitis-B vaccine?"

"Of course."

"So have I, which means we're both safe as far as that goes. But I wasn't going to stop and show you a doctor's certificate."

"Sometimes I think it's coming to that," I said. "You know, 'I'll show you *my* health report if you'll show me *yours.*'" We both laughed, if a little nervously.

"Speaking of health," I said, "I don't smoke. I haven't seen you light up yet, so you must not be a nicotine addict either."

"I like an occasional pipe or cigar after meals. Sometimes after sex, too. . . . And sometimes *during* it — a cigar can come in awfully handy in a scene. Would that turn you off?"

"Maybe," I replied, looking searchingly at him. *If I have a "type," he's it. I hate to think that* anything *he does might turn me off.* "It depends on how you use it, I guess. I don't *think* I'm into burns, but I've never tried."

"Not even hot wax?"

"Well, of course I've played with hot wax. Everyone's done *that.*" He smiled enigmatically — *am I missing something?*

"Anything we did last night you didn't like?" he asked.

"Well . . . there were a few things I didn't like much at the time — like getting stuffed into the trunk of your car, or being strung up and left to stew, not knowing where you were or what you were doing, not being able to *see* you. But that's normal in a scene. What counts is the trip as a whole, and that was great."

"You mean," he said carefully, "it's okay to do things to you that you don't like, as long as you like the scene overall — at least enough to want a rematch?" *Are we negotiating now?*

"Well, I guess so. . . . But when you put it that way it sounds a little scary, like a blank check."

"Maybe that's why they call it 'surrender,'" he said, sipping his coffee and staring at me over the rim of the mug.

It's hard to be afraid of someone who's just fed you a superb breakfast, but I shivered slightly, wondering what I'd let myself in for by agreeing to another session so soon. (*The victim had a hearty last meal, some kind of omelet.* . . .) We didn't pursue the topic of my limits any further, however, finally turning to less-charged matters — like his house.

When I complimented him on it, he told me he was an architect — *guess that explains the Wright drawing, and other things* — and had built the house about ten years earlier, following his own design and doing a good deal of the interior work himself or with the help of friends.

"It's really only a journeyman effort," he said, "my first complete building after getting my license. But I tested some ideas with it, and it still suits my needs. The best thing, of course, is the privacy of the enclosed courtyard — hardly a new idea. The Romans did it 2,000 years ago. But it's not common in American houses, which usually show their best faces to the street."

"But where *are* we? I can't see anyone building a house this big, with so much lawn around it, anywhere in New York City — unless you're a multimillionaire.... Well, maybe in Staten Island, if you can stand living with all those racist Republicans and gay-bashers. I wish they *would* secede!"

"We have racists and gay-bashers here in Westchester, too," Terry said with a rueful laugh. "But maybe they're not as blatant about it — the antigay prejudice anyway. And there are plenty of Republicans! Not all of them are ideological, though. I registered as one so I'd have a vote in the primaries."

"Yeah — that's why I registered as a Democrat in Manhattan. But I'd vote for a decent Republican, if there were any."

"Big of you," he said. "Anyway, I used to have an apartment in Manhattan, too — small, but convenient to work and to the bars. Before that I lived with my folks and commuted to classes at Cooper Union. I always wanted my own house, though. It gives you so much more scope to do what you want." *Yeah, like that ceiling hoist in the bedroom!*

"So where are we, exactly?" I asked.

"A little town you probably haven't heard of — Larsburg, northwest of White Plains. It's not one of the ritzy suburbs, like Scarsdale or Larchmont, but it's pleasant enough, and I was able to get the land cheap. The house is actually small for the lot, which increases the privacy."

When I pressed further, Terry said he was the principal architect in a small firm based in the city, but he often worked at home when he was brainstorming a new project. He also traveled a lot of the time, seeing clients or inspecting building sites. The biggest part of the firm's work was designing high-security

prisons for state governments, which had remained a growth industry all through the recession.

"You dress like that on a site inspection?" I asked, pointing to his work shirt.

"Sure," he said, "plus a hard hat. Turn you on?" He grinned.

"Yep," I replied, and grinned back. "I like a man who works with his hands as well as his head. That's what my father always used to say," I added, half to myself. *Only when he said "like," he meant it in the sense of approval, or friendliness. He didn't mean "like" as in, "I like the taste of your balls"!* Terry's voice pulled me back to the present.

"How would you feel seeing me in a business suit?"

"Don't like suits," I said in a pouty voice. "They're for bean counters — the Men Who Say No. I run up against them every time I want to make an improvement at the store that might cost a few bucks initially."

"You're awfully opinionated!"

"I know," I admitted. "That's probably why I end up gagged so often." *That* made him smile again.

The conversation lapsed for a few minutes, and then, curious all of a sudden, I asked if *he'd* ever had a lover.

"I had a slave once," he said, then paused, frowning, as if the memory was uncomfortable. "That was about five years ago. It was a traditional, by-the-book relationship, but I did love him. . . . It didn't work out, though. We broke up in less than a year and haven't seen each other since. After that I kind of soured on the idea of letting anyone get so close to me."

"So you play the field, too."

"I'm not as flighty as you seem to be," he protested. "I'm not into one-night stands."

"Did I say I was?"

"No, but every time I've seen you with a top, it's been someone different. And you're *always* cruising, even when you're out with someone." I felt myself blushing furiously at this all-too-true accusation. "That's your own business," he continued, "but I prefer repeat sessions with bottoms I've had good scenes with in the past. You're the first 'new meat' I've played with in a long time."

"So why'd you take me on?"

"Curiosity, in part. I know many of the guys you've played with, and aside from being fickle, pushy, and a smartass, you

have a good rep. So I thought it might be interesting to give you a try."

What is *this?* I wondered. *Verbal abuse to soften me up?*

"I guess I wasn't too bad last night," I said defensively, "or you wouldn't have invited me to stay."

"I'm not trying to put you down, Matt," he said in a kinder tone, though still with that devilish crooked grin. "You know how good you are. You're sexy, responsive, and experienced, with a high pain threshold. That counts for a lot. But don't think you can fool me or manipulate me. . . . I'm not easily pushed, as you may have gathered, and I own plenty of gags."

I blushed again and looked down, feeling a little like Elmer Fudd just after Bugs clobbers him for the umpteenth time. He must like it, or he wouldn't keep letting himself in for it.

"Maybe I can join your stable, and you can correct my character flaws," I said quietly when I looked at him again, surprising even myself. *Is that what I want?*

"Let's see how it goes this afternoon," he said with a smile. "We'll talk more later." He got to his feet, signaling the end of the discussion.

"You can relax here for a while before cleaning up. I'm going into the living room."

He refilled his coffee cup and took it with him. After a few minutes I heard music coming from that direction, but he didn't pipe it into the kitchen.

I lingered over my own last cup, my thoughts in an indecisive whirl. Did I really want to get involved with him? Did I even want another scene with him so soon? *I already decided that when I agreed to stay. . . . But I can still back out,* I reminded myself. *Maybe it'd be better to get together in a few weeks instead, after we've had a chance to digest all we've told each other. Give us a chance to recharge our batteries. . . . Naahh!* (My cock was already half hard again.) *He is* definitely *the most exciting man I've played with in years!*

Doubts more or less resolved — I rarely argue with my cock — I got up to tackle the mess. Terry seemed to have used a large fraction of the cookware he owned, but the meal had been worth it. Besides, everything but the pots just went into the dishwasher. While I was still loading the machine, he came back in with his dirty cup — and an armload of chains.

"I thought you'd enjoy working in these," he said, holding

out lightweight manacles and somewhat heavier leg irons — *not as heavy as last night's*, I was relieved to see.

"You're a prince," I said with an amused shake of my head, but I put down what I was holding, dried my hands, and extended them to be cuffed.

"Watch your mouth, boy," he said as he fastened the cuffs on my wrists, a 15-inch chain swinging between them. "Any more of your lip, and I'll wipe it off."

Looks like we've started!

"Sorry, Sir," I said, immediately taking a more submissive tone and stance. Getting into the right mindset took longer, although my cock responded immediately to the renewed bondage and domination by tenting out my shorts.

"Put these on yourself," he said, apparently still annoyed at my flippancy (or pretending to be), as he handed me the leg irons. I squatted down to lock the British-style cuffs over my boots (they had to be screwed shut), then handed back the key from the same position, which put my head about even with his belt buckle.

"Come to the living room when you're finished," he said, towering over me. His face was still stern, but judging from what was tenting out *his* pants, he was actually quite pleased. "Don't be too long."

My efforts were only slightly impeded by the restraints. I had to take shorter steps, of course, because of the leg irons, and to be careful not to swing the manacles' chain against a plate or glass, but in another ten minutes or so I had everything neatly squared away. The table and counters were clean, and the dishwasher was humming. I headed out to the living room to meet my fate.

CHAPTER 6
Solitary confinement

I passed through the dining area and into the living "room" without encountering another wall. Terry was seated in a leather recliner, facing toward the inner courtyard but closer to the outer wall. The carpeting largely muffled the sound of my leg chain, the music — some big romantic symphony — was climbing a crescendo, and he had the *Times* spread open in front of his face, so he didn't notice me immediately.

The drapes that had covered the windows behind him — not a curtain wall — were open now, letting in plenty of light. The lawn in front of the house was smaller than the one in back, but it still provided a substantial setback from the street, and tall shrubbery screened the perimeter — not much chance the neighbors might see me standing there in chains.

I stood there for a few moments, ten or fifteen paces from his chair, and just watched him, trying to determine the exact role he wanted me to play. I thought of marching over and announcing, "I'm ready for my close-up now, Mr. DeMille," but quickly dismissed the idea. *There's a time and a place to play the clown, and this isn't it.* Instead, I put the picture I had of myself in chains and fuck-me cutoffs together with the image he presented, of an accomplished professional man at ease with his morning paper. I was surprised how well they meshed. *Only I shouldn't be standing in front of him — I should be on my knees at his side.* My cock snapped to full hardness at the thought.

Without entirely understanding what I was doing, I quietly came as close as I could while saying nothing, doing nothing to draw attention to myself. Terry still gave no sign of noticing me, though he surely heard the light jangle of my chains through

the music. I sank to my knees beside his chair, rested my hands on my thighs — the chain between my wrists fell across my stiff cock inside the shorts — and sat back on my bootheels.

I expected him to say something, or to touch me, at any moment, but he continued ignoring me. *Maybe he's still annoyed about my sass back in the kitchen.* I was determined not to make the first move this time, to show him that I wasn't *always* pushy. Not considering the meaning of the gesture, I cast my eyes down to the charcoal-gray carpeting in front of my knees.

Every time the paper rustled, my heart leaped, convinced that now he would finally acknowledge me — whether with a caress or a slap, I didn't care. Long minutes passed, but somehow I summoned the patience to keep still and wait. Eventually I realized the waiting itself was part of the scene: *When you wear another man's chains, you're at his disposal.*

I let that idea rattle around in my head, not sure I liked it, not sure I didn't. I knew that I liked being firmly controlled in a scene, restrained and helpless, freed to react to pain and other stimuli as violently as I wanted because I was safe inside the magic circle of my bondage. I also liked being immobilized and forced back onto my inner resources, as during my night in the sleepsack. But being chained and ignored like this, made to wait till I was wanted, treated like a slave — that was a new experience. My cock liked it fine, but me . . . I wasn't so sure.

When Terry finally reached over and ruffled my hair, it was as if my whole body was as erect and sensitized as my cock. I rubbed my head against his palm, and when his hand traveled down my face and settled over my mouth, I licked it. I could taste the herbs he'd put in the omelets, plus a little salt from his sweat. He held my eyes closed with two fingers and stuck his thumb in my mouth. I sucked it like a cock, or a baby bottle, making little mewling noises around the thick digit. When he pulled it away, I groped after it, my tongue hanging out and my eyes still closed. His laughter rang out above my head, but I was beyond shame, driven by suddenly urgent need.

"I thought I fed you pretty well, boy," he said, "but it looks like you're still hungry."

"Yes, Sir," was all I could respond, hanging my head again. I didn't even know for sure what it was I needed so badly, only that he seemed to have it.

"You'll get all you can handle soon enough. Settle down now. I want to finish my paper in peace."

"Please, Sir . . . if I could lick your boots while you read?"

"Hmm . . . yeah. That'd be okay. I'd like that. Go ahead, boy, chow down."

He moved his left foot and lower leg off the recliner's footrest. I shuffled forward and bent over his laced work boot. I caressed it first with my hands and nose, savoring the mingled scents of leather, sweat, and dirt. I shuddered with the first swipe of my tongue along the side — it tasted so good! Licking his boots while he did something else, apparently paying no attention to me, was even more exciting than the ritualized bootlicking I'd done at the bar the night before. This time I had no sense of putting on a show — I was simply giving his due to the man controlling me. But at the same time, I was feeding my own hunger. *Hunger for what?* I wondered. *Not just his boots. . . . Is it him I need so much, or what he does to me? . . . Is he brainwashing me? Or am I doing it to myself?*

My questions remained unanswered, and for the next quarter hour or so I quietly licked his work boots, first the left and then the right. No more words were spoken, but occasionally he reached down and toyed with my hair as my head bobbed over his foot. I purred at these gestures, which seemed to simultaneously acknowledge my efforts and reinforce my submission. I felt more and more relaxed, happy to keep licking his boots indefinitely, until he was ready to lock me up as promised.

Finally, though, he put his paper aside and stood up.

"Come on, boy. Time to go downstairs."

I stood up, licked my lips, and grinned at him, a little sheepishly. His expression was too intense to meet. His eyes seemed to pierce my brain, or soul, and I quickly lowered my own.

"Turn around," he ordered. He clamped his big paw onto the nape of my neck and marched me back through the house. Behind a door off the kitchen was a staircase heading down — *probably the same way we came up from the garage last night.* He stayed behind me on the stairs, keeping hold of my right arm. The leg chain made even more of a racket on the polished wooden steps than the heavier chain on the irons I'd worn coming up the night before.

Terry turned me sharply to the left at the bottom, and in-

stead of going through the door into the garage, we walked back further into the basement. I noticed now, sans blindfold, that the walls and ceiling were poured concrete, the floor tiled in a black, gray, and red pattern. The light was from long, vertical incandescent tubes set into the walls every couple of feet. We passed the usual household appliances — washer, dryer, water heater, furnace — and then another space filled with office files, flat files, and other professional-type storage, all neatly arranged and obviously not neglected by whoever did the cleaning. Finally we reached a very solid-looking, burnished-steel door, which he unlocked.

The drop ceiling of the room beyond it was made of cream-color acoustic panels punctuated by flush-mounted lighting fixtures. The floor was thickly carpeted in black, and the wall to our right was all mirrors. The wall to the left was concrete again, but painted a pale gray, and from waist-high to above Terry's head it was covered with photos and drawings in narrow silver or black frames. The wide space between the walls held free weights, a Soloflex, a punching bag, and a low trampoline as well as a pool table and a pinball machine. I wondered how often he used the workout gear — *he's obviously no gymrat.* Somehow I couldn't picture him playing much pool or pinball, either. *Maybe he practices to make a good showing at the bars?*

My leg chain — a lot quieter on the carpet than on the tiles — prevented long strides, so we moved slowly through the room, which let me get a good impression of the art on the left wall (*the inner one?* I guessed, trying to orient myself relative to the house above us). It seemed to be all high-class gay erotica — artistic, not merely pornographic, and all involving leather or kink. I recognized images by Tom of Finland, Rex, Etienne, Arthur Tress, and other famous names.

"Are these *originals*, Sir?"

"Some," he said. "Others are the best reproductions I could get — or afford. You like erotic art?"

"Yes, Sir. Very much so. I love that Mapplethorpe in your bedroom." *Wait'll he sees what I have in mine!*

"I love it, too. . . . Just about everything in this house is something I love — or need . . . or once needed. I don't use this gym equipment much anymore. In fact, I didn't even buy it for myself."

He fell silent, and I guessed at the story. *He bought it for that*

slave, the one who left him — or that he threw out? I'll get it out of him later!

"Maybe you'll have some time to look at the gallery before you leave," Terry said finally, "but it's already after 1:00. I want to get you locked up so I can do some work without distraction. Move along."

So now I'm a distraction? I said to myself as I shuffled along. *Guess that's a step up from a fickle, pushy smartass. At least it means he finds me attractive!*

The walls converged ahead of us, and we passed through a narrow space with a staircase on the left and a large, glass-enclosed bathroom on the right (I could see a toilet, sink, shower stall, *and* a double-size tub). At the other end was a wall with another steel door, also locked.

Once we were through the door, my leg chain made a racket again — the narrow corridor had no carpeting, just bare concrete on the floor and bare frosted bulbs in the ceiling. There was more homoerotic "art," but unlike the images in the gallery, this was the kind of rough, raunchy stuff guaranteed to horrify even the most tolerant straight folks (or most "vanilla" gays, for that matter). On the left side the drawings and photos were all carefully framed, as in the outer gallery, but jammed together in heedless profusion. On the right were images ripped from magazines or fuckbooks, or even newspapers, and taped or glued directly to the concrete walls, layer upon layer as in a collage. A lot of it was pretty raw, not even craftsmanlike — fantasy drawings direct from the id, artless stills from the hardest of hard-core porn or photos of real-life torture, degradation, domination, and abuse.

Cum, sweat, piss, shit, and blood seemed to ooze from the walls. I imagined I heard anguished screams and meaty slaps of leather on flesh echoing in the enclosed space, already loud with the clank of my chains. Overloaded with images, my head spun as we traversed this nightmare alley, but my cock thickened. Terry said nothing, and I couldn't decide if his hand on my shoulder was reassuring or terrifying. *Is this passageway intended to psych him up? Or to terrorize his bottoms? Or both?*

The corridor angled again — *the outer segments of the house must surround a space down here corresponding to the atrium above —* and opened out into a wide room. It was brightly illuminated by track lights on the right side but deep in gloom on the left, to-

ward the center of the house. (*What's he hiding in the hole of the doughnut, under the wintergarden?*)

The whole right wall of the room was covered, floor to ceiling, by a wire storage grid, narrow shelves, and ranked drawers, ranging from minuscule to suitcase-size, like a Chinese apothecary's cabinet. A rolling stepladder gave access to the topmost storage areas. Leather and steel restraints, hoods, gags, chains, ropes, whips, cats, floggers, and straps were visible, all neatly arrayed. I assumed that items like clips, clamps, and ass toys were stowed in the drawers. A clothes rack held more uniforms and leatherwear, with appropriate caps and helmets shelved above them, boots set out below. *This isn't Westchester*, I thought. *It's Oz!*

We stopped near the middle of the wall, and Terry ran his fingers along the display of handcuffs with the air of a man picking out a necktie, finally settling on a heavyweight set with thick, rounded bows — imported German transport cuffs. He took the work manacles off me, hung them up, and replaced them with the handcuffs, double-locking them with swift, practiced moves. Next he pulled down a leather chastity jock and retrieved a butt plug, condoms, and a lube dispenser from the drawers.

"Can't have you jerking off in your cell," he explained with a wicked grin, then led me back toward where we'd come in. Next to the corridor opening was another steel door, this one with a barred spy window. Terry flipped a wall switch on the side before unlocking it.

When Terry had referred to a "cell" in his basement, I'd pictured something like a large closet with a barred door made from welded steel pipes, or maybe an oversize cage — the kind of thing you sometimes see in s/m clubs or porn magazines and videos. When he'd said at brunch that his architecture firm's main business was designing prisons, I raised my expectations, but even so, what was on the other side of the third steel door gave me a chill.

A concrete-block box that looked to be eight feet wide, eight feet high, and a little over twice that long, painted prison gray, was divided in half by a genuine double-hung, sliding, barred cell door. Inside the cell was a steel-framed bunk against the back wall, a folding table just big enough for a food tray, a straight-backed chair, and a steel sink and toilet. Outside was an old-style oak armchair on one side of the entrance, an open shower stall on the other, and a naked, wire-enclosed light bulb in the

ceiling. The light passing through the bars cast stripes across everything inside the cell — just like in a prison movie. With the outer door closed, a prisoner would be unable to see anything else in the basement. But with the light on, he could be watched from outside through the spy window.

While my mouth hung open in astonishment, my cock tried to tear through my ragged shorts. Terry pushed at my back, and I stumbled forward. My mind was still reeling at how far he'd gone to realize a fantasy. *What if he decides a few hours is far too short a "sentence"? What if he keeps me here for weeks — or years?* When we reached the cell door, which was unlocked and ajar, he slid it open with a *clang* that reverberated off the concrete.

"Go take a piss," he ordered, pushing me inside and following me in. "You won't be able to after you have this jock on."

I walked over to the toilet and opened my fly, freeing my stiff dick. I tried to focus on something unstimulating so it would soften. The handcuffs made it difficult: just *thinking* about cuffs gets me hard, and there they were on my wrists — in a prison cell! — while I held my dick to aim.

In the wavy steel mirror above the sink (a glass mirror, of course, could be turned into a weapon), I saw Terry sitting on the bunk, pulling condoms over the butt plug before greasing it up. He met my eyes and snickered at my struggle to pee. I sighed, moved my eyes away from the mirror, onto the blank wall, and tried to recall the lead editorial in yesterday's *Times*. It worked, too — presidential politics was definitely a soft-on.

I flushed the toilet and turned around.

"Take down those shorts," Terry said, getting off the bunk, "and lie here facing the wall."

I dropped the shorts and awkwardly maneuvered myself onto the bunk, lying bareass up on the coarse blanket. He made short work of loosening my asshole, though I was still a bit sore from the previous night, and shoved the plug in till it was firmly seated. Despite the discomfort, the pressure on my prostate revived my cock. I heard water running as Terry washed his hands, and then he barked at me.

"Stand up! Leave the shorts down."

I complied, standing in front of the bunk with the shorts around my boots. He glared at me while he wiped his hands on my T-shirt, as if daring me to say a word.

"Hands behind your head! Eyes on the ceiling," he snapped when he'd finished.

The damp, tight T pulled even tighter, rubbing my ringed nips, as I raised my heavily cuffed hands and got them out of his way. I felt Terry work my stiffening cock and balls — not gently! — through the cutout in the rigid, triangular leather backplate of the jock, then strap them down. He zipped up and locked the front piece (leather reinforced with steel), buckled and locked the waist and crotch straps, and pulled the denim shorts back up.

"Button your fly, asshole," he sneered.

I lowered my arms and eyes to obey, a little unsure whether I liked this scenario he'd started. He stood in front of me the whole time I struggled with the elusive buttons, half hunched over and fumbling with nervousness (the handcuffs didn't make my task any easier). Finished, I straightened up.

Terry — or, rather, the hard-boiled cop he was pretending to be — looked at me with an expression of distaste, as if he'd just eaten a bad clam, then spat in my face and, with no other warning, pushed his knee into my crotch, mashing my cock and balls between the two stiff leather pieces of the jock. I doubled over and fell back onto the bunk, stunned by the unexpected pain. By the time I was able to look up again, he was out of the cell and locking the door. He stood there for a moment, his mouth twisted between a smile and a sneer, before delivering his parting shot:

"Okay, punk. Sit tight 'n' think 'bout whether yu'd be better off cooperatin'. If ye'r smart, you'll have some answers ready by the time I get back. And watch yer mouth — there's a mike, so I c'n hear any noise ya make."

I watched through the bars as he stalked out of the concrete box. As he slammed and locked the outer door, and his spit dried on my face, I wondered how my request for confinement had turned into an interrogation scene. *I guess the man in charge gets to call the shots!*

I listened for his bootsteps outside the cell. *Nothing — good soundproofing.* I heard no sound at all, in fact, except a soft *whoosh* from inconspicuous air vents and the hum from the light. Terry's reference to a microphone was suddenly reassuring — *and probably intended to be*, I realized. If I got sick or panicked while locked up, he'd hear a call for help.

Thinking it over, I had to admire Terry's role-playing. Even

out of uniform, he'd exuded the authority of a veteran cop facing a smart-mouth young delinquent he suspected of serious crimes. *Can I play my part as well?* I winced at the lingering pain in my balls as I sat up on the bunk.

I'd never been in a real cell before, but prison fantasies had led me to plenty of books on the subject — and who could miss all those jailhouse scenes in popular movies and TV shows? The only things lacking in Terry's home lock-up, I figured, were the noise, stench, and omnipresent danger of a real prison — all of which I was happy to do without. I discovered one other not quite authentic touch: instead of a naked bimbo, the pinup calendar on the wall above the bunk showed a humpy motorcycle cop with his killer cock hanging out. I flipped through the other months, hampered somewhat by my cuffed hands — each one featured some macho gay icon, most of them uniformed: a cowboy, a soldier, a sailor, a flyboy, a Marine, a construction worker, a biker, a forest ranger, a fireman, a trucker, even a UPS deliveryman. I couldn't help smiling at Terry's twisted sense of humor.

I paced the small cell many times, dragging my leg chain and letting the feeling of being a caged prisoner sink in. Finally, I sat down again on the bunk — the butt plug forcefully reminded me of its presence as I bent my torso — and scooted back against the rear wall, accompanied by squeaks from the springs.

Not much to look at, I mused, *but it sure is peaceful.* Staring at the stripes cast by the light outside, I started to space out. Bondage and torture scenes flickered onto the movie screen in my head — shaky at first, like an old silent film, then smoother and more assured, amounting to an erotic *film noir* featuring me and Terry, dressed again as he'd been at the Spike, later joined by the motorcop from the calendar. The action got wilder and wilder, the delicious abuse more and more inventive, with quick cuts and dissolves covering impossible transitions. It finally evolved into a pornographic music video with leather-clad skinheads playing synthesizer Bach as arranged by Frank Zappa. I shook my head and sat up, breaking the spell.

I paced around the cell some more, looked through the calendar again, drank some water, and sat on the chair with my cuffed hands on the table, staring at the wall. I often found the monotony of a long-term scene more challenging than the restraint itself. *Getting* locked up (or tied up, whatever) is exciting;

staying locked up can become boring. My hard-on was long gone, my deflated dick slipping out of the straps holding it to the back panel of the jock.

Curiously, the greater freedom afforded by the chains between my wrists and feet — as opposed to a sleepsack, straitjacket, hogtie, or any other rigid bondage — made the "dead" time harder to take. Because I could move around, I felt I should be *doing* something. But there was nothing I *could* do. Thanks to the chastity jock, I couldn't even play with myself, just wait for Terry to return for the next scene in our drama. I could call out for him, but with what excuse? I could shout insults and try to provoke him to return, but that wasn't my style, and I was afraid of what he might do if I miscalculated. *What if he kicked me out and never wanted to see me again?* Despite any reservations about his earlier dramatics, I *had* to see him again — this man couldn't be merely a passing episode in my life.

May as well take a nap. Still short on sleep from the night before, I had the feeling I'd need to be alert and rested when Terry returned. I lay on the bunk on my side, my cuffed hands joined as if in prayer on the pillow beside my head.

Sleep did not come immediately, however. The silent stillness of my confinement triggered long-buried memories: *The first time Greg put me to bed in handcuffs, and how safe and protected I felt. . . . The time he walked in the door wearing his new engineer boots and I spontaneously went to my knees and kissed them — when I saw the pleased surprise in his eyes, I licked them all over, then spent the evening on the floor under them, my dick rock-hard the whole time. . . . The first time he hooded me — as far beyond being blindfolded as that is from just closing your eyes. It was as if he let me become a different person, in a different world, a world without boundaries or rules. . . . My first flogging — it felt great at the start, and then it hurt terribly, but I didn't want him to stop. . . . The first time he tied me up before fucking me — and the last time he was able to. . . . Watching him waste away, racked with pains that no one could transmute to pleasure, that not even the most abject surrender could halt. . . . The years of cruising and back-room crawling after he died, of making connections, of breaking them . . . of begging to be bound tightly, tighter, as tight as possible, while hanging loose inside. . . . "No strings, ain't no strings on me" became my theme song. . . .*

Other "significant others" came back to me — not all had

yet passed away, but they'd certainly passed out of my own life. *Alex, who looked great in leather and talked a hot scene but couldn't bring himself to give me pain. . . . Brian, so into his uniforms he almost forgot the sex. . . . And dear, funny old Herb, a campy "leather queen" but a wizard with rope. . . . Whipmaster Tom, always unlucky in love (I wasn't the first to disappoint him). . . . Frank, a real sadist with his electrodes and cattle prods, didn't even get hard until I was screaming my lungs out — not a trip I wanted to repeat. . . . Randy, good old or-ange-hanky Randy, ready to top, bottom, or switch at a moment's no-tice. A true master at piercing, he laughed when I said the pain as he pierced my nipples was "no fun" — and kept laughing as he pierced his own again just to prove me wrong. . . . And . . . and . . .*

Now there's Terry. Five years from now . . . or ten . . . will he be just a memory, too? . . . He says he's negative. I know I am. . . . Maybe it's time to stop running

Hey, whoa! Is this Matt Stone talking? I have a reputation to live up to! Everyone knows I don't need a lover, or a Daddy, or a Master — I've said it often enough. . . . I'm not some dumb kid with no life of his own, looking for an omnipotent Mr. Benson to carry him away and make him a sex toy. . . . I like *my life just as it is. . . . So? Does that mean it can't be any better? I loved being with Greg, too — just be-cause he's gone doesn't mean I can't make a life with anyone else. . . . Haven't I sowed enough wild oats?*

I shook myself and turned over on the bunk, lying on my back with my cuffed hands behind my head. The unmoving shad-ows of the bars across the gray ceiling held no answers, so I closed my eyes again to think.

What the hell started this off? Sure he's a great top — shit, who wouldn't be with a setup and equipment like this? . . . No, that's not fair — or true. It's not what he has but how he uses it. I'll bet he could pull off a terrific scene with nothing more than his hands and one boot-lace. Other guys could be given the whole contents of this basement and still wouldn't have a clue. . . .

I don't know how he does it, but he makes me want to please *him, not just play my part in the game so he'll get me off at the end. . . . Last night was way beyond what I expected when I cruised him at the Spike. . . . And then he was so natural, so* friendly *this morning — no self-conscious posturing trying to maintain a role. And no half-embarrassed rush to get rid of me before I saw his human side, either. . . . I really* like *him, even if he scares me sometimes. . . . Maybe this is*

*just the Stockholm syndrome, and I'm identifying with my "captor"? . . .
No way to be objective about it now. Have to play this scene through
and sort it out when I'm back home.*

Comforted by that easy resolution, I yawned and rolled on-
to my side again. *He'll just have to get used to my falling asleep in
bondage!* I thought before drifting off into unconsciousness.

CHAPTER 7

Assault and battering

The clang of the cell door sliding open startled me awake, but before I could open my eyes or sit up, I felt a jab in my ribs.

"Wake up, punk," the man snarled, jabbing me again with his nightstick. Reflexively, I tried to pull away, but he got me yet again.

"On your feet, asshole. Time to come clean." *Jab.*

I rolled off the bunk with a clatter of chain and got myself upright as fast as I could. *Jab.*

Standing in front of me was a tall, mustached man in a perfect CHP uniform, normally one of my favorite outfits: gold-and-blue helmet, mirrored sunglasses, heavyweight black leather motorcycle jacket over an open-necked tan shirt, basketweave gunbelt, holstered gun, black leather gauntlets, tight tan breeches with blue-and-gold stripes down the outside of the legs fitted into tall, snug, black boots — the works. He *sounded* like Terry, and he had the same height and build, but with the shades and the sneer in his voice, it was hard to be sure. As if impatient with my pondering, he jabbed the stick into my crotch, and when I bent over in reaction to the sudden pain, he pushed me down to my knees. Then *he* sat on the bunk and stuck a boot in my face.

"Start licking, dickwad. Do a good job, 'n' I may leave you in one piece."

Now I was sure it was my hunky host behind the mirror-shades — *who else enjoys boot service as much as I do?*

The gleaming police boots, however, were *not* the same as the ones I'd serviced the night before. These were Dehners, standard for the California Highway Patrol and many other departments outside New York. Probably custom-made and obviously

well broken in, they were polished to a mirrorlike gloss and fit Terry's calves as if molded to them. I bent my face and started tonguing them with deep respect.

While I licked one boot, he tortured me with the other, poking me in the crotch or belly, dragging it along my back, thumping my butt with the heel, scraping the sole on my neck. Then the same with the other boot. My knees hurt from kneeling on concrete, but otherwise I was in pig heaven. My newly stiffened cock rubbed painfully against the straps that had earlier held it against the backplate of my jock, and the butt plug seemed to reach new depths in my ass.

"That's enough fun 'n' games, punk," he said after only a few minutes, though, yanking on the waist strap of the jock to pull me off his boot. "Get up."

I stood facing him again, now dirt-smeared and disheveled. He spat in my face and smeared it around with his leathered palm, then turned me toward the door and pushed me roughly out of the cell, still holding tightly onto one arm. Outside, he unlocked the cuff on my left hand and quickly shoved me up against the barred door, facing toward the cell. He raised both my arms, passed the loose cuff around a bar above one of the flat horizontal crosspieces in the door, and refastened it on my wrist. While I had to hold my arms up to minimize the pressure on my wrists, the thick, rounded cuff bows weren't as likely to pinch a nerve as those of thinner, standard-weight handcuffs.

Naturally, Terry wasn't finished yet. After unlocking the cuff around my right boot, he undid my shorts and pulled them off. He kicked my legs a couple of feet apart, threaded my leg chain around several bars in the door, and locked the shackle around my boot again. The effect was to lock my spread legs in place, leaving me no way to kick or twist around. Finally, he pulled the T-shirt up over my head and bunched it up under my chin. If I bent my head forward a bit, I could rest it on another crossbar in the cell door, which may have been the idea.

I wasn't surprised when he hauled off and spanked my ass hard a few times, and I braced myself for more, but he paused first.

"Okay, fuckface. Are you goin' to talk? . . . Or do I beat it out of you?"

He's giving me an "out," I realized. *Maybe he's not sure I can*

handle what he's planning. . . . And maybe I can't. The hammering of my heart filled my ears as I assessed the situation. Terry, bless him, waited silently, letting me make up my mind. *So he'll have to scrape me off the bars when he's through — that'll be* his *problem! No way am I going to miss this!*

I took a deep breath, then sang out, "Eat shit and die, pig!"

Whommp! His hand slammed into my back, smashing my pecs into the bars and knocking my breath out. *Whommp!* Over and over. Later he alternated heavy slams with lighter but more focused punches and jabs, one after another in quick succession for a while, then spaced out, letting each bruise develop a little before he planted another alongside it.

Besides his hands, he used the nightstick, jabbing me with it and also slamming it down lengthwise. Though he'd started on my back, my butt and thighs got most of the attention as the beating continued. It hurt so much I couldn't even spare breath to scream. Sweat stinking of pain and fear poured off my body, and my eyes welled over with hot tears. I clung to the bars as to a life raft, hoping to melt through them into the imaginary safety of the cell. At the same time, a cooler, more detached part of my mind realized that the savage beating was controlled, limited by a concern for my safety: Terry never touched my kidneys, head, or joints. By the end, only that subliminal knowledge kept me from losing it entirely.

When the blows stopped suddenly, the silence was filled by the sound of heavy breathing — whether mine or his I wasn't sure. Probably both. My front side felt almost as bruised as the rear simply from being slammed against the unyielding bars.

"That's for starters, trashbag," Terry growled behind me. "I've got *lots* of ways t' make ya hurt. When I'm finished you'll *beg* t' tell me anythin' I wanta know."

I was in no position or shape to argue — I didn't even have the strength to beg for relief. I hung from the bars and silently prayed for a breather.

He must have needed a rest, too — beating someone up is hard work. After a minute or so without fresh assaults, I cautiously turned my head and looked. He was sitting in the wooden armchair, which he'd tilted back against the wall. He'd taken his helmet off and was running a hand through his sweat-drenched hair (he'd changed from gauntlets to short, tight-fitting gloves).

His jacket was also off — I saw it hanging from a hook on the wall — but the gunbelt was still around his waist. His short-sleeve uniform shirt, tight around his pumped-up arms, had huge sweat circles in each pit. He looked at me with that crooked smile of his and stroked his well-filled basket. Then he picked up a bottle of water from the floor and chugged from it. I looked away, licking my lips with a dry tongue.

"Thirsty, punk?" he called out. *I won't ask for it*, I vowed. "I'll bet you'd really like some of this water 'bout now, wouldn't ya? . . . No? . . . Guess I'll finish it m'self then." A rattle, as from dried bones, escaped my throat. "'Scuse me? . . . That mean ya *do* want some?"

I coughed. *Why* can't *I ask for it? Whose rules* are *these, anyway?* I was preparing to beg, but he was already beside me, pulling my head back with an iron grip on my sodden hair. My face was directly beneath his, though they were crossed and reversed — his chin above my left cheek, mine pointing at his right ear. I could see only myself in the mirrorshades, not a glimmer of his eyes. *I look like shit*, I thought, and as if in confirmation he opened his lips and spat a mouthful of water into my face.

"That what ya want, boyo?" he sneered as I spluttered (some of it had run inside my nose). "Ready for more?"

"Yes, please, Sir," I croaked out.

He moved his face away and raised the bottle to his mouth, tilting it back to make the liquid flow more easily. I could see his throat muscles working as he swallowed — there didn't seem to be much left.

He lowered the bottle and turned his face to mine again. I was prepared for another explosive anointment, but this time he let the water dribble slowly out of his mouth. I tried to catch his dribbles, and he tried to make me miss them, jerking me around by my hair. I did get some of the water into my mouth, but most rolled off my chin or into my eyes or nose. The T-shirt around my neck caught the rest.

Frantically playing a game whose rules kept changing, one we both knew I couldn't win, I forgot everything but his lips and face looming over me. Soon I lost even that as the water, my tears, and our mingled sweat drowned my eyes. I gave up and squeezed them closed, allowing him alone to determine (as if he hadn't all along) whether my thirsty mouth would be filled, my

urgent need met. He continued to tease me for a few moments, but then he put the bottle itself to my mouth, and when my lips closed gratefully around the neck, he allowed the last swallows to roll into my throat.

"See how nice I can be, asswipe?" He removed the bottle and raised my head, allowing it to rest against the bars again. "All you have to do is give up, stop fighting me."

I said nothing, conserving my strength for the next round.

He felt my cuffed hands and made me flex the fingers. Apparently satisfied, he stepped back and started working me over again, using just his tightly gloved fingers this time, lightly at first and then more and more vigorously. He pinched and rolled my nips, pinched the skin along my sides, pressed his thumbs into my armpits, pushed the butt plug deeper into my ass, dug in at pressure points on my back, and otherwise made me as miserable as possible. These less violent but more intimate assaults were accompanied by torrents of verbal abuse — on both sides.

Ungagged, I freely vented my pain with groans, gibes, oaths, and screams, trying to stay in character. I used every anti-cop slur I could remember, or invent, and Terry shot back like a trouper. But though he called me "cocksucker," "bootlicker," "ass sniffer," and similar endearments without compunction, he never once called me "faggot" or "queer," let alone "cunt" or "bitch."

Our weird water break had revived me enough that I started out determined not to be the one to call it quits — but I was quickly losing ground. I even began to worry it might not do any good to ask him to stop, he seemed so steamed up. He kept returning to the themes of what a stupid fuck-up I was to get into this situation, how totally helpless I was, and how dependent on his mercy — "Which is in mighty short supply, shit-for-brains!" Finally he went over the top:

"Go ahead and yell all ya want, fartface," he hissed into my ear. "No one'll hear ya 'cept me — an' y'r screams 're music t' my ears."

His stage-villain delivery of that cliché — already old when our parents were kids — convinced me that he was only acting, at least as far as the verbal abuse went, and he did ease off the pummeling soon afterward, then walked out of the room and left me hanging. By the time he came back in ten minutes or so, I was breathing more or less normally again — and wondering

just why I *had* gotten myself into this situation. My cock was back down to peanut size, and all I could feel was pain, not lust.

Instead of renewing the "interrogation," however, Terry went inside the cell and stood there looking at me through the bars, one boot propped on the chair and his arm draped over his thigh. I looked at him, too, and that answered my question. My cock stirred and grew inside the jock as we stared at each other. He looked delicious — so perfectly macho queer I wanted to eat him up, starting with the black chest hair curling out of his half-open shirt. I stared and licked my lips, thirsty now for more than just water.

Breaking the tableau, he made a production out of loosening his gunbelt and dropping it on the bunk. Then he unbuckled his matching pants belt and slowly drew it out. Looking straight at me again, he doubled the heavy black belt in his fist and tapped it on his raised leg, then slammed it down. *Whack!* It must've hurt, but his expression never changed. The same ghost of a smile flickered beneath his 'stache. He took his foot off the chair and shoved it aside so he could stand even closer to me on the other side of the bars.

"Still think I'm a pig, motherfucker?" he asked with quiet intensity.

I was ready to stop then — the pain part, anyway. My cock was roaring hard again, and I wanted to feel *his* prick up my ass instead of that damned rubber plug.

"No, Sir," I said urgently. "I'm sorry, Sir."

"Ready to talk, punk?"

"Yes, Sir. . . . But I don't know what you want me to say, Sir." I was tired of games.

He reached through the bars and started lightly working my sore nips. I hissed and moaned in response.

"Don't you, now?" he asked, and brutally twisted my right nipple. I screamed, from shock as much as pain. He did the same to the other side. I screamed again, definitely from pain this time!

"Please, Sir, I don't know what you want! Please tell me what to say!" I blubbered. My cock had deflated again, and I was getting scared.

He strode out of the cell and stood behind me. After an agonizing pause of several seconds, he lashed me full force on the butt with his belt, then again and again, three or four times,

maybe more — I lost track. I screamed again, even louder, at the first blow and just kept screaming till he stopped. I sagged against the bars, hyperventilating.

Terry stroked me lightly with his gloved hands, calming and soothing me, until my breathing returned to normal and I could stand straight.

"You know what I want, boy," he growled softly into my ear. "Just *think*. . . . It's very simple. It should be obvious — even to a stubborn smartass like you."

I had no idea what he meant. That's the trouble with these fantasy scenes — eventually the script runs out! I free-associated desperately, but nothing seemed remotely right. *What would satisfy him? . . . He's been playing a cop . . . a confession? Yeah! A confession! . . . But what should I confess? . . . Anything! Everything!*

"Yes, Sir," I said firmly, sure I had it now. "I confess. I did it! I'm guilty as hell. You've got me dead to rights. I'm the one!" Getting no response, I tried all the variations on this theme I could think of.

"Too bad, asslicker," he said after I ran down, "that's not it."

He started laying into me again with the belt, though I sensed a little less force behind each blow than in the first set. It still hurt, of course — a lot — but I started getting into it. Finally, my brain was pouring out enough endorphins to counteract the pain, and as the slow, even belting continued, the hurt transmuted to a glowing warmth. Instead of groaning and crying and stiffening against each blow, I relaxed into the lash, and my vocalizations changed to moans and sighs. My cock stiffened yet again within its leather prison.

Each belt stroke began to feel like a tiny orgasm; the neural fireworks were indistinguishable from those of pleasure. As the rhythmic beating continued, I felt myself being pulled along from peak to peak of sensation. Instead of being desperate for release, I didn't want it to stop. Eventually I realized how sensitively, how skillfully Terry was playing me, using my body to create an ecstatic experience.

A wave of gratitude washed over me, and I spontaneously shouted, "Thank you, Sir! Thank you!"

The lashing didn't stop instantly, but he did immediately begin ramping down. I continued to soar under his blows even as they progressively diminished to light slaps.

"That's it, boy," he said quietly when he stopped altogether. "Wasn't that easy?"

"Yes, Sir, yes! Thank you, Sir!" I gushed as he gently kneaded my back — which actually increased the pain.

"I'm going to give you one more heavy stroke," he declared. "Hold on tight. You can take it."

I awaited the finale, greedy for it and yet also fearful. As the moment stretched out, my heart thumped and my guts churned, reminding me that this little morality play was, after all, being enacted on the stage of my aching flesh.

Finally, he struck: one tremendous lash that seared my back from shoulder to thigh. Part of me cowered away, screaming like a wounded animal. But another part embraced the sensation. *Yes! Yes! Oh, yes! That's it!* By the time the warm afterburn set in, I was limp, almost unconscious, hanging by my wrists.

Terry hung his belt on the door and wrapped me in his arms, holding me up until I could support myself again. He unlocked the panel covering my half-hard cock, then unlocked my right handcuff, reattaching it to the bars so my left arm was still secured. He massaged my right wrist briskly and put my hand on my dick.

"Start jacking off, boy . . . slowly. Use spit if you need lube."

He went inside the cell, carrying his belt, took off his shades, and placed them both on the bunk with his gunbelt. He turned the chair to face me and sat down just a couple of feet away. As I slowly worked on my cock, he mopped his sweat-soaked hair with a bandanna, then unzipped his pants and took his dick out. He hawked a gob of spit into his right palm and slid the damp leather over his tight, purplish cockhead, moaning softly. I watched him, and he watched me, as each jerked his own meat. I didn't need any spit — my piss slit was oozing.

If he *had* shown me the script in advance, I wouldn't have believed this part: still chained to the door of the cell, aching in virtually every muscle and square inch of skin from my neck to my knees because of the abuse I'd taken at his hands, I stroked my cock slowly, making it hard again, as I watched my torturer pleasure himself. I licked my lips remembering the taste of his boots — and of his balls the night before. I still wanted to eat him up, but seeing him framed by the bars of the cell would have to do.

He was quite a sight, too — slumping in the hard chair with his booted legs splayed out and his gloved hand pumping the seven inches of hard pink cock poking out of his tan breeches. He had no trouble bringing himself to full erection. And when he paused to unbutton his shirt the rest of the way, exposing his hairy, sweaty chest, neither did I.

Eyeing him hungrily, I pumped my hard cock. My back and ass burned, and my nipples throbbed. I stared and pumped, again imagining my tongue spit-shining his whole body, from his brushcut head to his bare toes. I wanted to make him writhe in pleasure as much as he'd made me writhe in pain. I wiped my drooling mouth with my free hand and transferred the spit to my dick, whimpering as the decreased friction let my palm slide faster, intensifying the exquisite sensations streaming from my groin to my brain.

Terry was obviously enjoying looking at me, too. His eyes repeatedly raked my bound and bruised form, returning each time to my lust-slackened face. His crooked half-grin was almost fixed in place, disappearing only when he pursed his lips to freshen the spit on his glove. He seemed to be challenging me all over again with his eyes.

You're mine now, I imagined him saying in silent triumph. *You have nothing left to fight me with. And you don't even want to. You're broke and ready to ride. The only reason I'm jacking off instead of fucking you is so I can see what I've done to you — what I can do again anytime I want. You'll jump whenever I say jump, crawl whenever I say crawl, open your sassy mouth wide for whatever I want to put into it.*

Staring back, I projected equally silent bravado. *You "broke" me only because I let you*, I thought defiantly. *It's true I won't fight you, but that's because I want you, topman. You're no better than me, no stronger. You're a pervert and a pig like I am. We're two sides of a coin, the inside and outside of the same boot. Sure I'll crawl for you. I'll jump through your hoops, I'll drink your piss and lick your ass — because I want to. Because it feels good. But you don't own me. All you have of me is what I lend you. I can take it back anytime.*

This mental duel only made us hotter. Our needs were so complementary, it was a win-win game. I asserted my independence only to have the pleasure of surrendering it. He asserted his conquest only to elicit the greater prize of a willing submission.

Terry kept his eyes fixed on mine until they rolled back into his head. His hand on his cock was a blur.

"Aiee! Oh, shit!" he shouted. "Fuckin' close! . . . I'm comin', boy! Shoot, Matt! Shoot *now!*"

A geyser of cum erupted from his cock and shot across the space between us, through the bars and onto my crotch. That was all I needed! With his cum as added lube, I pumped my engorged cock. In seconds I was at the edge and leaping over it.

"Coming, Sir!" I yelled. "Ohmigod! Fuck! Aaah!"

A giant fist squeezed my whole body, and a black star went nova in my brain. I jerked against the bars, screamed, and shot, draining my swollen balls, releasing every tense muscle all at once, wracked with pleasure so close to pain the difference was merely semantic.

When I could see straight again, a few minutes or years later, I realized that I hadn't quite matched his distance record — my cum was splattered on the floor between his legs. He noticed it, too. He staggered to his feet, shook himself like a rag doll, and flashed me a big smile. Then he bent down and scooped the cum onto his glove. *Is he going to make me eat it?*

He came up to the door, reached through, and wiped the glove in my hair. After knuckling my head affectionately, he pulled me close so we could kiss between the bars. We swapped spit until he broke the clinch and left the cell, but only to come around behind and hug me tight. I groaned as his fingers lightly brushed my sore nipples, and nearly giggled as he nuzzled the back of my neck, tickling me with his moustache.

I was almost sorry when he disengaged to release my restraints. He took off the handcuff still holding my left hand, then unlocked the straps of the chastity jock and eased it down, and finally knelt to unlock the leg cuffs. When I was free, but still shaky, he turned me around and took me in his arms again. At first I laid my head on his shoulder but soon moved my face to his throat and began kissing my way toward his chest.

"Thank you . . . thank you . . ." I kept murmuring between kisses. Again without thinking about it, I'd dropped the "Sir" as soon as the last of his restraints were off my body. I held him tight and nuzzled at his furry, sweat-salty chest while he stroked my hair and kneaded my shoulders, both of us making little wordless noises of satisfaction.

My knees were wobbling, and I felt lightheaded, but I ignored the warnings. This was the first chance he'd given me to make love to him — not his cock or his boots or a scene persona, just *him* — and I wasn't about to waste it. Though we were both pretty rank, the smells hit my brain like perfume.

"I guess you enjoyed that," he said as I sucked his left nip.

"Ohmigod, man," I replied, looking up at him. "It was fantastic . . . unbelievable It was" Words failed me, so I just gave him the biggest, wettest, sloppiest kiss I could manage.

"I'll take that as a yes," he said with a grin after our lips unlocked. "I was worried it might be getting too rough for you. But you stayed with it."

I straightened up, swaying slightly in his arms.

"You scared the shit out of me," I said, looking him in the eye. "Didn't I say last night at the Spike that I wasn't looking for an interrogation scene?"

"So?" he shrugged. "Any regrets?"

"Well . . . no, I don't think so. . . . Ask me again in a week! If I have wet dreams instead of nightmares" We both laughed at that. I pulled back a little and waved my hand at the cell. "I never expected such realism!"

"If a thing's worth doing" He grinned, then looked me over appraisingly. "How're you feeling? Want to sit down for a while? Or lie down?"

"I'm fine," I insisted, and lightly stepped away from his protecting arms, drawing on my last store of energy to keep from falling. "Let me clean up, and I'll be good as new."

"Oh, I think you'll have some bruises for a while," Terry said with a smile. "Can you handle the stairs, or do you want to shower down here?"

"Doesn't matter to me." *What am I trying to prove? That I can walk away from the heaviest scene I've had in a year like it was a trip to the newsstand?*

He still eyed me dubiously, so I did a little pirouette for him. He snorted and turned to retrieve his gear from the cell. As soon as I saw his back, I staggered to the wall and leaned on it, hoping that would make the room stop spinning. Terry looked back at me, frowning furiously, but I waved him away. To prove I was okay, I bent down to pick up my discarded shorts and jock from the floor . . . and kept on going down, all the way.

CHAPTER 8
Aftercare and afterglow

When I came to, Terry's face was hovering above mine. At first I thought we were back in the scene, playing our water game, but he looked altogether different from the last time. No mirror-shades now, and his wide-set hazel eyes (*what a pretty color!*) were filled with concern. I saw my naked body in them, tiny and upside down, as if I was skinny-dipping. *Looks like fun!*

"Matt? . . . Matt? . . . Are you with me, Matt?"

His voice pulled the world back together.

I was lying on the bunk in the cell, and he was perched on the chair next to me. My legs were raised, propped up on the pillow and his folded leather jacket. My forehead throbbed.

"What happened?"

"You fainted and bumped your head on the floor. I doubt it's anything serious, but you'll have to lie still for a while."

"Okay," I said, happy not to have to make any decisions. *I sure screwed up the last one, didn't I?*

"It's my fault, really," he said in a tight voice as he lifted something wet from my forehead and stepped over to the sink. Running-water sounds. He came back and laid the wet T-shirt back on my forehead. He seemed angry, but not at me.

"I should have brought you down slower after the scene," he said, gripping my hand. I felt flesh (he'd taken off the gloves) and ran my thumb across his knuckles. "I'm really sorry, Matt. I haven't made that mistake in a long time. You did a good job of pretending to be back to normal, but I should've known better. What were you trying to do, anyway? Prove to me how tough you are?"

"Something like that," I conceded, shamefaced. *How trans-*

81

parent I am to him! "I'm sorry I tried to fool you." Even if he blamed himself more, I shared the responsibility.

"You paid for it. Learned your lesson?"

"Yes, Sir! Guess honesty *is* the best policy after all. . . . That's what they told me in Boy Scouts, but then they threw me out for admitting what Brian Tanner and I did in our tent at Jamboree, so I figured they were lying."

"You're incorrigible," Terry said, grinning and shaking his head. "Now I *know* it's not serious, if you're already wisecracking."

"Whatever you say, Sir," I replied, unself-consciously using the honorific again.

Terry gave me a sharp look, then released my hand and went to the sink again, bringing back a cup of water and holding it to my lips, his other hand cradling my head.

"Slowly Take small sips. . . . That's right."

The cool water tasted almost as good as his sweat.

"Any nausea?" he asked after I'd drained the cup. "Queasiness? Sharp pains in your head or anywhere else?"

"No, Sir, nothing like that."

"How many?" he asked, holding up three fingers.

"Three," I told him, then yawned. "'Scuse me, Sir!"

"It's okay, bucko. You'll be fine," he said. "But I still want you to lie quietly for a while longer. Don't move if you're the least bit lightheaded. Sleep if you want to. I'm going to tidy up a bit."

"Yes, Sir."

He pulled the damp T-shirt off my forehead, ruffled my hair, and stood up. His mischievous crooked grin was back. *Was it something I said?*

I watched as he carried the shirt and his gunbelt, pants belt, and sunglasses from the table in the cell — he must've put them there when he laid me on the bunk — over to the chair in the room outside. He detached the handcuffs and leg irons I'd worn from the cell door and added them to the pile on the chair, along with my chastity jock and shorts and his CHP helmet. Seeing I was still awake and looking at him, he came back into the cell and stood over me.

"Do you want me to sit with you, Matt?"

"You don't need to nurse me!" I protested. His mouth tightened, and I instantly regretted the outburst. "I'm sorry, Sir. I appreciate your concern. But I think I need a little time to myself."

"All right," he said, "but I'll leave the mike on. Shout if you need me. Understand?"

"Yes, Sir. Thank you."

Outside the cell door, he hesitated.

"Please, Sir," I said softly, looking right at him, not quite sure what I meant. *He* knew, though, and he gave me a big smile as he slid the barred door shut — and locked it. "Thank you, Sir." I let my head fall back to the mattress.

"I'll be back in a half hour or so," he said.

"Yes, Sir," I whispered, then closed my eyes. I was asleep before he locked the outer, guard-room door behind him.

For a change I woke up before Terry came back. It took a few moments to recall where I was, and why, and then I checked out my systems. *Heartbeat? Slow and steady. . . . Breathing? Normal. . . . Feet? He took off my boots*, I realized for the first time. I wiggled my toes and flexed my arches — *all fine. . . . Calves and shins? Fine. . . . Knees? A little scraped from the fall, but otherwise okay. . . . Thighs? Ouch! Bruised front and back. . . . Ass? The damned butt plug's still in there! That's the least of it, though. . . . Everywhere else is sore, too — it'll be one big bruise. . . . Cock and balls? Deflated . . . spent . . . retired from the field . . . a peanut and two walnuts. . . .* There was dried cum all over my crotch from Terry's hole-in-one. *Bladder? Ready to burst . . . surprised I don't have a piss hard-on.* I decided to try holding it awhile longer, obedient to his order not to get up again yet.

Stomach? Rumbling . . . I'm hungry! That's a good sign. . . . Abs? Fine. I slapped them to prove it — *ugh! Not so fine. . . . Chest? My nips feel bigger than my balls, and sore! . . . Tender spots all around 'em, too. . . . Back? Oh, God! Better not think too much about that. . . . Hands and wrists? Palms scraped . . . the fall again . . . cuff marks on both wrists . . . not very sore, considering . . . no tingling or numbness. . . . Arms? Fine, one elbow scraped. . . . Shoulders? Movable. . . . Neck? A little stiff — nothing new there! . . . Face? Feels clean — he must've washed it off. . . . Head? A small bump up front . . . doesn't seem to have broken the skin.*

I moved on to the intangibles. *Mood? Good overall . . . contented, relaxed. . . . Happy? . . . Yes! Why shouldn't I be? Haven't had a*

day off so jam-packed and fun-filled in . . . well, a long time. . . . Energy? Low but reviving. . . . Ready for more? No way! Definitely not. . . . Better quit while I'm still in one piece, save it for next time. . . . So there'll be a next time? . . . There will be if I have anything to say about it! . . . And what if I don't? What if he's not interested? . . . Impossible! He enjoyed it as much as I did! I'm sure of it. . . . Yeah, but what if he figures he's reached my limits already and would be bored doing it again? . . . What if he decides he hasn't reached my limits and wants more *next time? . . . I don't think I can handle much more pain. . . . But pain's not the only coin in this realm. . . . Hmmm*

I was contemplating that little riddle when Terry returned. He'd obviously used the break to take off his soiled uniform, and he looked great in black leather jeans, a narrow vest framing the Bill Ward hunk printed on his GMSMA Leatherfest '90 T-shirt, and black cowboy boots.

"How's the patient?" he asked as he unlocked the cell door.

"Fine . . . Sir." I was still a little confused how to address him. Part of me was content to continue "Sirring" him, but another part was anxious to reassert my independence. "Can I get up now?"

"Sure, just take it slow." He came in and stood by the bunk in case I needed a hand, but I felt fine aside from the bruises and stiffness — no more dizziness or weakness. "Ready to clean up?" he asked.

"Yes, Sir!" He grinned at my enthusiasm. "Should I shower over there?" I pointed to the open stall in the guard room.

"No. This scene's finished, Matt. Time to return to real life. You can use the shower in the gym — it's a lot more comfortable! — and then soak in the whirlpool until it's time to go."

"That sounds great." *I can hold my piss a few more minutes, I guess.* We smiled at each other. *Equals again? Buddies? Strangers in the night?* It didn't quite compute. In subtle ways, he was still the man in charge.

He grabbed his jacket from the bunk and stuck it under his arm. I followed him outside the "cellblock," he turned off the light, and we walked over to the wall of gear. I waited, dancing from one foot to the other trying not to piss on the floor, while he took the CHP badge off his jacket and located the exact drawer it had come from. *Is compulsive neatness his character flaw? What if he finds out I'm a slob at home?*

I assumed he didn't realize how urgently I needed the toilet, but he might have *guessed*. He turned to hang up the jacket, glanced at me, and asked mildly, "Is something wrong?"

"I need to piss, Sir!" I practically screamed. He grinned. *The bastard! He knew all the time!*

"No need to wait for me," he said. "The door to the gym isn't locked on this side. I'll be along in a minute, soon as I"

I didn't hear what he had to do first — as soon as he gave me permission I streaked down the corridor, barely noticing the porn gallery this time. Inside the gym, classical music was playing softly over concealed speakers, but all I cared about was getting to the toilet before I had an accident on the carpet.

Ahhh! It felt so good to piss finally, it was almost worth holding it for so long. Of course, there was a mirror just above the toilet tank — a decorating feature as essential to modern gay life as going to the gym and wearing tight T-shirts with clever sayings on them — but I knew I was a mess and didn't need confirmation. I closed my eyes and let it flow . . . and flow . . . and . . .

"I see you found it," Terry said cheerfully as he pulled the door open.

I clenched reflexively at this invasion. The last few drops already in my cock dribbled out, then nothing. I could've killed him, but I opened my eyes and forced a sick smile. He was right behind me in the mirror, looking like a leather-bar poster, while I looked like what the cat left under the bed.

"Ah, I'm not quite done, if . . . ah, you don't mind, Sir."

I'd managed to piss in his presence before, even with him holding my cock, but he hadn't interrupted me midstream. Now my sphincter was clamped shut tighter than a virgin asshole. He was amused.

"I'm surprised a bottom of your wide experience is still pee-shy," he said. "You really should get over it. Hell of a handicap in water sports, for one thing."

"I do *fine* once I get into it," I snarled, "but you startled me."

"I know. I intended to. Catching a man off guard is the only way to see under his masks. And I like to know who I'm dealing with." There wasn't the trace of a smile on his face.

I had no rebuttal, not even a wisecrack. I closed my eyes again and tried to relax so I could finish peeing. No luck. Even though he didn't say anything, his presence still inhibited me.

Maybe it's because he doesn't have me restrained. My head's not in bottom space anymore. . . . But he's *the one who said the scene was over, time to get back to real life. Then he deliberately jerks me around, lets me make a fool of myself waiting for his permission to go take a piss. And then breaks in on me while I'm doing it! . . .*

Wait a minute, I thought. *He didn't say, "The scene is over." He said, "*This *scene is over." Maybe this is* another *scene we're in, one he hasn't bothered to tell me about? . . . Or maybe this is what he considers "real life"? . . .* Terry touched my shoulder, and I looked at him again in the mirror.

"Don't let it worry you, Matt," he said with a smile. "You can finish in the shower. I promise to leave you alone."

I turned to face him, but all he did was give instructions.

"Use lukewarm water to start, then cool. If you use hot water it'll make your bruises swell up. When you take out the butt plug, rinse it off and toss the condoms in the wastebasket. Leave the plug on the toilet tank. After you're clean, get into the tub — I already filled it and set the temperature. It's on the cool side, too, but don't change it. The controls for the whirlpool are on the wall above it."

"Okay," I said, flashing him my warmest smile. I couldn't stay angry with him. "Thank you. Thanks for everything."

I meant it, too. *For a control freak, he's pretty nice — long as you do what he says, anyway.* But I couldn't resist a wisecrack.

"All right if I say, 'You're a prince, *Sir*'?"

"Smartass," he growled, then grinned before he turned and went out, closing the glass door.

I watched as he climbed the nearby stairs. *Where's that lead to?* I wondered. I didn't know the house well enough yet to be sure. *His bedroom? But I didn't see any staircase there. Secret passageways in the walls? After that cell, I won't put anything past him. . . . Doesn't matter. Time to finish that piss!*

After emptying my bladder, I pulled out the butt plug and dealt with it as ordered. I mixed the shower water till it was barely lukewarm and set the spray head for a soft stream before stepping inside. Even without Terry's cautions, I'd have known what to do — after all, it wasn't the first time I'd been beaten.

While I soaped myself, trying not to press too much on sore spots (though there wasn't much of me that *wasn't* sore), I played some more with the puzzle of the house's layout, trying

to match up the basement rooms I'd seen with their counter-parts upstairs — though I hadn't seen everything there, either. I had a strong suspicion that the "doughnut hole" in the base-ment was *bigger* than the courtyard upstairs, because the rooms around it seemed narrower. *What's his secret? A whole series of "fantasy rooms" like some of the baths used to have? A replica of the Mineshaft?*

I turned the water temperature down a notch for the rinse cycle, hoping it was cool enough to prepare me for the whirl-pool. There was shampoo in the shower caddy but no condition-er. *Guess he doesn't need it with his short hair.* There was no comb or brush at the sink, either, no doubt for the same reason, so I tried to untangle my curly locks with my fingers. There was also no razor. *I can't believe he doesn't have an extra one. Maybe he likes his bottoms to have beards — or to be scruffy in contrast to his neat-ness.* I rubbed my chin and had to admit that the stubble was barely noticeable. I often skip a day between shaves anyway.

The water in the tub was lukewarm, not cold, and I slid into it easily. It hurt a little when my bruised ass and back touched the hard enamel, but the tub was so large and deep that I could hold onto the rails at the sides and float. I reached up and turned on the whirlpool. Although the jets of water tickled at first, I was soon purring in pleasure at the gentle massage.

This is the life, I thought. *It'd be worth being his slave just for this — this house, and his cooking! . . . Yeah, but he probably kept his slave in the cell and fed him a nutritious gruel, or else dog food. That's why the poor guy left him. . . . Naahh! More likely, he* refused *to do that, and the slave got turned off! I can see it now in* The Star:

Shocking Tale of Slave Abuse!

Forced to live in luxury, slave runs away from his master. "He made me sleep in a bed," the ex-slave wailed, "and I had to eat his gourmet cooking! He even made me wear *clothes*! And when I begged him to torture me, he said, 'Not tonight, dear. I have a headache.' "

Carried away with my own silliness — no doubt an after-effect of my incredible endorphin high during the scene — I started splashing and singing off-key.

Sixteen today and strapped to the chest,
Yo, ho, ho, and a can of Cris-co.
Drink and the devil hath done for the rest,
Yo, ho, HO, with the can of Cris-co!
What shall we do with the drunken sailor?
What shall we do with the drunken sailor?
Shave his crotch with a rusty razor,
Use his mouth till he gets the flavor,
Ear-ly every morning,
Ear-ly EV-ery morning!

Hoo-ray and UP he rises! *splash*
Hoo-ray and UP he rises! *splash*
Hoo-ray and UP he rises! *splash*
Ear-ly in the morning! *ker-PLASH!*

I plunged my head under the water, twisted around, and emerged at the other end of the tub.

"Why doesn't he have a rubber duckie?" I complained aloud. "This tub *needs* a rubber duckie! And a boat! That's right, a big blue-and-red *steam*boat!" I put my mouth just under the surface and blew bubbles to make a wake.

My stomach growled again, reminding me of the time — or at least that it was getting on, since in this windowless underground wonderland I had no idea of the actual time. *Bet there's a clock in the gym. Gotta time those workouts.* I climbed out of the tub, turned off the whirlpool, and looked for a towel. There were several big ones hanging nearby: black, red, and gray. I was about to take one at random when I hesitated. *Is this a test? Is my choice significant?* Remembering that he'd said to use the gray towel in his bathroom upstairs, I reached for that one, but stopped again. *I've earned the black after this afternoon! . . . Oh, fuck it!* I used the red.

This time I was anxious to check myself out in the mirror. My backside was bruised a good deal more than the front, which I already knew, but it wasn't nearly as bad as I'd expected. I felt everywhere I could reach, and although my skin was still tender to the touch in a lot of places, there seemed to be no swelling. *I'll put A&D ointment on at home, and I'll be fine.* I rinsed my mouth out and brushed my teeth with my finger. *Another oversight — I'll have to speak to the manager of this fleabag!*

I walked into the gym still toweling my hair. I didn't see a clock, but my clothes — retrieved from his car trunk — lay on a weightlifting bench, my boots on the floor under it. The "Fit To Be Tied" T-shirt, quite a bit the worse for wear, was stuffed into one of the boots. *Guess it's a souvenir. Does that mean I won't be back . . . or that I will?* I found my leather cock-and-ball harness in the other boot, along with my bolo tie and the piece of rope I'd had around my arm, but I stuck it in my jeans. I wasn't horny enough to put the harness back on. *No loss — he already knows I can throw a respectable rod when I'm aroused.*

Since Terry hadn't come down by the time I was dressed, I took the opportunity to look more closely at the gallery. I started at the end near the dungeon and slowly walked toward the garage. It was a wonderful collection, even though the big names were represented mainly by reproductions. One of the Tom of Finland drawings was an original, though, and I looked at it especially closely. *Very good, but mine's better*, I decided. (I had a treasure in my bedroom, too — a fairly well-known Tom drawing of a leather couple that Greg bought for my 25th birthday. We had to skip our vacation that year to restore our savings account to health, and it was worth more now, but I'd sooner cut off my right arm than give it up.)

Now this is odd, I thought, looking at a tall, narrow frame that seemed to hold nothing but a glass-covered black expanse. *Did he forget to put in the picture?* The glass was somewhat reflective, and I could see myself as if in a black mirror. *Not bad*, I thought. My hair was every which way, but the day-old beard seemed to go with the rumpled T-shirt and worn jeans. I moved this way and that, striking poses, when I suddenly caught sight of a different figure in the glass — not my reflection but a dark-haired man in a leather cap, jacket, and chaps, viewed from behind. A whip dangled from one hand, and his cap was rakishly tilted. Half turned around, he was looking over his shoulder straight at me, an odd smile on his lips. "Are you coming?" he seemed to ask.

I stepped back in surprise, then looked closer. I realized then that the figure was drawn black on black. The slightly different shades made it perfectly clear at some angles, invisible at others. The more I looked, the easier it was to see, but the image in the glass still changed as I moved, flickering between the

leatherman and me — *his partner? slave? disciple? brother?* Captured by the magic, I didn't notice that Terry had come down until he was standing beside me.

"Extraordinary, isn't it?" he said.

"Yes . . . ," I said, reluctant to turn away. "I've never seen anything like it. Who did it? And where'd you get it?"

"A young artist in New York, Steven Evans. I saw it in a group show in a small gallery and bought it immediately."

"It's amazing . . . like he's caught our whole world in this one image."

"Except there're no answers here, just questions. . . . Now, if you can tear yourself away, how about a ride into the city?"

"Sure," I said, looking at him with a guilty smile. *With this next to me, I get seduced by an image? Dumb.* Really *dumb.* "But . . . could I get something to eat first? It seems like a long time since brunch." My stomach growled again, so loud that he heard it, too.

Terry laughed and glanced at his watch.

"I guess it *has* been a while. It's 7:10 now. I wasn't planning to cook tonight. We could eat in the city before I drop you off — at this hour we're only about 45 minutes from the Village. Can you wait that long? There's no place decent around here we would be comfortable dressed like this."

Is it a matter of comfort? I wondered. *Or worry that word may get back to your neighbors? I guess it's not easy to stay anonymous in a small town like this.*

"I can wait, Sir," I said. "I enjoy suffering — long as there's a payoff afterward."

Shamelessly flirting even with a soft-on, I raked my eyes from his face to his boots and back again, licking my lips the whole way. *Wonder how those cowboy boots would taste.*

"My momma warned me about pushy bottoms," Terry said with a laugh, reaching over to mess up my hair even more than it was. "Give 'em an inch"

"Hey, man — that was a lot more'n an inch you slipped me last night! Anyhoo, we'se jist talkin' po'k chops here. Feed me dinner, and I'll be yours forever, Sir. . . . Hell, since you've been such a gracious host, let me buy dinner. You pick the spot — anywhere that'll take my plastic."

"You're on. I'll decide where on the drive," he said as we started walking toward the exit. "Where do you live, anyway?"

"Upper West Side, 84th near Amsterdam."

"I don't know any restaurants around there."

"There're plenty, but the Village is fine if you prefer it. I'm 'amendable,' as my maiden aunt used to say."

"Sounds like you're giving me carte blanche, boy. Are you sure you're ready to do that?"

I looked to see how serious he was, but there was no clue on his face except that crooked half-smile, which could mean almost anything. I decided it didn't matter. *After what I've survived at his hands already, not much point in worrying about the next few hours!*

"Yes, Sir," I told him. "Carte blanche — for tonight, at least."

"For tonight, then."

We didn't talk again, each absorbed in his own thoughts, until after we were in the car. My earlier manic mood had subsided into a pleasant mellowness. Although I still ached all over, it felt good just to walk beside him, trying to match his long strides, our boot heels tapping a syncopated rhythm on the tile of the storage/utility room beyond the gym, then on the concrete of the garage floor.

The silvery Jag was parked head in. I studied it as we approached, trying to decide if it was old enough to be *more* valuable than a new one. *I hope not — millionaires can be so tedious.* Terry opened the driver's door and waved me around to the other side. Until that moment I wasn't sure he wouldn't put me in the trunk again. I got in and settled gingerly into the bucket seat (upholstered in black leather, of course), trying to find the least painful position for my butt, then fastened the safety harness.

"Hold out your hands," Terry said after I was buckled in. He snapped hinged cuffs on me, grinning at my surprised/pleased expression. *Does he have a pair in every pocket?* My cock stirred briefly but fell back, exhausted.

"You look so much better in bondage, I couldn't resist."

"Thank you, Sir." *What an odd compliment!*

Still grinning, he pulled a couple of web straps out of the glove compartment and bound my legs together above and below the knees. *He's as much of a pig for this stuff as I am!*

Once I was securely restrained, he opened the garage door behind us with a remote control, then started the car. It purred like the cat it was named after as we pulled out. Terry closed the

door again, pointed the car up a curving, well-graded driveway, and we were off.

I got a good overview of the house on the way to the street. Aside from its shape, the outside was fairly conventional looking, if modern in style, and modest in size. Almost the entire lower level except the garage entrance/exit was underground and thus invisible. Above, the parts of the walls that weren't all glass were clad in silvery-white clapboard siding (limed oak, he told me later). An ordinary entrance door was in front, at the end of a walk from the driveway, but I suspected that Terry — *and his tricks* — mostly came in and out through the garage.

The comfortable bondage and the smooth motion of the car made me relaxed and rather passive. I looked around as we drove through Larsburg, wondering why Terry had settled there, but it wasn't especially prosperous or run-down, nor particularly picturesque. So I let my mind drift. There seemed no need to say anything, but Terry made no move to turn the stereo on, either. I was enjoying the silence, but it turned out he was in a mood for conversation.

"You know," he said once we were on the parkway, "if I'd wanted to be alone, I'd have put you on a train — or locked you in the trunk again."

"Pardon me, Sir. But whenever I'm in bondage I assume I shouldn't speak unless I have to."

"That's a good assumption for a serious scene, but this isn't one. As I said, I like how you look in restraints. Unless we're in public, you can expect to be bound one way or another most of the time whenever we get together." *He* does *want to get together again!* "But that doesn't mean I want you to switch off your brain, or your mouth, unless I gag you. Understand?"

"Yes, Sir. What would you like to talk about?"

"Anything. Whatever you want."

I gave him a sharp look, wondering if he was teasing again. *He ties me up, then wants me to take the initiative? I'm a bottom, damnit! The whole point is not to have to make the decisions!*

"How about telling me about your car, Sir?" I ventured finally. *That seems safe enough.* "It's not new, is it?"

"Hell, no. Do I look like I could afford a new Jaguar?"

"Well . . ."

"Has that been bothering you? Thinking I'm rich?"

"It did cross my mind, Sir."

"Forget it. I'm a working stiff like you. I did pretty well in the boom years last decade, but now I have to hustle like anyone else. Architecture's a pretty dicey profession these days. My father was an electrician, my mother a schoolteacher, but now that they're retired, they have more in the bank than I do."

"I don't think I'll *ever* live as well as my parents did, Sir. I can barely afford to keep up the payments on my apartment. But they had a big house, took vacations overseas, put me through college, and saved enough for a comfortable retirement — all from a little office-supplies store."

"My folks weren't so well off. After I finished my professional training, it wasn't too hard to do a little better than they had. But now I'm scrambling not to slip backward."

"At least you have your house, Sir. I'm sure it's worth a lot more than my co-op."

"I wouldn't be too sure of that. Some of the, ah, specialized furnishings in the basement might make it hard to unload if I had to. And the upstate real-estate market is even softer than the one in the city."

"The house must have cost a lot to build, though."

"Not really — actually less than an average six-room ranch-style. It took me two and a half years to finish it, but I wasn't in a hurry. I used the time to find the cheapest way of doing every part of the job, while still using solid materials that would last with little maintenance."

"And your car, Sir?" I reminded him.

"*That's* certainly not low-maintenance," he laughed. "Quite the contrary! It was twelve years old when I bought it, and that was, oh, eight years ago now. It's so well built it could run another twenty, but only if you baby it like I do. Fortunately, all those Saturdays I worked in Uncle Max's repair bays taught me how to do the routine stuff myself. When it needs anything more serious, I take it in to his shop. That was our deal, after all."

"Deal?"

"I bought it from Max. He sells Jags, along with other European imports, and he's owned them himself for years and years. When I was a kid he'd let me play in his Jag when I visited, or take me for rides in it. I always dreamed of having one, but figured I'd never be able to afford it. When the house was finished

enough to give up my place in Manhattan and move in, I went to Max for a car. You have to have one up here. I figured he'd offer me a good deal on a Volvo or a Renault. I never even asked about a Jag, although he knew how much I loved them."

"So what happened, Sir?"

"Turns out one of Max's rich customers had just died, and the estate needed to unload his old Jag. It was in great shape, but not old enough to be a 'classic' or new enough to interest most people who buy luxury cars. Max let me have it for a song, provided I let him do the refinishing I wanted — the exterior was dark brown, with tan leather inside — and gave him any future maintenance or repair business for as long as I owned it.

"I couldn't pass up a deal like that, even if the refinishing did turn out to cost more than the car itself. So Max and I both made out okay."

"I also saw a Jeep in your garage, Sir. Is there a story behind that, too?"

"Nah. I actually got it a couple of years ago because I needed four-wheel drive to get to some of the sites we were building on — not because it's butch and fashionable. Guess that's a bonus! The company owns it, actually, though I pay the upkeep. I rarely use it now, mostly just when I have stuff to haul."

"Like a trick from the Spike, Sir?"

"Only if he was stuffed in a sack," he laughed. "The trouble with a Jeep is that you can see right into the storage area — no privacy at all."

We went on like that through the rest of the drive. Despite my "Sirring" him every other sentence or so, we talked easily — especially Terry, who turned out to be as voluble as I am once he got going. All I had to do was prompt him with a question or appreciative comment, and he'd run on for minutes at a time, telling stories about his family (especially Uncle Max, who sounded too good to be true) or sharing his strong views on food, music, art (erotic and otherwise), mutual friends (up to a point — he warned me off when I tried to probe him about other tops), gay organizations, sexual politics, and so on.

The only time we clashed was when we discussed "outing" prominent closet cases. To my surprise, he was all for it, while I was afraid it could backfire on us.

"Never, *ever* trust a closet queen," he told me earnestly.

"Especially in s/m. It's one thing to be discreet, but you can't trust someone whose whole life is a lie. If someone has power or wealth and still won't come out, it's usually because he's hiding something rotten, not merely being gay." *Guess he has other reasons for avoiding the local restaurants!*

My only disappointment with the drive was that, primly restrained upright in my seat, I couldn't touch him, and he rarely touched me — too busy with the stick shift, I suppose. *He fondles that gear shift like he's jerking it off,* I thought. *Oh well, boys and their toys*

When we reached the Village, we drove round and round until we finally found a parking space a few blocks from the Chinese restaurant he'd chosen. He released me, then restrained the car, using one of those massive steering-wheel locks they advertise on late-night TV.

"I'm surprised you leave this car on the street," I remarked as we were walking away. "Aren't you afraid it'll be stolen?"

"I wouldn't leave it on the street overnight," he said, "but as long as there are lights and people around, I'll chance it for a few hours. It's obvious that it's not new — even you knew that, and you probably don't pay much attention to cars. New models are what most thieves are after."

"I *like* not being part of the car culture, Sir. My friends with cars are always worrying about finding a place to park, remembering where they parked, or checking how early they have to get up to move it. If I can't walk or take the subway, I can just hail a cab."

Terry laughed. "I was the same way when I lived here. And when I commute during rush hour, I take the train, then walk. But I love to take this baby out on those old, empty roads upstate and let 'er rip. Maybe you'll come with me sometime."

"I'd like that, Sir," I said, wondering if he was only being polite or actually wanted me along on a drive.

The same surface camaraderie, with a growing undercurrent of sexual tension (*When will we get together again? And who's going to risk asking first?*), continued through our excellent meal of crystal shrimp dumplings, spicy crispy beef, chicken with long beans in garlic sauce, and Tsingtao beer (just one bottle each). I was glad I'd let him order for both of us since my choices would have been more pedestrian.

After the dumplings, Terry asked how Greg and I had met.

"About the fourth time we ran into each other at the Thalia," I recalled, "we decided that two guys on the Upper West Side who liked so many of the same old movies should get better acquainted."

"I don't buy that 'we,'" he said. "Which one of you made the first move?"

"Greg was the forward one — I was still pretty shy."

"Ha! You know, Matt, the secret to good storytelling is believability. If you want to fudge the truth, you should at least make it plausible."

"No, really! I was just out of college, barely out of the closet. I was surviving on temp work while I looked for a job that'd let me stay in New York. I had just enough experience to realize Greg was cruising me."

"So why'd you take him up on it?"

"I liked his looks — why else does anyone respond to a cruise?"

"Oh, I can think of a few reasons"

"They come later, Sir, after you start talking. Looks *always* come first in cruising."

"Seems like you could miss a lot of good men that way."

"Well, sure — but who says cruising is the only way to meet men?"

"Okay, okay!" he laughed. "Obviously I'm in the presence of a master! Go on — tell me the rest."

"Not much to tell. We went to his place for coffee and dessert, and about halfway through our cheesecake we knew that old movies weren't all we had in common."

"What tipped you off?"

"Oh, I think it was the bulge I felt in his jeans when he leaned over to refill my cup! It's a common enough story: two days later we came up for air, and a couple of months after that I moved in with him."

"A happy ending," Terry said. "I like that kind of story."

"Happy for as long as it lasted, at least. The charming prince did die in the end, you know."

"I know, Matt. I'm sorry."

"It's okay. It was a long time ago, and it's hardly a unique tragedy. These days someone's friend or lover or spouse dies of

AIDS every three minutes." *I can't believe I said that*, but there was no taking it back.

After a couple minutes of uncomfortable silence while we each remembered our dead, Terry tried to lighten the mood by telling me about how he'd first come out to his Uncle Max.

"I was in tenth grade, I think, and getting worried about sex. I felt I was different but didn't know what to do about it. Max and I had always been close, so I went to him for advice. I confessed that I was only dating girls so the guys I hung out with wouldn't think I was a fag."

"Don't you think they knew anyway, Sir? The straight kids in my high school knew about me long before I did."

"Maybe you're right, but I wasn't one of those dreamy, 'sensitive' young fags — not implying you were! I liked sports and the outdoors and working with my hands as much as my friends did, and I was big enough and strong enough to hold my own in the usual fights. I didn't hate girls — they simply didn't interest me. I couldn't see what was so fascinating about the ones my buddies obsessed over. The girls I enjoyed talking with were the tomboys, or else the plain-looking smart ones who never got asked out. I pretended to be as hot for pussy as my buds, only it was *them* I thought about when I jerked off. I wasn't exactly sure what guys could do with each other, but I thought I'd like to try it."

"Wasn't it quite a risk you were taking, telling Uncle Max?"

"I wasn't *certain* Max was gay," he admitted, "but I had a strong suspicion. He'd played football in high school, like I did, and my folks always said the girls wouldn't leave him alone. Yet he never married. 'He likes to play the field,' they said, but that didn't make any sense. He hardly even noticed women except for his mother and sister — my grandmother and mother. Even his secretary was male, though Max called him an 'executive assistant.' That was really unusual back then. So I figured he was like me and had learned what to do about it."

"Is that when he set you up with Tom, the mechanic?"

"*No* — that was years later, when I was in college. I wasn't thinking about kink yet, just cock. . . . Well, maybe *thinking* about it. But I didn't even realize how things like whips and chains related to sex."

"So Uncle Max initiated you?"

"Wrong again — you have a dirty mind! He *educated* me, from gay geese to Walt Whitman to Stonewall. He lent me books, not that there were many positive ones back then, and gave me sympathy and good advice. Most of all, though our sexual tastes weren't similar, he gave me a role model."

"You were very lucky, Sir."

"Don't I know it! Even if Max *had* been into chicken, or incest, it would've been worth it. He saved me so much grief. He taught me that as long as I was true to myself, I had nothing to be ashamed of."

"Why wasn't he more out of the closet himself, then?"

"He was as far out as he could afford to be in that era. His motto was, 'Be as open as possible, as discreet as necessary'."

"A toast to Uncle Max!" I said suddenly, raising the last of my beer. Terry looked startled and suspicious.

"I'm serious," I assured him. "He sounds great — I'd love to meet him."

"Maybe you will," he said, smiling. "To Uncle Max, then!" We clicked our glasses and drained them.

I picked up the check, and we walked back to his car for the drive uptown. He didn't tie me in place this time, but the damned gear shift and bucket seats still discouraged close contact. It was already late, and we both had to work the next day, so even though we were dressed for it, the idea of stopping off at the Spike or another nightspot wasn't appealing. I was still reluctant to part, however, so when he stopped the Jag in front of my building, I suggested he park it and "come up for coffee or something." He declined with a smile.

"Not this time, Matt. Thanks anyway."

"Could I have your number so I can call you?"

"No, not yet. But give me yours. I'll call *you* — next time I'm in the mood for some 'no-strings' s/m." My face flushed, and my gut twisted. It had hurt less when he kneed me in the groin back in the cell. *I thought he liked me!*

I glared at him through suddenly watery eyes — angry at his dig, even angrier at my own wounded reaction to it.

"Are you that insecure?" he challenged. "Where's the cocky smartass I dragged home from the Spike? *Of course* I want to see you again — how could you doubt it? But it's better if I call you — trust me, okay?"

"Yes, Sir," I agreed, helpless even to stay angry with him.

"Good. Now give me your number and get out so I can go home."

He took the card I extracted from my wallet, then pulled me close. I was nearly goosed by the gear shift as we kissed. I could taste traces of Chinese chilis and beer in his mouth.

"Take care of yourself, boy," he said after we broke apart. "Till next time."

"Thank you, Sir," I said softly. "I will. Good night."

I stood there on the sidewalk and watched him drive away. *Till next time*. Tired and sore as I was, and sexually drained, I could still hardly wait. When I couldn't see the Jag anymore, I turned and went into my building, whistling a chorus of "What Shall We Do with the Drunken Sailor?" on my way to the elevator.

CHAPTER 9

Depth charges

For the rest of the evening after Terry brought me home I wandered around my apartment, distracted and fidgety, unable to concentrate. I tried to read, watch television, listen to music, but they couldn't engage me. Too much of me was still locked up in Terry's cell, or chained at his feet, to be able to enter anyone else's imaginary world.

This was *not* how I normally felt coming home after a satisfying scene! The more intense, the more overwhelming the action, the more relief I usually felt at being alone again, my own boss again. But despite the long "decompression" period Terry had given me — first in the basement when I'd showered and relaxed in the tub, then on the drive back and in the restaurant — our encounter seemed strangely unfinished. I didn't feel returned home so much as cut adrift.

The comfortable clutter I lived in seemed alien, not welcoming, after the precise order of Terry's house. I threw myself into domestic chores I normally avoided as long as possible, but every so often I became lost in a trance of memory. Shaking out of it seconds (or minutes?) later, I'd realize that I'd frozen in position at the sink with a sponge still dripping in my hand, or standing at the door with a bag of trash to take down the hall.

My distraction was more than just reminiscence. I wasn't horny again, not yet, but something was gnawing at me. I suppose I just wanted more, wanted Terry to go on fulfilling my wildest fantasies one by one — including the wildest one of all, the one I'd packed away after Greg died, buried so deep I thought I was free of it: the fantasy of giving control of my life to another man.

It hadn't re-emerged in my conscious mind yet, but the

trim little boat of my self-possession was already rocking as it churned the deep water. I remembered my impulsive overture when we'd talked after brunch, asking if I could become part of his "stable." Did I have any idea what that would mean? I got tangled in a mesh of hypotheticals as I tried to work it out:

How can I be on call for him if I keep playing the field? What if he wants to see me and I already have a date with someone else? . . . But why would I want *to see anyone else? Only if he doesn't call!*

Again and again, I told myself there was no point getting carried away. *Terry will make the next move, if there's to be one. When he calls me — if he calls me — will be soon enough to decide how to pursue the matter . . . or to pursue him!*

Before getting into bed, I looked myself over in the mirrored closet doors, lightly touching each bruise I could reach. Some were already fading, but others had bloomed since I'd checked myself out in his basement bathroom. Angry black and purple patches, painful to the touch, stained my thighs, ass, and back. I got out the A&D ointment and gently rubbed it on, smiling at each twinge.

I did slow stretching exercises until the ointment was absorbed, then eased into bed. At first I enjoyed lying between my own sheets, free and unbound, and I was certainly tired enough to sleep. But I tossed and turned, unable to doze off, unable to stop thinking about Terry. My cock kept swelling up as I recalled his touch or smell. My wrists and ankles missed the weight of his cuffs and chains. My ass felt empty without his cock or butt plug. I wanted to be back on my knees licking his boots.

This is ridiculous, I told myself. *I'm just infatuated because I had a good scene after a dry spell from too much work.* But I didn't believe it. The way Terry and I had played together, the way he'd gotten into my head, was truly special, something rare and wonderful. *It might never happen again, so why shouldn't I be strongly affected by it?*

Finally, unable to sleep, I got up and went to my "toy chest," which held restraints and other gear I occasionally used on myself or when my buddy Stan and I played our turn-and-turn-about games. I rarely brought tops home for play — partly because I figured most would do a better job on their own territory, with their own equipment, and partly because I was reluctant to go under in my own space with anyone but Stan.

The best gear I had dated from my time with Greg. I dug out the collar he'd had made for me — I think I wore it only five or six times before he got sick. The inch-and-a-half-wide strip of heavy belt leather tended to get stiff from lack of use, though I still took it out every few months and oiled it, remembering. For the first time in years, I buckled it around my throat and fastened the little padlock at the back.

I shivered violently from head to foot as the lock snicked shut, and then I seemed to blush all over. *What the hell?* But after that weird initial reaction, I felt fine. I looked down at my stiffening cock and smiled. Next I took a pair of old-style British handcuffs from the chest — the kind Stan calls "comfy cuffs" — as my wrists were still sore from hanging on the door of Terry's cell. I locked them on, and to make things a little more difficult, I padlocked a short chain to the ring at the front of the collar and fastened the other end to the handcuffs. Now I couldn't quite reach my cock without some contortion. I went into the bathroom to piss, practicing no-hands aiming, and afterward studied myself again in the bedroom mirrors. *Terry's right*, I thought, grinning at my reflection: *I do look better in bondage.*

Yawning widely, I decided not to add leg irons, turned off the lights, and got back into bed, lying half on top of the covers, half under them. I let my thoughts drift, and they soon returned to my sessions with Terry, starting with that amazing finale in the cell when he put my hand on my dick so I could jerk off watching him through the bars as he did the same. Now, at home in bed, my cock was roaring hard and I was trying to fuck the air. My fingers futilely scrabbled to reach it, but I deliberately refrained from bending to make it possible. I even arched my back to increase the tension between my neck and wrists.

I flashed back to our first scene, at the bar, when he'd tortured my nipples and balls through my clothes, pressing my cuffed arms tight up against his leather police coat. Just running my hands across my nips was enough to enflame them anew. My balls were tight up against my cock, and I bent down to squeeze them. The stimuli I was giving myself were only shadows of what Terry had done, but they helped make my recollection seem more real, as if it was happening all over again.

Like a maniac, I leaped out of bed and grabbed for one of my combat boots — it was nothing like his police boots, but I

didn't have a closer match anyway. Bringing it back to bed with me, I lay on my side in a Z pattern, my mouth against the boot toe and my hand on my cock. Tonguing the leather as I teased my dick, I recalled when he'd made me — let me! — lick his boots for the first time. *Was it then that we bonded so tightly? Did he make me his right then?*

I remembered how he'd chained me up in his bedroom and then beat my ass and fucked me. The chains between the hand-cuffs and from the cuffs to my collar jangled furiously as my right hand stroked from the base of my cock to its increasingly sensitive head, so damp with precum I didn't need any lube. I moaned at the marvelous sensations I was giving myself — as proxy for Terry.

My nipples were throbbing. My asscheeks burned, and my anal sphincters twitched — it was as though his cock was still in-side me, screwing me royally. No need for a blindfold: I shut my eyes, and I was in his house again, at his feet, in his bed, in his cell — wherever he wanted me. Once again I was zipped and laced and strapped into the sleepsack, flying free and wrapped tight at the same time. Once again I lay chained in the trunk of his car, jolted by city potholes and lulled to sleep by its smooth speed on the northbound highway.

"Yes, Sir," I whispered softly as I pumped. "Anything you say, Sir. Anything you want." Once again I abased myself before him, worshipping his boots, his cock, his ass, his uniforms, his strong, sure hands, his wicked imagination, his sly sense of hu-mor, the twitch of his moustache as he considered some fresh way to tease or torture me. My cock was hard, *so hard*, yet it stub-bornly refused to shoot and release my aching hand and arm from its service.

I recalled sitting in chains on the floor beside his chair, his hand playing idly in my hair. But the recollection soon altered, shifting into fantasy:

Kneeling on the carpeted floor, sitting back on my bootheels, I wait with uncharacteristic patience, saying nothing, asking for nothing. I am perfectly content to wait. I'm naked except for sturdy black line-man's boots. No shorts, no T-shirt. He's dressed casually in a short-sleeve uniform shirt, jeans, and work boots.

My exposed cock is hard, and it would be dripping onto his car-pet except he's sheathed it in a rubber. I can't touch it, because my

hands are cuffed behind my back, but I wouldn't anyway, not without permission. Heavy leg irons circle my ankles over the boots, joined by a short chain that's pulled up and locked at the center point to my handcuffs. If I don't keep my arms held straight back, the cuffs dig painfully into my wrists.

A tight-linked chain joins my nipple rings, lying cold on my chest or swinging free if I lean forward slightly. Its weight isn't painful, but I'm constantly aware of it. A similar but much heavier chain circles my neck, fastened by a large padlock resting in the hollow of my throat. A leather blindfold, held on by elastic straps, snugly covers my eyes. While I can see nothing, my hearing and sense of smell seem to be sharpened.

When he's not touching me, my head is bowed, though my back is straight. I bend my head toward him like a flower following the sun whenever I feel his hand on my hair or, even better, stroking my face. Sometimes he playfully holds it over my nose so I can breathe in his scent, or over my mouth so I can lick his palm. Sometimes he plays with my nips. I push my chest out and twist from side to side to make it easier for him to torment the erect nubs — pinching them, rolling them, flicking them with a finger, pulling on the chain hanging between them. Best of all is when he sticks a finger in my mouth and lets me suck it. In fact, he's doing that right now — two fingers, which almost feel like his cock as he pumps them in and out, in and out

My own cock, which I'd kept stroking as the fantasy spun out in my head, finally exploded! I groaned aloud as cum splattered my belly, my chest, and the sheet, already damp with my sweat. I rolled onto my back, shattered with the intensity of the release, lying limp until my breathing calmed down. Remembering Terry's admonition not to waste cum, I scooped up all I could salvage, then slowly licked it from my hand, breathing in the fading briny smell, savoring the salty-sweet taste, pretending it was *his* cum and not my own.

As I floated down from the high I'd worked myself into, I wondered about my fantasy. *Why was* that *more powerful than memories of our actual scenes?* But a couple of huge yawns told me it was no time for analysis. I tucked the question away under "unfinished business," turned on my side, folded my cuffed hands next to my head, and fell asleep.

I woke a couple of times during the night to piss. Dropping each time out of a vivid, sexy, but immediately fading dream, I

was momentarily puzzled at finding myself collared and cuffed, but I left them on. After returning from the bathroom, I replayed the fantasy I'd constructed earlier, hoping to carry it further, wondering how it would develop. But each time I fell asleep again as soon as I got through the setup: *Kneeling beside his chair, collared, chained, naked, I wait patiently, saying nothing, asking for nothing, perfectly content to wait*

I slept deeply and woke surprisingly refreshed when the alarm went off at 8:00 a.m. After silencing it, I sat up in bed and looked in some bemusement at my cuffed hands. The shiny cuffs, the chain leading to the leather collar around my neck, the collar itself — all seemed remnants of a dream. Fantasy had fled, and I no longer felt disoriented or distracted. On the contrary: charged with energy, I was eager to go to work — eager to reclaim my life. The only thing my flaccid cock wanted now was another trip to the toilet. *Game over, man,* I told myself with a wry grin as I unlocked the cuffs and collar. *Welcome back to the real world.*

Terry's spell seemed broken. While I showered and dressed, then lingered over coffee (I had plenty of time to get to the store before we opened at 10:00 a.m.), I kept shaking my head and telling myself how silly I'd been, like a schoolboy with a crush on his teacher or a kid in the next grade.

He's a great top and a nice guy, and that's enough. You don't fall in love with someone after one night — at least I don't! And all that crap about being "perfectly content to wait." I hate waiting around!

I turned on the radio to check the forecast: "fair and cool" — leather weather. Pushing the season a few weeks, I hummed the chorus of "Autumn in New York," one of those great old songs only gay men seem to know anymore, but I couldn't keep my mind off Topic A for long.

I'd play with him again anytime, but I'm nobody's slave. . . . He said he's not looking for one, but I'll bet he expects all his "boys" to be pretty submissive, at least when they're with him. That's okay for a session, but all the time? I never did that even with Greg. He only put his collar on me when we were ready to play. The rest of the time we were equal partners — even if he did make all the decisions about money or the apartment or where we'd go for dinner or on vacation. Hell, I was grateful to him for handling all that! And that's one reason it was so hard for me to take over when he got sick

I headed back into the bedroom to get my watch, comb,

and other last-minute necessities. The Tom of Finland over the bed caught my eye. Although I treasured it, I was so used to its being there that I barely glanced at it most of the time. But having thought about it in Terry's gallery, and now thinking again about Greg, I stood there and really looked at it.

The drawing shows two hunks sitting on the floor, one nestled back against the other's chest, held between his breeched and booted legs. All that suggests a difference in role is that the man in front is naked except for his own boots while the other man's left boot is pressed against his balls. The naked man's hands are cupped around the other's clothed thighs, and his dick is hard. Equal partners? Top and bottom? Master and slave? You could make a case for any of those relationships, but what's beyond any doubt is that the men *are* partners. Their positions, facial expressions, body language — all rule out a casual pairing.

My heart seemed to skip a beat, and my eyes swam, as I realized how much I still wanted, needed what the drawing depicted — and how much I *hadn't* been getting from tricking around, staying free and unattached. I sat down hard on the bed, overwhelmed by thoughts I'd been holding back, trying to dismiss as the aftereffects of a "crush."

I don't know about being a slave — I do fine without anyone telling me what to do all the time. But "belonging" to someone — that sounds good. That sounds like what I really want. . . . Aren't the chains and straps I enjoy so much just symbols for bonds of affection, or at least desire? If a man ties me up, it says he wants *me enough to keep me near him. The bondage is only an extension of his arms, his hands. If he could hold me as tight with just his muscles, or the force of his personality — like those guys in the drawing, frozen in a moment of perfect communion — we wouldn't need rope and steel.*

I shook my head and stood up. *Too much philosophizing for so early in the day!* But I couldn't keep from teasing out the consequences. Even as I left the bedroom, ready to plunge into the workaday world, my mind was racing ahead on another track, toward a destination shrouded in uncertainty and risk.

Instead of the major set pieces of my time with Terry, it was the little things he did between and after them that now loomed large: the leg irons and manacles he'd given me to wear to clean up the kitchen, locking me in the cell to rest after my faint, the way he'd cuffed and strapped me in the car for the drive back to

the city. *No one else has wanted me enough to keep me bound after we've both come once or twice. . . . He said I "look better in bondage." What else can that mean, except he wants to hold onto me? That it's more than just good sex? . . . But can I handle a relationship with a guy who's as dominant as he is? It felt good letting him take the lead, "Sirring" him, obeying him. . . . If we get together often, though, we're bound to clash. I like having things my way, too!*

I was putting on my jacket when the phone rang. I almost let the machine take it, then shrugged — it was still early — and answered warily, expecting some insincerely friendly stranger trying to soften me up for an "investment" pitch (as if I had extra cash lying around on my salary!). I was astonished to hear a familiar bass-baritone voice wish me good morning.

"Terry?"

"Is this too early? Are you awake?"

Still under his spell after all! My cock leaped in my pants, and I fumbled my first response trying not to sound too eager.

"Yes — I mean, no, it's not too early. Yes, I'm awake. I just didn't expect you to call — so soon, I mean. Not after what you said last night."

"I know. I'm sorry about that dig — you didn't deserve it, except maybe by reputation. For a minute I pictured you going upstairs and checking me off on your scorecard. I didn't want you to earn extra points for getting my phone number."

My face flamed, as much in anger as embarrassment, and I considered hanging up on him. *Some "apology"!* But as he had the night before, he redeemed himself before I could protest.

"I regretted it as soon as I said it — your face told me that making points was the last thing on your mind. And even if it wasn't, I'm into games, too. I think we both scored pretty well yesterday, don't you?"

"A couple of touchdowns at least . . . *if* you're counting."

He chuckled, and I smiled into the phone, happy to have recovered my cool.

"So to what do I owe the pleasure of this call?"

"Oh, I always check in the next day with men I've worked over hard, just to be sure they're okay."

"I'm fine," I said lightly. *Physically, at least.*

"I felt sure that you would be, but sometimes a guy'll have a delayed reaction after a heavy scene. You know — like being

disoriented or unable to concentrate, feeling abandoned, having disturbing dreams. Depends on what kind of shit we stirred up."

My jaw fell open during this recitation. *Does he usually affect bottoms that way? I'm okay now — I think. Should I even tell him about last night?*

"There might even be a physical problem," he went on, "some kind of accidental damage that wasn't immediately apparent. You don't have any unusual or unexpected pain, do you?"

That's easy to answer.

"No, and my dreams were pleasant enough, thank you. I *was* a bit disoriented when I came home last night, but I'm fine now." *Yeah — I just love putting my whole life and future into question. Maybe give him a hint?* "I couldn't get to sleep, though, without putting on a collar and cuffs and jerking off thinking about you."

"That's no problem," he said. "I did the same."

"You put on a collar and handcuffs?" The image of Terry in bondage was ludicrous and hot at the same time.

"No, asshole — I jerked off thinking about *you*. No collar or cuffs on me, though in my fantasy you were pretty loaded down with ironware."

"Why am I not surprised?"

"Smart aleck. I thought you *liked* heavy metal restraints."

"Oh, I do. I *do*. I also like rope and leather, rubber and canvas, and being held down by my partner's muscles."

"Noted. And how about being held down by nothing but your own self-discipline, out of obedience and respect?"

"Just try me, Sir."

"We'll see," he said, but I could almost hear him smile.

Wanting to prolong the conversation, though clearly he'd accomplished his purpose, and it was well past time for me to leave for work, I launched another probe:

"Besides the bondage, what did you think about doing to me while you jerked off?" *I'll tell you mine if you'll tell me yours!*

"I thought about how much fun it is to mess up your hair! You expect me to spill all my secrets? If I tell you what I imagined, I won't be able to surprise you by doing it next time."

"Please tell me, Sir. I don't like surprises."

"No way! You *love* being surprised — *and* teased. That was obvious as shit every time I did it. You just don't like to admit it."

"Whatever you say, Sir."

"Cultivate that attitude. I like it."

"Yes, Sir!"

We both laughed, but I was a little uneasy. *I'm good at pretending to be whatever a top seems to want. But what if with him, I'm not pretending?*

"You know, Matt," he continued after a pause, "I wouldn't have been at the Spike myself Tuesday night if I hadn't been ready for something — excuse me, some*one* — new. But I never planned to go so far with you so quickly. Usually I don't even show guys the basement until I know them pretty well."

"When do you show them the rest of it?"

"You *are* a smart one. Guess I'll have to watch you every minute, won't I, or you'll slip the traces and go off on your own?"

"Is that a promise?"

"Is *what* a promise? That I'll watch you every minute? Or that I'll keep you on a tight rein?"

"Both. Either. I'm not picky."

"The hell you aren't!" he roared. "You know *exactly* what you want, don't you?"

"As a matter of fact, Terry, I'm not sure I do anymore...."

He didn't rush to fill the pause with questions — as I would have — but waited for me to say what was on my mind. *Should I really get into this?* I agonized. *Maybe I should just leave well enough alone and wait until our next date?*

"I know I want to play with you again," I said finally, "and probably again and again. I want you to carry me away and do wonderfully fiendish and perverted things to me. You're a great top — hell, you're the best.... I'm just afraid that ... I mean, I'm not sure Shit.... I'm worried about what it may lead to."

"And that is?" His voice had gone flat, toneless — *is that a danger sign?*

"I don't know! That's the trouble! This is unknown territory for me.... What I'm wondering about ... shit, but this is hard"

"Take your time."

"Thanks." I took several deep breaths and tried to collect my whirling thoughts before continuing.

"What worries me is that I'm going to end up letting you control my whole life. And I'm afraid I'll like it! ... It's like I'm already addicted to you. I want you so much it hurts. I don't want just to play with you. I want it to be real, to *mean* something...."

And that scares me. I don't know how to deal with it. What can it lead to, except being your slave?"

That stumped him, all right. Now it was his turn to think it over and figure out something to say. Time slowed to a crawl as I waited and waited for him to make some response.

It wasn't a proposition, so why's my heart thumping? What if he just laughs at me? What if he hangs up, or tells me to take a hike?

"That's an awfully big leap on the basis of one scene," he said finally, not laughing.

"Two scenes," I corrected him, "three if you count the sleep-sack, and almost a full day together."

"Whatever!" he barked, so loud I had to pull the receiver away from my ear. "It's still a big leap," he said in a more normal voice, "and rather presumptuous. How do you know I want anything like that with you?"

"I don't. But I hope you do — I'm also afraid that you do, because not all of *me* wants it. What made my dick hard fantasizing last night and what makes sense this morning are very different things."

"You fantasized about being my slave?"

"I don't know what else to call it. I didn't manage to come by just replaying memories, so I drifted into fantasy. And the one that finally popped my cork wasn't about any heavy action at all. . . . I fantasized kneeling at your side, naked and chained, blindfolded, collared . . . waiting . . . at your disposal. . . . And I loved it! Me, the guy who walks away from a movie or restaurant if there's a five-minute line."

"And what was *I* doing while you waited with such unaccustomed patience?"

I could hear a trace of a smile in his voice again, as if he, at least, was back on familiar territory.

"Reading, I think — I was blindfolded, remember? . . . Yeah. You were sitting in a chair reading, like you were yesterday after brunch. Occasionally you'd play with my hair or rub your hand over my face, or let me suck your fingers. That felt so good, being handled like that — casually, but possessively, like a favorite sculpture, or a pet."

"And that got you off?" he asked.

"Yeah. That got me off. And after I licked up the cum, I slept like a baby."

"You licked up your cum?"

"Well, you *told* me not to waste it. I pretended it was yours."

"I see," he said with a chuckle. "And you're worried because you had that fantasy?"

"Yeah. It doesn't make sense! I'm not the slave type."

"Meaning it's not what you want?"

"Oh, I probably *want* it, all right. I want lots of things that aren't good for me. Unsafe sex. Too many hot-fudge sundaes. Staying up all night fucking my brains out. Credit-card binges at Tower Records. Good thing I don't let myself have everything I want, or I'd be a real mess."

"You're clearly not a mess," he said, chuckling again. "Now, let me see if I understand you: the idea of being a slave turns you on, but you don't think you could handle the reality?"

Is he being deliberately obtuse?

"It's the idea of being *your* slave that turns me on," I told him, "or did last night — still does if I give into it. And it's not that I couldn't 'handle' it. You don't know just how much I *can* handle. But I don't think it would be *right* for me. I'm too independent, too assertive and headstrong to stay in anyone's shadow. I'd be torn in two all the time, wanting to be myself and wanting to please you at the same time."

"It's odd how you assume those goals are incompatible." He paused to let that sink in before continuing. "But I already told you I'm not looking for a slave. I tried that route, and it didn't work for me, either. So where's the problem?"

All of a sudden it hit me: *He won't admit he still wants it. Oh, shit! I can't just say, "I don't believe you," but that's what it amounts to. What kind of a minefield have I stumbled into? And what makes me so sure about what* he *wants when I'm not sure about myself?*

"Give me a minute, please. This isn't easy, you know."

He chuckled indulgently, apparently unworried about anything I might say. The silence stretched out as I searched for the right words. *I'm hopelessly late for work,* I realized, *and he must have other things to do as well, but this is too important to leave hanging — even if I fuck up by going too far.*

"Terry," I said finally, to emphasize that I was talking man to man, not bottom to top, "I don't know what happened years ago between you and your slave, the one who soured you on that kind of relationship. And I don't know about your relations now

with other bottoms. It's none of my business. But judging solely from our time together, I know you still *want* a slave."

He didn't say anything, but I could hear his breathing, so I plunged ahead.

"That's how you're bent — it's obvious from your house, your car, even your bondage and uniform gear. You enjoy owning things, putting your mark on them, molding and customizing them to your taste, then showing them off. You're willing to put in a lot of your own sweat to maintain them, too. Whether you admit it or not, it can't help but affect the way you do s/m."

I paused again, in case he wanted to challenge me. Still no overt reaction. *Is he still there? Please don't let him hang up on me!*

"I know that many tops call all bottoms 'slaves' and treat us pretty much the same," I continued. "But you know the difference, and so do I. I've never claimed to be a slave, never thought I wanted to be one. I'm a bondage pig, a masochist, and a bootlicker. I do what I enjoy. I can be submissive as hell during a scene if my partner wants it, and I enjoy that, too. But when it's over, it's over. Or at least it used to be."

I paused again. *What are you thinking? Give me a clue!* Taking a deep breath first, I finished laying out my case.

"Terry, again and again yesterday, you treated me like your slave — and you made me like it. You stirred feelings in me that I didn't know I had. Those feelings scare me now because I'm not used to them. I've had only one serious relationship in my life; the rest has been just 'rec sex,' playing around. . . .

"I guess what I'm saying," I concluded, "is that I'm *not* fine since yesterday. My body will heal on its own, but my feelings are too tangled for me to sort out alone. I need your help. I need to know what you want from me — what you *really* want. I'll give it to you if I possibly can, but I need a better idea of what it's going to cost me."

My heart was racing as I waited for him to reply — it was a long wait. I was about to interject something when he finally said, in a tight voice, "I don't think we should discuss this any further on the phone."

Sounds like I hit a nerve! But at least he didn't say we won't *discuss it further.*

"Hey, that's all right," I said with forced bravado. "Long as we can talk about it sometime. I hope you're not mad."

"I'm not mad," he said, not altogether convincingly (I was imagining steam venting out of his ears).

"That's good. As I told you before, I don't provoke tops deliberately unless they want me to, like when you hung me on the door of the cell yesterday. . . . So, do you want to make a date? Just to talk? Or . . . ?"

"I can't," he said. *Damn!* "Not just now. For the next few weeks I'll be traveling a lot — in fact, I have to go out of town tomorrow. I'll try to make the GMSMA meeting the week after next, but it's iffy. Maybe I'll see you there. If not, I'll call you after things calm down."

"No sweat," I lied. *That's it! I bare my soul to him, and he says, "maybe in a few weeks"? He's blowing me off. Bet I never hear from him again.* "I'd really like to see you sooner," I added, trying hard not to whine, ". . . if you can manage it." *I want my mouth in your crotch right now!*

"Believe me," he said, "I wish I could come over there and whip your insolent ass this morning, but I'm calling from my office, and the intercom has been flashing for ten minutes. I'd take you home with me this weekend, but I have to go out of town. Next time, though, I promise you'll see the rest of the basement."

"I'll be looking forward to it." *Maybe he's not brushing me off. Give him the benefit of the doubt!* "Thanks for calling . . . Sir."

"You're welcome . . . I think. We'll get together soon and sort this out. I promise. So long, Matt."

"So long" But he'd already hung up. *Do I have time to jerk off before leaving? . . . Yikes! I'm forty minutes late already!*

I called the store. Magda, the assistant manager — a dyke and a good friend — said they could struggle on without me for a little longer, but my conscience pushed me out the door.

Walking to the subway, I tried to clear the sex thoughts out of my mind and concentrate on the tasks ahead at work. *We're almost over the fall school rush. . . . Wonder how he'd look in an Army uniform. Maybe an MP? . . . Time to focus on the December holidays. . . . Doesn't have to be a uniform, of course — he'd look good in practically anything. . . . Christmas and Hanukkah generate more than a third of our annual sales. . . . Will he ever let me see him completely naked? I'll bet he's a sight, with that furry chest and arms and that trim butt. . . . Did those imported calendars come in yet? Have to ask Magda. It's not too early to lick his balls — I mean, to put the calen-*

dars out! Concentrate, damn it! Somehow I got onto the right train and off at the right stop, but I wished I'd worn a tight jock strap. *If I keep throwing boners all day, people will talk!* The staff did notice that I was a bit distracted, and they tried to keep me away from the customers.

"Got a new boyfriend, Matt?" Magda asked after cornering me in the office. We'd always been pretty upfront with each other.

"Could be," I told her. "It's early yet, and there're complications." I didn't spell them out for her. She knew I was kinky, but not *how* kinky.

"Well, good luck," she said. "You need someone steady. We all do, these days. And you've been bouncing around from one man to another for too long — ever since Greg."

Magda and I went way back, and she'd liked Greg a lot. Everyone had.

"He's not easy to replace, you know," I replied, "and maybe I like bouncing around, being a moving target, a rolling stone . . ."

"A lovesick puppy! This one must be pretty special. I've never seen anyone have such an effect on you. You keep falling into a daze, staring into space and talking to yourself. If I could read lips, bet I'd have the whole story."

"I'm glad you can't, then! I'll tell you about it once I know if we really have something. Meanwhile, give me a nudge when I space out; it's bad for business."

She laughed, patted me on the arm, and walked away. *Am I really that obvious? They're a pretty open-minded crew, but what if I have to start explaining things like a chain locked around my neck?* Magda, for instance, wasn't ultra-PC, but s/m role-playing bothered her, especially when it was more than just bedroom theater. She once said she could understand why I liked to be tied up, but bootlicking grossed her out. And she kept hoping I'd get over my taste for "fascistic" uniforms.

"I wish I *could* pick and choose what turns me on," I'd told her the last time we'd discussed it. "Life'd be so much easier if I could."

I certainly didn't *choose* to fall hard for Terry; it just happened. *Not that he's a bad choice, of course — he's a regular prize package. Even my mother would approve of him . . . well, maybe not his idea of a good time.*

By the time I left work that evening, later than my usual

quitting time because I'd come in so late, I was almost back to normal — calm and self-controlled. Still afraid that I'd scared Terry off, I tried to convince myself it was no big deal. *When we get together again, probably we'll both have cooled off. We might not even want to get together again. After all, a great memory is better than a disastrous rematch. . . . Yeah, sure, and tofu is better than porterhouse!*

I went to the gym before going home. My bruises provoked a few comments, but it wasn't as if I hadn't shown up with "love marks" before. The workout left me pretty sore, but I liked the feeling of pushing against my limits. Not for the first time, the parallels between masochism and bodybuilding crossed my mind — either way, you suffer for sex (don't believe any man who says he does it for his health, unless he's over 50). If you're lucky, you learn to enjoy the suffering.

I grabbed some Cuban-Chinese take-out afterward, which made it almost 9:00 when I got home. The light was flashing on the answering machine, but I decided whatever it was could wait until after I'd eaten. As usual in my bachelor life, I dined in the company of the TV. *Seinfeld* was on — the heterosexual neuroses of Jerry and Co. were a good distraction. When it was over, I turned up the volume on the answering machine and punched the playback button on the way to the kitchen. I almost dropped the dishes I was carrying when Terry's voice filled the apartment.

"Hi, Matt. That was quite a curve you pitched me this morning. We really *do* need to talk, and I still don't think it should be on the phone. I'll find some time next week when we can meet at a restaurant or something. I'll call and let you know. Meanwhile, I want you to have my phone number in case you need it."

Feelings of relief flooded me, making me miss the number, but of course I could retrieve it later. "I know you won't call unless it's important," he went on, "though if I'm too busy to pick up or not at home, you'll just get *my* machine." I figured that was the end, but after a pause his voice came back again, slow and serious. "Behave yourself, boy." After that ambiguous directive, he hung up.

I replayed the message to get his phone number, then twice more just to enjoy hearing him. My cock had been hard from the moment I'd recognized his voice, and I got a little giddy listening to the reassuring message again and again. *He's been seducing me with his voice,* I decided. *He's not all* that *handsome, really, and any*

number of men have better bodies or bigger cocks. But that dark-honey voice of his — he'd sound sexy reading nursery rhymes!

I ignored my dick for as long as I could, but I ended up jerking off twice in the next hour — and still wanted more. Sex with him, even sex *thinking* about him, seemed to feed rather than sate my lust. The head of my cock felt raw, but the damn thing just wouldn't stay soft. I was obsessed.

Finally, I decided to recreate my fantasy. *Maybe that'll give me some peace, or at least show me something.*

I stripped and put on my lineman's boots, lacing them tight up to my knees, and locked a heavy chain around my neck. I improvised a nipple chain by attaching it to my rings with small padlocks. I expected to stay in the same position for a couple of hours, so there was no need for tit clamps — just the weight of the chain would be enough to endure. Having no super-heavy leg irons like Terry's, I put leather cuffs over my boots instead and joined them with a chain. If I locked my handcuffs to that, it might be *too* much of a challenge to get loose again, so I attached a chain link with a screw fastener instead. All these preparations, of course, put my cock in such a hair-trigger state that I almost shot again when I worked a lubed condom over it.

I brought the handcuffs (the same Hiatt Darbies I'd slept in the night before) and my best blindfold over to the armchair I'd sat in to eat and watch TV. It was obviously the center of the living room, and I was sure Terry would sit there when he came to the apartment. (Eagerly anticipating that possibility, instead of jealously guarding my space, proves how besotted I was.)

Stomping and clattering back down the hall, I made sure the front door was locked, then turned off most of the lights, the telephone bell, and the answering-machine speaker. *Should I put on some music? No — keep it pure. Just bondage and silence.*

Finally kneeling at the right of the chair, I put on the padded, leather-lined blindfold and adjusted it until not the slightest bit of light was leaking through. Anything I "saw" now would be entirely in my head. I found the cuffs by feel, unscrewed the key I'd left in the lock of one cuff so I wouldn't lose it, and carefully put it down on the carpet within easy reach. I snapped the cuff onto my wrist and put both arms behind me to secure the other.

The moment of truth. The snick of the second lock seemed

unnaturally loud — not even sirens or car alarms on the street 12 stories below broke the silence. *Just one more touch.* Working again by feel, I slipped the short chain between the cuffs into the large, open chain link between my legs, then screwed the link shut, fastening my hands and feet together.

As long as I didn't let my hands go numb, I'd be able to free myself whenever I was ready. I wished I couldn't, but I wasn't suicidal. *If he was here, if this wasn't a fantasy, I'd be at his mercy — and under his protection. He'd decide when to let me out, after I'd waited and suffered long enough.*

I pulled at my bonds to test them, then settled back on my bootheels, squirming to find a position that didn't press directly on a bruise. *Why didn't I think of a buttplug? Too late now unless I start all over.* I straightened my back and bowed my head. Silently, I retold the story, trying to hypnotize myself into believing that I wasn't alone. *Naked, collared, in blindfold and chains, I wait beside him. . . . Nothing happens, but nothing needs to happen. . . . I wait. . . . I'm perfectly content to wait . . .*

"Like hell I am!" I shouted suddenly, as if a restraint *inside* me had snapped. "This is ridiculous! This is crazy!" I raged and pulled at the chains holding me. "I don't want to wait anymore! I'm sick of waiting!"

I thrashed around, groaning at the pain in my wrists as I pulled against the cuffs, and in my nipples as the chain between them swung wildly. I rubbed my head against the arm of the chair, trying without success to push off the blindfold. It wasn't an act. I really wanted to be loose, and I'd temporarily forgotten how to free myself.

"I've been waiting for a man like him all my life," I cried out loud. "Why didn't we get together sooner? Why didn't I meet *him* first, instead of Greg? Dear, dead Greg. It's been six years, damn it! I'm alive, and Terry's alive, and Greg is dead dead *dead.*"

Hot tears flowed down my cheeks from under the blindfold, and my cock shriveled.

"I need you!" I screamed at Terry's image in my mind. "I need your power and control. I need your tenderness, your care. I need it so bad"

I slumped down, my chest heaving. Moments later I was jolted upright by a different pain.

"Greg! Oh, my God! What have I said? Greg! I'm so sorry! I

didn't mean it! I loved you! I'll always love you! . . . But we started something, and now you're not here to help me finish it. . . . Oh, God. What am I going to do?"

Pressing my chest onto my thighs and my forehead between my knees, I became as small as possible, as if to guard my vitals against attack. I sobbed uncontrollably, no longer forming words, either aloud or in my mind, awash in grief, guilt, and self-pity.

I'd thought my life was in fine shape. I had a good job, good friends, a good apartment. I was healthy and in good condition. I didn't have too much trouble getting laid. But under the sunny surface, I was hurting — Terry only exposed the wound. Playing with him, getting to know him, opening up to him, all that showed me how much I needed to love and be loved, to *give* myself to someone, to belong to someone. It wasn't enough to play s/m games that scratched the itch in my dick and didn't touch the ache in my soul. Unwittingly, Terry had shattered my carefully constructed illusion that I was complete and emotionally self-sufficient.

I cried myself out, and then, piece by piece, undid and set aside the gear I'd put on: the handcuffs, the blindfold, the nipple chain, the leg irons, the collar, the boots. The condom had fallen off by itself, so I picked it off the carpet and threw it in the trash. My prick had shrunk so small I looked castrated.

After washing my reddened, tear-stained face, I went to bed. Even if I had to stare, sleepless, at the ceiling for a few hours, I was finished with makeshifts. *I should have buried Greg's collar with him. That's the last time I wear it, anyway.*

Lying there, turning the same thoughts over and over like marbles rolling between my hands, I finally achieved the peace of exhaustion. I slept like a dead man, without dreams.

CHAPTER 10
Tell Uncle Stan

At 8:00 a.m. Friday morning, the alarm roused me, but I was still in a fog and groped around trying to find and silence it. When I finally put my hand on the damn thing, I threw it at the floor. It shattered, and I was instantly ashamed. I lay in bed for a few minutes pulling myself together. I couldn't stop rubbing the sore spots in my mind, like wiggling a loose tooth, but I didn't feel too bad, considering. My breakdown the night before seemed to have had a purgative effect. At least I had a clearer idea what kind of beast my encounter with Terry had awakened.

"So you want to be his slave?" I asked myself out loud. No denial was forthcoming. "Well, it's a living, I suppose."

I had a piss hard-on (or at least mostly from piss), so I rolled out of bed and padded into the bathroom. Staring at the dark-yellow stream of morning piss gushing into the toilet, I wet a finger in it and stuck it in my mouth. *Bitter*, I told myself, *but so is mustard. . . . I could get used to it. . . . Maybe his tastes sweeter.*

After splashing my face in the sink and drying off, I studied myself in the mirror. I traced the shallow lines in my forehead and around my eyes and mouth. My strawberry-blond hair was still thick and wavy. My fair, freckled complexion and the dimples in my cheeks made me look twentysomething rather than 33, but I wasn't so sure now if that was an advantage.

"You're not a kid anymore, so don't act like one," I said, staring into my brown-gold eyes ("puppydog eyes," Greg had always called them). *Why not?* my image seemed to ask in return. *Why* can't *I be his "boy" full time? Let* him *be the grown-up and make all the decisions?* I shook my head in rueful dismissal. "So what happens when he's not around? Can't put everything else in my

life on hold waiting for instructions. These days even slaves have to be self-starters."

That suddenly reminded me of my responsibilities: Friday was always my day to open the store, since I liked to leave by 5:00 to get a head start on the weekend — though I'd worked late the last few Fridays and come in on the weekends, too. *Still plenty of time,* I decided after checking the clock in the kitchen, *but not if I moon around.* I jumped into the shower and got wet.

Exposing all parts of my body to the strong, warm spray, I felt as if it was washing more than just skin oil and sweat down the drain — like my feelings of guilt over my "disloyalty" to Greg and of self-pity for the years I'd "wasted" since. *It all had to happen just the way it did,* I realized. *If I'd met Terry ten years ago, I wouldn't have been ready for him, or him for me. I accept it all. I embrace it all. I'd do it all again.*

I studied myself again in the mirrored closet doors as I dried off in the bedroom, touching the marks Terry's blows had left, pressing the worst bruises just enough to feel some pain. I was proud of how much punishment I'd taken. All in all, I was proud of my body. Three gym sessions a week can't accomplish miracles — I wouldn't win any contests or video contracts, but I was fit and trim. My arms, legs, and butt were sleekly muscled and firm to the touch. Even if I didn't have a six-pack, my abs and pecs were certainly nothing to be ashamed of. Trying to see myself with Terry's eyes, I admired my slight furriness — the short, golden hairs almost disappeared at some angles, but at others they gave my skin a bronze sheen. The hair was thicker and darker in my armpits, between my pecs, and in a line spearing down to my pubic bush.

I struck various "slave auction" poses (not all that different from bodybuilding poses): braced, arms clasped behind my back . . . the same with hands behind my neck . . . crouched down, hands on top of my head . . . bent over, hands holding my ass open . . . kneeling, head bowed. Even without the ironware Terry couldn't resist loading on me (*bless his kinky heart!*), the poses gave me the feeling of being a piece of property on display — and displayed very well, too. My cock filled out and stiffened until it was a manly rod instead of a boyish stub.

"Not bad," I said, eyeing the slavemeat in the mirror. "Not bad at all. I'd bid on that one myself."

The posing got me so excited, in fact, that while I was on my knees, sideways to the mirror, I grabbed my cock and started pumping. When I realized what I was doing, I jerked my hand away as if burned.

"Slaves don't play with themselves," I chided. *If I belonged to him,* I thought, weighing the implications, *he'd own my sex as well as the rest of me. Slaves are supposed to come only on command, or with permission — and not very often. . . . Can I live like that? . . . What if he's away for a week? Or two or three? How long could I control myself?*

Contemplating that conundrum, I rose to my feet and hurriedly dressed, stuffing my stubbornly stiff cock into my briefs with some effort. I put on clean but well-faded blue jeans, a blue chambray shirt in an even lighter shade, and cowboy boots. Rummaging through the closet, I found a faded denim jacket that matched the jeans so perfectly they might have been a suit. *The blue of a summer sky*, I thought as I brushed my hair. *Robin's-egg blue. Cocksucker blue. . . . Can't I get my mind off sex for two seconds?*

I checked the clock and almost panicked. Now I *was* running late, so I skipped even a glass of juice and headed out, buying a large cup of coffee from a deli on the way to the subway. I drank it waiting for the train, trying to focus my mind on business. It didn't help that the platform was filled with humpy men I'd normally have enjoyed cruising. One adorable milk-chocolate number in ripped jeans, 16-hole Doc Martens, a "Safe Sex Is Hot Sex" T-shirt, and earphones, who *couldn't* have been more than 17, followed me into the train and kept "accidentally" swaying against me for three stops until I smacked his butt and launched him across the car toward someone of his own generation.

Opening the store kept me too busy to think much about sex until the rest of the day staff arrived, but even then I didn't have time for brooding. I'd let too much slide the day before to take it easy again.

During my lunch break, Stan called. We hadn't talked since the holiday weekend. He was going to the Bondage Club that evening and figured I'd want to join him. I'd been too busy to go for several weeks, which is one reason I'd been so hungry for action with Terry.

"Should be a hot night, Matt, with all those beach bunnies back in town."

"If they're not away at Inferno," I said, almost wishing I was there myself. *Is that where Terry went off to?* I wondered.

"Hey, not every guy who can tie a knot wants to pay top dollar to sleep six to a room in a fleabag 'resort' in Michigan."

"Sour grapes, Stan? You were glad enough to be invited two years ago. Enjoyed yourself, too, as I recall."

"Yeah, but they keep jacking up the price — and the attitude. It's like if you don't get cut open with a bullwhip, you're not a real bottom. I can just imagine the performance pressure on tops. I wonder how anyone survives it without heavy drugs."

"People must like it, or CHC wouldn't have had to expand it to two sessions."

"Who cares? I didn't call to argue with you about Inferno! Y' want t' come to Bondage Club or not? We could have dinner beforehand and catch up — I haven't seen you in more than a week. Time t' tell Uncle Stan what the boy's been up to."

"I dunno. I've got some thinking to do."

"What better way to do some thinking than strapped inside a straitjacket and hood?" Stan coaxed. "Or whatever. Y' want *me* to tie you up?"

"You're too kind, buddy," I said, chuckling. "Not tonight. But dinner sounds good. I *would* like to get your take on something."

"Sure thing. Bondage, counseling, dish, bad jokes — name yer poison. Florent at 7:00?"

We often met at Florent, a 24-hour-a-day bistro in the old meatpacking district (where the Mineshaft once reigned supreme), before Bondage Club, because it's just a few blocks from J's, where the club holds its sessions.

"Great," I said. "See you then."

I hung up the phone with a smile. I'm very fond of Stan, and I certainly needed a sympathetic ear. He wasn't just my bondage buddy but also my closest friend. While it was our love of bondage — and frustration at never getting enough of it! — that first brought us together, just being leathermen of a similar age trying to survive in New York gives even a Jew from the Bronx and a white-bread WASP from Ohio plenty to talk about.

Stan prefers being on the bottom as much as I do, but he's more knowledgeable about his passion than most tops — more skilled than many of them, too. He'd rather buy a new piece of

gear than eat, I think, and he's not houseproud, either, shacking up in a one-room East Village walk-up. He uses his equipment on himself when he can't get a competent topman — or me — to do the honors. He can get into, and out of, positions I'd swear were impossible for any human being to manage on his own. If you tie Stan up, you have to know what you're doing, or he'll free himself as soon as your back is turned — not because he *wants* to be loose, but only to test if his bonds are authentically inescapable. Anything less, he considers an insult.

Although he was a math whiz in school (Bronx Science and the City University), Stan's not ambitious and makes a modest living as a temp doing things with computers. His employers always love him, and any number of plum permanent jobs have been offered, but he prefers to keep his freedom — so he can get tied up more easily. While he'd never leave an employer in the lurch, if he gets an offer to spend a week in a well-equipped dungeon, he doesn't have to wonder if he can schedule some vacation. I envied him sometimes, but on the whole I preferred the security of a solid job and a comfortable home to his more bohemian lifestyle.

The rest of the afternoon seemed to fly, and on the way home I actually had to interrupt lingering thoughts about work to focus again on my quandary with regard to Terry. The note with his phone number was in my pocket, but though I kept fingering it like a talisman, I didn't call once I got home.

He's probably already out of town, I told myself, and besides, what can I add to what I've said already? That I've fallen in love with him? If he doesn't know that already, he's a fool — which he isn't. . . . That I'm sure, now, that I want us to be Master and slave? Am I? Playing those roles is great for a night or a weekend, but can two grown-up men with real jobs actually live that way? I didn't think Terry knew the answer any more than I did. By his own admission, his only prior experience owning a slave had ended in failure. *Maybe we can learn how to make it work together,* I mused.

First, though, *Bondage Club or no Bondage Club?* Meeting Stan for dinner and then going home alone wasn't very appealing, and the more I considered it, the more I felt it'd be good for me to go to the club, even if I just watched. A lot of the guys did that, though the ones who knew me might be surprised at my staying on the sidelines.

The next step was deciding what to wear. I noticed the "Fit

To Be Tied" T-shirt still lying on the floor where I'd dropped it on Wednesday night, and I shivered with longing for the man who gave it to me. *Maybe if I wear that tonight it'll break the spell.* The logic was dubious, but I put it on and checked the mirror.

The wrinkled, cum-and-sweat-stained T-shirt made me look sleazy, sensual, and vulnerable — in other words, "hot." I smiled and picked out a piss-stained jock strap and ragged jeans to complement it, thinking it was a good thing Florent didn't have a dress code. (Actually, considering its typical clientele — especially after 4:00 a.m. when the bars close — I was almost *over*dressed.) I cleaned and buffed my logger boots, however, before lacing them on. No way was I going to show myself in public with uncared-for boots!

The weather had turned cool during the afternoon, so I put on my leather jacket as well — I could check it at J's. For some reason, guys are more inclined to tie me up when they can see a little skin. Not that I *wanted* to get tied up that night. Yeah, *right!* Okay, so I'm a pig.

The long subway ride downtown and the short walk to the restaurant were uneventful, and I arrived a few minutes before 7:00. I sat at the bar and nursed a light beer until Stan came in.

He'd gotten a severe buzzcut since I'd seen him last. What was left of his thick black hair was high and tight, as if he'd decided to flaunt his jug ears instead of hiding them. ("Gives a man something to hold onto when he's fucking my face," he told me once when I asked why he hadn't had them fixed.) With bulging muscles stuffed into camo fatigue pants — he's a fanatical bodybuilder, possibly in compensation for being only 5'4" — a lavender tank top two sizes too small (his nipples were poking out), and spit-shined jump boots, he could have been on a recruiting poster for a gay Parris Island. He was carrying a nylon jacket and a small gym bag, which I was sure held bondage toys rather than workout gear.

He noticed my T-shirt right away, of course.

"Great shirt," he said. "Where'd you get it? And who broke it in for you?"

"Terry Andrews. Tuesday night I went home with him from the Spike and spent the whole next day there. He gave it to me as a souvenir."

"Hmm . . . he still think he's God's gift to bondagekind?"

"He's God's gift to me, I think. I've fallen hard for him, Stan. It's serious this time. I'm even thinking about becoming his slave, if he wants me."

He narrowed his eyes and looked at me intently, as if trying to see inside my skull. I blushed under his stare but held my ground like the Boy Scout I'd once been — trustworthy, loyal, and true.

"Better tell me about it," he said, followed by a long-suffering sigh. "But don't expect me to like it."

In the five-plus years I'd known Stan, since shortly after Greg died, we'd supported each other's determination to stay freelance bottoms — not beholden to anybody, answerable to nobody but ourselves. Besides that, Stan had a long-standing grudge against Terry, having approached him once at the Bondage Club and been turned down. For some reason, Stan had felt snubbed.

We moved to a table and ordered, a salad and skirt steak for me, just salad and a cup of soup for him. ("Never eat much before a play session," he always told novices. But I didn't expect to be playing.) Then I told him the story from the beginning.

Even though Stan's not into cop uniforms or boot worship the way I am (he thinks the only reason to wear boots is to protect your ankles from ropes or chains), he thoroughly approved of the way we'd started out at the Spike. But he scoffed at my hesitation to get into Terry's car trunk.

"Hell, why not? If I'm chained up good and tight, what do I care if I'm in a car trunk or a warehouse loft? I'm not going anywhere. It's all bondage space, 'specially with a hood on." (Stan's into hoods like I'm into boots. Hood him, and you can do just about anything you want with him.) "I'll bet it was more pride than fear that stopped you."

"I guess so," I admitted with a sheepish grin. "I didn't mind licking his boots in front of a couple dozen guys, but riding in his trunk like a spare tire"

Stan laughed — we know each other so well — and I continued the story. His eyes lit up when I described the extra-heavy combination irons Terry put on me at his house. I'd never seen, or worn, anything like them, but Stan knew who made them and where Terry probably bought his set.

I'd always maintained that I couldn't take rigid bondage for more than a few hours, so Stan was pleased to hear I'd enjoyed my

night in the sleepsack — he was always urging me to expand my limits. My out-of-body experience elicited a smug smile; whenever he'd described similar experiences, I'd played the skeptic.

He wasn't very interested in hearing about Terry's house or our brunch conversation, and when I told him about cleaning the kitchen while wearing chains, he rolled his eyes — he'd never mix bondage with anything as mundane as household chores. Trying to convey how good it had felt kneeling on the floor next to Terry in the living room, waiting in chains for him to take me downstairs, I noticed him checking his watch.

"I hate to rush this epic," he said, "but d'ya think you'll finish before they lock the doors of J's at 9 o'clock?"

"Maybe not the *whole* story," I said with a grin. "But I promise to wrap up the digest version for you in plenty of time — if I'm not interrupted."

Stan mimed zipping his lips and settled back to listen, but my account of our interrogation scene in the cellblock seemed to worry him.

"Call me sissy if you want," he said when I'd finished, "but you guys upped the ante awfully quick. What if you couldn't read each other's cues? He might have really hurt you."

"He did scare the shit out of me a couple of times," I admitted, "but he always managed to reassure me somehow before going further."

"You never used to find terror a turn-on."

"I still don't. It was . . . it wasn't the fear that was so exciting. . . . I guess it was realizing that I truly had no control over the scene. I mean, he was responsive to me — he wasn't just whaling away like I was a piece of meat. But I couldn't predict or manipulate what he would do. He broke down my defenses until I had nothing left. All I could do was hang there and take whatever he dished out. But once I accepted that, it became wonderful — I didn't want him to stop!"

Stan sat quietly for a minute, looking down and playing with a spoon. I could almost see the logic gates opening and closing at a furious rate between his jug ears. If he'd been one of those mainframes he kept humming, his face'd be lit up with activity-signaling LEDs like a Times Square billboard.

"You're lucky, Matt," he said finally, facing me again. "You had the kind of experience we all hope for. I can see why you'd

want to have it again — but is that enough reason to enter a relationship? You certainly can't expect it to happen every time you play with Mr. High and Mighty Andrews. What if you play again and it isn't nearly so wonderful? Will you forgive him for not being perfect? Will *he* forgive *you*?"

"Hey — I'm not one of the novices in that group you lead for GMSMA. I don't expect ecstasy every time. Hell, I wasn't expecting it this time! I was just horny and wanted some action. But I got more than I bargained for — in a lot of ways — and now it's hard to settle for less."

"That's a big leap, boyo. Why is being a bottom who takes his pleasure where he finds it 'settling for less'? Why do you have to start thinking master-and-slave? Do you really want to be at his beck and call? To have him dole out orgasms as a reward for pleasing him? Or punish you when you *dis*please him? How far are you willing to go? What if he wants you to quit your job, move into his house, and stay naked and chained all the time? What if he says we can't see each other anymore? If you take this 'slave' business seriously, you have to think about stuff like that."

Stan's volley of questions brought my own qualms to the surface. "Master" and "slave" sounded so *serious*, so *permanent*. I wanted more than just another "scene" with Terry, much more, but did I really want *that*?

"I don't know if 'master' and 'slave' are the right words," I told Stan. "Set them aside for now. . . . Let's just say I want him to want *me* so much he won't let me go. . . . I want to feel his chains, or his ropes and straps, holding me in place, preventing me from resisting or escaping him, helping me surrender to him. I want to stare through the bars of his cell and know I can't leave until *he's* ready to release me. . . . I want him to train me to service his cock and balls and nipples and ass the way he likes. I want to follow his orders, to give him anything he asks of me. . . .

"I want to make him happy. I want to see that sardonic half-grin of his turn into a wide smile of pleasure. I want to see a glow in his eyes when he looks at me. . . . I want to lie against his chest, bound and gagged — or with my hands and mouth busy loving him — and hear his heartbeat slow as his whole body relaxes. I want to go to sleep with his cock up my ass and his hand around my balls. . . . I want him to challenge me to become stronger, and smarter, and more confident — so I can lay it all at his feet."

Stan was shaking his head slowly — more in amazement, I thought, than reproach.

"I can't give you *reasons* for it, Stan," I explained. "It's not something I worked out on a spreadsheet. It's just how I feel. . . . It isn't the ecstasy I reached during our scenes that hooked me. The image I can't get out of my mind is domestic, almost humdrum: sitting or kneeling at his feet, wearing his collar and chains, feeling him stroke my hair, or tease my nipples or cock, waiting for orders. I want that so much it scares me."

"It scares me, too, buddy! I've never seen you get so carried away. Remember: he's not a god, not your Daddy, not International Mr. Leather — he's probably not even the hottest man in Westchester! He's a good top, I'll grant him that, and he showed you a good time. Why isn't that enough?"

"It stopped being enough a while ago. I just never realized it — and you never noticed, either. I'm getting too old to be a partyboy. I need a man I can love, someone to share my life with, someone to give myself to."

"Sharing is fine — it's giving it away I can't understand!"

"I don't, either," I laughed. "I've never felt this way about someone before. He got inside my head — further inside than anyone since Greg. He opened a door in me I didn't know was there, a door that Greg and I never had a chance to find. Probably Terry didn't even intend to open it. But he did, and now I'm stuck. I can't go through that door alone, and I can't shut it again, either. As long as it's open, I'll want to explore the other side. I don't think I'll ever be satisfied until I do."

"I don't want you to get hurt, Matt — hurt inside, I mean. Excuse my bluntness, but how do you know he wants any more from you than a good fuck? Didn't he tell you he *doesn't* want a slave anymore? You were together less than 24 hours — and you were blindfolded, hooded, or locked alone in a cell for most of that time. How can you be so sure about his feelings?"

"So maybe I'm wrong," I said hotly, glaring at him — although I knew he meant well. "But we managed to talk a lot, and a lot got said between the words. We couldn't have played together so well right from the start if we weren't *simpatico*, if we didn't fit each other like hand and glove."

"Or foot and boot?"

"That too," I grinned, relaxing my defensiveness. "Of course

I can't be certain," I conceded, "but the way he looked at me, the way he touched me — it was like a man browsing in an expensive shop and wondering, 'Can I afford this?' He's fooling himself about not wanting a slave. It's so obvious that it's what he wants, and *he* won't be happy until he gets it."

"And you think you're 'it.' Does he realize how vain you are?" Stan asked maliciously.

"I tried to hide it, but he guessed," I admitted, grinning.

"He'll have his hands full if he takes *you* on. Maybe instead of trying to talk you out of it, I should warn *him*."

"He already knows I'm pushy, flippant, and a motormouth — as well as vain. If he still wants me given all that, you don't have a prayer of talking either of us out of it."

"Okay, okay, maybe you're ready for a steady relationship," Stan conceded. "Fine, even if it's with Mr. My Shit Doesn't Stink Andrews. I won't like it, but it's your business. And I doubt he'll reject you. All kidding aside, you're a damn good catch — better than he deserves, as far as I'm concerned. So go ahead: become his lover, his significant other, his registered domestic partner! You don't have to be his slave to do all the things you said you wanted."

"Of course I don't *have* to be his slave," I snapped, annoyed. "No one has to be a slave today, at least not in this country. But what if that's what I *want*? What if I *want* to be his property?"

"I can't understand why you, of all people, want to be *anyone's* slave! You're not an overgrown boytoy who needs an adult to wipe his nose and keep him out of trouble. Lovers can tie each other up, too, you know."

"I know. I've been there — remember? But I don't want to just recreate what I had with Greg. I want more now."

"What's wrong with continuing what you and Greg started? You two would have gone a lot farther if he'd lived, and look at all the experience you've accumulated since."

"Enough to know that more of the same isn't enough. I need something else now, something more ... well, more serious, more committed. Belonging to Terry could be it. I want to find out. Don't I have the right to make that choice?"

"Sure you do," Stan said, "as long as you're clear about what you're doing. Help me understand it, though. Why would you want to be *owned*? What's in it for you?"

"What's in it for you when you spend a week in bondage? You do it because you enjoy it, because it makes you feel good."

"That's different." He seemed shocked at the comparison.

"How? You surrender control to someone you trust. Sometimes you can't even breathe unless your top allows it. Seems pretty submissive to me, Mister."

"But I only submit on my own terms," he said, "after negotiation. I don't throw myself at his feet and say, 'Do whatever you want with me.'"

"Try it sometime. Y' might surprise yourself and like it."

We glared at each other, but Stan broke eye contact first. I savored my petty triumph until I recalled all the times I'd benefited from his playing the devil's advocate.

"Hey, Stan — I'm sorry. I know you're not giving me a hard time just to be mean."

He looked up and flashed me a grin, then turned serious again immediately.

"I'm not trying to put down your kink, Matt. If that's what you really want, you'll have my support; you know that. But it worries me."

"Hell, it worries me, too! If Terry walked in that door right now, I don't know if I'd throw myself at his feet or run the other way. You can't say anything against it that I haven't already told myself. That's why I wanted your advice."

"My advice, Matt, is to go to Bondage Club tonight, get into a hot scene with someone else, and put this infatuation of yours into perspective before you do something you'll regret."

"There's not a lot more I *can* do. After what I said to him on the phone yesterday, the next move is his. All I can do now is wait, and try to be patient."

"That's not easy for you, is it?" he said with a grin. I sighed and shook my head.

"He said he'd call me 'next week,'" I added. "I don't know how I'm going to make it through *tonight* with this hanging over me. It's not him I'm worried about — it's me. Am I ready for this? What if I botch it?"

"I'm more worried you'll be good at it! And then I won't know you anymore; you'll be someone else."

"That's nonsense, Stan. I won't be a different person if Terry makes me his slave, only more of what I truly am. This 'infatua-

tion,' as you call it, means that I'm finally letting Greg go and allowing myself to love again. I just hope Terry can forgive whatever mistakes he made with his first slave and allow himself to be a Master again. He'll turn bitter and angry if he doesn't. So you see, we need each other."

"It's already started," he said, shaking his head. "Last week you were a bondage pig like me, and now you're spouting psychobabble. You're bewitched."

"Try 'enthralled,'" I told him. "It's the exact word — you can look it up."

"Spare me the word games. . . . Your bootlicking, for example — that doesn't worry me at all. I know it isn't shame or self-contempt that makes you do it; you just love men's boots, and you know where to stop. You never lick the soles . . ."

"I hate to break this to you, Stan . . ."

"You pervert! But I've never seen you lick a guy's bootsoles."

"I don't do it in public. How do I know what he's stepped in on the way to the bar, or in the bar?"

"That's what I mean — you set intelligent limits and stay inside them. That's a bottom's privilege — and responsibility — no matter what he's into. A top *has* to respect the bottom's limits, or the scene'll collapse and *he* won't get what he wants — at least not a second time.

"But a slave? If you take slavery seriously, where do you stop? . . . A slave is property; he has no rights, no say-so, except to leave the relationship. If your Master tells you to do something you don't enjoy, or don't think is right, that's tough — you'd have to do it anyway. Why would you want to put yourself in that position, Matt?"

"It does sound crazy, doesn't it?" I grinned at him. "I'd have asked the same thing a few days ago. I've always enjoyed being submissive during a scene if my partner wanted that, but when it was over, it was over. 'Bottoming is what I do, not what I am' — that's what I *used* to say."

"So why the change?"

I shrugged. "Beats me. Maybe it's 'cause I saw how he handles his property. If he's as careful with me as he is with his kitchen knives, I'll have a long, healthy life. And if he treats me like that old Jaguar he babies, I'm in clover. . . . Don't leave your mouth open like that, Stan. Something might fly in."

"If you expect Mr. A Place for Everything and Everything in Its Place to be your sugar daddy, you're in for a rude awakening."

"C'mon — I may be lovesick, but I'm not stupid. I don't expect *any* of this to be easy."

"You don't think he'll change you?"

"No: he'll motivate *me* to change me. I won't need my defense mechanisms with him. He stripped them away once, and I survived just fine. But longtime habits are hard to break. His discipline could help me become the man I want to be."

"A doormat?"

"No, damnit! An unselfish lover. A giver, not a taker. Someone who's happy and secure enough not to need a new sexual conquest every other week."

"It'll be like Anna Russell said of Brunnhilde, 'Love certainly took the ginger out of her!'"

I laughed at Stan's reference to a classic old comedy routine — a parody guide to Wagner's *Ring* cycle — that I'd played for him when it came out on CD the year before. Silently, I licked my index finger and chalked up a point for him in the air.

He grinned, then added, a little wistfully, "I think you're fine the way you are, Matt."

"Thanks, pal, but you only say that because we've never been lovers, or even roommates."

"Asshole buddies doesn't count? What about all the times I let you win our little contests?"

"Bullshit! If you weren't as bad at Scrabble as I am at chess, let alone arm-wrestling, I'd never get you to tie me up."

"So I'll let you pick the game next time — even though it's my turn."

The snappy reply at the tip of my tongue went unspoken as what Stan had seen already finally hit me — there might not *be* a "next time" for us. For the first time in more than five years, I had to face the possibility of having to choose between love and friendship. Now I was the one to look away first.

"Shit, Stan," I said when I had control of my voice again, "you don't think he'd really try to keep us apart"

"That's just it," he said softly. "You don't know. If you give him that power, you can't stop him from using it. There's no love lost between *us*, and he might figure I'm a bad influence on you. I told you, you have to think about such things."

"Well, maybe I *am* just projecting what I want him to feel about me. Maybe when he does call me again, I'll get a brushoff. D'ya think I can find a Master you're *not* on the outs with?"

We both laughed, and Stan signaled for the check. Florent was crowded by then, so they were glad to be rid of us. I let Stan do the math, handing him my wallet to extract my share. Outside, I tried again to make him understand.

"Look, Stan, I've read the same porn stories you have, and I've seen the same sorry specimens who follow them like recipes. But once in a while you see a couple of guys who make the archetypes work for them, who seem like flip sides of the same coin, happily inseparable."

"Yeah — they come along just often enough to lead a lot of poor fools into hell trying to be like them."

"You're not the first to scorn lovers as fools," I laughed, "and I won't be the last to fall in love despite it."

"Promise you won't sign a slave contract without letting me see it first."

"I promise."

I smiled down at him. Although no older than me, and a lot shorter, he acted like my big brother — the one I never had.

He checked his watch again.

"It's almost 8:30. Are you coming? About 50 feet of tight rope would do you a world of good. And a gag — *especially* a gag. Did anyone ever tell you that you talk too much?"

"Oh, once or twice. . . . Sure, I'll come along, but don't be bent out of shape if I just watch."

"Suit yourself," Stan shrugged. "I hope I find someone who ties mean knots. I want'a *feel* it, not sleep through it."

"I've gotten rather fond of falling asleep in bondage," I shot back, recalling several occasions in Terry's house. "And especially of waking up in it! Different strokes, Stan Now let's go see what the boys in the back room at J's are up to!"

CHAPTER 11

Tryout at the Bondage Club

Despite my longwindedness, we made it over to J's in plenty of time. After we paid at the door and checked our jackets, Stan moved off to see who else was there. I stayed at the bar sipping a Coke, greeting guys I knew as they came in, wondering if I really wanted to stay. Sure, I'd have liked to get tied up and played with, but the man I wanted to bottom for wasn't present. Although other good tops came in unaccompanied, carrying their own bags of gear and clearly ready for action, I didn't make any overtures. I wouldn't want a man to be working on me while thinking about someone else, and under the circumstances I doubted I could give anyone besides Terry *my* full attention.

I wish he was here, I thought for the fourth or fifth time, and for the fifth or sixth time reminded myself that he wasn't even in town. *But what if he were?* I speculated. *What if I looked up this second and saw him in the mirror standing behind me? What would I do? What would he say? What would* he *do?*

I'd been glib enough with Stan, but I was still unsure what I wanted from Terry — except that I wanted *him* as badly as I'd ever wanted anything in my life. *Master? top? Daddy? lover? partner?* I rolled the words around in my mind, trying to see if one fit better than the others, but they were all so vague, so open to interpretation. It was like being back in Philosophy 101, only with more interesting questions:

D/s Dilemmas

- If you love your slave, is he your lover?
- If your partner calls you "boy," is he your Daddy?

- If your lover would do anything for you, does that make him your slave?

- If a bottom surrenders unconditionally to a top he trusts, does that make the top his Master?

- If you love, honor, and obey a top, how is that different from serving your Master?

- If you stay in role only during sex, does that mean you're faking it?

- If your sex roles permeate your lives, are you and your partner losing your grip on reality?

- How do you tell love from lust? And are they points on a line, or totally different things?

I'd tied myself up in verbal knots — and, thanks to my big mouth, maybe Terry as well. *Lord knows what he thinks of me now — "killer bottom," probably. It wasn't enough to tell him on the phone what I want. No, I had to tell him what he wants, too! He's probably running as fast as he can in the opposite direction. Stan's right: I need a gag — preferably Terry's cock or boot! And then if he'd only blister my ass until I can't think at all! Fat chance of that happening tonight.*

It was 8:40, and the bar was filling up. As Stan had predicted, it was a good night for the club. Stan himself was nowhere in sight — *probably found someone who ties mean knots.* I didn't want to go home alone so early, so I stayed, resigning myself to an evening on the sidelines. *Can't even get plastered with just soda and juice — I shoulda brought some beer.*

I lifted my head to finish my Coke. As the can touched my lips I glanced into the mirror and almost dropped it.

"Terry?" I blurted out, not entirely sure that the image facing me was him — it was too much like my fantasy. The tall leatherman in the mirror neither moved nor spoke as I slowly lowered the can and turned around, half expecting him to vanish like a ghost.

He didn't. He just stood there silently, less than a yard away, as I satisfied myself it was really him. The gleaming brim of his Muir cap shaded his hazel eyes, but I recognized his mobile, expressive mouth — the left corner was twitching under the clipped moustache, as though he were trying to suppress a devilish grin — as well as his large nose with the creased bridge (*broken in a*

schoolboy fight?) and his strong chin bristling with 9 o'clock shadow.

The heavy CHP motorcycle jacket he'd worn for our interrogation scene hugged his wide shoulders. The jacket was open, and under it he wore a gray leather uniform shirt. Its collar was also open, letting his chest hair curl out. My mouth watered as I thought about foraging in it, and my cock was already threatening to split my threadbare jeans.

A steel chain encircled his left shoulder, and his powerful, meaty thighs were encased in black leather breeches — a wide gray stripe and a narrow yellow one ran down the outer seams (*for bondage and piss?*). The wide, basketweave-stamped police belt threaded through the snaps on his jacket hung open, but an identical belt on his breeches was cinched tight enough to produce visible love handles. Handcuffs gleamed on that belt, but there was no holster or nightstick to accompany them, just his keys, and he wasn't wearing any police insignia. Short, skintight black gloves strained over the knuckles of his large hands, clenched at his sides.

My heart pounded as my eyes traveled down, past his well-filled basket, to his knees, where his breeches disappeared into tall, immaculately cared-for engineer boots, the thick soles planted solidly about a foot apart on the sawdust-strewn floor. A black leather duffel bag was parked beside him. The oil-tanned leather of his boots was a glossy matte black, not shiny like his police boots. Saliva dripped from my half-open mouth before I snapped it shut and swallowed self-consciously, shaking my head to clear it before looking up again.

Even at a distance, I could feel the tension in his body. *Why is he here?* I wondered. *Was he lying about having to go out of town? Or did his plans change? Did he come here to find* me, *or was he looking for someone else, expecting me to be moping at home?*

"What a nice surprise, seeing you here," I said as casually as I could manage. "Weren't you supposed to be out of town?"

"Not another word, boy," he ordered in a tightly controlled voice. The ghost of a grin had vanished, and his jaw was set. "Never mind where *I'm* supposed to be. Think about where *you* ought'a be. Show me you meant what you said yesterday. Show me that you're worth more of my time."

His bass-baritone rumble made me vibrate like a tuning fork,

and my cock was so hard it hurt. Thinking fast, I solved the puzzle of his unease. *He's taking a risk. Lots of guys here know both of us. I could humiliate him with a single word, a single gesture of rejection.*

Terry's head shifted upward slightly, and I looked into his eyes. Along with the easy self-confidence, the powerful mind and will, and the playful sadism that had first captivated me, I sensed his vulnerability. *What* they'd *think of him isn't important — it's what he'd think of* himself *if he's misjudged me.* I'd told Stan that Terry opened a door in my mind I didn't even know was there. Apparently I'd opened one in his that he'd slammed shut and locked years ago. *He's not totally sure of me, but he trusts me not to hurt him, not to make him sorry he tried.*

I didn't want that kind of power; it scared me. Like most bottoms, I preferred an invulnerable top — an indestructible superman who'd give me what I needed, and take what he wanted, without my having to worry about *his* feelings at all. My heart pounded harder as the seconds ticked by and Terry's jaw clenched tighter — though he was waiting with more patience than I'd have shown in his place.

If I give myself to him, I'll be slave to a man, not a fantasy — a fragile, imperfect, fully rounded human being, not Robotop. Can I handle that? . . . If he's willing to take on all of my shit, why the hell not? . . . Why do we make it so hard for ourselves, anyway? Why can't we love each other without working through all these issues of power and control? Another puzzle piece suddenly clicked into place. *Maybe working through them is* how *we love each other.* I knew what I had to do — I'd known from the start. Now I was ready to do it.

I dropped to my knees, crossed my hands behind my back, and bent my head over his boots. I kissed the toe of the left one slowly and reverently, then the right. I shuffled forward, folded myself as small as possible, and laid my cheek on the instep of his left boot. The leather was surprisingly soft and cool against my skin. When he didn't shake me off, I closed my eyes, keeping my hands behind my back and my ass in the air.

Time seemed to stop. I couldn't hear anything from the other men in the bar — either they were watching us in rapt silence, or we were in a world of our own. The movements of my heart and lungs became slower and more regular as tension flowed out of my body. The uneasiness I'd sensed in Terry also vanished; his boot under my cheek was a rock that would never fail me. I actu-

ally stopped thinking, my restless mind suspended in a timeless moment. From his cap to the soles of my own boots, we were one.

Time started up again when Terry bent down and, without moving his boot or my head, swiftly, efficiently bound my wrists with what felt like strips of leather. I moaned as he cinched them cruelly tight.

"Thank you, Sir!" I rubbed my face against his boot. "Please, Sir! Make me yours!"

"Quiet, boy. Kneel up."

I raised my head and straightened my back. In front of my face, stretched between his hands, was a beautiful black leather collar. The thick, heavy strap, about 2 inches wide, had a line of small chain-link studs running along each edge, sturdy D-rings, and a solid locking buckle. It looked brand-new, unworn. I swallowed and blinked my eyes to clear the tears filling them.

"Do you want it?" he asked softly.

"Please, Sir, yes," I said in an equally soft voice.

I leaned forward to make it easier for him and also pulled my arms against the bonds holding them behind me — not in an attempt to escape but to enjoy the feeling that I couldn't.

He buckled the collar around my neck, pulled it snug but not tight, and closed the small padlock. The strap felt stiff against my throat when I lowered my chin, but it was lined with soft, smooth glove leather. Terry grabbed the D rings at either side and slid it around my neck a quarter-turn in each direction; it dragged a little against my skin, but not painfully. He'd obviously chosen it (*or designed it?*) for long-term use.

My chest was filled with joy, a little fear, and a lot of excitement. Underneath it all was wonder at how different I felt from other times I'd been collared in a scene. *This is a* slave *collar*, I told myself. *It's not a bondage toy, not a fetish object, not a fashion statement. It's a symbol and tool of control. While I wear it, this man owns me. I belong to him, and I have to do whatever he tells me. Isn't that what I wanted?*

"It looks good on you, boy," Terry said as he ruffled my hair, jerking me out of my trance. "I knew it would."

I looked up and saw him smiling, seemingly relaxed. Although I quickly glanced down again, I was satisfied. *If he's happy, I'm happy.* He ran a gloved hand over my face, encouraging me to kiss and lick it.

"Your neck *needs* a collar, doesn't it, boy?"

"Yes, Sir!" I responded, but with three of his fingers probing my throat, it came out a grunt.

"Yeah, you need it bad. That's why I had this made for you today, dickhead — paid triple for a rush job, too. I'll take that out of your hide, of course."

"Yes, Sir! Thank you, Sir!" I said into his palm. "You won't regret it, Sir!"

He pulled me toward him and caressed the back of my head as I hungrily licked his crotch, as eager to prove my love as to consummate my lust.

"That's enough, boy," he said finally, lifting me off him.

I repressed the impulse to say, "Yes, Sir" — *he doesn't need my agreement every time he says something!* — and contented myself with kissing his boots again.

"Stay there, dickhead," Terry said above me in a loud voice. "In fact, put your head on the floor. I don't want you flirting with every stud who passes."

Obediently, I bent down until my forehead touched wood. As Terry walked away I squirmed a little, widening my legs and pulling my head in, until I felt stable — a human tripod — if not exactly comfortable. I'd always said I "wasn't into humiliation," but my cock was hard as I knelt with my face in the dirt and my hands tied behind me, waiting for my Master to reclaim me.

The bubble of silence had vanished. The footfalls of men in boots (or even sneakers) vibrated the floor all around me, and conversation and recorded music rolled over me. I was nudged several times, and a few guys amused themselves by wiping their bootsoles on my hair or ass. I didn't move. The noise of horny men psyching themselves up for three hours of bondage and JO grew and grew. My ass was slapped and even kicked more than once, but I forced myself not to react. I was sure Terry'd be watching, judging my obedience but also ready to protect me from any real harm. I wondered if Stan saw me. *He's probably tied up, too, by now.*

The crowd began to move toward the back of the bar, where it opens up into a wider space with several different side rooms and areas. Apparently the circle was forming, a tradition at the NYBC and many similar clubs: after the doors are locked, everyone who wants to participate introduces himself and, if he wish-

es, says something about what he's into or looking for. The process can be tedious for regulars, of course, but it breaks the ice for newcomers and helps everyone zero in on the guys whose interests seem compatible.

A familiar pair of boots straddled my head, and Terry commanded me to stand up. When I swayed for a moment after getting on my feet, he steadied me with a strong hand on my shoulder. I kept my eyes lowered, but he lifted my chin and made me look in his face. He had a goofy smile, not his usual lopsided grin, but his eyes were bright and clear. *He seems happy.* I smiled back at him. After that reality check, he pulled me toward his chest, and I kissed and licked all the flesh and leather I could reach.

He laughed when I slurped my tongue under his chin, rasping at his beard stubble, and held me tighter. When I stood on tiptoes to reach higher, he gave in and bent his head so we could kiss. I let him pillage my mouth with his tongue — and tried to suck it back into me when he began to withdraw. I felt his chuckle more than heard it. I tried to look at his face again, but he spat in his palm and rubbed it over my lips and cheeks, cleaning off the dirt from the floor. Finally he knuckled my head and held me at arm's length. He'd checked his jacket and cap, and thanks to his short sleeves, I'd felt his muscular, hairy arms brush mine when we hugged. I licked my lips, wondering how one of them would feel shoved up my ass.

"That was fun," he said, grinning widely, "but we'd better get back there or they'll start without us."

"Who cares?" I said, then, realizing the lapse, flinched and lowered my eyes. "Sorry, Sir." Terry laughed it off.

"We'll talk about protocol later, boy. Tonight, as long as you're respectful and obedient, don't worry about it."

When I glanced at him gratefully, still a little unsure I wasn't in trouble, he knuckled my head and laughed again.

"*Relax*, Matt. You worry too much. Here — this'll help." He pulled a pecker gag out of his bag, stuffed it in my mouth, and buckled it tight around my head. "Now you won't have to think about what you say — 'cause you won't be saying anything."

He chuckled as I moaned around the spongy plastic plug, happy to have something cock-shaped to suck on.

"Carry this, dickhead," he said and slung the strap of his bag over my right shoulder and across my chest; the bag itself

banged against my ass just below my bound hands. It didn't weigh as much as I'd expected — *no extra-heavy irons this time?*

Behind me, he rummaged in the bag, then came around in front again to clip a leash to my collar — four feet of tightly braided leather in a beautiful combination of black and silvery gray. Like the collar, it looked new, and I wondered if he'd bought it, too, just for me. *New slave, new collar and leash — kind of like an engagement ring!* As he slipped the loop at the other end of the leash over his left wrist, he looked into my eyes and grinned again.

"Move it, dickhead!" he said as he turned and headed toward the back.

I followed him, keeping my eye on his trim leathered rear, wanting to get my tongue all over, and into, his ass. But something nagged at me: *He keeps calling me "dickhead," like it's a name.* I wasn't sure I liked it — then again, I wasn't sure I didn't. *Doesn't matter, I guess, long as* he *likes it.*

"Good boy," Terry said when we reached the circle, almost the last ones to join it. He patted my head and pushed me to my knees beside him. Tentatively, I sat back on my heels. He didn't object, and when he saw that the bag's strap wasn't long enough to let it rest on the floor behind me, he adjusted it.

I glanced around the circle, again looking for Stan, but mostly kept my eyes on the floor in front of me — I wasn't eager to exchange glances with anyone else I knew. Although I wasn't ashamed of being Terry's slave — far from it! — I doubted the others would understand. I was still having trouble understanding it myself! I knew I *liked* it (my cock was a steel rod in my jeans), but despite Terry's grins and hugs, part of me still worried about what I'd gotten into.

Working my jaw around the gag, I concluded that I could scream if I had to, but I sure couldn't talk — which was just as well, because this slave business was still too new for me to talk about it in public. *I sure do want to talk more about it with him in private, though — a lot more!*

When it was Terry's turn, about a quarter of the way round, he said he was "into rope, leather, steel, rubber, and anything else I can use to make a man helpless and ready to give me whatever I want. But I'm not shopping tonight; I have my catch already. A lot of you probably know this cocksucker" — he grabbed my hair

and pulled my head back so everyone could see my face — "as Matt Stone. I won't ask how many of you have already had him, 'cause it'd embarrass him if anyone said no." There was nervous laughter as my cheeks flamed red.

Okay, I thought as he made me face the too-familiar crowd, *so he thinks I need taking down a peg or two. Deflate my vanity or something. I can handle that. I probably need it, too. My cock's still hard, anyway.* Terry let my head fall back before continuing.

"This is the age of recycling," he said, "so tonight he's my slave. I'll decide later if we'll go any further — this is like a screen test for him. Since he's always horny, and definitely thinks too much, I've given him a new name: dickhead." He grabbed my collar and pulled me up off my heels. "Don't slouch, dickhead. It's bad form." There was more laughter, and my face reddened again.

"Do you like your new name, dickhead?" Terry asked teasingly, apparently determined to humble me thoroughly.

Equally determined not to let him throw me, I nodded my head firmly. By then I'd decided that I *did* like the tag. It sounded tough and hot, more like an affectionate nickname than a put-down.

"Don't you agree it fits you well, dickhead?"

Again I nodded. My sex drive is so wrapped up with fantasies and fetishes and other ideas in my head that it *did* sort of fit.

"He's very agreeable when he's gagged," Terry explained with a smirk, drawing more laughter. "I'm still working on his attitude the rest of the time. . . . Your turn," he said at last, gesturing at the man on my left, a nebbishy guy I'd often seen prowling around the perimeter of the action on club nights.

As far as I knew, he never actually got into anything at the club — probably because the little he typically said about his interests wasn't enough to encourage anyone to take him on. At Bondage Club, "I like to tie guys up" is a little too generic to set any pulses racing (unless the man who says it happens to be your wet dream on looks alone). But this night the nebbish opened up, perhaps encouraged by Terry's example.

"I like to tie up young, athletic guys so tight it hurts, then gag 'em and make it even tighter. After they've suffered for an hour or two and are all sweaty and sore, I like to lick their bodies all over, jerk off on them, then jerk them off."

When he finished, you could've heard a handcuff key drop.

Maybe no one knew if he could even tie a knot, but this time he'd have all the volunteers he could handle willing to find out. The intros got raunchier and wilder after that, and when the circle broke up and guys started pairing off, the overall energy level seemed higher than I could remember it being for a long time.

Several men came over to greet Terry, an infrequent visitor but a longtime member, and I stayed on my knees in front of him while they talked. One congratulated him for "making an honest slave" out of me.

"I haven't done anything to him — yet," Terry said. "Didn't you see how he threw himself at me as soon as I came in?"

I spluttered around my gag at this whopper, but he booted my ass, so I settled down. *Let him tell it his way.*

"Anyway, tonight's only going to be a test drive," he went on. "We haven't made any commitments. I'm not convinced yet that this fucker is ready to settle down, or that I want to go to the trouble of training him. He's been quite a slut — haven't you, dickhead?"

I blushed again and nodded. *Why's he keep harping on my sexual history? I didn't catch the plague. What more does he want?*

"Better an experienced slut who knows who he is and what he wants," one of the men said, "than some asshole kid fresh off the bus with his head full of *Drummer* fantasies."

I could've hugged him. I glanced up and tried to thank him with my eyes. He winked, and I recognized him — years ago we'd played together a couple of times. He wanted more, and I wanted variety, but we'd parted on friendly terms. Terry, however, wasn't as pleased by the remark as I was.

"Not every kid fresh off the bus is an asshole," he said in a serious tone, "*Drummer* fantasies or no. Sometimes they're simply ... unripe. Even a slut like dickhead here was a kid once."

He ruffled my hair and let me nose his palm, so I knew he wasn't upset with me, but I felt as if I'd missed a clue.

"Now, if you'll excuse us, gentlemen," Terry said, "I need to find somewhere to work on my slave-for-a-night before all the good spots are taken."

They were in short supply, too. Both of the club's bondage racks were in use already, as was the padded, eyehook-trimmed table, several eyebolt-equipped posts, and three or four chains hanging from the ceiling. But I didn't care. I'd have been happy

if Terry had done nothing more than strip off my clothes and let me lie at his feet. Oh, it would've been nice if he took the gag out to let me use my mouth on other things, like his boots and cock, but I could do without that, too.

There was one more delay, however. I was on my feet, his bag hanging off my back again, and he was leading me toward the small raised platform in the back, which has no special equipment so was still unoccupied, when Stan suddenly appeared and stood in front of us like a roadblock. Although he'd stripped down to boots and gym shorts, there wasn't a rope or chain on him. He looked ready to take Terry apart with his bare hands.

"Hello, Stan," my Master for the night — *and much more, I hope!* — said mildly, obviously having no trouble recognizing the man he'd supposedly snubbed. "Did you want something?"

"I don't like hearing you make fun of my friend in public. I want to be sure he's all right. . . . You okay, Matt?" he asked, stepping toward me.

I was touched by his concern, and despite being gagged I could have at least nodded. But Stan, in all innocence, had put me in an awkward bind: If I acknowledged him without permission, I'd piss Terry off. But if I didn't reassure Stan somehow, he'd *really* worry, and maybe start a fight. Terry had it all over him in reach and weight, but Stan was solid muscle. I didn't want to find out which of them would win. To my relief, Terry himself rescued me — after he was satisfied I wouldn't make a move on my own.

"There's no one here by that name, Stan. If you're worried about dickhead, just ask him — he has permission to answer by nodding or shaking his head."

Now poor Stan was in a similar dilemma: *Should he use Terry's name for me?* If he did, he'd be acknowledging Terry's mastery and my new status. If he didn't, I'd have to continue ignoring him. He shifted uncertainly on his feet, looking from me to Terry and back again. I was starting to think he'd punch Terry out from sheer frustration.

Finally Terry laughed. "Use your eyes, man!"

He grabbed the front of my 501s and ripped them open, then pulled out my rod.

"Look at his cock! You know him better than I do. If he was scared or turned off, this'd shrivel like a punctured balloon. He *loves* being treated like this. The more I try to humiliate him,

the prouder he is at being the center of attention. He blushes for a few seconds, but that only makes him look hotter."

I felt myself blushing again — and hoped Terry was enjoying it.

"Anyway," he continued, draping his arm around my shoulders, "I've had enough of those games for now. I'm going to get him out of these clothes, let him love my boots for a while, tell him some stuff he needs to hear, then truss him up like a Christmas goose and fuck him senseless. Nothing that a friend need be concerned about."

Stan's no fool. I obviously didn't need rescuing.

"I'll be watching you, man," he warned, glaring at Terry before stalking off.

"I'm glad you inspire such loyalty, dickhead," Terry said quietly when Stan was out of earshot. "I hope it means you know how to give it, too."

Should I nod? But he pulled me forward again before I could decide how to respond.

We halted at a small table in a corner of the platform. Terry took his bag off me and set it on the table, stripped off his gloves, laid them next to the bag, and felt my hands. My arms hurt by then, but despite the tightness of the bonds my fingers weren't going numb. Our hands clasped momentarily in a silent dialogue, and then he let go.

"Down, boy," he said, pointing at the floor between the table and the bench at the back of the platform. I settled onto my knees, and he tied my leash to a sprinkler pipe on the low ceiling above me.

"I'm taking out this gag," he said as he unbuckled the strap, "because I have to go piss. But I want you to kneel here quietly and not talk to anyone until I get back. Understand, dickhead?"

"Yes, Sir," I said after working my jaw back to normal. "But you could let *me* take your piss, Sir."

He grabbed my hair and pulled my head back until I was looking up at him. The collar's edge dug into the back of my head.

"Greedy idiot," he said, obviously angry. "I can overlook your speaking out of turn — this time — but I won't tolerate stupidity or thoughtlessness. You know better than that: *no fluid exchange.* You want to get us thrown out of here? Or have the club lose its meeting place?"

"No, Sir — I'm sorry, Sir. Please forgive me, Sir." I'd made the offer to please him but clearly hadn't thought it through.

Terry said nothing as he released my head, just growled and walked away. I hung my head and contemplated the prospect of being answerable to such a demanding Master, wondering if I'd ever be good enough to satisfy him. *Will he punish me whenever I fail to meet his expectations?* The typical emphasis on punishment is one of the things that had always turned me off about Master/slave scenes and relationships. *I want to obey him because I love him and enjoy pleasing him. I don't want to be coerced into anything — or made to feel guilty or inadequate all the time.*

When Terry didn't return after a couple of minutes, I shifted my position a little to get an unobstructed view of the developing scene out in the center of the room. The nebbish had one of the better-looking jocks in the club — a softball star, I think — tightly spreadeagled on a bondage rack and gagged with his own sock (it matched the one still on his other foot).

Spreadeagle is my own favorite position, so the boner hanging out of my jeans throbbed as I watched the nebbish add rope after rope to increase the tension. He was damned good, too. He'd used padded leather restraints for the jock's ankles and wrists, and he was making neat loops of rope around the well-muscled upper arms, thighs, calves, chest, and abs. Each time he tied off a new rope to the frame, his "victim" moaned and his hard cock jerked higher — or it did until his cock and balls themselves got tied down!

I was so caught up in the scene I was watching that I didn't notice Terry until he was practically next to me. He was carrying a can of 7-Up and a glass of ice.

"Did I say you could watch, dickhead?" he asked as he set the glass on the table beside me.

"No, Sir. But you didn't say I couldn't, Sir."

Terry chuckled and untied my leash from the pipe. He seated himself at the table, stretching out his legs so one of his tall boots brushed my flank. I stole a glance at him over my shoulder — he'd put the loop of the leash over his left wrist again, but the line between us was slack. He was drinking his soda. He raised his eyebrows at me over the glass, and I looked down again.

This stinks, I thought. *What's the use of having a hot-looking Master if I can't look at him?*

"You know, dickhead," he said in a lazy drawl, speaking to the back of my head, "you behave pretty well for a guy who says he never thought about being a slave. Oh, your manners and carriage could stand some work, but that's penny-ante stuff. I'm not interested in the kind of theatrics that wins contests, where I snap my fingers and you jump through hoops. . . . I'm sure you could do it, too, but that's not what I wanted you to show me. That's not why I came down here tonight. . . ."

His voice trailed off, as if he was unsure of himself suddenly — or unsure of me. The devil in me decided to goose him a little, show him that as much as I wanted him, I wasn't any wimp he could string along.

"So why *did* you come here tonight, Mr. Andrews?" I asked over my shoulder. "What *are* yoah intentions, suh? Hon'rable, Ah hope."

His face registered shock momentarily, then relaxed as he laughed heartily. *Well, I've made my point*, I thought. I gave him a quizzical glance with *one* eyebrow raised (a trick it took me years to perfect), then turned my head forward again with as much dignity as I could muster.

"It's almost 10:00, asshole," he said behind me, barely suppressing a chuckle, "and I've barely started tying you up. Ditch the Scarlet impression and stand up and turn around."

Once I was on my feet facing him, he pulled me toward him with the leash, finished undoing my pants, and slipped them off over my boots as I lifted one leg at a time. My cock throbbed when he touched it, and I almost shot right there. I watched helplessly as precum welled out of my cockslit and slowly spun down to the floor.

"Can't have you dribbling all over," Terry said as he got a rubber out of his shirt pocket and slid it onto my engorged dick. I prayed simultaneously for him to stroke me hard enough to bring me off and for him to *stop* touching me so that I wouldn't come too soon.

The condom was just the beginning. He pulled the leash end off his wrist and tossed it over my shoulder so it wouldn't get in his way, then got some more long, narrow strips of soft leather from his bag, the same he'd used to tie my hands, and proceeded to harness my genitals. He not only installed a tight band of leather around the base of my package but also painfully

stretched my ballsac, finally separating and tying off each ball so they were like little ripe plums.

"The porn stories make it seem so easy," he said in a conversational tone as he worked on me — as if weighing ideas in his hands, not my manhood. "Drag a man out of a bar and into your dungeon, attack his self-esteem, cut him off from everything he knows — work, friends, family — torture him for a few days, or weeks or months, break him down to nothing, then build him up again into whatever you want."

My cock jutted obscenely, the shaft swollen and the head a purple knob. I whimpered in a mix of pain and pleasure as he sheathed it tightly in leather all the way to the glans.

"Whether he loved you or hated you before," Terry continued, "if you 'break' him, the theory goes, he'll be your loyal slave for life." He looked at his handiwork approvingly.

"Uh-uh," he said, snapping his finger against each of my balls — I arched back and hissed through my teeth at each jolt of pain. "It doesn't work that way," he said, then slapped the head of my sheathed cock hard enough to make my balls bounce.

"*Aiee!* Shit, Sir . . . ," I started to beg — but we could both see that my cock was still hard, so what would be the point?

He sat back, grinning, and let me recover unmolested while he continued his little lecture.

"Yes, you can break a man with torture," he said, "and when he's broken he'll do whatever you tell him to. But he'll serve you out of fear, or because he can't think on his own anymore, not because he truly *wants* to please you."

I looked closely at him, a crooked grin on my own face, as I recalled my own earlier thoughts about punishment. *Do we really think so much alike?*

"Some guys may not care about that," he went on, "or they may *like* it that way — or think they do — but not me. Sorry if that disappoints you."

I shook my head, smiling broadly.

"Not at all, Sir. I'm glad you feel that way, Sir. Not that it surprises me, Sir."

"Don't be too sure you have me all figured out, dickhead," he warned. "But I *can* tell you I'd never want a man under my hand to come out of the experience worse than he went in, but only better, stronger, happier. That's the way I was trained."

"You were trained, Sir? As a slave?"

"Not now, boy. Someday I may tell you about it, but not to-night. Now shut up and listen. . . . I wouldn't even *want* a slave," he continued, "who wasn't eager to belong to me, who hadn't chosen me as his Master as much as I chose him as my slave. And any slave of mine should be as turned on by the bondage or tor-ture or humiliation I enjoy giving him as any bottom I might bring home for a more limited scene. For example . . ."

He sat up and reached under my T-shirt — the one he'd given me — to work my nipples with his fingers. I moaned and rolled my eyes, almost losing it again as he pinched and pulled at them.

"Oh, yes, Sir," I begged, "please, Sir . . ."

"Shut up."

Much as he'd done with the same T-shirt when my hands were cuffed to the cell door, he pulled it over my head and rolled it behind my neck. Taking a long, thin black cord from his bag — it looked like braided nylon, not leather — he tied one end around my left ball and ran it up through my right nipple ring, then down again to my right ball. He looped it around the ball, back up through my left ring, and down again to my left ball, where he tied it off after making sure that all the lines were taut. I was already moaning softly, enjoying the tension on my balls and nipples but sure that it was only going to get worse.

Terry slid another, shorter length of cord behind the one crisscrossing my chest at a point halfway between my nips and balls. He brought the ends of the short cord together in front and made half a knot, retaining one end in each hand. Slowly, staring at me with intense concentration — while I looked at him with a mix of fear and desire — he pulled the cord ends he held apart, which brought the lines between each of my nips and balls closer and closer together, increasing the agonizing tension. My knees trembled, and cold sweat broke out on my forehead and under my arms. I bent forward to relieve some of the pressure.

"Stop that, dickhead," he growled. "Stand up straight."

I groaned and obeyed, nearly screaming at the rush of pain when I straightened up. He cut me some slack for a few seconds, then began tightening the cords again. The pressure kept increas-ing. Sweat was pouring from my pits and pubes, and tears spilled from my eyes. I was bawling like a baby — but making no effort

to escape — when he finally stopped, slackened the tension a little, and tied the knot off, leaving my nips and balls painfully, but not unbearably, stretched.

"Good boy . . . good slave . . . you did fine," Terry crooned, gently stroking my sweat-soaked torso until my sobs and shakes subsided. Then he stood up and, with his hands on my hips, turned me so I was facing away from him.

He unhooked the long, braided-leather leash from my collar, and I felt him tie or hook it into the straps binding my wrists, then use it to raise my bound hands several inches up my back. Holding them in that position with one hand, with his other he drew the leash through my left armpit, across my chest and over my right shoulder, around behind my neck, then down over my left shoulder, across to my right armpit, and back to my wrists, where he tied it off. When he was finished, my forearms were held tight against my back, just below the middle, and my elbows jutted out to either side. I felt the taut lines of braided leather press against the sides of my chest and under my arms, but the bunched T-shirt cushioned my neck.

Terry hugged me from behind and lightly rubbed his fingers over my stretched-out nipples until I moaned. My cock, having softened as the pain from the nip-and-ball torture mounted, filled out again until the leather strips wrapping it made a tight, smooth sheath. I almost came as he rubbed the head of my cock while kissing the back of my head and licking behind my ears. My whole body seemed to have become a single sexual organ, so that anywhere he touched me it felt like a spit-slick finger gliding across the most sensitive part of my dick.

I was babbling incoherently when Terry finally turned me around again and pushed me to my knees. The continued throbbing in my nips and balls was almost pleasurable, and the leather tightly binding my hands, arms, and genitals was like a safety harness. I felt I could do no wrong with the parts of my body still free to move, like my head and tongue. I dived for his crotch, rubbing my face against him like a bitch in heat, slobbering and moaning over his leather. He indulged me for several minutes, stroking my head where it bobbed between his legs, but eventually pulled me off with a firm hand on the nape of my neck.

"Settle down, dickhead," he said, and seated himself again, stretching his legs out on either side of me.

I sat back on my heels, wincing as my nips were pulled tight again, and stared at his saliva-streaked crotch with my tongue out like a thirsty dog. Oddly, we still seemed to be alone in our corner of the room — or maybe I was just oblivious to anyone else, I was so focused on Terry. My eyes slowly traveled from the bulge between his legs down the length of his boots and back again. I sneaked a look back at his face: he had his crooked grin, and his eyes were sparkling. *He's pleased with me*, I thought. Satisfied, I lowered my eyes again.

"You're dying to lick my boots, aren't you, boy?"

"Oh, yes, Sir," I said, already drooling. "Please, Sir."

"Go ahead, then. Get your mouth and tongue on my boots. Clean 'em good. Love 'em."

I was tasting leather before he finished talking, starting at the toe of his left boot and working up. Despite the years on them, the oil-tanned engineer boots had a stronger leather smell than his patent-finish police boots, and their slightly rougher surface seemed to stimulate every nerve ending in my tongue. But the thick leather was surprisingly soft — so broken in it was like black velvet. I had to moan in pure pleasure.

"That's right," he said with a chuckle. "Whatever else you are — or become — you'll always be my bootslave, won't you?"

"You know it, Sir! Thank you, Sir," I said, pulling my mouth away from his boot for an instant.

Any more at home like you? I wondered as I returned to licking at the instep — meaning boots, not Masters. I *did* like being his bootslave. Somehow it felt more comfortable, easier to get my head around, than just being a slave, without qualification. *Let's see: I could be his chain slave, his rope slave, his cop slave, his erotic-art slave, his . . .* Terry interrupted my speculations, though not my boot worship.

"I'm due in Vermont tomorrow at ten in the morning," he said, as if discussing his schedule with a secretary. "I have to see a private client about building his dream house. He has a mountaintop all picked out. . . . I was going to leave this afternoon, have a relaxed drive, and stay overnight."

Grabbing a handful of my hair, he raised my head off his boot until our eyes met. His were shining with intensity, but mine had started to blur again with tears — from pain as well as joy.

"Damnit, Matt. I couldn't stop thinking about what you said

to me yesterday morning on the phone. I figured you'd probably be here tonight, at least to watch the action and talk with friends — and if you weren't, I'd have called and told you to get your ass down pronto."

"I'm glad you came here tonight, Sir. I couldn't stop thinking about you either, Sir."

He acknowledged my statement with the briefest of grins, then let my head drop back. I started licking again but soon froze as he gave me a verbal lashing.

"At first I was furious with you," he declared. "How *dare* you tell me I still want a slave? How dare you presume to know more about me than I know myself? And how dare you say you *might* want to belong to me, but I'd have to convince you?"

I felt defensive and ashamed at the same time. I'd *had* to tell him what I felt, and what I'd figured out. *Guess I could've been more tactful, though* Like most bottoms, I tended to forget that tops — the good ones, anyway — are often more sensitive and high-strung than we are. . . . *He must be going to forgive me, though, or we'd never have gotten this far tonight.*

"Eventually," he went on, his tone gentler, "after a lot of uncomfortable soul-searching, I had to admit you were right. I *do* want a slave: not just a regular boy I can work over and fuck, but someone I *own*, someone who'll do whatever *I* want, not merely what he's agreed to in advance or what I can coax him into. . . . Probably that's the only way I *can* love a man, by owning him. Certainly I haven't loved any of the bottoms I've played with since my slave left. Oh, I've been very fond of many of them. They're good boys — good men. But love? No.

"You're right, though, to be cautious about that kind of relationship — not only in view of my own track record, but also considering how many other guys've tried it and messed themselves up."

He stroked my head, and I gratefully resumed licking his boots. But I was listening to every word, too.

"So many guys call themselves Masters and slaves, and so few make it work. It's easy to do for a night, a weekend, even a week or two. But when you try to make it last indefinitely, day in and day out, try to make it real . . . it's so *hard*. So few succeed. Those who recognize it isn't working, call it quits, and say good-bye are the lucky ones. Others leave real wounds on each other,

like my first slave and I did, wounds that can take years to heal. And still others, maybe even sadder in the long run, protect themselves by denying their needs and avoiding the things that turn them on. Later they wonder why their lives feel so empty. . . .

"I'm glad you enjoy licking my boots, dickhead. I've never known anyone else do it with quite so much gusto as you. That's good, because I love boots, too, and I have a lot of them."

In response, I just slurped louder — and would've wagged my tail if I'd had one, so I wagged my ass instead.

"I've never understood," Terry went on, as if thinking aloud rather than talking to me, "how some guys can get off on forcing men to serve them — even in fantasy. What's that say about *them*, if their partners don't find serving them rewarding? . . . But there I go again, back on my soapbox."

I didn't mind. I could listen to his dark-honey voice all day, especially while savoring the rich, black leather encasing his feet and legs. After a few minutes he began talking again in a low voice that seemed to be pitched at my ears alone. Despite the noise from the activities elsewhere, I could hear every word.

"Let me tell you a story, dickhead, about these boots you're loving. They're special to me. They marked the end of my apprenticeship in s/m. Remember Larry? The bottom who taught me? I know I told you about him."

"Yes, Sir, I remember."

"Well, I bought these boots after the first time we played for a whole weekend at my little apartment in Manhattan. Usually I went out to his house in Queens, and even though I was the top, because he had a lot more experience, he made the rules. For instance, his lover stayed in earshot while we played, in case I fucked up and Larry needed help."

I absorbed his words, without thinking about them much, as I worshipped his beautiful boots. The head of my rubbered, leather-wrapped cock kept brushing against the floor as I moved, and I strained against the tight leather bonds on my arms, not to escape but to remind myself that I couldn't. My nipples were almost numb by then, but my balls still ached. And every time I swallowed or breathed deep, I felt his slave collar hug my neck.

"This time," Terry continued, "I did what *I* wanted, by *my* rules — and made him love it. I was nervous as hell — I'd never run a scene past one night before — but Larry never knew it. He came

at least six times. I'd have made him shoot again before letting him go, but he begged me not to: his poor cock was raw. So was mine. After I released him, he got on his knees and kissed my boots — the 11-inch engineers I usually wore back then. He called me 'Master' for the first time and thanked me for one of the best scenes of his life. Did wonders for my self-confidence."

I straddled his leg and slurped at his boot in long, sensuous strokes from the instep to the top, still listening carefully.

"After that scene, I had these boots custom-made. Had to send away for them — and return 'em twice before the fit was perfect. That was more than ten years ago, dickhead. I've had these boots ever since. They just get better the more I wear 'em."

By then I was lying on my side between his legs, straining to lick along the back seams of his boots, wanting to caress each stitch with my tongue. I could see he was right. The boots fit him so well there wasn't a bulge or crease anywhere on the shafts.

"They cost a lot," he went on, "but they were worth it. I could've gone through three pairs of cheaper boots in the same time — and not have enjoyed 'em nearly as much. I take good care of my boots. I recondition them regularly and keep 'em clean, with a little help from bootlickers like you."

Like me? I was suddenly outraged. *No one's like me! He said it himself!* I slid down to his feet and got onto my knees, ignoring the pains that stabbed me with every change of position. Fastening my teeth onto the front of the sole of his right boot, I shook it, growling all the while, like a dog worrying a bone. Terry started laughing, but I held on and shook it even harder.

"Okay! Okay!" he exclaimed. "I get the message, boy! I'm sorry! No one else is like you! No one else services my boots the way you do."

I released his boot from my mouth and began lapping softly at the instep, the picture of innocent submission. He was still chuckling, and I marveled at how well we communicated without words. *A good thing, too, because somehow he gets to do most of the talking! Master's prerogative, I guess.* I also marveled at his reaction to my little stunt. *A lot of other topmen would've ground me into the floor for that.*

"Now where *was* I, you jackass? I'm probably crazy even to consider taking you on as a slave — have to watch you every minute, or you'll be pulling *my* chain before long. What was it

Oscar Wilde said — when you feast with panthers, the danger is half the enjoyment? Something like that. . . . Anyway, I was telling you about these boots you've been lovin'. Not much more to say, actually. I've always given 'em what they need, and they've repaid me with years of faithful service."

Pretty sure, then, where he was headed, I still licked slowly and listened carefully.

"I enjoy owning things like these boots, dickhead: things that are well made, top quality, built to last."

His voice was *very* soft now, making me strain to hear it from my position down at his feet. Straddling his leg, I crept cautiously closer, alert for any sign I should back off.

"Any slave of mine, dickhead, would have to be like these boots: dependable and trustworthy, yielding and soft to the touch, but tough, strong, built to last. When I wear these boots, they cling to my legs and move along with me. But when I take 'em off, they stand up on their own. That's the kind of slave I'd want: well trained and eager to serve me, but able to stand on his own feet, too.

"While he's with me, I'd give him whatever he needs to stay healthy and happy — not always what he *wants*, but whatever he needs. And when he's on his own, I'd keep tabs on him, pulling on his leash if he got careless or too wild. But I can't afford a dependent, someone I'd have to support and discipline full time. That's too much work, and it stops being fun real quick."

I'd almost reached his crotch, softly slurping at his leather pants, which tasted slightly different from his boots, with even more of his own smell permeating them. I must have seemed to be enjoying myself *too* much.

Terry suddenly grabbed my hair and yanked my head up. He kept pulling until my chest was completely off his leg, bent back in a curve. The pain from the hair-pulling was nothing compared with that from the suddenly increased tension on my nipples and balls. I screamed and begged, but his face, no longer grinning, seemed carved from stone.

"Have you been *listening* to me, asshole, or just wallowing like a leather pig? Have you heard a *word* I've said?"

"Yes, Sir!" I protested. "I heard every word, Sir!" I was gasping, and he lowered me slightly. "You were telling me what you want a slave to be, Sir: tough and dependable and pliable and

self-supporting, Sir. Like your boots, Sir. I only crept closer to hear better, Sir!"

His features softened, and he let go of my hair, allowing me to bend forward enough to relieve the agony. But he didn't let me go back to licking his crotch. He slowly bent the leg I was straddling, pulling his boot back toward him and raising his knee under my butt. I lifted myself from my knees onto my own feet, but he made me plant my ass on his leg, just in front of his knee. My hard, sheathed cock lifted and pointed toward him — the reservoir at the end of the condom was white with all the precum I'd dribbled into it.

Smiling, he bent forward and kissed my eyes with incredible tenderness, licking the tears away. My heart melted all over again.

"Please, Sir," I whispered, dignity be damned. "I need you so bad, Sir. I'll do whatever you want, Sir. I'll be whatever you want me to be."

"Stop talking like a porn story, Matt."

His use of that name startled me, I was already so used to his calling me "dickhead" or "boy" or "asshole" — whatever. He sat back, and I noticed his moustache twitch slightly above his full, sensuous lips. He looked very serious, but a wicked sense of fun was never far from the surface.

"If I wanted a piece of blank manmeat to shape," he told me as I stared raptly, "I wouldn't be attracted to you in the first place. What would be the point of taking *you* as my slave and then trying to change who you are? I told you what qualities I expect in a slave. If you have them — and I think you do — we can make this work; if not, I can't give them to you. But it's not those qualities that make me *want* you. D'you understand?"

"I think so, Sir. A strong back, a tight ass, and a soft mouth aren't enough for you — you want to own my soul, too."

"Damn right I do!" he laughed. "If all I wanted was personal service and easy sex, I could hire it. If I'm going to go to the trouble of being any man's Master, he'd better throw some spirit into the bargain. I don't need a draft horse. I want a thoroughbred, and I'm willing to put up with some temperament for the fun of racing him."

"Like your Jaguar, Sir?"

"*Exactly* like my Jaguar. I knew you were a smart boy."

"Just trying to keep up with you, Sir. You know how they

say the brain is the largest sexual organ? Well, I'm afraid I'm a bit of a size queen there, Sir."

"So am I, boy, so am I," he chuckled. "We have the damnedest conversations! I think that's one of the things I like most about you — we start talking, and I never know where we'll end up."

"You were telling me what you want in a slave, Sir. Is there more?"

"Plenty! But you already knew that. Surrendering to me for a scene, which you're very good at, isn't the same as surrendering for the long haul. That'll be much harder — for both of us, especially given that temperament of yours. You'll have to learn to run in harness without losing any of your spirit."

"Doesn't sound all that hard, Sir, if you're the jockey. There's always the whip, of course."

"Wiseass — be serious for a minute! You know all those rules they make so much of in Master/slave porn stories? Like not speaking unless you're spoken to, not wearing clothes in the house, not sitting on the furniture, not looking your Master in the eye, not touching your cock, sleeping on the floor, etc., etc.? Listen carefully and I'll tell you a secret: none of that is really essential. Oh, rules like that can very useful for training and discipline, and some guys get off on them, but they're not *important*. They're trimming, not the heart of it at all.

"Paying attention, though — *that's* important. It doesn't make anyone a slave, or a Master, all by itself, but you can't be either without it. You just can't afford to take anyone you love for granted."

My eyes had filled with tears again by the time he stopped talking. How could I *not* love a man who spoke like that, after playing me as hard and as well as anyone had in years? *Could* we have them both — a high-intensity sexual relationship *and* a realistic life partnership?

"Maybe you'll become my slave, Matt," he said softly. "Or maybe if we start out on that journey, you'll decide it's not what you want after all. Maybe I'll decide you're not the right one for me, or that I want you in a different way. It's too soon to tell. But the *potential* is definitely there, and that's what I needed to be sure about. There's a fine chemistry between us, on several levels. Oh, you're still a pushy, self-centered smartass, but you'll get over it ... or I'll get used to it."

Terry was grinning openly now, and I felt waves of love —
and relief — course through me. But then he looked at his watch
and cursed.

"Oh, shit. Guess I got carried away with the sound of my
own voice — or with the feel of your tongue on my boots. It's af-
ter 11:00. At midnight they unlock the doors, and we'll have to
turn into something that won't scare the regular customers. . . .
Stand up."

I obeyed, wincing as my nipples were pulled. He immed-
iately reached for the cord connecting my nipples and balls and
untied it. When my nipples were free, except for the rings in
them, he pulled my chest toward his face, kissed each nip ten-
derly and licked at it for a few seconds, fingering and tugging at
my balls at the same time. The pain and pleasure were so intense
I almost shot, but he pulled off in time.

He released my other cock-and-ball bindings and stripped
the condom from my still-hard cock, then turned me around to
untie my arms. When they were free he rubbed them vigorously
and kissed my wrists. I wanted to hug him, but he forestalled me.

"Get down on your knees again, dickhead."

I glanced at him quizzically for an instant, then obeyed.

"Straddle my boot and jerk yourself off. I want to see you
come, slaveboy."

I moaned loudly as soon as I touched my cock. It was still
moist from the lube in the condom, and my hand slid over the
head as slick as Greg Louganis through water.

"That's right, boy," Terry said to encourage me. "Stroke your
meat. Pull it hard. I want to see you shoot your load all over my
boots. That's how I keep them in good shape, with cum. It's the
best leather conditioner there is."

While he talked, he pushed his boot toe under my still-sore
balls and jiggled them. I spread my legs wider, and he toed the
tender skin between my balls and asshole, then poked at the ass-
hole itself. I moaned and squirmed against his boot, my hand fly-
ing up and down my cock. I wanted to come so bad — and to
prolong this ecstatic foreplay forever.

"C'mon, dickhead," he said. "We don't have all night. You
should be hotter than hell by now. I want you to shoot for me.
Shoot on the count of three. . . . One."

"Yessir! Yessir! I'm going to come for you, Sir!"

I was humping his boot toe, bouncing my balls against the tall shaft.

"Two."

He almost lifted me off the floor on his outstretched leg. I threw back my head and groaned.

"Three!"

"*Ahhggh!* Oh, God, Sir! *Aiiee!*" I screamed, and my whole body convulsed as I shot spurt after spurt of cum onto his boot, his leg, his crotch. "*Ahh-ahh*"

It felt so good I almost passed out. I collapsed in a heap at his feet, mumbling, "Thank you, Sir! Thank you, Sir!" over and over. I was drained.

"Shut up, dickhead," he told me. "You have something better to do with your mouth."

I had a pretty good idea what it was. I hauled myself up and started licking my cum off his leathers like it was whipped cream. I followed the trail from his boot all the way up to his crotch, where a big glob had landed right on his cock. I licked it up and flashed him a shit-eating grin, then planted my mouth back on his crotch, clamping the hard shaft of his cock between my teeth.

"That's enough, boy. Time to get dressed."

"Grrr," I growled, holding onto his boner like a dog refusing to give up a bone.

He laughed, but lightly smacked my head.

"I *mean* it, boy. That's *enough*. No more tonight."

I pulled off and sat back on my heels, hanging my head and pouting.

"Oh, you're impossible," he said. "Put your clothes on and go get us something to drink. *Now*."

He stood up, stretched, and stifled a yawn as he looked around at the various scenes winding down in the rest of the room, then back at me while I rolled down the T-shirt and slipped back into my jeans.

"Probably ruined my reputation tonight," he said with a half-grin. "I usually give more of a show when I play in public."

"You'll hear no complaints from me, Sir."

"You'll hear one from me, asshole, if you don't put a cold Coke in my hand pretty damn quick. . . . Never should have told him protocol wasn't important," I heard him mutter behind me as I turned and headed to the bar.

I spotted someone who looked like Stan lying on his side, chest facing out, on one of the risers across from the bar. He had trunks on, so he was decent enough, but he was tightly hogtied and wearing a full leather hood with no mouth or eyeholes. Looking closer, I was sure I recognized the trunks and boots from earlier that evening and, even more, the short, heavily muscled body. I was relieved to see that whoever tied him up had also tied him in place so he couldn't roll off. He seemed to be breathing regularly (his chest moved in and out as far as the ropes would allow), and in his head he was probably a million miles away.

Waiting for a fresh glass of ice for Terry's soda, I glanced around for Stan's top. It was easy to spot him standing nearby, a tall black man in army gear talking with a couple of other guys but glancing at Stan periodically. I knew him slightly — *Carl? Craig? A good man whatever his name is. . . . Like the one I have waiting.*

I hurried back, finding Terry seated again, half turned away from me and watching the porn video on the monitor in our alcove while puffing on a big black pipe. Sweet smoke wreathed his head. He was awkwardly slumped in the undersized chair, and he rubbed the back of his neck from time to time as if he was tense, or sore. The gear he'd used on me was all stowed away — except the collar I still wore.

He didn't look at me as I set the drinks on the table and poured Coke into his glass. I set the can down, then moved behind him and laid my hands lightly on his shoulders. He seemed surprised at the liberty and turned his head back to look at me, but I spoke first.

"You seem to be in pain, Sir. Would you like me to massage your neck and shoulders?"

"Yes, that would be nice," he said after a moment's consideration. "Go ahead."

I ran my fingers around the base of his thick neck and across his shoulders, feeling for the tightness underneath the gray leather of his shirt. I was shocked at how knotted up he was.

"This may hurt at first, Sir," I warned. "You're very tight."

"I can take it, boy," he said. "Do your worst."

I'm not a trained masseur, but I learned a few tricks caring for Greg, and I used them all as I worked Terry's muscles like tough bread dough, kneading and pummeling them until they finally lay limp and smooth under my fingers. He bore the treatment

stoically, puffing on his pipe from time to time, until near the end, when he gave a massive sigh and seemed to let go all at once, as if finally permitting himself to relax.

I kissed the back of his neck and the top of his head (*he'll have a bald spot there in five years*), then got down on my knees beside him. Wordlessly, he handed me my 7-Up. I drank about a third of it — getting that big lug to relax had been a real job! — before setting it down on the floor in front of me. I sat back on my heels and crossed my arms behind my back.

Terry chuckled and wrapped his big hand around my head, ruffling my hair and stroking my face. I licked his palm and drew my nose across his wrist. He pulled me toward him and laid my head on his thigh, just in front of his dangling keys.

We sat like that for several minutes, saying nothing, needing no words. My cheek lay against his leather; his arm cradled my head, his hand squeezing my shoulder every now and then. Smoke rings from his pipe floated down to the floor in front of me, except when random air currents carried them away.

Finally he stroked my hair again and fingered the padlock at my throat.

"Party's over, boy. Time to take this off."

I looked up, and my eyes pleaded with him, but I knew he was right. He unlocked the collar and lifted it off. I felt more naked than when I was bareassed.

"Pull up a chair, Matt." I obeyed and sat across from him. "Did you have a good time tonight?" he asked after I was seated. "Sorry I never got around to fucking you."

"That's okay, Sir. I had a very good time. I'm sorry you didn't get off, Sir."

"That's not your concern," he said sternly, but then broke into a grin. "I had a good time, too. I don't have to shoot to enjoy myself. Later, on the road to Vermont, or lying on my bed in the guest house there, I'll think about tonight — and about our sessions Tuesday night and Wednesday, too. I'll probably shoot my load half a dozen times, remembering, and planning what I'll do with you next time.

"I can hardly wait, Sir!"

"Well, you'll have to, and so will I — but you *don't* have to keep calling me 'Sir.' You're not collared or bound now."

"I want to, though, Sir! ... Unless you'd rather I didn't?"

"Hmm," he stalled, rubbing his chin with his hand. "I have mixed feelings about that. I don't want you to 'Sir' me constantly merely because you think it's expected — I *would* expect it, of course, if you were my slave, but that's not settled yet. And I don't want you doing it because it makes *you* hot. That's a distraction if I want to talk with you on another level, like now. But if it's a sign of respect . . . you're nodding, but do you really mean it?"

I pulled back, hurt by his distrust.

"If you can't even believe I respect you, what's the use?"

"The boy I led out of the Spike a few days ago didn't respect much of anything," he said.

"He's not the same boy you left on the sidewalk Wednesday night," I answered back.

Terry grinned crookedly and puffed a smoke ring at me. I held my ground, determined not to cough or flinch, as it hit my face and slowly dissipated.

"Strangely enough," he said, "I think that's true, but damn if I know how it happened. D'you understand it?"

"No, Sir — I mean, Terry." I shrugged. "But it's real. I'm not the same as I was, and I don't want the same things anymore."

"What *do* you want now, Matt?" He looked me in the eyes with the utmost seriousness. "Do you really want to be a slave?"

"I think so, but I'm not sure I know what that really means. Years ago I tried it for a weekend with Jake — you know, sixty-something topman, shaved head, old leathers, hangs out at Altar on weekends and seems to know everybody?"

"Yes, I know Master Jake very well."

His cockeyed grin suggested that was an understatement. *There's some history between them! What?*

"He warned me I wasn't slave material," I went on, "and our weekend seemed to prove it. It was boring and frustrating, not exciting at all. After that, I never tried it again, never wanted to."

"And now . . ."

"I want *you* — no, that's not right. I want you to want me. . . . Still not on the mark. I want to belong to you. It's not that I want to be *a* slave — I want to be *your* slave. Hell, I am already, no matter what you decide. I don't think I'll ever get you out of my head and heart. If we were vanilla fags, it'd be a simple case of lovesickness. But we're leathermen, and the only way I can imagine being yours is as your slave. . . .

"It's funny," I went on as Terry listened intently. "Earlier this evening Stan asked me why I wanted you to own me. I told him I'd seen how you treat your property." He smiled at that, but what I said next didn't please him at all. "I don't see how the bottoms you play with regularly can stand it, knowing you care more about that Indian rug on your bedroom floor than about them, because they're just passing through your life, not an integral part of it."

"That's not true," he protested. "I choose my play partners as carefully as I choose my furnishings, and I cherish them at least as much. I would never have chosen you at the Spike if I didn't already know a good deal about you. Did you really feel uncared for when I played with you that night?"

"Initially, yes. Oh, I felt safe enough as far as limits and stuff — I didn't think you'd harm me. But there was a distance even when you were fucking me. The roles we were playing were like masks we hid behind. The sex was great, the bondage and pain play were great, but you were like a fantasy, not a real person."

"What changed?"

"Hmm . . . let me think a moment. . . . Yeah, that's it. It started to change when you were annoyed that you couldn't give me your piss. The mask cracked a little — you weren't just a top, but a gay man in the '90s determined to do the right thing and still not liking it one bit. And after you had me all strapped into the sleepsack, you told me you'd enjoyed yourself, that you were glad you'd brought me home. And then you gave me one of the most fantastic orgasms of my life."

"Is that so unusual, telling a sex partner that he's pleased you and trying to give him pleasure in return?"

"Not unusual *after* a scene, but yes, very unusual while it's going on. You still had me bound — far tighter than before, in fact. I was still in a submissive, subordinate position. But you treated me like a person, not a piece of meat."

"I don't see what's so special about that," he said.

"You haven't bottomed much lately, have you?"

"*Ahh* . . . I see your point."

"Anyway, it wasn't so much what you did as how it affected me. The real turning point, though, was later, after brunch the next day. Remember, you came in with chains for me to wear while I cleaned the kitcken, and I made a smartass crack?"

"Remember? I almost threw you out because of it!"

"I'm glad you didn't! But you made me see something. You said you thought I'd enjoy wearing the chains, and I realized that you were right. At first it seemed silly wearing them outside of a sex scene, but I got into it, and by the time I joined you in the living room, they felt perfectly natural."

"They certainly looked good on you, and you moved so nicely in them."

"Thank you! When I knelt down next to you in the living room, and waited there, in chains, while you read the paper and listened to music, it didn't feel like a 'scene' — it felt like life. For the first time, I thought about being at someone's beck and call, awaiting his pleasure, of being put into restraints for no practical reason except that he enjoyed seeing me in them. . . . No — not 'someone.' *You*, Sir."

He looked away from me and puffed his pipe, giving us both a chance to examine our hearts. When he turned back, we looked into each other's eyes, and I think we knew then there was no turning back. Still, ever cautious, Terry spelled it out for me.

"For me to own you," he began, speaking slowly and carefully, weighing each word, "I'd have to know you were willing to give me anything I asked for, no matter how hard, no matter how painful or scary. No reservations. No holding back. No waiting to be convinced."

"Yes, Sir," I said when he paused. He shook his head.

"It wasn't a question. I'll tell you when it's time for vows and pledges." Abashed, I lowered my eyes.

"For you to belong to me," he went on, "you would have to know, deep down, without any room for doubt, that I would never deliberately harm you, that possessing you was my greatest joy, and that every pain you endured at my hands only deepened my love for you."

I shivered, wondering, *Is that possible? Can two people really feel that way about each other? God, I hope so!*

"We're still a long way from that point," he continued, "no matter how sure we may both feel that we can reach it. I'm willing to start the journey with you. . . . Don't say anything now," he warned as I opened my mouth. "Don't make decisions while you're still thinking with your dick. Take some time. Look inside yourself — like you made me do."

"All right, Sir . . . Terry." I grimaced at the slip, but he took no notice.

"Think it through carefully, Matt," he said. "You have to be *sure*. I won't tolerate being jerked around. We'll spend more time together as soon as we can, not only playing but also doing ordinary stuff like going to dinner or a movie — you know, like dating." He grinned, and I returned it.

"Matt," he continued, his face serious again, "it's been years since I was a Master, and you've never been a slave — I don't count your weekend with Jake, or tonight. We both need time to grow into our roles, to experiment together, to see what works for us, and what doesn't.

"Don't imagine that you'll say yes, and I'll give you a contract to sign and a week's notice to get rid of all your possessions — or that you'll never have to make another decision. Even as my slave, you'll still live in your apartment, hold the same job, and do most of the same things you do now. You'll just do it all subject to my orders and according to my preferences."

"That's a relief! People talk like becoming a slave is a cross between entering a monastery and joining the Marines. But what you're saying actually sounds doable."

"Well, lots of men *do* become monks, or Marines. In your case, I think you'll find it's more challenging to make such a fundamental change in your life *without* being removed from a familiar environment to a more structured setting."

"Spoilsport!"

"It's no joke," he said with a rueful grin. "The hardest part of consensual slavery is dealing with clashes between the 'real world' — where both Master and slave are answerable to their bosses or clients or the government — and the private world they create by their commitment to each other and to their respective roles. Even if the Master can afford to keep the slave at home all the time, external reality has a way of breaking in."

"Sounds like you're speaking from personal experience," I said. *And I want to hear all about it!*

"Yes, I am." He paused and looked distant for a few moments before continuing.

"I used to be bitter about that, but now I think it's a good thing. Masters *need* to be reminded that we're not gods and aren't exercising power in a vacuum — or in a social structure that sup-

ports what we do. No one's going to help me keep you enslaved if you decide you don't want it anymore."

"But what about a contract? Isn't that where you spell out a slave's obligations?" Terry laughed.

"Since slave contracts are unenforceable," he said, "they're mostly just props for a fantasy. The only value I see in them is if they help the partners understand their commitments more clearly. *Writing* a contract can be a useful exercise — actually trying to live by one can be perilous. Anyway, with you I wouldn't want anything so rigid at the start. I made that mistake last time."

"Well, despite the challenge of making it real, I feel encouraged by what you've said. Fantasy is a lot of fun, Terry, but I want a real-life connection with you. I want to follow your lead, whether I'm in your cell or your kitchen — or at the movies."

"Good! I want that, too. I love temporary role-playing, like with my uniforms, but I'm ready for something more."

We smiled at each other — *equal partners in an adventure of inequality.*

"You'll think about all this when you go home?" he asked.

"Damn right, I will!"

"Also try to imagine what our ordinary lives might be like if you were my slave. Next time we get together, we'll compare notes." His grin was devilish, and I knew he had more than just talk in mind. "Deal?"

"Deal," I said eagerly.

"Good. Now pick up my bag and walk me to the door. I won't offer you a ride home — that'd be more temptation than either of us could handle. Stay here and socialize. Convince Stan I'm not an ogre. Do whatever you want. *You* don't have to work tomorrow . . . today, now," he said, checking his watch.

"As a matter of fact, I do," I said sourly.

"Then go home and get some sleep!"

After he'd retrieved his jacket and cap, we hugged and kissed for, oh, an hour or two.

"Be good, boy," he told me when we finally broke apart, and a moment later he was out the door, leaving me behind.

CHAPTER 12
Telephone training

I was still too wound up after Terry left J's to go home right away. I got a beer — the full bar was open again — and looked for a place to settle back to earth. Although the regular butch vanilla crowd was still coming in, most of them headed toward the back, where the lights were dimmed or off. The risers in front still had plenty of empty space. I settled down next to Stan's hooded head, admiring the elegant ropework that kept him captive. *May as well help watch over him*, I figured.

Leaning over to check Stan's hands, I saw the skin was still pink despite the tight coils of rope, so I didn't bother to feel them. When I looked up again, I noticed his top eyeing me suspiciously, so I smiled at him, and apparently he recognized me. He smiled back, and I sketched a respectful salaam. *He's a damn good-looking man*, I thought. *He looks sexy even without leathers.* His camo pants were tucked into jump boots, and he wore a camo field jacket — *pockets for days!* — and a fatigue cap. *Maybe his real service gear?*

I sipped my beer and pondered the events of the evening, my cock hard again in my jeans. Terry's words echoed in my head — he'd given me as much to think about as I'd given him the day before. We might be moving too fast into a particularly demanding kind of relationship, but what a way to go! *Wish we could've made a night of it*, I thought wistfully. *Wish I were going with him on that trip to Vermont. I'd happily ride in the trunk again if I had a whole weekend with him to look forward to!*

He hadn't even mentioned the town where he was going. *If I knew*, I speculated, *I'd take the train up there tomorrow and surprise him. But his office is bound to be closed, and I don't know many of his friends — assuming they'd even tell me. . . . Fuhgeddaboutit!*

167

Naturally, I couldn't let the matter go so easily. *Even if he has to see his client tomorrow morning,* I reasoned, *and check out the building site in the afternoon, he can't be planning to work* all *the time. . . . But if the project turns him on, he probably won't be able to stop thinking about it. Instead of imagining ways to tie up and torture me, he'll have visions of mountaintop aeries filling his head — like that Wright drawing in his bedroom, the sea-cliff house. . . . What if this is his big chance, the building of his career? I can't compete with that — and I wouldn't want to, either.*

Stan's top climbed up to us. After a nod to me, he put a hand on Stan's right pec and lightly squeezed. Stan jerked like a hooked fish, and the man bent over to whisper in his ear, continuing to stroke his chest and belly. His captive calmed, and the process of releasing him began.

"Do you want me to move away?" I asked softly while he was rubbing Stan's arms to restore full circulation. (My buddy was sitting up by then, with his arms free, but he was still hooded, and his feet and legs were still tied.)

"Suit yourself," the man said.

Damn! I said to myself. *What* is *his name?*

"Taking him home with you?" I wanted to talk with Stan, but not if it would interfere with their scene.

"What do *you* think?" Carl or Craig asked, a white grin splitting his dark face. "You don't think being hogtied for three hours is enough for him, do you?"

"Not likely!"

"I plan to keep him hooded and caged all weekend, maybe longer. We talked about a whole week, but my schedule isn't as flexible as his. I don't know yet if I can swing it."

"Why not get friends to watch him while you're at work?" I suggested. "I could take one weekday if you like, since I'm working tomorrow."

"That's a handsome offer," he said with a big smile. "Give me your number, and I may take you up on it. I'd trust a fellow bottom in this situation more than some tops I know."

I filled out a trick card at the bar. After I handed it to him, he gave me a printed card of his own — his name wasn't "Craig" *or* "Carl" but "Curt." We shook hands, and I excused myself.

With my friend in good hands, there was nothing to hold me at J's or even in the neighborhood. If I'd been seriously inter-

ested in cruising, I'd have walked up to the Spike or taken a cab down to the Altar. *No point in that now, is there?* So I retrieved my jacket, hailed a cab, and was in bed within the hour.

I lay awake for a little while, lightly touching my aching nips and balls, remembering how intently Terry had watched me as he pulled the cords connecting them tighter and tighter — and smiling at the memory. My last thought before falling asleep was to wonder if he had a similarly photographic recall of the pain in my face as he tortured me.

Although I had a full, and busy, day of work on Saturday, my mind kept wandering back to Terry. Just thinking about him playing with me made me hard, and thinking about him being my Master, of belonging to him, made me woozy. It was horribly frustrating that I wasn't in a position to do anything for him. *Here I am primed to serve him, and I can't.*

I made some calls to guys I thought might be close to him, hoping one of them would know where he was. (I'd have called Jake, since Terry had said he knew him well, but we only talked when I ran into him at the Spike or Altar, so I didn't have his number.) No luck — either no one knew, or no one would tell me. The consensus was that although Mr. Andrews liked to spring surprises, he *didn't* like to be surprised himself. That only made me more determined to come up with one he'd enjoy.

Maybe a fruit basket or flowers delivered to wherever he's staying? Hey, how about some of that special prewar Armagnac that Greg had liked so much? This was dangerous territory, giving one of my late lover's favorite treats to my new . . . well, what was he at this point, anyway? More than a trick, but not yet my Master. *He gave me a collar, but then he took it back, said he wasn't sure yet. I know I want to belong to him, if we can make it work. And even if we can't, he's the first man in years I've wanted to give anything that special to — or thought would appreciate it.*

As usual, though, I couldn't leave well enough alone: *What if he doesn't like brandy? Or Armagnac?* I needed a backup. *He's a smoker — pipe tobacco? Nah, too chintzy. A pipe? No — too intimate; maybe later. Cigars? He'd probably like that, but what kind?* I knew nothing about cigars, so I cornered Hank, our business-books buyer, who often smoked one — outside — during his lunch break, and picked his brain.

If I'd had any idea where to send the gifts, I'd have gone

out right away and bought them, but I didn't, so I stowed the ideas away for future use. But in off moments I worked out the details of wrapping and presentation.

I called Stan, too, but of course he wasn't home: *no doubt happily trussed up in Curt's cage.* I smiled at the image, a little envious. *I might have found the love of my life, but it's Stan who's getting the action.* For all I knew, it could be a week or more before Terry and I got together again. *What'll I do in the meantime? He won't just leave me hanging, will he?*

Once I was home, I had Chinese delivered for dinner and read for a few hours. I thought about going out — *maybe I can get Terry's Vermont address out of Jake?* — but something stopped me. After what had passed between us on Friday night, it just didn't feel right to go out and pretend to be available.

A little before 11:00 I put my book down, got undressed, and settled on the couch for some mindless channel-surfing, beginning with a gay porn show on the leased-access cable channel. The first time I'd tuned the show in, by accident, a pretty hot s/m tape had been featured, so when I'm home on Saturday night I'll watch just in case — there's rarely anything better on anyway. As usual, though, the clips were all vanilla. Even when the actor/models started out in leather jackets and boots, they shucked down to shaved, buffed skin as soon as possible. Whether they fucked 'n' sucked on the bed, floor, or pool deck made little difference — watching them didn't even get me hard.

By 12:30 or so, lonely and bored but still not sleepy, I was starting to regret I hadn't gone out, if only to socialize. Then the phone rang. *What the hell?*

"Hello?"

"Good, you're home," a familiar voice growled into my ear.

"Sir? I mean, Terry?"

My cock was instantly hard, and I turned off the TV with the remote.

" 'Sir' will do — tonight. You alone?"

"Yes, Sir."

"Going anywhere tonight?"

"I wasn't planning on it, Sir. I've had enough excitement for one week already."

"You don't expect me to believe that, do you?"

"Guess not, Sir. Just hearing your voice has me hard again."

"Did you do some thinking like I told you?"

"Yes, Sir, of course. But what I mostly thought about was how much I wished I was there with you, Sir."

"I'll bet," he said with a chuckle. "Are you naked?"

"Yes, Sir."

"Good. Where are you?"

"On the couch in the living room, Sir. I was watching TV."

"Wouldn't you feel better on your knees?"

"Yes, Sir. I'm sorry, Sir."

I got onto my knees on the floor, feeling just a little silly considering he couldn't see me.

"No need for apologies, boy — not yet anyway. . . . Are you on your knees now?"

"Yes, Sir."

"Why?"

"Because you told me to, Sir." *What kind of game is he playing now?*

"No, I didn't, boy. You're not listening carefully enough yet. What did I say — *exactly*?"

I had to think for a moment.

"You asked if I wouldn't feel better . . . oh, I see, Sir. You didn't actually say I should *do* it. Should I get up again, Sir?"

"No, stay there — but listen up next time."

"Yes, Sir."

"So answer my question: do you feel better on your knees?"

"Umm . . . yes, Sir, I do. . . . I did feel a little silly at first."

"Why?"

"Because you're not here, Sir, so I'm not really kneeling before you."

"*Wrong*, boy. That's exactly what you're doing — it doesn't matter if I can't see you. Do you submit only when you have an audience?"

"No, Sir! . . . Well, if you count the man topping me"

"I thought so. Being a slave isn't a performance, Matt — it's what you *are*. Or, in your case, what you think you want to be. It's as important for you to kneel to me in your head as in person, maybe more important. Understand?"

"Yes, Sir . . . I think so, Sir."

"I'll give you something to do to help you understand. Until further notice, every morning right after you get up, before you

piss, shower, eat, or dress, spend five minutes on your knees. Face a blank wall, and keep your hands behind your back. Set an alarm so you don't have to check your watch. Don't think about anything except why you're on your knees and how it makes you feel. Don't think about your job, or your friends, or what's in the news or on TV. Don't even think about *me* except in connection with your being on your knees. It's okay if you don't think at all, as long as you focus on your feelings. Got that?"

"Yes, Sir!" My dick was harder than ever as I imagined this little ritual.

"Do the same thing every night just before you get into bed, too, unless I call and give other orders — or you're actually with me. After a week or two, if you keep it up, you'll have a better idea of where you really want to be. Right, dickhead?"

"Absolutely, Sir."

"Which hand are you holding the phone with?"

"The right, Sir."

"Use your left, and put your right arm behind your back. Are you sitting on your heels?"

"Yes, Sir."

"Kneel up. Keep your back straight and bend your head so you're looking down at the floor. Don't look anywhere else. Keep both hands still. Don't touch yourself at all. . . . Got it?"

"Yes, Master."

"Damnit! You're overdoing again. We aren't there yet. Keep it 'Sir' for now."

"Yessir, sorry, Sir."

"Good boy. How do you feel now?"

"More like a slave, Sir. Like I can't move without orders . . . like I'm at your disposal, Sir."

"You like that feeling, boy?"

"I like it fine, Sir!" And I *did*, too. But why? I still wasn't sure.

"Is your cock still hard? Does kneeling for me turn you on?"

"You know it, Sir! I wasn't even feeling horny before you called, but now . . ."

"Now you'll stay that way, boy. You're *not* going to come tonight — understand?"

"Yes, Sir," I said, but stifled a groan.

"Got a problem with that, boy?"

"No, Sir!"

"Don't lie to me, asswipe!"

"Sir — it's not a problem, Sir," I said earnestly. "I *do* want to come, Sir, but it's okay if you'd rather I didn't."

He let out a huge sigh, then gave me another lesson.

"You're not dumb, boy, so it must be your ego that makes you so dense sometimes. I don't want your *permission* every time I give an order that doesn't fit with your immediate desires. I know consent in s/m has to be ongoing, but we're talking about a partnership here, not a one-night stand. You should want what I want *because* I want it. That's one difference between a slave and a bottom. I don't expect you to make the change right away, but do you even understand the difference?"

"Hmmm . . . yes, Sir, I think I do. Instead of saying I want to come but it's okay if I don't, I should have said — should have *felt* — that I want to stay horny for you, Sir."

"All you needed to say, boy, was 'Yes, Sir' — but with enthusiasm, like you really wanted to do whatever would please me. That's what it's about, not whether you come or don't come."

"But I *do* feel that way, Sir. I just said the other things out of habit." Other than a slightly skeptical growl, he didn't interrupt, so I continued.

"I love it when I come, Sir, but it also makes me lose my edge. I get sleepy and lazy. Being horny makes my tongue wetter and my holes hungrier, Sir. I can take more pain when I'm horny — that's always been true, Sir, it doesn't have anything to do with you and me. I just never saw it so clearly before. But on top of all that, I really get off on pleasing you. When you told me I couldn't come tonight, Sir, that I had to stay horny for you, my dick jumped and got harder than ever. . . . I *do* want to do whatever you want, Sir, just because you want it."

"We'll see," he said skeptically. "One thing I want you to do is get a speaker phone, or else one of those headsets operators use, so you don't need to hold the receiver when we talk. That way both of your hands can be behind your back, or on your tits, or wherever I want them. Since we aren't living together and I travel a lot, you can expect plenty of training sessions by phone."

"Yes, Sir. I'll look for one tomorrow, Sir." *Maybe sometimes he'll let me come, too?*

"Fine. Now that your head and body are in the right place, I'll tell you why I called. My client wanted me to have dinner

with him, but I'd had enough of him for one day. So I ate alone and drove 60 miles to check out the nearest gay bar — I just got back from there."

"Bet the locals crawled all over you, Sir."

I was jealous — and struggled not to show it in my voice — but the double standard involved in his going out while I stayed home never came to mind.

"Not exactly. The crowd was about what you'd expect for Vermont, a pretty broad mix. Several other guys were showing some leather, but they were pure vanilla underneath. They like leather well enough, but only as clothes. There were three drag queens — good ones, too, very elegant — but mostly a lot of neither/nor. No one I saw or talked with could get my mind off a certain humpy number back in New York."

"Anyone I know, Sir?" *He really wants me!* I exulted silently.

"Smartass. All the way back here, I was thinking how great it would be if you were in my room waiting for me. Thinking of all the fun things we could've done tonight."

"Sir," I interrupted, "I was thinking the same thing this afternoon! I even tried to find out where you were staying so I could come up and surprise you."

"Did you? And since you're *not* here, I take it you were unsuccessful in ferretting out my secrets?"

"Yes, Sir, and, no, Sir, I wasn't successful. No one knew, or they wouldn't tell me."

Terry laughed. "I guess I chose my friends well. Could *you* keep my secrets, boy — if I trusted you with any?"

"Yes, Sir," I said firmly.

"Even from your close friends, like Stan?"

That was harder, but "Yes, Sir," I answered after a moment's thought.

"Well, no need to test you on that yet. Now, back to the reason I called — if there are no more interruptions?"

I stayed silent.

"Good," he continued. "Since we seem to have shared the same fantasy, if we can't realize it in person, we can at least talk about it, give each other dream material."

"Like a bedtime story, Sir?"

"Sort of, but we'll take turns telling it."

"Sounds like fun, Sir."

"I'll start and describe my room here — ask questions if anything's unclear; you'll need to visualize it for when you pick up the story. You can relax a little now, too. Sit back on your heels if you like. But keep your hand away from your cock."

"Yes, Sir. Thank you, Sir. . . . I have a question already, Sir."

"You would! Okay — what is it?"

"Are you naked, too, Sir?"

"No, I'm still dressed: chaps and a bar vest over jeans and a plaid shirt."

"You took your boots off, Sir?"

"No — they're still on, too, and a studded belt."

"Which boots, Sir? The ones you wore last night?"

"Knee-high black logger boots — I *am* in the mountains. That meet with your approval?" he growled.

"Sir, I only asked so I could visualize you."

"Fair enough," he conceded. "Now for some scene-setting: Imagine a pleasant, airy room in a typical mountain chalet. Big, high bed with a brass frame — lots of places to tie things to. Good view of the Green Mountains from the windows, but I've drawn the curtains."

"What's the weather like, Sir?"

"Clear, cooler than the city, a bit nippy at night. There's a fireplace that must get a lot of use later in the year."

"Private bath, Sir?"

"Yes, with an old clawfooted tub and a shower curtain you pull around it. The two guys who own this guesthouse — gay, of course — are into antiques. They know why I'm here, and they keep begging me not to ruin the neighborhood by building some spiky modern horror with exposed utility pipes and industrial materials."

"You wouldn't do that, Sir, would you?"

"Not if I can restrain my client's desire to 'make a statement.' I keep telling him that building a private house on top of an unspoiled mountain is enough of a statement in itself. It isn't necessary to be any more flamboyant. What I'd like to give him is a building that'll look as if the mountain would be incomplete without it. . . . But I didn't call for shop talk."

"What else is in the room, Sir?"

"An honest-to-God bear rug and two easy chairs in front of the fireplace, a small chest at the foot of the bed and a night table

at the head, a big armoire — no closet — and a writing table and straight chair in front of one window."

"No TV, Sir?"

"It's hidden in the armoire. Gets five stations, none of them worth watching. Now tell me something sexy! If you *had* come up here to surprise me, what would I have found when I came in?"

So maybe he does *like surprises?* I wondered. *Should I have tried harder to track him down? Too late now, and that's not what he wants to talk about!*

"Hmm . . . considering the hour, Sir," I ventured, "I think I'd probably be curled up asleep on that bear rug, waiting for you to come back."

"That's a nice picture. And how would you be dressed — or would you have stripped?"

"No, Sir. I wouldn't have wanted to deprive you of the pleasure of ordering me to strip, Sir — or doing it yourself."

"Good answer," he chuckled. "Now tell me what you have on before I rip it off."

"Yes, Sir. . . ." I paused and thought furiously. "Well, Sir, on both occasions when we've been together, I've worn pretty basic butch sleaze, and I thought you might like something different. So before I left New York, I put together an outfit sort of like a uniform without actually being one, Sir. I started with a long-sleeve black shirt with epaulets and pleated, button-flap pockets, but no insignia."

"You'd need a tie with that. Sure you know how to put one on?" *He remembers I don't wear suits.*

"Yes, Sir. Should it be leather, Sir, or cloth?"

"Cloth. Clip-on. You won't be able to botch tying it, and it'll be easy to pull off."

"Very good, Sir. Shall I continue?"

"Yes, dickhead — until I interrupt or tell you to stop."

"Yes, Sir. My pants are also black, Sir, the same military-grade cloth as the shirt. They have razor creases and are bloused into spit-shined jump boots. The wide, plain black belt has a pewter buckle shaped like a pair of overlapped handcuffs."

"And?" *Does he have some other fetish I left out?*

"I also brought a leather baseball cap, Sir, so you won't think I'm taking myself too seriously."

"Hmmph," he snorted. *Better not overdo the comedy.*

"And no underwear except boot socks," I concluded.

"Back up a minute: how'd you get into the room, smartass?"

"I took a cab from the nearest train station, Sir, after verifying by phone that you weren't in, and reached the guest house about 8:00 p.m. It took a lot of fast talking to convince the man at the front desk that I was supposed to be staying with you, Sir, since you hadn't mentioned me. He almost made me wait in the lobby, Sir, but gave in when I offered to leave my watch and wallet as security."

"I'll bet. What'd you do after he let you in?"

"Used the bathroom, Sir, then sat down on the bear rug, leaning back against one of the armchairs. After a while I pulled my legs up and rested my head on my knees. I surprised myself at how patient I was being, Sir" Something between a chuckle and a snort came over the phone. "Sir?"

"It'd surprise me, too," he said, "you being patient," but his tone was more amused than critical. "Continue, boy."

"Sir, I waited and wondered where you'd gone to and when you'd be back. I also wondered, Sir, if you'd return alone or with a friend or trick. . . ."

"And . . . ?"

"I fell asleep, Sir."

Terry laughed. "You're like a cat or dog — every time I leave you alone you take a nap."

"Helps restore my energy for when you come back, Sir. . . . Isn't it your turn now, Sir?"

"Still pushy, too . . . ," he said, but since the story couldn't continue until he came back into the room, he'd have to tell that part. "Okay, let me think

"Right. When I come in, the host at the front desk says my guest is waiting in my room. I start to ask what the hell he means, but some intuition leads me to play along. I nod, check for messages, ask him to save me a Sunday *Times*, and head upstairs. I feel an adrenaline rush as I approach the room. I haven't had a colorful enough career to make the kind of enemies who wait in dark hotel rooms with guns, but I can imagine a few unsavory scenarios.

"I turn the key in the lock very carefully and open the door slowly. The room is dark, and there's no sound from inside. I stand in the doorway until my eyes adjust to the dim light from the

uncovered windows. I see a dark form sprawled on the rug in front of the fireplace. I reach to the side, find the dimmer switch for the ceiling light, and slowly turn it. When I see a flare of reddish gold, I grin, then come into the room, still as quiet as possible, and close and lock the door behind me. I walk over to where you're sleeping. Your face is peaceful, untroubled, and your chest rises and falls slowly as you breathe. I sit in the chair facing you, stretch out my legs, and just look, smiling. . . . Your turn, boy."

So soon! I almost panicked, wondering how I'd spin the story out with no preparation. But as I got into it, it seemed to tell itself.

"Stirring in my sleep, I suddenly sense your presence, Sir. I open my eyes and see your boot soles a few inches from my face. I don't recognize these boots, but I lick my lips in anticipation of becoming intimately acquainted with them. My eyes travel slowly along your leather-covered legs and up to your face, Sir. I see that crooked grin you get when you're thinking about evil things to do to me, and my cock gets so hard it hurts."

My cock *was* hard, and knowing I wasn't going to be doing anything about it somehow made it harder.

"Still a little groggy," I continued, dropping the "Sir" as I got caught up in the story, "I get onto my knees and bend over your boots. I kiss and lick them greedily until you tell me to stop. I crawl close to you and kneel upright, my hands behind my back and my head bowed.

"You tell me to stand up. I scramble upright and take a modified brace, my arms locked behind me, and aim my eyes above your head. You say nothing as you look me over head to foot, then order me to put my hands behind my head and turn around, *slowly*, then face forward again, at parade rest, with my legs apart."

"How's that make you feel, boy?" Terry broke in. "Exhibiting yourself to me?"

"It feels real good, Sir," I responded, continuing at a slightly higher pitch to suggest I was answering his question *within* the story. "'I hope you like how I dressed for you, Sir, though I also hope you won't keep me clothed for long. I like your *touching* me even more than your looking at me, Sir.'"

"'I'll touch you all right,'" he growled in character, "'and maybe you won't like it so much. Now, asshole, tell me what you're doing here.'"

"'I only wanted to give you pleasure, Sir, a break from busi-

ness. If you don't want me here, Sir, I'll leave at once. But please let me stay, Sir. I'll do anything you ask'"

"'You'd *better*, boy. Finish my boots while I think about it.'" Terry paused, continuing in a subtly different tone as he picked up the narrative again.

"You dive for the floor, slurping noisily as you worship my boots with your mouth. I can feel your tongue pressing down on the leather, sliding along the edges and across the instep. You slip my chaps up my calves so you can get at more of the boot shafts. While you're working, I reach down and mess up your carefully groomed hair. I tangle my hands in it and use it to direct your mouth. You moan and grunt as you slide around the rug on your belly, making love to me through my boots. Seeing you there, I have a hard-on that's ready to burst the buttons on my 501s.

"I think about cuffing you or tying your hands but decide not to — yet. I enjoy the way you caress my boots and legs as you lick, the way you carefully lift and turn my feet to get as much of the leather in reach of your eager mouth as possible. I think about the collar in my suitcase, which I stuffed in at the last minute without knowing why, but I decide that it, too, can wait.

"You look so fuckin' hot, dressed all spit-and-polish but lyin' on your belly like a dog. The combination is irresistible. I can't decide which to fuck first, your face or your ass. Your face is hidden, pressed against my boots, but your ass is bobbing in the air as you jackknife yourself to get closer to me. I lean forward again and start kneading and smacking your buns under the stretched black cloth. You moan louder, letting me know you love this treatment, want it, need it. . . . 'Isn't that right, boy?' I ask you. 'Don't you love it?'"

"'Yes, Sir!'" I chime in on cue. "'I love it! I can't get enough of you — your taste, your touch, grabbing me, stroking me, smacking me. I need you to take me and use me, Sir.'"

"'That's good, boy,'" he said, then smoothly slipped back into narrative, "because *my* need to fuck you, one way or another, builds until it's unbearable. I *want* to hold off. I want to keep control, plan each move, but I *can't*. I want you *now*. I pull my jeans open, dig a condom out of my vest pocket, and quickly pull it onto my hard dick. I pull another safe over it, too, because I'm way too hot to go slow and easy. I'm going to throw you a fast, hard fuck that'll make your eyes pop.

"I pull you up off the floor by grabbing your belt. I spin you around, facing away from me, and reach in front to undo your buckle. You try to help me, but we interfere with each other. I slap your hands away, and in seconds your pants are tangled around your boots. I see you told me the truth — no underwear. I rip your shirt open so I can get at your tits, pinchin' and twistin' 'em till you're hissin' like a radiator" His voice in my ear trailed off.

"Should I continue, Sir?" I asked when the pause lengthened. *Bet he's too busy stroking his dick to continue — or maybe he's struggling to hold off until he's ready to shoot?* The story had *me* pretty revved up, too, but with my stroke hand held behind my back, I was less distracted.

"Yeah . . . sure . . . go ahead," he said, the words seeming to be forced out between clenched teeth.

"You suddenly realize you don't have any lube handy," I said with an evil grin, then decided to spare him the delay of retrieving some from his luggage. "But when you feel my asshole with your finger, you realize you won't need any — I'm so open and ready for you that the lube on the condom will be enough. You target your rod at my hole and in one tremendous lunge, pull me onto you.

"I scream at the invasion but immediately begin moaning and flexing, shamelessly begging you to fuck me, 'Fuck me *hard*, Sir.' You say we'll have to work together, then wrap one hand around my stiff cock and the other around my swollen ballsac, clamping them as tight as a cock ring and ball stretcher, using them as handles to help push me further onto your cock or pull me off it again.

"We get a rhythm going. I push back as far as I can go, then slide forward until your cockhead almost pops loose from my hole. Then all the way back. You control the fuck with your grip on my equipment, but I do most of the work. My thighs and leg muscles are pumped up from the strain — it's like a heavy workout at the gym, only those never made my ass feel so good! Your cock feels like twice its normal size as it slides into me and out again, rubbing over my prostate each way. On the downstrokes it seems to fill me completely, threatening to come out through my throat. And the backstrokes make me feel as if I'm being turned inside out.

"You order me to play with my own nips, still sore as hell from the night before. I gently tug at them and throw back my head in a howl of pain. I try again, with the same result. Doing it to myself is *so* much harder than letting you do it. I drop my arms in defeat. Without interrupting the fuck, you squeeze my balls until I beg you to stop, then tell me all I have to do is keep my fingers on my nipples. I groan and try again. I can't help crying out at the pain, but as soon as I do your grip eases on my balls. I might try to deceive you, but you can tell when my cries are real, and you give my balls some relief only when it's clear that my nips are really hurting. My cock stays hard through all of this, and so does yours as it ploughs my ass. . . ."

"Okay, boy," he interrupted. "I changed my mind. I'm going to let you come, but only if you do it *exactly* when I tell you to. Put your hand on your dick and start stroking, but *don't* shoot until I tell you. Got that?"

"Yes, Sir! Thank you, Sir!" I wrapped my right hand around my stiff meat and pulled. *God, that feels good!*

"Now go on with the story — and keep it hot!"

"I'm so hard, Sir, as you fuck my ass, that I think I'm going to come too soon, but you pinch my stiff cock until it softens a little. Then you hold your hand against my mouth. I lick and slobber over your palm, and you return the hand to my dick. I almost scream because it feels so good. I keep fingering my nips, sending jolts of pain through my chest, as you fuck me harder. You keep handling my cock or invading my mouth with one hand while holding or squeezing my balls with the other"

"I ratchet up our fuck rhythm another notch," he cut in, "pulling your hot ass down to the root of my cock and pushing it back so fast I expect smoke to come out of your hole. The channel is still tight but slick with ass juices, and my cock glides in and out like a hot knife through butter. You're moaning and babbling continuously now, delerious, out of your mind with the combined sensations in your ass, your cock and balls, your chest, and your mouth. I wish I had that hot mouth of yours on my own tits, but that can wait, that can be the next course. I decide to bring you off first, knowing you'll tighten up as you come, and that'll bring *me* off.

"I put my hand back in your mouth for an extra-big load of spit. I stick three fingers so far down your throat you almost

choke, and I pull them out dripping with saliva and phlegm. As soon as I rub them over your cockhead you yell that you can't hold off any longer. You beg to be allowed to shoot, and I give permission as I stroke your cock hard and bang your ass harder at the same time. You're doubled over, with your face practically in your lap. I hold your cock so it's pointing at your face. I yell as I stroke and fuck you again. 'Shoot, damnit! Shoot now, fucker!' I mean it, boy! Shoot *now!*"

"*Aieee!* I'm com-mm-ming, Sir!" I yelled. Through the timeless haze of a monster orgasm, while my racing hand pulled spurt after spurt of hot cum out of my throbbing cock, I heard Terry continue his description of our imagined coupling:

"You scream and explode, shooting strings of cum at your face, crying and blubbering in an exquisite mix of pleasure and pain...."

I lay doubled over on my knees, not crying, not in pain, but still trembling and panting in the aftermath, while he narrated his own climax, mixing fantasy and reality.

"Just as I expected, your ass ring tightens up on my sliding cock as you come, and that little bit of extra pressure brings me off. Now I'm the one who's babbling. Now it's me who's coming, shooting, blowing cum into the rubber up your ass ... into my hand ... ahh! ... ahh! ... *aahh!* ... Shit, yes! So good ... *ahh!* So fine! ... *Yes!*"

For a couple of minutes there was silence as each of us enjoyed the afterglow of our respective eruptions. I watched the cum dribble down my slack fingers onto the carpet — and wondered idly how Terry *really* looked right then. I had trouble believing he was still dressed as he'd described. *He's probably naked in bed, lying on top of the covers, the phone half fallen out of his left hand, his right still curled around his slowly softening dick.... Wish my mouth was around it, licking up the cream!*

I brought my jack-off hand to my mouth and slowly licked up my own salty, slimy cum, slurping obscenely into the phone mouthpiece. It got his attention.

"Guess you enjoyed that," he said with a chuckle.

"Sure did, Sir! Thank you!"

"That's enough for one night, boy. Don't want to spoil you. Some Masters don't let their slaves come for *months*, and here I've let you get off two nights in a row."

"Thank you, Sir. You're very kind, Sir." *Months?*

"And some slaves never get to come at all, *ever*. How d'you think you'd like that? Staying horny for the rest of your life?"

Huh? Wait a minute! Did I miss something?

"Uh, if it's all the same to you, Sir, I don't think I'd like that at *all*."

Terry laughed at the distress in my voice, then reassured me.

"Don't worry, Matt. I like my partners to get off, long as they do it on my terms. It's a simple matter of feedback — if what we do doesn't get you hard, you're coming too often. Long as you stay horny enough to show you appreciate me, you'll get your reward."

"But, Sir, you know I go soft sometimes when I'm in pain, even if I'm enjoying it."

"If I already know it, why remind me? Don't you think I'm capable of allowing for that quirk?"

"Oh. . . . I'm sor– . . . Yes, Sir."

"Try trusting me, Matt — it's more fun that way. Now hang up and go to bed — after you do your kneeling exercise."

"Yes, Sir! Thanks again, Sir. Good night."

"G'night, boy."

CHAPTER 13

Heat transfers

On Sunday I woke up around 11 o'clock, and I was already headed for the bathroom when I remembered Terry's instructions: before *anything* else, I had to kneel for five minutes facing a blank wall. With a groan (I really needed to piss), I went back into the bedroom and set the alarm on my wristwatch for five minutes, then got on my knees in front of the wall. I crossed my hands behind my back.

It didn't feel sexy at all. The only thing making my cock at all hard was the pressure of piss from my full bladder. I sighed and forced it back.

I must have wasted the first two minutes, at least, fighting rebellious thoughts about how stupid and pointless this was, how easy it would be to tell Terry I'd done it without actually doing it, how unlikely it was that five minutes on my knees twice a day would make any changes in my personality or attitude. But as stubborn as I was in resisting my submission, I was even stubborner in trying to prove I could do anything he asked. Slowly, ever so slowly, with endless backsliding, I managed to still my racing thoughts and concentrate on nothing but breathing and staring at the blank, off-white wall six inches from my nose.

My breathing deepened and slowed, and my consciousness of the world beyond my patch of wall began to fade. I was actually starting to feel a sense of well-being blossom within me when the alarm on my wristwatch beeped, breaking my concentration.

Well, it's a start, I told myself as I got up and shifted back into the everyday world. *Maybe I should try it again after I piss and clean up?* I smiled at my characteristic pushiness, always wanting to go beyond what was needed, and firmly decided to do just

what Terry had ordered and no more. *Twice a day, he said, and twice a day it'll be.*

I was on the couch in the living room a couple of hours later, working through the fat Sunday *Times*, when the phone rang. My heart racing, hoping it was Terry, I ran to pick it up. An unfamiliar voice met my "Hello?"

"Matt?"

"Yeah, who's this?"

"Curt — remember? From Bondage Club the other night? I was topping your buddy Stan."

"Oh, sure, I remember. Hi. What's up? Still got Stan chained up in your dungeon?"

"Something like that," he chuckled. "If you can call a studio on West 25th a dungeon. Anyway, remember you offered to bondage-sit one day this week if I decided to extend our scene? To stay with him while I'm at work?"

"Yeah — glad to. Which day did you have in mind? I'm scheduled to take Wednesday off, but I can rearrange it if you need me another time."

"Wednesday would be fine — you'll be sitter No. 3. I've got friends lined up for Monday, Tuesday, and Friday. Thursday's the last hole to fill, and if I have to, I'll take a personal day myself. Good thing I don't need to tell them why!"

"Sounds good. How's Stan doing?"

"He's doin' fine — wearing *me* out, he's such a glutton. I'm looking forward to the break tomorrow. . . . Just kiddin', guy," I heard him say in response to some loud grunts in the background — I could just imagine Stan lying on the floor tied up at Curt's feet, hearing every word but unable to comment through the gag in his mouth.

"Just tell me when and where," I said into the phone. "Anything you want me to bring?"

"A good book," Curt said with a chuckle. "You won't have much to do, I hope, and he won't be in a position to carry on a conversation. And I'd rather you didn't play the TV or stereo. He'll be hooded, with earplugs, but you know the seal is never perfect."

"Sounds like you're planning a heavy scene."

"Yeah, something like that. We're going to see how he likes being hooded and locked into a small cage for a whole week, starting tonight."

"He'll love it," I said, but privately I had qualms. *A whole week?*

"He'll be glad he did it afterward, I hope, but I'm going to push his limits. I'm telling all the sitters that they can play with his bod or use his holes, but no talking, no mental stimulus at all, and he doesn't get out of the hood or cage. I'll give him an hour's break each evening, but I want him to stay locked up all the rest of the time. I'll go over the rules when you come over."

Curt gave me the address and set the time, 8:30 a.m. — an hour earlier than I'm usually out of the house, but he's a radiology technician at St. Vincent's, and they expected him to be in by 9:00. *Anything for a buddy*, I told myself.

Besides going out to buy the phone headset Terry had told me to get — and a new alarm clock — I spent the day at home doing chores. Liquor stores are closed on Sundays in New York, and the kind that might have the Armagnac are all downtown, as are the better cigar stores, so I put off buying Terry's present. I read for a while in the evening, then channel-surfed, hoping he would call again, but he didn't, and eventually I finished the day (past 1:00 a.m.) kneeling on the floor. Even without the distraction of a full bladder, meditation wasn't much easier this time. I was just getting into it, I thought, when my watch alarm beeped.

Because I'd slept in, of course, I had trouble falling asleep. I lay there in the dark trying to recapture the pleasant meditative state I'd briefly achieved on my knees, without any luck. I made up little mantras and repeated them over and over, such as, *I am Terry's slave. I am his property. He owns me and can do what he wants with me.*

It was laughable. Regardless of what I was telling myself, my real thoughts went in only two directions, either sexy things I wanted him to make me do or do to me, or else thoughts of my work and everyday life that seemed to have no place for him at all. I wanted to float in a sea of submission, and all I could do was swim from one little island of selfish concerns to another.

I started to reproach myself for my shortcomings but soon realized that that was as self-indulgent as my other behavior. *No one ever said I have to be a slave. He never said that was the condition for continuing to see me, to play with me. If I'm not cut out for it, so what? We'll find some other way to connect. . . . Yeah, right.* Feeling confused and frustrated, I finally fell asleep.

In the morning the alarm shrilled all too soon, tumbling me out of a blissful dream where Terry had been using my mummified body as a footstool, or bootstool. I shut the alarm off and lay in bed for a couple of minutes collecting myself, then grabbed my watch and went over to the wall. I knelt with my arms behind me as before, and as before my mind swarmed with inappropriate or irrelevant thoughts. But instead of trying to force them away, I simply focused on my physical situation and tried to get in touch with my feelings about it (more or less what Terry had told me to do in the first place).

Okay, I'm on my knees facing the wall. My hands are clasped behind my back, as if they were cuffed. . . . What's that feel like? . . . Like bondage, like being in someone else's control. . . . How do I feel about that? . . . Good . . . peaceful . . . relaxed. . . . Not apprehensive? I'm naked and unprotected, vulnerable. Staring at this wall, I might as well be blindfolded. . . . Good. . . . Why good? . . . I'm wide open, unresisting. My defenses are down — that means I'm trusting. . . . Trusting what? . . . Him. Myself. Life. The universe. . . . I'm not running scared. Whatever happens, happens. It's okay. . . . Isn't it humiliating kneeling here like this? Humbling myself before someone who isn't even here to see me? . . . Hmmm. Doesn't feel that way. My face isn't reddening, I'm not ashamed or embarrassed. . . . I'll bet I look good like this, sexy, attractive. . . . Being vulnerable and defenseless is sexy? . . . Yeah — why not? So is being commanding and controlling, but I can't be like that. . . . Why not? . . . 'Cause I'm a catcher, not a pitcher. . . . I'm happier receiving stimulus than giving it, accepting than forcing, obeying than ordering. My problem isn't that I'm greedy, but that I don't show enough appreciation for what I get. . . . So what's that have to do with getting on my knees twice a day? . . . I guess he wants me to take time to appreciate what he gives me, to appreciate myself *for being a good catcher. . . .*

When the alarm on my watch beeped, I stood up immediately, without regrets, and got myself ready for the day.

Work was busy and hectic, but I still found plenty of opportunities to daydream about Terry. I assumed he was still stuck in Vermont, and I embroidered on our shared fantasy of showing up unexpected in his room — and on the gift I would bring him. Off and on during the rest of the day, I turned the surprise-gift idea over in my mind, polishing it, refining it, working out how I'd manage to slip it into whatever scenario we got into on

the phone. If ever there was a case where it was the thought that counted, this was it! And if I couldn't work it into a phone fantasy, I'd present it for real next time we had a date in person, assuming he gave me any notice.

I was on edge all evening after I got home, waiting for him to call, convinced he would call, wishing I could call him. I had my clothes off and my new hands-free phone headset all plugged in. I couldn't read, I was so hyper, so I watched sitcoms and stared at the phone during every commercial.

Nada. Not a tinkle. *He's blowing me off,* I thought. *Found someone else to mind-fuck.* But I couldn't really believe that, not after Friday and Saturday night. *He's just tired,* I defended him to myself. *Or he's been arguing with his client all day and is in a bad mood he doesn't want to unload on me. Probably he'll call tomorrow.*

I shut off the TV after the weather report at 11:20 and was getting up to turn off the lights when the phone rang. I stared at the receiver as if hypnotized, suddenly almost afraid to pick it up. I grabbed it on the fourth ring.

"How are you, boy? Miss me?" he asked, and my dick stiffened immediately. The sound of his voice seemed to go through me all the way down to my balls.

"Fine, Sir. Yes, Sir. I was hoping you'd call last night, Sir."

"Didn't feel like it. I don't want to spoil you, get you thinking you can expect to hear from me every day."

"Yes, Sir. I understand, Sir."

"Do you? I doubt it. But you will, boy, you will," he chuckled. I made no reply this time, and he continued after a brief pause. "Got that headset I told you to buy?"

"Yes, Sir. I'm wearing it, Sir."

"Where are you now? Your bedroom?"

"No, Sir. I'm standing in the living room, Sir."

"Are you dressed?"

"No, Sir."

"Get on your knees, boy, and cross your arms behind you."

"Yes, Sir. Thank you, Sir."

"'Thank you' for what, dickhead?"

"For calling me, Sir. For letting me kneel, Sir. For mastering me, Sir."

"We'll see about that, boy. Been doing your meditation?"

"Yes, Sir!"

"Good. That's good. But don't expect too much from it. Don't strain to think the kind of thoughts you think I want. Concentrate on breathing and let the rest take care of itself. Got that, boy?"

"Yes, Sir." So much for the progress report I was eager to give him!

"Remember where we left off Saturday night?"

"Of course, Sir. How could I forget a scene like that, Sir?"

He didn't respond immediately, and I worried that I'd gone too far again.

"Unless I ask you to continue the story," he said, with a tone of great forbearance, "keep your replies brief and to the point. Understand, dickhead?"

"Yes, Sir." I enjoyed the discipline and at the same time felt it was absurd. *Whatever turns him on*

"Good. To make sure you remember, I want you to squeeze your tits — hard — for five seconds for each unnecessary word in your response just before the last one. I make the tally 50 seconds. Do you agree, boy?"

"Yes, Sir."

"Start when I say, 'Now,' and count silently to yourself. I'll time you on my watch. Now."

I pinched my nipples as hard as I could and began counting off seconds to myself, *One million one, one million two, one million three,* The pain built, of course, and by *one million thirty-nine* I was gritting my teeth and squeezing back tears. But damned if I would deceive Terry by going easy on myself.

I was still counting when he said, "Time! What's your count, slaveboy?"

"Forty-eight, Sir."

"Close enough. If you'd been off much further I'd have told you to practice with a clock. I want you to have a good sense of timing so if I tell you to do something in a certain amount of time, you won't need a watch. In a week or so, you won't need one to know when to finish your meditation. You'll have the five-minute period internalized."

He paused, but I'd learned to hold my tongue — though I really enjoyed saying, "Yes, Sir" to him!

"Are your hands back behind you?"

"They are now, Sir." I bit my tongue, realizing the gaffe.

"I'll reserve the ten seconds of discipline for now," he said. "I'm sure there'll be ample more before we're through. Now, I'm still here in Vermont, in that same guesthouse room. I'll pick up the story where we left off last time, just after we both shot. I'm sitting in a chair, and you're sitting on my cock. Got the picture?"

"Yes, Sir."

"I pull you back against my chest," Terry's voice purred into my ear, "letting you straddle my legs instead of crouching between them. My slowly softening cock is still in your ass. It feels real good there, and I'm reluctant to take it out. I wrap my arms around you, and you relax onto my lap, sighing and making other little sounds of contentment. I smear your cum around your face and pecs. Your nice neat shirt and pants are a mess, wrinkled and stained with cum, spit, sweat, and dirt from both our boots.

"You twist your head around and start licking my face like a puppy. I laugh and hug you tight as we kiss. I wiggle your ass around my cock — good thing I don't shrink as much as you do after I come. *Your* cock is thumb-size now, but I think I know how to make it big and strong again. . . . Your turn, boy."

"It feels so good sitting on your lap, Sir," I told him, using the story to communicate my current feelings, but reducing the "Sirs" to make it flow better. "I want to stay there forever, with my head on your shoulder and your cock up my ass. It's not just the good sex — I've gotten to feel so comfortable with you, Sir. I feel like I belong in your arms, or at your feet, or wherever you want me.

"I look up and see you grinning. I sense that a plan's been percolating in your mind since you came into the room and saw me sleeping on the floor — a plan you only postponed because you were so hot to fuck me. I hope the plan involves that brass bed and the rope you packed in your suitcase, Sir — lots and lots of rope. You didn't know when you packed it what you'd do with it, or to whom, but you always carry rope because it's so versatile, light, and innocuous-looking. You can do almost anything with it that you can with a closet full of more specialized equipment. In fact, you . . ."

"I get the hint, boy."

"Yes, Sir. Sorry, Sir, guess I got carried away . . ."

"Up to thirty-five seconds now. Just continue the story."

"Yes, Sir. You finally nudge me — I've nodded off again —

and tell me to pull off and stand up. Your cock comes out of my ass with a little plop, and after you strip the condoms off it you squeeze your cum onto my cock and make me rub it around, work it into the skin. You laugh when I start to get hard again, Sir."

"Are you hard now, boy?" he interrupted me.

"Like the Chrysler Building, Sir." *Oops!*

"Nice image — I'll forgive your verbosity in this case. Too bad you can't do anything about that hard cock of yours," he said with a chuckle. "Go on."

"Yes, Sir. We hug and kiss again standing up," I said, "and you slip my shirt all the way off. You tell me to take my pants and boots off, too, then go into the bathroom and clean up.

"I'm standing naked at the sink, trying to comb my hair with my fingers, when you come in. You've taken off your shirt but put your vest back on. Your chest pelt looks almost as black as the leather framing it, Sir. Your cock and balls, still half-hard, are hanging out of your jeans. I start to drool, looking at you, Sir, at your chest and pits and hairy arms, thinking about everywhere I want to put my tongue. You stand at the toilet and start to piss, but you cut off the flow when you see my tongue hanging out. You laugh and ask if I really want it. I get on my knees beside you, Sir, and beg.

"You turn and stick your cock inside my mouth and let me have a couple of drops — they're sweet and salty, hardly bitter at all"

"Don't be too sure, boy. It depends on what I've eaten and drunk."

"Yes, Sir. ... I swallow and beg for more, beg you to let me have it all. You give me a mouthful and stop again. You ask if I really understand what it means, taking your piss."

"Do you, Matt?"

"I think so, Sir."

"Do you understand that once I start giving it to you, you'll go on taking it whenever I tell you to, wherever we are — no matter what it tastes like, no matter whether you want it or not?"

"Yes, Sir."

"And how would that make you feel, being my personal urinal? Feel free to give a full answer."

"Privileged, Sir. If I can't have your cum, your piss is almost as good — and there's a lot more of it, Sir!"

"Greedy little bastard, aren't you?"

"Yes, Sir, when it comes to you, Sir."

"You say the nicest things, boy! Most of the time, anyway. And so far you've followed through. But this one may be tougher than you think.... Go on with the fantasy, though. I like it so far. Tell me what you think it'll be like when I let loose down your throat, make you a real piss slave."

"Yes, Sir."

I had to think a bit before going on. Despite everything else I'd done, I'd never taken a man's piss in my mouth. I'd bought the hard line, *Never share body fluids* — no distinctions. Slowly, though, it'd become clear that kissing was safe, and sweat was safe, and oral sex was probably safe if you didn't have open sores in your mouth or throat. And Terry had told me that piss was safe, as far as AIDS, anyway. I believed him, and the thought unleashed a raging thirst for piss — *his* piss, anyway — that I hadn't known I had. But this first time was merely a fantasy, and I had only my imagination (and the memory of a few hundred porn stories) to guide me.

"You tell me not to suck, Sir, not to lick," I said, "just to hold my lips closed around your cockhead and swallow. You say that anything I spill I'll have to lick up from the floor. I try to say, 'Yes, Sir,' around your deliciously thick, soft-hard fleshy cockhead, but it comes out garbled.

"You stand there and milk your shaft to get the flow going again. It begins, Sir, flooding my mouth with hot piss, and I swallow faster and faster to keep up. I worry that I may press too hard on your sensitive cockhead, or not hard enough and let some of the fluid dribble out. I worry about keeping my teeth from hurting you...."

"You worry too damned much," he said. "Relax and take it. Let me do the thinking."

"Yes, Sir. Thank you, Sir.... You run your hands through my hair, messing it up again, telling me I'm doing fine, telling me that I'm going to be a first-class piss slave, telling me how great it feels finally to piss in my hot mouth. Your praise relaxes me, Sir, and I swallow and swallow, barely tasting it anymore, just feeling the hot piss pour straight from your cock into my mouth and down my throat to my belly.

"I want to tell you how much I love it, Sir, how much I

want to feel your piss *on* me, too, feel you spurt scalding piss all over my body, drenching my hair and face with it, marking me with your scent like a dog marks his territory. But all I do is swallow, and maybe that's enough. Maybe that tells you all you need to know. . . ."

Terry picked up the story without missing a beat, though once again sounding a cautionary note:

"I pull my cock out of your mouth and slap your face with it. Back and forth. It doesn't hurt you, but it reinforces the message that your face is where I park my cock, at least when I'm not shoving it up your ass. You stay on your knees on the hard tile floor while I wash my hands.

"You seem subdued and hang your head. Your arms automatically slide behind your back. You wanted my piss, and you enjoyed taking it; guess now you're thinking again, mulling over what it means. It's not all sweet and romantic, being another man's urinal — it can be a heavy trip, as you'll learn. I'm glad you've finally done it, though. Nothing puts a slave's head in the right space quicker than a fresh load of his Master's hot piss — especially when he *hasn't* asked for it.

"I figure you need to piss, too, so I tell you to take care of it, quick, then join me in the main room. When you come out of the bathroom, you keep your head bowed humbly, but your eyes go everywhere. I'm sitting in the opposite chair from before, watching you, and you see the pile of rope at my feet. Your cock instantly gets hard again.

"I motion you to your knees in front of me, but facing away, with your back and arms between my legs. I take a length of the soft, braided-nylon rope and tie your hands behind you, palms together this time. You automatically bend forward to make it easier for me. You're breathing heavily and sweating again, excited and maybe just a little scared, but your cock is still hard. . . . Isn't it, boy?"

"Oh, yes, Sir, harder than ever, Sir. This is so hot, hearing you talk about training me, tying me up, using me, Sir. I wish it was really happening."

"It *is* happening, boy — don't you realize that yet? I don't have to be in the same room to train you, to make you mine."

"Yes, Sir. Thank you, Sir!" I breathed a sigh of relief — he'd let my gush of words go by without punishment.

"By the way," he said, with unholy glee, "I lost count of the unnecessary words you used just then, so we'll just up the ante to an even hundred, shall we?"

"Yes, Sir." I stifled a groan at the thought of how my nips were going to feel the next day.

"I love handling your body, boy, but it's your mind I really want to fuck with," Terry went on. "You said you'd changed since we left the Spike together last week, and you're going to change even more. You're going to lose a lot of useless baggage and get in touch with your real self. If there's a slave buried under that arrogant, self-centered façade, I'll find it."

His words stung, and I felt my face flame again. I seemed to spend a lot of the time with him being embarrassed.

"I love knowing how much you crave my touch," he continued, "even when it's painful, knowing that you need my bondage, however restrictive. You have no idea what I'm going to do to you, and no control over it, either, but you can barely wait for me to do it. Oh, you can tell me to stop at any time, and I will — but unless you have an awfully good excuse, some unexpected emergency, doing that would end everything. You'd be free, but out of here, out of my life. You don't want that to happen, do you, boy? You can speak freely."

"No, Sir! I couldn't bear to lose you, Sir, not now. But you wouldn't really hurt me, would you, Sir?"

"Oh, I'll hurt you plenty, boy, whenever I want. But I'd never intentionally *harm* you — damage you. Didn't I tell you that Friday night?"

"Yes, Sir, but this is still so new to me — surrendering so completely, without reservations, without prearranged limits. It helps to be reassured from time to time, Sir."

"If you were really here with me, Matt, instead of only imagining it, you wouldn't need me to say anything to reassure you. You didn't need verbal reassurances Friday night, did you?"

"No, Sir, I didn't. Just the way you touched me, the way you looked at me, told me all I needed to know."

"That's right. That's how it works when two men are really in sync. They don't need a contract, negotiations, rules — not if there's love, and trust, and communication. Understand?"

"Yes, Sir. But — permission to ask a question, Sir?"

"All right," he said, "what is it?"

"Do you mean, Sir, that if I ever say that something you do to me hurts too much, or if I question any of your orders, you'll throw me out for good?"

"No! I mean nothing of the sort. All I mean is that I don't believe in using safewords with an experienced player. As long as you're willing to let me be in charge, I feel I have your consent to do whatever I want and think you can handle. And if you're *not* willing to let me be in control, what's the point? It's *my* business to be able to tell when I'm reaching your limits, or pushing past them. But that doesn't mean I don't want any feedback from you. I *want* you to tell me how you feel, good or bad, and I expect complete honesty. I just don't want you to think you can control me by what you say. Understand?"

"Not completely, Sir. You mean I can't ask you to stop when I've had enough, Sir?"

"You can *ask* anything you want, Matt, and either I'll grant your request, or I won't. But the only *command* you have a right to issue is to tell me to stop completely and let you leave. I can't take that right away from you, and I wouldn't want to, either. At any time you can say, 'I want out of here,' and I'll honor it. But you can't expect to use that safety hatch and come back again later, because what it means is that you don't trust me. I won't have anything to do with a man who doesn't trust me."

I made no immediate reply: this was a big idea to digest. It *sounded* good, but it went against the way I'd been taught since I came out in the modern leather scene. "Make sure you have a safeword," novices are always told these days — maybe even two, one for *slow* and one for *stop*. "And if you can't talk, make sure you have some other prearranged signal."

I'd never questioned the idea, but when I looked back over my career as a bottom, I realized that the only times I'd ever *used* a safeword were with tops I shouldn't have gone with in the first place — because they were too inexperienced or too arrogant to pay attention to their bottoms, or too drunk or stoned to read nonverbal signals. With good tops, like Terry, I'd never needed that kind of control. And Terry, I suddenly realized, had never given me a safeword in the first place — and I'd never missed it.

Terry was very patient as I thought about what he'd said, but I didn't want to push my luck.

"Sir?" I said just to let him know I was back.

"Finished thinking it over? Decided you can trust me?"

"Yes, Sir"

"You may speak freely."

"Thank you, Sir. I've always trusted you, Sir. You just made me realize how much. Your approach makes perfect sense to me, Sir. Thank you for explaining it."

"Good. Now back to the business at hand, which I believe was tying you into a pretzel. . . . You want to try telling it? But forget about the brass bed — we're not there yet."

"I murmur softly as you tie me," I said, buying time as I pondered how to continue the interrupted narrative. *If I'm supposed to have no idea what happens next, how the hell does he expect me to describe it?*

"You can barely hear me say, 'Yes, Sir, please, Sir, thank you, Sir,' all run together, like a mantra, over and over. I've said them before to other men, but they were never as meaningful. Each time I say 'Sir' to you I feel it in my balls, in my gut. It's a good feeling, like a key turning in a lock, or a knot pulling snug." *If he doesn't want to tie me to the bed, what else would he do with a pile of rope?. . . Ahh! That's it . . .*

"After my hands are bound behind me, Sir, you tie my elbows together, and you run a loop of rope around the front of my chest and through my tit rings, too. There's no tension on the rings, just the rope lightly rubbing my sensitive nipples with every breath I take, but that's enough to keep me moaning softly." I took one hand from behind my back for a few moments and rubbed my sore nips so I could moan convincingly into the phone. Heavy breathing was all I heard from the other end.

"You order me onto my stomach on the bear rug, pull my feet into your lap, and proceed to tie them as firmly as my hands, then do the same with my knees. I sense where this is going, Sir, and the idea makes my cock so stiff it's a wonder I don't arch off the floor. You bend over to join my feet and hands in the hogtie. I feel the strain in my shoulders immediately, but you've coiled and cinched the ropes so carefully that my wrists and ankles don't hurt at all. . . ." Terry took back the reins of the story.

"I loop rope around your eyes," he began, surprising me, "pulling your head back and blindfolding you at the same time. You gasp at the unfamiliar sensation, and you can't see me smile at your response. I turn you on your side, your back away from

me, and rope your genitals again, working the ties into the other ropes so that if you struggle you'll pull on your balls as well as your limbs. I move to finish off your bondage with a rope gag between your teeth. . . ."

Suddenly remembering my own surprise, I interrupted him.

"'Please, Sir,' I beg as soon as I feel the rope at my lips, 'permission to speak, Sir.'"

"'All right, what is it? Make it quick, and it had better be important.'"

"'Thank you, Sir,' I say. 'At your convenience, Sir, please check the bag that I left on the chest at the foot of the bed. That's all, Sir.'"

"'That's *all*, fucker?! You drop a mysterious hint and shut up? You're really asking for it, aren't you?'"

"'Mmnnppghgh . . .'"

"'Oh, *right* — you can't say anymore because I've gagged you. How con-*vee*-nient.' . . . I pull the gag rope tight enough to hurt, then go over all the other ties and tighten them, too, so you can barely move a muscle. I pull you around so that you're lying parallel to the front of my chair. I get up and find that bag you mentioned, set it on the table beside me, and sit down with my boots propped against your belly. You moan louder, and I amuse myself by teasing your sore tits and hard cock and swollen balls with my boots."

I could almost feel myself lying there, and it took effort to keep my hands away from my dick, which was as hard as he'd said, but I wouldn't touch it without permission.

"I lazily stroke my own hard cock," Terry continued, no doubt describing his actual behavior as well as telling the story. "I'm not ready to come again yet, but I love watching you lying at my feet, squirming in your bonds — my captive, prisoner, slave, plaything."

I wasn't ready to come either, even if he'd let me. I wanted to stay horny and on my knees with his honeyed voice in my ear as long as possible.

"I remember the bag and open it," he said. "Tell me what I find, Matt. What has my uninvited guest brought me?"

I had my answer all ready, one I hoped would please him.

"There are two wrapped packages inside the bag, Sir," I began. "One is wide and fairly flat, the other tall and square in cross

section. Both are covered in black paper tied with silver cords. You tear open the large package first, Sir.

"Under the paper is a wooden box closed with a little latch, with a cubical package wrapped in the same black paper and tied with the same cord sitting on top of it. Burned into the wood is a coat of arms, the name of a French vintner, and a date from before World War II. You open the box, Sir, and find a bottle of fine Armagnac, dusty with age."

I heard a surprised intake of breath on the other end of the line, but he said nothing, so I continued.

"When you open the cubical package, Sir, you find a white cardboard gift box; inside is a crystal brandy snifter wrapped in yellow tissue paper. And when you open the wide, flat package, Sir, . . ." I paused dramatically.

"Well . . . ?" he prompted.

"Sir, you find a wooden box with red and gold seals containing twenty-five Partagas 898 cigars."

There was a *long* silence, so long I was afraid we'd been disconnected.

"Sir?" I asked finally. "Are you there?"

"Yeah, I'm here," he said, but his voice seemed thinner, as if he were farther away — or speaking with some difficulty. *Did I do something wrong?* Then, "I thought you didn't like cigars."

"I don't, Sir, but you said *you* do occasionally."

"Why Partagas?"

"I asked someone at work who smokes cigars, Sir, and he said they're very smooth and mild, with a subtle flavor. I thought you might like them — and that they wouldn't drive me out of the room."

"But 898s?"

"They're packed so they stay round, Sir. I know how particular you are, and I thought you'd appreciate that."

"And the Armagnac?"

"It's not as refined as cognac, Sir, more earthy. The best ones are just as smooth but have more character — that's from experience, Sir, not something I was told. . . . Sir? . . . Terry? . . . This is a fantasy, isn't it? Make it a bottle of whatever you like." *Why's he reacting so oddly?*

"I *love* Armagnac," he said after another pause, in his normal voice. "And when I smoke cigars, I usually smoke Partagas

898s. That's what's so fucking *weird* about this. How could you possibly know?"

"Just lucky guesses, Sir — or unlucky ones. I'm sorry if I offended you."

"No offense, boy — no offense at all. But I don't believe in 'lucky guesses,' either. I thought you said my friends wouldn't tell you about me?"

"Sir, they wouldn't tell me where you were staying in Vermont, or they didn't know. And when I asked what I could get you as a present, they told me to forget it, Sir, that you hate surprises and didn't need anything. But I thought it would be okay in our little fantasy, Sir, especially after you revealed that you'd also thought about my coming up there and surprising you. I hope I didn't step out of line, Sir."

"It's okay. Truly. As a rule I *don't* like surprises, but it was a generous impulse. If you were actually here, tied up at my feet, and you'd left those gifts for me, I'd be very, very pleased.... Although if you *did* know me well enough to have followed me here, they wouldn't be so surprising...."

"Oh, let it go," he said, then yawned suddenly. "Want'a go on with the story or call it a night?"

"Whatever you want, Sir." I was smothering yawns, too, my knees hurt, and my dick — which had softened when I thought I'd pissed him off with my "gift" — still hadn't revived.

"Don't pull that shit," he barked. "I'll do what *I* want in any case. If I ask what *you* want, I expect you to tell me. Withholding information is what's manipulative, not being honest about your desires. So I'll ask again: do *you* want to continue or quit?"

"I'm sorry, Sir." *God, he's touchy!* "I see your point, Sir, but, with all respect, I wasn't trying to be manipulative. It's late, Sir, and we're both tired. I'd love to get off with you, Sir, or just help you get off alone if you prefer, and if you want to go on with the story, Sir, I'll do my best to hold up my end. But if you don't want to extend the fantasy tonight, Sir, I'll look forward to finishing it with you another time."

"That's a long-winded way of saying the same thing, that neither of the choices I offered is appealing. Make that 200 seconds of tit torture you owe me. Just tell me what you *want*, and I may give it to you. You can speak freely, but to the point."

"Yes, Sir," I said. *Pleasing him in one way*, I thought, *sure*

doesn't make him less strict in others! I guess that's good in a Master. So what do *I want anyway?*

"What I *want*, Sir," I decided, "is for you to tell me how you'd put me down for the night if I were really there with you. Would you leave me tied up on the floor? Release me and take me to bed with you? Or . . . ? I'd like to know, Sir, so I can think about it when we hang up and I do go to sleep here, alone."

Terry chuckled. "Poor baby, can't get your mind off that brass bed, can you? Guess I'll *have* to tell you a bedtime story."

"Please, Sir."

"You're still in the living room, right?"

"Yes, Sir."

"Can you move the phone into the bedroom?"

"No, Sir, but I have an extension in there."

"Good. I'll hold on while you switch phones and hang this one up. Be quick about it!"

"Yes, Sir!"

I raced into the bedroom and exchanged the handset of the phone there for my headset, verified that Terry was still on the line, ran back into the living room to hang up that phone and turn off the lights, and was back on the phone in the bedroom in under 30 seconds.

"Are you in bed now?" he asked.

"No, Sir."

"Well, what are you waiting for? Hop!"

The bed covers were still tangled in a pile where I'd left them that morning. I straightened them out and lay down on top of them. I turned off the night-table light, the better to concentrate on Terry's voice over the phone.

"In bed, Sir."

"Do you have a light on?"

"No, Sir."

"Are you under the covers?" I hastily slid under them.

"I am now, Sir."

"Okay. Lie back and just listen. *Don't* play with your cock. If it gets hard, let it alone. In fact, keep both hands on top of the covers."

"Yes, Sir. Anything you say, Sir."

I was, of course, rock hard again and aching to stroke my-self despite my earlier willingness to forgo an orgasm. I arranged

my hands flat on top of the covers as ordered. When I heard Terry's voice again, it was pitched even deeper than before, and he spoke slowly, hypnotically.

"After examing your present, I go over to the bed and sit down to take off my boots, then my chaps and jeans. I put the boots and chaps back on. I come back to where you're lying on the bear rug — hogtied, blindfolded, and gagged. You're almost still now, and your moaning has died down to a thin background noise, but I know that you're in pain. Your cock has softened because of it, but as soon as I brush it with my boot toe it stiffens again. My own cock, hanging loose, arches upward in response to your reaction.

"I bend down to check your hands, and you clutch mine tightly. I ask if you're okay, and you grunt yes. I turn away again to look for an ashtray, but I hadn't asked for a smoking room, and all I can find is the little china soap dish from the bathroom. I open one window for ventilation. The air from outside is cool.

"I sit down again and amuse myself by rubbing my boot toe against your chest and genitals until you're moaning loudly and squirming as much as you can. I stroke my hardening cock, but I still don't want to come again, not yet.

"I open the bottle of Armagnac and pour two fingers into the snifter, then set it on the table while I prepare a cigar. After I light it, I prop my boots against your belly and sit back to savor the first few puffs. I blow the smoke toward the open window. Your nose twitches when you catch a whiff, but you don't try to voice any complaint — and your cock stays hard. Your whole body goes rigid, however, when I kneel beside you and bring the hot end of the cigar close to your cockhead — not close enough to burn, but you feel the heat. Your woody wilts from fear, and I move the tip to your balls instead, singeing a few hairs but not touching your flesh. Even though I keep stroking your belly with my other hand to reassure you, your cock doesn't fill out again until I move the cigar away from your genitals entirely.

"I bring it close to your left tit, but although you flinch and gasp, your cock doesn't waver. I lift one of your rings and hold the smoldering tip of the cigar against the metal for two seconds. When the ring heats through, you howl through the gag and try to pull away....

"Now, boy, I want you to put both hands on your tits and

pinch as hard as you can while you work off those 200 seconds you owe me."

"Yes, Sir," I say through gritted teeth. *One-million-one, one-million-two, . . . one-million-forty-five, . . .*

"Feel free to make noise if you want," he said cheerily, causing me to lose count for a moment.

It hurt! But I was determined not to cheat. I pinched myself as hard as I thought he would have if he'd been there with me. *One-million-eighty-two, one-million-eighty-three, . . .*

"One hundred," he said when my count was a hundred and four. So I counted four seconds over again. Before the second hundred was up, I was moaning out load and thrashing back and forth under the covers.

"Two hundred," he said as I counted 197. "Relax, boy. Put your hands back outside the covers. You've paid your penalty, and it's easy duty from here on."

Easy for you to say! I thought. But I bore him no resentment. However painful, the discipline made me feel closer to him, more worthy of him.

"I stop torturing your tits with my cigar," he said, apparently back in the story. "I'm just testing you this time, and I've learned all I need. I sit again and hold the bowl of the snifter in my palm, warming the brandy with my body heat. It's all heat transfer, energy transfer — the snifter in my hand, my hot piss in your mouth, my cigar on your balls, my belt on your back, your asshole around my cock, your tongue on my boots

"I inhale the bouquet of the Armagnac before taking a sip. *Ahhh!* It's wonderful. I roll the fiery smooth liquor around my mouth before swallowing . . . *mmnn,* among the best I've had. I salute you with the glass — a pity you can't see it. I inhale again, sip again, savor and swallow again. What a marvelous gift!

"I smile down at you, tightly bound at my feet and obviously loving it, despite the pain, since your cock is stiff. Your cock *is* hard, isn't it, Matt?"

"Yes, Sir." And it was. Though it had softened while I was pinching my nips, it stiffened up again as soon as he let me stop.

"Good. That's how I like it. Your cock looks much better when it's hard and dripping than soft and shriveled up. I don't think I'll let you come so often anymore. I'll keep you naked and horny. You'd like that, wouldn't you?"

"Yes, Sir."

"You don't sound very convinced."

"Permission to speak freely, Sir?"

"Granted."

"I really like to come, Sir. I'm used to coming at least once a day, most days, Sir. You won't really make me stay horny, will you, Sir?"

He laughed. "Sure I will, boy, but you'll work up to it. You can stay horny tonight, can't you? You said it yourself just a few minutes ago."

"Yes, Sir. For tonight, Sir."

"That's enough for now, boy. Now lie there and *listen*."

"Yes, Sir!"

"I cross my ankles and rest my booted feet on your naked hip. Your flesh twitches under me as you realize what I've done, that I've made you my bootstool. You moan, your cock jerks, and your whole body shudders — once. Then you're still again. I continue to sip and puff as I look at you.

"Some say pure bondage is boring for the top, but I'm quite content to watch you. Indeed, I'm fascinated by your every twitch and groan. You're in pain, and I put you there. I could stop it at any time, but I don't. And you love me for it. . . . It's an amazing spectacle. One of the wonders of the world.

"Sometime during this tableau vivant, I realize that I'm happier than I've been in years. By the time I finish my cigar and brandy, I've decided that owning you will be worth the trouble. We're so obviously right for each other that it would be crazy not to try. . . ."

He must have heard my little cry of joy as he said that, because he asked if I'd like to add something.

"Thank you, Sir," I replied in a voice thick with emotion. "All I can say is that I feel the same way, Sir." I remembered the story and tried to speak on two levels at once, as he had done. "The pain and constraint of your tight ropes on my body, the weight of your booted legs, and the whiffs of cigar smoke I'm just as powerless to evade all confirm that I belong to you, and that's exactly what I want, what I need. I'm so glad that I please you, Sir."

"So am I, boy, so am I. . . ."

Tears ran down my cheeks as the silence stretched out. I

wondered again if he was still there, but I hadn't heard a disconnect. Eventually his seductive voice filled my ear again.

"After I stub out the cigar butt, I get up and kneel beside you. I roll you onto your belly and slip my arms underneath you. You have no idea what's happening and cry out as I carefully lift you and stand up. 'Don't worry, I have you,' I say once you're safely balanced in my arms. I carry you into the bathroom and lay you in the tub. You go rigid and make a loud noise when your skin touches the cold enamel, but I soothe you with my hands and you calm down. I put the drain cover in the tub.

"I have a piss hard-on and aim it right at you. Soon my stream of hot piss is splashing onto your bound hands. I think I hear you whimper. I aim higher and drench your back and head. You cry out, louder, but it clearly isn't a protest. I move to the end of the tub and soak your roped mouth. I know you swallow some because I can see your Adam's apple bob up and down. I aim the last of my piss at your feet and ass.

"I stand there for a couple of minutes looking at you. I love how your golden hair, damp and dark with my piss, is plastered to your skull. Your shiny boots glisten with beaded drops of piss. Yellow piss drips from my white ropes.

"The tub slants down to the closed drain, and your face is hanging above a small puddle. I know you can smell it. Without saying a word, I undo the rope gag and blindfold so you can move your head freely. You twist around and try to see me, but I've stepped back so you can't. I won't tell you or clue you what to do. You wriggle in your bonds, trying to ease the pain in your shoulders and limbs, then stare at the cooling piss in front of you. What'll you do, slaveboy?"

"After hesitating a second or two," I said, "I lower my face to the puddle, taking tentative little licks at first, then big greedy slurps. Cold piss isn't so bad — I may even come to like it — and I want to please you, Sir."

"You do please me, boy, especially because you did it without being ordered. My pissing on you, or in you, isn't solely an act of domination — marking my property, underscoring our respective roles and status. It's also an act of love. 'This is from my body: Take. Drink. Become one with me.' . . . You do understand that, don't you, Matt?"

"Yes, Sir."

"Are you hard?"

"Yes, Sir."

"Good. Keep your hands away from it. . . . After you've licked up all the piss, I sit on the edge of the tub and ruffle your damp hair and tell you how happy you've made me. I untie the rest of the ropes and rub your arms and legs. You hurt even more for a couple of minutes as full circulation returns, but soon most of the soreness is only a memory. I tell you to take off your boots, laughing as you squirm around in the damp tub. I take out the drain plug. I make you lie on your back in the tub with your feet up on the end. It's your turn to piss, and the position makes you piss all over yourself, helped along by my hand aiming your cock.

"You take some of your piss in your mouth, but most goes down the drain. I explain that *your* piss has no special value and doesn't need to be recycled. Your pride flares up momentarily, but you see me grinning, and we both laugh. I wash you off with the shower, cleaning my own hands and arms in the process. I throw you a towel before I leave and tell you to join me in bed after drying off.

"I take off my boots and chaps but leave the vest and put on a leather jock. I close the window, draw the curtains, and turn off all the lights but a little one by the bed. I turn down the covers, but before I lie down, I slip a couple of items from my bag under a pillow. You come in from the bathroom, your hair still disheveled but otherwise practically glowing. Like a little kid, you run over to the bed and jump onto the end, kneeling there and grinning down at me.

"I fold open my vest, and you crawl over and lie with your mouth on one of my tits and your hand on the other. I simply enjoy your tongue action for a minute or two, then retrieve the pair of cuffs I hid under the pillow and lock one onto your free hand. You keep licking but automatically put your other hand, the one playing with my tit, behind you next to the first. I don't fasten the cuffs that way, however, but lock your hands in front of you.

"When I pull out the leather collar I had you wear at the Bondage Club and buckle it around your throat, you go nuts, licking not only my tits but everything else you can reach. I attach the leash and put the grip over my left wrist. Finally, I padlock your cuffs to the ring at the front of the collar, so you can

sleep comfortably but can't play with yourself. . . . I wish I was there to do it to you now, boy. I bet you're playing with yourself despite what I told you."

"Oh, no, Sir. I wouldn't do that, Sir. I'm still hard, Sir, even more than before, but I'm not touching it."

"Not even rubbing it against the sheet?"

"Well . . . uh . . . but it doesn't do any good, Sir! I could never come that way."

"Never say 'never,' boy," he warned, laughing. "But you said you're sleepy and don't care if you come tonight anyway. Now that you know what you'd be in for if you were really here, we can say goodnight."

"Sir?"

"What is it?"

"Is it okay if I jerk off tomorrow, thinking about our story?"

"Are you wearing my collar?"

"No, Sir — unfortunately."

"No whining! Did I give you any orders about jerking off after tonight?"

"No, Sir."

"Then you'll have to decide for yourself what to do, won't you, boy?"

"Yes, Sir, I understand. . . . But when'll I see you again, Sir?"

"I'll let you know. I hope we can get together this weekend. I'll call you after I get back home. Is that your last question?" His tone implied that it had better be.

"Yes, Sir. Thank you, Sir."

"You're welcome. Pleasant dreams."

"You too, Sir." I lay back in a happy, horny daze.

When the disconnected phone buzzed in my ear, I took off the headset and exchanged it with the regular receiver, then hung that up. Automatically, my hand moved toward my stiff, twitching cock, which would need only a few strokes for cum to explode out of it. But as soon as I touched it, I jerked my hand back as if burned. *No! No cheating!* I sighed and lay back, my hands on top of the covers. Thinking ahead to the weekend, hoping Terry and I would do in person half of what we did in our story, I fell asleep.

CHAPTER 14

Cagesitting

Tuesday passed without incident, or calls from Terry. I went to bed early, after jerking off remembering our fantasy, then doing my meditation. I set the alarm at 7:00, instead of the usual 8:00, so I could be at Curt's on time Wednesday morning for my stint as a "bondage sitter." But even though I dragged myself out of bed at that ungodly hour, I arrived ten minutes late at his apartment — on the fourth floor of an old brownstone way west on 25th St., practically to the river. He was not pleased, and his dark-brown face was set in a scowl when he opened the door and let me in. I started to apologize, though I was winded from rushing up the stairs, but he sloughed it off.

"No time for that. Get your sorry ass in here and I'll show you where everything is."

It didn't take long to tour the L-shaped studio, but Curt's annoyance subsided by the time we finished. Stan was already in place in his cage out in the middle of the living area. It was no slapdash construction made of wooden dowels and glue but solidly welded together from heavy-duty steel bars and flat strips in a dark-gray matte finish. The hinged door at the front was closed with a very stout padlock.

The top was barred just like the sides, and the floor was a solid plate — Curt had put a leather-covered pad on it, to give a prisoner's knees and butt a little relief. The cage was mounted on wheels, though it was so heavy that not even the most vigorous thrashing around by the occupant was likely to move it.

Stan's short, heavily muscled body was naked except for eight-inch black lace-up boots and a hood, fist mitts, and ball stretcher and cock sheath all made of black leather. He was sit-

ting up against the end of the cage opposite the door, held there by chains around his chest and waist. His arms were pulled behind him and locked together outside the cage with heavyweight handcuffs. His feet were stretched out in front of him and chained to opposite sides of the cage.

Curt had laid out more gear on a low coffee table near the cage: leather and steel restraints, long strips of leather, a small paddle, a riding crop, a short flogging strap, a cock whip, emery boards, a Wartenburg wheel, clothespins, ropes, chains, and various clamps, clips, and locks. There was also a bowl of condoms and a lube dispenser.

Back in the kitchen, Curt handed me a typed summary of things to do, and not do, with regard to Stan. He kept his voice low as he emphasized the key points.

"You can use anything on the table or already on him in the cage, but nothing else — except your hands, of course, or your cock if you feel like fucking him. But I don't suppose you have much experience with that."

"Oh, you'd be surprised," I said with a smug grin. "Stan and I've fucked each other lots of times."

Our mutual bondage play was pretty easygoing, though, compared with the intense scene Curt was running.

"Whatever," Curt said, rolling his eyes. "Just don't get carried away torturing him. Remember: bondage is the main event here. Paddling, tit play, or fucking are only side shows to keep him and you from getting bored."

"I understand. Too much pain could overload him and make the bondage harder to take."

"Right! Guess you do know what this is about," he said, and actually smiled. "Stan's handling the scene real well so far. Don't blow it by being too hard on him — or too easy. You can change his restraints or position any way you want, but don't let him out of the cage, don't take the hood off, don't let him come, and don't talk to him! You can do what you need to without talking, and if you have his gag out and he tries to talk to you, don't answer!

"If he starts babbling and seems panicky, soothe him with your hands. He'll calm down after a while and accept the situation. But if you really think he's about to crack, call me at the hospital. I don't expect you'll have any problem, though —

maybe by Friday or Saturday, but this is only the third day he's been in there."

"Does he know it's me today?" I asked.

"He saw my roster of sitters, but he's probably forgotten which day this is because his time sense is distorted. There's no need to remind him. You're here because you're his friend, but I want you to act like you have no special feeling for him at all. Pretend he's an animal in a zoo and you're the custodian. Take good care of him, have fun with him, but don't get too chummy. Understand?"

"Yes, Sir! One zookeeper at your service!" I said brightly.

"One clownish bottom, you mean," he said, scowling.

"Hey, man, it was a joke! I understand what you're trying to do, and I won't mess up. You can trust me."

"Do I have any choice?" he groused. "I've gotta run. I'll call around lunchtime to find out how you're doing, but if it's anyone else, let the machine take a message."

"Okay," I said. "Don't worry."

"Easy for you to say! For a top, it comes with the territory."

After he'd gone, I walked over to have a closer look at the cage and my bound buddy inside it. The bars were solid, one-inch-diameter rods, eight inches apart, set into flat steel strips about halfway up on each side. Double-width strips, bent at right angles, ran along the edges. Overall, the cage was a yard high, four feet long, and two and a half feet wide — not even Stan could lie full length in it.

I crouched down to look closer at the hood, which seemed familiar — *yeah, that's Stan's own hood.* He'd commissioned it from a friend of ours who's one of the best leather craftsmen in the Northeast, and they spent weeks doing fitting after fitting until Stan was satisfied. And after he'd used it for six months, he took it back and had it adjusted again for the stretch in the leather!

The first time I saw that hood, I begged Stan to let me put it on, just to see what it felt like, but he refused. I kept after him, though, and finally he let me give it a try. It was hopeless — it was so perfectly fitted to Stan's head that I couldn't even pull it all the way onto mine. It's not that my head is that much bigger, but just a fraction of an inch here and there was enough.

Heavily padded with foam rubber *and* cotton batting, totally lined with smooth leather, and with more leather glued over all

the outside seams, the hood has no eyeholes, only a couple of grommetted holes at the bottom of the nosepiece and a two-inch round hole at the mouth. The mouth hole can be filled with a rubber plug gag attached with heavy-duty snaps on either side and at top and bottom. The plug narrows toward the front so he can close his jaw around it. All of the external hardware is finished in black — the back zipper, the locking post, the D-rings at the top and at the front and sides of the wide collar, the grommets for the breathing holes, and the gag snaps.

When Stan is laced into the hood and the gag's in place, as it was on this occasion, it looks as if his head is a round, black ball. Only the nosepiece interrupts the smooth surface — the eye sockets are so well padded not even a slight depression betrays their location. A short, stiff tube runs through the gag plug to ensure he can breath or to let him receive fluids.

Curt had left a plastic hospital urinal hooked to the side of the cage to take care of fluids coming out. His instruction sheet said to give Stan a pint of juice every three hours and to let him piss every four hours; if he asked to go sooner, I should make him hold it. He had his main meal early in the morning, Curt had explained, so he wouldn't need to shit during the day. They took care of that in the morning, too, when he also washed Stan. Despite his efforts, the prisoner smelled a little ripe, but the effect wasn't unpleasant if you like male bodies in the first place.

My instructions were to leave Stan's butt plug alone unless I wanted to fuck him. His ass certainly looked tempting enough — if I could get to it through the bars. As Curt had suggested, I made an effort to think of my buddy as a caged animal or a sex toy, not someone I cared a lot about.

On a sudden impulse, I reached into the cage and pinched his nipples. He jerked in his bonds and groaned around the gag as I played with them. I assumed he wasn't complaining, because his cock got harder than it'd been already. I was yawning from lack of sleep, so I smacked his ridged abs a few times and then withdrew to go back to the kitchen and start the coffee machine. Curt's kitchen was well stocked, and he'd said I should help myself to drinks or food.

While the coffee was brewing, I took another look at the sleeping alcove and Curt's elaborate steel-pipe bondage bed — more like a jungle gym than a place to rest. A trunk full of equip-

ment was under the bed, and there was more gear in the closet. The ceiling was at least ten feet high, with hooks here and there that obviously weren't for hanging plants, and there was a rectangle of heavy-duty ring bolts on the living-room wall.

Curt and Stan are made for each other, I thought, *real bondage fanatics — like someone else I know!* This wasn't their first scene together, but they weren't anything like a regular couple, or at least hadn't been up to now. *Maybe Stan'll fall in love with his jailer, à la the Stockholm syndrome. If so, maybe he won't be so skeptical about my desire to settle down.*

Other than the bondage facilities, the apartment's furnishings were conventional — comfortable and attractive, not overly trendy. The walls and ceiling were painted the same off white as in most city apartments. Brightly colored woven rugs overlapped on the parquet floor, and a pair of carved African masks hung above the couch. There weren't many books, but plenty of magazines, videotapes, and CDs. I was tempted to explore Curt's music collection, but I obeyed his order to maintain silence. I could have used headphones, of course, but then I might have missed any distress noises made by my charge.

The full reality of what Stan was going through hadn't sunk in yet. I sat in comfort in an armchair, my legs resting on the ottoman, and sipped coffee in the eerie silence, staring at my caged buddy. Only the regular rise and fall of his sculpted chest — as far as the chain around it would allow — betrayed that he was still breathing. From time to time the muscles in his arms or legs bulged and then relaxed, and I realized he was straining against the bonds. They held him fast. He wasn't going anywhere unless I let him — and I'd pledged that I wouldn't. I tried to imagine how it felt to him.

Locked up for 23 hours a day in that cage, in that hood. No let-up. No way to lie down or stretch out, even if he was allowed to. Unable to piss when he wants or eat when he's hungry. Unable to prevent his keepers from torturing him or fucking his face or ass. No sounds or sights, just the feel of chains, leather, bars, and whatever other restraints his keepers want to use. No way to control what's happening, no communication. No exercise, no way to relieve the aches his limbs must feel. Just 23 hours a day of silent confinement and suffering, for a whole week. So why's his cock so hard? What is he getting out of this, anyway?

I could enjoy rigid bondage for a few hours, or even over-
night, as in Terry's sleepsack, but Stan's situation scared me silly
— and at the same time made my imagination run wild. I didn't
think I could take it for more than a day, if that long. Yet Stan
seemed none the worse for wear, as far as I could tell, after al-
most three days. Grinning sadistically, I decided to make things
a little harder for him and sorted through the gear on the table. I
settled on a pair of medium-strength nipple clamps linked by a
chain as well as another long chain with spring clips at both ends.
I knelt down and reached into the cage to attach the clamps.
Stan jerked and moaned as each one went on, but his cock stayed
hard inside its leather sheath.

I clipped one end of the long chain to the D-ring at the
bottom of his ball stretcher. I'd intended to run it out to the front
of the cage and fasten it to the bars, but a more diabolical idea
came to me — I ran it up to the top of the cage, looped it over a
bar, and ran it back down and around the chain between his nip-
ples. To the accompaniment of groans from my prisoner, I pulled
the loose end up until there wasn't much slack and clipped the
chain to itself. His nipples and balls were now both under con-
tinual moderate tension, and any squirming he did would just
make it worse. Of course, he *did* squirm and twist, as much as
the heavy chains binding his chest and waist would allow, trying
to dislodge the clamps, but in vain.

I surprised myself at how much I enjoyed watching Stan's
helpless suffering. *Guess there's more than a little top in me after all,*
I thought, sitting in the armchair again. As I finished my coffee, I
checked my watch — only 9:45 a.m. I decided to let him suffer
another hour and then rearrange him in the cage and give him
some juice. I picked up my book (*Coming Out Under Fire*, a history
of gay men and women in World War II) and started to read.

The buzz from the coffee kept me going for a while, but it
wasn't long before the silence, the comfortable chair, and the dif-
ficulty of concentrating on a mere book while a naked man was
sitting in a cage five feet away from me combined to send me into
a doze. I drifted in and out of consciousness, thinking first about
Stan and what he must be feeling, then daydreaming about Terry
shoving me into a similar cage.

*He doesn't hood me, though, just cuffs, plugs, and gags me. He
says he wants me to see where I am, to see for myself that I'm caged*

like an animal, to see him moving around outside the cage, out of reach. I stick my face through the bars and stare at him like a puzzled puppy, whimpering and whining until he tells me sharply to calm down, to be a good boy and be quiet. So I pull up my knees and sit there, looking at him relaxing in his armchair, reading a book. . . . Except I'm the one in the armchair! I have a book in my *hands.* I shook myself awake and checked the time — *almost noon! Poor Stan!*

I got up and went over to the cage. *He's still breathing, at least!* As gently as possible, I removed the nipple clamps and let the chain to his ball stretcher fall slack. He shrieked into the gag, of course, as each clamp came off, and jerked wildly for a few seconds before simmering down. I fought an impulse to apologize to him. *It's no big deal,* I told myself. *So he had 'em on for two hours instead of one. No harm done.*

I slicked my fingers with spit and massaged his nipples, trying to soothe them. At first that pained him even more, but soon he was moaning softly, and his cock was fully erect again. I stroked his cockhead, too, with my moistened fingers, and he tried to hump into my hand. I was tempted to bring him off, but Curt's instructions were to deny him any relief. *It's probably kinder not to let him come until the scene is over. He'll never get through a whole week of this unless he stays horny!*

I got the keys and released the chains holding Stan to the bars. I unlocked one of the handcuffs and let him pull his arms inside the cage but immediately repositioned them overhead and refastened the cuffs so the chain between them passed over one of the top bars. The fist mitts were well padded, so I wasn't worried about letting his arms hang from the cuffs for a short time. Once he no longer felt my hands on him, Stan scrambled around in the cage until he was on his knees instead of sitting, just for the relief of a change, I suppose. Made no difference to me — I'd be fastening him into a new position soon enough.

Curt called while I was in the kitchen, and I assured him Stan was fine. I didn't tell him about the nipple clamps. He reminded me it was time to give the prisoner some juice, and I said I was already getting it. *Tops are such control freaks!*

I carried a pint of apple juice and the funnel over to the cage. Bending Stan's hooded head up, I inserted the funnel into the tube in his gag, which Curt had told me would signal to him that some kind of liquid was coming. Stan knelt quietly while I

slowly poured the juice into him, the only sound his swallowing. When it was all gone, I removed the funnel and patted his head, which he lowered and rubbed against one of his arms, as if trying to scratch an itch.

Kneeling down, I reached into the cage and kneaded his stiff shoulders, which he seemed to appreciate, then teased his sore nips, which he didn't, or not as much. I fondled his cock to stiffness and squeezed his balls until it softened again, then repeated the treatment several times. I unlocked one of his cuffed hands, bent his head down, and refastened his hands to the back of his collar. I wiggled the plug in his ass until he was squirming and squealing like a pig. I pinched and tickled him, teased and tormented him, getting hotter and hotter from the sense of power his helplessness gave me. *This is my closest friend, and I'm using him like a hustler!*

Finally, inevitably, I took out the plug and fucked him. I'm not proud of myself, but I did enjoy it! Slamming into Stan's butt, which I'd pulled up against the bars, his booted feet sticking out and held apart by my own knees, feeling the cold steel confining him with every stroke, I imagined I was Terry fucking me — claiming me, possessing me, owning me. *This ass is mine*, I told myself, *and there isn't a damned thing he can do about it.*

I was a wild man. I couldn't remember when I'd ever fucked Stan — or anybody — so hard or with such abandon. My hard cock seemed much longer than six inches as I rammed it into his hole and dragged it back out. I didn't even wonder how it felt to him! His small, tight body shook with the force of my thrusts. Stan loves being fucked, so I wasn't worried I was hurting him, or maybe I just didn't care. I used his pecs as handles, my fingers digging into his nipples, and he must have had some pain from that, but all I could think about was how good it felt to bury my throbbing dick in his hot ass. I *took* my pleasure from him this time, with no regard for his.

I practically ripped his nips off when I came, finally, slamming myself against the back of the cage so hard I'd have bruises to show for it. I kept enough presence of mind not to say anything that might let him know who was fucking him. I just clawed his chest and howled wordlessly as I shot into the rubber deep inside his ass, my mind exploding into bright orgasmic shards. When I pulled out and let him go, he collapsed in a heap on the

floor of the cage while I slumped back onto the rug, panting and heaving.

After the room stopped spinning and I could sit up again, I checked my watch and found it was past time to let Stan relieve himself. I reached into the cage and manhandled him up on his knees, then stuck his hard cock — slick with precum — into the urinal. I had to squeeze it several times and pull it in a milking motion until he got the idea. Finally the pee started trickling out, then streamed into the urinal.

He had a lot to get rid of and almost filled the thing before stopping. I shook off the last drops for him and took it away. Then I put a fresh condom on the butt plug and worked it back into his ass. He stayed on his knees with his ass pushed back and his dick hanging down while I walked toward the bathroom, but when I returned I found him sitting up with his back at the end of the cage again, his legs stretched out.

I looked over Curt's authorized toys again. There was a set of heavyweight manacles and leg irons that I liked the heft of. I did Stan's hands first, removing the handcuffs and fist mitts and fastening the manacles behind his back. The 18-inch chain between them would give him a good deal more freedom than before yet still keep his hands away from his cock. Then I locked his feet in the heavy shackles, affectionately rubbed the leather ball that was his head, and went into the kitchen to fix myself some lunch.

I made a sandwich and brought it back to my chair with some fruit and more coffee. I put my feet up again and sat back to watch. Stan was experimenting with different positions, trying to get comfortable, making a lovely noise clanking his chains and scraping his cuffs against the bars. Finally he settled down in a semi-fetal position on the floor of the cage.

I looked at him as I ate, once again trying to imagine how he was feeling as he lay there. *Is he in pain? Angry? Scared? Hungry?* There was no way to tell unless he started making noises. But he was quiet and still, just lying there breathing, not calling attention to himself in any way. He wasn't due for more juice for a couple of hours, and I didn't feel like torturing him now, so I picked up my book and more or less ignored him.

I read fairly continuously, looking up whenever Stan rattled his chains but otherwise leaving him alone. Perhaps a real top

would have taken more advantage of the situation, but having fucked him once I felt no desire for more. (I still felt a little bit ashamed for enjoying it so much.)

This time I'd taken no chances and set the alarm on my watch. It shrilled at 3:00 p.m., and I got up to get Stan's juice. There were several kinds in the refrigerator, and to give him some variety I poured a pint of tomato-vegetable.

I reached into the cage and yanked him to his knees, then pulled his head back. He made no attempt to resist. I set up the funnel and poured a little bit of juice through his mouth tube so he'd realize what was coming, then slowly gave him the rest. I realized that some of the thick juice would stick to the inside of the tube and give an off taste to anything else poured through it, so with an evil grin I pulled out my cock and gave him a load of piss as a chaser.

His head jerked once when the first drops hit his mouth, but he swallowed it all with no complaint as far as I could tell. I wondered if that meant he remembered who was "sitting" him today after all, since he knew I was healthy, or if he just had complete trust in Curt's choice of custodians. *Or maybe he's too far gone in there, inside his hood, to think about such things?* Even though I knew my own piss was safe, I worried that I'd pushed Stan too far. *Is it because I want to take Terry's piss so much?*

I sat with Stan for half an hour or more afterward, gently stroking him and trying to convey silently that he was in safe hands — unlike those of the nut who'd tortured and fucked him that morning! He seemed pathetically grateful for the attention, squeezing my hands in his when I removed the manacles to check his wrists and rubbing his hooded head against my arm when I fondled his nipples and pecs. Being in the cage seemed to have made him uncharacteristically submissive. Without any prompting, he got onto his knees and bent his head down to the leather mat, crossing his arms behind his back.

Is he trying to tell me something — that he needs to shit, perhaps? I wiggled the plug a little, and he just ground his ass against my hand. But when I tried to pull it out, he clenched around the base to keep it in, so that wasn't it. Between his legs, his harnessed balls were like hairy plums, and his cock was hard and dripping again. He moaned and shivered when I stroked it.

So I spanked him. I took the paddle Curt had left out and

painted Stan's ass red. Not just pink, not just flushed, but bright cherry red all over, just this side of bruising. He was more than docile at first, pushing back toward me and gently swaying on his knees with each blow, but later on he showed some signs of trying to avoid the paddle, so I grabbed his balls and pulled on them until he held still. To his credit, he kept his arms behind him — if he hadn't, I'd have tied them there.

I imagined how Terry would deliver a paddling — slowly, methodically, rhythmically, thoroughly — and did my best to emulate him. The bars of the cage limited my swing, but the inarticulate noises Stan made through his gag got louder and louder nonetheless, eventually rivaling the sound the leather-covered spring-steel paddle made as it slapped down onto his reddened ass cheeks.

Satisfied that I'd saved him from boredom for a while, I put the manacles back on and let him rest on the floor of the cage, ignoring the little whimpers that escaped the hood from time to time. But it was hard to concentrate on my reading. Stan's voluntary victimhood was hard to resist, even for another bottom. With that hood on, it was easy to forget he was my friend, easy to forget he was even human. He was like a life-size GI Joe doll (the short model) that I could play with and torment to my heart's content. Curt was due home by 5:30, so I didn't have a lot of time. I looked over the gear on the table again. *How can I cause him the most stress with the least effort?*

I started by getting him up on his knees again, spread apart as far as possible. I fastened his ankle cuffs to the back corners of the cage with chain and tied his knees to the sides with straps. I pulled his manacled hands back, fastening the chain to the top of the cage so his arms were stretched and pulled up. Next I attached a chain to his ball stretcher and pulled that to the front of the cage, where I looped it around a bar. After bending him double and pulling his head forward as far as it could go, I fastened the other end of the chain to the D-ring at the top of his hood, then sat back and examined my handiwork critically.

He was stretched tight, with his knees spread and his arms pulled back, and if he moved his head at all it would pull on his balls. His ass was nicely presented, still glowing slightly. I'd neglected his nipples, but they were now hard to get to, hidden by his bent-over torso. I reached underneath to check his cock: rock

hard. Far from doing him an ill turn, I was obviously just an instrument of my friend's passion for bondage.

So I got the chain-linked nipple clamps and attached another long chain to the one between them, then reached under Stan to put the clamps on him again. Running the extra chain through his crotch, up along the crack of his ass, and over his back, I clipped it to the collar of his hood, leaving only a little slack. Stan groaned and shivered, and when he didn't feel my touch anymore, he wiggled back and forth and side to side, testing his bonds, seeing how much pain he could cause himself.

I sat and watched, fascinated, as he howled and strained to the utmost, shaking the cage, while his cock dripped honey onto the leather mat. After the first paroxysm I was a little worried that he was panicking, but when I stroked him gently he settled down right away, and the noise he made was more like purring than a sign of distress.

So I let him alone and watched. He would wiggle around and howl for a couple of minutes, then subside into silence and stillness. Finding his condition unchanged, he'd start up again, playing Samson among the Philistines, trying to bring down the temple of his bondage. But as strong as he is, Stan's no Samson, and the steel chains and bars held him fast. I became so absorbed in watching him I lost track of the time — I should've drained his urine at 5:00 p.m. — and was still sitting by the cage, enthralled by the spectacle, when Curt arrived back home. Hearing the door open, I looked up.

Curt put his finger to his lips and came over silently to see what I was doing. He examined Stan very carefully without touching him, gave me a funny look, and gestured for me to follow him into the kitchen.

"I thought you were a total bottom, man," he whispered when we were out of earshot. "That's some nasty position you've got him in. How long has he been like that?"

"Not long, only an hour or so. He's okay — you can see his dick is hard."

"So how'd it go today? Did he give you any trouble?"

"No trouble at all. It was great! I didn't expect to get so sadistic with him, either, but he's irresistible like that, hooded and gagged so he can't sass back. I followed all your rules, but I did fuck him and play with him some. He wasn't bored!"

"You gave him his juice and collected his piss on schedule?"

"He's a little overdue for his second piss break, but he's had his juice twice." I didn't tell him about *my* piss break, hoping Stan wouldn't remember it by bathtime, assuming he was allowed to talk then. "Want me to drain him before I go?"

"Nah, I can handle it. You've done enough damage for one day," he said, grinning. "Thanks again for helping out."

"My pleasure," I said, "in more ways than one! But do you really think he can last a whole week?"

"I hope so, 'cause I've got two more sitters scheduled! Yeah, he can handle it. He's a strong little fucker, and his head's really into it."

"That's obvious. Whatever I did to him, he seemed to enjoy it."

"The boredom is the worst part, as you said. He generally prefers being left alone in bondage, but after the first day in the cage, he said he'd rather be flogged bloody than be left alone there, untouched, for another day."

"What do you do with him at night? Is it safe to leave him gagged?"

"No, and that's why I don't do it. I take the gag out at night and also remove any restraints that keep him from changing position inside the cage. The hood goes back on, of course, and he's usually handcuffed and shackled. I lock a hard jock onto him so he can't play with himself. Don't tell anyone," he said with a wide grin, "but I even give him a pillow to sleep on."

"Whotta guy," I said, grinning back, "a sadist with a heart of gold."

"Believe it, man. I *like* this boy, and I want to be able to play with him again sometime. Now g'wan, take off! I have a prisoner to tend to."

"Okay, Curt, you're the boss. But thanks for letting me in on this deal!"

I was halfway down the stairs when I remembered my book. *Fuck it*, I decided. *I can pick it up another time — gives me a good excuse to see how they're doing!*

CHAPTER 15
Suddenly on hold

After I left Curt's on Wednesday, I strolled down through Chelsea, stopped in a couple of bookstores, had dinner at a Mexican place, and headed home. Despite the distractions of the walk, my mind kept coming back to Stan in the cage. Not for the first time, I envied his freedom to decide on the spur of the moment to spend a week in bondage. Although I can take a day off work on short notice, longer vacations have to be planned months in advance.

Stan makes more money working part time than I do full time — anyone who can keep a big computer network humming is worth his weight in platinum — and he keeps his life loose by settling for an efficiency apartment in a seedy building on the Lower East Side, "East Village" purely by courtesy. He doesn't entertain, and except for sleeping and getting tied up (by himself or a trusted bondage buddy like me), he's hardly ever there, hanging out at his gym or the leather bars most of the time he isn't working. And when he *is* tied up he isn't "there" either, but off in his own universe somewhere.

"I could be bounded in a nutshell and count myself king of infinite space," Hamlet said. Stan might not recognize the source of the quote, but he would certainly understand the idea. Bondage as a solution to New York City's housing shortage! When you can't move, see, or hear, you don't have to notice that you're living in a dump.

Wonder if Terry has a cage like that? What would I do if he wanted to keep me in it for a week? Could I handle it as well as Stan? Or would I crack and beg to be freed? Do I want to find out?

My cock seemed to like the idea. Once I was home I stripped

and laid on the bed, idly stroking myself and recalling how I'd tormented poor Stan. I imagined Terry doing the same to me — or worse. I imagined the ache in my limbs, the pain in my nipples and balls, the delicious soreness of my plugged, well-used ass. I imagined how I'd react when Terry returned and touched me again, even if to cause me fresh pain — how I'd yearn to feel his hands on my flesh, or his cock down my throat, how I'd strain my plugged ears to hear his approaching bootsteps.

But he wouldn't plug them all the time, or hood me constantly. He'd probably enjoy gagging or muzzling me, cuffing or tying my hands, and letting me watch him through the bars, desired but unreachable. . . . Maybe he'd put the cage in his home office so I could watch him working. When he wanted a break he'd come over and tease me, torment my nipples, give me water or drain my piss — or let me drink his piss. . . . He might loosen my restraints and let me relax for a while, or make them tighter and more stringent, emphasizing his total control. He'd toy with my cock and balls, stroke me hard . . . harder . . . bring me almost to the edge . . . but stop short and not let me come . . . never let me come, not while I was in the cage.

Only when he finally took me out, and let me slobber my gratitude all over his tall black boots, his shiny Dehners or his well-worn engineer boots . . . only then would he let me come at last, stroking my hard cock with my cuffed hands . . . still chained, still under restraint, but allowed to reach my dick, allowed to give myself the long-delayed release . . . allowed to spurt my hot cum all over his boots, shooting over and over, covering them with slime . . . and then kneeling low and humbly licking it off, cleaning my discharge from his boots, rasping my tongue over the fragrant leather, making him feel it . . . loving him through his boots . . . proving my gratitude and devotion until, moved by my display, he'd reach down and pull me up to my knees, allow me to take his stiff cock out of his pants and spear it into my throat . . .

I hadn't *intended* to shoot — it just sort of happened. I held up my hand and looked at the wad of cum in my palm. If Terry was there, he'd have made me eat it, so I did. I brought my hand to my mouth and slurped up my load, swallowing it, licking off the residue until my hand was clean, if still sticky. *I'd rather eat his*, I grumbled.

I lay back and drifted in a pleasurable haze for another half hour or so, thinking of nothing in particular, letting images of Stan, Terry, and myself float across my mind's eye. *Wouldn't it be*

nice if life was always like this? I thought. *No work, just bondage play and fucking and jerking off? Of course, it wouldn't feel so special as a regular diet.*

Eventually I got myself together enough to look through the mail, check the phone messages — nothing from Terry, unfortunately — and straighten up the living room a little. I ended the day with some TV and, of course, my five minutes on my knees facing the wall.

I floated through work on Thursday, anticipating hearing from Terry about the weekend. The thought of spending two entire days with him, under his close control, was intoxicating. I kept imagining what he might have in mind for me, though I'd have been happy enough just to follow him around and lie at his feet like a puppy. I had the distinct feeling that this weekend would be my real "audition," the night at the Bondage Club being more like a test drive. *If I don't screw up, maybe he'll give me a full-time collar this time.*

It wasn't Terry's take-charge attitude but his sense of responsibility that made me trust him. *If he owned me, he'd take good care of me.* And I wanted to take care of him, too, to do all I could to make his life more pleasant and satisfying. *I don't want just to submit to him in a scene. I want to follow his lead in everything.* And that meant waiting for him to decide the next move.

One of my late-shift clerks called in sick, so I stayed to help cover the early evening store traffic, had some dinner delivered there, and didn't get home until almost 10 o'clock. The machine was flashing — *Terry called!* I grinned happily and punched the play button.

"Hi, Matt," the message started. "Sorry I didn't catch you in. I'm also sorry that we won't be able to get together this weekend as I'd hoped. Something's come up. It's . . . difficult. I'm not sure when I'll be able to see you again. . . . It's not business but . . . no, I can't tell you about it like this. Later, after I know what I'm going to do. . . . Please understand — it has nothing to do with you. I've had some great times with you, boy, and I'm truly glad I got to know you better. I hope we can pick up where we left off, but . . . well, I can't make any commitments right now. Take care of yourself, Matt."

I fell into the nearest chair, trying to comprehend what he'd told me. All that came through immediately was that he had a

personal problem to deal with and was putting me on ice for the interim. Feelings of rage at being treated so casually warred with concern for him. *What could it be that he can't even tell me about it? Do I dare call him back to ask?*

I played the message again, and then a third time, looking for clues in his oddly strained voice, so uncharacteristically hesitant and unsure. *What could have rattled him so much?* My mind raced, inventing explanations, imagining disasters. *What if I can help? He might be embarrassed to ask me.*

I dug out the number he'd given me and called it. Of course, I got his machine — nothing like phone tag when you really *need* to talk live. But I'd barely gotten out the "Sir" that began the message I was going to leave when he picked up.

"I'm here, Matt. What is it?"

"I heard your message, Sir, and it got me worried. Is there anything I can do? Any way I can help?"

"No, there isn't. I'd let you know if there was. And don't call me 'Sir' right now. I'm not in the mood." His tone was chilly.

"I'm sorry. Can we talk at all?"

"I'd rather not. I told you I'd explain later, after I get things sorted out myself. I'm sorry," he said in a slightly warmer voice. "I know how disappointed you must be. I was looking forward to our first weekend together, too. It's just not possible right now."

"Yes, S . . . Terry. Whatever you say. I'm sorry to intrude."

"It's okay, Matt. I can understand that you might have been worried. It'll work out all right, but it's going to take some time." It sounded as if he'd covered the phone with his hand for a few moments. *Is someone there with him?* "Maybe we can talk a little at the GMSMA meeting next week," he said when he uncovered the mouthpiece again.

"Sure thing. See you then, I hope."

"Fine."

"Bye for now, then."

"Goodbye, Matt."

The click as he hung up sounded unnaturally loud, and I felt sick to my stomach. I went into the bathroom, where I saw the ashen face of a stranger in the mirror. I quickly knelt in front of the toilet and puked out the remains of my dinner.

That was the last kneeling I did for a while. Like Terry with being called "Sir," I was no longer in the mood. I was sure he'd

dumped me, and I was furious he hadn't been honest enough to say so. I just couldn't imagine any trouble he could be having that he'd be so reluctant to explain. If his business was failing or his parents were sick or he'd just been diagnosed with cancer, there'd be no reason not to tell me. Oh, he might not go into details, but he could at least say what it was all about. The only thing that seemed to fit his odd behavior was that he'd found a new boy-friend — or that an old one had got his hooks in him again.

Stan's right, I thought, *relationships aren't worth the trouble. They never last anyway, so why even start? Fuck this Master/slave shit. Back to being a freelance bottom! I can hang loose, get laid when I want to, how I want to, and not have to answer to anyone the rest of the time. Good friends and good tricks, that's all I need.*

That mood carried me through the night, though I tossed and turned with bad dreams I couldn't remember on waking, and on Friday I threw myself into my work, attacking the pile of pa-per on my desk with manic energy, muttering under my breath.

"Trouble with your new flame, Matt?" Magda asked.

"Yeah," I admitted sourly. "He dumped me, I think, and for no reason."

"You 'think' he dumped you? Aren't you sure?"

"Well, he never said we were quits, just the usual line about how he doesn't have time right now but he'll let me know. I think he found someone new on a trip to Vermont last week."

"And your evidence for this is . . . ?"

"I don't have any. It's just a strong feeling. But I'm sure he was with someone else when I called last night."

"Maybe you're leaping to the wrong conclusion, Matt. Just last week you seemed so happy. Why give up on him so easily?"

"Oh, I know you dykes mate for life," I grinned at her, "but we guys don't take this stuff so seriously. It's just sex, isn't it?"

"Is it? Ask yourself that — ask yourself real hard," she said as she left the office. "It's *your* life you may be fucking up."

I shrugged and went back to work, but Magda's question nagged at me. *Would I be so upset at "losing" Terry if it had been just a sexual infatuation? And if not, isn't he worth a little patience — in case my interpretation is wrong?*

I shook my head and refused to think about it for the rest of the day, and after work I went to dinner and a dumb action movie with some friends. They wanted to finish the evening at

Rawhide in Chelsea, a "leatherette" bar, so I tagged along. I let the hard music and the hard bods flexing to it sedate me for a while, but around 12:30 I came to my senses, realized there was absolutely no reason for me to be there, and went home. On my way to bed, I automatically paused by the wall where I'd been meditating, but I turned away angrily.

I slept badly again. I woke shaking and drenched in sweat from one dream. I couldn't remember the beginning, but it ended with Terry walking away from me — I called out, but he didn't even turn around. *Just my body's way of getting me to wake up and go piss*, I told myself. *Doesn't mean a thing*. I tossed and turned for a couple of hours before falling again into an exhausted slumber. If I had any more dreams about Terry, I couldn't remember them.

Saturday was a work day, as I'd had Wednesday off, and a fairly heavy one. There was less business trade than during the week, but plenty of tourists and students came in. Loggy from lack of sleep, I drank cup after cup of coffee and somehow made it through the day till closing. By the time I got home and had dinner, I was so exhausted that I laid down for a nap. I woke about 10 o'clock, feeling much better, and decided to get dressed and go out. I was horny again, and lonely and depressed to boot. While I wasn't *sure* Terry had dumped me, I couldn't convince myself he hadn't, either. At least I wouldn't run into him and whoever my replacement was — he almost never showed himself in the bars on weekends. I hoped that a room full of other hot men would get my mind off him for a while. *Maybe I'll even score with one of them!*

I went to Altar, a leather bar that had opened a couple of months earlier down in Tribeca. Until it closed a year later, it gave the Spike some much-needed competition on weekends. It was mostly dead on weeknights, because it was so far from any other gay nightlife, but it became *the* place for hard-core leathermen to go on Friday and Saturday nights.

I dressed simply in worn jeans, T-shirt (a drawing of a bound man licking a boot adorned my right pec), leather MC jacket, and lineman's boots. When I got down to the bar, I saw several men I knew (some slightly, others more intimately), plus others I didn't — *don't know yet*, I said to myself. A cold front had come in, and soon the place was wall-to-wall leather.

Despite my bravado, even after several turns around the

room I still hadn't hit cruising speed. With the guys I knew, all I could manage was gossip and other small talk. There was just no sexual electricity, even with topmen I'd enjoyed playing with in the past. Whenever I saw someone interesting I didn't know and tried to chat him up, I was easily distracted by bits of conversation around us, and I couldn't stop mentally comparing him with Terry — invariably to the newcomer's disadvantage. So I moved on to someone else, only to have the same things happen again. When I caught myself being rudely brusque after one guy took the initiative and cruised me, I retreated to a corner and cooled it. *Don't want to get a rep as a prick-tease. Just* looking *can't get me into trouble.*

I was nursing my third soda and feeling fairly down in the dumps when I saw that Jake had taken his usual stool at the end of the bar. (It was when *he* switched his allegiance from the Spike that Altar really caught on.) Jake was as "old guard" as you can get, having come out into the leather scene in the late 1950s. Now pushing 70, he'd been a mere lad in his early 20s when he'd started — much younger than usual back then. His custom-made leathers were far from new, but they still fit him perfectly. The back of his shaved head gleamed under the rim of his Muir cap. His long, black Fu Manchu 'stache made him look even more forbidding with the cap off. When I saw a space open up next to him, though, I settled back against the bar so I could face him and also keep an eye on the milling crowd. Out of respect, I waited for him to speak first.

If you didn't know better, you might peg Jake as an old alcoholic, since he didn't circulate and cruise, just sat at the bar and let others approach him. But if you watched closely, you'd see how long he nursed a single drink (tipping the bartender generously) and how easily he could tell what was going on behind him by looking into the mirror over the bar. He didn't miss much. He was never surprised when a friend came over to chat, and he always knew who was looking for what just by how they were dressed, how they moved, and where their eyes went.

"Hello, Matt," he said after a few moments, turning only his head toward me. "Haven't seen you in a while. How're things going with you and Terry?"

I stared, slack-jawed, while he sipped his drink and smiled like a leather Buddha.

"How do you know about me and Terry? Did *he* tell you?"

"Yes, my young friend, we've talked. But I also have other sources. Surely you didn't imagine that the kind of show you two put on at the Spike the other week would go unremarked? In the old days, of course, leading someone out of the bar on a leash was nothing special — it was practically *de rigueur*."

At first I was embarrassed by the idea that Jake's spies were reporting on my affairs, but by the time he delivered his punchline, deadpan, I was laughing. Jake always scoffed when I said he was mellowing, but in the '70s he wouldn't even have spoken with a bottomman who didn't approach him correctly, let alone befriended one. These days he'd speak affably with anyone who was reasonably polite. More than a few young leather punks — profusely pierced, mohawked bad boys who'll do anything with anyone, regardless of roles or rules, as long as it feels good — confided in him like a favorite uncle. It was probably one of them, his West Street Irregulars, who'd ratted on us. I was glad, actually, that he knew about Terry and me, because I wanted his advice.

Jake and I went back more than five years. In my first forays into the scene after Greg's death, I wasn't at all sure what I wanted or what to look for. I liked older men, and I'd heard Jake was one of the best topmen around, so I came on to him. He explained that he was mainly interested in slaves, not bottoms, but I didn't grasp the distinction — a lot of the guys I'd met called all bottoms "slave," at least while the scene lasted. I kept after Jake until he decided to *show* me the difference.

My weekend as his slave was — as I'd alluded to Terry — the most boring and unsatisfying s/m experience I'd had. I kept waiting for Jake to *do* something to me, to play my body like an instrument, but all he did was go about his life while using me as a household and sexual convenience. Whether he was fucking my ass or telling me where to put away the dishes I'd just washed and dried, he treated me exactly the same. It wasn't a role he was playing — we weren't doing a "scene." The phone rang as I was sucking his cock, and he made me continue while he chatted with his friend. *That* was truly humiliating, and I didn't like it one bit.

When he let me go, I was willing to take his word that I was no slave at heart, though I also nursed a suspicion that he wasn't such a great Master after all. He was cordial but distant when our paths crossed later on. It took me a couple more years and a lot

more experience to understand why all the best topmen deferred to him, or why so many handsome and accomplished bottoms were eager to be trained by him.

Eventually I approached Jake again, but more as a student than a trainee, and we talked and talked — actually, he talked and I listened, except when he quizzed me to be sure I'd been paying attention. He explained, then, that what he'd put me through that weekend had been a deliberately humdrum sample of erotic slavery as a way of life, rather than as an exciting interlude in an otherwise "normal" life. The slaves he trained got plenty of excitement — but *after* they'd learned to derive most of their reward from obedient service itself.

Jake's "philosophy" of erotic slavery was pretty hard-nosed. For instance: *Most slaves aren't selfless at all but extremely self-centered. They don't get off on serving so much as on being told what to do. They may love their Masters, and sincerely want to make them happy, but the essential thing for them is that someone else is willing to make their personal decisions — or at least give them clear guidelines and limits so they don't get lost in an endless sea of possibilities. That's why training and discipline are so important: a Master "hooks" the slave by relieving him of personal decisions, but then he has to refocus the energy saved into serving the Master's needs.*

When I first heard that line of thought from Jake, a few years previously, it just seemed to confirm his judgment — and mine! — that I was no slave. I didn't seem to fit that particular mold. But now I wasn't so sure. I *liked* it when Terry told me what to do, just as I'd preferred to let Greg make most of the decisions for both of us — until he couldn't anymore. I recalled more of Jake's theories, which seemed to take account of the differences between slaves as well as their similarities.

It's a myth that most people want the maximum possible range of choice, Jake had told me. *Few actually* enjoy *making choices, and most would be happier if they didn't have to make so many — slaves just carry that common attitude to an extreme. There are plenty of good slaves who have no trouble making decisions and taking responsibility for them at their jobs, but when it comes to their personal lives, they agonize and procrastinate. These slaves realize what an immense gift it is for a Master to take on that burden, so they try to make it as light for him as possible — meaning they accept even decisions they don't like with good grace and don't demand perfection from the*

Master, but simply decisiveness. Other slaves, though, seem to take it for granted that there are these men called Masters who'll be happy to do what the slaves don't want to do for themselves. Luckily, they're right! Masters crave authority and responsibility, while slaves want to be free of them. It's a truly symbiotic relationship.

His take on why so many Master/slave relationships fail was consistent with his underlying view: *It's hard work being a Master, harder in some ways than being a slave, and some men can't keep it up. They slack off, take it easy, and before they know it, they've squandered the magic. It isn't a matter of keeping up the rituals — any good protocol allows for "down time" when things aren't so strict and formal — so much as maintaining the Master's authority. He must always be the one who makes the decisions, even if he decides not to decide something, to leave it to the slave's discretion.*

But a good Master hardly ever gives his slaves choices — not even for fun, and especially *not as a reward. It's ludicrous: the slave gives his obedience in return for being relieved of personal choices, and the Master tries to reward him by giving him a choice of food or recreation or sex! I've even seen Masters make a slave choose what he'll be flogged with, or between a flogging and cock-and-ball torture, say. That spoils the whole thing. It's not simply unfair to make a slave choose his torture — it's counterproductive, undermining the very basis of a slave's commitment. It's the Master's job to make decisions and the slave's job to follow them. Anything else turns the world on its head.*

The only choice a slave needs to make, Jake insisted, *is whether to obey and remain a slave, or to disobey and lose his position. And it's the Master's job to make that choice as easy as possible until the habit of obedience is deeply ingrained. A good Master, like a good military officer, never gives an order he has any doubt will be obeyed. The hard part is for the Master to keep a slave contented, actively preferring slavery to freedom, without making him lose the sense that he's a slave. If you're too kind and accommodate too many of a slave's likes and dislikes — and they all have 'em, they're just not important — he'll probably leave you for a sterner Master.*

Jake was keenly aware of how artificial it can seem to talk of "slavery" in a free society: *A slave is property, of course, but since you can't keep slaves today against their will — which is a good thing, I think! — it's best to view them as* leased *property, which must someday be returned to the owner in good condition, not goods to be consumed or used up and then thrown out. Ultimately, a slave's owner is*

himself or his god or the universe, but in no case the Master he serves!
Masters are caretakers and stewards, and if we get our own needs met
in the process, it's only fair.

A slave who's well trained and well treated — which doesn't
mean indulged or cosseted — will tend to increase in value the longer
you keep him, like real estate. Putting in time and effort to train and
discipline him is like building on leased property, improving its value
not only to you as lessor but also to the leaseholder. Buildings decay if
they're not continuously used and carefully maintained — slaves are
no different. Even a slave who's too old to be physically very useful, or
attractive sexually, can have inestimable value as a companion and
confidant, or as a trainer for new slaves.

Jake also explained something I'd often found puzzling: the
desire of many slaves to be used by someone other than the Mas-
ters they'd chosen to serve — to be lent out, shared among the
Master's friends, made to turn tricks for money like a whore, even
"sold." *It emphasizes their sense of being property*, Jake said. *What-*
ever a Master does to his slave in terms of bondage, sex, or s/m might
be done by a top to his bottom lover; but lovers don't lend their part-
ners to friends, or make them service strangers. Even if a slave hates
the idea of being lent to someone else, he'll be a better, happier slave
afterward. It's not the service itself that's important, or how in particu-
lar he's used, but simply that he doesn't have any say in the matter.

Jake had taught me that I *wasn't* a slave, and I'd been happy
enough as a freelance bottom. I didn't have any trouble making
my own decisions, and I didn't have any burning desire to be an-
other man's property, leased or otherwise. But Terry had treated
me more like a slave than any other top had done in a long time,
and I'd responded more profoundly to him than to anyone else
since Greg. I still had trouble seeing myself as a slave, but I *want-*
ed him, I wanted him bad, and I didn't think he'd let me into his
life except as a slave. I figured Jake could help me sort it out — if
it wasn't already too late.

"Can you be seduced into slavery against your will, Jake? I
mean, can you respond to someone like his slave — respond emo-
tionally — even though you're not actually cut out to be a slave?"

"You'd certainly think so," he said, "from the literature of
romantic love, but all that guff about being a 'slave for love' is
only metaphor. If you don't *need* to be a slave, love won't make
you one. If that's what your beloved demands, in time you'll come

to resent him. And if you put the burden of Mastery on someone you love against *his* true feelings, he'll come to resent you. No, I think it has to be something you're both comfortable with from the start, or it's a mistake. But Terry didn't set out to make you his slave, did he?"

"The opposite, in fact — he told me he *wasn't* looking for a slave. You know, 'Been there, done that.' I'm the one who pressed the issue. I even told him pointblank, after our first sessions, that I thought he really wants a slave but is afraid to admit it. Pissed him off, too, but later he admitted I was right."

"Why did you press the issue?"

"Because he treated me like a slave, and he was making me like it, while claiming he was doing something else."

"For example?"

"The way he took my obedience for granted, his assumption that I'd jump whenever he snapped his fingers, and just wait patiently for him the rest of the time. The way he kept pulling more out of me than I thought I wanted or was able to give, making me eager for his approval. The way he handled my body — like he already owned it."

"And that kind of treatment bothers you, Matt?"

"What bothers me is that it doesn't! I want more of it, from him anyway, and I don't understand why!"

"Why is it so hard to understand?"

"I'm not *supposed* to enjoy being treated like that! You said so yourself, that I'm not a slave at heart. And it doesn't fit my concept of myself, either. Unless you count bootlicking — which for me isn't servile or humiliating at all — I've never been into role-playing sex games, just good, intense physical stuff, the kind where you hug or shake hands afterward and walk away drained and cleansed."

"How did you walk away from your sessions with Terry?"

"Wanting more, wanting to stay with him, feeling abandoned when he drove away. . . . Feeling abandoned *now*, simply because he said he couldn't see me for a while. Am I just lovesick? Or could I be slave material after all?"

Jake was silent for several minutes, stroking the ends of his moustache and staring into his glass. I waited silently, but my heart was pounding in anticipation of his verdict. I didn't know which judgment I feared more: that I was ready to be enslaved,

or that I was merely in love. *Neither is likely to make my future life any easier*, I concluded.

"Hmmph," Jake finally grunted, then looked up at me. "I understand now why you're so confused. I'd have to say the answer is, both. Terry obviously tapped a deeper, stronger vein of submissiveness than either of you knew you had. And since he's still gun-shy about a Master/slave relationship after the failure, as he calls it, of his first one, he may be pulling back a little. The trouble is, you've fallen for him — and fallen hard."

He paused and rubbed his chin before continuing.

"I can't say which came first, whether you fell for him because of the submissive feelings he roused in you, or whether he reached that hidden core of feelings in you because of your strong attraction to him. But does it really matter? In either case, he has you 'enthralled' — a fine old word that can mean both *enslaved* and *enchanted*. The best, and happiest, slaves are usually both. Love can't *make* you a slave, as I said earlier, but it *is* much easier to be the slave of a man you love."

"But what should I *do*?"

"Nothing you *can* do, Matt, except follow his lead. It won't kill you, you know," he said with a grin, "to allow a top to be in control for a change."

Blushing, I asked, "But what if I've lost him already?"

"What did he say, exactly, in that message he left?"

"Well, the last thing was, 'I hope we can pick up where we left off, but I can't make any commitments right now.' And then he said I should take care of myself."

Jake was shaking his head. "You're a fool if you think that was a brushoff, Matt. I've known Terry a long time, and the last thing I'd call him is flighty. *You're* the one with the love 'em and leave 'em reputation, not Terry! I think he's extremely interested in pursuing some kind of a relationship with you. But didn't he warn you it couldn't be a live-in arrangement?"

"Yes, and that's fine. But what'd he tell you? What's going on with him now?"

"I've already said more than I should. He'll tell you what's going on in his own way, when he's ready. Learn some patience! Use this period to cool down and think about what you really want. But don't assume Terry's giving up on you. If he ever does, you'll know it."

"What if he decides he *does* want me as his slave? Do you think I can do it? What if I can't? What if I let him down?"

"I wouldn't have thought you could be a slave, Matt, but then, I wouldn't have thought I'd see you blush, either. You're going through changes, boy. Let them happen! Stop fighting it."

"Guess you're right, Jake," I said with a resigned sigh. "And thanks — you've helped me a lot."

"I think you're worth it, Matt. And so, I'm sure, does Terry. Now go on home and get some rest. There's nothing here for you tonight."

"Yes, Sir," I said.

"Smartass — get out of here."

"'Night, Jake. And thanks again."

CHAPTER 16
Payback

After my talk with Jake, I slept better than I had on Friday, but on Sunday afternoon I was still a bit down in the dumps — and even hornier than before. So I called Curt to ask if I could come by and pick up my book. Stan had been due for release from the cage on Saturday night, and I figured chatting about his experience would at least get my mind off Terry, if not my dick.

"We're spending a lazy day together," Curt told me. "The marathon cage scene is *over*. Why don't you join us for dinner? Say about 7:00?"

"That'd be great! Thanks. Anything I can bring?"

"Nah. I've got all I need right here." *I'll bet he does!*

I still didn't want to arrive empty-handed, but you can't buy wine on Sunday in New York, so I picked up a chocolate-mousse cake at Zabar's on the way downtown and showed up right on time. Stan let me in. Like me, he was wearing jeans and a T-shirt, but they must have been Curt's, as they didn't quite fit. His feet were bare. Otherwise, he looked as fit and sassy as ever. No one seeing him would have guessed what he'd gone through in the past week. We hugged and kissed, then strolled into the kitchen arm in arm to watch Curt make jambalaya, one of his specialties.

Curt looked both cool and "hot" in khaki shorts, an Army T-shirt, and spit-shined paratrooper boots over white athletic socks. I started to explain a theory I was forming about tops who liked to cook — something about their need to control everything — when he told us to get lost until he called us.

The table was already set. I looked around for the cage and almost didn't see it next to the couch. A piece of wood was fitted over the top, and a lamp was sitting on it. But the door faced out,

so it would be easy to put it to use again. I started to throw a woody at the thought of being locked inside it, but I told myself that this was a purely social occasion, just dinner with friends. It didn't help. My cock was straining against my jeans.

Stan must have noticed, but he didn't say anything as we sat on the couch to talk. He immediately jumped up again to get us some wine. I looked after him into the kitchen and saw him hug Curt from behind and nuzzle his shoulder. *Hmm*

Stan returned with the wine and sat down next to me, smiling like a man without a care in the world. The smells from the kitchen were making my mouth water.

"So how's it feel to be a free man again?" I asked after we clicked glasses and sipped.

"It feels great just to be able to *move*," he said. "And to be clean!"

"When did Curt spring you?"

"I think around 6:00 last night, a couple of hours before dinner, anyway. He let me out, took off the hood and gag, and carried me into the bathroom — I couldn't walk on my own right away. He dumped me into a lovely hot tub. Oh . . . yeah, I guess he took out the butt plug first!"

"That'd make sense," I laughed. "But I bet it wasn't long before he plugged you again with something else."

"You have a dirty mind, Mr. Stone," Stan said with a grin. "It was *at least* half an hour before we started fucking."

"In bed? Or on the floor of the bathroom?"

"Mostly in bed, but also on the floor and out here and just about everywhere else in this place. I was so horny by then, I was almost out of my mind. Can you believe that sadist didn't let me come once while I was locked up? Not once! I did have a couple of wet dreams, though."

"Poor baby," I clucked in sympathy. "Was that the hardest part to take?"

"No. The hood and the earplugs were the hardest part. . . . Surprised me, too," he said when I lifted an eyebrow. "You know how I love that hood, and for the first day or so I was in heaven. I just shut down the part of my brain that deals with the outside world and dived into myself. My babysitter that first day wasn't very demanding — I don't know if Curt planned it that way or not. He pretty much left me alone except for giving me juice and

draining my piss. And Curt hadn't got too creative yet with my bondage aside from the cage and hood themselves. My hands were cuffed behind my back, but that was it. I could move around in the cage however I wanted most of the time, and I kept some muscle tone with rather unorthodox isometric exercises."

"But that wasn't how it was the whole week," I said with a straight face. "You got more of a workout from some of the other sitters, didn't you?"

"Yeah," he said, looking right at me, "especially that bastard on Wednesday. He pinched me, and fucked me, and twisted me up, and then spanked me in the bargain. If I ever find out who that was, I'll . . ." But by then I was grinning and he broke into laughter.

"You were just so irresistible, Stan," I said. "You brought out the latent top in me. I hope you enjoyed it as much as I did!"

"Fuckin'-A," he said. "You were great! I wasn't sure it was you, because you were so rough, but it was just what I needed. The whole trip was. I've never felt so totally open and vulnerable before, or so confident I could take anything, too. It was like . . . well, the cage became my shield as well as my prison. I knew you guys wouldn't take me out of the cage, so there was always that limit on what you could do to me."

"I thought I did a lot. How about the other sitters, besides the lazy one on Monday?" I grinned at him.

"They came up with all kinds of stuff. Curt has some really twisted friends."

"For instance?"

"Well, one guy hogtied me and hung me from the top of the cage, upside down, with weights on my tits and balls. After a while, the pain in my arms was so bad, I was afraid they'd pop out of the joints."

That sounded dangerous, and I was about to ask about it, but Stan changed the subject.

"So how're things with your boyfriend — y'know, Mr. I'll Call Him Dickhead If I Want To?"

My face reddened and my stomach twisted simultaneously. I felt I should defend Terry, but I was also pissed at him.

"I really didn't mind that name, Stan," I said. "When he teases me like that, it doesn't seem mean or hurtful. It's actually kind of sexy."

"If you're into verbal abuse, maybe. So what did he do to you after he got rid of my interference? I would have checked in with you later if I could, but I was otherwise engaged myself."

"I noticed! I was there when Curt untied you, but I left while you were still hooded."

"So he told me."

"Anyway, Terry used only the simplest techniques and materials, nothing flashy or elaborate, but it got surprisingly intense — more in terms of pain and domination than pure bondage."

I briefly described the way he'd tied me and the nipple/ball-torture combo setup he'd used. I glossed over my bootlicking, as that holds no interest for Stan.

"And we had the most amazing talk afterward."

"Sure you did. He's a talker, that one."

"Damn it, Stan! I learned a lot about him from that scene and conversation, and I think he liked what he learned about me. We're connecting in a way I haven't with anyone since Greg. He doesn't want a doormat as a slave, a no-account boy with no life or mind of his own. I think he wants someone who'll challenge him, make him work to stay in control."

"Then you're his boy, all right!"

"I hope so."

"Only hope? Why aren't you sporting a collar already?"

"Well, I figured I'd get one this weekend. He called me from Vermont, where he had to go on business, the Saturday after the Bondage Club, and then again on Tuesday night. We had these mind-blowing phone-sex sessions, and I was supposed to spend this weekend at his place."

"So why're you hobnobbing with us peasants?"

I glared at him, but he just grinned back.

"On Thursday he called it off," I explained, and the memory twisted my guts all over again. "He said something unexpected had come up, something he couldn't tell me about yet, and as a result he wouldn't be able to see me for a while."

"He *dumped* you?" Stan asked angrily.

"That's what I thought at first, but he never said so. He said he hoped we could pick up where we left off."

"He probably doesn't have the guts to make a clean break."

"C'mon, Stan, be fair. You have a grudge against him because he turned you down once."

"That's not it," he claimed. "He just bugs me. He's too tall. Too full of himself. Isn't that reason enough?"

"Well, he doesn't bug *me*. I love him, Stan, and I'll wait if I have to — but not forever. Anyway, Jake says he's sure Terry still wants me."

"Jake? That old spider who props up the bar at Altar?"

"The same. I like him. He's interesting to talk with, and he seems to be close to Terry."

"Figures those two would get along. . . . Matt, you know I want you to be happy, but unexplainable hitches in an affair are *not* a good sign. It could mean he's found someone else he likes better. Maybe he decided you're more independent minded than he really wants, or that you'd be too much work to control."

Stan's guess was too close to my own fears for comfort, but just then Curt called us to the table. He told me where to sit, and Stan went into the kitchen to help carry the food out. It was interesting to watch them together. Stan deferred to Curt if he gave a direct order — after all, he was as much a guest in Curt's home as I was — but didn't act submissive otherwise. He was playfully affectionate, touching or kissing Curt every chance he got, smiling at him, radiating such waves of good cheer that it was hard to believe this was my cynical friend. Curt, for his part, appeared amused by Stan's attitude, as if confident it wouldn't last.

Stan's remark about being hogtied and hung from the top of the cage still bothered me. I'd given him a moderately rough time, but I hadn't done anything truly unsafe. After we'd tucked into the jambalaya — and showered Curt with deserved praise — I asked him about the episode.

"The man who did that is a doctor where I work," Curt said, "and he knew exactly what he was doing. I'm sure Stan was in no danger at all."

"But how did Stan know that?" I pressed.

"He knew that I chose the sitters, and presumably he trusted me not to leave him with anyone irresponsible or stupid. That right, Stan?"

"Sure," he said. "I was scared, of course, but that was okay. I'd asked you to put me in there. I'd given you permission to turn me over to other tops. If one of them played rougher than I usually liked, tough! Once we started, I'd just have to deal with it. 'Consensual nonconsensuality,' I think they call it."

"You wanted to feel what it was like to be a real prisoner," Curt said, "and that's what I gave you."

"For which you have my undying gratitude and appreciation!" Stan exclaimed. "I'm not the one shaking my head over it — it's Matt. He worries too much: about me, himself, the world in general. I think you could use a week in a cage yourself, buddy. It would teach you what's important, like breathing and sex, and what isn't, like almost everything else."

This was an old argument: Stan's basically an anarchist, and I'm a wishy-washy liberal always worried about doing the right thing. Curt didn't seem very interested in that line of talk, so I asked Stan why the hood had been the hardest part of the experience to endure.

"It's not just that you itch and can't scratch," he said, "or that you can't see anything or hear more than vague noises and your own breathing. It's that when there's so little other stimulation, the constant pressure of the hood around your face and head gets magnified into the most awful creepy-crawlies. That's one reason I was so grateful when you guys worked me over, even when you made me hurt, because it helped me stop noticing the hood for a while."

"He actually begged me several times to leave it off after his morning break was over," Curt said, "but I'd promised to ignore his pleas, and I did."

"He's a very hard man," Stan said, shaking his head in mock horror, "a very hard man. And we all know what they're good for, don't we boys and girls?"

We gave him his laugh, and he grinned like a kid who's just broken up the class behind teacher's back.

"Actually," Curt said, "I don't think I'd do it that way again no matter what the bottom asked for. Someone less experienced with hoods than Stan, or wearing a less well-fitted hood, would have cracked. Next time I'll leave the hood off at night, when we're both sleeping."

"That's assuming you get another pigeon for your cage," I said. "Who else would want to go through that?"

"Oh, you'd be surprised," Curt grinned. "Stan's hardly the first prisoner I've had in there, even if he stayed the longest. Why, I'll bet I could talk *you* into giving it a try."

"C'mon, Matt, you know you want to," Stan urged. I looked

from his familiar smirk to Curt's white-toothed grin splitting his dark face and back again. My cock was hard. *I'm doomed!*

"Give it a rest, you guys," I protested feebly. "I can't get into a scene tonight. I've gotta work tomorrow."

"Just a couple of hours, Matt?" Curt said. "And then we'll let you out and have dessert." The way Stan was grinning, I didn't think chocolate-mousse cake was what they had in mind!

"He can dish it out, but he can't take it," Stan sneered, and that was a challenge I couldn't ignore. *How much can they do to me in a couple of hours, anyway?*

"Okay, okay. Just two hours. Promise?"

"Sure, sure, Matt," Curt grinned. "Two hours. Starting *after* you're inside. Now get out of those clothes!"

I got up from the table and stepped toward the living area, facing the couch and trying to hide my excitement, though of course they'd see everything I had soon enough. Stan cleared the table, and Curt went for some gear. When I was stripped he told me to use the bathroom, but after that there were no more delays.

When I returned, the lamp and top had been removed from the cage, which they'd wheeled out to the center of the room. I was quickly cuffed behind my back, my ears plugged, and laced and strapped into one of Curt's hoods. It wasn't custom-made for me, like Stan's was for him, but it was plenty snug. There was no gag, just a breathing hole at the mouth along with the nose holes, but my jaw was held closed.

I sank to my knees when Curt pressed on my shoulders, and he or Stan guided me into the cage. I stopped moving when I was unable to go forward anymore, then heard the muffled sound of the door slamming shut behind me. I tried to squirm around to face out again — not that it made any difference, since I couldn't see — but I'm too tall (five inches taller than Stan) and wasn't able to manage it. So I sat back against the door and stretched my legs out. Since I couldn't get them quite straight inside the cage, I stuck my feet through the bars.

That was a mistake — they shackled my feet so I couldn't move them back inside again. I made no resistance, just sat still and waited for whatever they'd do next. Sure enough, one handcuff was released so my wrists could be recuffed outside the bars, the way Stan's had been when I arrived on Wednesday. *If he's holding a grudge for how I treated him, I'm really in for it!*

But they left me alone after that, I'm not sure how long. I sat there and just breathed the leather-scented air, enjoying the quiet and darkness. It was actually very pleasant to sit like that, removed from responsibility — I didn't even have to hold up my end of the conversation! It wasn't as exciting as I'd expected, however. Adding sensory deprivation to the confinement diminished the impact of the cage itself. Hooded and bound as I was, I didn't have a strong sense of being *caged*. I could have been immobilized just as effectively in a number of other ways.

Nonetheless, as the time seemed to drag, isolation and immobility worked their spells on me, and I felt both more vulnerable and more submissive. My empty asshole twitched, and each breath of air against my naked skin made me long for a human touch, however painful. I imagined Curt and Stan watching me, laughing at me, and my face flamed. But what I *really* wanted was for them to play with me, even torture me!

I started shifting around as much as I could, rattling the metal restraints against the bars, trying to draw their attention. When that had no effect, I'm ashamed to say that I started *begging* for some attention, as well as I could through the tight hood. Still nothing. *Bastards! I can't believe Stan endured a whole week of this!*

They told me later, laughing hysterically, that it'd been only 50 minutes before I'd started to crack, and only 15 minutes more before they came to my rescue — not by letting me out, but by starting to torture me in earnest!

They warmed me up by stroking me gently till I was moaning in pleasure, then began tickling me all over, searching out my most sensitive spots. Once they discovered them, they uncuffed my hands and legs, then strapped my ankles to the back corners and my knees to the sides of the cage and my wrists to the top, above my head. My armpits, ribs, and crotch were thus completely accessible. While I could squirm a little, there was ultimately no escaping their teasing strokes.

Besides their fingers — all 20 of 'em! — they used an arsenal of "abrasion" tools Curt showed me after dessert: various little brushes (one designed for cleaning silk off ears of corn!), bigger, stiffer brushes for grooming humans, dogs, or horses, and half a dozen gloves or mitts — thick rubber with little nubs (also for horse grooming), leather, silk, coarse burlap, fur (I'd really liked that one!), and loofa (very, ah . . . invigorating when used dry!).

Between assaults on my soft parts, the fiends kept returning to my cock, teasing me into erection again and again. It seemed an eternity — but was only about half an hour — that I sat there, helpless, as they expertly tortured and teased my pits and chest and crotch until they were raw and enflamed, my abs and throat were sore from giggling and shrieking, and I was so desperate to get off I'd have done *anything* they demanded. I was way past fantasizing about Terry — I was nailed to the here and now, in Curt's cage, where he and my best friend had me at their mercy.

"You want me to make you come, boy?" Curt asked close to my ear.

"Yes, Sir, please, Sir!" I said as clearly as the hood would allow me.

"You pissed into my boy when he was under your care," he accused. *Oh, shit! I'm done for now!*

"Yes, Sir, sorry, Sir."

"I'll let you come, but first you're going to take a load of *his* piss. Nod your head if you agree."

I nodded vigorously, feeling as sure about Stan's health status as I'd expected him to be of mine. I felt one of them bend my head back and stick a tube into the breathing hole of my hood. I braced myself for the piss, and finally it started coming . . . tasted really rank, too! But . . . *is this really Stan's piss?* I asked myself as the sour, salty stream poured into my mouth and I swallowed it down. *It's . . . what the hell? Fuck! It's sauerkraut juice!*

In typical Stan fashion, Stan had gotten his revenge.

Of course, I was no longer in any mood to shoot my load, but Curt was as good as his word. After they let me out of the cage, after we had cake and coffee — I was still naked and shackled, but handcuffed in front, and sitting on the floor while they shared the couch — we adjourned to the sleeping alcove. I was again hooded, then tied face up on the bed in a *tight* spreadeagle (Stan knows what I like!). My dick stood up like a flagpole. Slowly, sensuously, they lubed it, and while one of them (Curt? Stan?) pinched and pulled at my nipples, the other (Stan? Curt?) stroked me — all too quickly! — to a most satisfying explosion.

After they'd released me, I offered to return the favor, with hand, mouth, or ass.

"Maybe another time — we're pretty fucked out already," Curt said, laughing, as they hugged me. But from what I felt as

they pressed against me, front and back, and the looks they gave each other, I figured they just wanted some privacy. It was clearly time for me to say goodnight, so I dressed and took my leave — but not before getting down on my knees at the front door and kissing Curt's boots in thanks.

"Hey, I like that," he said, then turned to Stan. "Wouldn't hurt you to get *your* tongue on my jumpboots, cageboy."

"In your dreams, mister," Stan said, grinning. Curt grabbed him and wrapped a brawny brown arm around his throat, holding both of his wrists behind him with the other hand.

"Matt, it's been a pleasure," Curt said. "And thanks for helping out on Wednesday. Now, if you'll excuse us while I teach this fucker some respect?"

"Sure thing, Curt, and thanks for the great evening. Talk to you soon, Stan?"

But he could only mumble and struggle — not too hard! — as Curt held him tight. I left them to it and headed home in substantially better spirits than when I'd arrived.

CHAPTER 17
Bondage night at GMSMA

I'd have gone to the GMSMA meeting that Wednesday, the first fall program after the summer break, even if Terry hadn't said he might be there. (It seemed more than a mere two weeks since we'd missed the season opener, a purely social meeting. Driving back to the city after our "first date," we never gave it a thought.) The topic was long-term bondage — something I had some interest in even before Stan's epic cage trip. I managed to leave work earlier than usual to go home and change. There was a nip in the late-September air, so I wore my leather jacket and chaps over my jeans, plus harness-strap boots and that handcuff-shaped belt buckle I'd described to Terry in our first phone-sex scene.

I got to the Center a few minutes past 8:00, plenty of time for socializing and cruising before the program. It was like Old Home Week as I greeted men I hadn't seen in months because they spent their summer weekends on Fire Island or upstate.

Stan, too, had said he'd be at the meeting, as I'd have expected given the topic, but I didn't see him anywhere. Around 8:20, however, Terry came in — and my heart sank when I saw his companion. I stood off to the side while they extricated themselves from the crush at the door.

Terry looked cheerful and happy, not preoccupied with any unexpected trouble. As usual, he was a fetishist's dream (*this* fetishist, anyway!), wearing the same gear as when he'd come to find me at the Bondage Club: leather breeches with gray-and-yellow stripes on the outside seams tucked at the knee into his "lucky" engineer boots, police handcuffs swinging from his wide belt, and short-sleeve gray leather uniform shirt, to which he'd attached his GMSMA name badge. Seeing him so apparently untroubled, I

seethed with resentment, once again leaning toward the idea that he'd dumped me — *he already has my replacement!*

The "replacement," who wore a red "newcomer" dot and carried both their jackets, had on faded, frayed jeans, knee-high black lineman's boots, and a tight, short-sleeve black latex shirt. He came up only to Terry's moustache, an inch or so shorter than me, but he looked a couple of years younger. His pale blond hair fell straight almost to his shoulders, framing a deeply tanned, stunningly beautiful face — almost elfin with high cheekbones, a wide forehead, a long, straight nose, and large, long-lashed eyes.

His lean body wasn't pumped-up, with more of a swimmer's build than a gym rat's. On his right bicep was a large blue-black tattoo in the abstract "aboriginal" style that had started to become popular on the West Coast, making me wonder if that was where he was from. I certainly hadn't seen him around the usual local watering holes. No keys or hankies indicated his role preference, but he didn't need any. No one'd ever take him for a top.

Seeing me staring at them, Terry smiled broadly and came over to where I was standing. His companion lagged a few paces behind, indiscriminately collecting flyers and brochures from the literature table near the door. *Definitely an out-of-towner.* I struggled to hide my feelings as Terry extended his hand, giving him a firm, cool grip.

"Hello, Matt. Good to see you. Sorry we couldn't get together last weekend. I hope you weren't too bored or frustrated."

"I managed," I said, biting my tongue to avoid saying more. "Sir," I added, not sure if it was expected or welcome.

"Good," he said with an easy smile.

Why are my legs weak? Damn him anyway! I'm mad at him, and all I want to do is get on my knees and kiss his boots!

"I'll call you after my surprise guest leaves," he said.

"Thank you, Sir. I'll try to be patient."

The actor-model-surfer caught up with us and was hovering at Terry's side.

"Matt, I'd like you to meet Philip," Terry said, nodding over at him. "Philip, this is Matt."

"Nice to meet you, Matt," he said with apparent sincerity, extending his hand with a smile. *His eyes are green, as green as my face must look.* "Terry's told me a lot about you."

"Has he? Nothing libelous, I trust."

I forced a smile and manfully shook his hand, then glanced over at Terry. The corner of his mouth was twitching, as if he was having a hard time not laughing at my discomfiture. He sent Philip off to save seats for them, then turned back to me.

"I told you about Philip," he said, "only not by name. Remember I said I'd had a slave some years ago, but it didn't work out? When we broke up, he moved to San Francisco, and after a while we lost touch."

"So *he's* the dumbass who let you get away? Thought better of it, has he, Sir?"

Terry's mouth opened, but nothing came out. For a moment his eyes flashed, as if he was going to be angry, but then he dissolved in laughter.

"I guess that's a compliment!" he said finally. "He *is* beautiful, isn't he? He's ripened since he left me. I'm not surprised you're jealous. We'll have a *long* talk about that, but not now. This is Phil's first trip back east. He called me out of the blue at my office last Wednesday to say he was in town and ask if he could see me. He was staying at the Y, and it looked pretty scuzzy, so I'm putting him up. We have a lot to talk over, and he's only here another week."

Now it was my turn to stand there with my mouth open, unable to think of a thing to say that could possibly fit the situation. Terry grinned at me again, then scanned the room.

"Better get yourself a seat, Matt — this looks like a sell-out crowd. Funny how bondage programs bring 'em out of the woodwork. See you later."

He ruffled my hair, then went to join his ex. I stood there looking after him, my stomach churning, until the lights dimmed and the announcements began.

There were no more seats to be had, so I found a bit of wall to lean against not too far from where Terry was sitting and tried to calm myself. When the announcements were over, the program started with a bang: a scrim at the front of the room was pulled away, and a spotlight picked out a leatherbound body hanging vertically from a scaffold. Hood, straitjacket, leg sack, suspension harness — all were black leather. *Whoever's in there is short but well built*, I thought. The scaffold wasn't all that high, and there was plenty of space under his swaying feet, but the arms of the straitjacket were stretched tight by his muscles.

After letting the audience get a good look, the program host told us that the bound man had been hanging there since 6:00 p.m., two hours before the meeting opened, which made it almost three hours by that point, and he'd actually been straitjacketed and hooded four hours before that. They'd given him a piss break and some water before adding the leg sack and suspension harness, then hauling him up off the floor. After this background, the host called three panelists up from the audience, two tops and a bottom.

They took chairs on either side of the hanging man, who remained the centerpiece. All capable speakers, they handled the material well, including the use of modern audio technology to enhance a long-term scene, or at least to help suppress the bottom's sense of hearing. Earbud phones, we were told, had been inserted in the hanging man's ears before the hood went on. The phones were connected to a cigarette-pack-size cassette player tucked under his arms where they crossed the jacket (the host pulled it out to show us, then put it back) playing a looped tape of white noise, supposedly loud enough so the prisoner couldn't make out a word of the program.

To prove that, the host said, when they released him they'd give him a nice prize if he could repeat a short phrase suggested by someone in the audience. After the rude jokes subsided, Philip offered "Slavery is freedom," and Terry squirmed. I proposed "Fit to be tied," which got a few laughs, and the GMSMA president suggested "Safe, sane, and consensual," which provoked groans. The host finally accepted "Supersadomasochistic-expialidocious," offered by a humpy bear in a Pennsylvania State Police uniform who'd obviously seen too many Julie Andrews movies.

They unstrapped the leg sack first and pulled it off, revealing muscular but hairless legs and a pair of white cotton briefs (understandably, the Community Center doesn't allow full nudity). *I know those legs*, I thought. They lowered him to the floor, unhooked the suspension harness, and pulled it off through the arms of the straitjacket. When the jacket itself came off, revealing an even more muscular torso, also hairless, I was sure. Finally, the hood came off, revealing good ol' Stan, who was greeted with a hearty round of applause.

He bowed with a flourish and took a seat onstage. After he'd downed a cup of water, toweled off the sweat on his face, head,

and torso, and pulled on a T-shirt, he was asked to repeat the code phrase, with three months paid membership at his gym as the prize — a powerful incentive. When he said he didn't have a clue, most of the audience seemed to believe he hadn't been able to hear. I had my doubts, however, knowing how well he could keep a secret. After all, I'd had dinner with him three days before, and he hadn't said a thing about participating in the program.

Stan described some of his longer bondage scenes — the seven hours he'd just demonstrated was only a warmup by his standards. He distinguished between immobility (as when he was hanging from the scaffold) and confinement (as in his week in Curt's cage) and said that while he often got lonely or bored if he was confined but could move around, when he was *completely* immobile he preferred being left alone as long as possible so he could retreat deep inside himself, rather than be played with or even noticeably monitored. One of the tops on the panel, named Frank something, cracked that playing with Stan was a good opportunity to go out for a movie. Everyone laughed, but when no one else on the panel qualified the statement, Terry's hand shot up. After being recognized, he stood up and added his two cents — or more like five bucks' worth!

"Two comments," he began. "First, as Frank's joke suggests, people often say that long-term bondage scenes are boring for the top, that it's purely a bottom trip. Stan's remark about preferring to be left alone when he's immobile may reinforce that. Maybe *some* tops feel that way, but I always find it very exciting to have a man immobilized or confined, completely in my control. I love to sit and watch him squirm, testing his bonds, testing my skill. And when he gives up and accepts the situation, when he surrenders completely — that's even better.

"But second, even if I need to leave him alone for a while, I keep an audio link open so I can hear any noises he makes. My play space is wired for sound, but if you're not as techie as that, you can use a baby monitor — or just stay nearby. I'd never go out to a movie! When I have a guy tightly bound and gagged, or hooded, I need to be able to get to him quickly if there's a problem. Of course, it's less critical if his mouth is uncovered and he can move around some, but even then I'd think twice before leaving the house." He sat down to loud applause.

The host thanked Terry for his contribution, and Frank as-

sured the audience that he *had* only been joking, that he'd never really leave home with someone helplessly bound inside. I wasn't going to let them off so easily, however, and stubbornly held up my hand until I was recognized.

"Recently I was hooded and strapped into a sleepsack for the night," I said, "but the top who did it was sleeping next to me. I could feel it when he put his arm over me, or lay with his back against me, and I could hear him snoring." That got a good laugh.

"Stan might say that such closeness detracts from the purity of rigid bondage, but I don't think I could have made it through the rough patches, when I went a little crazy from the immobility, if I hadn't known he was right there."

More applause — and more raised hands. Terry caught my eye and gave me one of his crooked grins. I snapped him a salute in return. The program host gracefully abandoned what was left of their outline and turned the rest of the meeting over to general discussion, but when the time was up he and his colleagues also got well-deserved applause. Afterward, several guys came over to thank me for what I'd said.

"If an experienced bottom like you can admit his limits like that," a top told me, "maybe the novices who come to these meetings will be a little more honest about theirs."

"Yeah, and maybe some of these tops who expect us to *have* no limits will think twice," a bottom chimed in.

"You both make good points," I said vaguely, continuing to make conversation while my eyes followed Terry and Philip. He was taking the boy around the room, apparently making introductions. My jealousy ran wild. *With Terry available, why does Philip need anyone else to play with while he's in town?* I didn't believe for a minute that they weren't doing anything together except talking. *And if Philip's leaving in a week, why is Terry so anxious for him to meet people he might not see again?*

I wasn't about to tag along after them, so I went up to the stage to talk with Stan while he finished getting dressed.

"So were you *really* unable to hear what we said while you were tied up," I asked him, "or just playing along?"

"Verily, Matthew, I'm cut to the quick that you'd doubt my word."

"Yeah, yeah . . . so could you hear us or not?"

"Actually, the earphones were pretty effective. I could make

out a word here or there, but it might have been my imagination. I sure didn't recognize that test phrase — sounds like it's from a T-shirt. Now it's my turn to ask a rude question: Who's the poster boy Mr. I'll Never Tie You Up and Go Out for a Movie has with him? Haven't we seen him in ads for safe sex? Something like, 'I'll do anything for a man wearing a rubber'?"

"That's Philip, Terry's ex-slave," I told him, laughing sourly. "He moved to San Francisco when they broke up years ago, and this is his first trip back."

Stan was shaking his head and giving me a look of pity.

"Do I have to spell it out, bud? Believe me, you're a sight for sore eyes and enough bottom for any sane top, but that kid's a stunner. If he has his hooks again into Mr. My Dungeon Is Wired for Sound, it's time to cut your losses — unless they're into three-ways and you can get sloppy seconds."

I glared at him, my fists and jaw clenched, ready to kill. The one I really wanted to strangle, of course, was Philip — or maybe Terry — but they'd already left.

"I'm sorry, Matt," Stan said with a contrite expression, "but you know me, always kidding. Seriously, I just don't want you to get your heart set on something you may not be able to have."

He put his arm around my shoulder. "C'mon, let's go to the Spike for a drink before we head home. Okay?"

"Okay," I said with a sigh, willing myself to relax under his familiar touch. "There's nothing I can do about it anyway. Terry's made it clear he has no time for me until Philip leaves, and if that beach bum manages to win him back in a week, it's my tough luck. Yeah, let's hit the Spike."

We were almost the last to leave. It took about 20 minutes to walk to the bar — Stan never passes up a chance for some exercise — and he had me laughing again most of the way as we dished the program and the audience.

"Where *are* all these guys when I'm hot to get tied up?" Stan wanted to know — as if there's any time when he *isn't* hot to get tied up. "They show up for these talkfests, and then I never see them again. There was this one sharp dude in the front row who kept eyeing me while I was talking. I winked back at him once or twice, but as soon as the meeting broke up he vanished. Now I'll probably never know if those were real antique Bean handcuffs he was carrying or a reproduction."

"Oh, I bet he'll turn up again," I said, "probably when you least expect it. Why, he could be at the bar right now."

"Yeah, right . . . along with Santa Claus," Stan grumped, but he started walking a little faster.

"Hey, what about Curt?" I asked him. "You seemed pretty lovey-dovey on Sunday, but he didn't even show up tonight."

"Curt had other plans tonight. We're not married, y'know, just because he orchestrated that fabulous cage scene for me."

"But don't you like him?"

"I like him plenty, and he likes me, but I also like variety. You should know that by now."

"Yeah, but I thought maybe you were changing — thinking about settling down."

"Ha! *You're* lovesick, so the whole world should pair off?"

"It could do worse."

"And I suppose we should all be Masters and slaves, too, now that you've seen the light!"

"I never said that."

"Well, be sure you don't think it, either, because it's crap. Matt, I'm not the marrying kind, or the slave kind. How can I respect your choices if you won't respect mine?"

"Okay, okay, I give up! Let's hit the Spike and find that sharp dude for you."

He wasn't there when we arrived, but by the time I'd had a couple beers and split two games of pinball with Stan, he showed up, and soon they were off in a corner talking handcuffs — and trying 'em out, too. I was feeling mellow enough by then to head home alone without leaving a trail of self-pity. Besides, it was a "school night," with work the next day, and I needed my sleep.

By Saturday night I was once more feeling horny, lonely, and depressed. I'd begun meditating again, but my heart wasn't in it as long as I knew Philip was in town. Obviously he was the "difficult" situation Terry was dealing with. *"Please, Massa, take me back! I promise I won't fuck up again!"* Yeah, right. *But with a face and body like his, who could say no to him?* Usually I'm proud of how I look, but next to Philip I felt outclassed.

Hoping to see Jake again — *Bet he knows all about Philip!* —

I got ready for Altar. I wasn't going there to cruise, so I dressed comfortably in jeans without holes in them, a plain gray T-shirt, and a leather vest. I arrived around 10:30 and found a place to perch while sipping a beer. If anything, the crowd was larger and hotter-looking than the week before.

I was on my second beer when Stan came in. He checked his jacket, leaving only his leather jeans and a light-gray T-shirt so tight it was practically transparent. Laced black work boots and a pair of hinged handcuffs on his right hip completed the picture of a muscle bondage bottom on the prowl. Doing an initial survey of the room from the bar after getting his bottle of seltzer, he spotted me and sauntered over.

"Hi, Matt, how's it going? You missed a hot night at the Cellblock on Wednesday."

"The Cellblock? I left you at the Spike. You seemed pretty interested in that guy with the Bean cuffs."

"He's from Minneapolis, and he was flying home the next day. I wasn't in the mood for a hotel-room scene, but I got his number in case I ever have to take a job out there — God forbid! After you and he left, the Spike was too boring, but I wasn't ready for bed. I didn't have a job lined up for the next day, so I walked down to the Cellblock. Dunno why, but the joint was jumping."

"So what kind of mischief did you get into?"

"Not much: just hogtied, suspended, and fucked from both ends while George sucked my cock and played with my tits."

"Don't you ever get enough?" I grumbled.

"Envious, Bucko?"

"Yes, damnit! Here I thought I'd struck the jackpot, found a man I could settle down with, and he sticks me on ice!"

"Well, don't say I didn't warn you!"

"Yeah, I know. So who did all this tying and fucking at the Cellblock? And how the hell does it stay open if they allow fucking? Even with a condom, that's illegal in a public space."

"I'm not sure — maybe they pay off the right people? I'm happy to enjoy it while I can, long as I'm with a top I can trust to take precautions."

"And were you?"

"Yes, Mom! Bill and Randy tied me up and took first dibs, and they promised to make sure anyone else who fucked me used rubbers, too. They blindfolded me right away, so I didn't know

whose cock was where, but I could tell the ones in my mouth were wrapped, and I trusted them to watch the back door."

"How'd you know it was George under you, then?"

"Are you kidding? Who else do we know who takes out his teeth to suck cock?"

We shared a laugh, and then he leaned close and asked in a low voice, "Are you sure you're okay? I could feel your 'Don't mess with me' vibes from across the room."

"Is it that obvious?"

"'Fraid so."

"Shit. I guess it's just that the more I look at other guys, the more I want *him*."

"Look, Matt," he said, "if I don't score tonight, how about coming back to my place, and we'll have some fun together?"

"Thanks, buddy," I told him, "but my heart wouldn't be in it." *Though it's probably the best offer I'll get.*

"Suit yourself. *I* still think you're fun to play with, as top *or* bottom."

He squeezed my shoulder and slipped off into the crowd.

Once Stan left me, I checked the bar and found Jake settled into his usual place. He must have come in while we were talking. I grabbed the first opening beside him.

"Hello, Matt," he said right away. "Feeling any better since the last time we talked?"

"No, Jake — I feel worse. I saw the competition. Terry's first slave, Philip, is back in town, and they seem pretty friendly for a couple who broke up six years ago."

"If I didn't already think you were lovesick, Matt, that would prove it. You couldn't be so jealous if you weren't in love."

"You'd be jealous, too, if you thought Philip was after the man you wanted," I told him. "He's drop-dead gorgeous."

"You're not exactly a troll," Jake said. "And you have some advantages over Philip you may not be aware of."

"Oh? Like what? You know all about this, don't you?"

"I know both Terry and Philip very well, Matt," he said. "Six years ago, Terry was the one standing where you are — in a different bar, of course — asking if I thought their relationship could be salvaged."

"Oh, Christ," I said, shaking my head, "is this New York? Or the boonies where everyone knows everyone else's business?"

"The serious s/m world is still very much like a small town — didn't you know? I keep tabs on the major players, and people seem to want to confide in me — perhaps because I never repeat what I hear unless it will do some good."

"And you're telling me I still have a chance with Terry?"

"Yes. Forget about Philip. Whatever happens between them now won't affect what might develop between you and Terry."

"I wish I could believe that."

"Believe what you like. I'm sorry, but I can't say any more. If Terry wants to fill you in, that's his decision."

"Speak of the devil," I said, "look who just came in."

Terry and Philip were working their way from the door over to the bar, heading right toward us.

Like Jake, Terry was in full leather from cap to boots, plus gauntlets and a leather shirt and tie under his jacket. Gleaming handcuffs hung from his left epaulet along with a heavy chain looped under his arm. I wanted to throw myself at his feet, but not in front of Philip. Tight leather pants and shirt showed off *his* sleek body. The pants were tucked into his tall lace-up boots and belted with a triple loop of thin chains held at his right hip by a big Harley buckle. His head and neck were bare, however. *At least Terry hasn't collared him again yet*, I told myself hopefully.

I stood straighter as they came up to us, and Jake actually turned halfway around.

"Evening, Jake," Terry said in a tone of deep respect, extending his hand.

"Terry," Jake said with a nod as they shook hands.

"Hello, Matt," Terry said, merely glancing at me before turning back to Jake. "You remember Philip, Jake."

"Indeed I do," Jake said with an avuncular smile. "Good to see you again, Philip."

"Good to see you, too, Sir," Philip said softly, his eyes shining. They didn't shake hands.

Despite Jake's hints, I didn't have the faintest idea what was going on. I felt like an outsider, and when Terry said, "Matt, would you excuse us, please?" I was almost eager to take off.

Moving away, I felt his hand on my arm. I paused, and he said into my ear, "Don't leave before we have a chance to talk. Okay?"

"Sure," I told him. "I'll be around." I didn't even realize I'd

forgotten to "Sir" him until I was several paces from the bar. *I doubt* he *noticed, either.*

I made my way slowly around the room — not cruising, just enjoying the sight and smell of my fellow tribesmen in their festive attire, surprised at how late it was already, almost 12:30. I caught sight of Stan again in the corner near the pool table — he was gagged with his own T-shirt, his hands were cuffed behind him, and his nipples were being manhandled, so I didn't interrupt. Like a buddy should, however, I tried to recall if I knew anything about the man working him over. When I finally hit on where I'd seen him last, I smiled. *They'll get along just fine. Stan'll have some bruises to show, but he* likes *being used as a punching bag. Good thing he can take it!*

After making small talk with a few guys I knew, I perched on one of the big oil drums Altar's management considered appropriately butch seating. The music was pretty loud by then, so I stared off into the distance, above the heads of the crowd, and let my eyes go unfocused, achieving a state of blissful nonawareness. When someone snapped his fingers in front of my face a while later — it could have been minutes or hours for all I knew — I jerked out of my trance. It was Terry, of course. I looked around, but Philip wasn't in sight.

"You often space out like that, Matt?"

"Not *often*, Sir," I said. "But it comes in handy sometimes, like inside a jail cell, or a sleepsack."

"I thought you enjoyed those."

"Oh, I did, Sir. I enjoy this place, too. But sometimes it gets to be a little too much and I need to get away for a while — without actually leaving."

He smiled, as if he understood perfectly. Nervously filling in the silence, I added, "I didn't expect to see you tonight, Sir. You usually avoid the bars on weekends. Showing Philip a good time?"

"Trying to," he said. "He's a writer, and one of the gay papers in San Francisco commissioned a major travel piece about visiting New York — it'll help pay for the trip. So of course he has to give a full report on our leather nightlife. He's finding it pretty tame compared with San Francisco's these days."

"We do all right, Sir — especially in private."

"*We* certainly do," he said, smiling again. "I hope we'll have another chance soon. Would you like that, boy?"

"You know it, Sir!"

"Good!"

He reached out and ruffled my hair with his gloved hand, then drew it across my forehead and around my face, ending at my lips. I opened my mouth wide. He inserted three fingers and let me lick and suck on them — I felt my cock straining in my jeans. *I want to get down on my knees in front of him. I want to lick his boots and crotch, to feel his cuffs around my wrists. I want him to carry me away again like the first time.* The urgency of my need filled my brain, and without taking my mouth off his leather-covered fingers, I started to bend my knees. He stopped me.

"Stay where you are, boy. Easier to get at your tits this way."

He began twisting my nipples through my T-shirt with his left hand, making me moan around the fingers in my mouth.

Oh, shit! He's got me going again! He can do anything he wants to me, and I'll eat it up! God, I want this man so bad!

Terry took his right hand out of my mouth and wiped the spit on my face while still playing with my nips with his left hand. Then he put *both* hands on me and worked them even harder. I moaned louder and hissed at the delicious pain. He moved closer to me, pushing my legs apart and pressing himself up against the drum between them. After a few minutes he pulled me toward him by my nips and bent his face down to mine. His tongue speared into my open mouth as he twisted my nips ever harder.

I was already melting into him, my nose filled with the bouquet of his leathers, when he released my nips and put his arms around me (pinning mine to my sides) in a bear hug that nearly lifted me off my seat.

When he finally broke the embrace and stepped back, I collapsed onto the drum — a puddle of unconsummated lust.

"Whew!" I said after I'd pulled myself together again. Terry was grinning down at me. "I guess that's not a brushoff, Sir."

"No, hot stuff, it's not a brushoff. It's a raincheck. I really want to spend more time training you, but it's impossible while Philip's here, and after he leaves next week I have more traveling of my own to do."

"I understand, Sir. Maybe you'll call me some evening?"

"I'll do that, boy," he said, flicking my nips again, sending electric sparks into my brain. "Count on it. And keep doing your meditations."

"Yes, Sir. Thank you, Sir!"

He messed over my hair again, then turned and headed off — to find Philip, no doubt. I stayed where I was, hugging myself in satisfaction. I was still horny — even more than before! — but otherwise my mood had turned around completely.

I smiled fondly at Stan when he came over, all in a flurry, to say he was leaving with Peter, the top who'd been "auditioning" him.

"I know," I told him. "I watched you two going at it."

"You think he's okay, Matt? He's *real* hot to trot."

"I'm sure you'll have a good time. Call me tomorrow night, okay? Or Monday if he keeps you tied up longer."

Uncharacteristically short of words, Stan just grinned and hurried off to join Peter at the door.

I checked my watch — it was late, 2:47. I tried to spot Terry and Philip in the thinning crowd. Just as at the GMSMA meeting, Terry was squiring Philip around, introducing him to all kinds of guys — tops, bottoms, switches, even nonplayers who simply dug leather. They would talk for a minute or two, then move on. *I guess it's all for that article Philip's writing, but still* Terry's body language wasn't at all like a top showing off his bottom, let alone a Master with his slave — even ex-slave. He looked less possessive than protective, as though he thought Philip was fragile or something. *He didn't treat* me *that way just now — thank God!* I shook my head. *Like Jake said, if he wants to fill me in, he will.*

Jake had already left, and Terry and Philip were edging toward the door. Stan was long gone. There was no one else in the bar I knew well or particularly wanted to meet. I hadn't been trying to score, anyway. *I've got Terry's raincheck*, I told myself, fingering my sore nipples. *Why would I need anyone else?* I was whistling as I walked up the stairs to the street.

CHAPTER 18
Getting the back-story

Another week passed, bringing us into October. Down at the store, Magda and I arranged a special window display to promote National Coming Out Day on October 11. I sprinkled a few nonfiction kink titles, like the *Leatherfolk* anthology, among the vanilla gay/lesbian/bi books. Two or three of our customers complained, but several more asked for the politically incorrect titles in the window, so we probably gained more sales than we lost.

Despite his promise, Terry didn't call me that week, and I was starting to think he wouldn't call me again at all. *Maybe he and Philip patched up their differences?* My fantasies about the exciting scenes I assumed they were having started crowding out my fantasies about what Terry and I would do next time *we* got together. I felt intensely jealous at the idea of Philip licking Terry's boots instead of me, of Philip taking pain for him instead of me, of Philip chained at his feet instead of me. It was as if I'd been given a taste of bliss only to have it snatched away.

Every night after work or the gym I'd hurry home, hoping to find a message from Terry on my machine. Every evening I'd jump up whenever the phone rang, hoping it was him. Nada.

Somehow I managed to keep up my twice-daily meditation on my knees facing the wall, though it was rare that I managed to achieve much stillness of mind in the five minutes that he'd prescribed. Of course, I tried extending the time, more than once, but when I imagined his mocking voice telling me, "You're overdoing again," the well-intended disobedience became worse than ineffectual. Instead of clearing my mind, all I managed to do was tie myself up in emotional knots and rationalizations.

The trouble was, I just didn't trust him as much now that

Philip had come back on the scene. Our connection was still too new, too undefined, for me to have the confidence in our future together that I needed. If we'd just been playing casual games of dominance and submission, as I'd done in the past, it wouldn't have been a problem. But I'd offered myself to him unreservedly, and he seemed ready to accept me — and then it all got put on hold. The delay fed my doubts while leaving me aching in a part of my soul I hadn't realized I had. I wanted — *needed* — to be possessed, taken over, subsumed in some greater whole. And though he'd spoken eloquently of his desire to take me that way, I didn't have so much as a collar to show for it. Oh, he'd marked me all right, but invisibly, deniably. He could walk away at any time, and I was afraid he already had.

I went out to the Spike and the Altar again the next weekend, to the first on Friday, the second on Saturday as before. (I couldn't face going to the Bondage Club again without him.) As before, however, whenever I started cruising a likely topman, the thought of actually going under for anyone else gave me a soft-on. I extricated myself from these abortive encounters as gracefully as I could and retreated to the shadows to drink and watch. I chatted with Stan or Jake, briefly exchanged small talk with other friends and acquaintances, politely turned aside overtures I'd have been pleased to get a month earlier, drank too much, and went home alone.

Finally Terry called, after midnight the next Monday, waking me up, and said he'd be at his office in the city the next day — just one month since our first session, when he led me out of the Spike on a leash.

"Are you free for dinner?" was all he asked.

It wasn't exactly the invitation I'd been hoping for, but I wasn't about to turn him down. We arranged to meet at 7:30 p.m. at a Thai restaurant in Midtown, close to the garage where he always parked when he drove in to his office. That was the total of the conversation — no sexy talk, not even "How've you been? What've you been doing?" Nevertheless, when I hung up, my cock was hard.

I had trouble getting to sleep again, I was so horny and excited, and started jacking off, imagining what might be in store for me after dinner, but I stopped before I came even though I had no orders to that effect. Of course, I'd JO'ed several times

since we'd last talked, plus coming on the two occasions with Stan and Curt, but that was when I didn't know when — or if! — I'd see Terry again. Having been summoned finally, I felt I should bring *all* of me to what I hoped would be our reunion, including a fully charged libido.

When I got home from work the next day, I quickly tidied the place up as much as I could, just in case Terry came back with me after dinner — *if he doesn't check the closets, I'll be okay!* I showered and shaved again, then put on and discarded three or four different outfits. I wasn't about to wear a jacket and tie. I have no objection to something tied around my neck, just not a scrap of colored silk! Still, it was a nice restaurant, not a dive, and I wanted to look sharp for Terry. Sleazy leather-bar cruisewear wouldn't cut it.

I finally put on neat black 501s, a heavy plain leather belt with a mirror-finish buckle, a long-sleeve black Western shirt with pearl-snap buttons, and black cowboy boots with a red stripe up the side (it makes them a bitch to polish). No underwear, and I left the top two shirt buttons open. I fastened a silver chain-link bracelet on my right wrist and checked the hall mirror. The black clothes went well with my reddish-blond hair, which I nervously brushed again. *This'll do*, I decided at ten after 7:00.

All the way downtown in the cab I worried about being late, but I arrived first and sat at a table anxiously sipping a Thai beer. *Why am I nervous? We're just having dinner, for chrissake!* I figured it was because I wanted more than just dinner. *But what, exactly? An evening of bondage, s/m, and hot sex? Well, at* least *that! But who knows what Terry has in mind? Maybe he's feeling lonely with Philip gone again — assuming he* is *gone! — and wants someone to talk to. Or maybe there's something he needs to tell me on neutral ground. Maybe* this *will be the brushoff*, I worried.

When he arrived, a few minutes later, I didn't notice him immediately. It wasn't until a tall man in a well-cut but very conservative suit strode toward my table, smiling at me, that I realized it was Terry. I was a little taken aback at his appearance, since up to then I'd only seen him in his leathers, a uniform, or outdoor work clothes. There was certainly nothing unmasculine about the way he was dressed, however, and he seemed as natural and unself-conscious in the business suit as in his leathers. I stood up to greet him.

"Hello, Matt," he said, and extended his hand.

"Hello yourself, Sir," I replied as we shook. We might have been straight male friends who hadn't seen each other in a while. But as I felt the same strong, firm grip that had belted my ass, laced me into a leather hood and sleepsack, twisted my nips, and mashed me into the bars of his basement jail cell, I gripped hard back. The corner of his mouth lifted in his characteristic half grin as we prolonged the shake a few beats longer than standard etiquette calls for.

"I almost didn't recognize you, Sir," I said as we sat down.

"Why? The suit? Didn't I tell you I'd be in Manhattan on business?"

"Yes, Sir. I should have expected it. But I never wear one myself, and I'm not used to being around people who do."

The waiter came over with menus and to take Terry's drink order — Thai beer, too.

"Does it bother you that I'm wearing a suit?" he asked after the waiter left.

"No, Sir, of course not," I said, smiling across at him. "You look great — like always. It's just that a suit doesn't quite fit the image I have of you, Sir. It doesn't *bother* me, but I can't quite see us doing the kind of things we both enjoy with you in a suit."

The waiter returned with Terry's beer and asked if we were ready to order. We hadn't even looked at the menu, so Terry put him off, then responded to my comment.

"You should be careful about images and preconceptions," he said. "They can trip you up. Few people will ever exactly live up to your expectations of them. But you're looking well, Matt. Black is a good color for you."

"Thank you, Sir."

"You don't need to 'Sir' me here."

"Wouldn't you expect me to if I was your slave . . . Sir?"

"Well, yes . . . but we still need to work up to that."

Then this isn't a brushoff! I stared into his clear hazel eyes for several moments before casting mine down — they were filling with tears anyway. *Philip or no Philip, he wants to go forward!*

"Unless it really bothers you, Sir," I said finally, recalling the qualms he'd expressed in our previous conversation along these lines, back at the Bondage Club, "is it all right if I keep it up, just for practice? 'Sirring' you keeps my head in the right place with

respect to you — that is, it shows my respect *for* you, Sir, and reminds me that you're not just some friend or fuck buddy but the man I hope will be my Master."

He eyed me sharply, then nodded.

"As you wish. Now let's decide what we're having for dinner. Shall I order for both of us?"

"Please, Sir," I said, though I was shaken for a moment by his coolness. Then I realized he was right: whether I "Sirred" him or not was no big deal — talk is cheap. But letting him order dinner for me was certainly submissive, and now I'd done it twice.

After studying the menu, Terry called the waiter over and asked for both spring rolls and summer rolls to start, fried noodles with chicken (the name of the dish, *Gai Pad Prik*, made me chuckle), and beef with basil.

"Now, tell me how you've been since I left you in the bar that night I came in with Philip," he asked once we were alone.

"I've been okay, Sir," I told him.

"Just okay?"

"Well, I've been pretty antsy, Sir, waiting for you to call."

"Sorry I was out of touch for so long — but you really need to work on developing some patience."

"Yes, Sir. But I couldn't get you out of my mind, Sir! Every time I jack off, I think about you and the times we've been together. And even when I'm not jacking off. I haven't been able to play with anyone else, Sir — any other top, that is. I did fool around with Stan the week after I saw you at Altar. His friend Curt was doing a week-long cage scene with him and needed 'sitters,' so I took one day. I'm afraid I got a little carried away and did more than just watch over him, Sir."

"I can just picture you," Terry laughed, "fucking Stan while he's hooded and caged."

"I did more than just fuck him, Sir. I tortured him first!"

"No! Really?"

"Really, Sir. I just imagined he was me and I was you, and it was easy," I said, flashing him an evil grin. "Truth is, I can't get off anymore *without* thinking about you, Sir. The same thing happened a week later when Curt and Stan had me over for dinner and sweet-talked me into taking a turn in the cage. I kept imagining it was you locking me up and toying with me, Sir."

"Well . . . it's flattering to be obsessed about," he said. "And

I've had just as much trouble getting *you* out of *my* mind. I'd have called you as soon as Philip left, but . . . well, I had some stuff to sort out first. And besides, I've been working hard and traveling as well, which leaves me pretty exhausted by evening. It takes energy to work up a phone-sex scene with you," he said with an evil grin of his own, "let alone one in person."

That was probably all I'd get as explanation, or apology, but I was relieved to hear it. Our appetizers arrived then, and we ate silently for a while, each pursuing his own thoughts. My cock was painfully hard just looking at him across the table, even with the suit. *I want him to take me home — my home, his home, any-body's home — and tie me up and fuck me silly!*

"So Philip's gone back to San Francisco, Sir?" I asked when the silence was beginning to feel awkward.

"Yes, for now. He left more than a week ago."

"For now, Sir?"

"He's moving back in a month or two."

Just what I need! Bad enough him being only a phone call away.

"I'm sorry to pry, Sir, but I can't help wondering what's going on between you."

"I'll bet you can't," he said with a rueful smile. "I can talk about it now, so what do you want to know?"

"Well . . . he showed up so suddenly, Sir, and you looked so comfortable with him. I was afraid you might be getting together again. I know you gave me a raincheck, Sir, that night at Altar, but that was before you spent another few days with him — or maybe more. I was afraid that was the reason for this dinner, to give me the heave-ho."

"Don't tell me the pushiest bottom in New York is jealous of an ex-slave." He sat back and grinned at me. *He's enjoying this!*

"Why shouldn't I be, Sir?" His grin got wider. "There I was, still floating on air after our scene at the Bondage Club, and then those incredible phone calls from Vermont. I'd spilled my guts to you, Sir, told you I wanted to be your slave, or at least try to be. And you seemed to want me, too.

"We seemed to click together, Sir, like I haven't with anyone else in years — not since my lover Greg died. Then this ex-slave of yours starts appearing everywhere with you. And he's so gorgeous, I figured he had the inside track." Terry was chuckling now, and I felt my face flame in embarrassment.

"If you only knew how far off you are, Matt . . ." he began, but I interrupted him.

"I *need* to know, Sir! I need to know where I stand with you, whether you want me to be your . . ." — the word "slave" suddenly stuck in my throat, the reality it represented scaring me as much as it attracted me — ". . . to be yours, Sir," I finished the sentence, looking down at my empty plate to avoid meeting his eyes. Terry said nothing, so I added in a low voice, "And I need to know why you and Philip broke up, Sir, so I won't repeat the same mistakes."

"Why do you think," he said, "that the mistakes were all on his side?"

I looked at him, startled, and saw that he was quite serious, though the ghost of a grin hovered at the corner of his mouth.

"We went into it together, Matt, and we're both responsible for how it came out. I failed as much as he did — maybe more, because I was older and more experienced, though not by much, and I was the Master, after all. It's not a pretty story. Are you sure you want to hear it?"

"More than ever now, Sir!"

"Well then," he said, "in the spirit of a cautionary tale, I'll oblige your curiosity. I did intend to tell you about it eventually. But Philip's reappearance, and the talks we had while he was here, have put a lot of the past in a new light. And the future. Maybe it's a good thing for us to go over this now."

Our entrees arrived then, and Terry took charge of dividing them between our plates. "Let's enjoy this while it's hot," he said, "and then I'll tell you the story." We ate quietly for several minutes while he almost visibly collected his thoughts.

"We were both a good deal younger," he said finally. "It was more than seven years ago when we met. This was after my triumph with Larry, the one I told you about at the Bondage Club, but even so I was still wet behind the ears in a lot of ways. I had all these fantasies about being a Master and owning a devoted slave to cater to my every whim, and Philip was a complete beginner — but all the more charming for that."

He paused, his eyes far away, smiling at the memory, then drank some beer and ate a few more bites before continuing in a quiet, even tone, as if he'd told the story many times before — or, more likely, rehearsed it many times in his mind.

"Phil's bright enough, but he'd dropped out of college and was working at a dead-end job, living in a secondhand sublet, a real slummy place, and trying to decide what to do with his life. At the same time he was trying to come to terms with his awakening sexuality. He came out as gay and a bottom at practically the same time, but just bottoming wasn't enough for him — he knew he needed to be dominated and controlled, but he didn't have any models for that except *Mr. Benson* and countless other stories in *Drummer*. As with you and me, it was spontaneous combustion the first time we played, and we obsessed about each other afterward. The same thing happened with each rematch. Our needs and tastes seemed more than compatible. In between, we talked endlessly, sharing our fantasies and dreams. He believed everything I told him about the scene, based on my few years of experience, and we both believed the stories we'd read."

"But you knew they were fictions, Sir, not real life."

"We weren't stupid, Matt — we knew the stories were exaggerated and unrealistic in many ways. But we figured they had to be based on *something* real. If we tried to behave like the guys in the stories and it felt right, how could it be wrong? We didn't know anyone else actually trying to *live* as Master and slave, and we had to start somewhere."

"Wasn't GMSMA any help, Sir?"

Terry made a face. "What do *you* think? It's a fine organization, don't get me wrong, but it's a terrible place to learn about, or even discuss, relationship issues. It's no accident so many programs are about technique, technique, technique — it's easy to talk to a roomful of strangers about technical stuff, but when it comes to opening up in public about anything vague and emotional, forget it!"

"Guess you're right, Sir. The meetings are too big and cold to delve into the more personal stuff. Please continue, Sir."

"Food first," he said, and attacked his plate again. I followed suit, and he continued a few minutes later.

"Even if Philip wasn't an empty-headed twit like Jamie, the slave in *Mr. Benson*, he wasn't his own man yet. Unlike you, he hadn't settled into an independent life that he'd have to change or give up to be my slave. I should have realized that meant he wasn't ready — how could he surrender to me before he'd really experienced the alternative? But I simply figured he was the per-

fect raw material." His voice rose a bit on the last sentence, and I glanced nervously around the restaurant.

"Good thing this place isn't crowded, Sir," I remarked. Terry looked at me blankly, then continued his story.

"I thought I could mold him the way I wanted, and we decided to live out our fantasies. I figured I made enough money for both of us, so I made him quit his job and move in with me. We went the whole route: he stayed home and did the chores, always naked and in chains, while I went off to work — this was before I arranged to do most of my work at home or on site. I did all the shopping, and I kept his clothes locked away. He wasn't allowed to answer the door in my absence, and he never went anywhere unless I took him."

"Did you do the cooking, Sir?"

"Most of the time. I taught Philip enough to manage when I was too tired or too busy. I like to cook — it relaxes me. Do you have a problem with that?"

"Not at all, Sir! I love your cooking. But in the usual fantasy setup, the slave does that, too."

"That's bullshit," Terry said. "If I'm a good cook and my slave isn't, why should I suffer from his ineptness? I figure a household should be run by the old communist ideal: *from* each according to his abilities, *to* each according to his needs. It isn't a good way to run a country, but I can't think of a better arrangement for people living in close quarters — whether they're Master and slave, husband and wife, lovers, or even roommates."

"You've got something there, Sir," I conceded. "Anyway, you were explaining your routine with Philip."

"As you can imagine, he never used my name, called me 'Sir' or 'Master' all the time — so you understand my mixed feelings about your doing it," he said, and I nodded. "Phil never even spoke except by order or with permission, and he never interrupted or argued with me — something I expect you'd have a hard time doing if I required it from you."

I managed to look sheepish, then gave up and grinned at him. He rolled his eyes and sighed dramatically.

"Who am I fooling?" he said. "You're not the kind of slave he was, and you never will be. He came *so close* to matching the fantasy — maybe our experience proves that it's *only* a fantasy."

"Maybe so, Sir, but I need *details* — what else did you do?"

"Well, I usually called him 'asswipe,' or worse, while I was training him, but later I used his real name most of the time. He didn't respond well to verbal abuse."

"Weak self-esteem, Sir? In my experience, bottoms who are secure in their self-image handle verbal abuse better than guys who're insecure, because deep down they don't believe it."

"You would know, Matt," he said. "Is that why you got off on my calling you 'dickhead'?" I blushed.

"Probably, Sir," I said with a weak grin. "It didn't seem abusive, somehow, more like a tease than a put-down."

"I suppose 'shithead' wouldn't have done as well, then?"

"Guess not, Sir." We both grinned at that.

"Lucky me for picking the right name — if you think luck had anything to do with it." He drained his beer, staring intently at me over the rim of the glass. I wiped the grin off my face.

"No, Sir, I don't suppose luck had much of anything to do with it," I admitted. *I keep forgetting how well he can read me.*

"Anyway," he said, continuing the story, "the slave training was supposed to make Philip stronger and *more* secure, if also more submissive. I broke him down only to build him back up again, but better. I didn't *want* a mindless robot. The more self-esteem he had, the more satisfaction I got out of his submitting to me. Guess I haven't changed much in that respect," he said.

"Guess not, Sir," I said, meeting his eyes until he smiled.

"The training seemed to work well for a while," he continued. "Phil would drop to his knees when I came into the room — if he wasn't already on them — and kiss my boots or feet with what appeared to be genuine reverence, and he did whatever I told him to without hesitation. But at the same time, our conversations became more and more free-flowing and interesting. He had a lot of time to think, after all, when I had him tied up, and the ideas he came up with, despite his lack of education, were often fascinating."

"Sounds idyllic, Sir, but when do we get to the sex part?"

Terry glared at me, then shook his head, more exasperated than angry.

"Right at the start," he said, "I had us tested for the AIDS virus, and we were both negative. Since I made sure we weren't exposed to anyone else's body fluids, when we were still negative after three months, I dropped the safe-sex rules between us."

"That *is* one of the great advantages of monogamy," I said, envious that Philip had been able to enjoy Terry's cock without latex barriers.

"Who said I was monogamous? Or him? I still fucked with other guys occasionally, and he was certainly fucked by friends of mine, or sucked them off. But I made sure we used condoms every time with anyone else, plus taking all the recommended precautions about piss, blood, etc. It was only between the two of us that I relaxed the rules."

"That sounds safe enough, Sir, though of course the bottom is always at greater risk."

"I'm glad you approve," he said drily.

"It's just that I appreciate how cautious and responsible you are, Sir," I said. I was already looking forward to sucking his naked dick after whatever waiting period he imposed had expired!

"I do my best. Shall I go on?"

"Please, Sir."

"Phil always slept in chains or other restraints, most nights on a futon on the floor next to my bed or else tied across the end so I could use him as a footwarmer. After the three months were up, he took my piss during the night — first thing in the morning, too, and then he got me going with a nice blow job. While I made breakfast, he would use the bathroom, and after breakfast he'd clean up the kitchen while I got ready for work."

"Did you eat together, Sir?"

"Usually. Most of the time I put his dish on the floor by my feet. He wasn't permitted to use the furniture, of course. Occasionally I'd feed him by hand from my dish, or make him wait to eat until I was all finished. Sometimes he ate leftovers standing at the counter. It all depended on my mood. It amused me to keep him guessing."

"I'll bet! You haven't changed much there, either, Sir."

"Is that a complaint?"

"No, Sir! Just an observation."

"Perhaps you should keep further observations to yourself until I'm finished. Eat your dinner and listen."

"Yes, Sir. Sorry, Sir." *Guess I need to learn to read him as well as he reads me — or else wait passively for orders all the time.*

"Each day before I left," Terry continued, "I'd put on Phil's daytime chains, which were lighter than the set he usually slept

in, insert a butt plug, put a chastity jock or some other device on him so he couldn't play with himself, and give him any special work orders for the day. I'd call home at least a couple of times a day, not on any schedule, to check up on him, find out what he was doing. He wasn't allowed to answer the phone unless it was me, just let the machine take messages.

"He wasn't allowed to eat again after breakfast, or drink anything but water, until his regular lunchtime. Sometimes I'd compose weird lunch menus for him, things even he could put together, like a peanut butter and tunafish sandwich, which he'd eat from a plate on the floor. If he'd been bad, or if I was feeling mean, I'd make him eat without hands, too."

"How'd you know he obeyed those orders, Sir," I couldn't resist asking, "if you weren't there to watch him?"

"If he'd really wanted to cheat, he could have. But remember my unannounced phone calls — he was very bad at lying on short notice. And every once in a while I'd come home early and unexpectedly, just so he'd know he couldn't take my schedule for granted. You're shaking your head — what?"

"Sorry to be skeptical, Sir, but there's still a lot of leeway for abuse in that setup."

"Do you mean that *you'd* have abused my trust in the same situation?"

"Well . . . ," I said, and blushed.

"Remember, Matt, *he wanted this*. He chose to be my complete slave, knowing what he was getting into. Obeying every little rule or command, no matter how irrational or inconvenient, was an essential part of the discipline he accepted. He egged me on, in fact, encouraged me to be as strict as possible. Whenever I tried to reward him by giving him a choice about something — what he'd have for lunch, what kind of bondage I'd put him in for the evening — he seemed to resent it. He always wanted me to decide for him." *Jake should hear this!* I thought, then realized he probably had. "Of course, Philip *did* abuse my trust later on, but we haven't reached that part of the story yet. More comments or questions?"

"Yes, Sir. I guess it was also convenient for you, having a live-in houseboy to do all the cleaning and stuff. If you'd kept him chained up tight all the time so he couldn't get into trouble, you'd have had to get someone else to do the housework, like

you do now, or do it yourself. And it wouldn't have been safe, either, going away and leaving him helplessly bound all day."

"Right on both counts," he said. "Even this fairy-tale Master/slave relationship had its practical side. I left him in chains, but he could get out of the house, or call for help, if something really bad happened, like a fire or a medical emergency. And his restraints were also loose enough to let him work. I enjoyed having the house kept spick-and-span — it's never looked as good since! Of course, there really wasn't enough straight housework to keep him busy the whole day, every day, even with caring for my leathers and boots added in, so sometimes I had to invent chores."

"Such as?" I prompted.

"Oh, like polishing all his chains with jeweler's rouge, or scrubbing the dungeon floor with a toothbrush."

"Or spinning straw into gold, Sir?"

"That was *my* job," Terry said, pokerfaced. "I was going to turn a golden-haired innocent into the world's most perfect sex slave."

"My hair's golden, too, Sir."

"But you're no innocent. You're a fucking pervert, thank the Lord." We grinned at each other.

"So why didn't your project work, Sir?" I asked.

"I'm coming to that. Do you want me to tell it or not?"

"Yes, Sir. Please continue." While I was eager to hear why he and Philip broke up, I was enjoying the juicy details of their story. I was actually surprised he was telling me so much of it.

"In the little free time I left him," Terry went on, "Phil was allowed to read whatever he wanted that was in the house, anything from porn to literature to my books on architecture and engineering. He devoured all the serious literature I had and begged for more, so instead of giving him choices he didn't appreciate, I gave him books to reward good service. Those he did appreciate.

"He said that if he weren't my slave he'd want to be a writer — the first sign of any nonsexual ambition he'd shown — and I said there was no reason he couldn't be both. I had him keep a journal, insisting only that he had to include everything he did for me, or that I did to him, and what he felt about it. So every time he sucked my cock, took my piss, or got fucked, he had to note it down and say something about it, and I got similar feed-

back on every torture and bondage position I tried. Since similar things happened every day, he was forced to become quite inventive, and observant, in order to come up with fresh descriptions. Part of it was the sheer challenge of finding new ways to talk about sex, but part of it was simply another way of trying to please me — his loyal, and only, reader."

"And were you pleased, Sir?" I felt compelled to keep probing, like testing a loose tooth with my tongue. I had to find out just what kind of a paragon I was competing against — or, if he was out of the running this time, that I would inevitably be compared with in the future.

"Yes, he pleased me," Terry said. "Philip has a real talent for writing, and I'm proud that I helped bring it out. I enjoyed his journal immensely. Of course, I always took what he wrote with a grain of salt, measuring it against my own observations of his reactions, since he had a tendency to embroider things — most writers do. But it made fascinating reading. I also used it to record his demerits."

"Demerits, Sir?"

"For every instance of unsatisfactory attitude or behavior he earned one or more demerits. That was in addition to any punishment I might mete out on the spot, such as slapping his face or making him miss dinner. And every Sunday night, before we went to sleep, we had a punishment session. He purged his transgressions during the past week and began the new one with a clean slate — though usually a very sore ass. On most nights, however, the first few hours after dinner were quiet time. After he'd cleaned up the kitchen, I'd put him in very tight bondage and read or watch TV with him nearby."

"Tight bondage, Sir? Like what?" *Details!*

"Oh, I'd hogtie him, or put him in a straitjacket or mailsack, or mummify him. Or I'd spreadeagle him to the wall or on the floor. I got pretty inventive, and he was a great subject. He never complained about that part of it — he loved being tied up, the tighter and longer the better. Still does."

I'll bet, I said to myself sourly.

"We didn't always have sex as part of it — rarely, in fact. I just tied him up and kept him nearby, enjoying his little moans as time went on, enjoying looking at his beautiful body straining against the ropes or straps or chains. It was after I let him loose

that we would have sex again, if I wanted to, and I usually did. We'd lie on the bed and he'd blow me or I'd fuck him. It usually wasn't reciprocal. I kept him pretty horny, letting him come only once or twice a week."

"How'd he feel about that, Sir?" I was pretty sure I could never stand waiting that long between orgasms.

"He didn't like it," Terry said, "but he accepted that coming was a privilege and that it wasn't right for him to do it without my permission. He simply wanted me to grant him the privilege more often. Sometimes he begged me to let him come, he was so horny, and sometimes he broke the rules and managed to jerk himself off on the rug or something. I would punish him severely for it, of course."

"Did you use coming to reward him, Sir? As positive conditioning?"

"Certainly, but I never held it out as a goal — he couldn't depend on it. If he'd been behaving well and had earned very few demerits, I was more likely to bring him off when we fucked in the evening, or to let him do it. But sometimes when he was facing a serious punishment session, I made him come first just to create a bigger contrast. It's tricky to punish a masochist! If he's horny enough, he can turn the pain of a punishment into a pleasurable experience."

I smirked, remembering the abuse I'd absorbed in our sessions, especially the jail-cell interrogation scene.

"I hope you're not thinking those were punishment beatings I gave *you*," he said, as if reading my mind. "I was only *pretending* to be angry. Besides, I'd never punish a bottom in anger. If I really get mad at a boy, I *don't* hit him — I throw him out."

"Slaves, too, Sir?"

"In principle, yes — though with a slave I'd have a much stronger commitment, and probably a lot more time and energy invested, so the provocation would have to be pretty extreme. Don't think that means I'd put up with any shit! If my slave fucks up, then obviously his training was insufficient, so first I'd try to correct his behavior with more stringent discipline. Only if that failed repeatedly — or if he flat out rebelled — would I give up and dismiss him. But that remains the ultimate sanction. Do you understand?"

"Yes, Sir, I believe so. You'd still leave me the option of

quitting at any time, Sir, but not the right to control what happens if I don't quit — including being punished to correct whatever you consider misbehavior."

"That's right. And you have no problem with that arrangement?" he asked, staring intently at me.

"Sounds fine to me, Sir! If I wanted to second-guess your every move, Sir, why be your slave at all? But I'd still want my feelings considered."

"Oh, I'll *consider* them," he said, smiling again. "But I won't always indulge them. You can have all kinds of different feelings in the course of a session, whether it's a play session or a punishment session, including some really negative ones. What counts is how you feel afterward. No matter what I put you through, no matter how rough it gets, or how humiliating, you should feel good about yourself when we're finished — and about us, about being my slave — or I've done something wrong."

"Yes, Sir." *Why doesn't every top or Master think like that?*

"But I was telling you about disciplining Philip," he added. "Do you still want to hear all this?"

"Please, Sir. It's fascinating." *And hot!*

"Well . . . back then I was naïve enough to use beatings to keep Philip in line — not abusive beatings, nothing that damaged him, just pain that was clearly not meant for mutual enjoyment. After I untied him each evening and we made love for a while, I allowed him to take a long bath, completely unrestrained except for his collar chain. Sometimes I went in with him and washed him myself, but usually I let him bathe alone. I trusted him not to jerk off in there, because it was part of his discipline, and because I could always tell when he had. He'd respond differently when he wasn't horny; he couldn't help it. Phil's journal made it clear that bath time was his favorite part of the day — not because he didn't love the bondage and the service and everything else, but because the contrast put them all in perspective.

"Anyway, when he came back to the bedroom on Sunday nights, all clean and relaxed — he shaved then, too, rather than in the morning — "

"Did you make him keep his body or pubes shaved, Sir?"

"No! I like body hair, as you must know." I smiled, remembering how he'd run his hands through my chest fur, although it isn't nearly as luxuriant as his. "I'm not into men who look like

boys. I only shave a partner's body when I have a good reason for it. Philip shaved only his face. . . . Shall I continue?" he asked pointedly, clearly peeved at my interruptions.

"Please! Sorry, Sir." *I can't help it! I want to know everything!*

"When he came back from the bathroom on Sunday night, he'd present himself to me on his knees, his head bowed — I was either in the armchair or lying on the bed — and ask to be corrected for anything he'd done that had displeased me. I'd read off the demerits accumulated in his journal so he knew what he was being punished for."

"Such as?"

"Interrupting me, for one thing!"

Terry glared at me — the muscle at the corner of his mouth was twitching, as if he were controlling himself with some effort. I pantomimed zipping my lips shut. He shook his head and took a deep breath before continuing.

"Or not addressing me properly. Or doing a careless job with one of his chores. Or being slow to respond when I told him to do something. Or, worst of all, coming without permission."

He paused and looked at me sharply, as if daring me to interrupt. I stayed mute and put on my most angelic expression. He frowned, not fooled for a minute.

"For the punishment," Terry continued, "Phil would lie over the edge of the bed with his ass in the air — no bondage — and take one stroke with a cane for each demerit. He really hated those canings. There was nothing sensuous about them at all. I hit hard, and I meant to hurt. Each stroke raised a welt. And he had to hold himself still by will power alone, plus counting off the strokes and thanking me for each of them.

"Because we did this every week, I was careful not to let the number of strokes grow too high. Most offenses would earn only one demerit, and in the course of a typical week he might accumulate between five and ten. Fifteen was an exceptionally high total. Even with five, he was usually crying by the time I finished. I would hold him in my arms and comfort him till he calmed down. Then I'd put him back into some kind of bondage for the night, typically very heavy chains, because he wouldn't need to be moving around much, and we'd go to sleep."

Terry stared off into space after this speech, apparently lost in his memories again. His eyes seemed to brim with tears, and

there was a wistful smile on his lips. *A lot of feelings under that macho facade*, I thought. Some would consider it weakness in a top, but I liked him better for it.

After a minute of silence I prompted him to continue.

"He never slept beside you in bed, Sir, always on the floor or at your feet?"

"Huh? . . . Oh." His eyes cleared, and he saw me again. "Yes, Matt? What'd you ask me?"

"I asked if Philip ever slept beside you in bed, Sir."

"Well, sometimes we started with him snuggled up against me, especially if I was really horny, and sometimes I'd fall asleep with my cock still in his ass or his mouth. The first few times I fell asleep in bed after he sucked me off, Phil's jaw closed when he nodded off, and he bit me, waking me up — not very happy, as you can imagine."

I couldn't help laughing at the image of Terry jerking awake because his sleeping slave bit his cock. After a moment when he seemed about to be angry, he chuckled, too — it *was* comical. The kind of problems leatherfolk have to solve! The vanilla crowd have no idea.

"I realized it wasn't his fault," he said, "and had a leather-maker create a head harness incorporating a rubber mouth guard like athletes use. It held his jaw open about an inch even while he was asleep, and the rubber over his teeth protected my cock."

"You know, Sir," I interjected, "this is a hot story! It's making me hard hearing it. It doesn't sound like a 'cautionary tale' at all but a model Master/slave relationship. You two had what a lot of guys just dream about."

"Is it what you dream about, Matt?" he challenged. "Would you like to live the way Philip did when he was my slave?"

"Well . . . ," I thought harder. "No, Sir, not really. I can see how it could get to be a strain after a while. Even with access to a good library, there's just not enough stimulation in housework, bondage, and sex alone to add up to a complete life, not for anyone with brains."

"Thank you, Gloria Steinem!"

"It's true, though, Sir! People need to interact with the rest of the world no matter how much in love they are with their partners. And you didn't even say if you and Phil were in love."

"Oh, it was love, all right, after a fashion. I loved his beau-

ty and docility and thought I could mold his character to fit my fantasy. He loved most of what I did to him, and he loved me as the author of it. But on a deeper level, I don't think either of us had any idea who the other was. His nakedness and vulnerability became a mask. And my role as 'The Master' was my mask. Talk about 'strain' — I felt I couldn't relax for a second. I felt I owed it to Philip always to be the stern disciplinarian I'd promised him I'd be."

"I'm glad you can relax with me, Sir," I told him.

"I'll take that as a compliment!" he said with a grin. "Do you want to hear more?"

"Please, Sir!"

"All right." He drank some water and checked his watch before continuing.

"Don't think I kept Philip chained up at home all the time. Occasionally we'd go out to the theater or a concert — his bondage was more discreet on those occasions, but he was still very aware of it. His crotch would be harnessed, of course, and his butt plugged, and there might be a chain between his tits, nothing you could see from the outside. A shirt and tie hid his collar — don't make a face, Matt! I know you don't like dress clothes, but they have their uses."

"If you say so, Sir," I allowed.

"You're incorrigible! . . . Where was I?"

"Dressing up your slaveboy for the opera, Sir." I grinned at him, and he just shook his head.

"Sometimes I used another device I had custom-made by one of the leather shops, 'dress manacles' — strips of soft black leather that fit around his wrists, under his shirt cuffs, and had tiny locks and D rings. We would take our seats at, say, the opera, as you suggested, without attracting the slightest attention, and then, after the lights were down, I'd lock his wrists together behind his back or in his lap."

"Sounds hot," I said.

"Oh, it was! For both of us. Of course, when we went out to the bars, we didn't have to be discreet, and I enjoyed parading him around on a leash and having him kneel down and lick my boots while I talked with friends. I'm surprised you never saw us."

"When was this, Sir, six, seven years ago? I was taking care of a dying lover, remember? And I was barely a novice in s/m. I

wasn't a regular at the bars then. Anyway, Sir, you still haven't explained why you two broke up. Even if your arrangement was too rigid to last, couldn't it have evolved into something more comfortable?"

Terry didn't answer immediately. He signaled the waiter to clear our plates away and bring coffee.

"I guess it never occurred to me that anything else was possible," he said when we were alone again. "We were doing it the way you're supposed to, by the book — the only books we had, anyway. And for a while we were both very happy. In fact, I still thought everything was perfect six months into the relationship when I suddenly noticed huge increases in the phone bills. Apparently Philip was spending a lot of time during the day talking with his old friends and even some of my friends. I confronted him about it and tried to discipline him in the usual way, but for the first time he balked. He accused me of ruining his life, of turning him into a sex toy or a household convenience."

"Uh, oh."

"I was flabbergasted," Terry said, "because I'd thought that was what he wanted. He'd given no other indication he wasn't as happy with our way of life as I was. He never hinted at it in his journal, for instance. And I truly wanted him to be happy. I'm a sadist, not a monster. I don't enjoy torturing a reluctant victim. So I tried to modify our arrangement, though it felt like I was betraying a dream."

After a pause to collect his thoughts, he continued.

"I agreed to make his slavery less total, more like the kind of bedroom theater that's very common today. I stopped the punishment sessions, though I still recorded demerits in his journal. Instead of caning him, we talked them over each Sunday. I let him know how disappointed I was by each failing, and he always apologized and promised to do better. I didn't realize that I was denying him closure — each demerit became a festering wound instead of a lapse he could pay for with pain and be done with."

"I never thought of it that way, Sir."

"Neither had I — it wasn't until much later, after he'd left, that I realized what I'd done. Anyway, I let him have his clothes back, and I gave him a house key and some money. He was free to come and go as long as he did his chores and made himself available sexually whenever I wanted him. I told myself that our

evenings could remain much the same as ever, that he'd just have more freedom during the day, when I wouldn't have to see it."

"And how did that work out, Sir?" I asked while our coffee was served. Terry waited until the waiter had gone again. It was past 9:00, and we were almost the only customers left.

"It was a disaster," Terry said, stirring his coffee. "After more than six months as my complete slave, Philip had forgotten how to handle freedom. He stayed out too late, missed meals, acted like an irresponsible teenager instead of a man in his mid 20s. Instead of feeling submissive, Philip felt dependent, which can only create resentment. We had furious rows and shouting matches — and the sex wasn't very good anymore, either. It took so much work to get him back into a submissive mood that by the time we were ready to fuck, I'd gone soft." We sipped our coffee in silence as we contemplated, from opposite perspectives, the wreckage of an "ideal" relationship.

"A few months later," Terry continued, "we agreed to call it quits. I staked him to a relocation in San Francisco, he moved out, and that was the last I heard from him — though for a while I kept tabs on him through friends out there — until he called me last month."

"How long were you together, Sir?"

"Less than a year. We went from being inseparable to being unable to stand the sight of each other in less than a year."

The pain of the memory showed on his face. He retreated into silence, staring down into his cup. When he looked up again, his face clear once more, a couple minutes later, I asked the obvious questions.

"So why'd he call you now, Sir — you, of all people? And why'd you agree to see him again?"

"You *are* jealous." His mocking grin was back.

"If you don't want to tell me, Sir . . ."

"No, no," he said, shaking his head, "you have a right to know. It bears on why *our* affair has stalled the last two weeks." He gave me a crooked grin, then drained his cup.

"It hasn't been only work and travel that've kept me from seeing you again," he said. "Philip's reappearance has a lot to do with it, but not in the way you've been imagining. He isn't your rival, Matt. I haven't been trying to choose between you. But Phil *is* unfinished business, and I'm afraid — in fact, I *hope* — that he's

going to stay that way for some time." He paused and looked down at the tablecloth, as if hoping to find a clue in its tarnished whiteness.

"I guess I'm old school in this," he resumed, "but I believe that once you accept another person as your property, you're tied to him forever. Even though I gave Philip his freedom, I still feel responsible for him. When I heard from friends in California, years ago, that he'd straightened out and was settled into a good job, I was relieved, and when I heard later that he had a new Master, I was doubly relieved. If he'd voluntarily returned to slavery despite his bad experience with me, then I hadn't corrupted him — he really *is* a slave at heart.

"His new Master had a good reputation — but I was puzzled to learn how strict he was. Although he let Philip go out to work, probably for financial reasons, he kept him on an extremely short leash otherwise. I'd thought Philip left me because I was too strict. But my friends said he seemed very happy." *More confirmation for Jake's theories*, I said to myself.

"A couple of years ago," Terry continued, "I heard that Phil had left his second Master, too, though neither would say why, and was living on his own again. He seemed to be doing okay. He had some clerical job, but he was also doing a lot of writing — the journal he'd kept when he was with me had been good training. He was even starting to get paid for it. Occasionally I'd see his byline in *The Advocate* or *Drummer*, but he mostly wrote for local West Coast papers. He was very active in the SF Bondage Club, and he even pledged The 15 at one point, but he didn't go through with it. With his beauty and experience, he had a lot of offers, guys who wanted to take him on, but he stayed unattached." Emotion seemed to grip him again, and he paused for a minute. *Is this the whole story? Feels like a key clue is missing.*

"When Phil called me," Terry continued, "he confirmed all that I'd heard. He said he wanted to see me again to repair any hard feelings he'd left behind. He felt it'd been his fault more than mine that our relationship hadn't worked out, but he said he had no regrets. He said he was grateful for all I'd taught him and for the love and care I'd given him." He coughed and glanced away before going on. *There can't be much more to reveal, can there?* He looked me full in the eye when he spoke again.

"He seemed genuinely changed, Matt — grown up finally

— and, frankly, I was curious about what kind of man he'd become. All he asked was to see me. He didn't make any demands. I asked him to stay with me because I didn't like to think of him at the Y or the kind of fleabag hotel he could afford."

"So where do you two stand now, Sir?"

"That's still not entirely clear," Terry said. "When he moves back here he'll stay with me again, at least at first. He can do the housework for his keep, though not as a slave, while he tries to get established as a journalist." I didn't like the sound of that at all! *Whatever he said about our not being rivals, if Philip's there on the spot every day, living in his house, why would he need me?*

"Sounds pretty cozy, Sir."

Terry glared at me. "Don't be bitchy, Matt. I hope you're not expecting an exclusive relationship with me. If I want to keep a whole harem in my house, that's my privilege."

"As you wish, Sir," I said with an ill grace.

"Cheer up, boy," he said, chuckling. "Think of the hot three-ways we could have. *You* said Philip is gorgeous, and he thinks you're cute."

"Being *cute*, Sir," I said with all the dignity I could muster, "is for those with no other redeeming attributes. I have no ambition to be cute. I disdain cute. Cute, Sir . . . is for *kids*."

I kept a straight face until Terry reached across the table, knuckled my head, and announced, "Too bad, dickhead, because *I* think you're cute, too," which sent us both off.

"Seriously, Matt," he said when we'd stopped laughing, "I wish you'd stop worrying about Phil coming between us. He and I can never recapture the feelings we once had for each other, and we're not going to try. But I have a responsibility for him."

"But do you have to let him live with you again, Sir? You wouldn't even consider letting me do that."

"It's different with you. You're such an independent cuss, for all this newfound desire of yours to be a slaveboy. You do fine on your own, and I think we'll do better together if we don't have to spend too much energy making allowances for each other's everyday needs and shortcomings. But Phil *needs* looking after."

"I just don't trust him, Sir, not that close to you. He'll seduce you again, and the times you'll want to get together with me will become rarer and rarer."

Terry rubbed his chin and stared at me with hooded eyes

for a few moments before saying, "I didn't want to get into this, Matt, but I guess you need to hear the *whole* story. You seem to think Phil and I made up, then fucked our brains out for the rest of the week he was here. We *did* make love several times, but I never tied him up, never did any s/m stuff with him at all. I'm not sure I ever can again, though of course he'd like me to. He slept in the spare room — except on the second night, the night you called. After we'd stayed up late again, talking and drinking ...and crying ..."

Crying? I suddenly felt queasy, and it wasn't indigestion. *Maybe I don't want to hear this after all?*

"We went to bed together that night," Terry started again, very somberly, "but all we did was cuddle and sleep." He paused and I braced myself, having a strong suspicion what was coming.

"You see, Matt," he said finally, "after we'd already made our peace with each other over the past, Phil told me . . . back when he'd been running wild, before we broke up completely . . . he . . . neglected to take precautions. That must have been when he got infected."

I stared at him, staggered and speechless.

"Yes," he said, "you understand now. Philip's HIV positive. He found out when he got tested a couple of years ago, after his second Master got sick. That's why they broke up — not because the man blamed Phil; he might easily have gotten infected from someone else, years before they met. But he couldn't stand to have his slave see him get weak. He pushed Phil out, wouldn't let Phil take care of him, though the poor kid begged to." In a low voice, as if to himself, he added, "Stupid pride . . . but perfectly understandable."

I could still only stare, my mouth hanging open. *Why didn't I realize this sooner? He and Jake dropped enough clues. What a self-centered idiot I've been!*

"The disease went very fast in this Master's case," Terry continued, "the way it does occasionally. He died less than six months after he fell sick. Phil's been on his own the last two years, surviving fairly well, too. When they split up, the Master gave Phil some money he'd been banking for him, and he also arranged with friends to help Phil get established, but after that the boy kept going on his own steam." He looked sharply at me, as if daring me to deny his former slave's achievement.

"That might not seem like much to you — you've been on your own for six years, right? But Philip is younger than you, and for a good chunk of his adult life he's been a slave, unused to making decisions. I really admire how well he's adapted. He says he misses having someone to report to, someone to keep him in line, to make all his effort worthwhile, but he can't bring himself to tell any prospective Master that he's infected. He insists on safe sex, of course, with anyone he plays with, but when it comes to starting a new relationship, he feels paralyzed. He won't make any commitments he might not be able to keep. He's been asymptomatic so far, but recently his T-cell counts started dropping. That's why he felt he had to see me."

"Are *you* okay, Sir?" I blurted out. "I mean, are you still negative?" I didn't ask, but only thought to myself — *could you have infected me?*

"Yes — still negative as of last week. Of course, after Phil's revelation, I got tested again right away. But, as you said, the bottom is always at greater risk. Still, when I think how close I came, how easily he might have given it to me, I could shoot him. And then when I think about *why* he let his guard down — because I'd been insensitive to his restlessness — I feel responsible. Most of all, I feel so fucking angry about the waste of his life! Now that he's finally gotten it together, when he should have many years of happiness and accomplishment to look forward to, he gets this death sentence!"

What could I say? I had my own long list of the dead or dying to mourn for. *Compared with how some of them fared, Philip is lucky — at least he has someone as loyal and responsible as Terry to turn to.*

"Doesn't he have family, Sir?"

"They washed their hands of him long ago. He really has no one but me to take him in. Luckily, I can afford it — I think. That depends on whether I can get him covered under the medical plan my firm carries, and whether he stays healthy past the waiting period for pre-existing conditions."

"Do you really know what you're letting yourself in for, Sir? It'll be a big role reversal for you, taking care of a dying slave." I grinned weakly at the feeble joke.

"I know what it's like," he said. "I've helped enough friends care for their loved ones. I guess it's my turn. And it's not as

much of a role reversal as you think — I can be the big mean nurse and make sure he takes all his nasty medicine!" He smiled, but his eyes brimmed with tears. "Besides," he said, "he doesn't even have full-blown AIDS yet. He could stay healthy for years — maybe even till they find a cure."

"I've stopped hoping for that, Sir. I don't think we'll see it in our lifetimes."

"You're probably right. I expect he'll die of it, whether it's six months from now or six years. But when you're 29, like Phil, what difference does it make, six months or six years? In either case it's not enough, it's not a full life. . . . And he's so goddamned beautiful." His hands spasmodically clutched the tablecloth, as if trying to squeeze the virus out of Philip's body, while tears rolled down his cheeks.

I reached across the table and touched his right hand. He seemed glad to release the cloth and grab me instead, holding my hand with a fierce, almost painful grip for several minutes. I wondered how to comfort him — a strong, capable man impotent to undo a disaster he'd done everything he could to prevent — but just holding me seemed to help.

"Thanks, Matt," he said finally, smiling and releasing my hand. "You know, I never intended to tell you so much, but you kept pushing."

"I'm glad you told me, Sir. Thank you."

"And this is *not* how I planned for the evening to go!" he said in a firmer voice. "I never intended to let Philip become the skeleton at the feast. And it's not fair to him, either — he's a fighter. I'm going to help him in any way I can, but that has nothing to do with you and me. I was going to feel you out, make sure you still want to be my slave . . ."

"You'd better believe it, Sir!"

"Noted," he said with a grin. "Then I was going to explain again how I handle limits, because it's something you need to be clear about. Finally, if all went well, I planned to take you home to your place, tie you up, beat your ass, and fuck you into next week."

"Still sounds like a great plan to me, Sir!"

"Think so? Maybe we can salvage it, then. I guess I did say enough about limits, anyway. That's what the tale of Philip and me is really about: if you don't recognize limits, if you get carried

away by a fantasy, you can get a nasty bump when you finally come down to earth. But you and I seem to communicate pretty well. If I ever take you too far, I'm sure you'll let me know! Just try and leave me the illusion that I'm in charge, okay?"

His crooked grin made it clear that any "illusion" would be on my part. I tried to match his bantering tone.

"Please, Sir! I wouldn't dream of trying to control you."

"Ha! And I suppose there's a bridge you want to sell me." But he was still grinning as he said it. "Anyway, when I think you're being too pushy, I'll just glare you down."

"Fair enough, Sir." I grinned back. *How many tops are secure enough to joke about such things?* "I'm ready whenever you are."

He signaled for the check, and in minutes we were out the door, heading for his car.

CHAPTER 19

Attitude adjustment

We picked up Terry's car at the garage and drove uptown to my apartment building — he remembered exactly where it was. After circling a few times, we found a near enough parking spot good till 9:00 a.m. Terry took a leather overnight bag from the trunk and gave it to me to carry.

As soon as we were alone in the elevator, he turned me toward him, unbuttoned my shirt the rest of the way, and started playing with my nipples. I threw back my head and moaned. He put his hands on my shoulders and wordlessly pushed me to my knees, then shoved my face into his crotch. The smell and feel of worsted wool put me off at first, but I felt his cock straining beneath the cloth and outlined its growing length with my tongue. My own cock stiffened despite worry that the car might stop at an earlier floor and someone would see us. I decided I didn't care.

Terry pulled me back to my feet before we stopped on 12, but he had his tongue down my throat when the doors opened — so much for discretion. He kept his hand on the back of my neck all the way down the hall to my door, and I half expected him to fuck my face as soon as we were inside. But when I unlocked the door and swung it open, he let me go and went in first to look around. By the time I reached the living room, after locking the door again behind me, he'd already scoped out the bedroom and was headed for what was clearly the most comfortable seat I had — my armchair. He ordered me to set his bag next to it. My cock leaped and my heart did a little flip-flop in my chest at the imminent realization of one of my fantasies: Terry in my chair, making it his own, like I hoped he'd make me.

I set the bag down and stood there, watching him look over

my bookshelves and the art on the walls — nothing like the gallery at his place, of course, just a few good prints and photos. The only treasure I had was the Tom of Finland drawing in the bedroom.

Although it was a mild night, I closed the windows and put the air conditioner on low. We were far enough above the street not to hear much noise from outside, but any noise *we* might make was better kept inside.

"You wouldn't happen to have any good Armagnac, would you?" Terry asked with a grin, recalling my fantasy gift.

I fetched the bottle and silently handed it to him. He examined the label, smiled when he saw the venerable date, and nodded his approval. "Pour some for both of us," he said.

Greg had been a connoisseur of spirits, though not a heavy drinker, and taught me to appreciate quality. There was a case of vintage port in the hall closet, still too young, that he'd laid down for "our second decade." *Maybe Terry'll drink it with me some day*, I mused as I took the Armagnac into the kitchen and poured it into snifters, *and we can raise a toast to Greg's memory — and Philip's, too, by then?*

When I returned with the filled glasses, Terry was examining my CDs. To my surprise, he was still wearing his jacket and tie. He selected a disc of Keith Jarrett's solo improvisations and told me to put it on, low. I handed him his glass, set mine down, and slipped the CD into the player. The crystalline sounds of Jarrett's piano filled the room — "like ice melting, if ice were silver," Edmund White once wrote of it.

I picked up my glass again and turned toward Terry, who was cradling his in one hand and inhaling appreciatively. When he looked up, I asked if I might make a toast.

"Let's hear it."

"May we each get what we want, Sir!" I said, my glass raised.

"I'll drink to that," he responded. We clicked glasses and sampled the fiery, earthy liquor. There was no burn on the way down, just a gentle but insistent warmth, like the afterglow of a good flogging.

Terry smiled in approval, then added with a crooked grin, "And may we still want it after we get it!" I raised one eyebrow but clicked his glass again anyway. He laughed as I sipped again.

Terry took another sip, rolled it on his tongue, then set his

glass on the table next to the chair. He took my glass as well and set it down with his, then proceeded to pull my shirt off and toss it aside. When my torso was bare, he ran his hands over my chest and back. I closed my eyes and practically purred under his firm, confident touch.

I opened them again when I felt him grab my crotch. He smiled at the way my cock swelled in his hand, then let it go. He lifted my right hand and gently removed my silver bracelet.

"This is very handsome, boy," he said as he set it on the table, "but tonight I have some different bracelets for you." With a flourish, he pulled a glittering pair of handcuffs from the back of his belt, where they'd been hidden under his suit jacket, and expertly snapped them on my wrists. Then he took out his keys and set the locks. He seated himself in the chair and pulled me down to the carpeted floor in front of him, my bare back between his legs. When I was settled, he handed me my glass.

We sat without speaking for 10 or 15 minutes, sipping the brandy and listening to the music. I leaned my head against his right thigh, and he ruffled my hair. My cuffed hands naturally curled together in my lap, the snifter between them. I raised them from time to time to take a sip. My hard cock was cramped in my tight jeans.

"I like your apartment, Matt," Terry said finally. "Like you, it's stylish without being overdone. And all those books — they're not the kind people buy for show."

"Thank you, Sir. I was a history major and English minor in college, and I got in the habit of reading. Besides, I can buy them for half price at the store, even less if they're returns."

"Very thrifty — a good quality in a slave," he said with a chuckle. "The artwork reflects you, too," he went on. "It's very up-front, very open about who you are. I like that. And that drawing in the bedroom is wonderful, sexy and romantic and macho and tender all at the same time. It is an original, isn't it?"

"Yes, Sir. Greg bought it for my 25th birthday. We couldn't actually afford it — he had to drain a savings account — but once I saw it in the gallery I couldn't stop talking about it."

"Sometimes it's worth a sacrifice to get something you really want, boy."

He pulled my head back into his lap so I was staring at him upside down, then dipped a finger in his brandy glass and drew

it across my lips. I opened my mouth, and he inserted his finger. He moved it all around, running it over my teeth and tongue and the inside of my cheeks. When he started to pull it out, I playfully tried to hold on by closing my lips and sucking. He laughed as his finger pulled free with a pop. The brandy and music and easy conversation had relaxed me considerably, and I felt I was ready for anything.

Terry pushed my head back to an upright position, facing away from him. I could hear him opening his bag on the floor next to him and searching for something. In a minute he said, "More jewelry, boy," and I felt a smooth steel chain slip around my neck. He locked it on, then twisted it around so that the small laminated-steel padlock hung in the hollow of my throat like a pendant. He pulled my head back into his lap as before. I felt like a doll he could manipulate any way he wanted — my will was paralyzed, my muscles slack and pliant.

"A collar becomes you, boy," he said, looking into my eyes. The words echoed in my enthralled mind as he bent down and kissed my throat on either side of the padlock.

"Give me your hands," he said then, and with a soft clink of the handcuff chain I raised them above my head, the snifter still cradled between them. Terry took the glass away, unlocked the left cuff, pushed my head and torso down, and pulled both my arms behind my back. He relocked the cuff and set it.

"Turn around, boy, and get on your knees," he said. I twisted myself into position facing him, my hands secured behind my back, palms together. I lowered my eyes and licked my lips in anticipation of sucking his cock. My own cock threatened to burst the buttons of my jeans.

"Lick my shoes, boy," he ordered in a quiet, even tone.

I stared down at his well-polished black wingtips, licked my lips again, and bent to begin servicing them. Whatever I expected, I soon found that shoe leather tastes much the same as boot leather. The discovery fired me up, and I squirmed around on the floor, trying to get my tongue on every square inch of his shoes. While I worked on one shoe, Terry rubbed the tip of the other one across my bare chest, teasing my nipples. I was so turned on that I forgot everything but tonguing leather, so I was caught off guard when he suddenly stood up and grabbed my belt. He pulled me up off his shoes, then swung me around, still on my knees,

so that my ass was toward him and my head away. He pushed my head down to the floor and pulled my cuffed hands up into the small of my back, telling me to hold them there.

I heard what sounded like a belt sliding out of pants and was sure of it when the first blow landed on my ass, the first of many. Terry beat me methodically, not with full force at first but steadily. His narrow, hard belt hurt immediately even through my softened, well-worn jeans, but the pain and the situation excited me. I moaned appreciatively at each blow and raised my ass higher, grinding my head into the carpet.

That encouraged him to renewed effort, and all too soon the cumulative effect pushed me toward a limit. The blows kept falling, moving slowly up and down from my waist to my thighs, then crisscrossing the same area on the diagonal, first from the left and then from the right. I was on fire, throbbing with pain. Even the touch of the denim sliding across my skin as I swayed in response to his blows became excruciating. The cuffs were also starting to hurt my wrists, and my arms hurt from holding my hands away from my ass, but those were mere background notes.

"Please, Sir!" I begged finally. "Please go easier! Please, Sir, I can't take much more!"

The carpet under my face was damp with tears. That damn dress belt of his hurt more than anything I'd been flogged with in a long time — a *lot* more than his cop belt in our interrogation scene. Despite the dubious protection of my jeans, my ass felt like it was being cut to shreds.

"Are you saying you want me to abort the scene and leave, dickhead?"

Oh, shit! He isn't kidding, either, I thought, remembering what he'd said at dinner. His way had made so much sense when he explained it, but it was hard in practice — harder than I'd expected. Terry waited silently while I futilely searched for a way out of his trap. I could tell him to end it, which would mean the end of everything between us, or I could let him continue until he was ready to stop, which would certainly involve more pain than I wanted. *Where's that famous masochistic "alchemy," turning pain into pleasure, when I need it?* I gritted my teeth and made my decision. It was no contest. If *he* wanted my pain, he could have it.

"No, Sir! Please don't leave. Do whatever you want to me, Sir. I'll take it, Sir — somehow."

"How much more can you take, boy?" he asked.

"I don't know, Sir! It hurts so much, Sir!"

"I thought you were made of stronger stuff, boy. You're disappointing me. I think you can take five more — five more good ones. And you'll count them off for me, boy. Understand?"

"Sir, yes, Sir! Thank you, Sir!" *Five more doesn't sound so bad*, I thought, but I was chilled by his next announcement.

"You're going to take them bareass, boy, and from your own belt." Terry reached under me to undo my belt and pull it loose, after which he unbuttoned my jeans and pulled them down to my knees. He ran his hands all over my ass once it was bare, feeling the welts he'd raised.

"No cuts, boy," he told me. "I didn't even break your skin."

Hard to believe, I thought, but I was relieved to hear it. His touch was oddly soothing, but I was filled with dread thinking about my wide, heavy belt slamming down on my already tenderized ass.

"Ready, boy?" he asked finally.

"Ye-yes, Sir," I responded with only a slight quaver.

Wham! He landed the belt full force right across my ass, just above my hole. I screamed, my vision went black for a moment, and my knees almost gave way. *Oh, my God! He's going to wreck me!* In a few seconds, however, I'd recovered enough to say, weakly, "One, Sir! Thank you, Sir!" My hands had slipped down over my ass, and I forced them back into position.

"You're going to have to be quieter, boy," he told me, "or your neighbors'll wonder what's going on. If you weren't counting I'd gag you." He pulled my left boot off then, followed by the sock, and came around in front of me.

"Here," he said, crouching down and dropping the rolled-up sock just in front of my mouth. "Bite on this if you need to."

"Yes, Sir, thank you, Sir," I said, and chomped on my own dirty sock like it was a savory steak. There was a long pause, and then the piano music, which had stopped sometime during the earlier beating, came on again, much louder. *At least it isn't opera*, I thought desperately.

The next blow seemed just a shade lighter, or maybe I was better prepared for it. I bit down on the sock instead of screaming. "Two, Sir! Thank you, Sir!" I called out after a brief pause to catch my breath and release the sock. My belt hurt over a broad-

er area than his, and penetrated deeper, but it didn't feel like a knife cutting into me. I caught the sock in my mouth again and prepared for the next blow.

Wham! He hit me right across both thighs. No knife, just a hot poker burning into my flesh! I screamed uncontrollably, but the sock muffled it. It seemed ages, but was probably only a few seconds, before I recovered and sobbed out the ritual response, "Three, Sir! Thank you, Sir!" *Only two to go*, I thought. *Please go easy!*

As if he'd heard my plea, the next blow went high, just below my waist, and was a little lighter than the others, though still no love tap. "Four, Sir! Thank you, Sir!" *Only one more.*

He made me wait for the last one, and my heart pounded as I became convinced he was planning to make it a killer. *Maybe he'll avoid the obvious and make it the lightest of all*, I hoped. *Then again, he probably expects I'd think of that and will do just the opposite.* I chewed on the sock as the seconds dragged out. My ass and thighs still throbbed from the previous blows, but the burning feeling was diffusing into a warmth that was almost pleasant.

Just as I was lulled off guard, he struck, and it *was* a killer! I couldn't even scream. I opened my mouth wide, all the air in my lungs came out in a whoosh, and the sock roll shot across the floor as I collapsed flat. It wasn't until Terry came around in front of me and pulled my head up by the hair that I was able to croak out, "Five, Sir! Thank you, Sir!"

"Does my suit fit your image of me now, boy?" he asked sternly. He was still fully dressed, but a little rumpled. Through my tear-filled eyes, in fact, there seemed to be two of him.

"Yes, Sir! I'm sorry, Sir."

"It's okay, boy. This wasn't a punishment, simply a little attitude adjustment. I thought you needed a lesson in how misleading images can be. I also *enjoyed* hitting you, but now I can take off this damned coat and tie and get comfortable!"

He lowered my head to the floor and moved out of my sight. I lay there, limp and exhausted, grateful to still be breathing. *Could I survive what he* would *consider a "punishment"?*

I let my arms relax as far as they could. As the burning sensation on my butt slowly faded, the pain in my wrists from the thin handcuffs moved to the foreground of my attention.

I heard Terry moving around the room. The piano music

stopped and something orchestral came on, but quieter — *Ravel?* I guessed, my mind too fuzzy to be sure. When I had some energy again, I got back onto my knees and turned to see what Terry was doing. He'd removed his coat and tie, as he'd said he would, but he still had on the rest of his clothes. There were damp sweat patches under the arms and on the back of his white shirt. He headed toward the bedroom. From his expression when he returned, I gathered that he was satisfied with whatever he'd gone to check on: maybe the arrangement of eyebolts on my platform bed (one at each corner, one in the middle of the head and foot, and two on each long side).

Although Stan and I had often played in the apartment, and I'd brought tops there on rare occasions, if I knew them very well and their own spaces were unavailable, no one else had ever made himself as thoroughly at home as Terry. This pleased and annoyed me a little at the same time. My cock was soft after the belting, but it jerked hard again when he came over to me and bent to pull off my other boot and sock, then slipped my jeans all the way off. He unlocked the cuffs and took them off, too.

"Up, boy, on your feet," he said and helped haul me up with his hands under my arms. He held me against his chest, pungent with his sweat, and wrapped his arms around me.

"Good boy," he said. "You took that pretty well after all. How are you feeling?"

"Not too bad, Sir. I guess I won't be able to sit for a while."

"That's no problem, because we're not finished yet! How are your arms and hands?" he asked and stepped back to examine my wrists.

"They're sore, Sir."

"Of course, but no pinched nerves or anything?"

"No, Sir."

He gently chafed the grooves left by the cuffs and gave my upper arms a brisk massage.

"I'll switch to leather restraints for now," he said as he turned me around and overlapped my arms behind my back so that each hand was grasping the opposite forearm.

"Think you can hold that position, boy?"

I could feel some stress already, but no actual pain.

"Yes, Sir," I said. "Maybe not all night"

"Good. I don't want you sniveling and whining to be let

go as soon as I have you tied up." His crooked grin took the sting out of his words. "Just stay that way while I get my gear."

He turned and went to his bag, from which he pulled coils of black leather, about an inch and a half wide and maybe six feet long unrolled. He proceeded to immobilize my arms with them, beginning at the center of my forearms, where they pressed together, and working out in both directions. I held myself in position while he worked, but I was looking forward to being able to relax into the bondage and let the leather hold me.

Soon he was finished with the basic tie and got creative, threading the leather around my upper arms, across my chest, and over my shoulders, creating an upper-body harness. My forearms were pulled tightly into my back while my pecs were pushed out, emphasizing my ringed nips, which were framed by leather but left uncovered. When he finished, I couldn't move anything between my neck and stomach, but the tight leather bindings felt great. My cock jutted straight out, hard and leaking.

Terry ran his hands over my arms and shoulders, then stood back and examined his work with a critical eye.

"It needs one more touch," he said, and turned again to his bag of tricks. (*Does he have any clothes in there at all?* I wondered). He pulled out a short length of heavy chromed chain with small clips at either end, then came over and attached it to my nipple rings. I let out a little hiss when he released the chain, then took a deep breath — or as deep as I could with the tight straps around my chest — as I adjusted to the weight pulling at my nips. Terry looked at me and smiled.

"Nice," he said. "*Very* nice — if I do say so myself. You have to see yourself, boy."

He clipped the braided leash to the front of my collar and led me to the full-length mirror in the bedroom. We stood there, Terry behind me, leash in one hand and the other on my shoulder, as I looked at what he'd done with me. He said nothing, but that mischievous half grin played over his lips.

My upper torso was bound and outlined in black leather, muscles visibly straining against the straps, biceps bulging on either side of my pecs. The bright steel chain between my nipple rings hung down across the leather strips crisscrossing my chest. My abdominals were stretched, emphasizing their definition, and my pubes were dominated by my rampant naked prick.

Just above the leather harness hung the small but solid padlock on the chain circling my neck. My face was a little flushed and my hair disheveled, but my eyes were shining. I wasn't sure what I resembled — *a barbarian captive? a bound gladiator? a desperado caught by a bounty hunter?* — but I liked it! The bondage didn't negate my strength but accentuated it, and my obvious virility spoke for itself.

Terry moved to the side so he was fully visible in the mirror next to me. His rumpled dress clothes didn't seem incongruous at all — the contrast emphasized my tamed animality. His dark, sweat-damp hair complemented my blondness, his moustache my clean-shaven face. My hard cock was matched by his own tool, visibly straining inside his pants.

"How do you like it, boy?" he asked finally, still looking into the mirror with me, still holding the leash.

"I like it fine, Sir! It looks great — and it feels great, too. Thank you, Sir."

"You're just born to be tied up, Matt! You're not bad looking to begin with," he said teasingly, "but in bondage you develop a sensuality, a vulnerability, that are irresistible. But enough mirror-gazing. Come along, boy."

He turned away and pulled on the leash, leading me back out of the bedroom and toward what I was already thinking of as "his chair." He stopped me directly in front of it and pushed me to my knees, then picked up my glass from the table and put it to my mouth, giving me the last few drops of the Armagnac.

While I remained kneeling by the chair (I tried sitting back on my heels, but my ass was still too tender, so I stayed upright), Terry went to put on a new CD — the Paul Winter Consort at the Grand Canyon — and to get two cans of 7-Up from the refrigerator. When he returned, he slouched low in the armchair and stretched his legs out on either side of me, then rested his feet (still in shoes) on my naked calves. Unzippng his fly, he worked his cock and balls loose from his briefs. His half-hard cock jutted out at a low angle, and his hairy balls were splayed out on the leather seat under it. After stroking himself lazily a few times, he popped one can and drank, then gave me some. The liquid gurgling down my throat reminded me that my bladder was full.

"Please, Sir, could I take a piss?" I asked when he took the can back.

"Not yet, boy," he said. "Hold it for now, like I am." He finished the can, slowly, looking at me over the rim. (I lowered my eyes, focusing on his crotch.) "Flogging is thirsty work, boy," he said, opening the second can. He took a couple of swallows and offered it again to me.

"No, thank you, Sir. I'm not very thirsty." (Actually, I *was* thirsty, but I was also afraid of pissing the carpet!)

He shrugged, drank some more, and set the can down. Then he reached into his bag and pulled out another coil of leather.

"Stand up, boy," he ordered, and when I was on my feet he grabbed my cock and pulled me close to him. "You need a little more decoration."

He began wrapping the leather strap around my cock and balls, starting with a couple of tight loops at the base, then several turns around my scrotum to push the balls lower and tighten the skin covering them. Finally he wound the remaining leather along the full length of my stiffy, creating a tight sheath that left only the head uncovered. All of which, of course, made me even harder than before.

"How's that feel, boy?" he asked, batting my sheathed cock back and forth with his hand and playfully squeezing my balls.

"It feels . . . ah, shit, Sir!"

I had started to say it felt good, but before I could finish the sentence, Terry rubbed a spit-moistened thumb over my swollen cockhead, wiping away the drop of precum pearling from the slit. The pleasure was so intense my knees weakened — it was a struggle to stay on my feet. But he wasn't finished. He squeezed my cockhead again to force out the rest of the precum near the tip, wiped it off, and cleaned his finger in my pubic hair. Then, to my astonishment, he leaned forward and put his mouth over my cock, licking and sucking it while he pulled hard on my balls.

"Oh, God, Sir! I'm going to come if you keep that up, Sir!" I choked out, my body shuddering at the mix of pleasure and pain. Having my arms tied made it hard to balance, and I worried about falling.

"Don't you dare come!" he said when he pulled off, just in time, and sat back in his chair with a smug grin. "You looked good enough to eat, boy, so I did. Get back on your knees now."

He sat there calmly, drinking his soda, while I shakily lowered myself until I was again facing his cock.

"Did you enjoy that, boy?" he asked.

"Yes, Sir! You caught me totally by surprise, Sir."

"I enjoy doing that, boy, as you should know by now. Anyway, it's time for you to return the favor — as soon as I get it gift-wrapped."

He pulled a condom from his pants pocket, opened it, and slowly rolled it over his hardening cock, making a big erotic production out of the safety procedure. I stared hungrily at it the whole time, licking my lips and wishing I could taste it raw instead of rubbered.

"Chow down, dickhead," he said finally, using the leash to pull my head onto his slickly wrapped tool. Another surprise: it tasted like chocolate! "Consider it dessert," Terry said drily when he saw my reaction.

I took a deep breath and plunged his cock down my throat until I felt his pubic hairs tickle my nose. The chain hanging on my chest swung forward as I went down, reminding me of its presence by the tug on my nipples. I slowly pulled my mouth back up his cock, suctioning my lips tight around the shaft. The chain swayed as I moved, feeling much heavier than when it had rested motionless against my chest.

"Ohhh, yes!" Terry said. "That's the way to do it, boy!"

I used every trick I knew to make his dick feel good, swirling my tongue around the head, licking up and down the shaft like a lollipop, deep-throating him in one smooth motion, then pulling off in stages, pumping his hard cock in and out of my mouth. The thin latex was stretched tight around his thick piece of meat, so I could feel every vein along the shaft and trace with my tongue the ridge where he'd been cut.

"That's good, boy . . . that's nice . . . keep that up, boy," he murmured in encouragement, his hands tangled in my hair. He may have intended to direct the action, to face-fuck me instead of letting me suck him, but I was giving him so much pleasure that he didn't try to take over. I savored the irony of "freely" serving him while I was bound — or maybe it wasn't ironic at all, but simply the way things ought to be.

Although my knees were getting sore and my bound arms were aching, my own cock stayed as hard as his. Part of that, of course, was the need to piss, which grew more urgent by the minute. But part was simply my excitement at sucking Terry's cock. I

had enjoyed sucking it the first time he gave it to me, in his bed-room, and it was every bit as good this time, too. He had a damn nice cock, and I liked being able to please him so much. After sev-eral minutes of my expert sucking and licking, accompanied by moans of pleasure from him, he pulled my head off his dick — almost reluctantly — and pushed me down to his balls.

"Chew on my nuts, boy — you know how I like it," he said, helping me get both balls into my mouth at once. They were a mouthful, all right! I clamped the neck of his scrotum between my teeth and ran my tongue around the hairy orbs. Above my head, I felt him pulling on his cock. His moans became more fre-quent and his mutterings less coherent. I sucked his balls as hard as I could, and soon I felt them pull tight.

"Ahhhgghh!" he screamed as he shot into the rubber.

I felt both glad and resentful. *Damn the virus! That load was rightfully mine!* I gently released his nuts from my mouth and straightened up. Terry was slumped back in the chair, his eyes closed, breathing heavily. His cock was softening slowly, the head lowering itself in little uneven jerks — the tip of the condom hung limply off the end, weighed down by a whitish blob.

"Good boy," he said as he opened his eyes and looked into mine. "That was fantastic! Do you always suck cock like that, or do I inspire you? . . . Don't answer that," he said quickly as he saw me smile. "I don't want to hear about your other conquests." He pulled the condom off and held it up. "Turn around, boy, and sit with your head in my lap."

I shuffled around as he directed and gently lowered my ass to the carpet (*oohh, oww!*). It was still very tender, but it didn't hurt too much if I stayed still — though my need to piss made that ever more difficult. I stretched out my legs — *now, that's a re-lief* — and leaned my head back until I could see Terry's face. He was upside down again, just as before my "attitude adjustment" beating. *He was right*, I decided — *it was a good lesson. Whether he's wearing a business suit or full leather, he's a hot man and a strong top. And a worthy Master? For sure! But will I make a worthy slave?* I gnawed at the idea as if at a hard nut I couldn't crack.

Terry squeezed cum out of the condom onto my left nipple and rubbed it around with his finger, then did the same with my right nip.

"Did you know cum is the world's best skin cream, boy?

This'll keep your nipples soft and sensitive. At least that's what I've heard," he said with a grin.

I just made purring noises the whole time, it felt so good. He smeared the last drops along my forehead and cheeks, rubbing it in with his palm. The sharp sex smell made my nostrils twitch. I still needed to piss, but the urgency had subsided.

We sat there without speaking for a few minutes, Terry playing lightly with my hair and nips. Eventually, he pushed me off his lap and stood up. He stretched and yawned — it was close to midnight on the living-room clock. He made no move to put his cock back in his pants, letting it dangle out of his fly. He also made no move to undress the rest of the way.

"How are your arms, boy?" he asked.

"Achey, Sir," I replied, "where they haven't gone numb."

"Well, I guess it's time to untie you."

He yawned again.

"Stand up, boy," he said and took hold of my leash again.

I leaned forward, and he helped me struggle to my feet, then held me at arm's length for a moment, looking at me — *enjoying the last sight of his handiwork?* — before he turned me around and started undoing the leather bindings around my arms and chest. When he had them all off, my arms fell to my sides like dead meat, but soon started tingling painfully as full circulation was restored.

Terry left the strip tied around my cock and balls and the chain hanging from my nipple rings. If he'd applied the clamps directly to my nips, they'd have been in worse shape than my arms by then. Still, the weight of the chain, and the way it shifted when I moved, made me ever-conscious of the symbolic bondage. With the leash hanging from it, the chain around my neck was more than just symbolic — I had to follow where he led me.

"We're both overdue for a good piss, boy," he said, turning and heading toward the bathroom with me padding behind him.

"Overdue" was an understatement. I'd been clenching furiously for the past hour, but excitement at the idea of our first piss scene in real life helped me hold it a little longer.

"Stand there, boy," Terry said when we were just inside the bathroom. He removed the leather binding my cock and balls, but instead of softening once it was freed, my cock stayed hard — *too hard to piss through.* "Get into the tub and lie on your back," he

ordered, unhooking the leash from my collar. "Get your head all the way down on the bottom and put your feet up."

Obediently, I arranged myself as Terry wanted. The enamel felt cold, but that helped soothe my sore ass — it soon warmed up under me. To get my head flat on the bottom, I had to jack-knife my legs, my toes creeping up the opposite end of the tub and my knees pointing at the wall behind me. My hard cock was pointing the same way. I relaxed my arms at my sides.

"Okay, Sir?" I asked.

"Spread your legs more," he ordered. I moved my feet out as far as they could go. He bent down at the faucet end and closed the tub drain.

"Keep your eyes and mouth closed," he said, and I obeyed. But I couldn't leave well enough alone. I wanted him to know how much I trusted him and that he didn't have to hold back for fear of freaking me out.

"Sir, if you want to piss in my mouth, please go ahead. I trust you, Sir. I believe you that it's not dangerous."

When he said nothing in response, I opened my eyes and looked at him. He was scowling down at me, his brow furrowed. It seemed like steam was about to come out of his nose and ears. *Shit! Blew it again! Can't I learn not to push him?*

"How about just doing what I *tell* you, boy?" he said coldly. "Is that too hard? We'll discuss any other ideas you have later."

"I'm sorry, Sir." I closed my eyes and mouth and settled back in the tub. A few seconds later his hot stream hit my chest.

"Ahh . . ." we both began to moan in satisfaction, and he laughed, breaking the tension created by my gaffe.

"Feels good, doesn't it, boy?" He chuckled as he played the stream all over my torso and crotch and legs. "Keep your mouth closed," he reminded me before soaking my head. His piss felt wonderfully warm and smelled ripe. "Let your own piss go now, boy," he said. "Piss it all out, piss all over yourself. Help me float you in piss."

Having held it in for so long, and being piss-shy and hard in any case, I couldn't let go immediately. By the time I'd relaxed enough for my pee to begin dribbling out, flowing down my cock-shaft onto my pubes, Terry's flow had slowed to a trickle. But mine strengthened, mostly spraying up between my legs and fall-ing back on my belly. When I finally finished, I thought I must

have pissed almost as much as he had. I was drenched from head to crotch, and with the tub drain closed, the cooling piss collected in a shallow puddle all around my upper back and head.

"Open your eyes, boy," he told me. "Look at yourself. Tell me what you see."

I raised my head and looked down my piss-streaked body toward my cock, soft now but already stirring and stiffening again. I looked at the chain between my nips laying across my chest. I couldn't see the chain around my throat, but I felt its weight. *What does he want me to say? What am I supposed to see?*

"I see a piss pig, Sir," I ventured. "I see *your* piss pig, Sir."

"Really?" he asked. "And how do you like that, boy? How does it feel lying in my piss . . . lying in your own piss?"

"It feels fine, Sir," I said sincerely. Even though the piss had cooled, somehow it still felt and smelled like sex. It was dirty enough to be exciting, but not so dirty as to be a turn-off. Terry's expression encouraged me to elaborate. "I like feeling something from your body on me, Sir." I looked closely at him again. *Do I dare bring it up again so soon?* "I'd really like to take it inside me, too, Sir," I said carefully, "especially since I can't have your cum."

"Maybe later, boy," he said. "Now hold up your hands."

I raised my hands, piss dripping off them, and he quickly tied them with the leather strip he'd taken off my cock and balls, then ran the excess up to the towel rack on the wall behind me and anchored it securely. My arms were stretched tightly over my head and a little backward. The arrangement wasn't escape-proof, but it would make getting out of the tub a much more involved project than getting into it.

"I'll be back in a while, boy," he told me. "You just lie there and enjoy your piss bath. I'll even turn off the light so the glare won't bother you."

He washed and dried his own hands before turning off the light and closing the door, leaving me alone. My cock got hard again as I wondered how long he'd leave me there and what he might do next. I was pretty tired, and sore, but still very turned on. *It would be nice to come,* I thought. *Dare I ask him when he returns? No, better not. He may not give heavy attitude outside a scene, the way a lot of tops do, but he sure doesn't like suggestions during one!*

Time passed. I squirmed around, trying to move my head and shoulders up a little to rest my legs and ease the pull on my

arms. I shivered as the piss on my skin evaporated, chilling me. It wasn't completely dark — some light penetrated under the door — but it was awfully quiet. *What's he* doing *out there?*

Terry returned after what felt like half an hour (but could have been much less). I was dazzled for a moment by the light, then saw that he was naked except for a leather jock he'd put on. I devoured him with my eyes as he casually sat on the edge of the tub. He was carrying a cigar, which he puffed into life. He was hairy all over, not just on his chest and crotch — dark hair curled everywhere over skin that was pale except on his forearms and face, where he'd gotten some sun, probably from work outdoors at the Vermont site. His upper arms and thighs were thick with muscle, but it was looser, less defined than mine, not as carefully sculpted. *God, he's big* — big hands, big feet, big head, big (but not huge) cock. Big belly, too, not really fat, but well padded. *What a pillow that would make*, I thought. *Rock-hard abs might look good, but they're no fun to snuggle against!*

Smiling down at me, he blew smoke over my head. My nose wrinkled and my eyes watered, but he was such a vision of easy masculine dominance I couldn't help but be turned on. To hint at my need, I wriggled in the tub so my cock wagged at him. He grinned and kept on smoking, then without warning flicked cigar ash onto my stomach. I gasped at the impact, expecting a terrible burn, but it proved to be little hotter than fresh piss.

Terry lifted his right leg and straddled the tub. He stuck his foot into my crotch and started kneading my balls and stroking my cock with it. I moaned at the pleasure-pain sensations. Wordlessly, he kept smoking, flicking warm ash on me from time to time and stimulating me with his foot. I started writhing shamelessly as the pressure in my balls built up.

"Please make me come, Sir! Please! I'm so close now, Sir!" I begged, my resolution not to risk pushing him forgotten in my urgency.

"Maybe I'll just leave you here, boy," he said calmly, all the while continuing his footwork on my cock. "Maybe I'll make you spend the night like this — lying in your own piss, arms tied, filthy with cigar ash. Maybe blindfolded and gagged. Bet you'd like that, wouldn't you boy?"

He's only teasing, I told myself. *He wouldn't really do that to me — would he?*

"No, Sir! Please, Sir! Don't leave me like this!"

"Which would you rather have, dickhead — to come? Or to be released?"

He really is a sadist! How can I choose? I knew I couldn't stand to spend the night lying in the tub with my arms pulled above my head, but I felt I'd go mad if he kept stroking me without letting me come. *What's the right answer?* I stared into his mocking hazel eyes without seeing any clue.

"You decide, Sir," I said finally.

Terry smiled — he'd won. *He won so easily! What's going to happen to my reputation as a tough bottom?*

"Good answer, boy," he said. "And because of that, you can have both."

Whew! That was a close one! Or is this what he intended all along?

He spat into his hand, reached down, and grabbed my cock. I bucked wildly, uncontrollably, and babbled as he stroked me. He leaned over and spat directly onto my cock a couple of times to maintain the lubrication, but it wasn't long before he pushed me to the edge and over it.

"*Aieee!*" I screamed and shot into the air so my cum rained down on me. "Oh-ahh-ahh!" Terry kept stroking my cock after I came, overstimulating me painfully. When he stopped finally, and spread the cum around my abs and pubes, I was gasping.

"Thank you, Sir! Thank you," I said as soon as I could trust my voice.

"You're welcome," he said, and flicked another wad of warm ash right onto ground zero, the tip of my spermy cock. I groaned. He stood up and stepped out of the tub.

"Before I release you, boy, I'd better get you cleaned up."

He opened the tub drain, turned on the water, adjusted the temperature, and switched the flow to the shower, drenching me in a lukewarm spray. I closed my eyes and mouth and spluttered until he directed the shower head away from my face, playing the spray across my body to wash off the piss, cum, and ash.

"I guess I'll have to let you loose so I can rinse your back, boy," he said, almost regretfully, as he undid the strap from the towel rack and helped me stand up. He left my hands tied and moved me around in the shower until he was satisfied that I was clean, then turned off the water. He grabbed my bathsheet off

the hook on the door, but he didn't hand it to me or use it on me himself.

"Stand in the tub until you stop dripping, boy," he said, "then join me in bed." He walked out of the door with my towel.

I waited a couple of minutes, feeling a little silly drip-drying in the tub, but orders were orders. When I got out, I wiped my feet on the bathmat. The rest of me was still damp. I walked into the bedroom, where Terry was lying on top of the covers, finishing his cigar. He flicked his ashes into a saucer on the night table (he probably couldn't find the one ashtray I reserved for incorrigible smokers). Laid out next to the saucer were the handcuffs he'd used earlier, a set of modern leg irons, a couple of padlocks, and an array of shaving gear. My towel was spread out on the bed beside him.

"Stretch out here, boy, on your back," he said, patting the towel.

Once I was lying down, he sat up and untied my wrists, then immediately handcuffed me again. After setting the locks, he reached behind my head and pulled up a chain he must have attached to the bed earlier. With his other hand, he pushed my arms up and over my head and padlocked the chain to the links between the cuffs. Next he put the leg irons on me and fastened them to the foot of the bed in similar fashion. He left very little slack in the chains, so I had to lie stretched out full length, completely vulnerable to whatever he wanted to do to me.

What he wanted to do first, apparently, was lie on his side next to me, propped up on one elbow, and fondle my body. He touched everything but my cock, which was hard again despite my eruption in the bathroom. If I hadn't been so turned on, his light touch would have tickled, but instead I closed my eyes and purred, perfectly happy to be treated as a sex object.

"Any complaints, boy?" he asked as he stroked, his words booming through my sex fog. "Anything you have to tell me?"

"No, Sir. Thank you, Sir," I replied. *Any complaints?* All I wanted at that moment was to lie there and feel his hands moving over my body.

"You know what I'm going to do now, don't you?"

"You're going to shave me, Sir."

"Do you like being shaved, Matt?"

"No, Sir."

"I'm glad you always give me straight answers," he said with a laugh. "Likes aside, I trust you have no objections."

"No, Sir."

"Any limits?"

I thought about it — *I sure don't want my head shaved, but if I ask him not to he might do it just to show me who's boss. If he does shave me bald I can probably handle it well enough at work. Hell, I've seen women with shaved heads in the store.*

"I guess not, Sir," I said finally.

"Good. And now that there's nothing more you need to say, I'm going to give you something to chew on. Open wide."

He produced a short, fat, cock gag, slipped it in, and lifted my head to buckle it tight.

"Feel good, boy?" he asked.

"Ummpffgh," I said, drooling over the dick-shaped rubber plug that filled my mouth.

"Glad to hear it. Don't go away — I'll be right back."

He went into the bathroom and returned with a hot, wet towel, which he used to prep my armpits, chest, and crotch. He removed the chain between my nips, then lathered me up and started shaving me clean with a straight razor, kneeling on the bed while he worked. I wondered why he was shaving me, considering what he'd said over dinner about not liking men who look like boys. *And he had his shaving gear in his bag all the time, so he must have been planning this from the start.* I shrugged mentally. *Guess he'll let me know when he's ready.*

It took less time than I'd have expected, maybe 30 minutes in all, for him to shave my torso, armpits, and legs. Although there's a fair amount of hair on my forearms, he left them alone for some reason. I managed to stay still when the razor tickled or pulled, but I made little muffled sounds behind the gag. Terry worked in silence, concentrating, betraying no feeling beyond a concern for a job well done. His jock occasionally grazed my thigh, so I knew he was hard, and my cock was erect pretty much the whole time, especially while he was working around it, taking the hair off my pubes and balls. After he finished with my front side, he turned me over and shaved my ass and the backs of my legs.

"Now you'll have something to remember me by," he said and wiped off the excess lather and cut hairs, giving my sore ass

a hard slap for emphasis. *As if I need help remembering him! Does that mean he's going away again for a long time? Till my hair grows out again?* Greg did that to me once — shaved me bare just before he left on a three-week business trip. I thought about him every time I itched!

Terry used the edges of the bath sheet I was lying on to dry me, then pulled it out from under me and carried both towels away. A couple of minutes later I heard him moving around out in the living room, probably turning off the lights and stereo. I chewed on the gag and shifted on the bed, shivering a little as air moved over my shaved body. *Now I feel really naked.*

When Terry returned, he took the gag out.

"Thank you, Sir," I said and flexed my jaw. It hurt a little, but — *no complaints!*

Stifling yawns, Terry unlocked the chains holding my handcuffs and leg irons to the bed, allowing me to lower my arms and shift my legs.

"Do you need to piss again?" he asked.

"Not yet, Sir," I said. "But I usually go a couple of times during the night."

"Well, be quiet and don't wake me when you do it."

He set the alarm on the dresser, turned off the light, and pulled the bed covers out from under me. After crawling under them, he threw the covers over me as well, then turned me on my side and put his arms around me. I was glad of the embrace, because his mood had become a little brusque and distant after the shaving. *Probably he's just tired*, I said to myself, wiggling even closer to him.

We lay there spoon fashion, his half-hard, leather-covered cock fitting in my asscrack. He casually toyed with my nipples and cock, stroking the newly bare, smooth skin around them, making me shiver and moan, wishing I could come again.

"How're you feeling, Matt?" he asked after several minutes of this teasing.

"Real good, Sir," I told him. "I feel like I was drained dry, then filled back up to the brim." *He's driving me crazy with his hands!*

"I suppose that means you're hot to come again! Well, I'm horny again, too. I'd fuck you and then jerk you off, but I'm just too tired now to enjoy it completely — maybe in the morning.

But I'm glad you're feeling good. That's how I like my boys to feel — except when I want them to hurt."

We lay silent for a couple of minutes, and though his hands kept moving lightly over me, I was beginning to doze off when he spoke again, very softly.

"I enjoyed this evening with you very much, Matt. It was good to unload with you about Philip. I enjoy keeping you guessing, but I don't think jealousy is a very useful emotion. You have nothing to be jealous about, anyway. I find I still care a lot about Phil, but I feel more protective toward him than sexy. I worry about him.

"With you my only worry is keeping one step ahead of you! But I can't resist the challenge. You give me more ideas than anyone I've played with in a long time! I can't stop thinking about things I'd like to do with you, or to you. Next time we'll get back on my territory. Would you like that?"

"Yes, Sir, I'd like that very much." *If I survive it!*

"Good. You don't have to work this weekend, do you?"

"No, Sir. Plus I have the holiday off." The next Monday was Columbus Day.

"Any other commitments?"

"Nothing, Sir." I didn't tell him that I'd stopped *making* any other commitments while waiting for him to get back in touch. *Don't want to feed his ego too much!*

"Great! We can really get down to it, then, find out where we want to go with each other. Meet me this Friday at Altar, 10:30 sharp, in full leather. Be prepared to come for the whole weekend, but don't bring any luggage or extra clothes — nothing at all, in fact. I'll supply a toothbrush and anything else you'll need. It won't be much: I plan to keep you naked and in heavy bondage the entire time. You got that, boy?"

"Sir, yes, Sir!" I said — and almost shot when his hand brushed across my steel-hard cock. "Friday, 10:30, Altar, full leather, no bag, heavy bondage all weekend. I can hardly wait, Sir."

"You'll have to, though, won't you? And so will I," he said and yawned again. "One more thing, boy — I don't want you jerking off between when I leave in the morning and when I see you on Friday. I want you horny and hot, like you were tonight and the other times we've gotten together. Understand?"

"Yes, Sir!"

"Good. Now go to sleep. We both still have to get up in the morning and earn some money to pay for our fun."

"Goodnight, Sir."

"'Night, Matt."

Yawning myself, I shut my eyes and snuggled closer, nestling my cuffed hands just below my chin. I lay there in Terry's arms until I fell asleep.

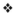

My bladder woke me a couple of hours later. I found that Terry and I had separated during the night. He was on his side but facing the other way, and I was flat on my back, my cuffed hands clasped together on my chest. I lay there for a few moments, staring at the ceiling, listening to the usual night noises in the apartment, and from the city outside, before easing out of bed to go to the bathroom.

My dilated pupils let me see shapes dimly in the dark, and of course I knew the apartment blindfolded. But I didn't want to wake Terry, so I moved carefully, holding my legs apart to keep the chain between them taut instead of letting it drag on the floor. The result was a kind of duck waddle that might have felt humiliating if there'd been anyone to see it.

After pissing in the dark bathroom, I closed the door and turned on the light. Getting a drink of water, I saw myself in the mirror. I'd been shaved a couple of times before, but not so often that I was used to it. I really didn't like the effect. Hairless male bodies never turned me on, and though I wasn't superfurry, I'd liked my modest pelt. *It'll grow back*, I consoled myself.

I turned around and checked my ass in the mirror — *not as bad as I expected*. There were several bruises but no cuts. The welts from Terry's belt had faded to white streaks. I couldn't touch my ass with my hands cuffed in front, but there was only a little throbbing as I flexed the muscles experimentally.

Facing the mirror again, I strove to see the "sensuality" and "vulnerability" Terry said came out in me when I was bound. The youngish man in the mirror was nicely set up, if no stunner, his nakedness emphasized by his smooth chest and crotch, the padlocked chain collar, and the handcuffs. *Vulnerable, sure, but sensual?* His cock was droopy, the hair on his head was every which

way, and he looked sleepy. *More comical than sensual*, I thought, smiling at my image. *What we do for love — or at least sex*, my cynical side chimed in. *Is it really love between us?* I wondered. *Or am I just bewitched by the hot sex and bondage? If so, what about him? It'd be awful if he's in love and I'm not. And the reverse?*

Shaking my head in bemusement, I waddled back to the bedroom, where I faced the puzzle of how to get in bed without waking him — he'd thrown off the covers, rolled onto his stomach, and flung his right arm across my side. Moving very, very slowly, I raised his arm just enough to slide under it, then carefully pulled up the covers. He stirred and curled his arm around my chest, then moved closer to me before subsiding into deep slumber again. Lulled by his regular breathing next to my face — it couldn't quite be called snoring — I soon drifted off myself.

CHAPTER 20

Fuck before breakfast

I was deep into a sleep cycle when the alarm shrilled. By the time I opened my eyes, Terry had already gotten up to turn it off. He flashed me a smile, yawned, and padded into the bathroom. I heard the sounds of his pissing and washing as I lay in bed collecting the shreds of my self-awareness.

When he returned, he pulled down the covers and got back into the bed, then turned me so my face was pressed against his chest. I nuzzled his nearer nipple and rubbed my cheek on his fur (*Glad he doesn't shave* his *body!*) while he stroked my back and ass, only a little sore by then. My cuffed hands played with his dick, which stirred lazily and began to stiffen.

"Still hot for that fuck, boy?" he asked.

I disengaged long enough to say, "Yes, Sir, please, Sir!" then went back to nursing at his chest.

"D'you need to shit first, or piss?"

"No, Sir."

"Well, get your mouth down there and make me hard," he ordered, gently pushing my head in the indicated direction.

I scooted down the bed. My own cock was also stiffening as I sucked in his half-hard tool and tongued the underside. His crotch smell was stronger than the night before, and even sexier — I sniffed it up like coke as my nose grazed his pubes. Pulling my mouth back along the full length of his naked cock, I quickly plunged to the root again, up and down, up and down, until it had hardened so much that the head went past the back of my throat on the downstroke. I wasn't awake enough to realize I was doing something risky — fortunately, Terry remembered before he started leaking precum.

"That's enough, boy. Pull off now," he said. "I've got to put a rubber on."

I lifted my mouth off him and knelt up, watching as he found a little foil package in the night-table drawer, took out the rubber, and slid it onto his proudly erect dick. He stroked himself a few times, then got up from the bed.

"Turn on your belly while I get some lube," he told me.

I stretched out in the middle of the bed, my cuffed hands resting above my head. I moved my legs as far apart as the shackles allowed. My shaved asshole felt unnaturally cool and exposed.

Terry returned and sat down next to me, resting his hand on my ass. He ran it slowly, teasingly over my buttcheeks, then poked his finger lightly at my hole. I moaned and wiggled my tail. He poked a little harder but made no headway, and I started to worry. *Am I really ready for a 7:00 a.m. fuck?*

"I think you need some warming up, boy," he said. "A nice spanking will relax that tight ass of yours, don't you think?" It didn't sound like he was asking for permission.

"Yes, Sir," I replied. "Please warm my ass again before you fuck me, Sir." *But please go easy!* I pleaded silently.

He started slowly, with light slaps, then put more force into them, connecting solidly with each blow and lightly stroking the reddened flesh before moving to a new target. He seemed to be trying to ensure an even effect. The blows stung sharply, but they didn't reach the level of real pain for some time, and by then I was so turned on, I was grinding my hips and rising to meet each slap. My whole ass felt hot, and each new slap sent an electric charge right to my groin — it's a wonder my stiff cock didn't lift me off the bed all by itself. *Now why didn't this happen last night?* I expected my ass to be too tender for a spanking so soon after a belting, but it seemed as if I couldn't get enough. *Maybe it's being slapped with his hand instead of a belt?*

"Your ass is nice and red, boy," Terry said finally, his hands kneading and caressing my inflamed butt. It hurt and felt wonderful at the same time. "Let's see if it's loosened up, too."

I felt something cold and greasy at my asshole, then a probing finger. This time it slipped in easily, and Terry pushed it far enough to touch my prostate, making me moan loudly and thrash on the bed. He pulled out, then pushed in again with two fingers and more lube, rubbing all the way around my rectal wall,

stretching, soothing, and lubricating it, preparing me for his cock — *seducing* my ass instead of invading it.

"Ahh, Sir! Please Sir, fuck me, Sir! I'm ready, Sir! Please give me your cock, Sir!" I was being "pushy" again, but it didn't seem to bother him.

"In a minute, boy. You're opening up nicely," he said as I kept moaning and babbling about how much I *needed* his cock inside me. "Three fingers now, just relax and let them in. . . . Yeah, that's right. In and out, in and out, smooth as silk. . . . I bet you could take my whole arm this morning, if we had the time."

I'd never been fisted, and didn't think I wanted to be, so I tried to deflect that line of thought.

"Please, Sir, it's your cock I need, Sir. Please fuck me, Sir."

"Don't tell me what to do, boy," he snapped. *Uh, oh! Went too far again.* "I'll give you what you need, whether you want it or not. I said I'd fuck you, and that's what I'm going to do."

His fingers pulled out of my ass with a pop.

"I'm sorry, Sir! But please plug me, Sir! I'm so ready, Sir!"

And I really was — I could *feel* the emptiness in my asshole once his fingers were gone, and I wanted it filled with his cock.

Terry shoved a pillow under me to raise my ass to a more convenient height, then grabbed my hard cock, pointing toward my head, and bent it down toward my ass, sliding his greasy fingers all along its length in the process.

"*Ooooh!* Yessir! Thank you, Sir!"

Next I felt his hands at my hips and his cock pushing at my asshole. After the spanking and finger exercises, it slid in smoothly — touching places a finger could never reach, rubbing past my prostate and driving me wild. Once he was all the way inside me, Terry lay against my back for several moments. Plugged cock to ass, we both moaned from pleasure. I felt full again.

When he raised himself and began to fuck in earnest, I was afraid he'd find me *too* loose, I was so relaxed, so I clenched my assring to give him a firm dick massage each time he stroked in and out. It seemed to work, because soon *he* was the one babbling incoherently, ejaculating disconnected words and phrases in accompaniment to his fucking. Not that I was all that coherent myself — far gone into rut, I was humping the bed in time with his thrusts, grunting my own sex talk into the mattress, carried away with the ecstasy of being fucked, and fucked well.

"Oh, yeah! Fuck me, big man! Pump your dick into my gut, fucker! Make me feel it!" I was too worked up to worry about proper forms of address, but he probably didn't hear me anyway.

I pulled at the cuffs and leg irons, not trying to get free but relishing the feeling of restraint. *You've got me chained down, helpless,* I said to him in my head. *I've gotta do what you want. But you're not doing anything I don't want. I gave my ass to you. I brought you here, and I gave it to you. Take it, man! Take it, Sir!* It wasn't long before he exploded inside me.

"Shit fuck piss damn hell!" he shouted as he came (only a Catholic-school boy could get such a charge out of those words). His cock was still inside me when I came, too, my own less colorful "*Aauuggh!*" muffled by the mattress.

Terry collapsed on top of me, and we lay still for a couple of minutes, just breathing. Then he rolled off to the side — his softening cock pulled out of my ass with a funny "plop!" I turned my head and looked at him lying there on his back.

"Thank you, Sir," I said softly. He reached over to check my cock. Finding it soft and sticky, he laughed.

"I thought I'd have to jerk you off, boy," he said, giving me his fingers to lick clean, "but it looks like you took care of it yourself. Guess I can't complain — I didn't tell you to hold off. That's the second time you've come when I've fucked you."

"Yes, Sir. It must mean we're in sync. Thanks again, Sir."

"You're welcome! *I* certainly enjoyed it. Now if I could just lie here for a few hours and recover!"

"What time *is* it, Sir?" I asked.

"Probably at least an hour later than I want it to be," he groaned, then heaved himself off the bed to check the clock. "Well, well, only 7:45. Guess I have time to shower and eat something after all."

He came back to the bed, got his keys from the night table, rolled me over, and took off the handcuffs and leg irons. The condom was still hanging on his dick, which decreased in size when he was soft much less than mine does. He pulled it off and emptied it on my forehead, then smeared it around my face as usual, dropping the used safe on my stomach.

"Get me a clean bath towel," he said, "and join me in the shower."

I breathed deep — the scent of Terry's cum turning me on

all over again — and got out of bed. I tossed the condom in the wastebasket, stretched, then rubbed my wrists and ankles, which were a little sore from the cuffs. They hadn't been tight, but the unyielding metal still left marks on my flesh.

Grabbing an extra-large towel from the closet, I went into the bathroom, already steamy from Terry's hot shower. I hung up the towel and got in with him. He presented his back to me so I could soap it, the water streaming down against his chest. I enjoyed rubbing my hands over his body and made the most of it, soaping under his arms and all over his tight butt, even in his asscrack. He arched his back under my hands and sighed in contentment. *I love being able to please him!*

"Good boy, you can wash my front, too," he said, turning around.

I soaped up his hairy chest and knelt to wash his crotch and thighs. I was washing his feet when I felt water pour down my back — I looked up and got a face full of fresh piss. Without thinking, I closed my eyes and opened my mouth, kneeling motionless except for swallowing, my arms crossed behind my back, as his strong, hot morning piss poured over and into me, baptism and communion in one. What he let me drink tasted bitter, yet there was a barely detectable sweetness underneath. The rest warmed my now hairless flesh and slid right off.

"Need to piss, dickhead?" he asked when he'd finished. "Go ahead — only East Side faggots get out of the shower first."

Chuckling at his joke, I willed my sphincter to release so my bladder could empty. It was easier than the other times he'd ordered me to piss in his presence, and soon my flow was drenching my knees, joining the remnants of his on its way to the drain.

When I finished, Terry directed the shower spray over me, washing off the piss, then turned it back to rinse himself off.

"Get up and wash yourself, boy, we haven't got all day," he said, handing me the soap and stepping out of the shower.

I lathered up while he finished at the sink — he'd brought his own toothbrush, of course.

"I'm going to check out what you have to eat," he said as he toweled himself. "Hurry up and join me. Don't dress yet." He walked out of the bathroom wrapped in his towel.

I spent as little time as possible on my hair (curls aren't as easy to wash and condition as his superbutch brushcut), and in

less than ten minutes joined him in my small kitchen, naked except for the chain around my neck and fairly damp — but feeling refreshed, almost buoyant. I didn't have to be at work until 10:00, so I wasn't as pressured about the time as Terry, who had to move his car by 9:00.

He'd thrown on some clothes (the tail of his shirt — a fresh one — was half out of his pants, he apparently hadn't found his belt yet, and all he had on his feet were socks) and was ransacking my cupboards. As soon as he spotted me he began barking out questions — or complaints in the form of questions.

"Where the hell do you keep the coffee? . . . Don't you have any sweet butter? . . . Is this all the juice you have left? . . . Why aren't your knives sharp? . . . Why is your refrigerator so empty? . . . Don't you cook at *all*, Matt?"

"Not much, Sir," I said when he let me get a word in. "But I can make coffee — I keep it in this cupboard — and I can thaw some frozen juice in the microwave, if you like. . . . What's sweet butter? . . . This is probably the sharpest knife, Sir," I said, handing him a small chef's knife I kept in a drawer.

"Fine — make plenty of coffee, not too weak. And keep it in the 'fridge from now on. And make the juice. Sweet butter is . . . oh, hell, forget it. I'll see what I can do with your stale bread, mediocre sliced ham, questionable cheese, and pitiful selection of seasonings."

Less than 20 minutes later, during most of which I concentrated on staying out of his way, we sat down to savory grilled sandwiches filled with ham and cheese, seasoned with mustard and God knows what else, plus my coffee and rehydrated orange juice.

"These would be *croques monsieur*," Terry said, "except the cheese is wrong, the ham doesn't have much flavor, and the mustard definitely didn't come from Dijon. I'll give you a shopping list of staples to keep on hand so I don't get stuck like this again — though desperation does add a certain spice."

"They're delicious, Sir. I'm sorry I'm not better supplied, but I usually don't eat breakfast."

"Bad habit, Matt," he said between bites. "It just makes you gorge yourself at lunch. But it's getting late — I've got to get out of here or they'll ticket my car, maybe tow it."

He poured himself another cup of coffee, betraying with

the slightest of frowns that it didn't meet his standards, and carried it over to the chair where he'd left his clothes the night before. While he finished dressing, I tried to restore some order to the kitchen. I wondered how he managed to use three pans and two pots for a one-dish meal.

In a surprisingly short time, Terry strolled back into the kitchen fully dressed and groomed, almost as neatly turned out as the night before. He carried his bag, which he set down just inside the doorway. Previously I'd been a little put off by the formality of his appearance, but after the little "attitude adjustment" he'd given me, as well as our night together, I had no trouble recognizing — under the elegant suit and tie — the wonderfully perverted stud who'd beaten, fucked, and pissed on me.

"Come here, boy," he said. "I have to take off that collar."

"Must you, Sir?" I blurted out. My eyes suddenly filled as I looked at him.

"Yes, I do," he said firmly. "And when are you going to stop questioning me and just do what I tell you? You haven't earned a full-time collar yet, Matt — and I'm not sure if you truly want one, or if I want to give you one. You're not my slave yet. Except for the orders I gave you about Friday, you're a free agent."

I stood in front of him, eyes downcast, as he unlocked and removed the chain from my neck. He touched my chin and raised my eyes to his again.

"Don't despair, boy," he said with a warm smile. "If being my slave is where you need to be, you'll get there. I'm not playing games with you. I simply don't want either of us to get hurt this time."

"Yes, Sir. I understand, Sir."

Do I? I asked myself as Terry folded me in his arms. *Does any of this make sense, except the sex, of course?* As we kissed — deeply, passionately — all my doubts receded again.

"We'll talk about it this weekend," he said when we broke apart at last. "Remember your instructions?"

"Yes, Sir. Meet you at Altar at 10:30 on Friday, full leather, no bag, ready for a bondage-packed weekend. No jerking off between now and then."

"That's it, boy," he said, glancing at his watch. "And now I've got to run. If my car has a ticket, you'll really catch it this weekend. C'mon, carry my bag to the door."

He turned and headed down the hall. I followed with his bag and returned it to him at the door. He tousled my hair once more, and then he was gone. I felt as if half my heart went with him. "A free agent." Suddenly that didn't seem like such a great thing to be, though it's all I'd wanted for years, since Greg died. *Well, so be it — at least until Friday night. Then we'll see.*

Thursday evening, late, I was leafing through magazines and channel-hopping, trying to bore myself enough to sleep, when the phone rang.

"Hello, Matt." Hearing Terry's voice thrilled me, as always — but a sudden premonition made me tense up. *Is he calling to cancel our date?*

"Hello, Sir."

"I was just remembering Tuesday night and wondered how you're doing. Looking forward to the weekend?"

"I can hardly think about anything else, Sir," I quickly assured him. "They've even noticed at the store how often my mind is elsewhere."

"I hope the staff isn't exploiting your distraction."

"No, Sir, they're a good crew. If anything, they're covering for me. But they're waiting for the other shoe to drop, wondering what's going on."

"What do *you* think is going on, Matt?"

"I'm not sure, Sir. I feel ready to commit, but you want more proof. You're probably right, Sir — I've never been owned before, and maybe I can't hack it. What I do know, Sir, is that you make me feel different from the way I've felt with any other top in the last six years."

"How so, Matt? Isn't it all pretty much the same in the end? Bondage, whipping, bootlicking, dominance and submission — they're only ways to trick your mind into allowing you to give and get pleasure. Do I have to do something unique each time to keep you interested?"

"No, Sir! I'd be happy if you didn't do anything to me, Sir, just kept me at your feet or by your side."

"D'you mean you don't *want* a heavy scene this weekend?"

"I want whatever will make us both happy, Sir!"

I paused, stepping carefully through the minefield of my emotions.

"I want to be a good partner for you, Sir. I want you to enjoy playing with me, not feel you have to wear yourself out keeping me excited every minute."

"Do you really mean that, Matt?"

"Yes, Sir! I do."

"That's good. And maybe that's what's different from your liaisons with other tops in the past."

"I don't understand, Sir."

"If you go into a scene with a topman thinking primarily of what you want him to do to you, you're turning him into your instrument. And if he approaches you the same way, the two of you are going to enjoy your encounters only as long as your fantasies happen to coincide. That's okay — I'm not knocking it. Good sex, and good s/m, is where you find it, and that kind of impersonal exchange can be very satisfying. But what you said to me just now is entirely different. You told me that what I do to you is less important than that's it's me doing it."

"That's it, Sir, that's *exactly* how I feel! The scenes we've had were great, Sir, and I'm looking forward to more, but somehow they're no longer the point. The s/m action is like the icing on the cake — only without it there wouldn't *be* a cake, would there? I'm not sure how to say it. It isn't that I want only vanilla sex with you, Sir, though that would be okay, too."

Terry laughed. "I'm not sure it's possible for two leathermen to *have* 'vanilla sex.' It's always a power exchange, no matter what it looks like."

"Yes, Sir," I agreed. "Even when we share a meal, even when you serve me food, Sir, you're still the boss."

"And you like it that way, Matt?"

"I like it a lot, Sir — a *hell* of a lot. It's something I must've needed for a long time, Sir, without knowing it. I *need* you, Sir. I haven't felt this way about anyone for years and years. . . . I wish you needed me, too, Sir."

"Maybe I do, boy," he said softly.

I held the phone tightly, straining my ears in case he said anything more, but there was no sound for at least a minute. I was beginning to worry he'd hung up, or got cut off, when he finally spoke again.

"You've come a long way in only a month, Matt. You're not the same selfish smartass I carried home from the Spike. I'm impressed, and very glad."

"Thank you, Sir. But you won't give up on me if I backslide sometimes, will you, Sir?"

"Not easily — but don't take that as a license to goof off."

"Yes, Sir — I mean, no, Sir! I won't!"

"Good. This conversation is a little premature, but I'm glad we're having it. It's hard to predict just how a courtship like ours will progress — even without the complication of an ex-slave who needs help landing on my doorstep. I've been a little worried that I'd gone too far with you too soon, made assumptions I wasn't entitled to make yet. So I called to give you the option of slowing down, of easing off for a while. But it seems you're even readier than I thought you were — or than *you* thought you were. Does any of this make sense to you?"

"Yes, Sir, I follow you. You don't have to spell it out."

"Good," he said with a chuckle. "I won't use the 'l' word."

"I don't mind saying I love you, Sir. I do. It's the other words I still have trouble with sometimes — 'slave' and 'Master.' I think I'm ready for them, Sir, but I can't be sure. I don't know what it would be like, and it scares me a little."

"Don't you think it scares *me* a little, too? After all, I'm the one who tried it once and fucked up. I don't want to ruin your life the way I ruined Philip's."

"You're too hard on yourself, Sir. He's the one who fucked up, Sir, and he might have done the same thing if he'd never met you — probably sooner, in fact."

"I hardly think *you* can be objective about it!"

"Maybe not, Sir, but you said *he* doesn't blame you. I think he realizes that he owes the best of what he is to your training."

"It would be nice to think so. Thank you. Now, back to us!"

"Yes, Sir!"

"Since you don't seem to want to slow down for a while before we proceed to the next step . . ."

"No, Sir!"

"Okay, then. I have certain plans for the weekend, but I can change them depending on how you react as we go along. Tomorrow night, though — I have a definite idea about that, and I want to make sure we're in sync."

"Yes, Sir. Whatever you say, Sir."

"Good boy! Keep that up!" he said with a chuckle, but there was an undercurrent of seriousness, too. It suddenly hit me, as it had at the Bondage Club, that he was risking as much as I was. *He's betting that he can keep the upper hand with me, that he can really be my Master and not just the orchestrator of my fantasies.*

"I won't let you down, Sir!" I vowed.

"Hmm . . . if I could see into that curly head of yours — no matter. All I really want from you, Matt, is to do what I tell you, to always give me your best effort, and to never lie to me. Think you can do that?"

"Yes, Sir." *Bet it's harder than it sounds!*

"Good. Now, even though you haven't had any classic slave training yet, at Altar I want you to act as if you had. Take your lead from me. Give me all of the old courtesies and *no back talk*. You know what I mean. I intend to give the Stand&Model crowd the kind of show that hasn't been seen in a New York leather bar in years, and I expect you to do me proud. Understand?"

"Sir, yes, Sir! At your service, Sir!"

"If that's sarcasm . . ."

"Not at all, Sir! Just showing I do know the protocol. I'll be glad to honor the old traditions, Sir, but isn't it time we forged some new ones?"

"Serves me right for picking a boy with brains," Terry said with a theatrical sigh. "Let's not worry about starting new traditions right now, okay? All I want them to see on Friday night is a leather Master breaking in his new slave. Consider it a textbook demonstration — from an old textbook." I could almost see his grin. "Later on, after we figure out what we're doing, there'll be time enough for people to wonder if the traditional categories are still adequate. But when we leave the Altar tomorrow night, boy, at least people will know you're off the market and that poachers will have to answer to me."

"Yes, Sir!" I said. I smiled at the pun on the bar's name and hoped it was intentional.

"It's pretty late, boy. We'd both better get some rest."

"Yes, Sir. But it'll be hard to sleep, anticipating."

"How about if I make it an order? Go to sleep, slaveboy!"

"Yes, Sir. That'll help, Sir. Thank you, Sir."

"Good night, Matt. Pleasant dreams."

CHAPTER 21

Before witnesses

I managed to take a short nap after dinner on Friday, then showered again after I got up. Just to be on the safe side, I washed out my hole using a soapy finger and plenty of water. With only barely visible stubble on my pubes, my half-hard cock and low-hanging balls looked unnaturally large in the mirror.

I put on a jockstrap and old blue jeans, without a belt. The crotch and ass were so frayed the covering was almost theoretical, but the jock would keep me street legal at least until I got to the bar. Black leather chaps went on over the low-slung jeans.

Checking myself out again in the mirror, I critically eyed the nipple rings glinting on my pecs and sucked in my gut. *My jeans're more ripped than my abs, damn it! Better not skip any more gym sessions!* Still, the way the shiny black leather hugged my hips and framed my crotch and ass wasn't bad, I thought, grinning at the "fuck me" image in the glass. I recalled the mysterious black-on-black portrait of a leatherman in Terry's gallery. *Nothing subtle or ambiguous here — maybe it's too slutty? Maybe he'd prefer it if I looked more reserved? . . . Nah! If he's gonna turn a slut into "an honest slave," I may as well look the part!*

I pulled on the "Fit To Be Tied" T-shirt he gave me (at least I'd washed it by then) and went looking for an appropriate pair pair of boots. The black harness-strap Fryes caught my eye. *They'd go well with chaps . . . but not with leg irons,* I realized. *Terry might want to chain my legs in the bar, so I'd better wear boots snug enough at the ankles to allow it — otherwise he'll make me take them off and walk around in my socks, or barefoot.* I didn't want to wear Army boots again, and my tall lineman's boots took too long to get on and off, so I chose an 8-inch pair of black work boots.

After lacing up the boots, I zipped the chaps closed, stomped on the floor to settle everything in place, and checked the mirror again. I smiled at what I saw. *He'll have no cause for complaint about how his boy looks!*

Since he'd ordered "full leather" despite the mild temperature, I put on my heavy leather motorcycle-style jacket. Checking the mirror, I decided to pull out the belt as too aggressive. The chain looped around the right shoulder — joined at the ends by a screw-on quick link instead of a lock and threaded with a short length of rope tied with a square knot — was my own private bondage lure. *But I've already hooked my fish . . . or, rather, he's hooked me!*

"Full leather" or no, I left my head bare. In the old days, we're told, bottoms never wore caps, and that was fine with me. I liked showing off my hair — as long as I had it. *He'll probably shave it someday to cure my vanity!*

I arrived a few minutes early. Altar wasn't half full yet, and despite the black-on-black effect of the dimly lit butch décor and the patrons clad mostly in black leather, I had no trouble spotting Terry. He was standing at the far end of the bar talking with Jake, who was, of course, dressed exactly as always, his vintage leathers perfectly maintained and his boots and cap brim mirror-polished. Terry's CHP-style MC jacket hung open, showing the black leather shirt and tie underneath, and his leather breeches with the yellow-and-gray side stripes were tucked into his "lucky" knee-high engineer boots, the ones whose story he'd told me at the Bondage Club three weeks earlier. A wide, basketweave belt with a plain, mirror-finish buckle was threaded through the belt loops of his jacket, his left shoulder was circled by a coil of bright chain, a riding crop poked out of his left boot, and his black leather gear bag was on the floor by his feet.

He wore gauntlets, and the visor of his cycle cap was pulled low on his forehead, shadowing his eyes. The only exposed skin was on the lower half of his face and the close-cropped sides of his head. But I'd never mistake that pepper-and-salt moustache, those large, slightly protruding ears, that strong chin or sensuous mouth — quick to laugh or bark orders but more often twisted in a sardonic half-grin — for anyone else's. He might not be the handsomest topman in the bar, and he didn't have the biggest reputation, but he could have had his pick of the available bot-

toms — or slaves. I was determined to give him no cause to regret he'd picked me.

His eyes had lighted on me almost as soon as I spotted him, but other than a quick smile he gave no indication that I should approach, so I stood quietly near the middle of the room — out of earshot but well within his line of sight — and let the growing crowd mill around me. I half bowed my head, but not so much that Terry's slightest gesture would escape me.

Seeking to calm the butterflies in my stomach — I had no idea what he planned doing to convey to the crowd that he'd claimed me, just that I was likely to be sore by the time it was over! — I pondered the relationship between Terry and Jake. I'd never suspected their obvious closeness, and the oddest thing was that Terry's behavior with Jake seemed to be much more deferential than my own. While I thought of Jake as a friend, and joked and laughed with him more or less as an equal, Terry's demeanor seemed like that of a junior officer with his commander. An air of discipline — of defined roles and status, of spit-'n'-polish formality — emanated from the pair of them. Although Terry was several inches taller than Jake, and decades younger, they seemed to spring from the same "old leather" mold. Like most guys my age in the scene, I'd made fun of that "antique" style, but I secretly yearned for it, too, and responded positively whenever it appeared genuine rather than forced.

While I watched, Terry and Jake were joined by two of the brightest stars in New York's leather firmament, Bill and Hank, a longtime couple I knew only by reputation. Terry seemed to be on familiar terms with them, however, and Jake, of course, knew everyone. Bill was in his mid-40s and okay looking, but it was his practiced whip arm and ingenious way with rope that guaranteed him a never-ending stream of hunky bottoms eager to be bound and flogged by a master. And everyone, top or bottom, wanted a piece of Hank, his gorgeous partner, an exclusive bottom who was said to be as nice a guy as he was good to look at.

Finally, Terry looked straight at me, as if just noticing my presence. His eyes raked me from head to foot, his mouth set in a stern line. I stood straighter, squaring my shoulders and sucking in my gut. Apparently satisfied, he beckoned me over. Bill and Hank made room, and I stood silently in front of Terry with my head bowed low, my legs spread, and my hands clasped behind

me, the very model of a humble slaveboy. I felt the four of them looking me over, though Jake, as usual, didn't even turn around — he could see me, and everything else of interest to him, in the mirror over the bar. I held as still as possible, determined that my behavior and stance would reflect well on Terry in front of his friends — *and his mentor?*

"Are you ready to serve me, boy?" Terry asked, his voice like dark honey in my ears. The music, the bar noises, the social chat and cruising overtures going on around us — all faded away as I focused on him alone.

"Yes, Sir!" I responded eagerly. I risked a glance up and flashed him a smile before resuming my submissive stance — the left corner of his mouth was threatening to curve into a grin, and his eyes were dancing. My cock was on the way to ripping a hole in my jockstrap. *God, I love him!*

I heard the creak of leather as Terry took something out of his jacket pocket, and then he was holding it stretched taut in front of my face — the same beautifully finished black leather collar he'd first put on me at the Bondage Club.

"You understand, boy, that if I lock this on you in front of these witnesses, you're mine until I release you?"

"Yes, Sir!"

"You still want it, boy? You want to be my slave?"

I looked into his eyes, then bent forward and brushed the collar with my lips.

"Please, Sir, make me yours."

"With this collar," he said, as much to the others as to me, "I claim this boy as my probationary slave and declare my intentions." Looking into my eyes, he continued, "If all goes well during your trial period and it is then still your desire to belong to me, you will have my protection and guidance for as long as I live, and in return I will expect your loyal, obedient service for as long as you live, unless I release you earlier.

"Kneel, dickhead." Despite the "humiliating" name (which I was coming to like), his tone made it clear that this was an honor, not a degradation. *They kneel to be knighted, don't they?*

Terry bent down and buckled the collar snugly around my throat, padlocked it at the back of my neck, and clipped the same braided leather leash to the D-ring in front that he'd used twice before. I swallowed hard and fought back tears.

"Thank you, Master," I said firmly when I found my voice again.

"Good boy," he said, his voice a trifle thick, too. "Now that you're mine, it's time to get you properly restrained. Put your head on the floor. Keep your hands behind your back."

After I complied, I heard him rummage in the bag at his feet, and then he snapped double-weight police handcuffs on my wrists, palms out, and set them.

"Put these on him, would you, Hank?" Terry asked.

Hank fastened a matching set of heavyweight leg cuffs around the tops of my boots. *Guess I chose the right pair!*

"Kneel up, slaveboy," Terry said and pulled on my leash for emphasis. He was leaning back with his elbows on the bar, which pushed his crotch forward and up. His stiffening tool was obvious under the leather, and I licked my lips at the sight of it. First things first, however. "Show your respect, slave," he said, grinning. "You know what to do."

I was kissing his left boot before he'd finished talking, then the right. The leathermen surrounding me were silent as I began methodically licking Terry's boots, beginning again with the left one. As soon as my tongue lapped the soft, oil-tanned leather I felt a circuit of energy flowing between us, down his leg and out through his boot toe to my tongue and on into my brain, where it energized my whole body, making my heart race and my genitals twitch, from my nipples down to my cock and balls and asshole, then up and out again through the collar and leash back to his hand and on to *his* heart and brain, and cock, too. My consciousness narrowed down to my mouth on his boots — *my Master's boots* — while at the same time expanding out to the very limits of my being. All of me focused on those columns of tough, velvety black leather rising before my face. Nothing else mattered — it was as if nothing else existed.

It wasn't the first time I'd licked his boots, of course, not even those particular boots, and I certainly hoped it wouldn't be the last, but in a curious way it seemed as if all my boot service — past, present, and to come — was merging into one transcendent experience. It was Terry's soul I was worshipping, or as much of it as I could encompass — spirit made leather — with my whole soul, communing with him through this humble service. Tears ran down my face onto the boot shaft, I felt so happy.

Eventually the transcendence faded, as it always does, and I was once again just a boot-loving boy licking his man's boot — which is fine, too. I realized that Terry and his friends had resumed their conversation, talking about me over my head as though I couldn't hear them.

"He seems to be well trained," Bill said.

"He behaves well enough in public," Terry replied. "That's the easy part — it's theater. In private he's still balky sometimes, but we're working on it."

My ears burned, but it was less embarrassing to keep licking boot leather than to show any reaction to his comment.

"I've heard he can be a real smartass," Hank added.

"Yeah," Terry drawled, "but I take care of that by keeping him gagged most of the time."

My back stiffened for a moment, but my cock never softened, so I swallowed my pride, relaxed, and just kept licking. *The only way to live down that kind of reputation is to earn a new one,* I told myself, *and I'll bet he's going to give me a chance tonight to do just that.*

"He's a good boy," Jake added in his precise voice. "He needs to learn how to trust himself more, so he can surrender without fear. I've done all I could by talking with him. Now it's up to him and Terry to make it real." *Thanks, Jake. I won't let you down.*

When I finished tongue-washing Terry's left boot, I moved over to the right and started at the bottom again. My knees hurt from the cement floor, yet I would have happily kept licking for hours. But as soon as I finished his right boot he pulled on the leash. I raised my head and looked at his serious smile.

"Thank Master Jake for all he's taught you — taught both of us," he said. "Go on, dickhead — pay your respects."

My feelings were oddly mixed as I shuffled on my knees over to Jake, who had actually turned around to face me. Since our "failed" session five years earlier, I had never "Sirred" him or given him any special homage, and he hadn't seemed to want it. *But if Terry calls him "Master," can I do any less?*

"Thank you, Master Jake, for your guidance and friendship," I said, seeing my dirt-streaked face in the sheen of his jackboots. "Sir, this slave also deeply appreciates whatever you have taught my Master. Sir, may I . . . ?"

"Go ahead, boy," he said. "You've earned it."

Slowly I bent my face toward the gleaming leather, afraid of marring the exquisite surface with my clumsiness.

"Do it, dickhead," Terry growled behind me, lightly kicking my upraised ass to encourage me. "Don't keep the man waiting."

I kissed each of Jake's boots reverently, then dreamily glided my tongue over the toes and along the insteps, as smooth as black mercury. Jake'd been like a favorite uncle to me, but now that I knew he was Terry's mentor, he was much more. I imagined him orchestrating our affair like a puppetmaster. *Well, if he pushed us together, I'm glad of it!* I stopped indulging myself and laid my forehead on the floor between his boots. The leash between my collar and Terry's hand stretched taut, reminding me of my primary allegiance.

"That's enough, dickhead," he said after maybe a dozen heartbeats. "There's someone else for you to thank. I learned all I know about whipping from Bill here. Since you'll be one of the prime beneficiaries, go kiss his boots, too, before he and Hank move on."

"Yes, Master," I said and shuffled around to face Bill, who was standing behind me, and then bent over to kiss both of his highly polished police boots. Terry had put a slight emphasis on "kiss," so I didn't try to go any further.

"Thank *you*, Sir," I said to Bill as I straightened up. He nodded gravely at me, then smiled at Terry. When he looked away I shrugged my shoulders for relief. The thick cuffs weren't hurting my wrists, but by now my arms were sore from the constraint.

"I'd have him thank you both more, ah . . . fervently," Terry said, "but I don't want to endanger the bar's license."

"Maybe we can arrange something more private sometime," Bill said. Jake made a noise between a laugh and a snort. I had no idea what his sex life was like anymore, but I doubted it was anywhere near as athletic as Bill and Hank's.

"We'd like that," Terry said. "Right, dickhead?"

"It would be an honor, Master," I answered sincerely, excited at the thought of playing with Bill — but also wondering how well I could keep up with Hank as a bottom. I certainly didn't have the whip-calloused hide he'd developed.

"We're going to wander, then probably make an early night of it," Bill said. "Good seeing you, Terry. Give us a call sometime. Goodnight, Jake."

"I expect it will be a very good night," he said enigmatical-
ly. "Be well."

"Good luck with this one," Hank said to Terry, ruffling my
hair. "I hope you have the patience to train him all the way."

"I think I do. If not, I know where to go for help. Take care,
guys," Terry said, slapping their shoulders affectionately.

I was still on my knees, facing away from him, as the duo
slipped off into the crowd, which now filled the bar wall to wall
and was still swelling. A few men glanced curiously at me, but
most took it in stride; a dog-leashed bootslave was not unusual
for this place. *They can't see what I'm feeling*, I thought. *If he wants
to make an impression, we'll have to do better than this.*

I felt Terry's gauntleted hand on my head, and I turned my
face toward it, rubbing my cheek against his leathered palm. A
wave of contentment and love washed over me. *Why can't it al-
ways be like this?* I wondered. But of course I knew why. We still
had to live in the real world, had to earn our livings and take care
of all the endless chores and challenges life presented. I thought
about what Terry had said just before he'd collared me, about
"protection" and "guidance," and "obedient service." *Can that be
for real? God, I hope so, but damn if I can see how we'll make it work.*

"Stand up, boy," Terry said softly and slipped his hands un-
der my arms to help me. When I was on my feet he turned me
toward him with a touch, then held me at arm's length while he
looked me over once again from head to foot. I stared down at
his handcuff tie tack.

"C'mere, asshole," he said finally. "Do I have to tell you
everything?"

Smiling, he pulled me to his chest in a bear hug. He ground
his mouth into mine and speared me with his tongue. I opened
wide, wanting to deny him nothing. When he broke off, I pushed
my face against his leathered chest, rubbing and licking, trying
to reach him through his sexy armor. He kept his arms around
me as I explored, burrowing underneath the jacket to get at his
armpits, sniffing the heady aroma of leather permeated by man-
sweat. I could feel and hear him laughing at my greediness.

"You're a real sex-pig, aren't you," he purred into my ear.
His hands were doing their own exploring, rubbing at the frayed
denim covering my crotch and ass. Eventually the inevitable hap-
pened, and the fabric tore along the back seam. That didn't stop

him; he just pushed his gauntlet through the tear and rubbed at my asshole until I was squirming helplessly. When he shoved one leathered finger into my hole, right there in the bar, I yelped. Quickly, he took it out and stuck it in my mouth.

"Suck," he ordered.

As I coated his finger with saliva, I tasted soap and my own faint musk as well as the smooth, fine-grained leather. I suspected I hadn't felt the last of it in my ass, and, sure enough, when it was slick with my spit, he put it right back, immediately plunging it to the hilt. I gave out a "*Woof!*" — not of pain so much as surprise — then started bucking my ass back toward him. He pulled me off his chest long enough to loosen his tie and peel back his shirt, then pushed my face onto his exposed nipple. I suckled like a calf at feeding time.

"That's right, boy," he whispered close to me. "Make me feel good with your tongue and lips while I work your ass."

Leaning over me, he kept pumping his finger in and out of my asshole while I licked and sucked his nip, moaning and wiggling my butt. From time to time he returned his finger to my mouth for more spit lube. *Am I glad I cleaned up back there!* Eventually he stuck *two* fingers in my mouth for me to lubricate, but when he tried to insert them my ass was too tight.

"Guess you need some loosening up, boy," he said, and the next thing I felt was a sharp pain across my butt. After the second blow I realized he was using the riding crop on me, and not lightly, either. With one hand he held my cuffed hands out of the way, in the middle of my back, and with the other he worked over my ass. I had to struggle to keep my mouth on his nipple as Terry pushed down on my back.

Whaapp! Thwaaack! The blows rained down with metronomic regularity, spaced about two seconds apart. I must have made a good target with my ass cheeks neatly framed by the leather chaps. The shreds of my jeans were no protection at all, though the black and gray hankies in my right pocket cushioned blows to that region until Terry removed them. Fortunately, he didn't keep hitting the same spots but methodically shifted his aim after each one to ensure full coverage. In just a couple of minutes the sharp pains of the individual blows had begun to merge into an all-over burn. It hurt and felt wonderful at the same time! Tears were welling in my eyes, but I didn't want him to stop.

Whaapp! Thwaaack! The beating went on and on, and as he worked over parts of my ass for a second and third time the pain escalated sharply — but so did the pleasure. The taste of his sweaty skin, the feel of his chest hairs under my tongue, the sound of the crop slapping against my ass, and the burning pain suffusing it — all saturated in the heady aroma of leather — came together in my brain with my love for him and my need for his dominance to produce an incredible high. I felt that if he weren't holding me down I'd float away.

Finally, the blows slowed, became lighter, and then stopped, but only so he could begin kneading and stroking my inflamed ass with his gauntleted hands. I whimpered and cried against his chest as he forced blood to flow back into flesh that had gone numb. But once the pain peaked and began to ramp down, I felt all of the tension flow *out* of my ass and back, and when he inserted two fingers again, after another trip to my hungry mouth, I practically pulled them into me.

My asshole fluttered around his fingers as they massaged my prostate, sending bolts of nervous energy up to my brain and out to the tip of my cock. That was anything *but* relaxed, swelling and straining at the jockstrap that kept it confined. When Terry bent me over so my face was against his crotch and started teasing my nipples with his other hand, I did more than whimper: the sensory overload pulled screams out of me, which I tried to stifle by pressing my face tight against his cock, hard under the leather of his breeches.

A small part of me marveled at what we were doing so publicly. But mostly I was far too preoccupied with what my tongue and nose and asshole and nips were feeling to do anything but react involuntarily as Terry played me like a fish he was landing. I pulled mindlessly at the cuffs binding my hands, but of course they held fast, and the feeling of secure restraint let me abandon all inhibition.

I squealed openly as he squeezed and pulled at my nipples, then finger-fucked my ass, then my nips again, then my ass, back and forth, then both together! It was too much! Even bent inside the jockstrap, my cock was hard as steel and building toward an explosion without a hand near it. I was wound so tight there was no escape. The tension in my groin kept increasing until I started to gasp, rushing toward orgasm.

"I'm going to come, Sir!" I whispered loudly, not sure if he could even hear me.

"Go ahead, boy," he told me in a loud voice. "That's the idea! Show everyone here what a slut you are, coming without a hand on your cock, just because I'm finger-fucking your hole."

"*Aaiieeee!*" I screamed as my cock exploded into the jock-strap covering it. "*Aaagghh!*" My whole body jerked with each spurt — one! two! three! incredibly, *four!* — and then I went totally limp, slumping against Terry's belly, held up by his hands in my ass and on my chest.

"Oh, my God," I moaned in pleasure and disbelief. "Thank you, Master," I whispered finally.

"Down, boy," he said quietly, gently pushing me. I was still facing him, and my mouth trailed over his crotch as I slid to my knees. "Turn around, boy," he said. "Let the gentlemen see you."

See me? Only then did it hit me that a good part of the bar must have been watching.

I turned around, still a little dazed, and saw a ring of men staring at me. A few applauded, some shouted rude remarks, but most seemed amused at the show we'd just provided. I was glad Stan wasn't among them — I'd told him what Terry had planned (as far as I knew, anyway), and he'd decided to give the Spike his patronage that night. He'd given up trying to protect me from Terry but still preferred to pass on the spectacle of "Mr. Too Big for His Boots taking you down," as he put it. There were plenty of other men I knew, though, men I'd tricked with, even men I'd rejected. *Shit — this is too much.*

I hung my head, flushed with embarrassment again, yet at the same time curiously proud of my performance. The afterglow of my orgasm was dissipating, my arms and legs were stiff, and my knees were sore, but I still felt pretty good, all things considered. Like coming off a scary roller-coaster ride, I was glad it was over but also glad I'd done it.

"Bet you're thirsty after that, dickhead," Terry said, setting a rubber dog dish on the floor in front of me and pouring it full of beer from a can he had ready. "Go ahead now, drink up."

I *was* thirsty. *And after what this crowd's already seen, what does it matter if they see me drink like a dog from a bowl on the floor?*

Bending down, I started lapping up the beer, getting almost as much on my face as in my mouth. I heard Terry above me trad-

ing cracks with one of the bartenders, who probably felt our scandalous behavior was good for business. I straightened up when I'd had enough, foam still on my mouth and beer dripping from my chin.

"All finished, boy?" Terry asked, but when he saw there was beer still in the bowl, he pushed my face back into it. "When I give you something, dickhead," he said in an angry tone, "you take it *all*, and be grateful. Next time you'll get it secondhand."

I spluttered as he released the back of my head, then resignedly lapped up the rest of the beer, cleaning the dish with my tongue until it was spotless.

"You okay, boy?" Terry asked in a kindlier tone after I finished, bending down to whisper into my ear.

"Fine, Sir, thank you," I told him quietly. "Just a little wiped out, and my arms and legs are getting stiff."

"We'll be leaving in a little while, and you can rest on the drive," he said. He pulled off a gauntlet and felt my hands. "Still warm! You'll live."

He retrieved the dog dish and dumped it in his bag, then pushed me back against the bar. I winced as my sore ass touched my heels and knelt up slightly. Terry planted himself in front of me, threaded my leash between his legs, and pulled my face up against his own ass.

I didn't need orders. I licked his leathered asscrack and butt cheeks as he stood there chatting with Jake. The body-warm leather bathed my nose and tongue in sexy smells and tastes.

"That was a fine show you two put on," Jake said dryly. "Perhaps not as uninhibited as some of those in the bad old days, when there wasn't such a fine line between a leather bar and a sex club, but quite edifying nonetheless."

"Thanks, Jake," Terry said, chuckling. "From you that's high praise! We enjoyed ourselves, anyway."

"Funny thing is," Jake continued, "when I tried making him drink from a dog dish five years ago, he froze. He stared at it like it was a snake that might bite him and told me he 'wasn't into humiliation.' He didn't realize his cock was hard as he said it. I knew then it was only a matter of time, but at my age I get impatient. I decided to let someone else bring him out. I've tried to keep him from getting hurt too badly in the meantime, while he ran through his other options. He tried awfully hard to convince

himself that he could be 'just a bottom' without surrendering all the way."

"The way I tried to convince myself I could be just a top? Without taking the responsibility of owning the boys — hell, the men! — I played with?"

"Pretty much the same. You're both damn stubborn."

"I'm glad you saved him for me, Jake, and pushed me to give him a chance," Terry responded. *So Jake* has *been orchestrating this affair!* "I can't take full credit for the changes in him, however. It doesn't seem to be anything *I've* done so much as simply the chemistry between us." *You're too modest,* I said to him silently. "He still has a stubborn streak, and sometimes he has to work out in his head that it's okay to do what I tell him. But it seems to get a little easier each time we get together." My ears were burning again as I licked ass. *Am I really supposed to be hearing this?*

"Don't count on it," Jake cautioned. "I suspect he still has more than a few sticking points you'll have to ease him past before he really settles into being your slave. Remember, nothing in his background or everyday life so far has prepared him for the kind of surrender you both want. Quite the contrary: everything he's learned tells him to hold back, to be as independent as possible, to respect nothing and obey no one unless he's forced to. His generation — and it's yours, too — is always looking for the path of least resistance."

"And a slave's way is to seek the hardest path," Terry said. "I haven't forgotten the lesson. It was two *years*, Jake! Two years you kept me chopping wood and drawing water for you after Phil left me, teaching me about slavery from the bottom up. Hardest thing I ever tried to do — *much* harder than earning my architect's license!"

"And you learned very well, my friend. You're my star pupil. And now it's time for you to be a teacher again. Finish what you started tonight. Make this boy yours through and through. Teach him how to submit and serve. He'll love you more the better you train him."

Jake rubbed my head affectionately, as if to say that he'd known I was listening, that he'd spoken for my benefit as well as Terry's, but I kept my face where it was supposed to be, in my Master's ass. I couldn't have looked at him anyway, as I was still stunned by Terry's revelation. *Terry was Jake's slave! Or was at least*

trained like one! I tried to imagine a younger Terry naked and collared, on his knees in front of old Jake, his hands held behind his back, or restrained there. *Would his cock have been hard? Would he have been excited by the submission the way I am? Or doing it halfheartedly, as a means to an end? Jake would never have tolerated that! And Terry would never do anything halfway, either. Does that mean the ass I'm licking has felt Jake's cock? Or a buttplug? Probably!*

After Jake and Terry finished talking, a whole series of men came up to Terry to congratulate him on our performance, or to ask how he'd managed to train "a cock-tease like that one" to behave like a real slave. I didn't listen carefully at first, still wondering about the extent of Terry's submission. It didn't lessen my respect for him in the slightest — quite the contrary. *He knows what it feels like to give up control, to trust, to obey and serve. He's been there, too. But he felt no need to stay there. He wasn't looking for a Master but learning how to* be *a Master.*

When I started paying attention again to the conversation over my head, I was amazed at how freely Terry embroidered the truth, telling the guys absurd stories about how he'd "broken" me. My jaw dropped at hearing that he'd kept me chained in a dark cell for weeks, flogged me bloody every night, hung me by my thumbs for hours every morning before tying me into a pretzel, fed me nothing but moldy bread and fresh piss, carved his initials in my ass with a dull knife, fucked me with 20-inch dildoes, and so on. Every once in a while Jake tossed in an especially baroque detail, such as that Terry frequently visited a nearby pig farm before making me lick his boots clean. And they just ate it up, too. An admiring, "No shit! Really?" was the closest any of them came to skepticism.

He interrupted these tall tales long enough to move me around to his front, so I could lick his crotch. His cock was hard again inside his pants, so I guess he got off on the stories as much as the guys who heard them did. While at first I was shocked by what he was saying, soon I caught the spirit of it and had to keep from laughing at the huge contrast between his storytelling and what had really happened. *What would they think,* I wondered, *if I piped up and said that he's so careful he waited a month before letting me drink his piss? Or that it's really his great cooking that made me love him?*

The flow of chatter over my head ceased eventually as the

bar became more and more crowded and the music louder. Off in our own little world, Terry and I concentrated on the connection between my tongue and his cock through his leather. He got even stiffer than before as he grasped my head with his hands and pressed me to him. I licked harder, trying to suck him through the leather, and he began to moan softly. I was getting turned on again, too, but I think the bartenders were starting to worry. Finger-fucking was one thing, but if Terry pulled out his cock for me to suck, it could mean big trouble. Before things went that far, though, he broke the connection, straightening up and pushing my head away from him. He took a few sips from his can of soda and offered me some.

"Here, dickhead," he said, leaning down, "finish this off before we go."

"Thank you, Master," I said, and swallowed the cold liquid as he held the can to my lips — wishing that it was warm liquid from a different source only a few inches farther away.

"Time to stand up, boy," he said, and helped me to my feet. I swayed a little until my legs readjusted to carrying my weight, but Terry steadied me against him, rubbing my stiff arms inside my jacket. "Don't worry," he said softly, close to my ear. "A lot of guys are so brainwashed by years of bad porn they'd think what we really did was too tame. So I gave them something 'hot' to beat off over."

"Your stories will probably get even more exaggerated as they circulate, Sir."

"Good," he said smugly. "Those who know us, really know us, will discount them, and the rest will keep their distance. Tops will know you're with me now, and bottoms will know that I'm busy keeping you in line — after all, you're a hard-assed bastard it took me weeks to break. Isn't that the reputation you've always wanted, Matt?" His smile took the sting out of the dig.

"Not anymore, Sir," I said, smiling back. "Being your slave is all I want, Sir."

"I hope that's true, boy," he said thoughtfully, not smiling. "We'll see. Now head over to the can. I expect you have some piss to unload before the trip, and I want to plug your hole. Pick up my bag."

"Yes, Sir," I said and bent down to grasp the handle in my cuffed hands. I stood up and shuffled toward the toilets, taking

small steps because of the leg irons. Terry was right behind me, my leash in one hand and the other gripping my arm. Once we were inside, he took the bag and unbuttoned my fly so I could piss — but stopped when he found that the cum in my jock was still wet.

"Can't waste this good stuff, boy, can we?" he asked with an evil grin.

"No, Sir," I said, resigned to eating my own cum, cold.

He scooped the slimy stuff out of the jock and fed it to me on his glove. At least the leather gave it some additional flavor! When the jock was harvested to his satisfaction, he held my cock — now hard again, of course — over the urinal so I could piss.

"C'mon on, dickhead," he said impatiently. "We don't have all night. Unload that beer piss or you'll have to hold it another couple of hours."

Get soft enough to piss with this stud in full leather standing next to me holding my dick? No way!

"Please, Master," I told him, "I can do it easier if you don't hold me. In fact, Sir, if you'd step away so I can't see you. . . ."

Chuckling, he released my cock and walked to the urinal farthest away from me so he could relieve himself. As long as I could hear him pissing, though, his golden stream wasted in the porcelain trough instead of down my throat, I couldn't let go. My hard cock bobbed in space over the urinal mouth, but not a drop of piss came out, just a string of precum!

When he came back over and saw my lack of progress, he chuckled again and stood behind me, pressing himself against me. I figured that would only make things worse, but he started whispering hypnotically next to my ear, telling me how much I *wanted* to piss, how *good* it would feel, how good it would make *him* feel to see his slave *pissing on command*, how it was all *ready* to rush out, like coming, if I would only *relax* and let it *pour* . . . and so on, until, by God, I was pissing out a torrent! The hot, pale yellow stream, unaimed, splashed around in the urinal, but Terry was pressing me so hard against it there wasn't much chance of its going astray. And if some of it splashed onto my ripped jeans, so what?

While I was still pissing, almost moaning in relief, I felt his finger invade my hole again, opening me, loosening me up for the plug. He pulled the finger out, only to return it covered with

lube, cold and greasy. He packed lube into me, first with one finger, then two, three, four, and finally I felt the plug pressing against my hole.

"Open up, dickhead," he said into my ear, "lemme plug your hole, boy, keep it stuffed and happy until your Master's cock can take it, take your slave cherry, your first fuck as my slave. You want that, boy, don't you? You want me to plug you an' fuck you, chain you an' beat you? You want to be trained, don't ya, boy? Ya want'a learn how t' be mine? How t' submit and serve?"

"Yes, Sir! Please, Sir! Please do it, Sir, everything you said, Sir! Please make me yours, Sir!"

The huge plug was twisting in my hole, pushing forward, straining my asslips, sliding inexorably into me — and I wanted it! As if that realization provided the last necessary measure of relaxation, the plug suddenly popped in, and my sphincter closed around its neck. My ass was *stuffed!*

"Good boy!" Terry said, smacking me for emphasis. "That's my good boy! You pissed for me, and you opened up your ass for me. That's the way it ought'a be. Just do whatever I say. Give me whatever I want, your ass, your mouth, your tits, your cock — anything. Isn't that right, dickhead?"

"Yes, Master! Anything you want, Sir!"

"Well, as soon as I wash this lube off my hand, boy, and button you up, what I want is to get us out of here and on the road. Here, hold the bag again."

I stood on the side, my soft dick hanging out, my face reddening at the amused stares and lewd comments of the other men in the room, pissing or waiting to piss, while my Master washed, unable to help him. I couldn't even hand him a towel, or button up my own fly. *He doesn't really need my help, I realized. How can I serve him? His life is so full and well organized! I guess it's like buying a gift for a man who has everything: the thought — the giving — counts more than the gift. Maybe my willingness to serve him, to obey him, is more important than anything I actually do.*

"C'mon, boy," he said, interrupting my reverie. "Time to put away your joystick." He stuffed my cock back in the jockstrap and buttoned me up. "Let's go home."

We stopped by the bar to bid Jake good night. Terry shook his hand, and I stood there, blushing again, while Jake looked me over carefully, as if seeing me for the first time and appraising my

worthiness for his "star pupil." Finally he smiled and knuckled my head.

"I could give you all sorts of wise advice, Matt," he said, "but I think there's been enough talk between us. I've enjoyed our friendship, but now your life is entering a new phase — if you let it happen. He's ready to lead you! Don't cheat him, or yourself, by fighting it."

"Thank you, Sir. I won't, Sir."

"G'wan, get out of here, you two."

Terry pulled himself up very straight, inclined his head to the old Master, and led me toward the door.

We moved slowly because of the crowd, the noise of my leg chain drowned by the loud music. At the exit, Terry stopped and pulled me to the side. As if to leave no doubt, in my mind or anyone else's, about how much he cared for me, he embraced and kissed me again, holding me tight against him for several minutes before we finally turned and left. Carrying his bag in my cuffed hands — it wasn't heavy now that I was wearing most of the gear it had held — I followed him out, collared and chained but proud to be at the end of his leash.

CHAPTER 22

Welcome to my dungeon

As we climbed the stairs out of the bar, the sound of my leg chain was loud in the silence. I was glad Altar wasn't anywhere near a residential neighborhood. A smirk of Tribeca trendies leering at us would have spoiled the mood.

I was almost looking forward to another relaxing ride in the trunk of Terry's old Jaguar, but when we stopped on a side street around the corner I saw that he'd brought the Jeep. He didn't plan to let me sit next to him and chat, however.

"Face front, dickhead," he ordered after opening the tailgate and rear window. He unclipped my leash, took his bag from me, and set it on the tailgate, then unlocked my handcuffs and pulled my jacket off. I rubbed my sore wrists and bare arms as he folded the jacket and laid it on the left side of the cargo area, behind the driver's seat. My asshole twitched around the plug, but it felt good. So did the leather collar around my neck; just as the first time I wore it, it felt like it belonged there.

Terry turned me around and again crushed me to his chest. I inhaled the scent of his body-warm leathers and began licking whatever I could reach. He laughed aloud and kissed me fiercely, possessively.

"Three days, boy!" he said, pulling back and holding me at arm's length, his strong hands clamped onto my shoulders. We stared into each other's eyes, smiling, until at a nod from him I dropped mine submissively. "Three days of nonstop bondage and confinement, three days of all the flogging and fucking you can handle! Three days as my full-time slave, doing whatever I tell you with no backtalk. How's that sound to you, boy?"

"It sounds great, Sir!" I said, looking up at him again — his

338

enthusiasm was contagious. "Three days or three years, Sir! I'm your boy!"

"We'll see," he said with a wry grin. "Anything you need to tell me before I secure you for the trip?"

"No, Sir."

"Good."

He fastened the cuffs on me again, but in front, and reached into his bag for what proved to be a well-worn leather head harness with a detachable gag. He turned me around and put it on me, tightening the straps till it was snug. The rubber gag — with a breathing, or piss-feeding, tube through the middle — was like a short, fat, chewable cock filling the front of my mouth.

"Climb in, boy," he ordered, giving me a boost with a firm hand on my sore ass. "Use your jacket as a pillow."

I tumbled into the Jeep and squirmed around until I was in a tolerably comfortable position in the narrow space behind his seat, with my knees bent and my legs pulled up a little. Terry had chains already prepared in all four corners of the cargo area, and in a few minutes my shackled feet were locked in place and chains were looped around my knees, chest, and waist and pulled tight enough that I couldn't roll around. His last step was to lock my cuffed hands behind my head to the rollbar on the side of the Jeep. After wriggling in my bonds enough to test them thoroughly, I settled back onto my jacket with a contented sigh. *So nice to be tied up by a man who really knows what he's doing!*

"That ought'a keep you happy for an hour or so till I get you home," Terry said, sitting on the open hatch door of the Jeep and reaching in to run his hand over my exposed butt. "If I can resist pulling over on the way and raping you first."

I could only grunt in response. He laughed, then reached over to squeeze my crotch. He unbuttoned my jeans again and pulled my hard cock and balls out of the damp jock strap, squeezing my cock and rolling my balls around in his gauntleted hand, and jiggling the plug in my ass with the other, until I was moaning and writhing in pleasurable pain.

"You're so easy, Matt," he said in an amused tone. "It's almost no challenge to play you. Push your buttons — bondage, boots, leather, affectionately rough handling — and you're a bitch in heat. I'm amazed no one's ever enslaved you before."

I didn't try to answer, just groaned under his delicious tor-

ments. If I'd been able to speak clearly, I'd have explained to him that it wasn't my "buttons" but *who* was doing the pushing that made the difference — I didn't react this way to just *anybody*.

"Well, let's get this show on the road, boy," he said.

But he couldn't resist one more embellishment. With the air of an artist putting a last touch to a masterpiece, he took some strips of leather and tied up my cock and balls. Only then did he shake out a folded canvas tarp and drape it over me, covering even my face, before locking up the rear of the Jeep. I had no trouble breathing under the tarp, which smelled a little musty, with traces of gasoline and oil, but I may as well have been blindfolded, not that I could have seen much anyway with my face only a few inches from the back of his seat. Terry was no doubt more concerned with keeping anyone outside from seeing that I was half-naked and tied up. Under the tarp I was an unidentifiable lump, not a captive being "abducted."

"Get some rest, boy. You'll need it," he told me when the Jeep was moving. He put on a CD or tape, and the vehicle was filled with the sound of a classical guitar. I *was* pretty tired, and despite the hard surface under me, which let me feel every bump in the streets and roads we passed, I felt so safe and secure that I soon drifted into a deep sleep. I stirred whenever he stopped for a toll or changed the music but always dozed off again quickly.

I woke with a start, however, when Terry opened the back of the Jeep and pulled off the tarp. Blinking in the sudden light, I shook my head to clear it as he unlocked the chains holding me in place.

"Hope you enjoyed your nap," Terry said with a wide grin, "'cause you won't be sleeping again for a while!" He unstrapped the head harness and unlocked my handcuffs and leg irons. "Now get your ass out of there and strip down to your boots." I scrambled out of the Jeep and began taking off my clothes as he tidied up the bondage gear, packing it back into the bag he'd carried into Altar.

He took my T-shirt, chaps, and jeans from me as I removed them and stowed them in the Jeep, slamming the hatch door and window closed when I was naked. He recuffed my hands be-

hind my back before untying the leather strips he'd put around my hard cock and tight balls. Although the air in the garage was warm enough, I shivered from excitement, spiced with just a little fear now that I was truly at his mercy. *Can I take whatever he throws at me?*

"You look real good, boy," he said, running his eyes and hands over me. The feel of his large, strong hands on my body was so erotic that my cock, standing proudly from my recently shaved crotch, began dripping precum.

I melted into him as he wrapped his arms around me, pulling me against his leathered chest, holding my cuffed hands tight against the small of my back. My cock squeezed between his legs, and I laid my head on his shoulder. My throat vibrated with a sound somewhere between a moan and a purr as he stroked my back and kneaded my ass. I was totally lost in the moment, not thinking about what had happened earlier or what was to come.

"Ready, slaveboy?" Terry asked softly next to my ear.

"Yes, Sir." *Ready for what?* I asked myself. "Anything you want from me, Sir," I told him.

"Anything?" he asked, teasingly. "No limits?"

Why can't I keep my big mouth shut?

"Not for you, Sir. Use me any way you want, Sir. I trust you, Sir — and you did promise to protect me."

He laughed and pulled my head back so he could look into my eyes.

"I don't want to 'use' you, Matt. I intend to *play* you — like a violin or guitar. You're here so I can practice my art: bondage, confinement, torture, control — I can't create the effects I want by myself, and now I realize that I can't do my best work on a subject who doesn't belong to me. I need your unconditional trust and acceptance, whether you're suffering or blissed out with pleasure, to achieve what I have in mind. Understand?"

"Not entirely, Sir." I could see bondage as a form of sculpture, but it was hard to think of the cries and shrieks I emitted under torture as sweet music, though I suppose to a sadist

"That's okay. You don't have to understand it. Just do whatever I say. I won't promise it'll never hurt, because sometimes it will, only that in the end you'll be glad you obeyed."

He bent to kiss me, and I opened hungrily to him, sucking on his tongue and lips. When he pulled away I wouldn't let go

— I darted my tongue at his moustache and hit his chin, raspy now with beard stubble.

Laughing, he diverted my face to his jacket and let me lick my way down to his crotch. I was on my knees, licking along his thick cock under his leather, when he suddenly pulled a leather sack over my head, plunging me back into darkness, and tightened it with drawstrings in the rear. The only openings were tiny air holes near my nose. I could breathe well enough if I did it slowly, but the front of the hood pulled tight against my face every time I inhaled, and the strong leather aroma of the rough suede inner side filled my nostrils. When I exhaled it puffed out like a balloon, and my ears hummed with the increased pressure.

"I have a surprise for you, boy," Terry said. The thin leather was no obstacle to hearing. "Stand up and follow my lead."

He held my left arm above the elbow as we walked slowly from the garage into the basement of the house. The sound of our bootsteps was loud on the cement floor of the garage and then became much softer, almost muffled; I assumed we were crossing the carpeted floor of his work-out room and erotic art gallery. Between the smell of leather from the hood and the stale air that wasn't able to escape through its tiny air holes between breaths, I was almost giddy.

"You're doing fine, boy," Terry encouraged me. "Take it slow. We're almost there."

We walked a few more steps before he paused to unlock a door, then led me through a narrow corridor out into a larger space. (Hooded, I couldn't see the raw images of extreme torture covering the corridor walls, but somehow I still felt their baleful impact.) After a few steps, I figured we must be outside the cell-block where he'd "interrogated" me the last time, and I expected to hear the clang of the solid steel door opening, but it sounded more like a heavy wooden door swinging back on hinges. *Is that the surprise? Still another secret room?* I wondered as we moved four steps forward, then turned.

"Careful, boy. There are some steps to go down here. Take it slow."

I counted three steps before we moved out onto a level surface again. Even through my boots the flooring felt smoother than cement, and yet less even — sort of ripply — and much harder than vinyl or rubber. Our bootsteps echoed as we walked some

distance away from the steps. We stopped finally, and Terry said, "Stay there, boy," his voice booming in what seemed to be a large space.

I spread my legs a bit for a firmer stance and stood quietly for several minutes, my hooded head bowed toward my chest and my arms cuffed behind me. I felt the snug collar ride my neck and the hood collapse in and then balloon out with each deep, slow breath. The room was warmer than the garage, quite comfortable for a naked prisoner, but Terry must have been sweating buckets under all that leather. *Maybe he's taking some of it off,* I speculated while awaiting his return.

Eventually I heard his bootsteps approaching, and when he was in front of me he set something down on the floor with a metallic clang. Without a word, he removed the handcuffs and chafed my wrists and rubbed my arms, soothing away any stiffness. I was practically purring when he spoke again.

"Doing okay, boy? Any problems I should know about?"

"No, Sir. I'm fine," I answered truthfully. "I could stand to piss again, Sir."

"Hold it for now," he said, continuing to massage my arms, then my thighs and legs, almost like he was preparing me for something, or checking out my condition. His hands on me felt good, but I wondered what was in store. *Softening me up for the kill?* While I'd been genuinely looking forward to the "nonstop bondage" he'd promised, part of me just wanted to snuggle in his arms or at his feet and dreaded being bound and left alone. My half-hard cock reflected that ambivalence. The more exotic the equipment he used on me, the more elaborate the scenes he orchestrated, the more I craved the simple touch of his hand.

Those thoughts broke off when Terry pulled my left arm out toward him and start wrapping something around my wrist, some kind of bandage or other soft material — *rubber?* He did the same to the other one, and then he locked some kind of wide, very thick, and heavy cuff around each wrist. The cuffs fit snugly over the padding and had no give when I flexed my wrists, so I figured they were the same heavy metal set he'd used on me the first time, or something similar.

Terry adjusted my position, pushing me a little back and to the right, before pulling my arms up and out to the sides and anchoring the chains attached to the cuffs somewhere out of my

reach. When he finished I was tightly stretched, and my cock was about as hard as it gets. Another rattle of chain, and he was clamping even heavier cuffs around my boots.

"Good thing you wore these boots, dickhead," he said as he worked down at my feet. "Makes it easier for me — I don't have to worry about protecting your ankles. That why you wore 'em, boy?"

"Yes, Sir, more or less. I figured you'd want to chain my legs in the bar or after, Sir, and I didn't want to have to go barefoot."

"You figured right, boy," he chuckled. "It's always a pretty safe bet that I'm going to want you chained if I can, or restrained some other way. . . . Now spread those legs, boy. More! As wide as you can get 'em and not fall over."

The butt plug pressed more firmly against my prostate as I eased my legs apart, keeping my boots flat on the floor. This maneuver lowered my torso and thus stretched my arms even tighter. Terry anchored the chains so that my feet were at least a yard apart, and then he put another chain *between* the ankle cuffs, pulling inward, so I literally couldn't move an inch. The same for my wrist cuffs.

By then I was breathing hard, despite the hood, almost hyperventilating from excitement. My steel-hard cock was stabbing the air in front of me and beginning to drip precum. Maybe it's vanity, but I love to be spreadeagled! Just about any male body looks better that way, and it always makes me feel sexier and more vulnerable at the same time. Terry seemed to like it, too.

"Yeah," he said, his voice coming from in front of me again. His gloved hands lightly stroked my heaving chest and rippling belly as if to calm me, but it just made me hotter. "That's the way I like to see you, boy, all the time — in bondage, under my control. That's what I want. If you're not in bondage, you're not *my* boy, are you, dickhead? That's how you want to be, too, isn't it, boy? My bondage slave? My bondage toy?"

"Yes, Sir! That's what I want, Sir! Only . . . *ahh-hh!*"

"Yes, boy? What is it? What's worrying you?"

He was playing with my nipples, not hard, just lazily rubbing and flicking them with his fingers, and I was too turned on to think. *But there's something . . . something important* It was no use. At that moment I truly wanted nothing more than to be his full-time bondage toy.

"Nothing, Sir," I forced out. "I just wish I could see you, Sir, that's all."

I wanted to remind myself how attractive I found him, how much I lusted for his body. And I wanted to check if he had that crooked grin again, more mischievous than really cruel. *It's when he* stops *grinning that I really need to worry about what he'll do!*

"Soon, boy," he said. "Be patient. You have nothing to worry about — nothing except taking some pain for me. You can do that, can't you, boy? You want to please me, don't you?"

"Yes, Sir!"

I felt his hand on my balls now, and I moaned softly as he manipulated them, roughly squeezing them low in their sac and fitting something around it that finally snapped shut. The pressure when he took his hand away, abandoning my nuts to gravity, told me it was a metal "doughnut" ball stretcher, and a heavy one. I hissed and gritted my teeth, but the pain was quite bearable — for now.

Suddenly Terry's hands were all over me, teasing and tormenting rather than soothing, twisting my nipples *hard*, slapping my swollen balls and hard cock, squeezing my biceps and buns, gripping handfuls of flesh as if he'd tear them from my body — *taking* me, claiming me as his property, his plaything. I moaned under his touch but made no verbal complaint. I *wanted* to be exactly where I was, stretched out like a sacrificial victim, completely at his mercy, even if it hurt like hell. I felt totally alive, acutely sensitive to every stimulus, vividly aware of our relative positions and respective status. My role was very simple at that point: all I had to do was suffer.

He started slapping my chest and punching my abs, lightly at first and then hard, *harder*! Hooded, I couldn't see where the next blow was coming from. Rigidly bound, I couldn't move or resist, couldn't even flinch. Heavy, full-handed smacks raked the front of my body, rocking me in my chains, knocking the breath out of me so I couldn't even groan or cry out, just ride with the pain of his furious assault as it broke over me. I pulled furiously against my unyielding bonds, grateful that they prevented a cowardly escape, even more grateful for the thick leather of my boots and the bandages around my wrists that kept the metal cuffs from mangling my joints.

When my whole front side was one delicious ache, my skin

glowing with the heat of the blood his slaps had brought to the surface, he eased off and let my breathing and heart rate return to something like normal. My eyes were filled with tears, and I heard myself softly whimpering, but these were involuntary reactions. If he'd asked me if I wanted him to stop, I'd have said no without hesitation. This was what I needed: to feel his power and control, to be overwhelmed by his use of me. He didn't ask my permission, though. He took my (relative) silence for consent, or for all I knew he read my mind. He straddled my left leg (I could feel his leather breeches rub my naked thigh) and started slow again, lightly paddling my ass with one hand while the other slowly fisted my half-hard cock. My cock jerked in his hand whenever his slaps on my ass jiggled the butt plug, which only made him chuckle and do it again.

After a few minutes he stopped toying with me and just held onto the root of my cock and balls to balance himself as his blows on my ass became harder, then harder still. Soon he was whaling away full force, smashing his leathered palm across my butt cheeks so that I jerked and grunted with each blow. He let my strangled genitals go and moved behind me, hitting me with both hands in turn as hard as he could, *left, right, left, right*, moving up and down across my ass, *high, low, middle, high, middle, low*. My butt was on fire, but as just about every other blow drove the butt plug across my prostate, my cock was fully hard again. Some small part of my brain wondered if I could actually come just from being spanked.

I never got to find out, for Terry moved his theater of operations onto my back, still using only his hands, as far as I could tell, and still slapping more than pounding. But it definitely hurt — a lot. And yet it was starting *not* to hurt: the whole experience of being so intimately pummeled combined with the excitement of my stretched-out helplessness and the sensory imbalance of sightlessness with my overloaded touch and hearing to put me in a state of altered consciousness. My awareness was divided — part of it was still inside my leather-swathed skull, squealing like a trapped animal, but another part seemed to be floating serenely overhead, looking down equally on my glowing, sweat-soaked, pain-wracked body, sagging in its chains, and on the hard-working leatherman tormenting it.

When Terry finally stopped hitting me, I seemed to see him

still standing there behind me, watching me. I licked my lips and wondered what he was thinking. *Did he enjoy hurting me? Do I still please him now that my body must be as red as a boiled lobster?*

I hung in the chains and panted, the hood expanding and collapsing around my face like a bellows, for several long minutes before he finally unlaced it, came around in front of me, and pulled it off. The first thing I saw, blinking my teary eyes in the sudden light, was that he'd removed his cap and leather jacket, and his short-sleeved black leather shirt was now open at the neck, without the leather tie he'd had on earlier. But he still wore his gauntlets, and his leather breeches were still tucked into his tall engineer boots.

As my eyes adjusted, I saw that his face and arms were running with sweat, and his brushcut hair was plastered flat onto his skull instead of standing proudly erect. I chewed my lips and wished I could lick him clean. Despite the sweat, working me over had left him looking relaxed and happy. His characteristic mocking half-smile played on his lips as he looked into my eyes (before I lowered them).

"Welcome to my dungeon, Matt," he said, his honeyed baritone deepened by reverberation from the space around us. "This'll be your home for the next couple of days. Feel free to look around — as much as you can, anyway," he chuckled.

I had trouble just taking my eyes off him: the black leather seemed to soak up the soft yellow-white light. Turning my head to the side, I saw that the light was coming mainly from long glowing tubes mounted high, front and back, on steel-gray, I-beam-shaped pillars on either side of me. My chains were anchored to the same pillars, and I could make out similar pillars and glow tubes beyond them to the sides and across the room.

The more I looked around, the more my eyes widened in amazement. If Terry's jail cell was obsessively authentic, his "dungeon" could have been featured in *Architectural Digest*. The pillars I was chained to were part of a circle of eight similar pillars, and the gray, pie-shaped ceiling slabs they supported met at a point high above the center of the circle. That confirmed my suspicions about where we were: underneath the landscaped "hole" in his octagonal doughnut of a house. My memory of the flamboyant garden above us made the monochrome furnishings of the dungeon — black, white, gray, and steel as far as I could see,

except for an odd splash of color directly across the room — seem all the more severe.

The diameter of the circle formed by the pillars must have been at least 15 feet, and the dungeon space appeared to continue at least another 10 feet beyond them. Not all of the glow tubes were lit, and some of the "bays" between pillars were drowned in shadows. Turning my head to re-examine the pillars I was chained to, I saw that the flanges of the I-beams were perforated with large and small holes, no doubt to make it easier to run cables through a building but equally handy for attaching ropes or chains. The gleaming chains from my wrist and ankle cuffs were looped through large holes and fastened with snap-open carabiners, the kind used by rock climbers, rather than locks. Of course, since I couldn't reach the ends, there was no reason to bother with more secure fastenings.

I looked at Terry again, in awe at the amount of thought, effort, and, no doubt, money that had gone into this "dungeon," where every inch was as carefully designed as the lobby of a skyscraper. His smile had vanished, and his face was stern. *Uh-oh.* He reached out and raised my chin with a finger until I was looking directly into his eyes.

"I'm going to put you through the wringer, boy," he said, "and I expect you to take it all and beg for more. Understand?"

"Yes, Sir," I said in a small voice, and my cock drooped. I was coming down from my "high" during the previous scene. My arms and legs were hurting from the prolonged stretch, and I was tired, sore, and needed to piss. Much as I wanted to please him, I was past ready for a break.

"Don't worry, boy," he said, noticing my reaction. "I'm not going to demand anything you can't give me. If you try hard, you'll do fine."

He stepped forward and pressed himself against me, rubbing his sweat-soaked leather shirt and breeches against my tenderized torso. He licked at my face and nipples as I pulled uselessly on my chains, trying to touch him. My cock sprang erect again, poking at his own full basket, hard under leather. He stayed out of reach, laughing, until he brought his face back to mine and kissed me deeply. Our tongues entwined as I responded eagerly to the affection.

"I love you, Matt, but don't think that'll make me go easy

on you," he said quietly when our lips finally separated. *"Because I love you, I'm going to push your limits. If you're not ready to be the kind of slave I want, better we find out early. But I'm sure you can handle it."*

I opened my mouth to speak, and he held a finger against my lips.

"Don't talk now. There's nothing you need to say. Trust me." His voice was deep and slow, almost hypnotic in its effect as I stared into his hazel eyes — now brown, now gold depending on the angle of the light.

"Just keep still," he told me as he ran his hands along my arms and shoulders, feeling my muscles, once again soothing the tensions that his bondage and torments had created. "Relax. . . . Don't think too much. . . . Ride with the pain, don't try to fight it. . . . Relax. . . . Trust me. . . ." He bent to run his hands over my thighs and legs as well. "Trust me," he said once more when he'd straightened up and caught my eyes again. Forbidden to speak, I nodded.

He smiled and walked off toward my left, into the darkness. When he came back a few moments later he was carrying an aluminum bucket, which he fastened to the ball stretcher weighing down my nuts. He stood in front of me, unzipped his breeches and pulled out his beautiful, thick, cut cock, milking it slowly over the bucket.

"I've gotta piss something fierce, boy. Been holding it just for you."

The golden stream leaped from his cock and splashed into the bucket with a noise like rain on a tin roof and a smell that made me lick my lips in frustration. I'd never had much thirst for piss before, but every time I saw Terry piss — and didn't get it — all I could think about was how hot and good it would feel going down my throat. He sighed with satisfaction as he relieved himself, and I groaned as the bucket got heavier.

"When you're ready to piss, boy," he said, shaking off his dick and stuffing it back in his breeches, "do it right here in the bucket. But be careful: you'll lick up any you spill on the floor."

He caressed my face, twisted both my nipples, and playfully slapped my erect cock, making the bucket swing painfully.

"Just hang around the dungeon for a while, boy," he said with a mocking grin, "while I get comfortable."

And he calls me a smartass! I followed him with my eyes to a wide platform at the end of the room and up a short flight of steps, no doubt the same ones we came down. A massive door of darkly stained wood strapped with black metal in a quasi-medieval style stood ajar at the back of the platform. My Master went through his dungeon portal and closed it behind him with an echoing thud.

CHAPTER 23

Heart to heart and tongue to boot

Left alone in Terry's huge, unfamiliar dungeon, chained in a brutally tight spreadeagle, every muscle of my battered torso aching, a bucket of his piss swinging from my weighted balls, I found it hard to pull my mind away from fruitless speculation about how long it might be before he came back — or when he'd release me from the pillars. *If he's not going to let me serve him directly*, I thought, again imagining cleaning his sweat off with my tongue, *he should at least be here to* watch *me strung up like this!*

I forced myself to examine my surroundings again. Parts of the room remained indistinct, and others were simply beyond my range of view even with my head turned as far as it would go, but more and more details emerged as my eyes adjusted to the light. The floor, for instance, which had felt slightly uneven under my boots, appeared to be made of black slate, polished and sealed but left naturally irregular. The walls looked like huge slabs of poured concrete. As with the floor stones, the light-gray surfaces of the walls were barely finished, leaving the nature of the material undisguised. Aside from the vaguely medieval door, the style was brutalist modern, softened only by the warm light from the glow tubes on the pillars and on the wall with the door. I figured there were lights on the other walls as well, but they weren't lit. *I'll bet he has every one of them on an individual rheostat, with ganged controls to turn whole walls, or the whole ring of pillars, on and off at once.*

The platform in front of the door was actually quite well illuminated, and now that I wasn't distracted by Terry's presence, I checked out the splash of brighter color I'd noticed earlier. Covering the whole platform to the right of the entrance door (or to

351

the left as one entered) was an opulent Oriental carpet in tones of red, black, and gold. On it was a massive armchair carved out of black wood, with blood-red cushions on its seat and back, accompanied by a low table of matching design and a red and black leather ottoman. The table held a set of antique sandglasses in graduated sizes — *like the room in the Wicked Witch's castle where she turns over the red hourglass and says Dorothy has only that much time to live.*

I almost laughed when I made the connection. *Deep inside the butchest leatherman, the toughest top, you'll find a dreamy kid who watched* The Wizard of Oz *over and over again, wondering if he'd ever find a land "over the rainbow" where guys like him could be at home. We keep trying to find Oz, or to recreate it in miniature in our clubs, our resorts, our ghettos — or our dungeons.*

Still, the very theatricality of Terry's colorful oasis amidst the monochrome severity of the rest of his dungeon made it a powerful stimulus for fantasy. I grinned at the mental picture of myself prostrate, naked and chained, on the carpet before him, my tongue on his boot, like a prisoner kowtowing to the barbarian potentate whose forces have captured him. *Why the hell not? Why shouldn't he set the stage or direct the action any way he likes? And he's already captured my heart.* My cock, stiffly bobbing in the air, seemed to agree.

Looking downward, closer at hand, I noticed a circular area maybe nine feet in diameter in the center of the ring of pillars. Its perfectly smooth, dull-black surface was different from the shiny slate flooring elsewhere (*rubber?*), and it appeared to slope gently from the edges down to the center, where there was a perforated plate of bright metal. *A drain?*

Metal ringplates, obviously for anchoring restraints, were set into the floor around the perimeter of the dark circle, one every couple of feet, and just outside it, on my right, a group of pipes, valves, and hoses was set into the floor. That confirmed my suspicion that this was Terry's setup for water sports. I dubbed it the "piss pool," though he probably also used it for shaving and other messy scenes, as well as for washing prisoners during long-term confinement. *Tie 'em down and hose 'em off,* I said to myself. *No muss, no fuss, no piss on the carpet!*

When I looked up at the ceiling again, I noticed a heavy-duty chain and hook hanging down from a mechanical contrap-

tion at the very peak, no doubt a hoist for suspension scenes. Numerous small spotlights were set into the ceiling, aimed at different points in the dungeon, though none was on at the moment. In the bays between the pairs of pillars I could see larger pieces of equipment, including a sturdy wooden whipping frame, several cages, a bondage table or rack of some sort, and other devices whose function I couldn't puzzle out.

An intricate rope spider web was stretched between one pair of pillars, and another pair supported a veritable curtain of chains of various thicknesses hanging from a crossbeam. A metal helmet hung on another pillar, and on still another was a cage shaped roughly like a human body, the kind that in the Middle Ages was used to hold prisoners condemned to hang from a castle's walls to die and rot. I imagined being locked into it and hung up over the piss pool for a few days, twisting and swinging from my own useless attempts to escape — hungry, thirsty, befouled with my own excrement. The idea made me shudder, but my stupid cock stayed hard.

When does he have time to use half this stuff? I wondered. *And who does he use it on? Has he been waiting all this time, collecting all these "toys," for a slave worthy of his fantasies? Can I possibly live up to them?*

The growing pain in my stretched shoulders and thighs, plus the ache in my balls, drew me back to myself. The pleasant warmth of the room was actually making me sweat, or maybe it was the pain. I pulled at the taut chains, vainly trying to ease my limbs, and thought how Terry must have been roasting in his leathers. *No wonder he left to change. But I hope he returns soon! . . . Think about something else!*

I dived inward, following a thread of memories of youthful, long-forgotten bondage fantasies that my current situation had brought to the surface. Well before I knew I was gay, or even knew what sex was — before I reached my teens — I'd been fascinated by the idea of being chained in a dungeon. Of course, that was a staple image in the fairy tales I read voraciously, as well as in a number of popular comic strips, but I doubt if many other schoolboys passed otherwise boring hours on schoolbuses or at compulsory assemblies imagining every conceivable arrangement in which they might be chained, trying to decide which positions were best.

Even then, however, I figured that hanging someone on the wall by chains attached to his wrists or ankles, which happens all the time in cartoons and comic books, wasn't very practical for long-term confinement. The kind of standing spreadeagle Terry had me in was less obviously hazardous, and it's certainly one of the sexiest positions (probably why comic-book heroes so often find themselves in it), but even as a kid I remember wondering just how long someone could stay that way without damage. Several days? Half a day?

Not even that much. Even though I was in good shape, after an hour or so of being chained in Terry's dungeon, my muscles were screaming for relief. The cuffs pulled evenly on my wrists, and the bandages and the smooth edges of the irons minimized any nerve-pinching effect, but my arms and shoulders were painfully stretched, and my legs were even worse off. I could have stood straight easily, but with my legs forced wide apart, my inner thigh muscles were throbbing. And I was bound so rigidly that there was no way to relieve the stress. I couldn't even lean back against a wall.

Also, by then I really needed to piss. Almost grateful for the distraction, I looked down at the bucket and wondered how I was going to piss into it without being able to aim my cock. Obviously, Terry *wanted* me to make a mess so I'd have to lick it up. In the same perverse spirit, I did my best to disappoint him, releasing my urine in dribbles and brief spurts so it would fall into the bucket instead of in a steady stream that would overshoot and land on the floor. I did pretty well, too — only a few spurts splashed outside the bucket before I got the hang of it. Of course, by the time my bladder was empty, the bucket was a much heavier weight pulling on my balls. I held my silence as long as I could, trying to ride with the pain as he'd told me to, but finally several loud groans escaped me.

Annoyed with myself, I bit my lips and tried to empty my mind, to get some distance from the pain. I willed my arm and shoulder muscles to relax, to go limp in the chains, and visualized my sore legs as tree trunks, strong and solid and unyielding. It helped when music — spooky minor-key New Age noodling on an organ and synthesizers — started playing over concealed speakers, and when Terry finally returned, I wasn't screaming, just hanging there and moaning softly.

I looked up eagerly when I heard the door open. Terry was quite a sight, too, wearing studded leather arm bands, short leather gloves, a soft leather jock that barely held his half-hard dick, the same knee-high black engineer's boots, and a body harness that emphasized his nipples and pecs, the black leather setting off his fair skin. Black, black hair curled on his chest and edged his strong arms and thighs. The black and prematurely gray hair on his head once again stood up in a military-style brush, and the trim moustache under his once-broken nose was equally well disciplined.

Despite my pain, my cock stirred to life as I watched him. He was carrying a couple of bottles of beer. After closing the door and setting the bottles down on the table, he went to the wall behind his chair and opened a large control panel. I was suddenly spotlighted, at the focus of several strong beams. The bright light made me blink, and the contrast made it hard to see what Terry was doing. When my eyes adjusted again, I saw that he was sitting with his legs stretched out on the ottoman, sipping a beer, the very image of a macho stud at his ease, without a care in the world. All he needed was a football game on TV to watch. Instead, he had me.

I'd been composing speeches in my mind, irresistible pleas to be let down, but his sadistic cockiness stiffened my spine — as he probably intended. I gritted my teeth and stood as straight and still as possible, determined to prove I could take whatever he dished out. I kept my eyes either straight out or cast down, like a perfect slaveboy, but whenever I snuck a glance at him he was just sitting there calmly, drinking his beer and watching me, not even smiling.

After a while he got up and walked over to me. He checked the piss bucket, setting it swinging from my balls. I groaned.

"Not bad, boy. Only a couple of small puddles. You can lick 'em up when I let you down . . . if they haven't dried up by then."

I groaned again, louder.

"Got a problem with that, boy?"

The ghost of a grin on his lips promised no mercy. He was enjoying my suffering. *And isn't that what I'm here for?*

"I'm sorry, Sir," I said, "but this really *hurts*. I can't take it much longer, Sir."

"How much longer?" he asked, palpating my aching arms

and legs. This time his touch brought no relief but only triggered spasms. I stifled a scream.

"I asked you a question, dickhead."

"Fifteen minutes, Sir?" I ventured, not wanting to name a period that was too long to take or too short to be credible.

"Thirty minutes," he countered. "You can do it, boy."

He strode back to his oasis and picked up one of the sand-glasses from the table. "Thirty minutes, starting now," he said in a loud voice as he turned it over and set it down again.

Thirty minutes! I'll never make it!

Chained spreadeagle between steel beams, I glared at the sandglass, willing the grains to run faster. Whenever I darted a glance at Terry, he was slouched in his chair, watching me and grinning. Well before the time was up, I was whimpering contin-uously in pain and frustration, my eyes squeezed so tightly shut that I didn't even notice when the sand finally ran out.

Terry detached the piss bucket first, then freed my legs and helped me stand straight, and only then freed my arms. Rather than unlock the cuffs themselves from my ankles and wrists, he simply removed the chains between them and unhooked the oth-er chains from the pillars. I was so weak that when he unhooked the chain from my left wrist I started to sway, about to collapse, but he held the chain taut as he walked toward me until he could put my left arm around his shoulders and grab my waist. He guid-ed me a few steps to the right and lowered me slowly to my knees, then stepped away to unhook the last chain. Before he returned, I'd fallen flat on the floor. My arms and legs were dead meat. Ter-ry knelt beside me and massaged my limbs until I gasped from the pins and needles of returning circulation.

"Good boy," he said, stroking me gently. "You handled that better than a lot of guys. You'll be okay soon. Can you get up?"

As I struggled back up to my knees, the butt plug, which I'd almost forgotten, shifted inside my ass. When Terry hugged me close, tears overflowed my eyes and fell onto his chest. When I noticed, I frantically licked at my mess. He chuckled but didn't stop me. He kept his arms loosely around me until I stopped cry-ing, then firmly turned me around.

"A little unfinished business, dickhead," he said, pointing to the puddles of cold piss on the floor. My stomach heaved at the thought of licking them up, but his tone was uncompromis-

ing. I crawled over and bent my face to the slate flooring. The first tongueful was almost tasteless — and the floor was clean — so I was able to make short work of the rest.

"Looks like you enjoyed that, boy," Terry laughed. "Want some more?" I turned back to him and, smiling weakly, shook my head no.

Kneeling behind me, he doubled the chains attached to my leg cuffs and used the carabiners still attached to them to connect each one both to its own and the opposite cuff. The result was that the cuffs were connected by four equal lengths of chain about a foot and half long. I wouldn't be running any marathons with that setup.

"Stand up, slaveboy," he ordered, helping me, and when we were both on our feet he refastened the manacles in front of me the same way. They were a little lighter than the leg irons, but I could still barely lift my hands, and I sounded like a machine shop every time I took a step. His handling had pumped my cock erect again, of course, even though the heavy metal doughnut still pressed my aching, swollen balls down into their sac.

Terry slowly walked me across the room, detouring around the piss pool, and up the steps to the platform and over to his oasis. He shoved the ottoman aside and pushed me to my knees in front of his chair, where I crouched with my head bowed as he went to the control panel to shut off the spotlights and change the music. His kinder treatment after the torture he'd just put me through was sending me deep into an altered state in which submission and subservience ceased being a struggle and became as easy and natural as breathing. I was glad I'd pleased him, at whatever cost to myself, and eager to do anything he asked.

"Kneel up, boy," he said after he came back and sat down with his legs on either side of me. "Drink this," he added when I was upright, handing me a beer. "You probably need it."

"Thank you, Sir," I replied and swallowed a few mouthfuls.

"Relax, Matt," he said, smiling warmly. "Turn around and sit close to me."

"Thank you, Sir."

I twisted around between his outstretched legs and lowered my butt to the carpet. I eyed his high boots hungrily as I extended my own legs and leaned back against the front of his chair — much as I wanted to get down on them, I wouldn't make a move

without permission, or orders. I took a deep breath and exhaled, letting all the tension flow out of me.

Terry pulled my head onto his right thigh, stroked my hair, and rested his left hand on my shoulder. I felt as if warmth and ease were pouring from his hands into my body. I tried to kiss his left hand but couldn't reach it. Seeing my attempt, Terry lifted it to my mouth, and I pressed my lips to his leathered palm. He held it over my mouth and nose for a moment, making me breathe in the leather smell, then clamped it tight until I was struggling for air. When he'd made his point, he drew his hand back and gave me a couple of fingers to suck. After he pulled them out, he wiped them dry in my hair.

Pain faded from my limbs, replaced with a pleasant lassitude. Sitting down relieved most of the pressure from the steel doughnut on my balls, and my cock lay relaxed over them, filled out but not hard. The weight of my chains, too, was no burden as long as I sat still, just when I raised the beer to my lips. I sipped it slowly and finally set the bottle aside.

We sat there quietly and let the music wash over us — soft, romantic jazz piano, complex enough to repay close listening yet not demanding it. My head drooped, tightening the collar around my neck, and my eyes rested in the intricate pattern of the carpet between my legs. I don't know what Terry was looking at — maybe down at me; he ruffled my hair from time to time. I was aware, of course, that his leather-encased cock was just behind my head, but I was content to wait for him to give it to me.

It was so pleasant just to sit at his feet and let my thoughts drift, though they soon returned to familiar themes.

Is this what it would mean to be his slave, I wondered, *suffering and then being comforted, over and over again? How much of that can I take? Will it get easier as we go on, or harder? Will he push me further and further until I barely recognize myself in the adoring, brainwashed slave he's turned me into? . . . "Brainwashed"? That's a hell of a note! He loves me! And I love him, and I want to be his. If he trains me to serve him the way he likes, is that "brainwashing"?*

"I hear gears whirring, Matt. What are you thinking?" Terry asked finally, scattering my thoughts by rubbing the heel of his right boot against my cock. He kept it there while we talked, the hard rubber resting lightly on the base of my cock, which stiffened in response to the amalgam of affection and menace.

"Oh, just trying to understand my feelings, Sir," I told him.

"Which feelings?" He wasn't going to let me off with an easy, vague answer.

"Feelings about you, Sir. About being your slave."

"And?"

"I guess I have mixed feelings about it, Sir. Just thinking about belonging to you, Sir, or hearing you call me your slave, usually makes me excited and happy. But sometimes the idea of being a 'slave' seems so distant from me — something alien and incomprehensible, unreal."

"I'm not surprised. A month ago I'd have said, despite Jake's opinion, that there was no way you could ever be a slave. But a month ago I would have said I didn't *want* another slave."

"Excuse me, Sir, but that's exactly what you did say to me!"

"You've got me there, boy," he chuckled. "But it only proves my point: we've both come a long way in terms of admitting what we want. That doesn't mean it's not still hard. We can't ignore our history. With me it's my failure with Philip: I'm afraid of failing again. Even after Jake's training, even with years of success as a top, I'm not totally sure that I can be the kind of Master who inspires loyalty and trust instead of rebellion and resentment."

"I don't understand, Sir. You certainly inspire them in me!"

"It's only been a month, Matt, since our first session, and we haven't spent very much time alone together. It's a very tricky dance I want to lead you in, and sometimes I feel like I have two left feet. I lose my temper too often, I push too hard sometimes, I let my eagerness to try new things override your need for a firm foundation. Does that make it clearer?"

"Not entirely, Sir. Does Master Jake expect you to be perfect? I don't! Then you'd demand the same thing of me, Sir, and no way can I be a perfect slave all the time. You'll have to settle for a really good one!"

He laughed out loud and knuckled my head.

"That's exactly the kind of thing I mean, Matt — your sassy style. I don't want you ever to lose it. But you need to learn when it's appropriate. Can I discipline and train you without breaking your spirit? I don't want to turn you into a robot. I like your personality as it is. But I do expect you to learn to put my needs and wishes ahead of your own. Do you think you can?"

"I hope so, Sir."

"So do I, but it's more my responsibility than yours to make it happen. It's a Master's job to help a slave fulfill himself in service, and that sometimes means the Master's immediate desires don't get gratified because he's focused on training or preparing his slave for the future."

"Like not giving me your cum or piss too soon, Sir?"

"That's part of it, sure, though safer sex isn't just for Masters and slaves! Probably a better example is just taking the time for these little talks of ours. We do have the damnedest conversations, Matt! Sometimes I want to stick a gag in you, or my cock, to shut you up with your questions and doubts. But I know you need to understand what we're doing."

"Thank you, Sir."

"No thanks necessary — I enjoy our talks, too. They help me get clearer about my own feelings and desires as well as your needs. Knowing what's best for both of us in the long run isn't easy, and sticking to it when the old animal brain is telling me to do something different — like slap you silly or fuck the shit out of you — is even harder."

"But you did slap me silly just a while ago, Sir. You haven't fucked me tonight, though."

"I will, boy! Never fear! But what I meant is that I won't smack you around in anger, like an abusive spouse. That little scene we had earlier tonight, before I left you alone to stew in your bondage, was tightly controlled. I knew exactly how far I wanted to take you. I disciplined myself not to get carried away and damage you. Understand the difference?"

"Yes, Sir."

"Control, beginning with self-control — that's the heart of mastery. And it's as hard as it is satisfying to achieve it. I think that's why the kind of exaggerated slave discipline some Masters insist on is so seductive. Controlling someone whose personality has had all the edges sanded off is a lot easier than controlling someone real — someone like you."

"Hmm You mean, Sir, that you want me to serve you to the fullest extent, but in my own way?"

"Bingo! I knew you were a smart boy." I could *hear* the grin in his voice even without turning my head to look up at him. "Now, just what do I have to do," he continued, "to help you become the slave you want to be and can be?"

"I don't know, Sir. Whatever you're doing seems to be on the right track."

"I sure hope so, boy, because I'd hate to have to go back to square one with you and start again. Remember that I said we can't ignore our history?"

"Yes, Sir."

"Well, just as mine has made me afraid of failing again, yours has made you afraid of letting go all the way, of letting down your guard and really trusting a top or Master. Your last five years of whoring around are probably just a symptom, not the cause. I think the real cause is that you haven't quite forgiven Greg for dying on you right when you were discovering what you needed."

For an instant I hated him for saying that, for dragging my dead lover into the discussion. And then I realized, in a shattering moment of insight, that he was right. I sat there as if in a trance, transfixed by memories of Greg's discovering my submissive streak, teasing it out of me, becoming more and more openly dominant in our relationship, addicting me to his control — and then weakening in his illness, becoming dependent instead of strong, needy instead of commanding, helpless instead of controlling, finally fading and then dying, leaving me untrained, confused, not really knowing what I was, what we might have been together. Terry stroked my head gently as hot tears streamed down my face.

"It's okay, Matt. Go ahead and cry if it helps. Let him go. Forgive him. Forgive yourself for not being able to save him."

My body shook with sobs, and I rocked back and forth between his legs, my chained hands clutching his boots for reassurance. The pain of reliving Greg's death was blinding at first, but the more I cried, the easier it was to bear. It was like when a spring thaw cracks open an ice-locked river, allowing it to run wild and free once again.

When I'd subsided to mild sniffling, Terry produced some tissues from a drawer in the table beside him. *Always prepared! They'd have loved him in Scouts.* As I blew and wiped my nose, my self-knowledge seemed to have become crystal clear, as if I could read it off a page:

No wonder I became a pushy bottom and a slut. I was looking for a man to take me down, to make me his boy. I was challenging

every top I played with to finish what Greg had started. Only they weren't Greg, and they never knew what game I was playing. I never told them — I never told myself, because I didn't know. I thought I was a sensation seeker, that all I wanted were the thrills of pain and restraint, when all the time what I needed was to be owned, *to belong to someone who'd love me enough to train me and keep me.... Have I found him finally?*

"Get on your knees, Matt," Terry said quietly. "My boots need your attention, boy. Clear all that other stuff out of your head and get down where you belong."

His tone was firm but kind. He wasn't trying to humiliate me but to throw me a life-raft, something familiar and comfortable and sexy and easy. I felt a surge of gratitude as I twisted myself around and onto my knees, facing his left boot. I stared at it for several moments. *It's just a boot. Just a leather boot. It doesn't really mean anything . . . does it?*

"I'm waiting, boy," he said patiently. "C'mon, boy. Lick your Master's boots."

Yes! I fell on his boot as if I was starving, slobbering it with kisses, licking it and rubbing my face over the leather, cradling it in my chained hands so I could reach every part of it, even the heel and lug sole, with my mouth. *My Master's boots! I have a Master! I'm really a slave!* I went wild with bootlust. Exhausted from my ordeal spreadeagled between the pillars, still dragging heavy chains on my wrists and ankles, with a collar locked around my neck and a plug stuffing my butt, I felt deliriously happy, free of care, free to ignore everything but the leather under my tongue.

Terry grew larger in my mind as I went down, down, sinking deep into subspace again, diving below my conscious mind and all its judgments to a more primal level. He wasn't just a man: He was *the* Man, Masculinity, the essence of Maleness, everything I had ever craved or envied or admired in other men. Even though he was sitting motionless, passively receiving my worship, his body seemed to vibrate with the reserved energy of Action itself: He was the Doer, the Builder, the Hunter, the Protector, the Taker, the Fucker. *And he owns me! I belong to him, to this wonderful man, this Master!*

I rolled on the carpet at his feet, moving from one boot to the other, trying to give them equal attention with my tongue and lips and hands, lavishing spit and love on the tough but soft

black leather that bound and protected my Master's feet. The butt plug, his surrogate, shifted in my ass as I moved, probing me, reminding me that I was possessed inside and out, that no part of me was exempt from his control or use.

I worked my way up slowly, licking and massaging his powerful calves through the leather, worshipping my Master's legs, loving them, loving him, my eyes overflowing with tears of joy that fell and mingled with my spit, working it into the leather with my tongue and cheeks, into *his* leather, my Master's leather, striving to get as close to him as his boots, envying their intimate contact with his flesh, honoring them, loving him, licking, crying, rubbing my face up along his boots, always upward, up to the root, *his* root, the great cock I ached to worship and take into me.

As I crept toward his knees, close to the tops of his boots, I felt his hands in my hair, holding me, directing me, controlling me, I felt the hands that could hurt me or soothe me equally, however he willed, the hands of my Master, my Owner, my love, my destiny. Slowly he pulled me toward him, toward his crotch ... very slowly, letting me lick my full of his hairy thighs, feeling his strength, his firm-muscled flesh under my adoring tongue and lips, his hands twisting in my hair, pulling me along, keeping me on track, on course to his manroot, his glorious cock.

He spread his legs wide, opening for me, pulling me in, mashing my face against his leather jock, letting me feel his great hard cock growing inside it, growing for me, expanding to fill me, to fill my mouth, my throat, my ass. I slathered the leather with my saliva, made it shine. I sucked him, gummed him through the leather, making whimpering hungry noises in the back of my throat because his cock was so close, so very close to my lips, yet still out of reach.

He rubbed my face against the jock, pressed my nose into the snaps — *Yes!* He wanted me to free him, too, to use my mouth to take away the leather keeping him from me. *Yes, Sir! Thank you, Sir!* I pulled off the snaps, pulled away the jock, lunged for his cock as it sprang free — and was pulled back!

He held me just out of reach by his hands tangled in my hair! I reached out my tongue to him, touched his hard cock, but that's all I could do! Mindlessly, I pushed against the force holding me, but he effortlessly held me off, shaking my head, hurting me, punishing my presumption. Finally I stopped dead,

my tongue still hanging out, panting in frustration but obedient to his will.

"My balls, dickhead," he said in a voice like thunder. "Lick and suck my balls."

Eagerly, gratefully, I plunged my face into his scrotum, inhaling the perfume of mansweat mixed with leather, licking, slobbering over his balls, pulling them one by one into my mouth, sucking on them, almost chewing the tough, hairy flesh that enclosed them, rolling them from side to side in my wide-stretched mouth, feeling the hairs with my tongue, swallowing around them, breathing past them, worshipping them, licking and loving him any way he would let me.

When he pulled me off his balls finally, when they slid out of my mouth with an obscene plopping sound, my lips stayed fixed in an open ring of greedy flesh, and my eyes were crossed. He pulled my head back, back until I could see the whole length of his hard, erect cock arching proudly over me, seven inches of thick, delicious manmeat waving tantalizingly above my face. The heart-shaped glans with its wide piss-slit was right in front of my eyes, so close and huge that I could follow every tiny crease in its purple-red surface. As I watched, a drop of precum welled up and formed a glistening pearl at the tip.

"Is that what you want, slaveboy? You want your Master's cock?"

"Oh, yes, Sir! Please, Master! Please let me have it! Please let me suck your beautiful cock, Sir! Let me make you come, Sir!"

He said nothing more, just guided my mouth slowly toward it with his hands clamped on my head . . . so slowly, spearing the ring of my lips with his steel-hard, velvet-soft shaft, pushing it into me, giving me plenty of time to breathe and open my throat but allowing me not the least bit of control, giving me no way to stop the invasion if I wanted to. And I didn't want to! All I wanted at that moment was to feel his cock sliding into me all the way down to my belly. I opened wide, and he slid right in, over my tongue, past the back of my throat, and down my gullet as neatly as docking a shuttle at a space station. I didn't even *think* about gagging, I wanted him so badly.

My eyes glanced up and caught his for a moment as his dick rested there in my throat. His eyes were hard and bright, concentrated, completely absorbed in the sight of his hard cock

impaling my face. I closed mine and held still, wishing I didn't have to breathe at all, wishing I could hold him in me all night, forever. But he knew I couldn't, and he pulled me off him, slowly again, let me catch my breath, and then rammed back into me. He kept up that rhythm for a while . . . *out slow, in fast, out slow, in fast,* and then he reversed it — *in slow, out fast, in slow, out fast.* I managed to keep up with him either way, we were so perfectly in sync.

Terry kept his cock in my mouth as he stood up from his chair, pulling me with him. I felt the butt plug shift in me again as I moved, another sign of his possession, of his ownership and control. My own cock was hard and dripping (not that this mattered) as my Master, standing tall over me, over his slave, his beloved toy, continued to fuck my face. The rhythm became ragged only when he was close to coming. He kept fucking me and fucking me, driving me out of my mind with lust and love for him, driving out all other thoughts but thoughts of him and his joy in using me. For the first time he was fucking my face without a rubber, and I didn't care, I was so greedy for his cum. But *he* cared, and he stayed in control.

"Close your eyes and mouth, boy!" he ordered as he pulled out of my mouth. Moments later he trumpeted his release with shouts that echoed around the dungeon as wads of scalding cum — one, two, three, more! — landed on my eager, upturned face.

"*Ahhhh!*" he sighed a few moments later, and then, "You can look now, slaveboy."

He was grinning down at me, his cock hanging fat and loose from his jock, softer but not much smaller than when it was erect. He tousled my hair and sat down again in his chair, slouching lazily with his arms hanging over the sides, his eyes closed and a smile dancing on his lips. I sank down on my heels in front of him, holding still to watch over his rest as he had watched my torment. The sharp smell of his cum drying on my face filled my brain.

"You're a mess, boy," he said with a grin when he opened his eyes again. "C'mere."

I slid closer to him on my knees, lowering my eyes respectfully even though he was now only a man, not *the* Man, because he was still my Master. My earlier wild hunger for his boots and his body seemed sated, as if it wasn't only him who'd gotten off.

That's only right, I thought. *I'm here to give him pleasure, but his pleasure makes me feel good, too.*

"Now, tell me, slaveboy," Terry said as he smeared his cum around my face and into my hair, "how are you feeling? Still weepy and sad? Still confused?"

"No, Sir! I feel great, Sir. Thank you . . . Master." The word still felt strange on my lips, however much I might have called him that in my mind.

"Tired, boy?"

"Yes, Master."

"So am I, boy." He yawned widely, then grinned. "It's very late. Time to get you bedded down for what's left of the night." He stood up and motioned for me to do the same. "C'mon, boy. You're going to like this."

He turned me around and led me off the platform toward the piss pool. My chains clattered on the floor and dragged down my tired arms. Even the thought of spending the night lying in my own piss seemed good to me — as long as I could lie down. When we reached the edge of the black circle Terry stopped me, bent me over, and worked the butt plug out of my ass. I had enjoyed its stimulus of my prostate, but it was a relief to be free of it.

"Hmm, there's no shit on this, boy," he said after examining the condom-covered plug. "I guess you don't need to take a dump tonight."

"No, Sir. Thank you, Sir."

"That simplifies things. Go sit down in the middle there," he said, pointing toward the drain at the center of the pool, "unclip your chains and lie on your back while I get rid of this."

He walked off as I moved onto the matte-black surface. To my surprise, it yielded slightly under my boots. I picked my way gingerly until I reached the center and sat down. When I could feel the surface, I realized the pool was lined with solid rubber. While not nearly as soft as a mattress, it was a lot softer than the slate floor! It also felt warmer than I expected.

I unclipped the four-ply chains between my wrist and ankle cuffs, so there was just a single long chain hanging from each cuff, and lay on my back with my ass just above the drain, my feet pointed toward the door of the dungeon and his oasis. Even if I stretched out my arms and legs as when I was bound upright, I still couldn't reach the ringplates around the rim of the pool.

The noise of the chains as I shifted position was somewhat muffled by the mass of rubber. I didn't try to anticipate how Terry would restrain me but lay comfortably with my arms down, not far from my sides, and my legs only a couple of feet apart.

"That how you want to spend the night, slave?"

I looked up and saw Terry standing behind me, looking down with a half-grin, his cock still hanging out.

"However you please, Sir," I said.

"I think I'd rather you were a little less comfortable," he said. "Move your legs apart a little more and stretch your arms straight out to the sides — yeah, that's it, boy."

He squatted down at my right side, snagged the chain from my arm, and clipped it to the nearest anchor ring. He didn't pull the chain tight, leaving me half a foot or so of slack. My other limbs were quickly secured in the same way, and by the time he finished my cock was standing straight up, hard as steel and leaking precum. Terry laughed when he noticed it.

"You like this, eh? Can't ever get enough, can you? That's good, slaveboy, because I can't get enough either."

He sat down behind me with my head in his crotch, his booted legs stretched out across my arms. I could smell his man-stink, and if I turned my head I could take his cock in my mouth. I looked up at him, mutely asking permission.

"Go ahead, boy," he said. "Just nurse on it gently while I enjoy looking at you."

I drew the spongy mass of his cockhead into me and licked and suckled at it while he talked. (There was no taste of cum, so he must have washed it.) It felt so *right* to be lying there in chains, nursing on his cock. He seemed to like it, too, because he slowly grew harder in my mouth, his cock stirring and jerking as blood filled its reservoirs. I had to turn my head further to the side to keep hold of it.

"God, I wish I could keep you here all the time, boy! Just chain you up and leave you until I'm ready to fuck you again, or piss on you or smack you around. I'd go about my life upstairs, working or cooking or resting, all the while knowing you were down here, helpless, eager to take anything, to *do* anything if I'd only come back and relieve your loneliness and boredom.

"You'd be my fucktoy," he went on, growing more excited as he developed the theme — and his cock kept getting harder,

too. "You'd be my bondage mannequin, my personal piss bucket. You'd like that, wouldn't you, dickhead? Nowhere to go, nothing to do but hang around and wait for your Master to pay some attention to you. No responsibilities or worries. Heavy metal cuffs on your wrists and ankles and neck all the time, day after day, month after month, always chained to something, never able to move without an extra effort, if I let you move at all. You'd get so you'd feel like something was missing if I ever took 'em off you! But I'd only do that to put you in something else, strap you in a sleepsack or straitjacket, or weave you into my spiderweb of rope. Just to keep things interesting, to keep you — or me — from getting bored.

"You'd work your way through every bondage device I have, spend time in each cage, suffer every possible position. The different sections of my dungeon would become your stations of the cross — and every bit as painful, too. Eventually you'd be so familiar with every inch of this place you wouldn't even need to see it. I could lock a hood on you and never take it off. You'd have to imagine what I looked like. So what do you think, boy? Is that what you want?"

I let his hard cock slip out of my mouth so I could answer. The vague, unformed reservations I'd felt earlier burst to the surface of my mind again, suddenly clarified. Even though my cock was hard, too, I felt compelled to give him an honest, realistic answer rather than playing along.

"It's a hot fantasy, Sir," I told him, "and I hope this weekend will be something like that. I do like being chained up and played with, Sir, you know that, and I'd love to work my way through all your bondage stations. Being your prisoner or piss-bucket or whatever you want would be great, Sir — for a while. But not as a total diet, Sir. If you made me into nothing but your toy, Sir, I think you'd get bored with me pretty quickly. Unless I have a real life, Sir, how much is my submission to you really worth? If you take everything away from me, Sir, what do I have to give you?"

"Isn't that the idea of real slavery, boy? Once I own you, you *can't* give me anything more — I'll have it all. All that's left is for me to enjoy it. Whether *you* enjoy it or not won't matter."

"I hope you don't really mean that, Sir," I said. "That's not the way you talked before, Sir. You told me slavery was a way for

two people to love each other. How could I love you, Sir, if I was no longer able to see you or touch you? How could you love me, Sir, if you really considered me just a thing and not a person? I want to *serve* you, Sir, and that means being with you, seeing you, touching you — not being locked away, out of sight, most of the time. I want to share your life, Sir, not just your fantasies. I want to belong to you out in the real world, Sir, not just down here, in your private fantasy world."

"And you think that's possible for you, Matt? To be my slave in more than fantasy?"

"I sure hope so, Sir! I want to be there for you when you're tired, Sir, or sad, or just need a hand or a kind word. I want to do what you tell me even when there isn't a single chain on me."

"Well, we'll see," he said, getting to his feet. His flat tone was hard to interpret. *Is he disappointed in me? Skeptical?* "We'll talk more later. For tonight, or what little is left of it, I want to enjoy my fantasy! And it wouldn't be complete if I didn't leave you stinking of piss. Close your eyes, boy."

He drenched my head first, washing his dried cum off my face and filling my open mouth, then thoroughly soaking my hair. The taste and smell were strong — a single beer was hardly enough to dilute his piss — but it felt right to take it.

His bootsteps moved around me, and the warm stream hit my chest next, skipping my neck and shoulders. I opened my eyes a slit after it had played across my nipples and moved on down to my crotch, surreptitiously watching him soak my cock and shaved pubes. I loved how he looked pissing on me, and I loved how it felt. If it hadn't been for the doubts his fantasy had raised, I would have been completely turned on. As it was, I was still more than half hard when he ran out of piss partway down my left leg. The runoff gurgled down the drain, leaving only its smell behind.

"And what do you say, slave? Did you enjoy your Master's piss? You can open your eyes."

"Yes, Sir! Thank you, Master! Your piss felt and tasted wonderful, Master!"

"You're welcome, boy. Happy to oblige. Y'know, I once considered rigging up pipes so I could piss anywhere in the house and it would pour onto whoever I had chained here. But it was too damned complicated, and I was sure the building inspector

would never buy the explanation that it was a backup system if the sewer lines got clogged." He was grinning again. Whatever cloud had passed between us earlier was gone now.

"Whenever you need to piss, boy, just let it rip. It'll find its way down the drain eventually, long as your ass isn't covering it. Want some plain water before I leave you?"

"Please, Sir, yes."

It'd been a long night, and despite the beer and the mouthful of piss, I was thirsty. Terry did things with the valves at the side of the pool until he had a small flow of cool water from one of the hoses — it ran along my side on its way to the drain. He brought the hose to my mouth, filling it, and took it away until I'd swallowed, repeating this several times.

"Thank you, Sir, that's enough," I told him finally.

"Goodnight, boy. I hope you're not afraid of the dark."

"No, Sir. Goodnight, Master — sleep well."

He gave me a sharp look, as if suspecting me of sarcasm, then grinned and walked back to the platform. At the control panel he turned off all the lights except one by the door, and after he closed it behind him, that light went off, too. Terry's fabulous dungeon, and his new prisoner/slave, were drowned in total darkness.

Considering the sheer strangeness of my situation, it's a wonder I *wasn't* afraid of the dark. But the uniform blackness was somehow comforting in a way that dimness and shadows would not have been. I might as well have been tightly hooded — if I'd been able to hold my hand in front of my face, I wouldn't have been able to see it.

The silence wasn't quite as total as the darkness. I could hear the soft whoosh of air through ventilation ducts, an occasional gurgle from the plumbing, and even, I imagined, faint sounds of Terry's bootsteps from somewhere overhead. That was probably a delusion, as the house's ground-floor rooms were all outside the walls of the dungeon. *He'd have to be taking a stroll in his winter-garden in the middle of the night for me to hear him down here*, I told myself.

I wasn't in pain or distress, but I wasn't really comfortable, either. Despite my love of bondage, I'd have preferred to be sharing Terry's bed. *If this is what he wants, though, it's fine — I can take it.* I squirmed around a bit, testing the slack he'd left me, but

it was more of a tease than anything else: my body wanted to curl into a fetal position, and the chains wouldn't allow it. I'd have to sleep flat on my back with my arms and legs spread, or not at all.

I lay there staring into the darkness for some time, thinking about what I'd gotten myself into, wondering what it would be like to live at the mercy of Terry's obsessions. I wasn't afraid, exactly, just worried that I'd made the right choice in surrendering to him so completely. Of course, I had no idea then how much further in surrender I still had to go! I thought I was a slave already — in truth, I'd barely taken the first steps. The doubts I was mulling over should have been proof enough of that.

Eventually, exhaustion left me no choice, and I slept, fitfully — waking every time I tried to roll over and the chains stopped me, but I did sleep. And when a full bladder woke me some hours later, I followed orders and let my piss pour out onto the rubber surface I lay on. It felt warm, then cold as it pooled underneath my thighs, but I was asleep again before it all gurgled down the drain.

CHAPTER 24
A day in the dungeon

I woke with a start, disoriented, from a vivid dream when the dungeon door slammed (I'd been in Terry's arms, sucking his left nipple, while he affectionately stroked me and squeezed my ass). The lights on the pillars around me were already on, just as they'd been the night before. It took a moment to recall where I was, and I had no sense of the time — it could have been morning, high noon, or evening again for all I'd know.

Terry's bootsteps were loud on the slate floor as he walked toward me. I raised my head a little to see him, and the sight made my cock rise, too. Dressed in a summer-weight CHP motorcycle patrol uniform, though without the jacket, gunbelt, or helmet, he seemed fresh and chipper. The crisply tailored tan riding breeches hugged his thighs and ass, and on his legs were the gleaming Dehner boots I'd briefly worshipped in our jail-cell scene a month earlier. The short-sleeve shirt exposed his hairy forearms, but his hands were covered in short, skintight gloves, and a pair of mirrored sunglasses hung from his shirt pocket.

"Morning, boy," he said when he reached the piss pool and looked down at me. "Though it's almost afternoon. I don't often sleep this late, but you wore me out last night." (*I wore* him *out?*) "How'd you sleep?"

"Fine, Sir, thank you. And you, Master?"

"Like a log, boy," he said, his lopsided grin just short of an all-out smile, "and thinking of you chained down here gave me happy dreams. But I woke up having to piss something awful. I saved most of it for you, though."

Without ceremony, he unzipped and pulled his cock out, aimed it at my crotch, and let fly.

372

"*Ahhh . . . ,*" he said as the hot, yellow piss drenched my flagpole cock, bare pubes, and tight naked balls — sometime during the night they'd shrunk enough that the steel doughnut had slid off. Terry slowly moved the stream toward my face, shutting off the flow when he reached my chest and walking around behind my head before letting fly again. I opened wide, closing just my eyes. His bittersweet piss quickly filled my mouth, and I swallowed as fast as I could to make room for more. I didn't think about whether it was exciting or humiliating or sexy or disgusting. I just did it, as automatic as breathing. Terry soaked my face and hair, too, before his bladder was emptied.

"Thank you, Master," I said when I felt the flow stop, keeping my eyes shut tight.

"Good boy," he said. "Now I'm going to wash you off and go eat my breakfast while it's hot. I'll save you some for later."

I lay still — not that I had much choice! — with my eyes shut while he uncoiled the hose beside the pool, but yelped involuntarily when cold water hit my groin, instantly shriveling my hard cock down to a stub. I bit off any complaint as he sprayed me from head to calves, sparing only my boots. The leather collar he'd had made for me was now damp — seasoned? — with both piss and water.

I opened my eyes to watch him as he walked back toward his oasis, cold water still trickling off my body. His body language was jaunty, self-satisfied. *Does he expect me to be turned on by this kind of treatment? Am I? Not exactly*, I decided, *but I'm also not reacting the way I might have two months ago, or with someone else. I'm not altogether turned* off, *either. I accept it and wait for his mood to change. But is stoic acceptance enough for a slave? Shouldn't I be* glad *to be treated harshly if* he *enjoys it? Isn't it my duty to want whatever he wants? If so, being his slave may be more than I can do!*

I looked up and saw him, sitting in his black wooden armchair, serve himself from a tray he'd brought in. Since I don't like to eat so soon after waking anyway, I didn't feel any resentment, let alone anger, at being made to wait for my own meal — I just wished he'd let me *serve* him. Lying back on my rubber bed, still loosely spreadeagled by heavy chains, I tried without much success to take pleasure in my position — *I hope not a permanent one* — as a sextoy to be parked out of the way until wanted. At least the warm air in the dungeon was drying me off.

It was probably no more than half an hour before Terry finished his breakfast and came back to unlock my chains from the anchors around the piss pool. He gave me a towel to dry any part of my body that was still damp. I kept an eye on him for further instructions and at a gesture stepped out of the rubber circle onto the slate floor beside him. I would have gone to my knees, but he shook his head and turned me around, facing away from him, so he could adjust my chains to his liking.

Once again, he doubled over my wrist chains and locked the middle of each one to the opposite cuff, the end to its own cuff, but this time behind my back. He attached a long chain to the front of my collar with a large padlock, but he didn't click it shut yet. He threaded the chain under my right arm, looped it around the center of the wrist chains, and pulled it to the front again under my other arm, then up across my chest and over my right shoulder, under the arm chains (pulling them higher on my back) and over my left shoulder, down across, through, and up again, finally locking both ends of the chain to the same ring on my collar. The result was a kind of harness that pulled my hands in toward the small of my back and pushed my elbows out. The chains pulled tight across my pecs, but there was no pressure against my throat. My cock, naturally, was hard again.

Terry turned me around, grabbed my balls, and squeezed lightly. I closed my eyes and opened my legs wider, bracing for more ball torture. I wasn't *asking* for it, but if it's what he wanted, I'd make it as convenient for him as I could. All he did, however, was twist them a little and slap my cock after he let go.

"You never get enough, do you, boy?"

"No, Sir," I said, half proudly and half sheepishly. "I guess not, Master."

"You're going to get plenty this weekend, believe me."

He pulled a leather cock-and-ball harness off a belt loop and strapped it on me. The tight ring of thick leather at the base of my cock stiffened it even more, the wide band above my balls pushed them down into the sac, and the narrow strip in between tightened them so they looked like a pair of purple plums.

There was a D-ring on the back of the stretcher band, and to this Terry padlocked the ends of my leg chains, pulling them up off the floor. I had to stand with my legs close together so the chains could reach my balls. I could walk now without so much

clatter, but I'd have to take short steps or I'd yank on my balls. Just the weight of the chains was painful enough without that.

"I'm sure you need to take a dump by now, boy, so get over to the throne," Terry said, pointing me toward the wall that had been behind my back when I was chained between the pillars. Next to a large utility sink and a shower stall enclosed with glass reinforced by wire mesh, a steel toilet jutted nakedly from the concrete. *Prison-grade furnishings?* I wondered. Terry smacked my butt to hurry me, and I shuffled over as fast as I could without ripping my balls off.

Gingerly, I sat down on the rim of the cold steel bowl — no such amenity as a seat was provided. The chains between my balls and feet pulled tight over the edge of the bowl, angling my cock straight up. No way could I piss like that, so I got up again and stood in front of the bowl. Eventually my cock softened and a stream of piss hit the water. I aimed by flexing my abs and butt, since I was sure I'd have to lick up any I got on the floor.

When I finished peeing, I sat down again and tried to relax enough to shit. I saw that Terry had returned to his oasis and was calmly sipping coffee, watching me over the rim of his cup. *He's seen everything else I have, so why* not *watch me take a dump?* But it was still embarrassing to be so exposed and helpless.

"Let me know when you're done, boy," he called out.

Several minutes later, I called back, "Sir, I'm done, but how can I clean myself?"

"Wait there and I'll clean you, dickhead," he replied.

I felt my face flame red — I couldn't remember the last time anyone else had wiped my shitty ass. I shouldn't have been surprised, however. Terry was just reminding me of my dependence on him — and my complete accessibility. At least while I was in his house, I could keep no secrets, preserve no personal privacy. My dignity was at his disposal. *Will it always be like this, even when I'm back home? Can I handle that?*

"Stand up and turn around," he said when he reached me — after making me wait another five minutes.

He bent me over the edge of the sink and wiped me with dry toilet paper, discarded it, then wet some more and cleaned my crack thoroughly. He discarded that, too, and flushed the toilet. Finally, he stuck a bare finger up my unlubed asshole and probed around. Shameless now under his hands, I threw a rod again.

"Clean as a whistle, boy," he said, and sharply smacked each asscheek. "Stand over here while I wash my hands, and then I'll give you some breakfast."

After Terry had washed and dried himself, and put his gloves back on, he led me over to his oasis, using the chain crossing my left pec as a handle. It was a slow journey, because I had to take small steps to spare my balls, but he seemed to be in no rush.

Eventually we climbed up to the platform and walked over to his chair, where he pushed me to my knees. I sighed in relief as the floor took most of the weight of the chains attached to my balls. I smelled food from the direction of the low table, which held a tray with the remains of his breakfast and one dish still covered. He moved all but that dish off the tray and set it down on the floor in front of me — to protect the carpet, I suppose — then removed the cover, revealing a wide, shallow bowl holding a heap of scrambled eggs, with bacon and toast on the side.

Terry sat down in his chair, his booted legs crossed at ease in front of him, slightly off to the side to avoid the food tray. The delicious smells set my stomach to growling, but I hesitated, hoping he wouldn't make me eat like a dog. No such luck.

"Go ahead, boy," he urged me. "Aren't you hungry? Don't you like my cooking anymore?"

I would have looked daggers at him if I'd dared, but gave up and bent my face into the food dish. I scooped up pieces of egg with my tongue, dropping as much as I got into my mouth. When I picked up a strip of bacon with my teeth, as soon as I bit a piece off the rest fell back into the bowl. The same happened with the toast. I felt my face flaming in embarrassment again, but my traitor cock was hard. *How can I be enjoying this?*

The food *was* delicious, of course, if only lukewarm by then. Its taste wasn't impaired at all by my savage manner of eating it. Despite all I was getting on my face, or dropping on the tray, the food reaching my stomach was very satisfying. After a while, I felt less embarrassed. Terry wasn't actually laughing at me — just grinning devilishly — and I began to *consciously* enjoy eating like an animal. It was certainly more fun than "civilized" behavior!

Growling, I shook the toast in my teeth to tear off a piece, then crunched the crisp bacon as if gnawing bones, and when I'd eaten all the large pieces of egg, I licked the bowl clean without shame and chased the pieces that had fallen around it. By

the time I finished and sat up, I was grinning, too, and licking my chops. I wasn't sure if I should say, "Thank you, Sir," or bark!

Terry smiled broadly. "Good dog," he said and patted my head. He turned away and picked up the coffeepot from the table, then poured from it into another bowl, smaller than the food dish, and set that in front of me. I didn't hesitate this time but immediately stuck my tongue into the bowl and lapped. It *was* coffee — strong, black, and sweet, still hot but not scalding.

I lapped and slurped eagerly, soon getting the hang of drinking with my mouth open. When I'd finished the bowl, I sat up again and let my tongue hang out of my mouth like a dog's. Still smiling, Terry wiped my dirty face with a napkin, removing the traces of grease and coffee.

"Come and sit in front of me," he said, shoving the tray aside with his boot. I shuffled on my knees and settled between his legs, looking up at him. He nudged my hard cock with the toe of his boot. "Enjoy your breakfast, boy?"

"*Woof! Woof!*" I responded.

Terry laughed and called me a "good dog" again. "But that's enough for now! Isn't it fun, though, being an animal?"

"Yes, Master, thank you. It was great once I let go and got into it."

He smiled knowingly, as if to say, *I told you so*, then asked, "Do you want more coffee?"

"Yes, please, Sir."

"We're all out of fresh, but you can have some secondhand."

I licked my lips as he unzipped his fly and pulled out his piss-hard cock. He made no immediate move to give it to me, weighing it in his hand and stroking it slowly while he watched me watching it. This was a momentous occasion: although he'd pissed into my mouth from a distance several times, this would be my first time drinking his piss straight from the source.

"Come on, slave," he said finally. "Get your mouth where it belongs."

I sat up and leaned forward to take his cock in my mouth. It was only semirigid, but I tried to pull it deep into my throat the way he liked it when he fucked my face.

"Don't be greedy, boy," he said sharply. "You're just a toilet now. Hold it gently in your mouth until I'm ready. If you get me hard I won't be able to piss, and that won't make me happy at all."

I folded my lips around the heavy, fleshy tube in my mouth, breathing slowly and not moving my tongue. In a few seconds the stream started, quickly filling my mouth before I could gulp it down. Hot and bittersweet, it wasn't so different from coffee after all. *And maybe I'll even get some cream with it!* I gulped as fast as I could, struggling not to spill any, and gratefully sensed that Terry was adjusting his flow to my capacity.

"*Ahhh,*" he sighed, "that feels real good, boy. . . . Take it, take it all. Show me what a good toilet you are. . . . You wanted this, remember. You begged me to give you my piss. Now show me you can handle it direct from my cock."

The hot stream finally slowed to a trickle. I made no move to lick or suck him, but just let the thick, heavy flesh tube lie in my mouth until he removed it. Then he patted me on the head.

"Good boy. That was very good. What do you say, boy?"

"Thank you, Master," I said softly, not looking up.

He'd told me once that being a piss slave was a heavy trip, and now I knew he was right. I didn't feel *bad,* exactly, but I also couldn't think of myself in quite the same way anymore. Being pissed *on,* even if some of it went in my mouth — that was like a game. Being pissed *in,* like a toilet, and taking a whole bladder's worth — *well, guess I'm really a slave now.* And I felt a stab of guilt for using Stan that way when he *hadn't* asked for it.

"Matt — look at me," Terry's voice pierced through my self-absorption.

Gazing up into his hazel eyes, I saw only love and concern.

"You okay, boy? Is something bothering you?"

"No, Master, not really."

"Don't keep anything back from me! What were you thinking just now? You looked sad."

"Master, I guess I realized what it means to be your slave."

"And that made you sad?"

"No, Sir! Well, maybe a little melancholy, Sir. It was something like losing my virginity, Master — it'll never happen again." I grinned up at him.

"Matt, taking my piss should be something special for you — like it is for me when you do it. You gave me a great deal of pleasure just now, on several levels. I'd hate to think it was an ordeal for you. There are plenty of times I enjoy seeing you suffer for me, but pissing isn't one of them!"

"It was fine, Sir! I'm okay, Master, really. It just hit me that I'd passed a point of no return, Sir, taking your piss like that, and it shook me for a moment. I'm *glad* it happened, Sir. And I'll be glad to be your piss bucket anytime in the future, Master."

"Good boy! Now here's something to clean your palate."

He held a glass to my mouth of what looked like — and was — orange juice. It tasted ambrosial, and I drank it all down gratefully. When I was done, he wiped my mouth again.

"Thank you, Master!"

"My boots need attention, boy."

I didn't need more direction than that. My cock sprang rigidly to life as I scrambled onto my knees and then bent my head to his left boot, kissed the toe tenderly, and started licking. The leather smell filled my nostrils as I lapped the polished toe and heel. I knew the gleaming shaft was synthetic, as in all Dehners, but it felt like patent leather to my tongue. I ignored the pains in my knees, back, arms, neck, and balls as I lost myself in worshipping my Master's boots. Especially *these* boots.

"That's enough," he said when I reached the top of the boot. "Do the other one now."

As I moved over to his right boot, I heard a slight swoosh. Looking up, I saw that he'd pulled his wide uniform belt off, doubled it, and was now tapping it on his knee. Nervously, I returned to my boot worship. Sure enough, once I was bent over his boot again, he smacked me on the ass with it. A small yelp escaped me, though it wasn't a terribly hard stroke.

"Keep on licking, slaveboy. I'm only warming up your ass."

Smack! Whack! He worked his way over my ass with moderate slaps from the belt, light enough not to raise welts but heavy enough to bring the blood to the surface and suffuse both cheeks with a pleasant warmth. I was certainly enjoying it, and Terry appeared to be satisfied by my squirming and moaning when he reached down to rub and knead my ass with his gloved hands.

When I finished his right boot, Terry stood up and dragged me over to the ottoman. He laid my chest across it and started giving my ass and thighs a serious beating with the belt. These strokes raised welts, all right, and they hurt like hell. The chains from my legs pulled at my balls whenever my body jerked in response to his blows. I made a fair amount of noise, but I never begged him to stop. My head was hanging upside down over the

other side of the ottoman, and the tears rolled out of my eyes and across my forehead before falling onto the carpet.

"Do you know why I'm beating you, boy?" Terry asked after several minutes, pausing in his assault on my backside.

"Yes, Sir," I gasped out, "because you enjoy it, Master."

"So do you, boy — don't try and deny it." He prodded my half-hard cock with his boot toe. "But don't think I'm punishing you, either. I'm enjoying this too much, and I want you to enjoy it, too. If I do have to hurt you as a correction, you'll know the difference. Anyway, I could hardly get to sleep last night thinking about your bubblebutt chained down here. I felt I hadn't given it nearly enough attention, so I decided to take care of that as soon as possible today."

Whack! Crack! The beating continued.

"Yes, Sir, thank you, Master," I sobbed.

My mind was in a haze of agony and lust mixed inextricably together. Each blow began as a searing pain and ended as a warmer glow on top of the residual heat from the previous strokes. My ass and thighs must have looked like steak tartare. Finally, Terry wound up with a half-dozen extra-hard slams, then caressed and soothed me with his hands. I wiggled my flaming butt shamelessly under his touch, and soon, inevitably, he started playing with my asshole. I shivered and moaned as the first finger entered me, so smoothly he must have put some lube on it, and then the second and the third. I was wide open and ready. I *wanted* him to take me, to fuck me so I'd feel it for a week.

Terry stood up and walked around in front of me, but before I could beg him to fuck me, he seized a fistful of my hair, pulled my head up, and jammed his half-hard, rubbered dick inside my mouth. I licked and drooled over his beautiful cock, feeling it stiffen and grow under my tongue until I could barely hold it. He pulled out and walked back behind my prone, bound body. When I felt him kneel down and find his target, I braced myself. Sure enough, this time he fucked me deep in one lunge, spearing into my shit chute without restraint.

"*Oooff!*" I blurted out, expelling all the air in my lungs in a rush, but it soon turned to "*Ahhh!*" as his cock rubbed over my prostate on his return stroke. There was no pain from his insertion — at least, no pain that could register against the slowly fading pain of the beating. My own cock was rock hard again,

pressed between my belly and the pieced-leather surface of the ottoman. The slight stimulation as my body rocked back and forth above it was enough to start the cum churning in my aching balls, still tightly yoked by chains to my ankles.

"Oh, shit, Sir, that feels so good," I said as he rammed into me again. He held onto me with his hands as he fucked, kneading and squeezing the muscles in my back and arms and sides.

"Your ass feels good to me, too, boy," he said in turn. "It's red and hot, all bruised from my belt, just aching for my dick. That's where my dick belongs, slave, isn't it?"

"Yes, Master!"

It was no mere formula response: I wished he could keep fucking me like this forever. It wasn't just the pleasurable physical sensations — it felt so *right* to have his cock slamming into me.

"You love feeling my cock in your ass, don't you, boy? You need it there, don't you, slave?"

He never stopped fucking or handling my upper body as he interrogated me. He reached underneath me to pull at my nipples, sending jolts of electricity directly to the pleasure center in my brain.

"Yes, Master! . . . *Ahhh*," I moaned, alternating between intelligible replies to his demanding questions and guttural responses to his vigorous rutting.

" 'Yes, Master' *what*, boy? *Tell* me what you need."

"I need your cock pounding into my ass, Master. . . . *Aiiee!* I need you to fuck the shit out of me, Sir. I need to feel your dick filling me up, Master, shooting your hot cum inside me, Sir. . . . *Ooohh!*"

"It'll shoot into a rubber, boy, but you're goin' to get it just the same. Just keep on working that ass for me, come on, show me how much you like the feel of your Master fuckin' you."

He grabbed my pecs and lifted my torso half off the ottoman as he slammed into my hole again. His cock was fully hard now and as thick as it ever got, deliciously filling me with each stroke. He pulled almost all the way out and rammed back in again in a steady rhythm that buzzed my prostate each way.

I was nearly delerious with pleasure, but I retained enough self-possession to keep my hole tight and to push my ass back to meet him. I wished I could be in two places at once so I could hug *him* from the back, lick *his* neck and ears, and gently rub *his*

nipples through the uniform shirt while he rode me. It was too good to last long. Even without those embellishments, soon *he* was the one moaning in wordless ecstasy, and after only a couple more minutes, he screamed and shot into the rubber in my ass.

"Shoot, boy! Shoot now!" he cried, and I went over the edge myself, riding an overtopping wave of pleasure as my cock gushed onto the ottoman.

"*Ahhh*, shit, I'm *com-mmm-ing*, Sir!"

His cock still inside me, Terry lowered his chest to my back, onto my chained arms, and lay there for several minutes until we both stopped shaking and panting. His hot breath blew on my neck, and I sighed contentedly as he tenderly stroked my sweat-soaked hair.

Finally he raised himself, pulled out of my ass, and gave it an affectionate pat. It felt unnaturally loose and empty with his withdrawal, but Terry soon remedied that.

"I bought this new ass plug just for my new slaveboy," he said as he worked a thick rubber phallus, a good deal wider than his own cock, into my hole. "I hope you appreciate it."

"Yes, Sir, thank you, Master!"

My appreciation was sincere enough, but I still grunted as it hit "bottom" inside me. Terry smacked my stuffed and welted ass, eliciting a pained yelp, and pulled me back onto my knees. I gasped as the large plug shifted inside me.

"Look at the mess you made," he said in mock outrage at my cum spill on the ottoman. "Lick it up! All of it!"

I bent my head and slurped at the cooling, sticky puddle until it was gone. The remains on my cock and belly did not go unnoticed, either. Terry wiped as much as he could off with his hand and then, of course, had me lick him clean. I darted glances at his face while I licked his gloved hand, and he had his twisted, mocking grin the whole time. When he pulled the condom off his softening cock, he squeezed the cum out onto my hair, rubbing it around to be sure the aroma would linger. This time, of course, he didn't make me lick his hand clean but wiped it on a napkin from the table, then stuffed his softening cock back into his pants and zipped up his fly.

Over my shoulder, I saw Terry sit down again in his chair, lean back, and stretch out his legs. His shirt was damp with sweat, and there were lube stains around his crotch. I stayed on my

knees by the ottoman, head bowed, waiting for instructions. I felt wonderful and wasted at the same time.

"*Whew!*" Terry said finally. "That was good. In fact, it was terrific! Come sit in front of me again, Matt, so we can talk."

As I shuffled over to him on my knees, I imagined a whistle blowing "time out," but unlike my first night and a day in his house, we didn't need to put our roles aside to move from hot and heavy action to relatively "normal" conversation. *He's always in charge, never relinquishing his control of me for a moment, and that suits me fine, yet the* tone *of our interactions varies quite a bit. Is that the secret to making this work over the long haul?*

Instead of lowering myself to the carpet, I sat back on my heels, minimizing contact between my sore ass and anything else. The new plug shifted inside me again, but I was already more accustomed to it, and the effect was stimulating. My cock stiffened until it was at a jaunty angle between my legs. Terry noticed and grinned at me, then switched to a more serious expression.

"You still had some concerns last night, Matt, when I cut you off. Remember?"

"Yes, Sir. You seemed so turned on by the fantasy of keeping me locked up here indefinitely that I was starting to worry, Sir. You know I love bondage, Sir, but I have a job to get back to — or have you changed your mind about letting me keep my job and my apartment in the city, Sir, so I can be your toy full time?"

"Either you haven't been listening carefully enough, boy," he said, shaking his head, "or I haven't been explaining myself as well as I thought I had — probably both!" He gave me one of his half grins before continuing.

"Do you think I'd have built this place if I didn't have fantasies about confining someone long-term? It's no accident I specialize in prison design as an architect — I've been designing prisons in my head, and on paper, too, since I was a kid. I've always had dreams of taking a guy I liked and keeping him in a cage or cell, constantly available to me, vulnerable to my every whim."

We really are *a pair*, I thought, *recalling my own early confinement fantasies. Should I tell him?*

"But I'm not a fool, Matt, or crazy. I hope you realize that!"

"Yes, Sir, I do. It's just that I have a lot of the same fantasies, Sir, only in reverse, with me as the prisoner, and I was afraid we might get carried away and try to go too far in realizing them."

"You can trust me, boy, to know the difference between real life and fantasy, and where to draw the lines. I know I'll never be able to keep a man locked up for years, let alone 'for life,' in my private prison, but I *have* kept guys here for a week or more. I love going about my work upstairs knowing there's a hot man in my dungeon or jail cell — restrained, maybe suffering, but eager to do whatever I demand, whenever I want.

"I usually put off coming back as long as I can to build the excitement — for both of us. I think of him waiting for me, wondering when I'm coming back, wondering what I'll do to him next. I get off on making guys sweat, imagining how they're feeling, how they look in whatever bondage I've left them in."

"Is that how it felt leaving me here last night, Sir?"

"Yes and no. I did get a kick out of leaving you chained up here, but walking away without you last night was also one of the hardest things I've done. What I *really* wanted was to take you to bed with me . . . to kiss and cuddle, then fuck your hot ass. As I said before, it was hard getting to sleep thinking about your ass, about how good it would have felt to beat and fuck it."

"Why didn't you do it then, Sir?"

"Because I promised you a nonstop bondage weekend, and I intend to deliver," he said with a wide grin. "And because you *need* it, Matt. You need some solitary confinement to get in touch with your true self, and you need to learn what it means to be a slave — to be at someone else's disposal. If I'd treated you more like a lover last night and today, instead of a slave, it would only delay things between us, make it harder for us both to decide if this is what we really want. Does that make sense to you?"

"I think so, Sir. It isn't that I don't *want* to be your slave and your prisoner, Sir. It's just that it's hard to square what we do here with our lives outside, where you're an architect designing real prisons, not pretend ones, and I manage a bookstore. This whole place is a fantasy world, Sir, and I love it, but I can't live here full time."

"I'm not asking you to, Matt. I don't want you to. That's part of how I went wrong with Philip. He was my most treasured possession, but I forgot his human needs. A man can't flourish as nothing but a house pet, just as my Jag needs more than trips back and forth to the grocery store. Every once in a while, I have to take it out on the open road and floor the accelerator till every

bolt and valve vibrates. A slave who never leaves the dungeon will soon be good for nothing but dungeon service — if even that much. Ethics aside, that's a luxury I can't afford."

"I'm relieved, Sir, to hear you say it."

"It shouldn't come as any big surprise, boy! It's nothing I haven't said all along, except for that little speech late last night that seems to've spooked you. But you know I love playing 'let's pretend' — what else are all these uniforms of mine? You have to be able to hear what I'm saying on two levels at once, like when I called you those times from Vermont."

"Sir, is being your slave a 'let's pretend' game, too?"

"Matt, we made a commitment to try and be real with each other when I collared you at Altar — it already feels like days ago, doesn't it? You promised me your obedient service and loyalty, and in return I promised to protect you and guide you. I meant what I said, Matt. Did you?"

"I sure did, Sir!"

"Well, then. That much is real. But within those bounds, owning you makes it possible to play all kinds of fun games that I enjoy, and I hope you will, too. However, given that you're not going to be a live-in slave, one thing I'll insist on is that when you're here, you're *here*, not still thinking about your job or a thousand other 'real-world' things."

"You've got it, Sir!"

"It won't be easy for you," he warned. "You can't just snap your fingers and throw off habits and ways of thinking that've carried you through life up to now, especially since you may need them again when you go back to the regular world."

"I know that, Master, but it feels so right to be your slave, to wear your collar and do what you tell me — most of the time, anyway," I added dolefully.

"Matt, you've been my slave for less than 24 hours," Terry said, laughing. "I'd worry if you *didn't* have any doubts or problems adjusting!"

Speechless, I stared at him with my mouth open.

"Silly slaveboy! Stop expecting to do everything perfectly first time out of the gate! You're allowed to make mistakes — how else will you learn?"

He reached forward and ruffled my hair.

"Sir, thank you, Sir," I said and kissed his hand.

"Matt, you have to walk before you can run. When you've learned to let the outside world slip away and be my slave 100% in here — when it's no longer a conscious performance, something you do to please me, but simply who you are — then we'll work on how you can hold onto that sense of yourself out there, in so-called real life."

I felt my world turn upside down. *Which is the real me? The naked slaveboy chained in this dungeon, or the independent gay urban professional who lives by his wits?* I shifted in my bonds just to feel the palpable reality of his chains, his butt plug, my half-hard dick, the bootheels under my beaten and fucked ass. *Are my obedience and loyalty to him any less real than these?*

"Sir, do you mean I'll come to feel that my life outside is the fantasy, the performance?"

Terry's face lit up with a broad smile.

"No, but you're really close now, boy, which is amazing after so little training."

"Do you wish to instruct me, Master?"

"I'd rather *show* you, dickhead, but here's one more hint: Despite appearances, becoming a real slaveboy isn't about losing anything or becoming less than you were before. It's about being all that you were and much more, but in a different way."

I sat and thought about that for a couple of minutes, while Terry waited patiently, but it didn't get any less paradoxical.

"Sir," I ventured, "do you mean . . ."

"No," he said. "That's all for now. Think about what I said, test it against your experiences, and we'll discuss this again in a few days, or maybe longer."

"Yes, Master."

"Now, you dragged out of me how I felt about leaving you last night. I need to know how *you* felt. Was it hard staying here alone?" he asked, with just a trace of worry on his face. "Did you feel abandoned?"

He might have done this before with lots of other guys, but he'd never done it with me. Every new bottom, or slave, is another unique nut to crack, I concluded. I hastened to reassure him.

"It was hard at first, Sir, but it got easier because I felt your presence all around me. I was wearing your chains and lying in your dungeon, stinking of your piss! I couldn't feel abandoned. It was still you holding me, even at a distance."

"Bingo, Matt! That's exactly right: all the time you're in my custody, you're in my care, whether I'm there in the room with you or not."

He uncrossed his legs and sat up straight. "It's getting late," he said, "and I want to tie you up tight for the rest of the day, until dinnertime. Think you can handle it?"

"Sure thing, Sir!"

"Your cock seems to like the idea," he said, poking my hard pole with his boot. He moved the boot up to my chest and gently pushed me onto my back, my chained arms under me. The butt plug, shifting again, probed still another part of my innards.

Terry grabbed the chains between my legs and pulled my feet into his lap, painfully stretching my balls. He unlocked the padlocks at the ends of my leg chains and then the ankle cuffs themselves, letting the chains fall onto the floor between my legs. When my booted feet were free, he laid them back on the floor and stood up. *Bet my feet really stink by now*, I thought, wiggling my toes inside the boots.

Crouching beside me, Terry turned me over onto my stomach, released the chains between my hands and took off the wrist cuffs and the rubber bandages underneath, then unfastened the leg chains from the cock-and-ball harness and the harness itself. That left only my collar and the chain locked to it, now loosely wound around my torso.

"Stand up, boy," he said, and I scrambled to my feet. "Come along."

He led me with a hand on my shoulder as we stepped off the carpeted platform and walked out into the dungeon, stopping at the curtain of chains hanging between two pillars. Terry unlocked one end of my collar chain, unwound it from my torso, and fastened it to an even longer chain of similar weight, then attached that to one of the pillars, creating a long tether.

"You're going to be bound for a long time, Matt. Do some stretching and calisthenics to limber up and get your blood moving. I'll be back in half an hour or so with the gear I need."

"Yes, Sir," I said, but stood still, watching, while he went back over to the oasis. He moved the cuffs and chains he'd taken off my wrists and ankles out of the way, then picked the breakfast tray off the floor and gathered the other dishes onto it.

"Get moving, boy," he warned when he looked back at me.

Obediently, I started jogging in place as he picked up the tray and went out. The heavy door shut with a solid thud, and then there was a clang as he locked it behind him.

I was a little nonplused at the feeling of comparative freedom. I rubbed my wrists where the cuffs had been, though there was no significant chafing, and continued pumping my legs for a while. The slight rattle of chain from my tether seemed loud in the silence. I wondered again what time it was. "Until dinnertime," he'd said. *Guess there won't be any lunch break, then.*

I stopped jogging and tested the limits of my tether. I could move freely in a wide circle, and within it I could do knee bends, pushups, and even jumping jacks without much impediment — though plenty of noise — from the chains locking me to the pillar. Fighting down a sudden absurd attack of self-consciousness, I began the same warm-up routine I used at the gym. The knee bends really twisted the butt plug in my guts, so I cut that segment short and concentrated on stretches and wider-stance bends. I let myself flow into the motions. The chains occasionally threw my balance off, but I tried to ignore that and act as if I were going through a perfectly normal exercise session.

Terry hadn't returned by the time I finished my routine, but it felt good, so I started over. Stretch. Breathe. Turn. Breathe. Stretch. Breathe. Bend. Breathe. Stretch. Breathe. Turn. . . . *Now I know why prisoners so often get into body-building*, I thought. *It passes the time, makes you feel good, and helps relieve the boredom of confinement.* On the "outside" most people — including me! — feel exercise is boring, but that's because we have other things to do. What worried me was how I'd handle the waiting later on, when I couldn't move. *That* would be the hard part.

I'd worked up a good sweat by the time Terry returned with a double armload of leather gear. He dumped it on the carpeted platform and came over to me. Noticing that my skin was wet, he fetched the towel hanging near the sink.

"Stop and dry off, boy. I don't want you to catch cold."

He unlocked my collar chain from its extension while I was toweling myself.

"D'you need to piss?"

"Yes, please, Sir."

He led me back to the toilet and locked my chain to a ring on the wall between it and the sink.

"When you finish," he said, "brush your teeth, wash up, and take a long drink of water. There's a cup, brush, and so on in the sink." He walked back toward his oasis.

After pissing, I brushed my teeth, washed my hands and face, and rinsed the dried cum out of my hair and off my belly and cock. It felt good to be relatively clean (I glanced longingly at the shower stall), and except for my collar and the chain attached to it, which kept getting in my way as I washed, I might have been going through my normal morning ritual at home. The "guest" toothbrush looked brand-new — belonging to a control freak who watches every detail has its advantages!

As I was drinking a second cup of water, Terry came up behind me and rubbed my ass, still sore from the belting, and poked the end of the butt plug, wiggling it teasingly inside me. I moved back into his arms.

"How's your ass, boy? Need to shit again?"

He was playing with my nipples now, and my whole body vibrated with renewed lust.

"No, Sir, I don't think so, Sir," I gasped out.

"Butt plug still nice and tight?"

"Yes, Sir."

He unlocked my collar then and set it with its chain on the toilet tank. I rolled my head and stretched my neck muscles. Terry kneaded my shoulders and kissed the back of my neck, which felt too naked without the leather band. I purred at the attention.

"Now get over to the carpet, boy, double-time."

He turned me around and smacked my ass, hard.

"*Oww!* Yes, Sir."

I jogged across the cell as he sauntered slowly behind me. When I reached the oasis, I sank to my knees beside Terry's chair, staring at the black leather equipment he'd laid out for the upcoming scene: a straitjacket with a profusion of straps, padded gloves, a heavy-duty hood, and a leg sack — essentially the lower half of a sleepsack.

"Take your socks and boots off, boy," Terry ordered.

He sat in his throne-chair while I did so, watching me stuff the socks inside and neatly place the boots under the low table. As much as I like boots, it felt good to take them off after so long. I took a moment to wiggle my toes and sniff in their direction — *not so bad, unless he's into shrimping.*

"Move it, dickhead," Terry barked, but he sounded more amused than annoyed.

I quickly got back onto my knees in front of him, putting my hands behind my back and bowing my head.

"Come closer, boy," he said, picking up the gloves, "and hold out your hands."

I shuffled forward, and he slipped the gloves onto my outstretched hands. The sides of the fingers were sewn together, making them more like bulky mittens. He stood up and motioned for me to rise as well. Picking up the straitjacket, he held it so I could insert my gloved hands into the sleeves, then worked it onto my arms and turned me around to fasten the straps down the back. The smooth leather lining felt wonderful against my naked skin, though the jacket was twice as heavy as an unlined model.

"*Mmmm*," I murmured as the straps pulled tighter.

"You like that, boy? You like being all wrapped and strapped in my leather?"

"Yes, Sir! It feels great, Master!"

"I wonder if you'll like it as much a few hours from now," he said with an evil chuckle.

My hard cock stuck straight outward as he wrapped the long sleeves around me, worked them through the holding straps on the sides of the jacket, and pulled them tight behind my back — *very* tight. My arms hugged my rib cage, but I could still breathe shallowly. Terry pulled the dangling crotch straps through my legs and fastened them tightly in back, making me into a neat bundle from neck to waist. Finally, he turned me around again and slipped a short strap through a pair of D-rings on the front of the jacket, then around the sleeves, holding my arms tight against each other. I stood quietly as he looked me over.

"How's that, boy? Okay? No problem breathing?"

"I'm fine, Sir. Thank you, Sir."

Without being able to move my arms, my balance was a little off. It was as if my whole torso was one solid piece instead of a flexible mechanism. Terry noticed I was swaying slightly and helped me lie down along the edge of the platform.

"Lie there, boy, while I deal with your bottom half," he said.

He took the leather sack and slipped it over my legs and up my thighs. A soft, padded center panel kept my ankles and knees from rubbing together.

"Lift your ass, boy, so I can get this on."

I raised myself as much as I could, and between us we managed to pull the legsack over my butt. It had a couple of two-way zippers and the same kind of D-rings and straps as a sleepsack, and I expected Terry to zip me up and start lacing me into it. But first he fitted a leather cock-and-ball harness around my equipment. Since I was already steel hard, the harness didn't have much effect on my cock — but it sure felt good!

"Now I can finish strapping you in," he said with a satisfied tone. "Still feel okay, boy?"

"Yes, Sir! I feel great, Sir."

"Good boy." His crooked grin probably should have worried me, but I was too excited from the bondage to think about it.

He pulled the lower zipper on the leg sack up to my crotch, just under my balls, and then worked the top zipper down from the waist to my erect cock. The waist of the sack was equipped all around with little posts that fit through corresponding holes on the bottom edge of the straitjacket. Terry lined them up, turning me as needed to reach the ones on the back, and fastened tiny padlocks through holes in the posts to hold the two pieces together. He didn't bother lacing the sack with rope but simply pulled the straps tight around my ankles, calves, and thighs. When he was finished, I was tightly encased in leather from my neck to my toes and could hardly move a muscle. My rampant cock and tight, purply balls stuck out obscenely.

"I need to sit you up now, boy," he said as he swung my legs off the platform and turned me until I was facing outward, then bent my torso at the waist until I was upright.

The various straps pulled almost painfully as he shifted my position, and the butt plug probed new depths in my ass. Terry sat down behind me, straddling me, and hugged and kissed me for several minutes, ruffling my hair and stroking my bound body, or teasing my cock, while I moaned helplessly.

"This is going to be a sensory-deprivation trip of sorts, so I'm going to plug your ears and mouth, boy. If there's anything you need to tell me, do it now. I wouldn't try this with a novice, but I think you can handle it — and I trust you to tell me if there's any reason you can't."

"No reason I can think of, Sir, thank you. I'll be fine, Sir . . . Master."

I hoped my confidence wasn't misplaced, but nothing at that moment was bothering me, and I couldn't imagine what could happen that I couldn't deal with until Terry came back to check on me. I was actually eager for the bondage and isolation to be complete.

"That's my boy," he said.

It was the last thing I heard with full clarity for a long time, as he immediately produced soft foam earplugs from his pocket and gently worked them into my ears. The ambient noise of the dungeon, the creak of the leather binding me, the rattle of the keys on his hip, all fell away, replaced by the magnified sound of my own breathing.

I expected him to hood me next, but first he opened my mouth and inserted a rubber appliance like an athlete's mouth protector over my teeth. In front, between the upper and lower jaw guards, was a wedge of rubber that held them open half an inch or so. It wasn't uncomfortable, just odd. I felt around the inside of it with my tongue and found the breathing hole in the center. Next, Terry placed large wads of cotton over each of my eyes, holding them in place with sticky bandages. *Hearing and sight gone*, I told myself, *and taste and smell are pretty useless. Guess all I have left is touch.*

At last the hood slipped over my head, and he began to pull the laces tight. I'd seen earlier that it had no eyeholes, so the cotton and bandages must have been meant to ensure that no light reached my eyes through the nose holes or the small round mouth hole. Terry finished with the laces, and I felt and almost heard him pull a zipper closed in the back, tightening the hood even more.

Like the other gear, the hood was lined with smooth leather and felt wonderful — and also smelled wonderful, so that sense wasn't blocked after all. I pulled in deep breaths through both my nose and mouth, trying to catch a whiff of my hard-working captor's sweat. No go — all I could smell was leather and a bit of rubber from the mouthpiece.

The hood was already snug, but the pressure over my eyes and ears and around my jaw increased as Terry tightened and buckled the various straps. It wasn't anything I couldn't tolerate, however. I felt his hands working around the collar of the hood and figured he was attaching it to the collar of the straitjacket

with locking posts like those on the waist of the leg sack. When he finished he eased my head and torso down onto the platform, turned me 90° and lifted my legs back up, then adjusted — tightened! — the straps on the leg sack.

I thought he would leave me like that, and I relaxed into my luxurious bondage, still in a high state of excitement. Pain and then boredom would come much later. I felt a virtually even pressure all over my body, from the top of my head to the soles of my feet. My mitten-encased fingers were useless, and I could no longer even turn my head. My breathing slowed, my sense of time became fuzzy and erratic, and I began to float in that delicious nirvana that comfortable but rigid bondage always induces in me.

With the earplugs, I couldn't hear anything of Terry's movements, so I didn't know if he'd left the dungeon or was sitting in his chair watching me. After a while, however, I did hear a kind of high-pitched squeaking sound that seemed to grow louder as it moved toward me. I was beginning to panic, imagining all sorts of nastiness, when I felt a reassuring squeeze on my cock and heard Terry's voice right next to my ear.

"It's me, boy. Time to move you. You may be content to lie here, but I have other plans."

Soon he was wrestling my dead weight off the platform onto a cart or gurney, I supposed — one with squeaky wheels. The cart creaked and swayed on the uneven slate flooring as he trundled me to wherever we were going. My only hint came when there was a rattle of chain loud enough for me to hear, and then we stopped. For several minutes at least, my plugged ears registered occasional nearby chain clinks, and I felt Terry's hands on different parts of my leather-encased form as he prepared whatever surprise he had for me.

Finally, accompanied by a great rattle of chain, the gurney started moving out from under me. I didn't fall, however — I swayed in mid-air! My weight was very well distributed, with anchor points at the top and either side of the hood, on the collar, shoulders, and sides of the straitjacket, at my waist, along my legs, and at my feet. The overall effect was like being bound into a hammock, including some sagging in the middle and a good deal of bounciness at either end!

He must have attached me to the chain-hung beam between two

of the support pillars, I decided. *The noise is from unused chains clattering together as I sway against them — except that chains wouldn't have so much elasticity,* I suddenly realized. *He's used bungee cords!*

I felt him adjusting the suspension here and there until I was hanging as level as I could be. Now that the slight fear of the unknown was resolved, my cock was rock hard again. Terry teasingly rubbed his gloved hand over the head of it, slick with precum, and I shrieked and bucked wildly at the incredible sensations he was causing me, but all that happened was that I bounced at the ends of the bungee cords supporting me. My stomach did flip-flops at first, then settled down as I got used to the weird swaying.

"Feel good, boy?" he asked at my ear, but my jaw was too tightly bound to let me do more than mumble a reply.

He kept playing with my cock — and making me sway back and forth by pulling on my tight, leather-strapped balls — until I thought I would surely shoot my load, but he backed off every time I got close. I bucked my hips, but it only caused more useless bouncing; without his hand, my poor dick had nothing to rub against. It was an exquisite torture: I couldn't decide if I wanted him to stop or to continue forever. Of course, the whole point was that it *wasn't* my decision. He was in control, and I was his toy.

"Want me to make you come, slave?" he asked. I started to nod, and found I couldn't, but he went on. "Think you can handle a few hours of rigid bondage without a hard cock?"

Oops! No, Sir! I tried to shake my head hard in negation, realized I couldn't do that either, and started to make noises deep in my throat. Terry just laughed and pulled on my balls until he had me swinging back and forth.

"Relax and enjoy yourself!" he said finally. "I'll be checking on you from time to time, but you probably won't notice me. I'll give you a break in a couple of hours."

And then there was silence, except for the occasional slight tinkle of chains. I thought I heard a dull thud as he slammed the dungeon door closed, but it could have been my imagination.

CHAPTER 25
Make me feel good, boy

So there I hung, unable to move to any purpose, yet swaying and swinging every time I took a breath or flexed my leather-wrapped muscles. I was afraid of getting dizzy, so I tried to relax and go as limp as possible. Except for my arms, the bondage itself was very similar to the hood and sleepsack Terry had put me in that first night we played, more than a month before. And yet the suspension, combined with the earplugs, somehow made it entirely different. It was like being in a floating leather coccoon — *Will I emerge as a butterfly? Or a better slaveboy?*

My night in the sleepsack had had a perfect stillness to it, which allowed my mind to roam, but the bungee cords gave this scene a more dynamic quality. Despite my efforts to stay still, I was constantly swaying slightly, accompanied by a jangle of chain that my earplugs reduced to a soft tinkling sound, like distant wind chimes. Instead of my body feeling like a heavy weight that my spirit could leave behind temporarily, it seemed light and insubstantial, bobbing weightless in mid-air.

My sense of time passing became increasingly fuzzy. Overall, I was quite comfortable, though my arms began to ache after a while. Later on, I could barely feel them, but as long as I could wiggle my fingers and toes a little, I figured I still had enough circulation. I felt warm as toast, and was beginning to sweat inside my coccoon, but my exposed cock and balls were cool.

Though I was short of sleep, the coffee at "brunch" — both first- and secondhand — was still keeping me alert. *Does it count as brunch if you eat it from a bowl on the floor, without hands?* Instead of dozing off, as I might have in more conventional bondage, I found my mind racing. Obsessively, I replayed everything Terry

and I had done or said since he'd claimed me at the bar the night before, searching for any false notes, any reasons not to surrender completely. My cock stiffened and twitched during these reminiscences, as shameless as ever.

It all led here, to being helplessly bound in his secret dungeon, alone, unable to do anything, yet safe and secure, simply waiting for him to make the next move. I was sidelined for a while: not responsible for anything, not expected to do anything. I was as exempt from trying to please him, or to gauge his mood, as from having to govern my own controlling tendencies. All I had to do was breathe, and if I stopped thinking about that, my body would take care of it for me. Psychologically, I was content to float there for as long as he wanted me to — not that I really had any choice. *But that's the whole point, isn't it? To give up my choice and trust him to take care of me?*

Eventually, of course, the pain in my cramped arms and legs built up to the point where I was wriggling and bucking in a useless attempt to relieve it. I assumed Terry was monitoring me, but either he wasn't listening or watching just then, or he decided to let me ride it out, which was just as well. As always in a long rigid-bondage scene, the pain reached a peak where I would have been screaming and begging for release if I'd been able to, only to subside into a pleasant numbness a few endless minutes later. My mind was finally becoming numbed and dulled as well. *Shutting down. All nonessential systems shutting down — like my own* Star Trek *episode!*

I slipped into a dream state. Images of Terry and of things he'd done to me — or might do — alternated randomly with unrelated scenes from my job, my childhood, my everyday life, even my years with Greg. The constant tinkling and swaying worked itself into the dreams in the most bizarre ways, from fantasies of riding ski lifts to memories of riding cable cars on a trip to San Francisco. Replays of my most painful bottom experiences in the past — scenes in which I'd been whipped raw or had my nips or balls mangled or my ass abused — were overlaid with pleasant feelings of contentment and security. I smiled as I watched myself crawl or scream or beg, admiring the bottom's stamina and masochistic greed. *He'll make someone a good slave*, I thought, not quite realizing it was myself I praised.

I came to with a jerk when I felt a warm hand on my cock.

I started to shriek, frightened out of my wits, but cut it off when a familiar voice reached my ears through the plugs.

"Easy, boy! Don't be frightened! Just checking on you. It's been more than two hours."

I couldn't believe it. *Two hours!* I'd have guessed 40 to 60 minutes at most.

Terry squeezed my balls and jiggled the plug in my ass until I was writhing helplessly, swinging and jangling like a mariachi band.

"Have to get your circulation going again," he said at my ear, followed by an evil chuckle. He snapped off the genital harness and adjusted the suspension so I was slanting downward, with my feet lower than my head. He bent my cock down and worked it through some kind of opening, then told me I could piss. I certainly needed to, but I had trouble getting soft enough. *Feeling his hands on my body always gives me a hard-on!*

"C'mon, boy, I'm not going to stand here all day."

He kneaded my belly through the straitjacket, as if to coax out the piss, while encouraging me verbally, as he had back at Altar. Finally I let go enough for it to start dribbling out, and the dribbles grew into a strong stream. It flowed so fast through my dick, it was almost like coming! And when the stream eventually dried up, all the tension left in my body seemed to go with it. I sighed in relief. *Snug bondage and an empty bladder — what more could I want?* I should have known better.

"Good boy," Terry said, "that's my good slaveboy. Now I'll just slip this funnel through the hole in your gag and let you recycle it. Wouldn't want you to get thirsty!"

At least he warned me, and when the warm, bitter piss began to flow into my mouth, I was ready for it. I swallowed the first mouthful and waited for more. Soon we got our rhythm in sync, and he was able to pour the rest into me more or less continuously as fast as I could swallow it.

"I'm going to leave you again now," he said at my ear when all the piss was down. "Take a nap if you can, or just swing here and daydream about your future as my slave. Think about how good it feels to belong to me and to do whatever I tell you. Think about being tightly bound like this, or some other way, at least once every time you spend a weekend here."

He pulled my legs and torso up level with my head again,

strapped my genitals tightly again, and smacked my hard cock back and forth a few times before leaving me alone, a slaveboy rocking in his leather cradle.

Being his slave . . . belonging to him . . . obeying him . . . being bound by him. . . . The phrases echoed over and over again in my mind as I swayed from the springy cords. *He's right*, I decided: *it does* feel good. I couldn't guarantee that all my doubts and hesitations were behind me, but I felt as if I'd crossed a threshold. Fantasy had become reality, and it was better than I'd ever hoped for.

<div align="center">❖</div>

I jerked awake from a doze when I felt Terry's hand on my cock again. I had no idea how much longer I'd been hanging since he'd let me piss — it didn't *seem* long, and I didn't need to piss again, but it *could* have been another couple of hours. As before, he played with my cock, teasing me again and again almost to the point of coming, then pulling his leather-gloved hand away.

"I'm going to let you down, boy," he said at my ear eventually, but instead of pulling me onto the gurney or releasing the bungee cords that held me, he began with the locks connecting the leg sack to the straitjacket, and then the straps on the leg sack. Soon I felt cooler air on my sweaty legs and thighs.

He lifted my feet out of the sack and held them as he peeled it away from me, then slowly lowered my feet and legs to the ground. I felt his strong arms holding me, tilting my back and head up, as I found my footing and took more and more of my own weight. Finally, I was fully upright, though with the hood and straitjacket still on my balance was shaky. I took deep breaths through both my nose and the mouth tube.

I stood there, swaying against his chest instead of from the bungee cords, as he undid the padlocks connecting the hood with the straitjacket collar. My arms and torso felt numb, but my lower part was all pins and needles from restored full circulation. I thought he'd take the jacket off first, but it was the hood he tackled next, unbuckling the straps, unzipping it in back, and undoing the laces. I still couldn't hear, see, or talk with the earplugs, eye bandages, and mouthpiece in place. Terry held me against his chest, gently stroking my sweat-soaked face and hair, for another minute or two before removing them.

He turned me toward him then, still tightly straitjacketed, my butt still plugged, my cock and balls still harnessed — still very much his prisoner, his toy. I don't know how I looked to him, though he was smiling, but to me he looked good enough to eat. Sometime during the afternoon he'd changed into loose-fitting black leather pants bloused over gleaming jump boots, a short-sleeve black leather uniform shirt open at the neck, and gauntlets. (Okay, so he was showing off his wardrobe — I felt honored that he even bothered to dress up for me.) My cock got harder than before as I stared at his crotch and thought about servicing him. I licked my lips and worked my tight jaw muscles.

"You okay, boy?"

"Fine, Sir, thank you, Sir," I replied firmly, looking into his eyes for a moment before casting mine down again.

Terry unhooked all the bungee cords still attached to me and walked me slowly back and forth, half supporting me with an arm around my back, until the pins and needles stopped and I was limber again, at least below the waist. The butt plug shifted inside my ass as I moved, waking that up, too. We moved together toward the platform at the front of the dungeon, climbing the steps and stopping in front of his chair.

"I was going to keep you tied up even longer," he said, "but thinking of you down here all alone was starting to get frustrating. *I* got to feeling deprived. When I came in to check on you, I wanted to feel your mouth in my crotch and on my boots more than I wanted to keep you locked up."

He ruffled my hair and pulled my face toward his. I'd barely parted my lips before he was spearing his tongue into me. He licked and chewed my lips and chin like a man who was starving, at the same time pressing my straitjacketed torso against his chest in a strong bear hug. I gave as good as I got, too, chewing on his moustache and licking his sandpapery cheeks.

We traded spit for a couple of minutes before Terry pushed my head toward his chest. I trailed my tongue down his throat to the triangle of hairy chest exposed by his shirt, then moved on to the soft, fragrant leather. He unbuttoned the shirt and held me less tightly so I could explore his pecs and pits with my eager lips and tongue. His clean masculine smell overlaid with the scent of leather filled my brain, short-circuiting everything unrelated to lust.

I was working my way toward his belly button, feeling my own cock, which had gone soft during our perambulations, stiffening again as I licked, when he pushed me to my knees. The butt plug speared upward, and I rocked back on my heels as Terry sat down in his chair. Smiling, he stretched his long, booted legs out on either side of me. The shiny leather over his crotch was stretched like a drum by his aroused cock, but he didn't pull me onto it right away. He just sat there, stroking the bulge with his fingers, the thin black leather skintight over his knuckles, looking at me as I stared and drooled.

"Go for it, slaveboy," he said finally in a soft voice. "Make me feel good."

I dove head first into his crotch. Terry sighed softly as my tongue found the head of his dick through the leather and licked it again and again, as if I would free it by friction. He slouched lower in the chair to offer more of his leathered ass to me, pressing my nose into the seam of his pants. I licked everything within reach, snuffling and snorting like a truffle-hunting pig. His hands twisted around in my hair, sometimes directing me, sometimes simply reacting to the pleasure I was giving him.

Though I'd have enjoyed running my hands over his thighs and chest as I worshipped his crotch, I was just as happy to stay bound. The leather straitjacket tugged at me with every move I made, as if Terry himself was still hugging me, holding me tight, and I was deliciously racked with small pricking and stabbing pains as my gyrations pushed fresh blood through muscles that had gone numb. My hard, dripping cock gave evidence of my own arousal.

"Goddamn, slaveboy," Terry exclaimed, "but you have a talented tongue! You're getting me so hot! Ahhh! . . . Ease off, now. Work on my boots while I get my dick out and wrapped for you."

I pulled my head out of his crotch and glanced up at him. The big, goofy smile on his face, nothing like his trademark lopsided grin, showed he wasn't *always* totally in control, working exactly to plan. He could get carried away, too. I realized then how much I *liked* this man, not just lusted after him or idolized him.

I bent my head again and twisted to the side so I could get at his left boot. I ran my tongue along the smooth leather shaft lasciviously, not just licking but savoring it. I darted my tongue tip into each crevice between the laces. My spit beaded up on

the patent-finish leather, so I wiped and polished it with my cheeks and hair. Terry turned and elevated his leg so I could get to every part of the boot, finally propping the heel on my crossed, strapped arms so I could lick the dirt (there wasn't much) out of the treads on the sole. When I finished he replaced it with his right boot, and I began to work my way back up from the bottom.

"That's enough, boy," he said when I reached the top of the boot, where his pants emerged. "Sit up and drink this."

He held out a bottle of mineral water, the uncapped top toward me. I put my mouth around the opening like a calf on his mother's teat and drank thirstily, slugging down at least half before he pulled it away.

"Thank you, Master," I said gratefully, water dribbling down my chin.

"It's for my own benefit — I don't want your mouth all dry and gritty when you go down on me," he explained with a grin.

I stared at the open fly of his pants and his half-hard, rubbered cock and hairy balls. God, I wanted to taste his naked meat so bad! *Someday*

"Chow down, slaveboy. Make me feel *really* good."

I was on him before he finished speaking, sliding his cock into and down my throat to the root. *"Ahh! Yesss!"* I heard him moan as his pubic hair brushed my nose. I inhaled that good crotch smell, a heady mix of sweat and leather, with a strong background note of latex from his condom. My throat rippled around his shaft as I slid back up to the head, licked and teased the heart-shaped glans, and plunged down to his pubes again.

Terry made no move to control my service, just slumped back in his chair and moaned softly, getting harder each time I deep-throated him. The big guy let me do him any way I wanted, and I played him like a flute. I sucked, I licked, I puffed out my cheeks and blew, I twisted his cock inside my throat, I kissed my way from the root to the head and back again. He rewarded me with purring sounds from deep in his gut. His hands began to stroke my hair, then fell back, weak with pleasure.

"My balls, Matt," he whispered finally. "Lick and chew my balls. You know how I like it."

I pulled up, slowly, and let his cock slip out of my mouth, then moved down to his balls. No latex barrier there! I licked the large, hairy orbs with relish, inhaling the stronger smells closer

to his ass. He was clean enough, but even a freshly washed asshole has a trace of funk, and it was probably six hours or more since he'd showered. I have no taste for scat, but I do like to know it's a male animal I'm eating.

While Terry worked his cock with his hand above my head, I sucked first one ball and then the other into my mouth. My teeth clamped tight around his scrotum, and my tongue prodded and rolled the balls in my mouth. *I know how you like it, all right!* The sounds above me were becoming louder, and the jerking motion as Terry pumped his dick became noticeably faster. I held on tight, licking and sucking his balls as he pistoned his cock, wondering if he'd invite me back up for the finale. He did.

"Now, boy! Now! Get your head up here! Shut your eyes and mouth!"

I opened my mouth wide to let his balls slip out and then snapped it shut, along with my eyes, as I came up to cock level.

"*Aaarrggh!*" he shouted as *splat! plop!* his hot cum hit my face. "*Ahhh!*" and *splat!* Another spurt found its target. Cum oozed from my forehead and cheeks toward my upturned chin. It took all the self-control I had not to part my lips and lick it in. I contented myself with breathing deeply to pull in the smell.

"Oh, man!" Terry exclaimed, panting slightly, and then, laughing, "Looks like I hit the target, slaveboy. Here, I'll wipe you off."

He pulled my head toward him and used his leather-covered thumb — he was still wearing the gauntlets — to scoop up the larger gobs of cum and deposit them in my hair and behind my ears. The rest he smeared around my face so it was more or less evenly coated with his gism, then wiped his hand on my chest. I didn't mind — I was becoming used to this little ritual. As long as I couldn't take his cum inside me, he'd make sure I got the full benefit externally.

"You can open your eyes — if they're not stuck together."

"Yes, Sir. Thank you, Master," I said, then flashed him a satisfied grin as I sat back on my heels. His eyes twinkled merrily as he looked back at me.

"Liked that, did you, slaveboy?" he asked after a moment of silent communion, reaching down to squeeze my hard cock.

"Oh, yes, Master!" I wanted him to grope me some more, but he pulled his hand away.

"Good. So did I — very, very much. I think you deserve a break."

After standing up and stuffing his cock and balls back into his pants, he helped me to my feet. To my surprise, he guided me out of the dungeon and into the jail cell we'd used the first afternoon we played. He pulled the barred steel door just short of closed behind us.

"Need to piss again, Matt?"

"Yes, please, Sir."

"Go ahead."

While I stood at the toilet, waiting for my cock to soften and struggling to aim it without hands, he sat on the end of the bunk, turned and swung one leg up, and put his back against the concrete cell wall. When I finished peeing, he beckoned me over and motioned for me to sit in front of him. I climbed awkwardly onto the narrow bunk, but he pulled my back onto his chest and rested my head on his shoulder.

We sat like that, not speaking, for several blissful minutes. Terry idly stroked my cock with his right hand and cupped his left one over my mouth, eyes, or nose. I licked at it when I could and inhaled deeply to get the leather smell whenever he covered my nose. Occasionally he would slip one hand under my ass and wiggle the end of the butt plug. The light outside the cell cast barred shadows over us on the bunk. I might have been a prisoner befriended by a hunky, horny guard.

Eventually Terry spat on his palm, then rubbed it over my cock. It was my turn to moan helplessly. He stuck three fingers into my mouth for more spit and returned his hand to my cock. I went wild with pleasure, bucking under his hands and giving out little yips of delight. He put his hand to my mouth again, then to my cock, taking long strokes up and down.

"Now, boy, you're going to come for me. On my count. When I reach 'Ten,' you shoot. Understand?"

"Yes, Sir. I'll try, Sir."

"There's nothing to try, boy. Just *do* it. Hold on till I reach 'Ten,' then shoot for me."

"Yes, Sir," I said, a little doubtfully. I wasn't at all sure I could control my coming like that. I was afraid I'd shoot either too soon or too late.

"Don't *worry* about it, Matt. Trust me. Let yourself go, lis-

ten to my count, and you'll do fine. Don't think in terms of controlling yourself. Think of me controlling you. Just tell yourself that you'll come when I say 'Ten.'"

"Yes, Sir." *Come when he says 'Ten.' Come when he says 'Ten.' Come when he says 'Ten.' . . .*

"Okay, now. One."

His powerful hand stroking my cock hard from the root to the head felt so wonderful that I thought I'd lose it right then. But I held on. *Come when he says 'Ten.' Come when he says 'Ten.' . . .*

"Two."

Come when he says 'Ten.' . . .

"You're doing fine. Three."

I continued to repeat the mantra silently while he plumbed my mouth for more spit.

"Four."

Come when he says 'Ten.' . . .

"Five."

Oh, God! So close! I was so close! Ten! Come when he says 'Ten.' Come when he says 'Ten.' . . .

"Six."

Yeah, that's okay, I can do it. Come when he says 'Ten.' Come when he says 'Ten.' . . .

"Seven."

More spit. My mind was empty of everything but my awareness of his hand on my cock and the mantra, *Come when he says 'Ten.' Come when he says 'Ten.' . . .*

"Eight."

It felt so good to rub my cock . . . no, that's not right. I'm getting confused. I can't touch my cock. I'm still in the straitjacket. It's Master *rubbing my cock. He's trying to make me come, but I have to wait. I can't come until he says 'Ten.' Come when he says 'Ten.' . . .*

"Nine."

Almost there. I can do it. I can hold out . . . ahhh! I'm going to shoot! No!! Come when he says 'Ten.' Not before! Come when he says 'Ten.' Come when he says 'Ten.' Come when he says 'Ten.' . . .

More spit, another stroke, and as his hand approached the head of my cock, I heard him say,

"Ten! Come *now*, boy! Shoot!"

"*Aai-ieee!*" I screamed. "*Aagh-ghh! Ahhh!*"

Spurt after spurt of white cum splattered my naked leg and

his leatherclad one as my asshole spasmed around the butt plug. I arched my back and neck as I shot, then slumped back, a dead weight on his chest. For several seconds he kept stroking my hypersensitive cock, making me squirm and twitch at the sensory overload.

"Oh, my God, Sir," I said when I found my voice again. "Sir, please stop, Sir! That was incredible, Sir. Thank you, Master!"

"You're welcome, boy. You deserved it." He scraped the cum off his leg and mine, then brought his hand to my mouth. "Now eat up your cum. You know I don't believe in wasting it."

"Yes, Sir. Thank you, Sir."

I licked his hand clean, and he went back for more as I swallowed the slimy stuff. When I'd licked up as much as he could gather, he unbuckled the strap around my arms at the front of the straitjacket, then pushed me forward, aiming my face at the cum stains on his pants. My jack-knifed position made the damn butt plug poke at a hitherto undisturbed spot in my gut.

"Clean it off."

While I licked my drying cum from his leather, he unbuckled the straps in the back of the jacket, then helped me unbend my arms, which were pretty stiff.

"Get up for a minute, boy."

I scrambled off him and stood beside the bunk, the jacket sleeves trailing down in front of me. Terry unbuckled the crotch straps, pulled the jacket off me, and tossed it on the floor, then stretched himself out full length on the bunk before pulling me down beside him. The only way we could both fit on the narrow bunk was to lie on our sides, spoon fashion. I pillowed my head on his right arm, and his other arm curled protectively around me. My hands fell together in front of my chest as if they were cuffed.

Terry played with my nipples or stroked my face and hair as we cuddled. I purred in contentment, it felt so wonderful just lying there with him. The bondage and confinement he'd put me through were great, but lonely. I'd missed the human contact, the "intercourse" part of sex, and it seemed Terry had missed it, too, so we were making up for it! My satisfied cock shrank to a nubbin, and the cum smell on my face and hair diminished to a faint perfume. Terry's breathing became very slow and regular, and soon he was snoring softly.

We were both a little short on sleep since the day before. I found myself yawning, so I closed my eyes and drifted off, too. What woke me up, I don't know how much later, was a loud rumbling in my belly. Terry laughed — he was awake already.

"Mine's growling, too, boy. It's been a long time since we had brunch. Clean yourself up at the sink, and I'll go and make us something to eat."

Terry continued to lie there and watch me for a couple of minutes as I splashed my face and wiped off my sticky thigh. I was still washing when he got up, hugged me from behind, and told me I could take out the butt plug, too, ". . . unless you really like it in there."

I blushed and lowered my head. In the stainless-steel mirror over the sink, I saw him pick up the straitjacket and walk out of the cell, closing and locking the door behind him.

When I finished washing the cum out of my hair, I dried it off and inspected myself in the mirror. My hair was every which way, and as usual *chez Terry*, I didn't have a comb to straighten it out. *He must like the "casual" look*, I figured, *since not much happens by chance around here*. I did what I could with my fingers. My cheeks had a light fuzz, but there was no razor, either. I yawned again, shook my head to clear it, and returned to the bunk.

I lay face up with my arms crossed on the pillow behind my head. I realized that for the first time since I'd met Terry at Altar the night before, I was alone and unrestrained — unless you count the butt plug. I thought about taking it out but decided not to. My ass had adjusted to it, and though the lube Terry had used to insert it was long since absorbed, my ass seemed to be generating enough natural juices that it wasn't too irritating. The constant fullness and pressure reminded me of my submission. *Better leave it for Master to take out — when he's ready to plug me with something else*, I thought hopefully.

My stomach rumbled again. I *was* hungry. *I hope he isn't taking time to be creative in the kitchen! Just a hunk of bread and a piece of meat or cheese are all I need.*

When I heard his bootsteps again, I got off the bunk and stood expectantly at the cell door. He wasn't carrying a food tray. Instead, he had some chains draped over one arm and my boots and collar, retrieved from the dungeon, in his other hand — both hands were bare, the cum-stained leather gauntlets removed.

My shameless cock stiffened as he handed me the boots and a set of heavy leg irons through the bars. I sat on the floor to put them on while he opened the cell door. He stood there waiting until I was finished, and when I got up he turned me around and locked the matching manacles on my wrists behind my back. The chain was only about a foot long, so my arms were as useless as if I'd been handcuffed. Then he put my collar back on. I shivered with a jumble of emotions as the lock snicked shut. Despite being splashed with piss and cold water, it felt as soft and warm around my throat as ever.

"Come on, slaveboy, we're going upstairs for a while."

CHAPTER 26

Mutt comes out to play

Terry guided me with a tight grip on one arm as we walked through the storeroom and exercise room/erotic art gallery out to the garage, then up the stairs to the kitchen. He held himself to my shuffling pace in the leg irons, which made their usual music on the hard floors and steps. Lights had come on in the garden outside the glass walls, suggesting it was already evening, which I confirmed with a glance at the kitchen clock: 7:38 p.m. I smelled food and saw some dirty pans, bowls, and utensils in the sink, but no food was set out.

He steered me on through the kitchen to the living room, where the carpet reduced the clatter of my leg chain to a muffled tinkle. We stopped by his reading chair — a plate of sandwiches, some brownies, a thermos, bottled water, and a large mug were on the table beside it. At a touch of his hand on my shoulder I dropped to my knees, keeping them far enough apart to expose my hard cock and tight balls. After he seated himself, I glanced at his face, saw he had his crooked grin again — *be prepared for anything!* — and humbly cast my eyes down.

"Relax, boy," he said. "You don't have to kneel up or look away from me." I sat back on my heels and smiled at him.

"Do you have any idea how sexy you look like that?" he asked. I wasn't sure how to respond.

"I'm glad I please you, Sir," I said cautiously.

"Oh, you please me, all right. You please me more than any-one since . . . well, more than anyone in a long time. There's just one thing missing. Wait here," he said as he abruptly stood up. "Don't move."

I eyed the food hungrily, but as there was no way I could

snitch any with my hands chained behind me, I obediently sat still and waited. It was several minutes before Terry returned, carrying my braided leather leash, which he must have retrieved from the Jeep. My heart thumped, and I knelt up straight and bowed my head as he clipped it to my collar, slipping the other end over his wrist as he returned to his seat.

"That's better. How do you feel, boy?"

"Wonderful, Master. Now can we eat, Sir, please?"

"Okay, okay!" he laughed.

He picked up a dish towel from the table next to him and spread it on the carpet in front of me. Then he picked up the black rubber dog dish that had been concealed behind the plate of sandwiches. *Looks like the one he used in the bar — was it really only last night?* He set it down in front of me, turned it around, and filled it with a steaming red liquid from the thermos. I stared, speechless, as he poured. On the side now facing me, carefully hand painted in silver script, was the name "Mutt." *That wasn't there last night!*

My mind went into overdrive. Eating brunch like a dog had been fun, and I could have done it again in the same lighthearted way. But that name on the side of the dish changed things. *Mutt. Matt. Just one letter.* I glanced up to try and read his expression. On the surface, he seemed relaxed, casually amused, but I sensed a tense undercurrent. *Something is riding on my reaction.*

I was torn. *Do I want to be his dog?* It wasn't a scene I'd ever fantasized about, and I had no experience with it. It would mean no talking and no use of my hands, but I was used to giving up both of those anyway while I was bound and gagged. No walking, either, but I had no problem staying on my knees. *He must really want this*, I thought, looking closely at him again. *What do I have to lose by trying?*

I bent my head and barked, *"Rrruff! Woof! Woof! Rruff!"* Then I licked his hand where it lay on his knee and bent my face to the dog bowl on the floor.

A spicy aroma filled my nose, and I dipped my tongue into it to check the temperature. *Not too hot to lap up.* I shuffled closer on my knees and started in. It was really good, certainly not dog food! Something like a Manhattan clam chowder except that the vegetables were puréed — I had no trouble slurping them up. The clams sometimes got away from me, though.

Terry stretched his legs out beside me and settled back in his chair. I glanced up and saw him sipping from his oversized mug — *probably the same soup.*

"You like my soup, boy? I had some leftover gazpacho, so I extended it with some canned clams. Kind of a scratch dinner, but this is Saturday, after all."

He's not going to catch me that easily!

"*Aarrf! Rruff!*" I barked instead of answering in words. He'd have to figure out the meaning, but I did try to make the barks as positive as possible — the soup was good enough for a restaurant. I cocked my head to one side, staring at him worshipfully with my tongue hanging out, until he chuckled, then went back to eating. *My face must be a mess,* I thought as I lapped and slurped.

We finished our soup with no more "conversation." When I'd snared the last bit of clam with my tongue, after a furious chase around the bowl, I sat up and noisily licked my chops. Terry grinned at me.

"Good boy," he said and patted my head, then took a napkin, spit on it, and used it to wipe the soup splatters off me.

I made faces and squirmed during this operation, but he was undeterred. When he was satisfied, he wiped out my bowl with a napkin and refilled it with cold mineral water. I bent down and lapped thirstily while he sipped from his own bottle.

After drinking all he gave me, I knelt up and let my tongue loll doggishly. Terry just sat there, looking at me with a complacent expression on his face, so I took a dog's liberty and barked at him, "*Woof! Rruuf!*" — meaning, "More, please! Still hungry!"

It must have been pretty obvious, because Terry immediately reached for the sandwiches. I didn't see how I could eat one without hands, but it turned out he intended to feed it to me. He held out a half sandwich, and I bit off a mouthful. While I was chewing, he took a bite himself. I was glad he had eccentric ideas about the kind of food his "dog" should eat, because it was delicious: Canadian bacon and sliced garden tomatoes on sourdough bread with lettuce and mayonnaise — *homemade, I'll bet.*

"Ready for more, boy?"

"*Woof!*"

He let me take another bite, but I was greedy, and tomato juice dribbled down my chin. Terry reached over and wiped it off before it got too far.

We ate two big sandwiches that way, sharing them, and after another break for water, two of the brownies (which also tasted homemade). It was one of the most satisfying meals I'd ever had. It was as though every bite *counted* more than it usually does. From time to time Terry ruffled my hair affectionately, and before I took another bite I'd lick his fingers. I was completely relaxed in my dependency on him.

We sat quietly for a while after finishing. Slowly, in case he might object, I moved closer until I could rest my chin on his knee. Terry said nothing, only patted my head and squeezed the back of my neck.

"Stay," he ordered finally, slipping my leash off his wrist and looping it around the arm-rest of his recliner. He gathered up the dishes and carried them into the kitchen. I sat on my heels until he returned, blissfully doing nothing but digesting.

"You're not really fitted out right yet for a dog," Terry said as he dumped leather gear on the floor beside me. "I need to make some adjustments." He removed the manacles and leg irons, setting them aside. "Hmm . . . I guess I'll leave the boots, to protect your toes, but pretend they're paws. Here, put these on, boy," he added, tossing me a pair of leather kneepads.

After those were on, he strapped bondage mitts onto my hands, which I had to curl into fists. It did make them look a little like paws — and they may as well have *been* paws for all the good my fingers and opposable thumbs could do me.

"Now you look more like your name, boy. Get up on your hands and knees, Mutt. Look sharp, now. Wag your tail."

Although a shiver went through me at being called "Mutt," I complied, barking when I was in position. But I had no tail to wag. Checking my ass, Terry noticed I'd left the butt plug in.

"Guess you like having your ass stuffed, don't you, boy?"

"Arrff! Rruff!" *Dog or boy, I sure do!*

"That's good, but I have something else to put in now."

He smacked my asscheeks several times to loosen them up and pulled out the plug with a pop. He showed me its replacement: a longer, equally thick plug adorned with a hairy tail sticking out of the end. I lowered my head to the floor, whined, and covered my eyes with my paws. Terry only laughed at my mime of canine embarrassment.

"Don't be silly, Mutt. You'll love it once it's in. I promise."

"*Oww-oooo!*" I howled.

"Don't give me a hard time, you mongrel. Just hold your ass still and relax."

He softened up my ass by packing in lube with his fingers before trying to insert the tailed plug. But once he had it started, he just shoved steadily until the neck passed my sphincter and my asslips closed around it. It hurt at first but soon felt good.

"All set," Terry said. "*Now* wag your tail for me."

I felt my face flame red as I shook my ass.

"Excellent," Terry said and stroked my hair. Picking up the end of the leash still clipped to my collar, he added, "You need exercise, Mutt. Follow me."

He walked slowly around the room, and I followed him on hands (or paws) and knees.

"Good boy, that's good," he said to encourage me — and slipped a chewy candy in my mouth!

Soon he picked up the pace so I was practically trotting at his heels as we went round and round the large room, easily missing the relatively few pieces of furniture.

"Pretty soon, boy, you'll be ready for a run out in the yard." Somehow the prospect didn't fill me with joy. "Now turn the way I signal with the leash."

He soon had me zigzagging and switchbacking to a fare-thee-well. By the time he'd had enough, I was getting dizzy. He stopped and patted my head, slipped me another candy, and led me back to his chair.

"Lie down, Mutt. No, not that way — on your belly."

He moved me into the position he wanted, beside his chair, with my head between my "forepaws" and my "tail" down between my splayed legs. In the process, my cock got hard again. It had been relaxed while we ate and during the "exercises," but as soon as I felt Terry's hands on me, it stiffened right up. He tried bending it backward, pointing toward my ass, but I whimpered and jiggled my tail so much that he let it snap back under my belly. He laid the leash on the floor beside me as I quieted down.

"That's right. Good boy, good dog. Stay there, Mutt."

He went over to the stereo controls and put on some soft music — I paid no attention to his selection, being a dog and presumably uninterested — then got himself a book and a pipe before coming back and sitting down.

Will he take off his boots and have me bring his slippers next? But I played along. Even though part of me found all this pretty ridiculous, another part obviously enjoyed it, or my dick wouldn't have stayed hard. I sidled closer to Terry on my belly and rested my chin on the toe of his right boot, looking up at him with as doggy an expression as I could manage.

He noticed and smiled. After taking a puff from his pipe, he put it aside and reached down, directing me with his hand to turn over on my back. I kept my knees and elbows bent like a dog's legs, and he rubbed and patted my belly and chest while I whimpered in pleasure.

"*Woof! Wrruff!*" I barked.

"I know, boy. Feels good, doesn't it?"

Damn if it didn't — despite having already shot twice that day, my hard cock was dripping with precum again. Terry teased the head of it with his fingers, making me whine in helpless ecstasy, and stuck his hand in my mouth so I could lick it clean.

"Okay, Mutt. Turn over and jump up here. Come on, give me a kiss."

The connections in my brain buzzed confusingly for a moment until I figured out what he wanted. Then I turned over, raised myself on my knees, shuffled as close to him as I could get, and pawed his chest. It wasn't quite enough. I strained to get my head up to his face without actually standing up.

He laughed at my clumsiness but cooperated by lowering his head, and finally I was able to give him a real doggy kiss, lapping his face with my tongue. He grabbed me and rubbed our noses together, then pushed my head down onto his shoulder and wrapped his arm around my back, holding me against him. He stroked my back and ass with his other hand, wiggling my tail (making the butt plug probe deeper into my gut) as I panted and drooled on his leather shirt.

"Good dog," he said over and over as I licked his ear. "Good dog, you're such a good dog, Mutt, and I love you."

I thought I heard a catch in his throat and looked at him sharply. There were tears in his eyes! *I have no idea what this means to him*, I realized. *Better tread softly — very softly.* I licked his cheeks again and actually tasted a tear as it fell. I tried to lick his eyes, but he grabbed the back of my head and put my face down on his shoulder again.

"It's okay, boy," he said in a soft, tentative voice. "Nothing to worry about. You've just made me very happy."

"Aarrff! Woof!" I barked softly. I felt I would do anything for this man, now that he'd let me see his vulnerability. *If it makes him happy for me to be a dog, then I'll be the best damned dog in the world!*

"Okay, that's enough. Down, boy," he said in his usual firm voice a few moments later. "Lie there at my feet while I read and smoke."

I scrambled down, giving his face and throat a couple of last swipes with my tongue and licking my own precum off his leather pants where it had leaked from my cock. I settled on my belly across the front of his chair behind his boots. I twisted my head to lick the back of the nearest one, and Terry moved it a few inches so I could lay my paw on the toe and my face at the heel. He propped his other boot on my butt. *Ahhh!* I closed my eyes and let my muscles relax as much as possible. I could sniff the sweet-smelling pipe smoke curling in the air above me. With the music, I couldn't hear him turning the pages of his book, but I imagined it, and thinking of my man's . . . my Master's contentment, I fell peacefully asleep.

I slept lightly, opening my eyes every time Terry moved his feet or shifted in his chair, then drifting off again when he seemed to be settled. It was only when he snapped the book closed that I came fully awake again.

"Come into the kitchen, boy, and keep me company while I clean up the dishes from dinner."

"*Woof! Rruff!*" I barked as I stretched my muscles, or as much as I could while staying on hands and knees.

Terry picked up the leash again, and I followed his lead, trying to seem frisky and doglike. I was glad of the kneepads he'd given me when we moved from the living-room carpet to the parquet floor in the dining room and then the kitchen's ceramic tile.

I was starting to feel a little guilty at the thought of him doing the cleanup while I lazed around, but he let me know that I had my job, too.

"Here, Mutt," he said, unclipping my leash and holding out

a rubber bone in one hand and a ball in the other hand. "Just don't get in my way."

Determined not to sink this fantasy, I took the bone between my teeth and shook it, growling. Terry set the ball down and turned away. I proceeded to worry the bone from one end of the kitchen to the other. From time to time I'd drop it, look up as if puzzled, and go hunting for the ball. When I found it, I'd push it gently with my nose until it started to roll, then go galumphing after it, barking and carrying on. Out of the corner of my eye I tried to gauge the effect my performance was having on my audience, but all he did was smile down at me as he worked.

My back and arms started to hurt after 10 or 15 minutes of this doggy exuberance, and I hoped Terry was almost finished. I padded over to where he was standing and dropped the bone at his feet, my tongue lolling. He smiled, ruffled my hair, and said, "Good dog — lie there," pointing to a space on the floor just a couple of feet away.

Soon he slammed the dishwasher door shut, switched it on, and dried his hands with a satisfied flourish.

"C'mon, Mutt," he said as he headed to the glass doorway into the garden, not bothering with the leash this time.

I padded behind him on all fours, not especially thinking of where we might be going. Since I wasn't on a leash, I felt free to make little doggy detours, sniffing and exploring whatever caught my eye at ground level as we crossed the landscaped atrium of his house. The sky above us was black, but light spilled through the window walls of the rooms we'd just left, strings of little lamps outlined each pathway, and other, larger lights glowed among the greenery. Terry was indulgent and only snapped his fingers to bring me back to his heel when I lagged too far behind.

CHAPTER 27

Three slaves in one

Although the floor-to-ceiling drapes on the garden-side wall were drawn wide, the room we entered was dark, so I didn't recognize his bedroom until he turned on the inside lights. Besides, I was so caught up in being his dog that the location didn't register immediately as anything special. Terry lay down on his huge bed, which was neatly covered with a gold and gray quilt, not the black leather spread I remembered from my first visit. He propped his head up with pillows and patted the quilt beside him.

"Up here, Mutt," he said.

I tried to leap onto the bed like a dog, but lacking a dog's powerful hindquarters, or the nails in its forepaws, I got only partway up and slid off. I tried again, and the same thing happened. Finally I got far enough onto the bed to pull my hindquarters aboard one knee at a time. I crawled belly down over to my Master, who was laughing in delight at my performance. I licked at his face and pushed my head into his armpit to show my affection. Still laughing, he grabbed me and rubbed noses again before making me lie down where he wanted me, with my chin on his left thigh, my arms bent at my sides so my paws were close to my shoulders, and my nose aimed at his crotch.

"Good dog, such a good dog. You're just the best dog," he repeated, rubbing my back and patting my head.

I pushed my head closer and licked at the fly of his leather pants (his cock was half hard, like mine) while wagging my tail — which caused the plug to gyrate in my butt, stiffening my cock.

"Mutt's a good name for you, boy," he said. "Much better than Matt — when you're a dog. You like it, don't you, boy?"

"Arrff!" *Better than Rover or Towser,* I said to myself.

"Mutt's a great dog," Terry went on. "A much better dog than I expected. He must have had some prior training..."

"*Rrruuf! Woof! Woof!*" I interrupted, shaking my head.

"...or maybe he just comes from good stock," he continued, unruffled.

"*Arrrff! Arrff!*" I affirmed proudly.

"Anyway, I'm very pleased," he said, as if thinking aloud and not addressing me at all. "I've wanted another dog ever since I got my own place in the city and had to leave my German shepherd behind with my folks. But it wasn't practical to bring him with me then, since I either worked late or went out to the bars and sex clubs almost every night, and it still wasn't when I moved out here. I travel too much — it wouldn't be fair to keep a dog and not spend time with him every day. That's why I'm so glad Mutt can visit me occasionally — I'm sure he'll enjoy romping around this place more than being cooped up in Matt's apartment. We're going to have *lots* of fun together, aren't we, boy?"

He vigorously rubbed my head and ears as he spoke, then smacked my butt for emphasis when he finished. I lifted my head and looked at him cockeyed, the way a dog might who isn't quite sure what his Master wants from him. I really needed a pair of movable ears to create the full effect, but he caught my drift and laughed happily, though he grew pensive again soon enough.

"On the other hand," he said, "there are things I like to do that you can't do with a dog, no matter how smart he is — and Mutt's real smart, aren't you, boy?"

"*Woof! Rrruff!*"

"That's right, that's right," he soothed, petting me.

I let my tongue loll out, dribbling on his leather, as I listened carefully for more clues to what he wanted.

"Yeah, Mutt's a smart dog, but he's still an *animal*, not a person. I don't fuck animals, for instance, and I'd never dream of tying a dog up, or whipping him, just for fun. That wouldn't be right. Oh, I'll *punish* a dog if necessary, to train him to behave the way I expect, but I could never play torture games with Mutt like I do with Matt."

I whimpered quietly and rubbed my nose against his stomach to indicate that I understood and accepted the guidelines. No sex for Mutt, no bondage or s/m scenes, nothing that might distract me from just *being* Mutt — which was a pretty "heavy" scene

all by itself. Already I was able to find the right canine reaction to one of Terry's ploys without a lot of thinking about it. My performance as Mutt was becoming more spontaneous, seeming to flow naturally from somewhere deep inside myself.

We lay quietly for a few minutes, Terry continuing to pet my head and back with smooth, even strokes. I was starting to doze off when he spoke again in the same easygoing, ruminative tone as before.

"Sometimes I can't get all I want from Matt, either, though." I stiffened at that, wide awake and not at all sure I liked where he was headed. "Easy, boy," he said, still petting me, "calm down. It's nothing you need to worry about." When I was relaxed again, he continued.

"Matt has a strong personality," he said, again as if he was talking to himself and merely letting me overhear him. "Most of the time I like the way he stands up to me — even when he's submitting, it's as if he has to struggle to *contain* himself in the role of a slave. He *wants* to surrender — he knows he needs to, and he knows how good it feels once he does let go — but there's always that element of struggle.

"Over time, as we get to know each other better, I think it will be easier for him. Meanwhile, his feistiness is nothing I can't handle. On the other hand, sometimes I won't have the time, or patience, or energy to deal with it. Sometimes I won't want *any* kind of a struggle. I'll just want to play with my slaveboy, or have him service me, without any resistance or effort. No questions, no embarrassment to work through. And sometimes . . . sometimes what I'll want isn't a partner at all, but a punching bag or whipping boy, or a self-effacing servant who'll gratify my every whim without my having to think at all about *his* needs"

If I whimpered again, let alone barked, he might take it as a complaint, but it was really hard *not* to react somehow while listening to Terry describe what he felt I couldn't give him. *Is Philip going to be his slave again after all? Or is there someone else he's been training? Maybe he plans to alternate us?* A low growl involuntarily emerged from my throat.

"Easy, Mutt, it'll be okay," he said. "Trust me."

I barked, once, and then settled down to hear the rest.

"I know how risky it is to exercise that kind of power over someone," he continued as I fought for self-control, "and I also

know how hard it is for anyone to achieve that level of submission. Expecting a slave to stay at that level all the time is why a lot of relationships go sour. Even slaves need breaks from time to time, need some space to focus on themselves. Matt surely does! He's doing a good job of acting like a slave, but I think he's counting on not having to keep it up all the time."

That hit so close to home, I whimpered.

"Yes, boy," he said. "It's okay. Relax and listen. . . . Whenever I suggest some deeper submission, something open-ended and unpredictable, Matt gets scared and backs off. But owning a slave part time makes no sense. If I *own* a man, he's mine all the time, whether I'm actively using him or not. I'm not going to negotiate a schedule for his service, like I do with my housecleaner. . . . So I have this dilemma: How do I turn Matt into a real slave without destroying what attracted me to him in the first place?"

I was near tears, I was so upset and frustrated at this escalation of his demands. *I thought I was doing well and was pleasing him. I was happy! And then, with no warning, he throws me this curve ball.* Not knowing what to say, I didn't say anything, just lay there, mute and unmoving, as Terry wordlessly unbuckled my front paws — the bondage mitts — and the knee pads. He even removed the tail from the end of the butt plug. Mutt was gone. I was still collared but otherwise unrestrained.

Terry unbuttoned his leather shirt and pulled it open. "Get up here and lick my tit," he ordered.

Responding automatically, I straddled his leg and scooted up until my mouth was on his left nipple, tonguing it gently.

"Play with the other one with your fingers," he directed. "Lightly! That's right. . . . That's nice, just keep that up."

The sweat-and-leather smell from his nearby armpit was intoxicating, but I stayed focused on his nipples, tonguing and sucking one as I rolled the other between my fingers. My naked body settled against his leathers, and my cock expanded between my belly and his, probably leaking precum onto his shirt. While his taste and smell filled my brain, his left hand was stroking my ass and playing with the end of the butt plug, twisting it around and poking it deeper inside me. I was so turned on that I could barely remember what I'd been so upset about just minutes earlier, so it took me a little while to catch up when he spoke again.

"You see, Matt — you *can* respond like a proper slave, with-

out self-consciousness, without trying to second-guess your orders. You heard what I wanted and instantly did your best to comply. You didn't stop to think about it at all. But now that you *are* thinking about it, I'll bet you *enjoyed* snapping to like that, just like you're enjoying serving me now. Am I right?"

Did I enjoy obeying him unself-consciously? I stopped licking his nipple and stared into space, stumped. My left hand, as if on autopilot, kept stroking and kneading his right nipple.

"Sir, I'm confused," I said finally. "How can I know what I felt if, as you say, I wasn't thinking about what I was feeling? And anyway, Sir, how is what I just did so different from other times when I've obeyed you promptly, without hesitating or raising objections? I know there've been *some* times like that! And, yes, I do enjoy serving you, Sir — if that matters."

I put my mouth back on his chest, switching to the right side and using my right hand on his left nipple.

"You know it matters a great deal to me, Matt," he said. "I'm trying to help you, boy, not make difficulties for you. Sit up. Look at me!"

I pulled my mouth off his chest and sat back on his thigh. Staring into his eyes, I saw no anger or disappointment, just concern, tinged with amusement.

"Did you think I was criticizing you?" he asked. "Or rejecting you?"

"Well . . ."

"Give me a *little* more credit, boy! I know you have a hard time being a total slave constantly, and I'm trying to explain that you don't have to be. We'll take the most submissive part of you and separate him out, the way we did with Mutt. He'll be the selfless, unconditional, no-limits slave you'll never be because you think too damn much. This slave looks exactly like you, Matt, but in here," patting my head, "he's simpler, less conflicted. He has a lot less ego, and no false pride at all. He does exactly what I tell him, instantly, and he trusts me absolutely. He knows I take good care of my property, and he knows that's all he is."

"And then what'll *I* be, Sir, as myself?"

"You'll be Matt Stone, the pushiest bottom in New York, and one of the best, too. But you'll also be my boy, and you'll do whatever I tell you, too — unless you can talk me out of it."

He was grinning openly now.

"Can I still call you 'Sir'? And 'Master'?"

"That would please me very much, Matt."

"And this other character, Sir, my total-slave self? What's he called, and when does he take over?"

"I'll call him 'dickhead,' since you've already accepted that name, though he also answers to 'boy' or 'asswipe' or 'scumbag' or any other name I want to use. Like Mutt, dickhead appears only when Matt and I are together, and only when *I* decide I want him; he doesn't exist the rest of the time. All he cares about, or thinks about, is serving me and my dick."

I continued to look at Terry, mesmerized, as he described dickhead's character and rules of behavior.

"My slave dickhead never uses the first person, and he almost never talks unless I ask him a question. He keeps his eyes down, his legs apart, and his holes ready. If I haven't dismissed him but have no immediate use for him, he waits quietly on his knees, out of my way. His hands are always behind his back unless he's using them to serve me or I've restrained him some other way. He never touches his cock, and he never gets to come, unless it happens involuntarily while I'm fucking him."

I had to keep reminding myself that Terry wasn't talking about me, Matt, but only a *part* of me. As he went on, I felt relieved and grateful that he hadn't tried to impose such a strict regimen on me — except dickhead *was* me! It was only an act of imagination that separated us. *This sounds a lot harder than being Mutt! I guess it depends on how much of the time he wants me to be dickhead and how much I can be Matt.*

"He never uses the furniture," Terry went on, "or sleeps anywhere but on the floor or in a cage. He has no right to refuse anything I want to do with him, and he's punished if he doesn't address me as 'Master' at least once in every sentence. But no matter how rough I am on him, he's completely loyal and obedient.... Isn't that right, dickhead?"

Terry's tone of voice had been hardening with each draconian rule he laid down, and the sudden query was positively imperious. *Once again, he's taking a big chance on me*, and once again I quickly decided that letting him down wasn't an option. *Maybe it wasn't such a risk after all? He knows me by now!* I dropped my eyes, clasped my arms behind me, and took a deep breath.

"Yes, Master!" I responded firmly. *I can do this*, I told myself.

"Get down and lick my crotch, dickhead," he commanded, and I immediately lifted my ass off his thigh, scooted back, and got my mouth down onto his stiffening, leather-covered dick. My own dick, fully hard again, was scraping on the laces of his left boot.

"That's right, that's the way," he encouraged me, still in the same stern tone. "Keep on licking until I say different. You don't do *anything* unless I tell you to, dickhead, except breathe — and sometimes not even that."

My mind was a swirl of emotions, but I forced them to the edge of consciousness as I strove to concentrate on my — that is, dickhead's — steady crotch service. I tried not even to think, just lick. Except for the slurp of my tongue on leather, there was silence for a couple of minutes.

"Yes, dickhead will do fine," Terry finally said in a more re-laxed tone. "I'm going to enjoy owning him and using him as much as I enjoy my dog Mutt, but in an entirely different way. They mean different things to me, satisfy different needs, just as they represent different parts of you, Matt."

I lifted my head and looked at him, chancing punishment for disobeying his order. But the order to keep licking had been given to dickhead, and he'd just called me "Matt."

Terry was grinning crookedly, his eyes shining.

"Yes, you're still Matt, too," he said. "Matt's never very far away. After all, he's the man I fell in love with."

"I love you, too, Sir." Tears welled in *my* eyes now.

"I know, Matt. Now let dickhead get back to work."

I bent my head again to his crotch, where his cock was distinctly harder than before. Being dickhead was already easier now that I was sure I didn't have to give up being Matt. *This is going to work*, I thought, then stopped thinking and just licked leather.

"I don't know if Mutt and dickhead are the only additional personas we'll pull out of you," Terry said, "or if more will emerge later. I'm not looking for any others, but you never can tell. The three of you will probably be enough to keep things interesting! And don't think your alter egos are in watertight compartments, either. I expect you to be able to switch between them in a moment, like *that*," snapping his fingers, "the way you did just now. Is all this clear, Matt?"

"I think so, Sir."

I paused before going back to crotch-licking. Terry, of course, immediately picked up on the hesitation.

"And . . . ?" he asked. "Stop licking and look at me."

"Well, Sir," I said deadpan, my head raised, "I think Mutt and dickhead have the better deal."

He was hooked. He raised his eyebrows and stared at me.

"Explain," he snapped.

"I just mean, Sir," I told him, "that they get to spend *all* of their time with you. Whereas I, Matt, spend most of mine in another county — or even farther away when you're traveling. So it's like I have *four* personas, Sir: Mutt, dickhead, Matt when he's with you, and Matt alone — or with other people, which is the same thing as far as we're concerned."

I looked him straight in the eye during this speech, raised one eyebrow, and then calmly went back to licking his crotch.

"What *am* I going to do with you, boy?" Terry asked, chuckling. "Should I hug you or slap you silly?"

"Why not both, Sir?" I said, looking up at him and grinning. We both broke out in helpless laughter.

He reached under my shoulders and tossed me on my back next to him on the bed, then rolled himself over and straddled me, with his knees on either side of my torso and the heels of his boots digging into my thighs. That put his butt right above my erect cock, but somehow I didn't think he was planning to let me fuck him. He grabbed my wrists and crossed them above my head, holding them down with his left hand. After slapping both my cheeks, hard, with his other hand, he leaned down and practically raped my mouth with his lips and tongue — a rape I thoroughly enjoyed!

"What *do* you want, Matt?" he asked when he came up for air. "To move in here with me? I've told you why you can't."

"I know, Sir," I replied, staring into his eyes a few inches above mine, "and that's fine with me. Moving in with you would take some of the fun out of visiting, Sir — and I'd hate to have a two-hour commute to work." I grinned at him. I knew he realized that I'd happily put up with a lot more than a two-hour commute to be with him full time if he wanted me there.

"But it'd be nice if I had something to remember you by back in the city, Sir, something I could feel or see — besides my bruises — and know I'm yours, Master."

"Like what?" he growled, sitting back on my crotch and bending my cock in two under his leathered ass. I yelped, and he grinned and reached under himself to straighten it out, which felt a *lot* better!

"You were saying . . . ?" he prompted me.

"I wasn't asking for anything specific, Sir, just some sign of our commitment that I can see and feel when I can't be with you. Something permanent, Sir. A collar I could wear full time, maybe, or a tattoo or piercing."

"You want me to pierce you? I thought you hated needles."

"I *do*, Sir. I can't say a piercing would be my first choice, Sir, but if you decide that's what's most appropriate, it's okay with me. Just be sure and blindfold me first, and don't let me know what's coming, so I can't chicken out."

Terry laughed again.

"I'll think about it, boy. You *will* have some new everyday rules to help you remember what you are — I'll go over that later. Maybe a more concrete token isn't a bad idea, but remember that you're still on probation. I haven't made a final decision yet whether to keep you, and you haven't made a final decision yet whether to give yourself to me."

Speechless, I stared at him, my eyes brimming again. The idea that he might still give up on me was devastating. As we looked into each other's eyes, his expression softened, and he bent down to kiss me, tenderly this time.

"Yes, boy," he said, "I know it feels as if the decision has already been made, and maybe it has. Right now I can't imagine anything that would make me give you up. Nonetheless, you still need more training, or at least dickhead does. Besides, I promised you a heavy bondage weekend. I wouldn't want you to tell your friends I copped out and went all mushy on you!"

That was unworthy of a reply. I looked at him with my own version of his crooked grin. He laughed, then took the keys off his belt, unlocked my collar, and lifted it off my neck. Rolling away from me on the bed, he lay back and gave me my orders.

"Get your ass into the bathroom. Take out that butt plug and give yourself a hot shower. Do whatever else you need to, and then get back here. dickhead and I have a date in the dungeon. Use the gray towel, remember."

CHAPTER 28

On a tighter leash

I returned from the bathroom around 20 minutes later. It felt good to be clean again! The room was warm enough for me to be comfortable naked, but Terry must have felt too hot in his leathers — particularly because he'd been busy in my absence. Half a dozen pairs of his boots were set out along the foot of the bed, and a pile of gear was on the bed beside him. He was lying there with his eyes closed and his shirt off. When I got close I saw beads of sweat on his chest and face.

My first impulse was to climb up next to him and lick them off, but I remembered in time that I was supposed to be dickhead, not Matt. I stood humbly at the side of the bed, legs apart, arms crossed behind my back, head bowed, waiting for instructions. My cock, of course, being completely foreign to the idea of humility, let alone propriety, jutted out from my stubbly pubes at a proud angle.

"C'mere, boy," he said when he opened his eyes and saw me. I scrambled onto the bed and knelt at his side.

He picked out my collar from the pile of gear and held it open in his two hands. I lowered my neck onto it so he wouldn't have to get up, and I kissed his palm in gratitude when he stroked my face after locking it on. I wondered for a moment how Matt, Mutt, and dickhead could share the same collar when we were so different, but then realized, *we're all his property*, so it made a kind of sense — *as much as any of this does!*

"You'd better get that thing soft somehow," he said, tapping my hard cock. "I have a chastity jock to put on you, and I don't think those swollen nuts and sausage will fit through the hole the way they are."

425

Alone at home, I could induce an instant hard-on just by imagining kneeling naked in front of Terry as he prepared me for a bondage session, so it was no easy task willing my cock to go soft in his presence while anticipating whatever he had planned for dickhead in the dungeon! I summoned up every anti-erotic mental image I could think of, but my prick stubbornly refused to cooperate.

Finally he got tired of waiting and grabbed my balls, squeezing them hard enough to bring tears to my eyes and then shoving them, one at a time, through the hole in the stiff leather backing plate of the jock. The pain was enough to make my cock droop, and he seized it and shoved it through the hole almost faster than I could react. It stiffened up again as soon as it was through, of course, but that only made it easier for him to strap it down.

When he had all the straps tightened on my now upward-thrusting cock and skin-taut balls, he pulled up the zippers on both sides of the jock's leather-covered steel front plate and fastened their ends to the waistbelt with a pair of tiny padlocks. With a third lock at the center of the top edge of the cover plate, I was effectively denied any direct contact with my own genitals. Of course, as dickhead I wasn't allowed to touch them even if I could — I felt a flash of guilt as I remembered soaping my crotch in the shower. *Should I confess it?* But he gave me no chance.

"I hope you emptied yourself out in there," Terry said as he locked the buckle on the back of the waist strap, "because you can't go with this on, and I'm not taking it off for a while."

"Yes, Master, my . . . your slave's bladder and ass are empty, Sir." *Almost blew it there!*

"Good. Bend over and give me your ass. I have another plug to put in — don't want your asshole to get itchy from neglect."

I caught his grin before bending over but, given what he'd said about dickhead's character, kept my own face expressionless. *I love how he takes this stuff seriously, yet can still have fun with it.*

I'd used my hands for balance as I got my ass in position for him and left them at my side. He quickly corrected the lapse, reinforcing the order with a sharp smack on my ass.

"Cross your hands behind your back again. Always keep them behind you like that, dickhead, unless you're working and need them or I have you restrained some other way."

That's the second time he's told me, I noted. *Must be an important rule.* It was.

"Listen up, Matt. I'll explain this so it's easier for you to remember. Keeping your hands behind your back whenever I have no other use for them is an essential part of slave training. It not only leaves the front of your body defenseless before your Master, but it also reinforces, all the way down at the level of your muscles and nerves, that you're not free to act on your own but must await my instructions. Understand?"

"Yes, Master, thank you, Master."

"See that you remember it, slaveboy."

The new butt plug was as thick as the one Mutt's tail had been attached to, which I'd taken out in the bathroom, but a little shorter. I figured it was probably the same one he gave me in the dungeon after brunch. At first I struggled to open up for it but soon realized that only made it worse — *not* trying was more effective than trying. I let myself go limp as Terry worked my hole, and soon my asslips closed over the plug's narrow neck with an audible *plop*.

It filled me comfortably, and I started to sigh in contentment before catching myself. I didn't think dickhead was allowed to have personal feelings, or at least to express them. *How am I going to manage that?* I worried. *Can I ever stop thinking of myself as "I"?* The question itself showed the difficulty!

Terry pulled the ass strap dangling from the front of the jock tight between my legs and over the end of the plug, attached it to the waist belt, and secured it both at my waist and my hole — I heard two lock clicks, anyway, and every time the strap shifted afterward it pulled a little on the plug. It felt good having my cock and balls strapped down and my ass filled again, but I — or dickhead — managed to keep quiet about it. While I was still bent over on the bed, Terry fastened some kind of leg irons on my bare ankles. They felt much lighter, thankfully, than the ones I'd gotten used to wearing over boots.

"All set, dickhead," Terry said, smacking my ass and hauling me up to my knees on the bed beside him.

He jiggled the front of my jock, painfully pulling on my nuts — "Seems good and tight," he said, grinning — then twisted my nipples until I remembered to drop my eyes.

"Give me your hands," he ordered, and as soon as my arms

were in front of me, he locked Darby-style cuffs on both wrists, connected by a light chain about a yard long. The cuffs felt like the ones on my ankles, so I figured they must all be the same pattern. Terry fastened the manacle chain to the D-ring at the front of my collar with a heavy padlock, large enough that the chain moved easily through the lock's shackle. The body of the lock slapped against my chest whenever I moved.

"Get down there and take my boots off, boy."

I went to my hands and knees on the bed and turned myself around to crawl toward his feet, but I was barely underway when he shouted, "Halt!" *Uh-oh! Fucked up already!* I stopped instantly, wondering what I'd done wrong.

"Turn around, dickhead! Where'd you get the idea that you could turn your back on me? Is that how you show respect for your Master?"

I turned around and quickly laid my head on the bed, ass up, ready for punishment, hoping that would appease him.

"Are you asking me to punish you, dickhead?"

"Yes, Master, if it would please you, Sir."

"I already told you it doesn't, boy. Oh, it pleases me plenty to beat you, but I want you to welcome the pain, not fear it. Punishing you is something else entirely. I'll do it only when I have to, if you need it to help you remember how to behave. So tell me, dickhead: do you need some help to remember this rule?"

He's putting all the onus on me! Does he want me to beg for it? Will that turn him on? Except this didn't seem like s/m "play" — I certainly wasn't turned on, and I heard none of the glee in Terry's voice that accompanied his "sadistic" announcements. I'd let him down, even if unintentionally, by acting like Matt when I was supposed to be dickhead. I needed to set it right. Nervous about what I might be letting myself in for, I framed the request:

"Master, your slave humbly begs for correction to help him remember his place."

"Okay, dickhead. Remember, you asked for this!"

I heard and felt him getting off the bed, then the ominous *whoosh* as he pulled his belt out from his pants. Unlike the belting in the dungeon earlier that day, or even the "attitude adjustment" in my apartment a few days earlier, the only other times he'd belted me bare-ass, there was no warm-up, no erotic foreplay.

Thwack! He laid a stripe of fire across my back, from lower

left to upper right. *Whack!* A second fiery lashmark crossed the first. *Whap! Wham!* He laid a quick pair straight across the middle of my back, knocking all the breath out of my lungs and making my head swim with the pain. I grasped the difference from a "play" beating immediately.

"Now five on your ass, slave. Count 'em!"

Whack! "One, Master! Thank you, Master!"

Slam! "Two, Master," I sobbed out. "Thank you, Master!"

Whap! "Aauggh! Three, Master! Thank you, Master!"

Smash! "Four, Master! Thank you, Master!"

Wham! "Aiieee! Five, Master! Thank you, Master!" My ass blazed, and these lashes hurt all the more because there'd been no undercurrent of joy in their delivery.

"What do you say, slave, after making me punish you?" he demanded, pulling my head up by my hair and glaring at me.

I hated how he looked at that moment — *Is this the man I've come to love? Which is his real face?*

"Master, your slave is sorry for disappointing and inconveniencing you." And, boy, did I mean that! I hoped never to see this side of him again, while fearing that I'd see plenty of it before dickhead was fully trained. "Master, your slave is grateful for the correction and will remember never to turn his back on you!"

"That's good, slaveboy. It's over now." He lay down on the bed again. "C'mere," he said, and I moved toward him. He pulled me up against his chest, cradling my tear-streaked face against his shoulder. Gently he stroked me and murmured soothing words.

"It's okay, boy. You had to learn what it's like. You did fine. You can talk to me, Matt. Tell me what you're feeling."

"I'm confused, Sir! You never hit me like that before — it was awful, like you were someone else, someone I don't even like. I'm sorry I made a mistake, Sir, but do you expect me to be perfect right at the start?"

"No, boy. I told you I don't expect that, and neither should you. That's what training is *for*, to direct your responses and behavior over time toward what I want you to become. Usually I'll simply tell you when you make a mistake, because I know you want to do your best for me. Look at me, Matt."

I bent my head up and looked into his beautiful hazel eyes. He was back now — "my" Terry, the man I loved, not dickhead's stern Master.

"I'll never punish you, Matt," he said, "the way I just punished dickhead. I don't expect to punish Matt at all — positive reinforcement should suffice. But dickhead sometimes *needs* the strap; he'd be disappointed in me if I couldn't enforce my orders that way. It's part of who he is — and that means it's part of you. D'you understand me, Matt? Sit up and let's talk about this before it becomes a problem." He reached for the pillows and stuck two of them behind his head.

"I don't understand it, Sir," I said as I sat back on the bed next to him, my welted ass throbbing against the soft quilt under me. "Isn't dickhead just as eager to do his best for you as I am? Is he supposed to be a rebellious, recalcitrant slave, Sir? Is that what turns you on? Being able to smack him down?"

"God, no! . . . Feel my cock, Matt," he said, pulling my hand over to his crotch. "Does it feel like I'm turned on by disciplining dickhead?"

"Not now, Sir," I conceded after feeling his cock through the leather pants. It wasn't completely limp, but it wasn't hard, either. "Were you earlier?"

"No, boy, I was not. I felt it needed to be done, to clarify your role, but I didn't enjoy it at all. . . . Okay, that's a half truth," he said with a rueful grin. "I do enjoy owning a slave like dickhead, and disciplining and correcting him is part of the package. But it's not the discipline itself that I enjoy!"

"Why not, Sir? In all the porn stories, that seems to be the main thing Masters get out of it — they're always giving impossible orders so they can smack their poor slaves around when they fail to perform."

I grinned to show I was just playing devil's advocate.

"Have I ever given you an impossible order, Matt?"

"Umm . . . no, Sir, I guess you haven't."

"And I never will — at least not deliberately! Why should I need an excuse to beat or torment you? Since you're my slave, and a masochist, just wanting to do it is enough. Either you'll get into it too, or you'll go along to make me happy, right?"

"Yes, Sir, of course. At least I'll try. I suppose it's *possible* that someday you'll want to play and I won't be able to get into the mood . . . but you always seem to know how to fix that, Sir!"

"That's my job, boy. Masters of consensual slaves are seducers, not enforcers. I know I could lose you if you ever stopped

wanting to obey me, so it's my job to be sure that doesn't happen. I'm probably crazy for admitting it, but I expect you'd figure it out for yourself anyway."

"Guess we slaves have a lot of power too, Sir! And here I thought it was all about giving up control and becoming open and vulnerable."

"It still is. Your power is your ability to surrender, to voluntarily make yourself vulnerable to me — and to your own needs and hidden desires. Keep on giving yourself to me, and you'll find that there's always more to give. There are depths in you that you could never reach except through surrender. My role, and my pleasure, is to keep drawing more out of you, as from an inexhaustible well."

"I don't feel inexhaustible, Sir. You keep pushing me to my limits, and I'm afraid of failing you by not being able to go any further."

"But you always do, don't you? You keep springing back, ready for more. Do you know why?"

"No, Sir."

"I think you do: you're drawing on *my* energy, absorbing the force I pour into you when I beat you or fuck you or piss on you. The energy exchange is never one way — we feed on each other. That's why this works between us. If the circuit broke, if you ever shut down, stopped flowing for me, that would mean I wasn't feeding you, either. I've learned my lesson, and I'll never ignore that kind of warning sign again."

"I . . . I think I understand, Sir"

"But? I hear a 'but' there, Matt. What's troubling you?"

"What about dickhead, Sir? It's hard to see how I, Matt, can be your slave if I'm also dickhead, who's more of a slave than I could ever be."

Terry chuckled. "It's a metaphor, Matt. Don't take it too literally. I could have said instead that your normal slave protocol is relaxed and friendly, as long as you're respectful and obedient, but sometimes I want you on a tighter leash, with stricter rules. It's like being a soldier: you can either be at attention or at ease, but you're still a soldier either way and have certain basic disciplines you never forget."

"So dickhead is just me on a tighter leash, Sir?"

"If you find that easier to understand, yes. But for me the

differences go deeper, as I explained earlier. Remember what I told you about him?"

"Yes, Sir: dickhead is me when I'm *nothing but* your slave, with no other life or responsibilities or worries."

"Exactly! Smart boy," he said with a smile. "It's like a shared fantasy we can move into or out of, but at my initiative. When I call you 'dickhead,' take it as a signal that it's safe to let go completely and stop thinking about anything but serving and obeying me. When I call you 'Matt,' it means I want to spend some time with my complicated real-world slaveboy, despite all of his doubts and confusions and opinions."

"Put that way, Sir, it's a wonder you want to spend any time with Matt at all — dickhead is so much more accommodating."

"Don't sell yourself short, boy — or feed me any false humility. I love you as Matt *with* all of your complications and flaws, not despite them. I accept and even relish them because they're tied in with everything else you offer, like being able to surprise me! dickhead can't surprise me. The closest he can come is to disappoint me, like he did just a little while ago, but that's the last thing either of us wants from him."

"But dickhead is a *performance*, Sir, just like Mutt is, something that I, Matt, have to continually think about doing so I can please you."

"Yes and no. Weren't there times when you were Mutt that you *didn't* have to think about being a dog — you just responded like one without thinking?"

"Hmm . . . yes, Sir. There *were* times like that — surprised the hell out of me!"

"I'll bet they did," he chuckled. "They surprised me, too — very, very pleasantly. I thought you might have a doggy persona I could bring out, but I wasn't sure what it would take to evoke it. Turns out you only needed an excuse!"

"And you think dickhead is the same, Sir, a part of me that I just have to let out?"

"Yes, boy, that's what I think — and that's what I *see*, too, when you give it a chance. You *want* that classic slave experience, the kind you've read about, but you're afraid to let yourself go so far. Maybe you're afraid you won't be able to come back? Is that it, Matt?"

"Yes, Sir," I said in a small voice.

He made no response, and the silence lengthened while I turned over all he'd said in my mind.

"Sir," I said finally, looking into his face, "most of the time you make me feel safe, and I can let down my guard. But sometimes you talk like you want me to be dickhead all the time, and that scares me."

"Silly slaveboy!" He reached over and ruffled my hair. "Of course I'd like to have dickhead full time! And I'd like to be really rich and to have houses all over the world, every one of them completely different, and to get the Pritzker Prize for architecture, and to have the body of a 25-year-old with the sexual stamina of a teenager. Oh, and to be invited to cook for the Chevaliers du Tastevin, let's not forget that!

"But none of that is going to happen, and I can't live my life hoping for the impossible. I'm very happy to have you as my slaveboy and dickhead as a fringe benefit. You can trust me to know the difference. Since dickhead is only part of you, trying to have him full time would mean I'd lose your company, and soon enough I'd lose you altogether. Don't you think it would be foolish of me to risk that?"

"If you say so, Sir. I'm more worried about losing *you* if I can't be what you want."

"As long as you're obedient, you needn't have any worries on that score. This is just another example of your reluctance to follow my lead without first working out for yourself that you're doing the right thing. The whole point of dickhead is to make it easier for you, boy, not harder!"

"I think I understand now, Sir. Thank you for explaining it to me."

"You sure you're okay?"

"Yes, Sir — for now. I trust *you*, Sir, but I'm not sure how far I can trust myself, especially given all those hitherto unsuspected depths you claim to see in me!"

"You worry too much, boy. Give it a rest! It's Saturday night, and I want to use my slave. Ready to try it again, dickhead?"

I took a deep breath, then said, "Yes, Master. Thank you, Master."

"Then start again from where we were before you took that wrong turn."

I scuttled backward on the bed, head down, making my

slow, awkward way toward my Master's feet under his critical gaze. *It isn't easy being dickhead, not easy at all. He'll use me like he'd use a tool, and with little more thought for my feelings*, I reflected, almost bitterly. *But only the Master's feelings count for dickhead! Always remember that!*

When I could see the toes of his boots, I kissed them, then unlaced the boots and pulled them off.

"Use your teeth for the socks," he said as I reached with my hands.

I bent over the sweat-stained white sock on his left foot, sucked the toe far enough into my mouth to be sure I wasn't biting him, and gripped it with my teeth. It was a job getting it off that way, and for the other one I started at the top and nosed it down his leg first. I tried to do it as efficiently and pleasantly for him as possible. Despite the sweat, his feet didn't smell bad, and the main thing I tasted from the socks was wool.

"Clean my feet, dickhead . . . with your mouth," he added when I seemed to be at a loss about what to do next.

Blushing a little in embarrassment, even though I'd licked his boots any number of times, I bent and took his big toe into my mouth. Despite the lingering pain of my recent punishment, and the implicit humiliation of the foot service, my cock was straining against the leather straps holding it. *dickhead reveres his Master,* I told myself, *and any intimacy with his body is a privilege.*

I sucked his toe as if it were a small cock, licking all around and beneath it, until he cautioned, "Easy, boy! Don't tickle me! Gently does it."

Using just my mouth, keeping my chained arms at my sides, I washed each of his toes in turn — gently — guided by the small sighs and moans of satisfaction I could hear from the other end of the bed. After licking out the sour-tasting crevasses between the toes, I started on the soles and somewhat fallen arches of his large feet, taking long steady swipes with my tongue, savoring the salts deposited by his sweat. He seemed to be enjoying it, too, but after a while he fell silent.

I licked even more gently than before, listening carefully for some order of correction, and heard nothing but the sound of his breathing — until I was startled by what was unmistakably snoring! Glancing up, I saw that his eyes were closed again, and his naked hairy chest was rising and falling in a steady rhythm. I

smiled fondly at him, feeling submissive but not at all overawed, before returning to my foot service, taking care to rattle my chains as little as possible.

I had licked all of both feet twice and was starting on the left one again when he woke up finally, shaking himself and snuffling like a bear. Even though my back ached from bending over for so long, and my tongue was raw, I forced myself to hold still and keep licking, neither stopping nor looking up at him without orders.

He must have been pleased by my self-control, because he said, "Good boy. Now stop licking and put my socks and boots back on."

I couldn't imagine how to do it without hands, so I used them. The manacle chain had been awkward at first, but by then I automatically extended whichever hand I needed while bringing the other closer to my neck, or bent my head toward my work to give maximum slack for both hands. It took longer to get his boots back on and neatly laced than to take them off, but in only a few minutes I was able to kiss the toecaps again and sit back on my heels, head bowed, hands laying on my thighs since I couldn't put them behind me, patiently awaiting my next task.

"Your brother Matt has mostly gotten a free ride this weekend, dickhead." I couldn't resist checking his face at this jibe — the left corner of his mouth was twitching, meaning he was suppressing a grin, so I looked down again without qualms.

"I've played with him but haven't gotten any work out of him," Terry continued. "Slaves should be useful as well as entertaining, so I want you to clean and shine some of my boots while you're locked in the dungeon." He pulled a jumbo laundry sack out from under a pillow. "Here," he said, tossing it at me, "take this and fill it with the pairs I set out."

I took the sack and crawled backward till I could slide off the bed to the floor right in front of the line of boots. Kneeling on the rug at the foot of the bed, I looked them over as I calculated the optimal way to load the bag. The lineup included his Dehner police boots, his favorite old knee-high engineer boots, the police boots he'd worn with his New York City Highway Patrol uniform way back at the Spike (side-laced at the top instead of buckled like the Dehners), a pair of 10-inch-high tan lace-up work boots, black cowboy boots — and black wingtip dress shoes.

The shoes tipped me off: *He's having me clean every piece of footgear he's worn in the times we've been together — except the paratrooper boots he's still wearing. These work boots must be the ones he wore the morning after our very first scene, after I spent the night in the sleepsack, and these cowboy boots look like the pair he put on to drive us back into the city that night.* The shoes, of course, were the ones he'd worn to the restaurant on Tuesday, the very ones he'd made me lick back at my apartment — then beat me so I'd remember he was no less of a topman in them than in his boots. Except for the work boots, which were caked with mud, probably from a construction site, none of them was especially dirty, just scuffed and streaked from normal wear.

I heard Terry get up from the bed, and I adjusted my position as gracefully as possible to keep facing him, following his movements out of the corner of my eye. I put the dirtiest pair in the sack first and was reaching for the Dehners when he walked past me toward the other side of the room. He retrieved his shirt and put it on again, and by the time I finished filling the bag I smelled smoke. I glanced over and saw my Master leaning back in his armchair in front of the glass wall, legs crossed at the ankles, smoking a cigar and blowing rings at the ceiling as he looked out into his private garden.

Should I say something? I wondered when I'd finished, settling on my heels (and wincing from the welts on my ass) as I faced him. *No — better just wait for him to give the next order.* I kept my eyes down and tried to be patient. My cock was still hard inside its prison, but perhaps not quite as stiff as before. Patience is not one of my strong suits — or at least not one of *Matt's* strong suits. *dickhead is patient,* I said silently, trying to hypnotize myself. *dickhead waits on Master Terry's pleasure. dickhead doesn't care how long anything takes 'cause he doesn't have anything else to do.*

Time stretched out as Master Terry enjoyed his cigar, and the sound of my chains jangling seemed unnaturally loud whenever I shifted slightly. Otherwise, the silence seemed to pile up around me in heaps — or maybe it was just the growing cloud of smoke in the room. I strove to empty my mind and simply be receptive, not pushy. It must have worked, too, because I entered a kind of trance — my pulse slowed, my breathing became regular but shallow, my eyes unfocused — as I waited there on my knees for Master's next move.

If he'd simply called out an order, I might have missed it. Fortunately, he stood up first and walked over to me, which jarred me into alertness. When his jump boots entered my circle of vision, I was ready.

"Kiss your Master's boots, dickhead," I bent over and softly kissed each gleaming toe. "That's how you'll greet me whenever I come to you or you enter my presence: kneel, or bend down if you're already kneeling, and kiss my boots. Doesn't matter if it's been five minutes or five hours. Understand?"

"Yes, Master."

"Now get up, boy, and pick up that sack you filled. Double-time — we don't have all night."

Fighting stiffness from the long wait on my knees, I scrambled to my feet. Lifting the sack with both hands, I staggered and realized I'd never be able to carry it that way.

"Sling it over your back," Terry ordered brusquely, but when I still had some trouble balancing — that sack was heavy! — he discreetly steadied me.

Bent over like a coolie under his load, I shuffled after Terry. Instead of leaving the room and crossing the garden to the basement staircase off the kitchen, he led me into his walk-in closet. He pulled up a trap door, revealing his private stairway down to the exercise room/erotic-art gallery.

"You can walk down ahead of me, dickhead. Be careful on the stairs."

Thinking he meant I should go down backwards, still facing him, I started to move into position, but he corrected me, laughing, and even helped steady the bag, which had an alarming tendency to shift from one side of my back to the other as I walked down the stairs. I had no chance even to think about how I was feeling or what I hoped would happen, I was so focused on safely delivering my burden.

At the bottom, he took the lead again as we turned left, out of the exercise room and through the steel door and corridor of bad dreams into his most private space. Terry unlocked and pulled open the wide, ironbound oak door to the dungeon, motioning me inside. Remembering in time, I turned around and walked in backward. He laughed again at my careful, hesitant steps past the threshold, so I wasn't sure if I'd done the right thing or gone overboard. A single light had come on when the door opened,

and after following me in, he flipped on more lights from the control panel.

"Put it there," he said, pointing to the floor in front of the raised platform I privately called his oasis, "then get your ass back outside."

He turned and strode out the door, leaving me to wrestle the sack as well as I could down the short flight of steps and over to where he'd indicated. I set it down and, taking advantage of my brief solitude, stretched and rubbed my arms.

"Out here, dickhead, on the double!" Terry roared, and I hurried to join him as fast as my two-foot leg chain would permit. He was standing by the equipment storage wall facing the dungeon entrance, frowning at my slowness.

"Pick that up," he said, indicating a wooden box with a metal shoeshine stand set into the top. After I got a good grasp on it and straightened up, he slipped a large roll of paper towels under each of my arms.

"Now march, face front, back to the dungeon, and don't dawdle."

The wooden box, though heavy, was easier to hold onto than the sack of boots had been, but it was a strain to keep from dropping the towel rolls. I was able to walk pretty steadily, however, pacing myself by the length of my chain.

To encourage me, every few steps Terry swatted my sore ass with a long leather slapper he carried in one hand. *There are some advantages to always facing him!* I thought, and by the time we were back in the dungeon my bottom was burning, though the feeling wasn't nearly as unpleasant as I'd have expected after the discipline session in his bedroom. His swats seemed more playful than punishing, and maybe that made all the difference.

"Set it all down," he ordered when we'd reached where I'd left the sack. "Now go over to the sink, rinse the bucket, and fill it halfway with cold water. . . . I mean *now*, dickhead," he shouted, giving my ass a ferocious smack when I hesitated a few seconds, trying to remember what bucket he was talking about.

I backed away until he turned from me and then scurried across the room to the sink and looked around, soon finding the bucket he'd given me to piss in the night before. I rinsed it out and filled it as ordered, then hurried back and set it on the floor.

Terry had seated himself in his chair, and when he saw me

return and kneel, ready for orders, he told me to take the boots out of the sack and line them up in front of the platform:

"Neatly, dickhead," he warned. "Keep the pairs together."

When I finished, he told me to open the box of cleaning gear and take out what I'd need. I sat down on the floor, gingerly, and was arranging cans of soap and polish, applicators, rags, and brushes from the box so they'd be handy as I worked when I suddenly heard bootsteps behind me.

"Who told you you could *sit*, slave?" His tone was icy. "Get on your knees where you belong," he added before I could make any excuse.

I scrambled to obey, chains jangling and eyes brimming in frustration. *I was doing so well!* I faced toward him and kept my head bowed almost to the floor, wishing I could sink through it. From the corner of my eye I could see his booted feet planted on either side of me, the slapper dangling threateningly from one hand.

"Don't ever sit in my presence, dickhead, even on the floor, unless I specifically say you can. If I don't give you orders to the contrary, *always* stay on your knees. Understand, slave?"

"Yes, Master," I said, choking back an apology — it would be "unnecessary talk," something dickhead was forbidden. I felt truly contrite, if also frustrated at how hard it was to stay in this kind of total-slave headspace.

"Do you want a reminder?"

"No, Master, thank you. Your displeasure is enough punishment to help me remember, Master."

"Let's hope so. Now get back to work," he growled, and turned on his heel.

Can't kiss his boots if he won't stand still! I told myself, then knelt up on the hard floor and stared at the cleaning supplies and boots, wondering which pair to tackle first. I looked up automatically when Terry — back at his control panel — aimed a spotlight directly at my work area, creating a pool of brighter light around me and the boots.

"Can't do good work without good light," he said, grinning, then took his seat again, stretching out his left leg and dangling the right one over the padded armrest. His mood seemed lighter, though I couldn't help wondering how much of his anger at dickhead's transgressions was a performance for my benefit.

"Listen up, dickhead," he said before I could get started on the boots.

I looked up to show he had my attention, then lowered my eyes once more in respect.

"I don't want to have to give you unnecessary orders. I'll tell you what I expect, and you figure out how to do it. You've gotta be smart to serve me, not just a smartass. Got that, slave?"

"Yes, Master. May your slave ask a question, Master?"

"Was there anything unclear in what I said?"

"No, Master, but" I paused, unsure if I should go on.

"But, what? And it'd better be relevant."

"Master, you said earlier that this slave wasn't to do anything except breathe without orders, Master. So your slave isn't sure how much initiative he should take, Master."

"Hmm," he said, then broke into a grin. "That's a fair question, dickhead. Let me see

"When I give you work to do, like cleaning these boots, it's your job to figure out how to get it done without getting in my way or making me wait unnecessarily. Also without breaking any of your standing rules — like staying off the furniture, kneeling with your eyes down and legs apart unless you're told otherwise, keeping your arms crossed behind your back when you're not using them or otherwise restrained, not turning your back on me, not talking unnecessarily. Have I left anything out?"

"Yes, Master: dickhead is to use only third person in referring to himself, and he must call you Master in every sentence. And he's not allowed to touch his cock or to get off, Master. That's all your slave remembers, Master . . . except, yes, there's one more: Master, your slave is to kiss your boots whenever he enters your presence or you come into a room where he is, no matter how short or long the separation."

"I'm *so* glad you remembered that one, dickhead! I'd hate to have to punish you again so soon."

I made no response, just waited silently on my knees with my head bowed.

"Good slave," he said, and I felt a little wave of pleasure. *I can do this!* I told myself again.

"Now," Master continued, "when I'm playing with your ass, or any other part of your body, that's different — *that's* when I meant you don't do anything but breathe without orders. But

even then there'll be some things I'll train you to do automatically, like playing with my tits while you suck my dick. If you just remember that your only concern is to make me happy, dickhead, you'll do fine. Understand?"

"Yes, Master."

"And? You don't think anything else is necessary?"

"Thank you, Master, for instructing your slave. Master, your slave regrets he needed prompting, but he truly appreciates any help you give him in improving his service to you, Master."

"Good boy. Now take a break and come up here. Give your knees a rest and sit with your face in my crotch."

He put both of his feet flat on the floor in front of him as I stepped onto the platform. I walked toward him, wondering if I should be crawling instead, and sat down as ordered between his legs, sliding my own chained legs underneath his chair. My shoulders rubbed his leathered thighs, and he pressed my face against his leathered crotch.

He'd thrown a rod, and he rubbed my mouth and nose against it. He even massaged my shoulders gently as I began to lick it, tentatively at first but soon with more and more confidence that this was what he wanted me to do.

"Feel my dick, boy? . . . Sure, you feel it. . . . Hard, isn't it? . . ." He was speaking in that slow, hypnotic, sexy way of his that always made me melt. "You understand what that means, don't you, boy? . . . Yeah, you know. . . . It means I'm turned on treating you like this. . . . It means I *like* seeing my boy groveling in his chains, kneeling on the hard floor, just waiting for me to take pity on him. . . . I wasn't hard when I was punishing you back in the bedroom, but I'm hard now. . . . Never get the idea that you can please me by giving me an excuse to punish you. . . . It's your obedience that pleases me, your humility, your respect and trust. . . . Understand, dickhead?"

"Yes, Master."

My own cock was rock hard in its leather prison, straining against the straps holding it flat against my pubes. My harnessed balls were painfully tight and swollen on either side of my dick. The butt plug rocked back and forth inside me as I moved my head up and down, forward and back over Terry's crotch, tracing the line of his hard dick under the leather, slurping over the neatly cut head, trying to reach all the way back to his balls.

"You like being dickhead, boy, don't you?"

"Yes, Master," I said, then returned to licking his leather.

"Yeah, you like it all right. You fuckin' *love* it! — even when you *think* you don't. . . . You know you need it. . . . You *need* to be brought down — all the way down to the floor where real slaves live, waiting for their Masters' attention. . . . You need to lose everything else for a while, all your pride and sass, and be only my tool, my property. . . . You need to lose so much of your precious ego that you won't even *think* about anything but pleasing me, obeying me, serving me. . . . You don't have to concern yourself with anything else, 'cause that's all you are right now — my tool, my toy, my slaveboy."

An unvoiced *Yes!* resounded in my mind. Despite my earlier qualms, I truly *wanted* him to train me. I wanted to "snap to" without having to think first. I wanted "dickhead" — this shared fantasy — to become a real slaveboy. And if a lot of my motivation was simply smartass Matt Stone's need to prove he could do anything he set his mind to, so what? I was sure that between us we'd eventually succeed, that we'd make dickhead so real he'd energize into full, eager availability whenever Terry snapped his fingers or called his name.

And whenever that happened, Matt and Mutt would just have to wait their turns until after Terry got whatever he wanted or needed from dickhead — and I would have to trust that the rewards of dickhead's service would somehow stay with me once I was Matt again, the way I felt following my episodes as Mutt. Whatever effort and even pain being Mutt cost me, the obvious joy he gave Terry made it more than worth it. Besides, I'd learned by then that being Mutt felt good in itself. *There's obviously something in me that's fulfilled by being a dog, or at least one with a Master as attentive and loving as Terry is with Mutt. Will I find being a selfless slave to dickhead's sterner, crueler Master just as satisfying?*

"You belong to me now, dickhead," my Master went on as I eagerly licked his leathered crotch. "I own you. And you like that. . . . You like that a *lot*. . . . You really get off on being owned, being property. . . . A thrill goes right through your whole body when I say that, doesn't it? . . . Answer me now, dickhead. Take your mouth off my dick and tell me how you feel about being my property."

"Yes, Master, yes! Your slave loves belonging to you, Mas-

ter! He loves serving you, Master. Making his Master happy is all he wants, all he cares about!"

I was practically in a trance by then, and not even in the privacy of my head did I hedge these avowals. I *was* dickhead at that moment, and incapable of lying to my Master.

"That's right, that's good, boy. Put your mouth back where it belongs. . . . That's your natural place, slave — on the floor with your face in my crotch, except when you're on my boots."

I went back to lapping his leather, though I had enough self-will left to think that it'd be nice if he took his cock out for me to suck all the way, instead of through his pants. But I only *thought* it — I didn't say another word.

"You're going to do a great job on my boots," Terry assured me. "You're going to take your time and clean and polish every square millimeter. . . . You're going to give them all spit shines, using your tongue as much as the rags and brushes. . . . You're going to make love to me, your Master, by cleaning my boots. You're going to show me how devoted you are by how much care and elbow grease you put into them. . . . And you're going to *enjoy* doing it, dickhead, aren't you?"

"Yes, Master!"

"Yeah, that's right. You're going to approach this work as a privilege and a treat, not as a punishment or a burden. . . . You're going to tackle these boots like a kid let loose in a candy shop. You're going to have a ball working on them, like it's the most fun you've had in years. . . . Your cock is going to stay hard the whole time you're working on them, and when you finish, you're going to wish I'd given you a dozen more to clean. Isn't that so, dickhead?"

"Yes, Master! Thank you, Master, for allowing your slave to clean your boots!"

Maybe we were laying it on a bit thick, but the effect was to psych me up — and very effectively, too! — for what would otherwise be a pretty dull training exercise or household chore. It was also a genuine relief to learn that dickhead was allowed to have feelings after all. As a total slave, of course, dickhead was rarely free to *act* on his feelings, let alone avoid chores he might not enjoy, but Terry clearly wanted him to find his servitude satisfying on the whole. Slavery was more than dickhead's vocation — it was his *raison d'être*; he couldn't exist except as Terry's slave.

And what about me, Matt? I wondered. *Can I ever be myself again without the Master who showed me that I'm a slave at heart?*

"Now get to work, dickhead," my Master said.

I pulled myself away from him and got onto my knees, then shuffled backward to a respectful distance before rising to my feet. He got up as well and escorted me down the three steps from the platform and over to my work area. On my knees again, I kissed his boots and oriented myself to face him as he moved away, but he walked out into the center of the dungeon instead of back to his chair.

Keeping one eye on him, and recalling his words about appropriate initiative, I reached for his "lucky" engineer boots first, hoping the choice would please him and maintain his good humor. I was working saddle soap into the leather when he came back, carrying a heavy chain about a yard long and a couple of padlocks. He made no comment on my choice, but simply fastened one end of the chain to my left leg cuff and the other to a ringbolt in the platform.

"I'm going now," he said. "This'll keep you from getting into any mischief. While I'm away, you may sit on the floor if you like, or kneel or stand as you prefer, as long as you get on your knees again and show proper respect when I come in."

"Thank you, Master," I said, then froze — *was that "unnecessary" speech?*

"Don't worry, slave," he said with a smile. "There's no offense in thanking me for favors." He stood there for a moment, silent, starting to frown, until I remembered to take leave of him by kissing the shiny paratrooper boots he was wearing.

"Good boy, dickhead. The important lesson here isn't that you forgot the ritual at first, but that you remembered in time, before I had to remind you. That shows you're trying to do better — and you will.

"Enjoy your boot service, dickhead," he said as he turned to go. "If you need to piss, hold it till I return."

Silent, I stayed on my knees, swiveling to follow him, and kept on soaping the tall black boots as he climbed the steps and walked out through the dungeon door. The moment I heard the door click shut, I sat on my ass and leaned against the side of the platform with a relieved sigh. But after a minute's rest, I was eager to get back to work.

CHAPTER 29

Boot meditations

The jangle of my manacle chain echoed in the empty dungeon as I — that is, dickhead — worked on Master's tall engineer boots, the ones he'd told me he'd gotten for himself ten years earlier after his first successful weekend session as a top. The embossed Wesco logo was still barely legible at the top of the shafts — back then it meant more than it does today, but Terry always seemed to have an eye for quality in his possessions. *And what does that say about me?* I thought with a tinge of pride.

That pride was balanced, however, by the humble posture enforced by his restraints. While I had become adept at adjusting the length of chain between each wrist and my collar as needed — I could even stick one hand almost all the way down into the toe of a boot as I soaped it with my other hand — I had to keep my head down, close to my work.

The slate floor was cold against my striped butt at first, but it soon warmed up under me. I fell into a work rhythm, my hand moving from the water bucket to the saddle-soap tin to the boot lying across my thigh and back again. I worked up a good lather on each patch of boot leather before rinsing it off and starting again further up. The thick, well-worn hide molded itself around my arm, and the velvety surface seemed to soak up light as well as soap and water. I felt I could lose myself in its black depths. The boots weren't especially dirty, except the Vibram soles and heels, and I went over those twice to be sure I'd gotten out every spec of foreign matter — after all, my tongue would probably be on them soon!

Terry had said to take my time, not to hurry, and I was more than happy to obey. As he'd also said, I was enjoying my boot

service — my hard cock inside the chastity jock proved that! Having nothing to do but clean boots, the boots of the man — the Master — I loved, was a treat. I had no distractions, no competing duties or concerns, no clock to watch or even any way to tell the time. It must have been late evening by then, but it made no difference to me. Sitting chained in Terry's dungeon cleaning his boots seemed like a perfect way to spend a Saturday evening. *Far better than cruising a leather bar, anyway, looking for what I already have, a good man to belong to and serve.*

When I finished cleaning the Wescos, I set them aside to dry before oiling them — they weren't the kind to take a high shine. *Which ones next?* Inevitably, I chose the Dehner patrol boots. For a few moments I simply caressed those ultimate cop boots with my hands, feeling the heavy but supple synthetic leather shafts — hard to believe it wasn't real cowhide! The grain was fine and tight, so nothing interrupted the smooth, glossy blackness except the stitching around the instep lace panels and the discreet strap at the top rear of each boot.

The heels were tall enough to hold firm in a motorcycle's foot pegs, but low enough not to distort normal walking. Terry's black cowboy boots had higher heels, slung further back, and he'd walked just slightly bowlegged in them, which I'd found charming — it set off his neat butt! The Dehners, however, were designed to give an MC officer maximum dignity and solidity in all circumstances, whether riding, standing, walking, or chasing a suspect. The toes were rounded, not pointed or squared off like most cowboy boots, and not as flat, either, as on his other police boots. The real leather across the toecaps was thinner and even more supple than the shafts — I'd barely had to press down with my tongue for Terry to feel it when I licked them.

It was hard to decide which turned me on more, the Dehners or his Wesco Boss boots. Both pairs had been custom-fitted, and they hugged Terry's powerful calves as tightly as I wanted to myself. The Boss boots represented a major landmark in his personal history, as well as symbolizing what he wanted in a slave — one who'd be as tough, strong, but yielding and submissive to his will as they were, always ready to meet his needs yet able to stand alone when necessary. The Dehners, though, seemed to have the greater charge of authority, of power. Who's more obviously macho, more in command than a motorcycle cop?

Of course, real power in the world is often concealed, I realized. *Or it shows itself more subtly than with muscles and guns.* So Terry's expensive black wingtips, which reflected his actual status as a successful architect, represented more real-world power than his cop boots. *I'll do them next, after the Dehners*, I decided.

I pulled out the laces of the Dehners, being careful to memorize how they'd been strung so I could put them back correctly later. As with the Wescos, I began with plenty of saddle soap, but the soapy towel glided so easily over the shiny surfaces it was almost superfluous. Still, there were smudges here and there to be wiped clean, and then the soles, of course. Even the natural oils from Terry's hands had left their almost invisible mark. As I lathered and wiped the glossy shafts, rinsing them clean and lathering them again, I imagined caressing his strong, hairy calves and feet. Lifting the boot tops to my face — the linings darkened by stains from his sweat — I inhaled a heady mixed scent of leather and my Master. *He oughta bottle this!*

The soles, a light tan when the boots were new, were now a dull gray from a thousand tiny scratches — these boots were well worn, not merely costume for an occasional night in the dungeon or evening at a bar. *Maybe he wears them when he's out on the Harley, or alone at home, puttering in the kitchen*, I thought with a smile. No matter: I was sure they didn't spend most of the time wrapped in tissue paper in a box, waiting for the next uniform club beerbust.

The double soaping had already left the Dehners gleaming, but I was determined to give them the kind of super-shine they must have had only rarely since they were new. I got out a can of black polish and hunted in the bootblack stand for cotton balls and matches. *Surely he knows that trick? . . . Found it!* I took out a little box of wooden matches and lit one, then touched it to the open can of polish. As soon as it was liquified, I snuffed the flame with the can lid, barely escaping a burn.

I licked a small area of the toe of one boot, about as much as a large postage stamp, then applied liquid polish to the damp leather with a cotton ball, working it in until only the smallest caking was visible on the surface. I continued in that pattern for a half hour to forty-five minutes, working from the toe to the top of each boot, sliding the chain between my wrists back and forth as necessary. When the polish in the can got hard again, I lit another match and ignited it as before.

I tried to avoid getting too much stray polish on the dungeon floor, piling the used cotton balls on a piece of toweling, but I was less successful at keeping myself clean and soon decided there was no need. *If he finds me streaked with polish and sweat, it'll only prove that I obeyed his orders to throw myself without stint into my work!*

The noise made by the manacle chain was practically the only sound. *No background mood music for dickhead.* Although I shifted my ass and legs from time to time to keep from getting too stiff, I remained in much the same overall position, on the floor just below the carpeted platform with Terry's armchair, facing the closed entrance to the dungeon. The colored sand glasses were still on the side table, reminding me of my agony chained between two pillars the night before.

Lick, polish, rub, lick, polish, rub — the silence and the repetitive motions lulled me into a half-conscious state. I even had hallucinatory flashes in which I seemed to see Terry sitting in his chair, looking down at me with varying expressions — sometimes stern and hard, but more often with his mouth twisted in a half grin and his eyes twinkling. His dress varied, too: everything from a three-piece suit to near nakedness in a leather harness and jock pouch to cop and military uniforms to sexy-looking work clothing, biker leathers, and cowboy gear.

Finally the Dehners were completely polished — all they needed was buffing to bring up their shine. I decided to set them aside while I finished the Wescos and did his shoes so the polish would soak into the leather as deeply as possible. It wouldn't do to have any excess stain Master's hands or uniform breeches! But first I got onto my knees, bent over, and kissed the toes reverently, imagining that they were filled with his feet, and touched my forehead to the floor in front of them.

"Slave," I whispered, almost afraid to speak it too loud, "slave . . . slave . . . slave"

I repeated the hard word over and over to drive it into my mind. I went further, affirming in a low voice that "this slave, called dickhead, belongs to Master Terry as much as these boots do, as much as these chains locked onto his limbs, as much as the collar around his throat, as much as this dungeon and Master's house that he's part of. . . . His slave . . . his human property . . . at his disposal . . . at his bidding . . . with no rights, no limits"

As Matt, of course, I knew perfectly well that at any time I could say, "Stop, this isn't what I want anymore," and Terry would release me. But I also knew that if I ever *did* say that, it might end more than just dickhead's existence — it would likely also be the end of everything Terry and I wanted and were already so close to having: a deeply rooted, flexible, but intense partnership that was as much emotional as sexual. *I can't belong to him and still be in control. I have to take a leap of faith and put myself in his hands, for better or worse. Can I do it? Can I stay the course? Can* he?

I left the questions open — *only time will tell* — and got back to work. The Boss boots required a treatment different from the Dehners, and I searched the shine kit for what I needed: black dubbin, a compound of wax and oil with blacking included — already soft, it didn't need to be liquified. He had some, of course. The clean boots also didn't need my spit at this point, much as I always enjoyed licking them. As with the Dehners, I worked on a small area at a time, applying the dubbin with a wad of toweling and rubbing it in until no excess was visible. To give my ass a rest, I got up on my knees again. My boot-covered forearm was like another leg; I planted it firmly on the floor and leaned over it as I worked. Unlike the patent-finish Dehners, the Wescos would never be glossy, but a hard buffing later, after the oil treatment, would give them a subtle, understated gleam.

When I finished applying the dubbin and they were standing together ready for buffing next to the Dehners, I bent and kissed them, too, and again spoke a litany of enslavement: "dickhead, Master Terry's bootslave, humbly offers this product of his service. . . . Master can do anything he wants to his slaveboy. . . . Master owns dickhead absolutely. . . . dickhead is bound to serve and obey Master and to give no thought to his own comfort or desires. . . . Master will provide anything his slave truly needs. . . . dickhead is Master's property and shall not want." *Hmm . . . guess Matt isn't the only one who gets a little carried away!*

Sitting back on my heels, I picked up one of the dress shoes — the left one — and recalled my initial disappointment at seeing Terry in them, and the harsh lesson he'd given me about respecting them. I kissed the toe and rubbed the perforated overlay across my cheek. Similar shoes might be worn by some swishy paperpusher, but these were the "power shoes" my Master wore to meet clients who'd entrusted his firm with multimillion-dol-

lar projects. They deserved, and would get, every bit as much respect and care from me as his engineer and police boots — beginning, as before, with a thorough washing.

After rinsing off the saddle soap and carefully drying the shoes, I licked a small area at a time and applied liquified polish just as I'd done with the Dehners (I had to use a toothbrush from the supplies to get polish into all the little perforations across the front). Even unbuffed they were a deep, glossy black. I set them down and bent my head to kiss each toe again, remaining for a few moments with my head pressed to the floor between them. I imagined Terry's feet filling the shoes and his stocky but elegantly tailored form rising to his full, commanding height above my bowed head and bent back.

"Slave . . . slave . . . slave . . . slave Master's loyal and obedient slave"

I sat up, the old doubts rising again to the surface of my mind. *Do I really want this? Why should I want to be his* slave? *I'm not a dumb kid with nowhere else to go, nothing else to do with my life. I love him, but does he have to* own *me for us to share our love?*

My hard cock wanted it, at least until he let me shoot again — that was obvious from the way it strained against the leather straps he'd harnessed it with. My ass wanted it — that was obvious from the way it fluttered and throbbed around and against his butt plug. My mouth wanted it — that was obvious from the pleasure it gave me licking and kissing his boots and shoes.

But does my heart truly want it? Am I dickhead or Matt? They weren't the same: dickhead didn't need to think about a job or a career, didn't need friends or a place of his own. dickhead was alive only here, in his Master's power places, locked in his dungeon or cell, chained to his bed, wearing his collar, manacles, and shackles, or whatever other restraints it pleased him to use.

As dickhead, yes, I want it — need it. It feels good being his property. It feels right. Seeing the pleasure Terry got from ordering me around, from orchestrating the minutest details of my existence as his prisoner and slave, was all the compensation I needed — even if I didn't altogether understand *why* it gave him such pleasure. *Is that the key? Do I want to be his slave because* he *needs it? Is my submission a gift to him?*

Finally, I shook my head, rattling the padlock and chain at my neck. *Figure it out later!* I told myself. *You've got boots to polish!*

I retrieved the Dehners and began buffing them, concentrating only on bringing out a perfect shine. I kept checking my own reflection in the curving surface of each boot as I brushed and buffed it, stopping only when I could clearly see the fuzz of my near two-day-old beard. They were like black mirrors when I finished, and I was filled with pride at a job well done as I carefully restrung the laces, cleaned off the last traces of polish from the strap buckles, and set them side by side on the carpeted platform above me.

The shoes, of course, with so much less surface area, went much faster, and I never did work up quite as high a shine on them as on the boots — it would have been vulgar. But they had a serene glow when I tied off their laces and set them next to the Dehners. The Wesco boots took the longest to buff up to a gleam worthy of my Master. I was soaked with sweat and my arms were sore when I finished and set them, too, on the platform.

I sat back and rested while I considered the three pair that were left: the NYPD boots, the mud-caked tan work boots, and the black cowboy boots. I chewed my lips, a little raw from licking leather, and as I looked from one pair to the next, trying to decide, I realized that I needed to piss. *Gotta hold it!* I told myself and clenched with grim determination until the urgency passed. I had finally chosen the cowboy boots and was vigorously soaping them when I heard a key turning in the dungeon door's lock. By the time the door itself swung open, I was on my knees facing it, head bowed over my labors.

Although acutely aware of Terry's presence (I kept turning my body to stay facing him), I carefully refrained from looking up as his bootsteps approached me. Only when the shiny tips of his black jump boots entered the circle of light in which I was working did I set the cowboy boots aside and bend down toward him. He said nothing as I lightly kissed his jump boots and laid my forehead on the floor between them, clasping my hands behind my head so that the manacle chain wouldn't scrape over his boots. Prostrate at his feet, I had no idea if he was still carrying the slapper or some other implement of punishment, but my whole backside was wide open to any attack he might deem warranted. I felt exceptionally naked and vulnerable — and my cock was harder than ever.

We held the tableau for at least a minute, during which my

anxiety mounted. But then he moved away from me, closer to the platform. Twisting to follow him, I could see out of the corner of my eye that he was sitting on the edge, next to the boots and shoes I'd finished — just three pair. *Are they enough? Did I choose the right ones to start with? Did I do a good enough job? Should I have worked faster?* My cock shriveled again and my heart hammered in my chest as the silence stretched out.

"Good job, dickhead," Master said at last, and the breath I'd been holding came out in a rush that I struggled to keep silent. "Very nice job on these. And good choices, too. I felt you'd understand what I wanted. It's not quantity — *never* quantity — but only quality that counts. Even if you can't finish all these others tonight, *this* is how I want my boots and shoes handled. I can see the love and care you lavished on them. And I can see you didn't spare yourself in working on them.

"Kneel up, slaveboy . . . look into my eyes."

I obeyed, though my own eyes were so awash in tears it was hard to see him clearly. He'd replaced the leather uniform shirt with a vest, but he still wore the same leather fatigue pants bloused into gleaming paratrooper boots as before. He seemed far more at ease, however, than when he'd left me in the dungeon two or three hours earlier. Somehow he seemed younger — happier and more contented, anyway. *Had this been a test for him, too?*

My fears about his stern, masterful side were disarmed. Sitting at his ease before me, his long legs swinging, heels tapping on the side of the platform, he wasn't a distant, stony figure of menace but a magical amalgam of Master, lover, and partner — not my nemesis but my other half. The power I'd given him over me coursed back through me, energizing me, practically levitating me into his arms as he stood up and waved me toward him. I melted into his chest, and when our lips finally met, the electric discharge didn't dissipate the circuit but completed it. We were a twirling Roman candle of love and lust as we clung together, my naked skin and chains against his skin and leather, until he finally laughed and held me away from him. He looked into my face and, grinning, traced the streaks of polish that stained my cheeks.

"You probably need to piss by now, don't you, boy?" he asked, ruffling my sweat-matted hair.

"Yes, Master," I said quietly.

Terry pulled a small ring of keys from his pants pocket and

unlocked the chain holding me to the platform and then the pad-locked front of my chastity jock. He unzipped the sides and re-moved the triangular piece of steel-reinforced leather. I squirmed as his fingers brushed the hypersensitive velvet of my cockhead.

"Hold still," he ordered, unstrapping my rod, which imme-diately jutted out obscenely from the leather back panel. "Okay, boy, now you can go pee — but make sure that's all you do! Turn around and double-time it, now hop! . . . Not in the toilet, piss-face!" he called when I headed in that direction after backing away a few steps. "Kneel in the middle of the rubber circle and face me. I want to watch you."

I trotted over to the piss pool as fast as I could with the short leg chain, making a racket that I'm sure amused him until the pool's rubber lining finally muffled the noise. Once in place, on my knees with my legs spread, just beyond the center drain, I looked back toward Terry — he'd retired to his armchair for the show. At first I had my usual attack of pee shyness, but my blad-der was so full, and I'd gotten so used to having him witness my most intimate functions, that in less than a minute I was spray-ing a strong, fragrant stream at the drain. I lowered my eyes and was enjoying the luxury of holding and directing my own cock as I pissed when he reminded me that for dickhead this was no luxury at all but a punishable presumption.

"Get your hands off your cock, dickhead!" Master roared. "Where'd you get the idea you could touch yourself?"

I pulled my hands away as though my prick had suddenly become red hot, and as a result my piss stream went out of con-trol, spraying not only all around the pool but even beyond it. With superhuman effort, I slowed the stream to a trickle and then dammed it up altogether.

"Your slave forgot himself for a moment, Master!"

"Is that supposed to be an excuse, asswipe? Jeez! Didn't I tell you never to touch your cock? Are you trying to provoke me, fucker?"

"Oh, no, Master! Never, Master! Your slave forgot, Master, because he needed to piss so bad and didn't want to make a mess."

"Yeah, sure . . . tell it to the Marines. I *know* you can control your piss without touching yourself, dickhead. I've seen you do it. Isn't that right?"

"Yes, Master. Your slave is really sorry, Master."

"You'll be sorry, all right. Now finish up your business — the right way — while I think of an appropriate punishment."

Shame-faced, my dick utterly deflated, I concentrated on releasing my sphincter again so that the rest of the piss I'd stored up could dribble out. No longer a strong, proud stream, it dribbled out in a hesitant, stop-and-go fashion — as much landed on me as on the floor of the pool. When I was sure there was no more to release, I looked over at Terry.

"Go lick up any piss you sprayed beyond the pool," he ordered. *Might have known that was coming!* While I was crawling around the edge of the pool on my hands and knees, lapping up the mercifully small puddles I'd found, Terry came over and unwound the hose next to the pool.

"Back in there, stinkbug," he said. "I have to clean you off." Although I was filthy enough to need a thorough bath or shower, he contented himself with rinsing my legs and feet, then shut off the water and pulled me out.

"Your cock's all shriveled, boy," he said. "How'm I going to strap it in now?"

"Master, your slave's cock is soft because he disappointed you." I still felt ashamed and unworthy, furious at myself for making such an elementary error.

"That's good. You *should* feel bad about disappointing me, dickhead. But you'll disappoint me again if you don't get that cock of yours hard in about 15 seconds. You have permission to touch it if that helps."

I grabbed my dick and stroked and teased it back to life, my head a carnival of turn-on images since that night at the Spike when Terry first carried me away.

"That's enough, boy!" he said, laughing, as my cock grew bigger and harder by the second. "Don't you dare come — that's a reward for Matt, not you."

Moving fast, before I lost it again, he strapped my stiff dick against the jock's backplate. Then he pulled the cover plate from his pocket. After zipping up the sides, he reattached the tiny padlocks, three at the top and one at the bottom.

"Now, down on the floor and start doing pushups, quick!" I dropped into position beside him on the slate floor. As I rose into the first pushup, his belt slashed across my ass. "Count off, asshole!"

"One, Master, thank you, Master!"

Down again, then up. *Wham!*

"Two, Master, thank you, Master!" *Whap!*

And so on to a count of 15, divided between my back and ass. Either because he wasn't hitting me as hard, or because I accepted the punishment better — after all, this time I clearly deserved it — these strokes hurt less than the earlier, smaller set in his bedroom. I was panting hard by the time he stopped, and my backside was flaming, but I felt cleansed rather than devastated.

"Thank you, Master, for correcting your slave," I said when I was on my knees again facing him.

"Don't forget why you needed it. Now you can finish those boots you were working on." He headed toward the front of the dungeon, and I got to my feet and followed him. "As further punishment," he said when I reached the work area, where he was waiting for me, "you can stay on your knees for a while."

"Yes, Master, thank you, Master," I said as I knelt and kissed his boot toes.

Terry chained my ankle to the platform again, then climbed up, sauntered over to his chair, and sat down while I resumed saddle-soaping his black cowboy boots. The pain in my back and ass had already faded to a pleasant warmth.

"Have you ever thought, Matt," he said after a few minutes of staring at the polished footgear lined up in front of him, "just what wearing police or army boots means to me — beyond putting together a hot costume for cruising? Or did you think that's all there is to it?"

I was startled for a moment by his calling me Matt after so long as dickhead.

"Oh, no, Sir," I replied, looking up at him. "I can tell how seriously you take your uniforms. You try to live up to the standards of the men who wear them in real life, as part of their job. I really respect that, Sir — not all uniform buffs have that attitude." I lowered my head again and kept working on his cowboy boots while he talked.

"Cops have a bad rep among a lot of people these days," he said, "especially gays. They're the bad guys, the bullies and bastards who keep us down. But did you know that the motto of most police departments is 'To Protect and Serve'? A cop is given power so he can protect law-abiding citizens against the crimi-

nals and sociopaths who prey on them. That's the idea, anyway, and that's what I think about when I put on a cop uniform.

"When I go out cruising dressed as a cop, I'm not looking for a fag to beat up but for a buddy who needs a strong arm to help him through the night. And even if I find a man who needs punishment, he's got to be strong enough to take it and go on again afterward, washed clean by the experience. I'm especially drawn to the kind of bad boys who really want nothing more than a strong authority figure to make them toe the line, to make them do what they know they should do anyway.

"Remember the night we first got together, boy? Back at the Spike? How you came on to me?"

"How could I forget, Sir?"

"You cut right to the chase. You didn't even say you wanted my cock. You went straight for my power button, asking for discipline ... confinement ... control. I'd been eyeing you for a long time, boy, wondering if you'd be worth the trouble. Your rep was against you, y' know. 'Matt Stone'll do anything you want,' guys told me, 'except let you inside his head.'"

"Sir, I'm glad you gave me a chance, and 'inside my head' is exactly where you did get!"

"I'm glad too, boy, but that night I was close to telling you to piss off. Oh, you looked real hot, all right, and you said all the right things. *But what's in it for me?*, I wondered. *Why should I fulfill your fantasy?*

"I decided to test you, to see how far I could push you before you turned tail and ran. I set a lot of store in how a man responds when I cuff him the first time. If he's too scared, or if he seems blasé, I figure we're not likely to have a good scene. Your response was all I could ask for, though I could tell you were surprised I was doing it in the bar. That little shiver that went all through you when I set the locks ... there's no way to fake that."

Never underestimate how much he notices, I told myself.

"But what really convinced me to give you a chance," he went on, "was the way you licked my boots — like a starving man at an all-you-can-eat buffet. And when that guy asked if you felt humiliated by it, you told him it was an honor. You couldn't have given a better answer if I'd rehearsed you. And I could tell you meant it, too — you weren't saying what you thought I wanted to hear. I know some tops use bootlicking for humiliation, but

the way I feel about my boots — especially my uniform boots — makes me very particular about which tongues I allow on them.

"You couldn't have known that, so it had to be that you feel the same way — I mean, that you're particular about whose boots you lick. And it gave me a real charge, seeing your curly blond head bobbing up and down over my cop boots. You were about the least humble sight I've ever seen — you made me feel honored by your obeisance.

"I don't know how much you've played on the other side, Matt, but do you know what it feels like when a man's tongue presses against your toes or feet through your boots? When your feet are inside socks and the socks are inside sturdy leather boots and you *still* feel his tongue muscle pressing against your skin? That's another sign of a bootlicker who's really into it, one who truly appreciates what he's being allowed to do. . . . Does any of this make sense to you, boy?"

"Yes, Sir! Perfect sense, Sir."

As Matt, anyway, I understood completely — Terry's attitude toward boots was one of the things that had attracted me to him. *But what about dickhead? Should he play a little dumb? Nah — he doesn't want a dumb slave!*

"Your slave dickhead understands, too, Master."

Terry looked straight at me, his eyes boring into mine until I dropped them.

"That's good, dickhead, because I expect you to be every bit as smart as Matt and to know everything he knows."

"Yes, Master."

"Good boy, dickhead — just remember that this is what you *want*, that you *chose* to be my slave. Isn't that right, Matt?"

"Yes, Master . . . I mean, yes, Sir. You're confusing me, Sir!"

"Don't worry, boy. You're doing fine. dickhead fades in and out a little, but he's a real part of you, not just an act. It'll get easier with more practice."

"I hope so, Sir."

"Stop trying so hard, Matt. I accept that you'll make mistakes — you have to accept it, too. I'll punish you for them, of course, but that's part of the process. Don't think of your mistakes as failures. You said it yourself: dickhead can't be a perfect slave right away. Think of him as trying to *become* the perfect slave. That's what's exciting: the struggle to submit completely.

"And remember, too, that you're not going to be dickhead all the time, not even down here in the dungeon. I learned from my mistakes with Philip, and you can be sure I won't repeat the same ones with you. I'll find new ones!"

He grinned down at me, and I smiled back, though it was hard to imagine him making many mistakes. *And how would I feel about it if he did? Could I forgive him? Or do I need him to be perfect?*

"It's getting late, dickhead," he said, scattering my thoughts. "Much as I like having my boots serviced so well, there are other things I want to do with you tonight. Finish up the pair you're working on, and when I come back we'll get you cleaned up."

He stood up and walked right up to the edge of the platform so I could kiss his boots. When he turned to go, I picked up the cowboy boots again. I'd finished saddle-soaping them while he was talking. They weren't supposed to have a mirrorlike surface, so I didn't bother flaming the polish, just licked a small patch of leather and rubbed it in cold. The dungeon door opened and closed behind him before I was ready to move on to a new patch.

CHAPTER 30

By candlelight

I finished the black cowboy boots before Terry returned. When I went to set them on the platform I noticed that he'd taken the Dehners and Wescos with him; only his shoes were still sitting there. After sitting back and resting for a few minutes, I felt antsy and decided to take some initiative and try to at least clean his work boots. I broke off as much of the mud as I could with my fingers before attacking them with wet towels. It was a really messy job, and when the door opened again I was even filthier than before — but the boots were clean enough to begin saddle-soaping them whenever he gave me the chance.

I didn't look up when he came in but stayed on my knees with my head bowed, waiting. It was a longer wait than I expected, and I was starting to wonder if he was just sitting there looking at me when the spotlight defining my work area cut off, the other lights in the dungeon dimmed, and music filled the space, some kind of electronic stuff, dark and brooding with a slow but steady pulse. When his boot toes entered my visual field, I saw that he'd changed from the jump boots to the Wescos. I bent to kiss them and kept my head down until he spoke.

"Kneel up, dickhead. I see you kept busy while I was gone. That's good — that's the kind of smart service I like."

My cock stiffened, and I licked my lips as I looked at him: It wasn't only his boots he'd changed. The vest and pants were gone, and he was wearing only a leather body harness, a jock pouch, arm bands, and gauntlets. I glanced up — he also wore his trademark half grin. *What devilment has he planned now?* I wondered as I looked down again.

Terry crouched down and unlocked the chain holding me

to the platform. He reached for my collar, hooked a finger in the D-ring at the front, and pulled me upright as he stood himself.

"Take that," he ordered, pointing at a pile of gear on the edge of the platform, "over there," pointing toward the piss pool.

I picked up the gear, which consisted of numerous neatly coiled lengths of thick black rope, a small, firm pillow covered in rubber, and a paper bag folded closed at the top so I couldn't see what it held. I backed several steps away from Terry before bowing slightly, turning, and walking toward the pool. He paced right behind me.

I was pretty sure I was in for some piss, but I couldn't think what else he might have in mind. He wasn't about to clue me in, either. When we reached the edge of the pool, he had me set my burdens down and wordlessly proceeded to remove my manacles, leg irons, and chastity jock — the last with some difficulty as my cock was too hard to pull through the hole until he deflated it by mashing my balls.

"All work and no play makes a slave boring," he said with a grin as he began constructing rope cuffs around my wrists. "I'm sure you agree, Matt."

"Yes, Sir!"

What kind of play? What's in that bag? I wondered as he crouched down to do my ankles. When he was finished, a neat coil of rope was knotted snugly around each of my extremities. Terry slipped a longer piece of rope under each cuff and told me to lie down in the pool, off-center, with my ass away from the drain and my arms and legs spread out. He adjusted my position with tugs and commands until he was satisfied, finally slipping the little pillow underneath my shoulders so my head fell back, pulling my throat into a straight line divided in half by the leather collar.

I knew better than to ask questions and lay there quietly, staring at the ceiling far above me, while Terry wove the ropes from my cuffs into the anchor rings around the edge of the pool. The rope bondage felt very different from the chains he'd used previously to restrain me there — more intimate somehow, and certainly tighter. There was enough extra rope from my wrists for him to attach the rings at the side of my collar as well, making it impossible for me to raise my head or even twist it much, and the ropes from my ankles ended up tied around my ballsac, pull-

ing it down and away from my body. My cock, of course, pointed almost straight up.

Despite the discomfort, already building, of being immovably stretched out, I was incredibly excited by the tight restraint. Terry knelt between my legs and gently stroked my stubbly shaved limbs and torso, eliciting moans of pure pleasure.

"How're ya doin', boy?" he drawled.

"Great, Sir."

"Ready for some hot action?"

"Yes, Sir!" I responded eagerly, moaning again and closing my eyes as he pulled on my nipple rings.

"Good."

I heard a sound that was very familiar but not quite identifiable. When I felt the first spot of heat, just below my right nipple, I knew it had been the grinding of a lighter flint. I groaned at his pun, not at the pain (as yet very moderate) from the hot wax. I generally enjoy wax scenes a lot — it's a wonderfully sensual pain and rarely too severe. Of course, I should have realized that a routine hot-wax scene wouldn't satisfy my new Master!

I felt another flash of hot pain in the same area, and then still another. I had expected him to move the candle around, perhaps drawing patterns, the way other tops had done, but he concentrated on the same spot, then pressed something against me there. *A votive candle?* I guessed, and I was certain of it when he repeated the process under my left nipple, at the end of my sternum, and on both thighs.

By the time Terry finished placing the fifth candle, the first had spilled over. When I flinched at the pain from nearly a teaspoon of hot wax all at once, the slight motion of my chest triggered the second candle to deliver its own fresh load. I moaned and flinched again, which triggered another candle. And so it went as my own involuntary reactions to each wax spill caused the next one, until there was a regular rhythm of pain — and from just five small candles! And he kept on adding more!

I was moaning loudly even before he finished setting all of them. I couldn't believe how many candles he was using — any time a top had used votive candles on me before, it'd been maybe half a dozen at strategic points. Terry was practically outlining my body with flame. Each one caused pain when my involuntary twitching, or just the rise and fall of my chest as I breathed,

shook the pool of liquid wax at the tip and spilled it onto my tortured flesh. With all of them together the pain was nearly constant — nearly, but not quite. There was a ragged rhythm to it, just enough differentiation so that I could feel my left side, say, burn along its line of candles a moment before I felt a similar flare along my right arm or on my right thigh.

The worst part was that I, myself, was responsible for each flare of pain. Again and again I strained to hold still, to merge into the stiff rubber surface under me, only to set off an even more widespread conflagration moments later as my sore muscles inevitably spasmed. I slumped back in defeat, only to be roused by a new shower of fire.

Terry stood behind my head and looked down at me, watching me suffer, listening to my moans and cries accompanying the eerie music he'd chosen as background. I stared up into his eyes with helpless entreaty, but he was unmoved. After several minutes like this, he turned and walked back toward his oasis. When I rolled my eyes up as far as they would go, I could just follow him, his tall form seeming to be upside down, as if he was walking on the ceiling. When he reached the platform he went straight for the control board behind it, and soon all the lights on the dungeon pillars went out. Except for a light on the wall behind him, the only illumination in the huge room was the flickering glow from the dozens of candles stuck to my flesh.

I gave up trying to see him then, except in my mind's eye, where I imagined him sitting in his armchair with his dick out, stroking it lazily as he watched me. I hoped he was enjoying my pain, the only gift I was in a position to give him. The dungeon was filled with shifting shadows cast by the dancing light from the candles stuck to my body. The soft, spacy music continued its meandering course as they burned down. The liquid wax reaching me should have grown hotter as the candles grew shorter, having a shorter distance to travel, but fortunately it cooled a little running over the hillocks of hard wax left around each candle by previous spills.

Time passed in fits and starts, marked by long moments of pain when a row of candles spilled over, then a brief respite before another row overflowed. Counterpointing the sharp pains from the wax was the duller but growing ache of my stretched muscles. My cock had long since shriveled, as it always does when I'm hurt-

ing. My balls tried to withdraw upward but were held fast by the rope, and the ache from them speared upward through my torso.

The pain upon pain was driving me into my body, tightening my world into a smaller and smaller realm as everything else fell away from consciousness. I couldn't think. I couldn't protest. I had no room for anger or fear or lust, only pain. Finally, before I was crushed by the agony, the masochistic alchemy transformed pain into bliss, and I floated free. There was my suffering body lying stretched out on the black rubber, bound with black ropes, and there was I observing it, inside and outside at once, buoyed on a wave of ecstatic chemistry. The natural opiates flooding my nervous system fixed a gulf between me and the pain. I was still aware of it, but it had no more power to hurt me.

It was then that Terry came back, kneeling down behind me, trapping my sweat-soaked skull between his booted calves and naked, powerful thighs and pushing his hard dick into my mouth. Now I understood the reason he'd put the pillow under my shoulders: with my neck stretched out, my throat was wide open, giving him a clear shot.

His leather jock was gone, and his balls rested on my nose. New sensations called me back to myself as the delicious stink of his crotch filled my head and I tasted the latex sheathing his cock. He didn't push all the way into my throat immediately but let his dick rest in my mouth until I began to respond, tonguing and sucking it while I sniffed his balls. He stroked my face and neck with his gauntleted hands. The candles kept spilling as our motions jiggled them, but I felt the flares of pain like distant thunder. The whole active part of my consciousness was preoccupied with the cock filling my mouth — *my Master's cock*. All I wanted was to open myself to it ... to him ... for him to take me ... to possess me utterly.

Slowly, he began to fuck my face, pushing into my throat and then sliding out, in and out, setting up a smooth rhythm. I let my throat go slack and tried to inhale as he thrust and exhale as he withdrew. There was no more sucking or licking. My throat was just a tight sheath for his cock to slide in. My own cock stirred and began to harden again, but otherwise the rest of my body might have been someone else's. I was totally concentrated on his fucking my face. I willed my saliva to flow freely to coat his dick and ease its passage, and at the same time I managed to

set up a pattern of swallowing while his dick was down my throat, squeezing it and exciting him even more.

"Oh, yes, that's right, boy, that's real good," he murmured, bathing me with approval, encouraging me to even greater synchronization with his fucking.

He kept talking all the time he fucked me, weaving a hypnotic spell with his words, binding me to him as securely as with his ropes and chains, though in my altered state of mind no words were necessary. The play of the muscles in his thighs against my head, the force of his cock sliding down my throat, even the funky smell of his ass as it passed over my face — all spoke volumes.

"You've got it, boy. . . . We're right together, in sync. . . . You're taking my cock down your throat and I'm fucking you, boy. . . . You like me fucking you, don't you? . . . Of course you do, that's what you live for, to be fucked, fucked by me . . . fucked over, fucked silly, fucked out. . . . Not fucked up, though, no, you're not fucked up . . . you're all right . . . you're with me. . . . You're just fine, boy, you're getting what you need, giving me what I need, boy. . . . We need each other. . . . That's right, you and me, boy, me fucking and you getting fucked. . . . That's how it is, that's how it should be. . . . No pain now, is there boy? . . . I knew when you were ready. . . . I could tell from watching you when the magic worked and you stopped hurting. . . . I like seeing you suffer, boy, suffer for me, but it's even better to see you change, see you flip over into pleasure, see when those endorphins kick in and you start flyin'. . . . That's when I knew it was time to fuck you, boy. . . . Don't wanna fuck you when you're hurtin', boy, no way! . . . Don't want you ever t' put hurtin' 'n' fuckin' together in your head. . . . I want t' fuck you happy, want t' fuck all the pain out o' ya, show you the pain's not real, boy. . . . Only joy is real, only the connection between us . . . you and me, me and my boy . . . fuckin', gettin' fucked, bein' there for each other. . . . That's what you want, isn't it, boy? . . . That's what *I* want, Matt. . . . I want you, boy. . . . I need you . . . need to hurt and heal you . . . need to feel you under me . . . with me . . . part of me. . . . I need to . . . oh, shit, boy, I'm coming! . . . I'm goin' to come in your mouth . . . down your throat. . . . Here it comes, boy! . . . The rubber'll hold it, boy, but you'll feel it . . . feel me come inside you. . . . Oh, oh! . . . Here it comes! . . . *Ah-hh-hhh!* . . . Shit, boy! There's more . . . *ahh-hh!*"

I felt it all right, felt it like a rocket going off in my throat! Just the after tremors of his climax bounced my head up and down on his dick. He stayed inside me after he came, and I felt his dick softening and shrinking. I held my tongue still so that it wouldn't overstimulate his cock while it was hypersensitive.

When he pulled out finally, he rocked back on his heels and pulled off the rubber. As usual, he squeezed it out on my face and smeared the cum around with his hand. I pulled the sharp smell deep into my lungs, heedless of how many burning candles spilled over on my inflated chest. *Someday he'll let me eat it,* I promised myself.

Terry stood up behind me. I looked up to see him stroking his cock, already stiffening again. My eyes crossed with the strain of focusing on him at that angle. I could tell he was aiming his dick, and a few seconds later the piss started streaming onto me. He tried hard to put out all the candles with a single uninterrupted stream, but several on my left side eluded him until his second spurt. His hot piss felt cool and soothing compared with the burning wax. I lay there bound in the darkness, wrinkling my nose at the weird smell from the piss-doused candles.

"Close your eyes and mouth, boy." He pissed all over my face, washing off his dried cum. "Now open your mouth," he said, and finished relieving himself there. The piss was strong but sweet, and I drank it down eagerly.

"If you need to piss, boy, go ahead. Just let it go."

It took a few moments before I could relax enough, but the darkness helped. When my cock started spraying piss, Terry saved me the trouble of trying to aim it, stepping between my legs and pushing it back toward me with the sole of his boot. Piss sprayed all over my chest and arms — some even hit my face — only to run off, like his, and find its way to the drain in the center of the pool. He was still pressing my cock against my belly with his boot when I ran dry.

I noticed that the music had stopped when I found myself following his bootsteps as they moved away from me. A minute or so later the lights started to come back up, and he approached me again. He pulled out the pillow under my shoulders, easing the tension in my neck, and stood where I could see him easily, looking down at me with his mischievous half grin.

I ran my eyes over him hungrily, from the tall boots I'd

oiled so carefully, now splashed with piss, up to his mobile face creased with laugh lines and his sweat-soaked brushcut. His cock was as soft as it gets, just under six inches of thick, prime meat swinging heavily over his hairy, low-hanging balls. His belly hinted at a developing pot. His broad, furry chest, still framed by the leather harness, made me want to forage for crumbs. You might not even consider him handsome, but he was my heart's desire. *I'd go through fire for him*, I thought, then realized I just had.

"You should be grateful I shaved you Tuesday night," he said, smiling, as he knocked several candle stubs off me with the edge of his boot. They pulled at my skin before they came free, and I was far enough down from my earlier high that it *hurt*, but he ignored my yelps and continued the painful process. "Think how much more this would hurt if you had all your hair back."

So that's how long he's been planning this!

When all the candle stubs were off, he took a scrub brush from the paper sack the boxed candles had been in, knelt down, and brushed me until every shard of wax was gone. That hurt even more, but in a tickly way that left me wanting to laugh and cry at the same time, especially because Terry kneaded my sore muscles with one hand as he brushed me with the other. I felt as raw as a newborn by the time he finished.

"God, I love seeing you like this," he said, crouching between my legs and grinning down at me. "You look so beautifully *used*. Ravished — like a banquet table after a feast. Or a bedroom after two guys've fucked their brains out. A real fine mess."

"Thank you, Sir." *Odd sort of compliments!* "Any chance the mess could get cleaned up, Sir?"

"Soon, boy. Don't rush things."

He bent forward and laid his body on top of mine. My toes felt the tops of his boots, and my cock, hard again despite the discomfort, was pressed flat underneath his abdomen. I groaned softly as his full weight settled on me, the studs on his harness pressing into my ravaged chest. He stretched his arms out along mine and intertwined his leather-gauntleted fingers with my bare ones. His head rested next to mine, his mouth at my ear, tickling me with his moustache.

"You've done real well, Matt. You've taken everything I've thrown at you with hardly any complaint. We've made beautiful music together. I'm proud of you. I'm glad I have you."

He raised his face and pressed his mouth to mine in a passionate kiss. I opened up to him gratefully, letting his tongue ream out my mouth before I ventured into his. I lay under him, my heart racing, not daring to wish for anything more.

What I got was more than I could have hoped for. Terry raised himself on his arms, bent his head down again to kiss my eyes and nose and forehead, then got up and walked around behind my head. He knelt down with my head between his legs as before, but this time he stripped off his cum-streaked gauntlets, slipped his balls into my mouth and sat on my face. I automatically started licking them, but he bent forward, rubbed the pre-cum off the head of my cock with his naked hand, and to my complete and utter amazement took it all the way down his throat in one gulp!

My cock was engulfed in moist heat and massaged by rippling muscles. I screamed into his crotch and suctioned his balls like I was trying to swallow them. Terry slowly pulled his head off my cock, keeping his lips tight around the shaft, soaking it with his spit, then went down on me again.

"*Aarrgghh!*" I screamed again. *If he does that one more time, I'll shoot for sure.* And if he didn't, if he just let my cock rest in his hot mouth, I could have died happy.

I licked and sucked his balls and sniffed his sweaty ass while he slowly pulled himself off my dick a second time. He hadn't put a condom on me, and after my leaking cock slipped out of his mouth, the next thing I felt on it was his hand pumping the spit-slick shaft and massaging the head with his thumb.

"Ohmigawd! *Aaiiieee!*" I had time to scream around his balls before I exploded in a mind-wrenching orgasm.

He was lucky I didn't bite off his nuts — my whole body pulled tight for an endless moment and then collapsed in release. My head slumped back, and his balls popped out of my mouth.

"Th-th-thank you, Sir," I stuttered into his asscrack. I wasn't sure he could even hear me, but I was too wasted to say it clearer.

"Good boy," he said as he lifted his butt off my face and sat back on his haunches. "Lots of sweet cum that time. Lots of good skin cream for my best bondage slave."

He scooped up my cum and started rubbing it into my sore pecs. My body was still stretched tight in his ropes, and I trembled and moaned under his touch.

"Here, boy, lick it off my hand," he said as he stuck the slimy fingers in my mouth. I licked and swallowed my own ball juice.

"What do you say, boy?"

"Thank you, Sir," I said, a little more firmly than the first time. "That was incredible, Sir. Thank you."

He gave my face a pat and began undoing the ropes that held me stretched out — as the tension on each limb slackened and full circulation returned to my stiff muscles, I groaned, as much in relief as pain. When all the ropes were off me, leaving only the leather collar, Terry helped me to my knees and handed me the paper candle sack and the brush.

"Clean up the mess here first, boy," he said, "and then we'll see about getting you cleaned up."

He watched as I collected the candle stubs strewn around the piss pool and the larger shards of wax, then used the brush to push the smaller pieces into piles I could scoop up with my hands and dump into the bag. There was still a strong smell of piss but no visible puddles, and I figured the smell must come from me. Despite my waxing, brushing, and piss bath, I still had streaks of boot polish and dubbin all over my hands and arms and the front of my thighs, plus dried cum on my face and chest. Raunchy sex is fun, but what I wanted most right then was another hot shower with lots of soap! Terry seemed to agree, because when I'd cleaned up the pool as well as I could, he had me stand and removed my collar. I kissed his hands as they pulled it from my neck, reluctant to let it go.

"A little piss won't hurt this," he said, "but gallons of hot water and regular soap are bad for leather, so I'll hold it while you shower. You can give it a good cleaning and oil treatment tomorrow when you finish my other boots."

He held me to his chest for a few moments, fingering the butt plug still in my ass, before pulling that out, too.

"Take this with you and wash it, Matt," he told me. "Use the toilet if you need to, but no hanky panky! Understand?"

"Yes, Sir! Of course, Sir," I said, a little peeved that he'd suspect me of wanting to jerk off so soon after he'd made me come.

I gingerly carried the brown-stained plug to the utility sink, stripped off the condom covering it and tossed it in the toilet, rinsed the plug, and left it in the sink. I turned on the shower

taps — which were outside the stall — trying for a warm but not too hot mix, and then went inside and under the spray.

"*Yowch!*" Much too hot on my tenderized skin. I had to go back outside twice to adjust the temperature. *Would it've killed him to put the taps* inside *the stall?* I grumbled silently.

I stood there soaking for a couple of minutes before picking up the coarse soap provided in the stall and lathering myself. Without the use of a brush or washcloth, I couldn't remove all the stains from my bootblacking service. *I suppose they'll wear off in time — unless I keep getting new one*s. Considering how many different boots Terry had, many more than he'd worn with me so far, that was fairly likely.

Although I was still inside Terry's dungeon, naked and vulnerable, I was as "free" as I was likely to get in his house, with neither collar nor restraints. I didn't much like the feeling. My neck missed the leather band around it, and my arms and legs seemed to move awkwardly without any chains as ballast. Although Terry's obsessive control could be annoying at times, on the whole I preferred it — it made me feel secure and cared for.

I needn't have worried about being emancipated, however. When I looked up after rinsing the soap out of my hair, I saw Terry standing outside the door of the stall, with his devilish half grin, as if on guard against unauthorized self-abuse. The leg irons and manacles I'd worn earlier were draped over his shoulder, and just seeing them made my cock start to rise.

"Finish up quick, boy," he said.

"All done, Sir."

He turned off the water and handed in a towel. When I was dry, but wishing I had a comb and a mirror, I stepped out of the stall and knelt before him, placing my hands behind my back and bowing my head.

"Good boy," he said as he reinstalled my collar. My cock was instantly hard.

"Thank you, Master," I said and kissed his left boot — I tasted piss and frantically licked away the stains on both of them.

Laughing, Terry let me finish the impromptu cleaning, then ruffled my damp hair and pulled me to my feet and into his arms. The hug was long and tight. I closed my eyes and began to purr against his shoulder as his hands kneaded my back and ass, but it turned into a wide yawn.

"I'm sorry, Sir!"

"It's okay, Matt. I'm pretty tired, too. It's late and we both need some sleep."

Hooking his finger in the ring on the back of my collar, he pulled my head up and back for a deep kiss. When he took his tongue out of my mouth, he laid my head back on his shoulder and locked the manacles on my wrists. Pressure on my shoulders told me to drop to my knees again, and he crouched, too, so he could fasten the leg cuffs and slip the manacle chain under my feet so it would be in front when I stood up.

"Now, boy, how shall I put you to sleep tonight? In the puppy cage this time? Locked into a sling? Chained against one of the pillars?"

"Whatever pleases you, Sir," I said warily, not sure if he really wanted my input or was teasing.

"Don't think I won't do all of those sometimes, Matt, and worse," he said, lifting my head with a finger under my chin so I could look into his eyes. "But tonight I want you with me, close at hand. Let's go to bed, boy."

We stood up together and walked across the dungeon floor and up to the platform, silent except for the familiar noise of my leg chain. Terry picked up the cowboy boots I'd finished, looked them over, and gave them to me to carry upstairs, carrying the shoes himself.

When we were back up in Terry's bedroom, he allowed me to take off his harness, jock strap, and arm bands. After I turned down the leather bedspread to reveal the cool gray sheets, he sat on the bed so I could remove his boots. I knelt on the floor between his legs, but he didn't let me touch them immediately.

"You cleaned these so well, boy," he said with a mischievous grin, "maybe I'll wear 'em to bed. Would you like that?"

"Yes, Sir!" Despite all of the bootlicking and bootcleaning I'd done already that night, I was still eager to slurp my tongue along those midnight leather shafts, or at least to feel them with my toes.

"Jake says that in his day a top would never allow himself to be seen totally naked, but I figure that if I have to keep some

clothes on to retain your respect, there's something more serious wrong between us. What do you think, Matt?"

"I agree completely, Sir! I like seeing you naked and relaxed, Sir, but I could never forget that you're my Master."

"Good boy! I *will* keep my boots on tonight, though. They haven't looked this good in a long time, and I swear I can *feel* the energy you put into cleaning them for me. It's as if they're re-charged or something! So kiss them and we'll get into bed."

"Thank you, Master." I took a deep breath and bent my face down to his "lucky" boots, planting a wet, lingering kiss on each one, first the left and then the right, as always.

Before he let me climb into the bed, Terry fixed the mana-cle chain so I couldn't touch my cock — looping it around my neck and slipping a padlock through two links and the D-ring at the front of my collar. That left about a foot of chain from the collar to each wrist, and I couldn't slide the chain back and forth as I had when I was working.

He put a piss jar on the floor beside the bed for me and fas-tened my collar to the head of the bed with a long chain.

"You can get up to piss if you need to," he said, "but be quiet about it so you don't wake me. If I need to piss I'll let you have it. That way I won't even have to sit up."

"Yes, Sir, very good, Sir," I said, grinning at him.

I was way past feeling anything negative about taking his piss — *as long as he doesn't start feeding me his shit.* That was still a hard limit for me.

He turned off the light and pulled me against his chest so we were lying spoon fashion, his half-hard cock teasing my ass-crack and his hands roaming over my chest, playing with my nipples and cock, which quickly got hard again.

"I was going to ask how you were feeling, boy, but I guess this is all I need. Don't you ever get enough?"

"Guess not, Sir!" A huge yawn slipped out. "Excuse me, Sir!"

"It's okay, Matt. You *should* be tired. It's been a long day for both of us. Hard to believe it's only a little more than 24 hours since we left the Altar — in more senses than one!" he chuckled. "We've come a long way very fast, haven't we?"

"Yes, Sir," I said, pressing his hand to my lips. "It's been amazing, Sir. You've taught me so much about myself, Sir. . . . Your slave loves you very much, Master," I murmured into his palm.

He held me tighter and kissed the nape of my neck, below the leather collar and manacle chain marking me as his property.

"I love you, too, boy, all three of you — Matt, Mutt, and dickhead. You're more precious to me than anything else I own. I feel happier and more complete just thinking about owning you and training you. Jake was right about you — and you were right about me. I *need* this. You give me things I could never get from a freelance bottom, no matter how much of a bondage pig he was. You're giving me your *self*, letting me reshape and remold you after my own design — though I wonder how much of what you're becoming was there in you all along. Quite a lot, I think. You've been needing this, too, haven't you, slaveboy?"

"Yes, Master. It's not always easy, Sir, being your slave, but it always feels *right*, like it's what I was born for. . . . This house feels like my home already, Sir."

"That's good, boy. It *is* your home, as long as you understand your place in it — vital, but subordinate. I have plans for Sunday evening, boy, but most of the day is open, after we get some sleep. Is there anything in particular you'd like to do?"

"Whatever pleases you, Sir," I said as before, deferentially but thoughtlessly. This time, though, he'd really wanted my input and wasn't pleased at all.

"Don't be dense, boy, or play games with me!" he said, twisting my nipple painfully. "We'll do whatever pleases me regardless. When I ask what *you* want, I expect you to tell me. Even dickhead is allowed to have preferences, as long as he doesn't act on them without orders. But I want to know everything that's going on in my boy Matt's head. Understand?"

"Yes, Sir. Forgive me, Master. You mean my preferences for bondage play, Sir?"

"Yes, or whatever else you'd like. I might not give it to you — it depends on whether I want to reward you — but knowing what you enjoy helps me control you more effectively."

"Yes, Sir. Thank you, Sir," I said automatically, while a shiver — of fear? or excitement? — passed over my body. *So even my likes and dislikes will become means of control?*

"What I'd most enjoy, Master," I continued after a few moments' thought, "is being allowed to serve you, Sir, as your house slave and body servant, instead of being locked away again. I wish you'd let me fuss over you the way you do over me, Sir!"

He laughed and nuzzled my neck again.

"It's a deal, boy! I won't lift a finger, except for cooking — I'm not enough of a masochist to let you take over there! But surely there's something else you'd like, too. Don't think you're going to get out of a few hours of rigid bondage after you clean up from brunch, even if it's not in the dungeon. How do you want it?"

"Ropes, Sir! Please tie me up with rope, snug and tight, not stretched out like tonight with the wax — if that would please you, too, Sir, of course."

"Hmm . . . I think that'll please me fine, boy! And now, boy, close your eyes and go to sleep. Dream about my ropes crisscrossing your body, holding you tight, binding you, making you helpless and happy and safe."

And I did.

CHAPTER 31
Bondage alfresco

"Wake up, sleeping beauty," Terry said. "You want to sleep away the whole day?"

I opened my eyes — and promptly shut them against the light filling his bedroom from the floor-to-ceiling windows. He twisted my nipple, and I yelped and opened my eyes again, looking up into the bright hazel eyes in his grinning face. He was still naked, except for his old Wesco Boss boots, and propped up on one elbow next to me in the bed.

"Good morning, Master," I said to him, lowering my eyes in respect. "How may I serve you, Sir?"

"You can get your mouth down where it belongs, boy, and take my piss."

I quickly slid down the bed, with much jangling of chain from my leg irons and the long tether from my collar to the bed frame, and seized his half-hard cock in my mouth. He made it easy for me by staying on his side so that I could face him instead of leaning over him, which is fine for cocksucking but not a good angle for swallowing a steady flow of piss.

As soon as my lips were tightly locked around the shaft, with the velvet head of his cock resting on my tongue, and I'd taken a deep breath of air into my lungs, he relaxed and let the hot, bitter stream emerge. I gulped and gulped, straining to keep up with him so that none of the precious fluid spilled out of my mouth. My cheeks bulged out as my mouth filled, and he gave me a respite. It took several swallows to empty my mouth, and then I took another deep breath.

He took that as a signal that I was ready for more. We repeated the same ritual three times before he was empty. I lay

there nursing his softening cock until he pulled me off it and commanded me to give him a tonguebath, beginning with his crotch, sadistically denying me his boots! I was more than happy to oblige, despite an urgent need to relieve my own full bladder. I clamped down harder and concentrated on licking.

Terry rewarded my service with sighs and purrs of contentment as I worked over his hairy body with my mouth, kissing and licking every inch of skin I could reach. He generally left it up to me how long to spend on any part or where to move next, but occasionally he'd play little games, like trapping my face between his thighs or in an armpit until he decided to let me go. With the shortened manacle chain locked to my collar, my hands were almost useless, but there was just enough slack so that when my face was pressed to his body, I could knead and massage the muscles on either side of whatever part I was licking at the time. He seemed to enjoy that bonus service, especially on his pecs and arms. He turned over when I finished his front, and I began again with the backs of his thighs, just above his boots, and worked up.

I'd just finished licking the back of his neck and was starting in on his ears when he reached behind his back and pulled me down beside him.

"Enough, slaveboy! I'm hungry. It's time to get this show on the road."

Amazingly fast, he unlocked and removed all of my chains, and my leather collar, then directed me to take off his tall boots. I removed them carefully and kissed each toe before setting them beside the bed. Terry led me into the bathroom and had me sit on the bare toilet to piss.

"Get used to that, Matt. It's how I want you to piss from now on — sitting on the toilet bowl, not standing up — unless you have other instructions. Not just when you're here but when you're back in Manhattan, too."

I looked at him in surprise and was opening my mouth to ask a question when he forestalled me.

"Not now, boy. We'll talk about it later. I just want to plant the seed in your head so it's not a total surprise."

He stepped into the shower, so I suppressed all the questions bubbling up in my mind and concentrated on pissing so I could join him. It took a long time to let go after clenching so hard, but when I finally did, it felt so good, I almost shouted.

Terry was already soaped up when I climbed into the over-size shower stall, but he handed me the washcloth. I washed and rinsed him lovingly, kneeling to clean his cock and balls, and his ass, while he stood passively accepting my service, only a slight lifting of the corner of his mouth betraying his satisfaction. I was a little chagrined that his cock didn't stiffen under my hand, but I had to admire his control.

When I'd finished, he took the washcloth and scrubbed me in turn, just as thoroughly but much more roughly. He paid particular attention to my asshole, reaming it out with two soapy fingers. After our shower, I knelt beside him while he shaved and then dried him off.

"You can stay scruffy for another day or two, boy," he said with a grin before brushing his teeth, "but dry yourself off, and use the spare toothbrush after I'm finished."

Since he wasn't wearing boots, I couldn't kiss them, but I knelt and kissed his feet before he left the bathroom. Brushing my teeth, I looked for a hairbrush or comb and as usual found none. *But after those comments in the dungeon last night, I guess there's no doubt he prefers the disheveled look for me!*

When I joined him in the bedroom, he already had on gray breeches with black stripes along the outside and a matching uniform shirt with a New York State Police patch. I knelt and helped him into his Dehners, seeing myself reflected in the shine I'd so painstakingly put on them the night before.

"No time for boot worship, Matt," he said with a chuckle. "Just kiss them for now."

Instead of replacing my leather collar, he gave me a heavy chain collar, padlocked in front. After adding comfortable Darby-style leg irons and manacles, he headed to the kitchen, going the long way through the house instead of cutting across the central garden. I followed. He never had to look back to see if I was with him — he could hear my leg chain clattering the whole way. In the kitchen, I jumped to obey the orders he barked at me. Within minutes he had several pans going on the stove, delicious smells already rising from them.

Half an hour later, on the lawn behind the house, which we'd reached through the glass wall at the back of the kitchen that looks onto it, we were eating eggs scrambled with chopped scallion and bits of lean salami, fresh biscuits, and fruit salad. At

Terry's direction, I'd pulled over a chaise for him to lie on and knelt in the soft grass beside him. He allowed me to hold a plate and use a knife and fork, but I'd have been perfectly content to eat from his fingers or Mutt's dog dish if that had pleased him. The sun was shining, and the air had an Indian summer warmth, so I was comfortable naked. The tall, thick hedges and trees surrounding the property guarded our privacy.

We didn't talk much. The night before had been so intense, such a watershed in our relationship, that any more talk seemed superfluous. From time to time I felt his eyes on me, and when I looked up I'd see him watching me, his trademark crooked grin just on the verge of breaking into a smile. I'd smile back before lowering my eyes again to my food — or looking around at the landscaped greenery or back through the kitchen to the more colorful pleasure dome at the center of his house, the flip side of the dungeon where I'd spent most of the long weekend so far.

We were so perfectly in sync that as soon as Terry finished his cup of coffee, I had the pot ready to pour him a refill. And when he finished eating and sent me into the house for his pipe and tobacco, my appetite was also sated.

Once he had the pipe going, he ordered me up beside him on the chaise. Lying there with my head on his chest, straddling his leg, I rubbed my face against his shirt, trying to smell him as he traced patterns on my back and ass with his hand. My cock was hard again, and I worried about dripping on his breeches, so I squirmed until it was safely pointing into the space between his legs. His restlessly moving hand seemed to be claiming me all over again.

Despite the coffee I'd drunk, I dozed off lying there, half on top of him, dreaming happy, confused dreams of bondage and bootlicking, of laughter and tears in my Master's service. I woke with a yelp when he slapped my butt.

"Time to get up, Matt. C'mon — on your feet."

I scrambled off him and stood there, shaking my head to clear the cobwebs.

"Go clean up the kitchen," he ordered.

I picked up the cluttered serving tray and carried it into the house, then began loading the dishwasher. Terry went past me to the stairs leading down to the garage, and a few minutes later he came back carrying my leather jacket, which I'd left in his Jeep

on Friday night. I gave him a quizzical glance, but he didn't stop to explain.

I watched him carry it out to the center of the garden and lay it on the wooden bench under the trellis, which was covered with grapevines still in leaf. Through the kitchen window walls I could see him disappear into his bedroom on the other side of the house. I was washing pots when he emerged again, carrying crotch-high lace-up boots, an armload of white rope, and some other gear I couldn't identify from a distance. He set it all down with my jacket on the bench, then moved the bench out from under the trellis, leaving a clear field between the uprights.

As I was finishing up, he came back into the kitchen.

"Ready for some fresh-air bondage, sport?" he asked with a big grin.

"Anytime, Sir," I said, grinning back.

"Go take a piss first, and shit, too, if you can, then join me."

He showed me a little bathroom off the kitchen. After using it, I walked out to the trellis. Terry hadn't been idle in my absence. He was building a rope web inside the trellis, not a spider web of concentric circles, but more like a skewed checkerboard with diamond-shaped openings, each less than six inches high. The steel-pipe frame, which seemed sturdier than it had any right to be for its ostensible purpose, provided a perfect anchor for his ropes, and now that he'd moved the bench from underneath the trellis, I could see steel rings set discreetly in the flagstones between its uprights.

"Put these on," he said after removing my chains and holding up leather shorts that had the crotch cut out, "then the socks and boots." Long, thick boot socks were laid out on the bench. "Even with the socks, the boots will be loose on you, but you're not going to be walking in them."

My cock was already hard as I picked up the leather shorts. Terry grinned at me but said no more, he was so absorbed in his ropework. I pulled the soft, well-worn leather over my ass, which it fit snugly. There was a zipper up the asscrack, but since it was closed I left it that way. The opening at the crotch was surrounded by snaps, obviously so it could be covered if desired; apparently Terry wanted my cock and balls available. There were zippers along both sides, probably so the shorts could be removed even if the wearer's feet were tied. *Did he have these made for Philip? I*

wondered, a little uneasily. But the boots were clearly Terry's own, and I was excited about wearing them.

After I had the socks on, I slipped my leg into the right boot. From the instep to mid-calf, the laces were threaded but loose. From mid-calf on up the laces had been pulled out, and the boot top fell away from my leg. I debated whether to thread all the laces first, or begin by tightening the ones at the bottom — it was going to be a big job either way. I propped the sole on the bench and started lacing.

It went surprisingly fast, and my cock was hard the whole time, but when I reached mid-thigh — still almost a foot from the top of the boot, which was, of course, too tall for me — I ran out of lacing and had to go back and tighten it before I could finish. I pulled the laces as tight as I could, and when I reached the point where I'd stopped the first time, there was more than enough lace to finish up to my crotch and tie it off with a big bow. After folding the top few inches of the boot down over the shorts. I lowered my foot to the ground and stamped a little to settle into the boot — it felt great!

I glanced over at Terry, who was still working on his web, weaving ropes into diamonds. He gave me a stern glance, as if to say, "Get back to work," so I quickly tackled the other boot. This time I tightened from the bottom and rethreaded the laces as I went, and I was finished in only about ten minutes. I turned and faced him, my cock proudly erect through the hole in the shorts.

"Put on the mittens and then your jacket," Terry ordered.

The mittens must have started life as heavily padded leather ski gloves, but strategic D-rings had been added at the wrists and tips, and the thumbs were sewn to the finger pouches. I slipped my hands into them, then pulled on my jacket. I wondered about zipping up the front, but with the mittens on I couldn't do it, and probably Terry would want my front side available anyway. If he wanted the sleeve zippers closed, he'd have to do that himself, too.

I stood there watching, enjoying the feel of all that leather against my bare skin, as he put what seemed to be the finishing touches on his web. I relished the quiet confidence and skill of his movements, wishing I could lick off the sweat beading his forehead. He straightened finally and beckoned me closer.

"Stand here with your back against the web."

I got into position, facing across the garden toward the living room, and automatically crossed my hands behind my back, but he reached around me and pushed them down again to my sides.

"Don't anticipate, Matt. Simply do what I tell you."

"Yes, Sir, sorry, Sir."

He smiled, so I knew he wasn't seriously annoyed, and as I stood there waiting, looking at him, loving him with my eyes, he methodically uncoiled a hank of rope, letting it fall into large loops on the ground. I was practically vibrating with sexual tension, I was so eager for him to tie me up.

But as Terry continued to uncoil his ropes, laying each one aside before starting on another, his eyes moving from me to the trellis to the ground and back again while his hands worked on their own, his expression serious, concentrated, I began to cool off. *He's designing my bondage in his mind,* I thought. *Planning each move, each tie. It's like I'm a prison he's designing. When the design is complete in his head, when he knows exactly how the finished structure will look and work, when he's figured every stress, provided for every contingency, then he'll begin.*

I wasn't sure if I liked being looked at that way, as a structural element, not a person. He must have sensed my ambivalence, because he suddenly flashed me a grin.

"Rope bondage is different from steel or leather, Matt," he said, almost apologetically. "It's much easier to do badly and harder to do well. You have to calculate each tie so that it's secure but not too tight. You have to make the different ties work together so they reinforce each other — otherwise some'll tighten and others loosen as the bottom pulls against them. You have to factor time into the equation, because what looks good and feels good at the start might not be so good a few hours later. And because I'm going to tie you standing, I have to take special care to give you some support without cutting off any circulation. That's why I had you dress in heavy leathers, so you can relax into the ropes without compressing any veins or nerves."

"You're very considerate, Sir," I said, smiling to blunt any suggestion of sarcasm.

"What I am is a control freak. I believe that any pain you feel from something I do to you should be deliberate, because I *want* you to feel it. I detest unplanned distractions, like cramps,

abrasions, or numbness from bondage bungles. And I expect you to let me know *immediately* if anything like that happens. Understand?"

"Yes, Sir!"

"Right. Now shut up and let me do this properly."

Another "Yes, Sir" was on the tip of my tongue, but I bit it back and nodded my head instead. Even though the implication that I'd been the one doing the talking was unfair, I'd learned by then that "Shut up" meant, "I don't want to hear a peep out of you, not even an acknowledgement of this order."

Finally, Terry moved behind me and started tying me into the web. Even though my eyes were uncovered, I couldn't see a lot of what he did, only feel the effects. To my surprise, his very first loop was around my neck, but he left it very loose, and moments later he pulled that loop down toward my chest with ropes crossing under my arms. While there was no pressure against my throat, my shoulders were firmly pulled back against the web and secured in place. Other loops crossed my upper chest and under my arms again, and then he pulled them, behind my back, up and through the ring of a large panic snap at the top of the trellis. If I'd gone limp, the strain on my arms would have been too much, but as long as I continued to stand, the ropes took some of my weight while the thick leather of the jacket distributed the pressure in my armpits.

He looped still another rope behind my neck, then crossed the ends over my chest and ran each one through a nipple ring. When he tied them off again in back of me the loop wasn't as tight as the others, and it didn't bear any weight. But each time I filled my lungs with air, I could feel the ropes slide over my nipples and pecs.

Next he secured my lower torso, crisscrossing my abs and running triple loops of rope under my butt and around the doubled-over tops of the boots, which held my thighs immobile without putting too much pressure on my groin. When he was finished with this phase, I felt a distinct lifting effect from the ropes, as if I could sit back into the web like a hammock. *He obviously intends for this to be a long session!*

As well as I could, I watched him as he worked on me, lacing me into his web, securing me for . . . what? the rest of the afternoon? His face was so *intent*, with his tongue tip just peeking

out between his lips on one side the way it did when he was concentrating. My heart melted as I looked at him, saw his love for me subsumed into his perfectionism, his need to dominate and control whatever he touched. The sure, confident way he handled my body thrilled me. I felt so safe with him, even when he gave me pain. I went almost limp as I relaxed into the ropes, my legs inside his tall boots — *his boots!* — still supporting me, but lightly, effortlessly. The musk of his mansweat, and my own, rose like perfume to my nostrils, mixing with the heady aroma of the ripe and overripe grapes left on the vines over my head, whose leaves sheltered me from the strong early afternoon sun that filled his atrium with a golden light.

My arms were still free, but that soon changed. Terry closed the wrist zippers on my jacket and lifted and bent each arm to work it through the web behind me, just under the level of my pecs. In back of me again, he pulled both arms through and down, then crossed my wrists and tied them securely. I barely felt the pressure of the ropes through the padded mitts, but I knew I wouldn't be getting out of this on my own.

He wasn't finished, however — far from it! Threading a rope through the rings at the ends of the mitts, he pulled my bound wrists upward until they were back at the level where my arms passed through the web, then worked the ends of the rope up over my shoulders, across my chest, down under the opposite arms, back up to the top of the trellis, and down again to each elbow, which was individually tied to the web. I had immediately felt some strain in my shoulders when he'd pulled my hands up, but that largely eased as the weight of my arms was distributed. The tension on the mitts, though, made me unable even to wiggle my fingers.

As if to show me how well supported I was, Terry suddenly kicked my legs apart. Of course, that immediately tightened every loop of rope holding me to the web, as was probably his intention. I felt snug and safe, not hurt, and my cock was leaking precum. He wiped it off with his hand and fed it to me.

"Oh, Sir," I babbled as his thumb rubbed over my swollen cockhead, "that feels so good! This is so great! Thank you, Sir! I could come right now if you do that again, Sir!"

"Do you *really* want to come now and stand there the rest of the afternoon with a limp dick?" he asked, still stroking my

cock and putting his hand to my mouth so I could lick off my own slime.

"No, Sir! . . . *Ooohh!* Yes, Sir, please, Sir! . . . *Ahhh!*"

"Please, what, boy? 'Please may I come, Sir?' or 'Please *don't* make me come, Sir'?"

"I don't know, Sir! I can't decide. . . . *Ooohh!* . . . I'm so hot, Sir! I'm ready to shoot, Sir! . . . Please help me hold back, Sir!"

He took his hand off my cock and stepped back, looking at me with an amused half grin.

"I think you'd better wait a bit, at least until I finish tying you up."

"Yes, Master," I gasped. "Thank you, Sir. . . . That was awfully close, Sir!"

"Yeah, you're a regular little firecracker, ain't ya, boy? Heat you up a bit and you're ready to pop."

"I guess so, Sir," I said with a sheepish smile.

He shook his head, still grinning, and knelt to tie my legs. He was as methodical there as with everything else, and when he'd finished I couldn't move them at all. If I even flexed my muscles I felt the ropes tighten against the crotch-high leather boots encasing my legs. As a last touch he tied the base of my cock and wound rope around my scrotum, forcing my balls low, then clipped the handle of a plastic bucket to the front of my bound ballsac.

My cock was full and hard, jutting out over the bucket I would in time weigh down with my piss. My abraded nipples throbbed with feeling — not pain, not pleasure, just aliveness! I was alive and healthy and in my Master's house, in His bonds. Nothing else mattered.

Terry stood back and looked at me then from all sides, evaluating his handiwork like a painter assessing a just-finished canvas. Apparently satisfied, he came close and held me, slipping his arms through the rope web to hug me, spearing my mouth with his tongue, covering my face with hungry kisses, which I returned with equal passion.

"God, I love how you look tied up," he said, stepping back again. "You want it so bad, you're practically glowing, vibrating. I can almost envy you . . . but you miss the best part — you can't see yourself."

Terry casually lifted the mirrorshades hooked into the pock-

et of his police shirt, slipped them over his ears, and gave me one last warm look before pushing the lenses back over his eyes. The shades transformed him, combining with his gray uniform shirt and breeches and spit-polished motorcycle cop's boots to give him an aura of impersonal authority — not so much "my Master" as simply "The Man in Charge."

He stooped and picked up one of the last lengths of rope, then ambled over toward me. I looked at his eyes as he stood before me, repeatedly pulling the soft, thick, white rope between his hands, but all I could see was my own reflection in the lenses. *Is that why he put them on?* I wondered as I squinted at my tiny form, tied into the web he'd woven. My elbows stuck out at my sides, and the open leather jacket pulled away from my chest. My legs were like the posts of an A-frame, my swollen scrotum at the apex. My stiff cock was foreshortened in the mirrored glasses because it stood almost straight out from the fuzz of my recently shaved crotch.

A cool breeze flowed across the hair stubble on my chest and made my nipples stiffen so that the rings tugged at the ropes passing through them. Except for the rise and fall of my chest as I breathed, my head was the only part of my body I could still move, and I suspected it wouldn't be long before it, too, was immobilized.

I seized this last opportunity and glanced away from Terry, looking past the garden and through the glass walls that circled the atrium, first left into his kitchen, where he'd prepared the food that still warmed my belly, and then right into the master bedroom, where we'd spent the night — the morning, really — and finally straight ahead into the living room, where he'd first brought out my doggy self, Mutt. It was all so calm and peaceful looking, almost ordinary. There was no sign of the controlled violence he'd inflicted on me, and that I'd endured, gladly, for the past day and a half.

Terry still hadn't made a move, just held his relaxed stance about two feet away from me, the doubled rope in his hands and his crooked grin the only hint of his plans. *What's he waiting for? Does he want me to say I'm ready?*

Closing my eyes for a moment, I inhaled deeply, savoring the mixed scents of the last flowers in his garden before the first frost. I caught lingering food smells, too, and a sudden sharp

whiff of his sweat as the breeze shifted. The afternoon sun was pleasantly warm against my leather-covered backside. I clenched my ass — *why hasn't he plugged it?* — and felt my cock rise higher than it already was. I opened my eyes and looked again at Terry.

As if that'd been the signal he was waiting for, he stepped forward and raised the taut, doubled rope toward my mouth. I opened my lips automatically, still staring at my own reflection in his mirrorshades as he slipped the soft, clean, well-used cotton cord between my teeth. I bit down to hold it there as he moved his hands behind my head and pulled the gag tight.

He ran the rope through the web, of course, so it also pulled my head back against the other ropes crisscrossed behind me and prevented more than the slightest lateral motion. He pulled the doubled rope around and through my teeth twice more before tying it off. I chewed on the gag, soaking the rope strands with my spit. It held my jaw, lips, and tongue immobile enough to block articulate speech, but it didn't prevent mouth-breathing or swallowing. I grunted experimentally just to see if I could.

Terry had been standing so close to me that my dripping cock had brushed the front of his breeches, leaving little streaks of precum a few inches above his boots. Of course, I couldn't tell him about it, but when he stepped back to view the effect, he noticed my cast-down eyes and discovered the soiling.

"You're a regular leaky faucet," he said, laughing. "Maybe I *should* milk you before I leave you there. Would you like that, boy? Would you like me to make you come now?"

"*Ehh! Ehh! Eeehh!*" I tried desperately to communicate despite the gag.

"Eh? What's that? Can't understand you, boy," he chided maliciously.

"*Eeerhh! Ehh! Ahh ahhn uhh omm!*"

"Is that a yes?" He stroked my cock, eliciting a loud groan. "You like that, boy?" I moaned as loud as I could. "Yeah . . . you like it. You always like it when I play with your dick, especially when you're all tied up and can't do a thing about it."

I almost came right then when he spat on his palm and rubbed it along my shaft and over the head of my cock. But he had no intention of letting me climax so easily.

"You like it when I play with your tits, too, don't you boy?"

I groaned in pain and ecstasy as he pinched and rolled my nipples between his fingers, then tugged at the ropes threaded through my rings, pulling them out as far as he could before letting them snap back. I'd have rolled my head if I could, but all I could move was my eyes.

"Your balls, too, slaveboy? You like your balls played with, don'cha?"

He rolled each bound nut in his fingers, causing excruciating pain that seemed to go straight to my dick. *If he keeps this up, I'll shoot even if he doesn't touch my cock again!*

"How 'bout your ass, boy? . . . Don't want me to neglect that, do ya? . . . I'll bet you'd like something long and thick up your chute right about now, wouldn't ya? . . . Long and thick. . . . Wonder what that could be? . . . Have any ideas, boy?"

While he was talking, he'd reached through the web beside me and managed to pull down the zipper along the back seam of the leather shorts. He'd wet his finger with my precum and was working it into my asshole, making me squirm and moan even more than before.

"Uhh eeh! Eeahh uhh eeh!" *Fuck me! Please fuck me!* I tried to tell him, but it came out gibberish. I think he got the idea anyway, though.

"What's that, boy?" he said as he fingered my prostate with two fingers. "You're telling me to give it to you harder? Really stick it to ya? Well, that's exactly what I'm gonna do. I'll just pull these fingers out and put a rubber on, and then I'll throw ya a fuck ya won't"

Too late! Terry had miscalculated for once, and while he was still pulling his fingers out of my ass, I exploded. My cock was already bent upright by his body pressing against me, and my cum hit the underside of his chin.

I screamed and jerked against the ropes. He pulled back in surprise, and my next shot landed on his shirt. The one after that sprayed his crotch. He was too stunned to move away, and my last few spurts dribbled onto his shiny boots. I noticed most of this, of course, only after my eyes had rolled forward again and I'd stopped shuddering from my untimely — but quite wonderful — orgasm.

When I did get a clear look at him, it was a good thing for me I was gagged, because I couldn't help laughing — luckily, my

mirth was inaudible. He was quite a picture standing there in bewilderment, with his mouth hanging open, a blob of cum on his chin, and white splotches on his shirt, pants, and boots. He even took off his sunglasses and looked at them for a moment, as if they might be at fault. Then he looked at me, down at himself, and back at me. He wiped the cum off his chin with his hand, then looked at that as if wondering what to do with it. He looked at his shirt again, shrugged, and wiped his hand there.

Finally he looked at me and said, with a rueful half smile, "Remind me to blindfold you *first* next time. Some disasters can be salvaged if there are no witnesses. In this case I think a retreat is in order. Don't go away." And with that feeble joke, he turned and went back into the house by way of his bedroom.

CHAPTER 32

Food for the gods

I giggled, or as close to it as I could with the rope gag in my mouth, as Terry beat his retreat. *He said he wanted me to be able to surprise him!* Of course, I hadn't done it deliberately, and I'd cheated myself out of a hot fuck, but what the hell — the expression on his face had been worth it. *So he's not a mind reader after all. That's a relief! I don't think I'm ready for that level of control. What he already has is plenty.*

The extent of that control was manifest in the ropes that held me so I could barely move a muscle, except to breathe, and even that was a delicious torture thanks to the lines threaded through my nipple rings. All I could do was hang there, helpless, until it pleased him to release me.

Not that I wanted to be released yet! Even though I'd just had an explosive orgasm and was no longer horny, I was enjoying the secure but comfortable bondage . . . if only there hadn't been bugs in his garden! Various flying critters seemed to find my sweat irresistible, and I swear some of them took bites out of me, too. I tried jerking against the ropes and grunting into the gag to scare them away, but they soon became accustomed to my useless exertions and ignored them. I imagined Terry lying on his bed, or sitting in his bedroom armchair, smoking a cigar or pipe and watching my wriggling with an amused smile.

And eventually, of course, I needed to piss. It was like my first night in the dungeon all over again. I didn't need to be told that any piss that missed the bucket and splashed on the flagstones would end up on my tongue. But the rope bondage left me much less slack to aim my cock than the chains in the dungeon had done, and the damned bucket hanging from my balls

moved whenever I did. I couldn't even look down to see what I was doing!

My first few spurts of piss arched all the way over the edge of the bucket. I groaned in frustration and strained to hold the flow back, releasing it in tiny dribbles. It seemed to take forever to empty my bladder that way, but when I was finished the increased weight of the bucket pulling on my balls assured me that I'd hit the mark more often than not.

I sighed deeply and relaxed into the ropes. Aside from the occasional bug bite, I was again perfectly content. Despite the recent vivid demonstration that Terry was only human, his house still seemed like a wonderland and he the wizard controlling all that happened within its walls. I didn't have to worry or think about what would happen next. *My fate is in good hands.* I let my eyes close and my mind drift through the lazy afternoon. More and more of my muscles relaxed, leaving only my legs and my heart doing any work

Terry's bootheels clicking on the stones behind me clued me to his return, but instead of letting me see him, he stood behind me and worked more rope through the web and around my eyes, covering them with loop after loop until I was effectively blinded. I felt his fingers at my ears and realized he was working plugs into them. The ambient noise dropped away, and I found myself bound in silent darkness, blocked from the sunlight and the sounds of insects, passing cars, and birds overhead.

Master said nothing, and his hands lifted away from me, but in a short time I moaned with pleasure as he toyed with my nipples and genitals. I groaned when the weight of the bucket between my legs began to increase noticeably — he was pissing into it! He set it swinging, pulling back and forth on my tortured balls. As a last touch he unhooked the bucket and poured some of the piss between my teeth, held open by the rope gag. The sharp-smelling urine, his and mine mixed together, puddled on my tongue and dribbled down my throat. The scent and taste filled my head so completely that I didn't realize he'd left me alone again until after he hooked the bucket back onto my balls and minutes passed without another touch from his hands.

Time really dragged then. I'd long since sucked all the piss taste out of the ropes between my teeth and added another bladder load to the bucket between my legs. All I could think about

was moving my arms, or resting my legs, which had held me up for so long. My limbs ached from the prolonged immobility. *This isn't fun anymore! Why doesn't he come and let me down?*

Sometime later I jerked in the ropes when I felt strong fingers on me again, feeling me here and there, no doubt checking for circulation problems. I groaned loudly, and he asked me close to one ear if I had a problem.

"Be careful how you answer, slaveboy," he warned. "It's not a problem if you're uncomfortable. All I need to know is if something is really wrong, like your hands are numb, or your leg is cramped, or you feel faint — stuff like that. Now, if you have a problem like that, grunt twice."

I could have cried in frustration, but I held my peace, well aware of how disappointed he'd be if I wimped out without a good reason.

"Nothing's wrong, then. Grunt once if that's correct."

I grunted once.

"Good. Enjoy yourself. I'll let you down in time for dinner."

And then he set the bucket swinging again! *"In time for dinner"! How long will that be? I'm still full from brunch!*

The achiness in my limbs, and the creepy-crawly feeling on my skin from unscratched itches, got worse for a while, and I was close to screaming out to Terry for relief, though I had no idea if he was even close enough to hear me. But the discomfort finally faded away, as it always does eventually in a long bondage scene, and I felt that incredible sense of lightness and well-being that washes over me when my body and mind finally accept immobility and silence. I didn't have any out-of-body experiences this time. Rather, it was as if I went down inside myself, and the deeper I went, the bigger became the space I explored.

It was all there, all my memories, my whole past neatly cataloged and available to my wandering gaze. Each person who'd been important in my life was represented by a different room — some closet-size, others big as houses. I didn't explore the ones from my childhood or those representing my deceased parents. But there . . . that was Greg, a whole mansion with many rooms. I passed through some of them, smiling at the vision of our first fumblings with bondage and s/m, wincing again at the pain as his health failed. . . . I hurried on, crying inside but ready to let him go. . . .

I laughed at Stan's sliver skyscraper, aptly representing our narrow but intense connection. . . . Master Jake's ancient brownstone was, of course, meticulously maintained. *But where's Terry? Surely he's here, too?*

I turned a corner in my inner city and gasped. Standing all alone in a huge landscaped park was an immense building, practically a city in itself. My virtual eyes had no trouble piercing its walls to lay bare the intricate structure, the interlocking layers and manifold spaces it contained. The core went down to bedrock, and some of what went on in the subterranean levels was so vile and degraded, it shocked even me, an experienced pervert. *These aren't my memories! Am I trying to warn myself against him?* Aboveground, all seemed rational and ordered, but here and there I noticed a bohemian twist that belied the building's bourgeois pretensions. And the highest spires were frankly queer, so flamboyantly gaudy and glorious that they made the entire supporting structure seem drab, prisonlike in comparison.

"Terry!" I called out as I ran toward it. "Terry! Master! I'm here, Sir! Please let me in! Oh, please!" I cried, my cheeks burning with frustrated tears because the building came no closer the more I ran, always shimmering just out of reach. "Help me, Master!" I wailed

The ropes dropped away from my eyes, and he was standing in front of me, working to release my gag.

"It's okay, Matt. I'm right here. You were dreaming," he said as he dug the wax out of my ears. But he looked worried.

"Sir . . . I was . . . you were" I babbled, trying to grasp the reason for my panic even as it swiftly faded past recall.

"It's okay now," Terry said again when both my ears were clear. "It was only a bad dream." He wrapped his arms around me, through the web, and kissed me, hard. That helped pull me back to reality in a hurry!

"Welcome back, boy!"

"Thank you, Sir," I breathed after he pulled away. I smiled at him, and he relaxed.

"My fault, really," he said, stroking my hair and face. "You didn't even notice the last few times I checked your skin temp, and I didn't want to pull you out of your bondage reverie by talking. I guess I spaced out a little myself, sitting here on the bench and watching you. But without external stimulation for so long,

your trip must've turned sour. Can you stand for a few more minutes while I untie you, or should I cut you down?"

"Please don't damage your beautiful ropes, Sir! I can wait, Sir, now that I know you're with me again."

"Good boy," he said with a grin.

I looked him over as he worked to free me, first unhooking the bucket weighing down my balls. He'd changed clothes after I came all over him and was wearing jeans, the black cowboy boots I'd polished, and a flannel shirt, which made me notice how cool the air had become now that the sun was down — and then it hit me. *If the sun is down, I must have been tied up more than four hours! No wonder I slipped into altered states.*

The electric lights in the garden had come on, along with lights in several rooms of the house, streaming through the window walls around the atrium. Terry worked quickly but methodically, as always, to free me from the web. It took almost as much time to get me out as it had taken him earlier to tie me up, not counting the time to build the web itself. When he was finished, he took me into his arms again for a lingering kiss. He fingered my asshole through the slit in my shorts, and I wondered if he'd fuck me after all. Seems he was wondering the same thing.

"Can you handle getting fucked right here, Matt, or do you need something to drink first and more time to get over your bad dream?"

"If you *don't* fuck me right here, Master, I might rape you instead!"

"Can't have that, boy!" he said with a laugh. "Go kneel facing the end of the bench and stretch out on it."

I got into position, with my belly and chest on the bench and my ass sticking up, though the tall boots made it hard to bend my legs. I wasn't the least bit surprised when Terry retrieved some of his rope and started tying my thighs to the legs of the bench, then tied my hands together and pulled them out as far as possible beyond my head, anchoring them at the other end of the heavy bench. I think I'd have been disappointed if he *hadn't* tied me. He seemed to feel that every minute I was free of bondage was wasted, and I couldn't disagree, at least while I was in his house. It wasn't that he *needed* the bondage to dominate me, but it made his control so much more vivid and satisfying for us both.

My hard cock and sore balls were mashed between my abs

and the wood of the bench. My asshole twitched. I wanted my Master's cock, and I wanted it now! But he took his time.

"I'm sure you're ready, boy, but you know how I hate to fuck a cold ass. I'm going to warm it up first. You like that idea, slave?"

"Yes, Master! Please beat my ass before you fuck it, Sir."

"You know I'd do it even if you *didn't* want me to, don't you, slaveboy?"

"Yes, Sir. All that matters is that *you* want to, Sir."

"Damned right it does. Hold on tight now."

Wham! Whap! It was his belt, I guessed, that slammed into my ass. The thin glove leather of the shorts I was wearing provided practically no protection. In fact, it probably made things worse because he couldn't see the effect his blows were having. *Whack! Wham!* I grunted with each blow, more and more loudly, but they kept coming. My ass was burning, but better that than itching because my hole was empty! I thrust my ass up and back as encouragement for him to plow me.

The beating continued, however, for another ten minutes or so before he unzipped the sides of the shorts and pulled them off me. I moaned as his hand caressed my belt-warmed ass.

Whack! Smack! Five times the belt slammed into my naked ass, pulling screams out of my throat, before he was satisfied.

"This is getting to look very nice," he said finally, caressing my blazing bottom again with his hand, "but I have other plans for it later, so I'm going to stop and fuck you now. How's that sound, boy?"

"Great, Sir! Thank you, Sir! *Please fuck me, Sir!*" I wailed, tears streaming down my face, because I needed it so bad.

"My pleasure, boy," he said as he inserted two lubed fingers to open me up.

I flexed my hole around them, loose and then tight, to show him how ready I was. Two fingers became three, and then four, and then I felt the unmistakable pressure of his rubbered cockhead pushing into me. I released every muscle I could control in my ass, and his fat seven inches slid all the way home in a rush, gliding over my prostate and straightening out the kink in my rectum. I could feel his wiry pubic hairs, and the zipper of his jeans, scrape against my ass cheeks. I took that cue to tighten, gripping his rod for all I was worth.

Terry just grunted, and slowly pulled back. I kept the pressure on his cock as it slid backwards out of my chute, and then, before it was completely free, he slammed forward again. This time I grunted as his cock battered my rectum. We soon worked out, without a word spoken, a complementary rhythm of speed and pressure that gave us both the greatest pleasure.

Not even his hand on my own cock had felt as good as his cock riding my well-warmed ass while I was tightly bound in place under him. It felt good all over. It felt as if we were merging, two bodies animated by a single will: his. Every sensation felt good, whether from the abrasion of my cock against the bench or Terry's hands kneading my back under the leather jacket I still wore or my hands twisting in the ropes or his cock reaming my shitchute. It was all good, all right, all as it should be.

I wanted the fuck to last forever — in and out, loose and tight, fast and slow, in and out, forever. I was grateful that Terry had more control than I'd shown and could hold off coming for so long. But he couldn't do it indefinitely. His pumping became more urgent, his breathing more ragged. In and out, in and out, loose and tight, fast and . . .

"*Ahhh!* . . . Shit, boy! I'm coming! . . . *Ahhh! Damn that's good!* Jesus, Mary, Joseph! What a hot ass you've got!"

He collapsed on top of me, his breath warm against the back of my neck. I smiled and relaxed under him, as perfectly content as if I'd shot again myself, especially with his cock still sheathed in my hole. Since his pole, unlike mine, doesn't change size much between hard and soft, I still felt comfortably full.

He lay there so long I wondered if he'd fallen asleep, but finally he kissed my neck, then pulled out of my ass with a grunt and got to his feet.

"That was worth waiting for, boy," he said as he squeezed out the condom on my asscheeks and rubbed his cum into my skin. "Right, Matt?"

"Yes, Sir! It was wonderful, Sir." *Except I feel empty again!*

"Well, you just lie there and rest for a little while. I'll come back soon with some irons for you to wear while you take down my web and coil up all the ropes. . . . Oh, almost forgot. This'll keep you happy while I'm gone," and he shoved a fat butt plug against my hole and twisted it until I opened up and let it in.

"Thank you, Sir!" I called after him. *He thinks of everything!*

True to his word, Terry returned in a short time, announcing himself with the clatter of chains dumped on the flagstones behind me. It was a good thing, too, because I was getting chilly lying there with my ass out. But he didn't let me put the shorts back on after he untied me from the bench, just told me to zip up the leather jacket.

"You'll be warm enough after you've been moving around awhile, boy, especially dragging *these* leg irons," he said, grinning up at me as he locked an extra-heavy boot cuff on my right leg. He fastened the other cuff and stood up to apply the matching manacles.

"What do you say, boy?"

"Thank you, Master, for putting me in chains again."

I was quite sincere. I really do enjoy bondage, especially from him. Nonetheless, I could easily imagine reaching a point where I'd want to say, *Give it a rest, man!* Not yet, though.

"That's right, boy — you know you love it. And even if you don't, I do! Now, undo all of the ropes and coil them neatly. You know how, don't you?"

"Yes, Sir."

"Don't take too long. I'm getting hungry," he said, heading toward the kitchen after I knelt and kissed his boots.

I'd been worried about reaching knots high over my head, but Terry had placed them all lower down, no higher than my shoulders. When I undid them, I was able to pull the ropes loose even if they looped around parts of the trellis I couldn't reach. I did have to pull over the bench to retrieve the panic snap. Fortunately, the chain between my legs was just long enough to let me get up on it and down again, though the sheer weight of the four-inch-wide solid steel cuffs over the heavy boots made this an ordeal.

As Terry predicted, I warmed up quickly from my labors, and though I still loved the feel of wearing his tall boots, I found myself looking forward to being naked again inside the house. My cock was soft and shriveled from the cool night air, but I still felt terrific, riding the high of my long bondage scene — not at all diminished by the scare at the end — followed by a great fuck.

In half an hour there was nothing left of Terry's web but a pile of ropes on the ground. I moved the bench back in place underneath the trellis and sat on it to deal with them. It was

damned awkward while wearing manacles, but soon all the ropes were reduced to neat coils laying on the bench beside me.

I wasn't sure if I should wait for Terry to come fetch me or take the initiative of heading after him. Deciding to wait a few minutes, I sat there listening to the gentle night sounds of crickets and watching for fireflies — though I should've known it was too late in the year for them.

Once again, I heard Terry's bootsteps before I saw him, and by the time he reached me I was on my knees waiting for him, head bowed in respect. He stopped right in front of me, putting the gleaming toes of his cowboy boots square in the center of my vision. Neither of us said anything as I bent down to kiss them, first the left and then the right.

"Good boy," he said when I knelt up again. "Stand up."

When I was erect (in both senses!), he unlocked one of my wrist cuffs, pulled off my leather jacket, relocked the cuff, and hung the jacket over my shoulders. Then he told me to hold out my arms, close together, and proceeded to lay the long coils of rope over them until I held them all, with the panic snap on top.

"Go to my bedroom," he told me. "I left the door ajar for you; be sure to close it when you're finished. Put the rope in the bin in the closet. You'll recognize it because there's more rope still in it. Put the snap with the other hardware. Leave your jacket on the floor. Use the bathroom — be sure to clean off any lube left on your ass. Then join me in the kitchen. Move it, boy! My risotto waits for no man, nor slave, either."

Terry may be a sadist in the dungeon, but it's in the kitchen that he's truly a tyrant! In the dungeon at times, he'll seem to be amused at the idea that he can give me orders and I'll obey them, no matter what. Some of the things he has me do seem calculated less to humiliate or degrade me than to prove to himself how far he can go. But in the kitchen he never plays any games. The "work" is all, and human feelings don't matter a bit.

From the moment I appeared at the kitchen doorway after my errand to the bedroom, he was barking orders, cursing my clumsiness, railing at my ignorance, and taking for granted my instant obedience. I quickly learned to hold my hands apart so that the chain between them stayed taut and controllable instead of swinging back and forth and breaking things. I held my tongue, took deep breaths, and tried to do whatever he told me

without getting in his way. "Risotto," he'd said. I didn't even know what that was, or why preparing it should put him in a state of barely controlled frenzy.

Finally it was just him and one pan he was constantly stirring, occasionally adding more liquid from another pan. Everything else was done, or as done as it could be. The salad was tossed, but not dressed. The bread was in a warm oven, and the wine, a riesling, was uncorked and sitting on ice. To my surprise, given that I was naked again, except for the boots, and heavily chained, he said he wanted me to sit at the dining table with him and share everything, even the wine, so I set two places. But with nothing for me to do until it was time to dress the salad and slice the bread, I knelt on the kitchen floor and watched him stir.

"Risotto, Matt," he said in a more relaxed tone after about 15 minutes of constant stirring, "is the queen of Italian cuisine, a dish of rice so perfect it could be the food of the gods. It's tricky to make and has to be served exactly when it's ready, not a moment too soon or too late." He kept stirring while he talked, not looking up from his pan.

"There are many kinds of risotto, depending on what kind of meat, seafood, or vegetables are added to the rice. I don't want this meal to be too heavy, since we have some business later in the dungeon, so I'm making a saffron risotto with shrimp and scallops. . . . It's just about done," he said at last, and then repeated my instructions. "Take the bread out of the oven, slice it, and put it in the basket covered with a napkin. Then dress the salad — be sure to mix the dressing thoroughly."

I leapt to obey, chains clanking. In another house, the combination of heavy slave chains and an elegant table service might seem silly, but here it was just part of the deal. My part finished, I stood beside his chair, ready to pull it out for him when he brought in the risotto. Soon he arrived with the steaming bowl, and I had to admit that it *smelled* "divine." After he was seated, I went to my own chair, just around the corner of the big table. (Earlier he had me cover the seat with a towel to spare his expensive upholstery.) But before I could sit down, he stopped me.

"Pour the wine, Matt, for both of us, while I serve this. Be careful with your chain."

I filled his glass first, stopping two-thirds of the way at his nod, and then poured the same amount into mine. By then he'd

heaped risotto on both our plates, topping it with freshly shaved parmesan cheese from a dish I'd set out earlier.

"Sit down, boy," he ordered. "Just put your nose over the plate and inhale!"

"It smells wonderful, Sir," I said after taking a fresh whiff.

"Taste it!"

I couldn't remember when anything I put in my mouth — not even his cock! — tasted so delicious. It was creamy and nutty and starchy all at once, and the briny flavors of the scallops and shrimp blended with the earthiness of the rice and cheese into something greater than any of them. I looked over at Terry. He was sitting there with his eyes closed, chewing slowly and somehow smiling broadly at the same time.

We ate in silence, slowly, until we'd both finished about half of our servings. Then Terry wiped his mouth and raised his wine glass. I followed suit, a little more noisily thanks to the manacles.

"A toast," he said. "To all the pleasures of life, and especially to sharing them with people we love."

"Yes, Sir! Thank you, Sir!" I responded as we clinked glasses and then tasted the wine, which was excellent.

I was both pleased and a little disappointed at his words. Although glad to be classed among the "people" he loved, I had hoped for something more. *Dare I call him on it? . . . Yes!*

"Sir, may I propose a toast, too?" I asked.

"Certainly, Matt, whatever you like."

"Then, Sir, a toast to *us* — to Master Terry and his boy Matt, his slave dickhead, and his dog Mutt. May we always be true to each other and live happily ever after!"

His face clouded over for an instant, then cleared into a big smile. He clinked his glass against mine.

"To us, boy! You're jumping the gun a little, but only a little. And I knew you were pushy. I want that 'happily ever after' as much as you do."

My eyes swam with happy tears as we drank.

"There's still some risotto," he said, "and let's not neglect this excellent salad you tossed." He helped himself to salad and bread, then passed them to me. After we concentrated again on the food for a few minutes, he re-opened a ticklish subject.

"Remember I told you Philip is coming back to New York?"

"Yes, Sir, and that he'll live with you at first."

"At least for a few months, maybe indefinitely, until he gets enough freelance work to live on his own. It's a fair arrangement: he'll help keep the place in order in return for room and board."

"Almost like being your live-in slave again, Sir."

"Jealous, Matt?"

"A little, Sir. Even as your tenant, he'll probably get to see a lot more of you than I will, Sir."

"Nevertheless, everything's changed between Phil and me, Matt. I feel a responsibility toward him, but he isn't my slave anymore, and he won't be again. He's not my lover, either, though I do love him. He might help out as junior top once in a while — like keeping an eye on you when you're all tied up and I have work to do! — but he'll have to find someone else to top him. It would tear me to pieces to lay a hand on him."

"I understand, Sir," I said, without much conviction, staring down at my plate.

"Do you, boy? I wonder. . . . Look at me, Matt."

I did as he commanded. His expression seemed grimly determined. *Better listen carefully*, I warned myself, *because he's not going to want to repeat this.*

"I have enough love in me for you and for Philip, too," he said. "Whatever I give him is something you don't need, and if he also needs what I give you, I can't be the one to give it to him anymore. You're not sick, or unemployed, and you don't need my help just to survive. You bring as much to the table in this relationship as I do — don't ever forget that.

"But Phil is still hurting, still fragile, and he turned to me because he has no one else to turn to. I'll be very happy if I can build him up again in the time he has left so that he's as strong as you are now and can give somebody — not me! — as much as you do."

"Yes, Sir," I said, ashamed of my egotism and lack of trust. "Thank you, Sir. Please forgive me, Sir, for being jealous."

"I do. I expected it. But I also expect you to get over it! You won't have to compete with Phil for my affection or attention, Matt, and if you start to play those games, you'll just make me very, very angry. I know it will be hard at first, but I want you two to be friends. You can help each other weather my moods and whims! Understood, boy?"

"Yes, Sir."

"Okay. That's enough on that subject for now. So tell me, how do you like my risotto?"

"It's probably the best thing I ever ate, Sir! I could be your slave just for your cooking, Sir, even if there was nothing else!"

"Well, eat the rest, then," he said, looking pleased. "And afterward you can tackle the mess in the kitchen. I wouldn't mind keeping you around for KP even if *you* had nothing else to offer! Cooking's no fun if you have to do the cleanup, too."

"*Is* it fun for you, Sir? You look so grim in the kitchen sometimes, as if it's torture."

Terry laughed.

"No, just concentration. I get wrapped up in what I'm doing and forget the social niceties. Remember, I've lived alone for a long time, except when I have weekend guests. You'd probably think I look pretty grim in the dungeon, too, if you could see me while I work on you, but you usually can't. Now, help me finish this bottle of wine. It's too good to waste, and you don't want a drunken top beating on you tonight, do you?"

"No, Sir. Thank you, Sir."

We sipped from our glasses silently, each lost in his own thoughts. *"Beating on me"?* He'd said he had something special planned for later, but that was the first clue about what it might involve.

To my relief, Terry removed the punishingly heavy leg irons right after we left the table, and he ran my manacle chain through the one around my neck so it would be easier to keep out of the way as I worked.

"Take off those boots now, boy," he ordered on his way out to the kitchen. "You don't need them without the irons."

"Yes, Sir. Thank you, Sir." He left too fast for me to kiss his boots. *That's dickhead's ritual*, I told myself, *though I wish he'd give Matt some rituals, too! Maybe that rule about pissing sitting down is a start?*

I sat on the floor to unlace the crotch-high boots I'd worn for the past six hours or so. Terry reappeared from the kitchen before I'd finished, and I scrambled to my knees.

"I started the coffee. When it's done, bring me a cup in the living room. You know how I like it. Have a cup yourself if you want, either in the kitchen or with me when you're finished."

"Yes, Sir. Thank you, Sir."

He simply nodded and headed off in the other direction.

The kitchen, of course, was an unholy mess. Somehow Terry's one-dish meals always required dirtying at least half a dozen pots and pans! But I had no resentment at being stuck with the cleanup — I'd do more than scrub a few pots to eat like that again! Besides, as his slave, it was my duty to do his shitwork. That was the deal. He would make the decisions, take the responsibility, and do the work of topping me, including keeping me in bondage as much as possible, and I would follow his orders, serve him any way I could, and give him my respect and loyalty.

It seemed like a fair trade — but would I feel the same way after dragging home from a long, stressful day at work? Would I feel as submissive if I wasn't in bondage, wasn't likely to be anytime soon, and had blue balls from not being allowed to come for a week or two?

I shook my head. *Only time will tell! All we can do is try our best.* I had to trust that his experience would tell him when I might need a little extra incentive or reminder to stay on course. *How difficult can it be? My cock's hard right now, and I'm not even slightly tempted to touch it. If I have trouble keeping my hands off it when I'm back home in the city, I'll ask him if I can wear a jockstrap or something. Unless he buys me a chastity belt first!*

When the coffee was brewed, I prepared a mug for Terry, black with one sugar, and took it to him in the living room. He seemed very relaxed, sitting in his recliner reading the "Arts and Leisure" section of the Sunday *Times*. Something classical, for cello and piano — *Brahms?* — was playing on the music system. Like a well-trained butler, I set the mug down on the table beside him, silently except for the light jangle of my chains, and backed away. He didn't even look up from his paper, though he reached for the mug and took a sip as I was leaving the room.

Twenty minutes later, the dishwasher was humming and every surface was clean and tidy. There was only enough coffee for two large mugs and a little bit more, so before preparing my own mug, I went in to ask if Terry wanted a refill. He didn't, so I poured mine, shut down the coffeemaker, cleaned it, and took my coffee out to the living room and knelt next to his chair.

After I set the empty mug down on the floor, his big hand reached over to tousle my hair and toy with the chain around

my neck. I rubbed my cheek along his arm and kissed his palm. We remained in companionable silence, listening to the music, until the CD finished. Terry continued to sit still, stroking my hair but not saying anything, for another minute, as if hesitating to proceed to whatever "scene" he'd planned to climax the evening.

"Okay, boy, time to move on," he said finally and stood up. I scrambled to my feet facing him, my mug in one hand. He took it from me and set it on the table.

"Follow me," he said and headed back toward the kitchen, then down the stairs to the basement.

I had mixed feelings about our destination. Much as I'd enjoyed most of my time in the dungeon, I was getting used to being a "house slave" and liked it upstairs. Whatever was going to happen in the dungeon, I was pretty sure it would hurt, probably a lot! Pain could be fun, but I needed to work up to it. He knew that, of course, and how to prepare me for it, too.

"Time for some serious bondage again, boy," he said when we'd reached the dungeon anteroom. "Gotta get your head where it should be before we can play."

Leading me to the equipment rack, he started by putting a heavy steel doughnut ball stretcher and matching cock ring on me, then encased my equipment in a chain-mesh sack so small that he had to bend my hard cock in half to get it in.

"I don't think that will fall off even if you lose your hard-on, boy — but you won't get soft as long as you're chained up, will you?"

"No, Sir! Thank you, Sir!"

He replaced my neck chain with a heavy steel collar and added heavy leg irons — not as heavy as those I'd worn over his boots, but plenty heavy nonetheless. He repositioned the manacles behind my back. With all this heavy metal in place on me, and carrying still more chains and padlocks, Terry escorted me into the dungeon and over to the circle of perforated I-beams that hold up the ceiling, underneath the atrium garden.

Backing me up to one of them so I faced the center of the room, he made me crouch down and then chained both my leg irons and manacles to the beam about a foot off the floor. He padlocked a short chain to the back of my collar and locked its other end to the beam near where the leg and wrist chains were attached. Once all the locks were in place, I could no longer

stand straight but only kneel, crouch, or sit close to the beam with my knees pulled up to my chest. My hands couldn't touch either my crotch or my face, and my cock was impossibly, painfully hard in its cruelly confining pouch.

Terry stood back a foot or so and looked me over. The twinkle in his eye and half smile on his lips told me he must have liked what he saw. I struggled into a kneeling position and looked back at him, then lowered my eyes to his boots. *I can't even bend down enough to kiss them!*

"I'm going to leave you alone for a while, boy," he said finally. "You'll have nothing to do but think and rattle your chains. And here's what you can think about: when I come back I'm going to whip the shit out of you."

I jerked my head up and stared at him. My heart was hammering, and the blood must have drained out of my face — and out of my cock, too. The chain-mesh pouch felt loose, not constricting.

"Trust me, Matt." He stepped close and rubbed my face in his crotch. "It'll hurt like hell, but by the time I finish, you'll be *mine* in a way you aren't now. This is our real wedding ceremony, slaveboy. The one at Altar was just the engagement. I'm going to seal our pact with blood, sweat, and tears — my sweat, your blood and tears. . . . Don't be afraid of it, Matt. Accept it, ride it, learn to fly."

He kneaded my shoulders, and while some of the tension flowed away under his hands, I was still terrified. I'd never gotten into blood scenes, even before the plague, and now I was so conditioned against any sex involving blood that just the thought was enough to send me into a panic. Terry caressed me and ruffled my sweat-dampened hair, finally tipping my head back and bending to kiss me. I responded as I always did to his tenderness, my cock stiffening again until it was cramped inside its metallic prison.

"Don't think about blood, or pain," he said softly after he pulled his mouth away. "Think about me making love to you with my whips, caressing your body with every lash. Think about waves of intense sensation carrying you away to places you never dreamed of."

"Yes, Sir," I said, still uncertain, reflexively kissing his denim-covered hard-on while he held me.

I wanted to put my arms around him, but the chains prevented that. *I'm a naked, chained slave. Do I have any choice?* That was no comfort, because I certainly *did* have a choice. I knew I could say, "No, I won't do this," and he'd let me go. *But at what cost? Would he just send me home and try again another time? Or would it end things between us altogether? Better he never lets me go!*

"Are you okay, Matt?" Terry asked, releasing me from his hands. "Will you go through this for me?"

"Yes, Sir! I'll do my best, Sir. But"

"No buts, boy! Don't try to negotiate an out, don't look for loopholes. Either we go ahead full steam, and deal with any icebergs as we come to them, or we stay in port. I'm a good skipper. I know all the hazards. Which do you want it to be?"

"Full steam ahead, Sir," I declared with more conviction than I actually felt.

"That's my good boy." He smiled down at me. "Now rest and psych up for our session. Think about what it'll *mean* for us, not what it'll cost you. I wouldn't put you through this if I didn't think you could handle it. I'll be back in about an hour."

Before leaving the dungeon, he turned off all of the lamps except the one right above me on the pillar I was chained to, leaving me alone in a pool of light, surrounded by inky darkness. I shivered as the heavy door closed, but despite my nakedness the temperature was actually quite comfortable in the huge open space. A gentle heat continually rose around me from hot-water pipes running under the slate-flagged floor.

I scrunched down on the floor and thought about other whippings I'd had. It wasn't my favorite scene. The early stages were always exciting, as I was tied in place and warmed up with a light strap or flogger, but I usually found the more "advanced" stages unpleasant or worse. Sometimes only pride and stubbornness let me endure enough not to get a reputation as a candyass.

If the scene leading up to the whipping was really good, I might succeed in walling off the pain as if it were happening to someone else. I could take a lot more that way, but I didn't really *enjoy* it like some guys did — not the way I enjoy a heavy bondage scene! And I couldn't remember ever enjoying being *cut* with a whip.

I'd heard about whippings that were as sensuous as a good fuck, a form of lovemaking, but I'd always dismissed it as exag-

geration. Though I felt pretty sure about Terry's feelings for me, and mine for him, I figured this whipping he'd planned for me would be a fairly grim rite of passage. I was determined not to let him down, but I wasn't expecting to like it.

CHAPTER 33

Good boys get flogged

I knew Terry had returned — I suppose about an hour later, as he'd said, but it was hard to keep track of the time locked in a room with no windows or clocks — when lights suddenly blazed on all around the inside of the circle of I-beams. The door swung open, and I scrambled noisily to my knees as he approached. When he came into the light, I saw he was stripped for action, wearing only his leather jock and torso harness, short gloves, Muir cap, and the same crotch-high boots I'd worn that afternoon. *Too bad I wasn't there to lace 'em up!* He carried a long leather bag in one hand. I watched as he set it down on the far side of the circle and then moved into the shadows.

He re-emerged pushing a wooden A-frame on wheels. He rolled it around a bit until he found the exact spot, then chocked the wheels and lowered thick metal rods in the corners of the frame deep into corresponding sockets in the floor. He shook it vigorously to test how firmly it was held. Apparently satisfied, he strode around the piss pool and came toward me.

Already kneeling with my arms behind my back, I could do nothing more to show my respect except lower my eyes. My field of vision was filled by his leather-encased legs and thighs, but I couldn't kiss them until Terry unfastened the chain holding my collar to the pillar.

"Kiss my boots, slaveboy," he said after doing so, his voice even more than usually low and sonorous.

As I lowered my face first to the left boot and then to the right and kissed each toe once, the "gears in my head," as Terry calls them, whirred frantically. *Am I Matt or dickhead now? At a time like this, the difference between us seems razor-thin.* I knelt up

again, my head still bowed. I wanted to lick and love the boots thoroughly, of course, but in either persona, I'd wait for orders.

"Now my gloves, boy," he said in a slow, measured voice. "Kiss the hands that are going to whip you."

This is new! I thought. *It's like a litany he's following.* My cock was hard enough again to be bent in two inside the chain-mesh pouch as I touched my lips to his extended hand. I kissed the palm and when he turned it over, still extended, the back as well.

My lips had barely lifted from the leather when, without warning, that same hand snapped like a whip against my cheek — hard. I cried out and jerked my head up, rattling the chains still holding me to the pillar at wrists and ankles. Terry looked at me with a tender expression and gently caressed my face with the same hand that had slapped me. Then he pushed my head down again and extended his other hand. My heart pounding, I kissed his palm as before, then the back. Again I was rewarded with a hard slap, followed by a gentle caress. My eyes grew moist as I absorbed his message.

"Thank you, Master," I said softly.

"Now kiss my jock, boy. Kiss the cock that's going to fuck your ass after I beat the shit out of it."

I pressed my lips to the leather-covered mound, feeling his hard cock inside, cramped almost as badly as mine. When I pulled my head away, Terry grabbed my hair with one hand and ripped at the snaps on his jock with the other. His cock sprang out into my face, fully erect — and already sheathed in latex. He rammed it into my mouth as far as it could go while I struggled to control my gag reflex. After pumping it down my throat a few times, he pulled out and slapped my face with it before tucking it (with some difficulty) back into his jock. Then he turned around and presented his bare ass.

"Kiss my ass, boy, both sides, and then lick the crack," he ordered over his shoulder.

I did as he said, increasingly excited at the ritual we were performing. I pressed a wet kiss onto each of his furry, muscular asscheeks, first left then right. *He has such a neat butt*, I couldn't help thinking, *it's a pity he never gets fucked. Or maybe he does? Maybe he'll let me* — make *me* — *fuck him sometime?*

I pushed my nose into his crack and slowly slurped from top to bottom. He was clean, as I knew he would be, but all I

smelled and tasted was *him*, not any soap or artificial chemical scent.

I can just picture it, I mused as I licked. *He'll be lying on the bed with his knees up and legs spread, his ass raised on a pillow, holding my leash in one hand and playing with his cock with the other, looking at me. I'll be collared, of course, with my hands cuffed behind my back, maybe attached by a chain to my balls, and clamps swinging from my nipples. At his direction, conveyed just by pulls on the leash, I'll eat out his clean ass, opening it up. Then he'll grease up my stiff cock, which would already be rubbered, with the same hand he'd been using on his own cock, and I'll slowly work my dick into his hole, pacing the fuck however he wants, giving him the same kind of pleasure he gives me . . .*

"Time to stand up, slaveboy," he said, breaking my daydream as he turned around and reached down behind me to unlock me from the pillar. I was stiff and clumsy, so he helped me up with hands under my arms. The chains jangled as I moved.

"Kiss and lick my tits."

Eagerly, I pressed my lips to each of his nipples, centered in large rings on his harness, and while I suckled at his chest he twisted and pulled my own nips, sending bolts of exciting pain through me.

"Enough, slaveboy," he said after about a minute of this complementary nipple play. "Now kiss me — kiss your Master."

I lifted my head to his and opened for his tongue, but he remained passive this time. So I licked and nibbled at his lips and ran my tongue over his moustache until his lips parted and he let me in. While I sucked at his mouth and rolled my tongue around his, he vigorously kneaded my shoulders and back, attacking the knots of anxiety I'd built up while waiting for him to return. It hurt at first, but my tense muscles soon relaxed under his hands.

"Are you ready now, boy?" he asked, pulling our faces apart.

"Yes, Sir," I replied with more firmness than I really felt.

"Still afraid?"

"A little, Sir."

"There's nothing to be afraid of, Matt. Haven't you learned to trust me yet?"

"I trust *you*, Sir. I don't know if I trust myself to respond the way you want."

"You can't trust anyone else if you don't trust yourself," he

said gravely, holding my eyes until I looked down, abashed. "Try surrendering for a change," he went on. "Let go. I know what I'm doing, and I'll be with you every step of the way."

I looked into his bright hazel eyes again and felt my last resistance melting.

"Yes, Sir. Thank you, Sir," I told him calmly. "I'm yours. Do whatever you want."

"Good *boy*," he said, and proceeded to unlock my manacles and take off the chastity pouch, freeing my stiff dick to stand out from my crotch at a jaunty angle.

"Go use the toilet," he ordered. "Take out the butt plug, rinse it, and leave it there."

"Yes, Sir, thank you, Sir," I said, and walked toward the alcove with the sanitary facilities.

The sound of my leg chain dragging on the floor seemed embarrassingly loud in the silence, but I suspect Terry liked hearing it. I sat in near darkness on the cold, bare steel toilet and tried to will my bowels into motion so I'd be clean when he fucked me.

Over near the whipping frame, Terry was removing equipment from his bag and setting it out ready for use. A long chain ran between the two pillars nearest the frame, maybe seven feet above the floor — well above his head, anyway — and he carefully hung a couple dozen floggers, cats, and whips on it using S-hooks that he also took out of his bag. *Anyone else'd just drape 'em over the chain*, I thought to myself, marveling anew at his attention to detail — *or is it obsessiveness?* Apparently satisfied with his selection and how they were arranged, he walked back to the front of the dungeon, climbed the platform, and fiddled with the master control panel near the door.

The lighting softened except for a couple of ceiling-mounted pinspots directed right at the working side of the A-frame, and instrumental music filled the space. Nothing I recognized, it was slow and repetitive, some minimalist or New Age composition that initially seemed static but over time almost imperceptibly evolved. The effect was hypnotic, calming.

I was flushing the toilet when he came to get me. First, however, he bent my chest over the sink, "So I can make sure you're clean, boy." During the examination, he teased me, making me blush at being turned on by his probing my hole. When he was finished, he washed his hands and, smiling as though we were

out for a stroll, took me by the arm and led me across the room, preceded by my traitorously erect cock.

When we reached the A-frame, he removed the collar and leg irons I wore and replaced the metal restraints with fleece-lined leather ankle cuffs joined by a light chain, foam-padded leather wrist cuffs designed for suspension, and a padded leather posture collar that held my head up and supported my chin (not so incidentally, I guessed, it also kept my mouth shut!). Finally, he had me buckle on a black leather weightlifter's kidney belt equipped with a heavy-duty D-ring on each side.

Naturally, Terry's whipping frame was the deluxe model. The sturdy wooden beams were smoothly finished, and the lower crosspiece at the front was elevated six inches above the floor so that the man being whipped could stand firmly instead of having to twist his feet to the side or perch uneasily on the beam itself. There were eyebolts all along the bottom of the crosspiece for attaching ankle cuffs, allowing the width of the prisoner's stance to be adjusted as desired. Terry clipped my cuffs to bolts about two and a half feet apart.

At the center of the frame was a movable crossplank about a foot wide, padded and leather covered. Terry set the plank at the height of my abdomen and leaned me against it, then used short chains and clips to firmly attach my kidney belt to eyebolts at either end.

"This'll keep you from thrashing around, boy," he said, "and the belt and collar will shield you if my aim is ever off."

Finally, he used a quick-release panic snap to clip my wrist cuffs to a long chain dangling from the apex of the frame, high above my head. He adjusted the tension so my arms were fully extended but not uncomfortably stretched. My head, held up by the posture collar, rested between them, and my whole body was perhaps 30 degrees off the vertical.

"Try wriggling, boy. I need to see if you're securely fastened — and you need to realize it, too."

I found that I could wiggle my ass a little, or shift my legs an inch or so in or out, but that was about all. From my waist up the restraints, the position, and gravity itself combined to keep me effectively immobilized. And the frame seemed fixed in concrete. My cock was about as hard as concrete, too. *Well, I always did like rigid bondage!*

"Can you talk?"

"Na . . . not very well, Sir," I said, struggling against the up-ward pressure of the posture collar.

"Good enough," Terry said with a chuckle. "I don't want you to talk anyway, unless I ask a direct question, and then you can grunt — once for yes and twice for no. Understand?"

I grunted once.

"Good boy! Any problem I should know about?" he asked, stroking my ass teasingly. There were still a few tender spots from the belting that afternoon, but I was sure I wouldn't notice them soon enough — they'd have too much company! I grunted twice.

"Good boy!" he said again. "You'll be standing there a long time, and I don't want you distracted by muscle aches. We'll take breaks along the way, and I'll let you down for a while. Anything you need to say before we begin?"

What can *I say? "I love you — please don't hurt me too much"?* Again I grunted twice.

"Good."

He kissed my shoulders before stepping over to his array of gear. The A-frame was set parallel to the chain the whips hung from, but I could see them if I raised my head and looked over to my left. I eyed the collection nervously, suddenly realizing that they were arranged from lightest to heaviest. The last one on the right was a long blacksnake whip, but even the shorter whips and cats next to it could slice a man's back to ribbons. I started to get scared again, and my cock softened. *"Trust me," he'd said. But this would be so much easier to take with a blindfold or hood!*

Terry took down the first implement, a doubled leather strap less than a foot and a half long, and came over to the A-frame with it, straddling the sidebar so he was facing me. He held the leather to my lips.

"Kiss it, boy," he ordered, and I did. "I want you to see and welcome everything I use on you tonight," he went on. "No sur-prises. Also no hiding behind a hood or blindfold."

Is he reading my mind after all? Or am I so transparent?

He ran the twin strips of heavy but supple leather across my lips and cheeks, and under my nose. The working ends were cut off at opposite angles, resembling a snake's forked tongue. The intoxicating leather smell helped my cock fill out again.

"I made this slapper myself, boy, years ago, out of a belt I'd

worn for years before that. It's one of my oldest pieces of equipment, and a very personal one. I don't use it on just anybody."

"Thank you, Sir," I murmured indistinctly, my mouth still pressed against the leather strap and my chin against the collar.

"I'm going to do my very best for you, slaveboy," Terry said, "and I want you to understand and appreciate my efforts. Is that clear?"

I stretched my head back enough to say, "Yes, Sir! Thank you, Sir!" in a loud, clear voice. *I've* got *to endure this for him! Lord, give me strength!*

"That's my boy," he said, pulling the slapper away from me and kissing my forehead paternally. "Remember, Matt. Don't try and talk to me while I'm flogging you. It's not critical with this little slapper, but later on it might distract me, and if I land a stroke wrong it'll hurt you more than me! Trust me — I'll know if you're in trouble and need to tell me something."

I had no doubt of it. We hadn't used safewords in any of our prior sessions, and Terry had proved over and over how well he could read me. I actually felt safer, or at least less burdened with responsibility, knowing that the decision whether to stop or go on at any point was out of my hands. Bound in place, totally vulnerable, I was freed from any need to act and could simply *re*-act without having to think about it first.

He went around behind me again and trailed the slapper lightly over my back and ass, not hitting me yet, just stroking me sensuously, over and over. Torn between desire to get on with it and anxiety about what was coming, I shivered under its touch.

The first blow startled me as the two pieces of leather loudly cracked together, but it was actually no more painful than a friendly backslap. Terry continued at that level until he'd covered my whole backside from the nape of my neck to just above my knees, except for the waist and kidney area protected by the belt — waking up my skin, sensitizing it, seducing it. I felt suffused with a gentle warmth as my blood rose toward the surface, and I relaxed into my bondage, no longer holding myself tight against the feared assault.

Slap! Slap! The warmup continued at the same steady pace as Terry increased the force of his blows one notch, and then another, going over each area several times. The pattern of his blows was similar each time, enabling me to anticipate them to a de-

gree, but the effect wasn't mechanical, just methodical and pre-cise — like Terry himself. I was lulled by the confidence that he knew exactly what he was doing. *I like this so far!*

Terry's blows seemed to fit the pulse of the music. Together they slowly built up in tempo and intensity. I found myself mur-muring or humming along, losing my self-consciousness as the waves of stimulation grew stronger and stronger. I couldn't have said just when the slaps became painful. I'm not sure they ever did. But by the time we finished this phase of the scene, he was slamming the strap against my skin with real force. Out of con-text, I'm sure it would have hurt a lot, yet he'd prepared me so carefully that I had no trouble handling it.

When he finally did stop, after a short period of tapering back down to light slaps — which stung more now than when he'd started — he gently stroked my sweat-slick skin with his gloved hands, rubbing me down as he might a lathered pony.

"You're all pink, boy," he said, "practically glowing. How do you feel?"

"Guh — great, Sir!" *That damned collar!* But I knew it was for my own protection. "Thank you, Sir!"

"It's only the start, boy. We have a long way to go yet."

He moved away, returning the slapper to his bag and tak-ing down a short whip of some kind from the hanging assort-ment. It was made of brown leather and didn't look like anything I'd seen before.

I also noticed that the music had changed. It was fuller and more richly orchestrated than before, and the primary tempo was slow again. *He must have put together his own tape*, I thought. *Does he use it for everybody, or did he make this one just for me?* I smiled at my own vanity.

As before, Terry brought the whip over and ordered me to kiss it. Then he held it out straight in both hands for me to look at. It was about twice as long as the slapper, but almost half of that was a braided handle, with a knotted strip of rawhide at its top so you could hang it up. The lash itself was a pair of similar rawhide strips, square in cross section and maybe eight inches long. The unknotted ends were cut off at opposite angles.

"This is a dog quirt," Terry said. "It's unusual because it's so short — must have been intended for small dogs."

He grinned at his joke, and I earned a momentary glare by

raising one eyebrow. My arms ached a little, but I had no qualms about continuing.

"Quirts are usually pretty severe," Terry went on, "but this little guy is a creampuff. Most of the men I've used it on can't get enough, they say it hurts so good."

He drew the whole length across my lips — from the knotted keeper and along the handle (hard and stiff at the beginning but flexible toward the end) out to the tips of the flexible lashes. My cock was hardening again, and I was eager to feel the little quirt do its work.

This time he didn't start by trailing the whip ends over my skin but immediately gave me a light stroke across one asscheek, then the other, followed by a slow, steady rain of blows all over my ass — not as slow and methodical as with the slapper, but just as thorough. My ass quickly warmed up even more.

Terry's testimonial was perfectly accurate. Even when the blows became heavier and closer together, they still felt delicious. The effect was totally different from the feel of the slapper. Instead of just stinging the surface, the quirt's tails compressed a narrow line of flesh right under the skin. It didn't feel quite like the cut of a cane (*thank God!*) or the thud of a nightstick. Except for the surface sting, it felt like the palm-edge chops of an overly enthusiastic masseur.

That analogy was strengthened when Terry moved to my back. The large muscles resisted initially and then softened as he worked me over. I moaned as he hit harder and harder, but the meteors of pain were so mixed with pleasure I couldn't tell where one began and the other left off. The music surged, the cracks of the quirt beat a tattoo on my flesh, and my pulse and breathing quickened correspondingly.

As the steady flogging continued — up and down my back, along my thighs (where it hurt a lot more, but I didn't mind by then), and again on my ass, much harder than at first — I stopped noticing things, stopped keeping track of the time. My eyes closed, and my mind emptied of everything but the warm, intimate pain covering my backside like a blanket. If I made any noises, they were involuntary. The sensations from each stroke merged with those still ricocheting from previous ones nearby and with residual background sensations across the whole area Terry was working on. My threshold of pain kept rising as my nerves became

habituated to the repetitive stimulation. The afterburn never had a chance to die away, but kept building toward some unimaginable climax.

It was far too soon, of course, for a climax. Eventually the flogging, and the music, imperceptibly turned a corner and started to wind down. Terry's pattern of blows recapitulated earlier stages, ending with light stings from just the tips of the lashes before ceasing completely. I lay limp against the frame, my legs weak, though the chains at my arms and waist wouldn't let me fall. My cock was as limp as the rest of me, but it wasn't a negative reaction, just nervous exhaustion. The music stopped.

The next thing I knew, Terry's bare hand was feeling mine. I couldn't distinguish any pain or numbness specifically in my wrists or hands, but he unclipped my wrist cuffs from the chain holding my arms up and let them hang down at my sides, then took off the posture collar. *Is it over?* I wondered. *Are we finished?* I wasn't sure how I felt about that. Despite my worries earlier, I wanted to keep going for as long as he wanted me to.

"You need a break, boy," Terry said as he unclipped my belt from the cross plank. "Can you hold yourself up if I release your feet?"

"Y-yy-yess, Sir," I stuttered, as if I'd forgotten how to talk.

I wasn't even entirely sure what I'd said "yes" to, just that I couldn't imagine saying "no" to him. I clung to the frame as he knelt to unclip my leg cuffs from the eyebolts. He straightened up and slipped an arm under mine to help steady me. *I can smell the sweat he worked up — or is it mine?*

"Step back away from the frame, Matt," he ordered.

I stepped back, swayed against his support, and straightened up again.

"That's fine," he said, "you're doing fine, now another step."

He stayed right with me as I stepped backward, the chain between my ankles jangling, as if we were dance partners. I felt much steadier already.

"Okay, good, now another one. . . . That's right. Good."

His hands fell away, and I stayed upright without help. As I looked at him watching me, my cock revived, ratcheting upward until it stood proudly erect again. Terry fairly beamed, like a father watching his toddler's first steps.

"Looks like you're all right, boy."

I just smiled back. He turned me around gently and clipped my wrist cuffs together behind my back. The smooth, stiff leather brushing my sensitized skin hurt a little, but not enough to mention.

"Walk that way," he ordered, giving me a little push toward the center of the dungeon.

I turned and walked to the edge of the piss pool, dragging the light leg chain, when he said, "That's enough. Wait there a minute." I heard a strange noise behind me for a few moments, and then he said, "Come on back."

When I turned around, I saw that he'd dragged the leather mat I'd slept on the first night over to the whipping frame and laid it half on the floor and half up against the frame. He sat down on it, leaned back, and stretched out his legs as I walked toward him. My heart filled with love, and my cock with lust, as he laid his cap aside and wiped the sweat from his hair with his hands. I wanted to lick him clean.

"Lie down with me, boy," he said, "on your stomach. . . . No, closer than that. . . . Put your head up here," he said, patting his right thigh, "and straddle my leg. That's right."

Laying my head on the supple leather covering his thigh, facing his jock, I saw only a narrow strip of naked, hairy flesh between where his boot left off and his jock began. My own crotch lay on the boot covering his left leg, my hard cock pressed into the lacing. Then he unclipped my wrist cuffs and pulled my arms around his waist, finally crossing his legs over my right ankle. I sighed in contentment. *This is what I want most of all*, I thought, *this closeness, this sense of being held by him, of being protected and cared for. He may think I don't need it, but I do, I do*

I flinched as he began to explore my back with his gloved hand, but he was very gentle, barely skimming the inflamed flesh at first, then stroking and rubbing it lightly once I accepted his touch. It sort of hurt but felt more pleasant than not. *This is great! Maybe we'll just stay like this.* I made happy purring sounds and dreamily licked at his boot as far as my tongue could reach without moving my head. He stroked my hair and face, too, and let me suck his fingers.

We *did* stay like that for several timeless minutes, without a word or sound except our breathing and heartbeats — until they became too slow and quiet to hear. I might have been in a wak-

ing dream. Our bodies and souls seemed to merge. I couldn't tell anymore where his left off and mine began, or vice versa.

"I guess you're enjoying this session so far," Terry said finally, looking down at me with his crooked grin.

I snorted — *why restate the obvious?* — then grinned back.

"Since it was a dog quirt I used on you, Matt," he went on, "I think I should solicit Mutt's opinion, too. How'd *you* like it, Mutt?"

The cue worked as if I were programmed, which I suppose I was by that time.

"*Rrrowff! Rrruff!*" I barked at him and wiggled my ass, then let my tongue loll out of my mouth and panted noisily. He looked pleased and tousled my hair.

"Good dog, that's a good dog," he said.

I wasn't finished, though. Exploiting the privilege of a dumb animal, I attacked him with my tongue, rasping all the skin I could reach and drilling his belly button with my nose until I had him laughing helplessly.

"Okay, okay! I get the message, boy! Lay off! Enough!" he said when he had control of himself again.

I pulled back a little and cocked my head, letting my tongue loll again and filling my eyes with my best approximation of a dog's unconditional love and adoration. Terry's eyes gleamed, and years seemed to slide off his face. His smile wasn't the slightest bit crooked or ironic but so wide and open it gave him the goofy expression I'd learned meant he was utterly happy.

Mission accomplished, I laid my head back on his thigh, but resting upright on my chin like a dog, not on the side as before. For as long as I could, I held my mouth open and dribbled onto his boot. I imagined Mutt as being a big, sloppy St. Bernard, or maybe a young German Shepherd, drooling over everything. I didn't know how Terry saw him — and still don't; we've never discussed it — only that Mutt fulfills some deep need of his.

He stroked my head and neck and kept saying, in a soft, almost wistful voice, "Good dog . . . you're such a *good* dog, Mutt . . . such a great dog. It's really amazing what a good dog you are. Simply amazing. . . ." I wished I had a tail to wag for him.

"*Woof! Rruff!*" I barked instead.

He smiled but said nothing more for several minutes, just stroked me and scratched behind my ears.

"Well, that's two of you heard from," he said at last, once again in his normal authoritative tone. I looked up at him, figuring he was about to cue dickhead, my other persona. *This one'll be harder*, I thought, *because at least down here in the dungeon, the boundary between Matt and dickhead seems pretty fuzzy.*

It wasn't that dickhead was loosening up — not him! not if I could help it! or Terry, too — but that my behavior as "Matt" was becoming more and more overtly slavish. While I still resisted some of the implications of being owned, it was already clear that being Terry's obedient, respectful slave fulfilled as deep a need in me as owning such a slave did in him. *Why else would I want to wear his collar? Or to serve him?*

He interrupted my reverie. "I don't really need to ask dickhead what he thinks, do I, Matt? It doesn't matter what he thinks, as long as he follows orders — he's only a slave, right?"

"Yes, Sir," I replied, and to underscore that it was Matt answering, not dickhead, I added — with a tinge of bitterness that surprised me — "dickhead's *only* a slave, Sir, so it doesn't matter what he thinks. Like a robot, or a cartoon, he'll think whatever you want him to think, or nothing at all . . . Sir."

Terry's face softened, a smile flickering on his lips.

"Matt, it isn't that I don't care about dickhead's feelings. I *do* care, but I also understand him. He *needs* me to be stern and strict, a real hard-nosed bastard who won't let him get away with jack-shit. Being a slave is all he is, and he doesn't want me to let him forget it, because if he did, what would he have left? Isn't that right, dickhead?"

Like a puppet whose strings had been pulled, I was up on my knees before I realized it, my arms crossed behind my back.

"Yes, Master!" I snapped out.

"Go climb that pillar over there, dickhead."

I backed away hurriedly and then stood up and *ran* to the I-beam he'd pointed at, as fast as the chain between my legs would let me, threw my arms around it and scrambled halfway up by hooking my fingers and toes in the perforations before Terry, laughing, called me off. I slid down, fast, ran back, and threw myself on my knees at his feet.

"Lick my bootsoles, dickhead."

I bent down and slobbered over his treads, uncomplainingly sucking down bits of garden dirt left from my own — that is,

Matt's — wearing of the boots that afternoon. I didn't think about what I was doing, just obeyed Master's orders. That's what I was *for*, right?

"Enough, Matt. Come back up here. End of demonstration."

I shook my head groggily as dickhead slipped away again. *Does he have me hypnotized or something? Or have I hypnotized myself?* I crawled up Terry's booted leg as before, lying on his thigh and looking up, puzzled, at his crooked smile.

"You see, Matt, dickhead is a real part of you, but only a part. You're not only my slave. You're my boy and my dog and my lover, too, all wrapped up in one. This scene tonight isn't for dickhead. It isn't for Mutt, either, though I love him, too. Tonight is just for us, you and me, Terry and Matt."

I lowered my eyes, not from respect this time but to hide the tears that suddenly filled them. He wasn't fooled. He reached out his hand and caught one as it rolled down my cheek.

"It's okay to cry, Matt. I did yesterday. And you can say anything you want. Don't hold back."

"I . . . I . . . don't know what to say, Sir. . . . Just that I love you so much. I never thought I'd find someone like you. . . . I never thought I'd *have* a lover again, just fuckbuddies and good friends. . . . And then to find a Master in the bargain, when I didn't even know I needed one! . . . Thank you, Sir. Thank you for everything. Please don't ever let me go."

"Have no fear of that! You're mine, body and soul, and I intend to hold onto you. I'm yours, too, though in a different way. . . . And in case you've forgotten," he said, "or thought I had, we're not finished with your whipping! All I've done so far is warm you up! Get on your feet."

I groaned but complied, stepping off the leather mat onto the floor. Terry put his cap back on and told me to drag the mat over to the platform at the front of the dungeon, laying it on the carpet beside his armchair. When I returned from that errand, he pushed me against the belly bar of the A-frame and secured the kidney belt as before. He put the posture collar back around my neck, pulled my balls down to fasten a leather stretcher around my scrotum, and reached around my chest to hang small weights from my nipple rings.

He attached my wrist cuffs as before, and after securing my legs, he clipped a light chain to my ball stretcher and ran it down

to an eyebolt between them, fixing it so there was only a slight tension as long as I didn't move (not that I *could* move much anyway), or my balls didn't try to retreat upward, or he didn't grab the chain and pull on it. I figured that the latter two were pretty likely to happen before we were finished, just as I expected the weights hanging from my nipples to get jostled or yanked eventually. I couldn't imagine why he wanted to add those relatively prosaic pains to the prodigies of torment he could achieve with his whips, but I didn't question him.

I turned my head to see what he selected next. *He can't be going to use* all *of those on me tonight!* Sure enough, he skipped over several of the lighter choices and took one from near the middle, a long flogger.

Following the established ritual, he brought it over for me to kiss, then drew the flat, half-inch-wide tails across my face. They were very supple, but not soft, and I could tell they had some heft. They seemed to go on forever as he slowly pulled them past my nose, and when he stepped back and let me see the whole thing, I estimated the tails were almost three feet long, plus the short braided handle.

"You'll really like this one, boy," Terry said with an evil grin. "It has a tremendous range, from a teasing snap to a solid thud. It takes a lot of energy to cause serious pain with it, but I'll enjoy working up a sweat."

I'll bet, I thought, still half convinced that what he'd consider "serious pain" would be way past what I could possibly endure. I braced myself as he went around behind me, but first he teasingly pulled the tails of the flogger across my shoulders and down my back several times.

Suddenly he draped the tails over my shoulder and walked toward the front of the dungeon. I realized that he'd forgotten the music moments after he did. A sort of pizzicatto twittering soon filled the room. It was nothing I recognized, which didn't surprise me, as Terry's musical tastes were clearly much broader than mine. The music made me twitchy as I waited for his return, but before he retrieved the flogger and stood behind me again, the twittering had already modulated into a richer, rounder string-orchestra sound.

After a couple of distance-gauging strokes that barely grazed me — I felt the air moved by the swinging lashes more than the

leather — he started working me over with just the tips of the tails, stinging a small area and immediately pulling away. Less methodical than with the slapper or quirt, he didn't restrict himself to covering my whole ass or back or all of my thighs before moving somewhere else. He kept me guessing where he'd hit next, but the whoosh of air as the tails swung toward me always tipped me off an instant before I felt them hit. The narrowly localized stings reminded me of the last phase with the quirt, when he'd also used just the tips of its tails, but those sensations had been very light in comparison. With each new tool, it seemed, he began at a higher level.

The nerves in my backside apparently hadn't returned to their base thresholds despite our relatively long break, because it was awhile before I began to perceive the stings from the flogger as truly painful, though I certainly felt them. They came closer together and seemed sharper as the music grew louder and faster, competing with the sounds made by the flogger itself. Terry was now hitting many of the same spots a second and third time. I began to gasp and cry out whenever he hit a particularly sensitive spot, but the effect was still like biting into a pepper in a spicy dish — the pain intensified the overall sense of warmth and excitement, balancing out to a predominance of pleasure.

He began laying more of the tails across my tenderized flesh — lightly at first, then harder and harder. It felt like a cross between slaps and stings, but spread over much wider areas than before. I was moaning almost continuously, because it hurt and felt good at the same time. I sensed a glowing warmth rising all over my backside, and each new blow set off a burst of stronger sensations that seemed to spread both across the surface of my skin and also down into my muscles.

The force Terry was putting into his blows kept building, and he started pausing for a few seconds between strokes. As I had earlier, I closed my eyes and stopped thinking as much as possible, letting myself become wholly absorbed in sensation. In retrospect, the pain was probably considerable, well beyond my usual tolerance (or at least what I usually enjoyed), but by then endorphins were cascading from my brain down through my nervous system, short-circuiting the pain messages and creating a natural high. It wasn't directly sexual — my cock was only half hard — but I welcomed each stroke and wanted more.

The music surged, and Terry started really slamming into my ass, first one cheek and then the other, several times each, and then he was all over me, unpredictably striking anywhere between my neck and knees. Some harder blows even glanced off my protective collar or the kidney belt as he used more force than finesse. The flogger tails bunched tightly together as he swung, pounding me like a solid club and knocking all the air out of my lungs. Pain surged through a whole new layer of flesh — I scarcely felt these blows on my skin at all anymore, but well below it. My hair was soaked with sweat, and salty rivulets seeped down my face.

I tried to merge with the frame I was bound to, but there was no retreat or escape. Despite being tightly restrained, my body shook each time he struck. Terry told me later that I was screaming loudly but said nothing coherent — certainly I never asked him to stop. And no wonder: his onslaught only stimulated my brain to produce more and more of its natural opiates, pushing the pain to the background. Each new *thunk!* set off fresh fireworks of mingled pleasure-pain sensations. I might have been dying, but I didn't care.

I had no time sense left at all — he might have been hitting me for minutes or hours. It was about half an hour in all, he told me later, before he tapered off, dropping back through earlier levels, down to light snaps at longer and longer intervals, and finally stopping entirely. My screams, he said, had changed to random babbling, made even less coherent by the interference of the posture collar. He stepped close to me, hung the flogger beside me on the belly bar of the frame, and nuzzled my ears and kissed my shoulders until I was quiet. Those gentle touches, too, hurt and felt good at the same time, I realized as I came back to myself.

"It's okay, boy," he said into my ear. "You're doing fine. I've stopped for now."

I moaned, and he tugged both nipple weights at once. I gasped at the sharp pains in my chest, but the pain in my backside dropped several notches. *The music's stopped again*, I thought irrelevantly as he removed the posture collar.

"*Ahh*, Sir . . . thank you, Sir . . . thank you," I murmured.

Terry said nothing more himself, at least with his mouth, but his hands spoke volumes as he kneaded and rubbed the large

muscles in my back or played with my weighted nips or stretched balls. The new pains eased the older ones until the totality came within my ability to handle.

His hands lifted away, and I felt a cool spray all over my backside. The tremendous afterburn began to fade. With a gentle touch, he wiped away the blood from abraded welts on my ass and thighs with a sterile gauze pad, then showed me the pad.

"See, boy? Just a few drops. You probably thought it was a lot worse."

Actually, I hadn't realized I was bleeding at all and grew a bit queasy at the sight.

"You did great, Matt," he said into my ear, his voice slow and quiet, soothing. "I'm really proud of you."

He hugged me tight, wrapping his arms around my chest. I gasped when his harness scraped against my back, but I quickly pushed that pain aside, thankful for the affection. He smelled pretty high — *he said he'd enjoy working up a sweat!* — but it was like perfume to me. *I probably smell kind of ripe, too.* He rubbed his leather jock against the crack of my ass, and I felt the hard cock inside, straining to get out and plunge into me, where it belonged.

"Please fuck me now, Sir!" I begged. "Please! Now would be perfect, and I need it so bad!"

Terry broke our embrace and stepped back again.

"Not yet, boy. We're not nearly finished yet."

I groaned. I didn't want any more pain — this was already the heaviest flogging I'd ever taken. Terry came around in front of me, talking while he refastened my wrist cuffs much lower on the chain holding my arms up. He also unhooked the clips holding my ankle cuffs and ball chain to the whipping frame as well as my kidney belt to the belly bar.

"I think you can take some more, Matt, and I want to give you more. . . . Not a lot more, but you're real close to something, and I don't want you to miss it. . . . Besides, I want to leave some marks."

I groaned again at that.

"You may think I've pounded you into hamburger," he said, sounding amused, "but you have only a few small scrapes and cuts. The rest is bright red, with bruises developing here and there, but it's no big deal."

I snorted and gave him a look he didn't have to be a mind reader to know meant, *Easy for you to say!*

"Hey," he said, and grinned. "I didn't mean it didn't hurt, or that it doesn't matter that you took it for me. All I meant was that in a few days, maybe a week, all the outward signs will be gone, *as if* it never happened. I want to give you something more lasting than that."

I was tempted to make a sarcastic crack, at least silently, but then remembered how proud I'd been of the "souvenir" bruises from the time he'd belted and pummeled me against the bars of his jail cell in our first encounter.

The chain holding my arms was slack enough to let me stand up straight. Terry stood aside and watched while I twisted and flexed my limbs to restore full circulation, which of course only reminded me that they hurt, too. My cock was drooping at quarter-mast.

Besides checking in with various parts of my body, I was thinking furiously. I felt I'd had enough and wanted the scene to end, but I *didn't* want it to be my decision. If Terry was set on continuing and I withheld consent, it would disappoint him, at least hurt his pride, maybe even make him angry. *I don't resist when he pushes my limits in other scenes, so why let a little blood and pain scare me now? And what kind of a slave says "No" when his Master wants something from him?* I decided to try just telling him my feelings and leaving the decision to him. *Isn't that what slaves are supposed to do?*

"The flogging was great, Sir," I said, looking right at him, "but I don't feel I can take any more right now. I'm really tired and sore, Sir. Can't we stop, Sir?"

He looked at me with an enigmatic half smile while my heart pounded — it seemed like several minutes but was probably only seconds — and then came over and hugged me. He put his mouth over mine, and we kissed deeply. My cock stirred again, back up at least to half-mast.

"If you truly want to stop now, Matt, we can," he said after our lips parted. "I won't send you home — at least, not until tomorrow evening — and I won't hold it against you. If dickhead resisted me like this, I'd have to discipline him, but I told you this session wasn't for him, and I meant it. You have to *want* what I'm trying to give you, or it's no good. . . . We'll save what I

was hoping to accomplish tonight for another time — if that's really what you want."

Damn! He's throwing the whole thing back at me!

"Sir," I said carefully, "I want to please you, and I *do* trust you. I guess I'm just afraid of failing you, Sir. I mean, failing you by breaking down after you've started whipping me. I don't feel good about asking you to stop now, Sir, but I'd feel awful begging you to stop later."

"You need to learn that when I'm taking you somewhere in a session, Matt, you *can't* make a mistake! When you truly surrender, you're not responsible anymore. I am. Your reactions are simply that — *re*-actions, not actions. As far as you're concerned, there are no consequences, only feelings. That's why I don't give you a safeword to use, because the last thing I want is for you to be thinking, *Is it time? Have I had enough? Should I bail out now?* Leave all that to me, and I promise you won't regret it. Besides," he said, grinning, "I intend to gag you so I won't have to listen to any begging!"

"Sir, you could sell exercise classes to couch potatoes!"

"Is that a yes, boy?" he asked with that crooked grin of his, the one that never seemed to mean the same thing twice.

"Yes, Sir! Thank you, Sir! Please may I have some more, Sir!"

"Good boy." He lifted the flogger off the frame. "I need to clean this," he said, "and I'll get us both some cold water, too. Can you stand there okay?"

"Yes, Sir," I said, and he walked off.

CHAPTER 34

Sealed with a whip

My neck was aching, so I moved my head in circles until the ligaments crackled. Turning backward as far as I could, I saw Terry washing the flogger in the sink, pouring some green liquid on it and spreading that on the tails with his hands. Then he rinsed off the green stuff and the foaming suds it made, shook the flogger out, poured a clear liquid over the ends, rinsed them again, and hung it on a wall hook to dry. I turned my head back to my left, to look again at the line of flogging and whipping implements. A dismaying number of cats and singletails hung to the right of where the flogger he'd used had been, and they all looked fearsome! *How many more'll be hanging there by the sink, after he's cleaned my blood off them, before he's through?*

When I looked back toward Terry again, he was gone, probably getting some cold water. Even though he'd been right about my enjoying the flogging, I couldn't help worrying. *If I already have cuts just from a flat-tail flogger, what's going to happen when he lays into me with a braided cat or a singletail whip?*

"Slice and dice, that's what it'll be," I muttered gloomily, then shut up as I heard his returning bootsteps.

"Here's something to drink, boy," he said as he came up beside me with a couple of bottles of water, blocking my view of the whips. *Rather look at him anyway*, I thought, then tried to squelch even silent commentary.

My arms had enough slack that I could have held a bottle myself, but Terry grinned and held it for me, putting it to my mouth and tipping it up so I could drink. I was thirsty and finished half of it before slowing down. He pulled it away and asked, "Enough?"

"Yes, Sir. Thank you, Sir."

He put the bottle to his own lips and took a few swallows, then turned to contemplate his tools. I heard more *glugs* as he finished the first bottle while making his selection — a cat o' nine tails. He put down the second bottle and got something out of his bag on the floor, but he held it behind him so I couldn't see as he approached me with the cat.

"Kiss it, slaveboy," he said, holding first the handle and then the lash ends to my lips.

The braided leather tails felt hard and mean when I nuzzled them, and the knotted tips were round and tight. He held it out for me to look at, and I estimated its working length as about two feet — less than the flogger he'd used.

"This is a fine instrument, boy, handmade by someone who really understands what a cat is for — because she uses them herself, and she's had them used on her. . . . It's not a 'toy,' " he said. "It's intended to hurt. It could even kill, if that's what one wanted to do. Or if the user was careless enough."

Is he trying *to give me a soft-on?* I whined inside my head. Terry smiled as if he'd heard me again, though he was no doubt only reacting to my horrified expression.

"I'm not careless, boy. And I certainly don't intend to kill or maim you. But I want to give you some intense pain, and this is my tool. . . . Pain is a tool also. It unlocks things in people. Unlocking the things we hide deep inside ourselves can free us, or it can destroy us. . . . I hope it'll free you, Matt. You've come a long way since our first scene, but you still have a lot of nasty knots inside you. This is your chance to unravel them, to let them go. . . . But if that doesn't happen, if the pain starts having a bad effect on you, I'll see it coming and stop in time. . . . Do you believe me, Matt?"

"Yes, Sir." *Do I?*

"Are you *sure* you believe me?"

"I want to, Sir."

"But something deep inside you still doesn't trust me fully, does it?"

"I don't *know*, Sir."

I was nearly crying again. I felt torn apart trying to be honest, trying to please him, and trying to reassure myself all at the same time.

Terry leaned over and kissed me. I surrendered to the familiar pleasure, glad of the temporary escape from the uncertainties he'd raked up again.

Sometimes I wish we weren't so damned verbal! I thought. *Other guys manage to play without all this* talking, *don't they?*

"It's okay, Matt. You don't have to believe or not believe. You don't have to *do* anything. Let me do it. If you'll trust me enough to let me chain you down tight again, so you *can't* back out, that's all I need."

We stared into each other's eyes for a timeless moment.

"Okay, Matt?" he asked. "Are you still willing to go through with this?"

"Yes, Sir. Please do as you wish, Sir."

"Good."

He held up the item he'd been holding out of sight — a rubber bit gag.

"I'm going to gag you now, boy. This cat is tricky to use, and I don't want you distracting me. You can still make a lot of noise — you just won't be able to talk."

He slipped the solid rubber bit into my mouth, then buckled the strap at the back of my head to hold it in. The hard rubber pulled at the corners of my mouth and held my jaw open. My tongue was free to worry it like a sore tooth.

"If you bite down on it," Terry said, "it will help you handle the pain. Better than biting your tongue, anyway."

I gnawed at the bit and tried not to give in to fear as Terry came around behind me. He buckled the posture collar back on, fastened my wrist cuffs high over my head again, and clipped my kidney belt tight to the belly bar. After kneeling down to reattach my ankle cuffs and ball chain to the crossbar of the whipping frame — and give my balls a parting yank — he walked back toward the front of the dungeon.

Time to change the music again, I guessed. Whatever he put on this time was positively eerie. There was no strong pulse, and it rose and fell in pitch and volume almost randomly, with intermittent empty, spacy segments punctuated by keening sounds like the call of a lonely comet. *Maybe opera wouldn't be so bad after all,* I thought. Nevertheless, by the time I heard the wind of Terry's practice strokes behind me, the music had helped me get into a more open, receptive mood — or at least a less verbal one. It was

hard to form so much as a coherent sentence in my mind with those weird sounds wailing around me.

When Terry found his range, the strokes were pretty light at first. As with the flogger, he began by hitting me with just the tips of the cat's tails, flicking them at my skin and yanking them back. Sometimes the multiple stings from each stroke came so close together I couldn't clearly distinguish them, though occasionally one or two tails would hit apart from the others. *This isn't so bad*, I thought, and started to relax.

He took his time, leaving a few seconds between strokes and building up the intensity very slowly. He played with my pain threshold, hitting hard enough to evoke a cry from me, then backing off and hitting more lightly around the same area before returning for an even stronger blow. It was starting to feel as if he was hitting with more than just the tips, but I wasn't in a good position to tell for sure. I wore a blanket of warm pain again, and endorphins were surging through me. The sensations I felt were "intense," but I couldn't say yet if the *pain* was any more intense than in the previous session.

Then Terry gave me something totally new. Instead of pulling back at the end of each stroke, he started whirling the cat and letting the tails slam across my body at fraction-of-a-second intervals. Each blow covered a wide stripe of my back or ass, and the next would fall close by. Nothing previous had prepared me for this. The actual force of each blow was probably *less* than before, my rational mind told me, but they came so close together, and so continuously, that it felt like he was attacking me with a circular saw. I imagined blood spraying from my lacerated flesh. I screamed for him to stop, but nothing intelligible emerged from my gagged mouth.

He didn't ignore my distress, however. He eased back, slowing the cat's spin and drawing out the time between hits. He also increased his distance so that less of the tails dragged across my skin. Now it merely felt like knives being drawn across me, then needles, then pencil points, and finally nothing. I stopped yelling aloud when I felt Terry's hand on my shoulder, squeezing it lightly. *Please, enough!* I begged silently, hoping he *could* read my mind. *I can't take any more!*

"It's okay, boy," he said into my ear. "It's okay to scream. I know it hurts. Deal with it. There's more, but you can take it. You

probably think I've sliced you to ribbons, but I didn't. There are just a few small cuts. I'll put bandages on you so I don't hit them again."

Thanks a lot! How about not hitting anything *again?*

"I know you can take more," he continued. "And if you ride the pain far enough, it'll disappear. It'll change into bliss."

I tried to disagree, to tell him respectfully that he was full of shit, but the damned gag made mush of whatever I said. I wasn't in a panic, not yet, but I was getting close. I felt incredibly helpless. All I could hope was that Terry's skill and concern for me would make him see that he'd gone too far, way past my limits.

But he was implacable, unreachable, kneading and massaging my tortured backside with his hands but making no move to release me. He did get bandages from his bag and stick half a dozen or so on my back and ass before resuming the flogging. He also tightened the chain pulling my balls down and added weight to my nipple rings until I was whimpering from those pains.

I don't understand this! How can he do this to me? I thought he'd stop when I'd had enough! Hot tears flowed down my face, as much from anger and frustration as pain.

And yet . . . and yet — when the next stroke from the cat hit me, high on my back, it seemed to connect solidly but hurt much less than I expected. My nipples hurt, my balls hurt, but my back barely hurt at all. Before I could reason it out, Terry hit me again, another solid stroke lower down. Same thing — I felt it land, but it didn't bother me. He continued to strike hard, keeping the tails together so that they hit with a thud, followed by a sting from the tips as he snapped them back, and I continued to feel more pain in my nips and balls than my back. It wasn't that my back was numb, since I could definitely feel it wherever he hit — it just wasn't unpleasant anymore.

He changed his pattern after working down one side of my back and up the other, landing similar thudding blows *across* the previous ones. I wasn't surprised when these did hurt, though still not as much as I'd expected. What *did* surprise me was that the pain in my nipples and balls started to fade away!

I realized suddenly that Terry knew *exactly* what was happening inside me, that he understood the mechanisms of pain far better than I did and knew how to play them off against each other. I felt ashamed of my anger and lack of trust. *You were right,*

Sir, I told him silently, meanwhile moaning through the gag in a tone that he would know meant I was riding the pain, not fighting it anymore.

He must have gotten the message, because he ramped up to a new level of force, slamming the cat into me so hard that each blow knocked my breath out. He gave me a chance to breathe between strokes, forcing me to fall into his own rhythm. I couldn't think. I couldn't scream. All I could do was absorb each blow and take a breath before the next one.

When he finished crosshatching my back, he moved on to my ass and thighs. That hurt at first — it hurt a *lot* — and I started screaming again, but before he was through the pain had again been transmuted. It didn't quite become pleasure, yet I felt it less as an assault and more as an intense rhythmic pressure. *He's not trying to hurt me: he's pouring energy into me.*

Finally, the beating slowly ramped down. After it stopped, Terry began to knead me all over with his hands. Every square inch of skin on my backside felt totally alive and sensitive. In fact, it seemed as if my perceptual field had expanded so that the volume of air an inch or so above my skin was somehow part of me. His touch was electric, orgasmic, ecstatic. Tears poured from my eyes, but not because I was in pain or unhappy!

He brushed the sweat-limp hair from my forehead and took off the posture collar and gag, then bent my head back to kiss me. Coherence was returning, but I still didn't try to speak aloud.

Why can't I surrender without question, Sir, without resistance?

"Go ahead and cry, boy. You're over the hump," he said, looking down at me. "You're not fighting it anymore. Let it go, let it all go."

You're not mad at me? I asked with my eyes.

"You're doing *fine*," he said firmly, stroking my cheek. "You *will* do fine. Trust me. Trust yourself."

He kissed my mouth, then felt my hands and unclipped my wrist cuffs from the chain holding my arms up, lowering them to my sides. They tingled as full circulation returned. He rubbed my shoulders, kneading out the tension. I realized that he was wearing latex gloves now, not leather, and that the music had stopped.

"We're not quite through, but you're almost there," he said. "I need to give you some more pain, and then we'll see."

I straightened up, shivering as he continued to stroke me gently. *More pain?* I had to stop trying to anticipate him, to imagine what the next stage would feel like. *Let go, just let go*, I told myself over and over.

He sprayed my backside again with a cool liquid and wiped it off thoroughly. I looked down and saw blood streaks on the gauze he dropped to the floor. I didn't care. He stood behind me and played with my nips and balls and asshole, sending jolts of pain and pleasure through me as if his hands were wired to a generator. He lubed my ass and opened it with his fingers. I didn't urge him to fuck me, or *not* to fuck me. I simply waited, open to whatever he wanted to do — without conditions, without reservations, without holding anything back.

Terry unhooked my leg cuffs and kidney belt from the whipping frame, leaving me attached to it only by the chain clipped to the wide leather band strangling my ballsac. Pulling me a couple paces away from the frame, he crossed my arms behind my back and used short chains to attach each wrist cuff to the kidney belt on the opposite side. It was like a straitjacket in reverse, and equally snug and constraining, except that it left my front side wide open and vulnerable. I loved the feeling — and even the pain as my stretched arms rubbed against abrasions from the flogging. Then he stepped around in front of me, straddling the ball chain, and pushed me to my knees so I was staring right at his bulging black leather jock pouch.

"Get it out, slaveboy," he said brusquely as he leaned back against the A-frame, spreading his boot-clad legs a little wider. "Make me feel good."

I leaned forward and fastened onto one of the jock snaps with my teeth, worrying it until it came loose, then attacked the next one. There were three across the top of the pouch, two on each side, and one at the bottom, but I didn't bother with that one. I let the leather pouch hang as I impaled my throat on the hard, rubbered cock that was pointing right at my face.

God, it felt good! The ripe leather-sweat-lube smell of his crotch took over my brain. My throat gaped wide, and I gobbled his cock to the root without a hitch. The last time I'd deep-throated a man that easily, I was stoned on hash. *I must be stoned on endorphins!* I thought. *"Make me feel good," Master said. What can I possibly do to make him feel as good as I do right now?*

I licked and I sucked. I pumped his dick up and down my throat. I twirled my tongue around his rod, then drilled it into his piss slit as far as the loose latex at the tip would let me. I slurped. I gagged. I blew. I hummed marching songs. I nibbled his nuts. I tongued the sensitive ridge of flesh between his balls and his asshole. I threw every smidgeon of cocksucking expertise I had into the battle, along with the full resources of a throat that for once felt infinitely stretchable.

When I heard moaning sounds from above me, I figured I was on the right track. When he pulled my mouth off his cock and onto his balls, I was pretty sure we were close to payday. And when he pulled me to my feet, pushed me against the whipping frame again, undid my arms, and fastened me to the frame again even tighter at all points than before, with both the posture collar and a fat leather plug gag to keep me quiet, I was ready to be ridden. My empty asshole quivered, eager to be plugged with his steely cock as my own smaller but equally stiff rod fucked the air.

Terry rammed into me with no more preparation or hesitation — and it felt fine! I *wanted* to be taken, hard, just like that, and he was doing it. He drilled me as hard and fast as I'd ever been before, and he kept pulling out just to the lips of my asshole before slamming in again. I *liked* it that I could barely move a muscle or utter a word. It just added to the experience that he dug his fingers into my pecs and used them as handles, that his harness straps scraped over my welted back and made it bleed, and that two or three times his boot "accidentally" jarred the tight chain from my balls and pulled them an inch lower than I'd have thought possible.

None of this exactly "hurt," not in any usual sense. Oh, I felt it all right, felt it so well that I was screaming into the gag. But they weren't screams of protest — they were like the screams you hear from people riding a roller coaster or leaping off a bridge with bungee cords tied to their feet. And the way it felt every time his hard cock rubbed over my prostate — that wasn't ambiguous at all. That felt *goo-o-ood!*

It didn't last long — it *couldn't* last long with us both so close. I shot first, but only because he spat in his hand and pulled my dick as he slam-dunked back into my ass. That's all it took, two or three spit-slick pulls, and my balls pulled tight against the unyielding chain and my cum was flying and I was shrieking

and my ass tightened around his cock and he was shooting and screaming and pumping and chewing my ear until I thought I would pass out, but I didn't.

Terry slumped heavily against me, his dick still in my ass. I could hardly breathe, but he reached up and released the gag, letting it fall to the floor. I raised my head and pulled in lungfuls of sweet air, full of sex smells, as I hung there on the whipping frame with my Master's cock slowly relaxing inside me.

"Sir, thank you, Sir! Sir, thank you, Sir! Sir, thank you, Sir," I kept saying, over and over, like a mantra. Finally he pulled my face around and stopped my blathering with a kiss.

"You're welcome, slaveboy. Now shut up. Master needs some quiet to think about what the hell he's going to do next."

He pulled out of my ass and stood up. He stripped off his condom and emptied the cum on his latex-gloved palm, then painted my face with it, especially under my nose so I could smell it — smell *him!* My nose tickled from the sharp cum scent, which always reminds me of laundry detergent just as it dissolves into the wash, and I sneezed.

"Bless you," he said automatically, then wiped his sticky hand on my chest.

When he noticed fresh blood on my back, he got his first-aid supplies and cleaned it off, applying a couple of small bandages. He checked my engorged, purple, painful balls and loosened that chain a bit. He felt my hands, was satisfied at their condition, and left them alone. He examined my nipples and hung another small lead weight from each one; all I felt from them at that point was an increase in pressure, not pain. The posture collar got turned around so that it covered even more of the back of my neck but didn't force my head up so much in front.

We shared the second bottle of water, now tepid but still delicious. Finally, he walked back to the control panel and adjusted the lighting so that it was almost dark everywhere except right on my backside. After all, there was no need for me to see what he was doing! He didn't put on any more music, however, and his bootsteps on the slate floor of the dungeon echoed in the silence.

During all of this, to my own amazement — and probably his, too — I never asked a question, made a suggestion, or gave the slightest indication that I wanted him to do anything except

whatever he'd decided to do. No pleas to be let down, no attempts to persuade him to spare me any more flogging or whipping. Did I *want* to be whipped, the way I had wanted to be fucked? Not exactly. What *I* wanted was to be and do whatever *Terry* wanted me to be and do. And if he wanted me to leave the dungeon sporting some lasting cuts and welts, so did I.

It turned out to be a good attitude to have, because that's exactly what he *did* still want. When there were no more preparations to be made, he selected a longish, tightly braided black whip and brought it over to me. He had me kiss the round Turk's knot at the handle end and then drew the whole tapered length through my lips, all the way down to the cracker at the working end, while he told me about it.

"This four-foot signal whip, Matt, is the first serious single-tail I ever bought, and the one I learned with. I could show you scars I gave myself before I could control the backswings. I can't show you the poor old teddy bears I practiced on before I ever touched a bottom with it, because they got cut to ribbons — the teddy bears, that is! You've been terrified of whips like this for a long time, and for good reason. In the wrong hands, they can do a lot of damage. Even in the right hands, they can deliver a hell of a lot of pain. But you learned tonight that you can take more pain than you ever thought you could, didn't you, boy?"

"Yes, Master! Thank you, Master!"

"I didn't want dickhead to answer me, Matt."

"Sorry, Sir — right now it's hard for me to tell us apart."

"Understandable, but I want you to try."

"Yes, Sir. Tonight was definitely an eye-opener, Sir. I feel like I'm welted and bruised all over my backside, Sir — and it doesn't bother me a bit! I'm ready for whatever else you want to do, Sir."

"It's good you're still on an endorphin high, boy, because you'll need that cushion. I'm not going to try and work miracles tonight. You've already proved yourself, and more. But I said I'd leave some serious marks, and I like to keep my word."

"Yes, Sir. I'm ready, Sir."

Coming behind me again, he trailed the whip slowly over my left shoulder and let it slither down my back, then repeated it on my right side. I shivered at the whip's leathery caress of my hypersensitive skin but said nothing more.

"I'm going to give you fifteen strokes with this whip," he

said, "all on your back. And instead of gagging you, I'm leaving your mouth free so you can count them off in traditional fashion. You know how it goes?"

"Sir, you mean, 'One, Sir, thank you, Sir. May I have another, Sir'?"

"That's right, boy. You may not have had much training before me, but at least you've read some of the right books!"

"No, Sir. Master Jake taught me that, Sir. But it seemed silly before."

"And it doesn't seem silly now?"

"Not at all, Sir. I understand now that you're giving me a gift with each stroke, so it only seems right to thank you, Sir."

"And asking for another?"

"Sir, that tells you I'm ready."

"Good boy! It took a long time for some of Master Jake's lessons to sink in for me, too. Guess we have that in common as well — we're both stubborn and need to learn in our own time.

"The first cracks you'll hear," he said as he walked further back behind me, "will be practice shots so I can gauge the distance. Don't start counting until you're actually hit."

"Yes, Sir."

Crack!

It was like a pistol shot going off at my left side, in the space between me and the frame. I was glad to be fastened down so tightly, because otherwise I would have leaped and probably blundered right into the whip.

Crack!

The right side, then. It didn't seem quite as loud.

Crack!

That one was *behind* me, but very close. I almost felt it — or at least the air that was slammed out of the way of the whip's cracker as it broke the sound barrier. I gulped and braced myself for the actual stroke.

Crack!

There was an instant between hearing the sound and feeling the impact — a narrow line of searing heat streaking from my left shoulder across to my right side. It was not unlike what I'd felt the night before as the candles spilled over and the liquid wax ran across my skin until it cooled, only the line of heat was longer than from any candle, and it moved faster — *much* faster.

After expelling all the air in my lungs in an involuntary *oof!*, I took in a long, deep breath and let it out slowly. The lash welt felt fuzzier now, and the pain was already fading. *I can handle this*, I thought, and then remembered what I was supposed to do.

"One, Sir! Thank you, Sir! May I have another, Sir?"

Crack!

Ahhh! I moaned this time but still didn't cry out. As far as I could tell, this stroke hit below the first one and parallel to it. It felt a tiny bit harder, too, more like a hot knife gliding across my skin, but it didn't cut the surface, merely grazed it. The resulting welt throbbed dully as I breathed in and out.

"Two, Sir! Thank you, Sir! May I have another, Sir?"

Crack!

"*Aiiee!*" I shrieked. *This one cut, I'm sure of it!* The welt was still lower down on my back, and I'd have bet it was perfectly parallel to the others.

"Don't forget to breathe," Terry said quietly in the reverberating silence. "Just keep breathing, slaveboy, and let me worry about everything else."

I collected myself with a couple of long, slow breaths as the line of sharp fire he'd laid across my back faded to a dull throb. *Where are those endorphins when I need them, damn it?*

"Three, Sir! Thank you, Sir! May I have another, Sir?"

Crack!

"Ohmigod!" I howled. I imagined gouts of my blood spurting at him in the wake of the lash. My skin felt sliced and bruised at the same time, but all focused in a terribly narrow line across my back, parallel to the others. *Don't forget to breathe*

"Four, Sir! Thank you, Sir! May I have another, Sir?" As hard as it was to force the words out, it never even occurred to me not to say them.

Crack!

Ahhh! *Was that one a little lighter? Or am I just taking them better?*

"Five, Sir! Thank you, Sir! May I have another, Sir?"

Crack!

Definitely a lighter stroke, about as low on my back as he could go without hitting the kidney belt.

"Six, Sir! thank you, Sir! May I have another, Sir?"

"Not yet, boy," he said, coming up close to me and pulling

at my weighted nipples and stretched balls. "Good boy, you're doing fine."

I moaned at his familiar sure-handed, possessive touch. The additional pain in my nipples and balls overloaded me with more sensation than my system could process, and as before the effect was to reduce the pain in my back. He pulled his gloves off and let me kiss his hands, sucking the fingers he pushed into my hungry mouth.

"Good boy," he said, "you're a good boy. And you're *mine*. You belong to me now, boy. I've marked you, and I *own* you."

I said nothing, just licked his hands.

He stepped back again and cracked the whip off to the side to get my full attention.

"Take a deep breath, boy, there're nine more to come."

Even though I feared the remaining lashes, if my restraints had been removed, I'd have stayed right where I was until he gave me leave. I finally *felt* owned — and I liked it. I liked it a *lot!* I didn't need to run anymore, to search for an elusive satisfaction at the hands of one man after another willing only to rent rather than own. *I'm where I belong. This is home.*

Terry delivered the next set of six strokes from the opposite side, and they slanted from my right to my left, again starting from my shoulder and moving down to the lower middle of my back. Because each stroke crossed a previous welt slanting from the left, every one of them pulled a scream out of me. Nonetheless, the pain of the strokes tended to blur together after the first second or so of each new one, and thanks to a renewed endorphin cascade, I started to *enjoy* the whipping, not merely endure it. I was floating in a red-tinged bubble of pain/pleasure or pleasure/pain. Each new stroke shook the bubble but didn't break it.

"Twelve, Sir! Thank you, Sir! May I have another, Sir?"

But Terry called another break, giving me water and playing with my nipples and balls again. He also massaged my back and shoulders — and not gently, either — restoring full circulation and reawakening nerves that hadn't been stimulated since he'd used the "thuddy" flat-tail flogger much earlier in this long session. My vocal response to the wildly contradictory sensations all this produced was a random mix of shrieks, sobs, and giggles.

"Good boy," he said finally. "We're almost finished. Three more hard ones, and we're done. Take a deep breath."

While I filled my lungs and tried to stay calm, he stepped back and gauged his distance with a couple of test cracks. Then he let me have it, searing across my back from far left to far right and crossing *two* previous welts, not one.

Crack!

I opened my mouth to scream, but nothing came out. As the intense pain from the lash richocheted through my endorphin-drenched nervous system, it was as if a block of black ice at the core of my brain — years of congealed rage and hurt and frustration — cracked in half, and then again, shattering into a million dark shards, which finally melted from the heat of Terry's whip. I still couldn't scream, only cry. My breast shook with sobs as tears engulfed my face and poured onto the floor. I remembered there was something I had to do, to say, but whatever it was seemed as distant as the moon.

"It's *okay*, boy," Terry said again and again into my ear as he held me from behind. "Let it out, let it all out."

I heard but didn't understand, not consciously. I continued bawling helplessly, incomprehendingly. I felt a tremendous sense of release, of lightness and freedom, but I couldn't have begun to verbalize it.

"That was No. 13, Matt," my Master said. "Seems that it's a lucky number for you. I was hoping for a breakthrough like this, but I wasn't counting on it."

He came around in front of me. My eyes were so awash that I could barely see him in the dim light.

"Do you want to stop, boy?" he asked.

I shook my head. *Stop? Stop what?*

Seeing I still looked puzzled, he asked more clearly, "Do you want me to stop whipping you, Matt?"

I shook my head again. *Want? Me?*

Still not convinced, he asked, "Do you want me to whip you some more?"

I shook my head once again, as if to clear it of the incomprehensible questions plaguing me. Terry took off his cap and scratched his head. Suddenly he grinned crookedly.

"I guess that means you want *me* to decide, Matt."

Bingo! I nodded vigorously, smiling through my tears, and his face lit up, too.

"Good boy! That's my good boy!"

He walked behind me again and shook out his whip.

"Get ready for No. 14, boy."

Crack!

Like lightning cutting through a night sky, the whip traced a line of fire across my back above the previous stroke. I laughed and cried at the same time. I felt so intensely *alive*, and so deeply loved!

"This'll be the last, boy, No. 15," he said.

Crack!

It landed lower down, below No. 13, and pushed all the air out of my lungs in a rush. It felt like a deep knife slice, but I didn't care. Its icy burn, and my embrace of it, was my validation, the end of my doubts. Now I knew what I was, and hoped I would always be: *property of Terry Andrews.*

CHAPTER 35
Owned

Terry kissed and caressed me when the whipping was over, then took the weights off my nipple rings. He sprayed my back-side with disinfectant, bandaged the cuts that were still bleeding, and rubbed soothing lotion all over. After taking off the protective collar, he even got a damp towel and wiped the sweat and remnants of his cum off my face and head. I relaxed in my still tight bondage and let him take care of me, saying nothing in my post-verbal state but softly purring at his gentle touch.

"You're going to have some nice marks, Matt," he said finally, sounding pleased. "Tomorrow, when I let you see them in the mirror, I'll bet you'll feel proud of what you took tonight. I know *I'm* proud of you!"

He was looking right at me, so I realized he expected some sort of response.

"Ah-h-h . . . y-ye-yes . . . S-S-Sir," I stammered out. "Yes, Sir, thank you, Sir," I said more firmly. *Can't ever go wrong saying that!*

By the time he'd released me from the frame, I'd reanchored myself in the here and now, but I was still wobbly and needed his help to stand and then walk around. As soon as I could manage unassisted, I got down on my knees and kissed his boot toes.

"Thank you, Master," I said spontaneously, "for taking me on this amazing journey. Please forgive me, Sir, for doubting you."

"There's nothing to forgive, slaveboy. I told you — you're allowed to make mistakes, as long as they're honest ones. I'm sure you learned a lot from this one."

While I knelt there, he took the leather cuffs off my wrists and ankles, only to replace them with the leg irons and manacles, as well as the steel collar, that I'd worn hours before when I was

541

chained to the pillar, waiting for him to come back into the dungeon to flog me. This time, however, he fastened the manacles in front rather than behind my back.

"Thank you, Sir," I said automatically — yet also sincerely. It felt oddly reassuring that he seemed to hate leaving me out of bondage for more than a moment. *If he ever loses me, it won't be from carelessness!*

"Now go lick up your cum from my floor, slaveboy," he ordered once I was properly fitted out in mobile restraints.

Since whatever I shot had dried by then, it took me a couple of minutes, kneeling inside the A-frame, to locate the stains. I tongued the slate floor, reconstituting my cum so I could lick it up. My ass hurt too much to rest it on my heels, so I kept it elevated. My back throbbed as the battered muscles stretched and moved under the lacerated skin.

"Stand up, boy, and follow me," Master ordered when I'd finished, turning to walk toward the front of the dungeon and mount his platform. As he adjusted the lights to black out the rest of the room and illuminate the area we occupied, I clattered up the steps after him and knelt before him, awaiting orders.

"Lie down here," he said, indicating the leather mat that I'd placed beside his chair earlier, "belly down and with your head at this end, close to me."

With the thick carpet under the padded mat, it was pretty comfortable, and I stretched out gratefully, sighing softly in contentment and exhaustion. From somewhere Terry produced yet another chain and a pair of padlocks. Using these, he connected my collar to a ringbolt on the nearer leg of his massive wooden armchair, which I sometimes thought of as his "throne."

"Rest there for a bit, slaveboy," he said, and walked out of the dungeon through the nearby door.

I took him at his word and dozed off, so I'm not sure how long it was — ten minutes? more? — before he came back with a couple of beers, my dog bowl, and a towel. He laid the folded towel on the carpet in front of me and set the bowl on top of it.

"I don't think Mutt will mind if you use his bowl tonight, boy," he said as he poured one of the beers into it. "Easier for you to drink out of this than sitting up on your sore ass."

"Thank you, Sir," I said, waiting for him to sit and open his own beer before lapping at mine.

He stretched out his booted legs, crossed at the ankles, and sat back, silently drinking his beer and watching me. I wrapped my chained arms around the dog dish to stabilize it and slurped up the cold beer as quietly and neatly as I could, but it was a good thing he'd put the towel down to protect his gorgeous Oriental carpet! At least a quarter of the beer splashed out of the dish before I was through.

I snuck peaks at Terry's face every once in a while, and when he wasn't sipping his beer he was grinning at me. He was obviously enjoying my situation, so I enjoyed it, too. I was too wiped out to wonder if I felt "humiliated" or not. And the beer tasted good! I needed the liquid, having sweated so much from the stress of the whipping, and the small amount of alcohol on top of the endorphins still in my system quickly gave me a pleasant buzz.

When I finished the beer, Terry took away the dish and the damp towel and moved his right leg closer to me, nudging my face with his boot. I shuffled forward and tongued it dreamily. For once we seemed to need no words. "Good boy," was all he murmured from time to time, "such a good boy." I had no doubts about my feelings for him, or his for me, nor any more hesitations about submitting to his will, whatever that might be. Lying there naked in his chains, the welts he'd given me still throbbing subliminally, my tongue caressing his boot leather, I was completely content, completely present in the moment.

Eventually he stood up, breaking the spell. I started to get up on my knees, but he stopped me. Instead, he knelt beside me and removed my manacles, but only to replace them with triple-weight German handcuffs, which he fastened to my collar chain, about a foot away from my face — "to keep you from playing with yourself, boy," he explained with a smirk. My cock, which had been fairly soft before, perversely stiffened under me.

"I'm really proud of you, Matt," he said again, still kneeling and lifting my face with his hand so that I could look at him. "You took the whipping even better than I hoped you would. I want you to lie here and rest while I clean up my gear, and then I'll come back and we'll talk. Okay, boy?"

"Yes, Sir. I mean, yes, Master." Even though he'd called me "Matt," I was still full of my new sense of being truly owned.

"Either will do, boy. Don't worry about protocol right now. Sleep if you want to."

"Yes, Sir. Thank you, Sir."

He tousled my hair and then got up and walked out of the dungeon. I rested my head on my arms, squirming a little to get my collar, the handcuffs, and the chain between them arranged comfortably.

Piano music started playing softly — more of those Keith Jarrett improvisations Terry liked so much — and he came back into the dungeon. He adjusted the lights again, dimming those near me, and walked off the platform toward where he'd left his gear. I closed my eyes and stopped trying to keep track of where he was, letting my mind drift with the music. I could still feel every welt if I focused on it, but there was no reason to. The sensations that flooded through my body with every slight shift in position eventually ebbed into an overall feeling of vivid warmth that was quite pleasant. I dozed off again, deeper this time.

Sometime later, I woke to the gentle nudge of Terry's boot against my cuffed hands — not the same boots he'd been wearing. He'd changed into his favorite old engineer's boots, merely knee high instead of crotch high. I started to get up onto my own knees, but he waved me back down, so I just propped myself up on my elbows and turned my head to look at him. He was sitting again on his "throne," sipping another beer and looking down at me. He still wore the leather jock, but the chest harness was gone, replaced by a simple bar vest, and his head and hands were bare.

"Have a nice nap, boy, while your Master was working?"

"Yes, Sir, thank you, Sir. How may I serve you, Master?"

"You're serving me just *fine*, boy, lying there in your chains, looking so peaceful after being whipped and fucked. A dungeon without a well-used slave in it is so dreary, don't you think?" The corner of his mouth was twitching, so I played along.

"Yes, Sir, that's very true, Sir," I said gravely.

"In that case, slaveboy, I'll just have to keep you. You'd like that, wouldn't you — staying here all the time, always my prisoner, no interruptions by so-called reality at all?"

"As you wish, Master. Should I give notice at my job, Sir, and clear out my apartment, or will you?"

"As I wish?" he laughed. "You bet I wish it — don't tempt me, boy! I also know it ain't gonna happen. C'mere, you silly ass. I want t' touch you with more than my boot."

I did get onto my knees then and shuffled closer. At his direction, I laid my cuffed wrists on his right thigh and my head on his knee. He ran one hand through my disheveled hair and let me lick and suck the fingers of his other one. His thumb was like a pacifier I didn't want to let go, but he insisted.

"Don't think I wouldn't enjoy taking you all the way down, Matt," he said, suddenly resuming the conversation, on a theme we kept returning to. *It must frustrate the hell out of him that he can't have that kind of slave,* I thought to myself. *But if he actually wanted it from me, could I still say no?*

"I would really enjoy turning you into a total bondage toy," Terry said, "keeping you locked up in a cage, or a box, all the time I wasn't fucking you or playing with you, or using you as a toilet. Almost every top has that fantasy — and most bottoms, too! But I know it has to remain only a fantasy, except for limited periods. You know why that is, don't you, Matt?"

"Uhh . . . because it would be wrong, Sir? Or at least illegal?"

"Well, that, too," he laughed. "But would it still be wrong if both guys wanted it? Maybe not. I'll tell you why it doesn't work — not because it's immoral or illegal. Because it's too boring!"

"Having a full-time slave is boring, Sir?"

"*No*, not having a full-time slave — that's great. It's having a slave who's *nothing but* a sexual plaything and household appliance, who doesn't have any life outside of what his Master does to him and how he's used. I almost made that mistake with Philip. But he rebelled, and instead of clamping down, I let him go and grow up — a better outcome, I think, aside from his getting sick.

"What's exciting about the fantasy is the challenge of reducing a man to an unresisting object. But once you've *done* it, the challenge is gone, and there's nothing left to hold your interest. If I'm going to piss into a slave who has no more inner life than a porcelain toilet, I may as well piss into a porcelain toilet! There's less upkeep, and it's more convenient."

"I'm glad you remember the difference, Sir," I said dryly.

"If I ever forget, Matt, I'm sure you'll remind me!"

"Is that an order, Sir?"

"Yes, boy, that's an order: Don't let Master forget that his slave is a human being — or that Master isn't a god! Think you can do that?"

"Yes, Sir. No problem, Sir."

We were both chuckling by then, which may seem odd considering that I was still naked, in chains, and on my knees. But neither of us noticed any incongruity.

"Seriously, Matt," he said, "the reason I can enjoy treating you like this," waving his hand to encompass my present circumstances, "is because I know that tomorrow night I'm going to take you back to your apartment, and on Tuesday morning you're going to wake up on your own, shower and shave, pick out your own clothes, make your own breakfast — don't forget to eat one, boy! — and go into work, all without my having to direct you. You'll do a great job supervising a dozen employees and dealing with all kinds of real-world problems, and in your free time the rest of the week you'll see your friends and amuse yourself however you want, with little or no intervention by me.

"And as a result, when I do get you under my thumb again, whether here or on the phone or at your place, you'll have regenerated that independent personality I so enjoy dominating and controlling. You'll never stop being mine, belonging to me, but if I micromanage every moment of your existence, you'll lose the capacity to surprise me. If I reduced you to a sextoy, or even a houseboy, you'd cease to have enough depth to keep me interested in you. Does that make sense to you, Matt?"

"Yes, Sir, it makes a lot of sense . . ."

"But? What's the 'but' you're hesitating to say?"

"*Rrowf! Grruff!*" my doggy persona barked.

"Hello, Mutt!" Terry said, smiling, and scratched behind my ears. "Good boy! I didn't know you'd joined us. What is it, boy?"

I let out a string of barks impossible to transcribe. I wasn't sure what I, or rather Mutt, meant by them, but Terry seemed to have no trouble arriving at an interpretation.

"I understand, boy," he said indulgently, still petting me. "You want to be sure there's time for you to come out and play, time when Matt doesn't have to worry about that icky real world of his but can just be my pup. Don't worry, Mutt. I enjoy playing with you too much ever to give you up. In fact, tomorrow afternoon is going to be just for us! We'll take a long walk outside and play catch and have a great time together. Sound good, boy?"

"*Rruff! Woof!*"

"Good dog, that's a good dog, Mutt! Go to sleep now, boy, it's late for you to be up. . . . Are you with me again, Matt?"

"Sir, my Master, Sir!"

"*Et tu*, dickhead? Now *you're* feeling insecure?"

"Sir, yes, Master. Permission to speak freely, Master?"

"Granted, slave."

"Sir, thank you, Master. Sir, this slave begs the Master, with respect, to remember how much his strict service to the Master means to the slave. Sir, even if the Master does not wish to enforce such discipline full time, the slave respectfully begs the Master to continue to make such service a regular part of his slave's life. Sir, thank you, Master!"

Terry looked thoughtful and didn't answer immediately. I shifted nervously on my knees. *Am I nuts? Being dickhead is the hardest thing I've ever had to do!*

"I was going to take you up to the bedroom again tonight, Matt," Terry said finally, lifting my arms off his leg and pushing me back a little, "but I've changed my mind. I said tonight was for us alone, you and me, not dickhead or Mutt, but I see now that it's impossible to keep you three neatly separated. I also see dickhead is feeling neglected. It wouldn't do for him to get the impression that I'm soft and indulgent. So dickhead is going to spend another night in the dungeon. In view of the condition of your back, though, I'll let him sleep right here instead of on the main floor or in a cage."

"Sir, thank you, Master!" *Can I really feel grateful to be kept out of his bed? Then why is my cock so hard?*

"Before you return to sleepyland, slave, you're past due for some latrine service. Get over here and take out your Master's piss hose!"

I scrambled around between his parted legs and lowered my head to his jock, worrying at the snaps with my teeth as before. His cock sprang free, without a condom, and I took it into my mouth. As it lay on my tongue, softening a little as he prepared to piss, I inhaled his crotch smell. On top of the basic leather-and-groin-sweat aroma, it now had a strong stale-cum odor from when he fucked me — *was it a couple of hours ago already?* I tightened my lips around his meaty shaft as the piss started to pour out of it. I noticed that it was well watered by the beers, but there was little chance to savor it, I was so busy swallowing. He'd be furious if I let any spill on the carpet!

Terry held my head in place with his large hands, and when

he saw my cheeks bulge he choked off the piss flow until I caught up. But he didn't wait for me to signal him that I was ready for more, as he had that morning. He regulated the flow himself, adjusting to my physical capacity with no regard for my feelings in the matter. This was no longer an equal exchange. I was simply there to service him. *As a slave should be,* I told myself.

"That's good, dickhead," he said, "you're a good toilet slave. Take it all and don't spill a drop. You wouldn't want me to piss into a cold, dead toilet when I can use your hot mouth instead?"

Of course, my only answer was to keep swallowing as fast as I could, taking his stream of hot liquid gold as long as he wished to give it to me. And this, too, felt entirely right and proper.

"*Ahh!*" he said finally, "that's it, boy, no more. Let go."

I swirled my tongue around his cockhead to get the last few drops and let it slip out of my mouth.

"Get your mouth on my balls and crotch," he said, shifting his ass further forward on his seat and wrapping his hand around his dick. "Lick out all those good smells, boy."

I didn't need any encouragement! I buried my face in his crotch as he began stroking his slowly hardening dick above my head. I hadn't gotten far, though, before he stopped me.

"I have a better idea, slave. Move back."

I backed away from his crotch, as far as the chain connecting me to his chair would allow, anyway. Terry stood up and undid the straps of his open leather jock, tossing it on the chair behind him. His cock, still mostly hard, waved in the air, tantalizingly close, as he shucked out of his vest and removed his armbands. Naked except for his boots, he bent and unfastened the padlock that connected my handcuffs to my collar chain, then the cuffs themselves. He turned me around and refastened the cuffs behind my back. Since the cuffs rested in the small of my back, which had been protected by the kidney belt, they weren't scraping against welted flesh, but I still felt some twinges as my arms brushed against my upper back.

He lay down on the leather mat where I'd been resting and used my collar chain as a leash to pull me down on top of him. He slewed my face around on his chest until his left nipple was between my lips. I sighed and happily sucked and licked it. He stroked my hair and ran his hand along my arms toward the thick steel cuffs around my wrists. He played with my cuffed arms as I

suckled him, pulling the cuffs toward my head so my elbows had to bend out, raising both arms together until my shoulder joints ached, then lowering them again. I moaned and whimpered a little but never stopped sucking. He teasingly stroked my fingers, captured and useless. My cock was hard again and dribbling precum as it rubbed against his thigh or the leather mat. The chain from my neck to his chair lay on his chest and jingled softly at my slight movements.

"Y'know, dickhead," he said after several minutes of this, "I worked up quite a sweat flogging Matt tonight."

"Sir, yes, Master," I responded tentatively, not sure what he was after.

"Don't you think you should clean me off?" he asked.

"Sir, yes, Master, thank you, Master. May your slave give you a tongue bath, Master?"

"Yes, slave — start with my pits," and he shoved my face directly into his left armpit, rubbing my nose in the sharp-smelling tuft of hair.

The smell and taste of Terry's sweat, much of it dried by then but quickly reconstituted under my busy tongue, was like a sex drug that went straight to my brain. My fantasy of controlling him with a skillful tongue bath went out the window as I found myself reduced to a licking machine, mindlessly slurping and lapping at whatever flesh he put in reach of my mouth, letting him make all the decisions as he used his hands and the chain leash to maneuver me from pit to pit, lat to lat, pec to pec — ever downward toward his hairy, sweaty, funky crotch.

I stopped thinking. I didn't even pause to savor his salty sweetness. I paid no attention to pain signals from my ass as I sat back on my heels for better balance leaning over his body. I licked and swallowed and licked some more, occasionally humming unconsciously at the pleasure of serving him so intimately. He was sighing and moaning, too — we made quite a duet, Master and slave both in heat, communicating by tongue but without words, the jangle of my chain the only accompaniment.

When I reached his crotch, he told me to stop and move down to his knees, just *above* his beautiful, delicious boots, and work back up. He moved his legs apart to give me room to kneel between them. My tongue rasped all along his inner thighs, or as much as I could reach, until he was practically giggling. Finally

he pulled me back toward his crotch, where his fuckpole was standing tall.

I licked all around it, soaking his pubes with my saliva and whuffling noisily as I rooted through his crotch hair. Terry wordlessly spread his legs even more, and I dived for his crack, slurping up and down and from side to side until I wasn't the only one moaning incoherently. Finally he slipped his balls into my mouth, and I sucked and chewed for dear life until my jaws were aching. I felt him stroking himself again over my head, and eventually he pulled me off his balls, hauled me up onto my knees between his legs, bent me into a Z-shape, and plunged my head all the way to the root of his naked cock.

I'm sure I must have been in some pain by then, but all that mattered was giving good head to that seven-inch tubesteak down my throat. I rocked back and almost off, then sucked tight and plunged it into my throat again. Three or four of those and Terry was ready to blow. Since he wasn't rubbered, he pushed me off and began stroking himself to his climax.

"Here it comes, slave," he yelled, and his cock shot directly into my face. "*Ahh*, shit, that's good!" I'd closed my eyes in time, but most of the cum hit my cheek. "Christ almighty!" he yelled as the next spurt splattered my chest, and a third wad landed in my crotch.

I sat back on my heels, Terry's cum dripping off my face and down my chest, as he collapsed back on the mat, closing his eyes and moaning and sighing like an athlete who'd just won a hard race. Momentarily forgotten, a mere instrument of his pleasure, I was free to analyze my feelings. *Do I feel "dirty"? Am I any better than a used scumbag?*

Even as dickhead, though, I had no talent for humiliation. Instead, I was filled with pride that my Master had preferred to shoot his cum on me rather than into a condom! I *enjoyed* smelling him on my face and chest. I looked forward to his rubbing his cum into my skin, unless it dried out first. But that'd be okay, too — I even liked the feeling as his cum dried on my skin, then cracked and flaked off.

Finally, Terry opened one eye, then the other, looked at me, then closed both again and sighed deeply. When he opened both eyes again mine were respectfully lowered, but I could still feel him staring at me, picturing in my head that crooked half smile

of his. If nothing else, my hard cock pointing at him must have looked amusing.

"Guess I hit the target again, eh, boy?"

"Sir, yes, Master, right on the money," I replied, glancing up and venturing a small grin back at him. *Why should dickhead be a gloomy Gus and never crack a smile?*

"And how's the target feel?"

"Master, the target feels very good, just a little sore in its arms and ass, Sir."

"And horny, too, I see."

"Sir, yes, Master."

"Do you want to come, dickhead?"

"Sir, thank you very much, Master, but no, Sir."

"Why *not*, boy?"

"Master, your slave dickhead's understanding of your rules is that only his brother Matt is allowed to come, Sir."

Terry laughed.

"*Good boy!* Not only a great cocksucker and bootwipe, but honest in the bargain! A slaveboy in a million — but I knew that already. Master forgot that rule for a moment, dickhead. Thanks for the reminder! But you know I can always make an exception if I wish. Would you like me to?"

"Sir, no, Master, thank you. Master, Matt has come twice today already, and if he comes again now, it might take the edge off dickhead's discipline, Sir."

"You mean you'll get lazy and disrespectful?"

"Master, no, never that! Master, it's only that your slave finds it hard to stay as focused as he should be if he isn't at least a little horny, Sir."

"What's there to focus on, boy? You're going to be sleeping in a few minutes."

"Master, yes, but sleeping in chains, alone in the dungeon, still takes some focus to accept in the proper spirit — with gratitude and appreciation for your pleasure in thinking of how you left your slave, Sir." *Was that too much talk for dickhead?* I worried.

"Okay, dickhead. I get the message. You're training your Master, you know, at the same time he's training you. I can't read your mind, much as you might like me to, and I can't always know what's best for you without help. So it's good that you feel you can share things like that with me."

"Sir, yes, Master, thank you, Master."

"C'mere, boy," he said, pulling me toward him. "Lie down with me for a while. No, wait, let me rub in your skin cream first."

I shuffled close to him on my knees, and he smeared the small amount of undried cum around with his finger. Then he let me lie next to him, sheltered under his arm, my face against his chest. We lay there quietly, bonding together just as Terry and Matt had done earlier. It seemed that dickhead's service, too, however strict, would not be devoid of affection.

We dozed off, but he woke again when I started snoring.

"It's really late, boy," he said, getting up, "and we have things to do tomorrow."

He refastened my handcuffs in front of me as before, then told me to lie down while he got some things. He came back with a bucket for my piss, which I really needed by then! But he didn't let me use it right away, leaving it behind his chair, away from the carpet. To my surprise and delight, he also carried the crotch-high boots he'd worn earlier.

"Here, use these as a pillow," he said, folding them over a couple of times and laying them on the end of my sleep mat. "I kept them down here for you to clean tomorrow. Since it seems that I can't let you come as a reward, you can have this instead."

"Master, thank you, Sir!" I said as I rubbed my face into the soft, fragrant leather. Stealing a glance at his face, I saw a fugitive smile alternating with a sterner expression.

"Sleep well, slave," he said as I kissed the Wesco Boss boots he was wearing in farewell. "You've earned it."

As soon as I heard the door lock behind him, I was up and over to the piss bucket. Terry had turned off all the lights except one glowing softly beside the door, but it was enough to see my way. I almost pissed on the floor in frustration, however, when I discovered that the chain holding my collar to his throne chair wasn't long enough to let me reach the bucket and piss standing over it, kneeling, or even crouching. (It never occurred to me to move his chair, and it was probably too heavy anyway.) And I couldn't aim my cock from a distance, as my cuffed hands were locked to the collar chain stretched taut behind me, though that was nothing new — Terry seemed to like putting me in positions where I had to piss without being able to aim.

That finally reminded me that he'd said I wasn't *supposed*

to piss standing up anymore, even as Matt — he wanted me to piss sitting on the bare toilet bowl, *without* touching my cock to aim. So I got back on my knees, leaned over and grasped the empty bucket with my teeth, and dragged it close enough to be able to half sit, half crouch on its rim, as on the toilet bowl, and hang my cock hang down into it before I let loose.

Ahhh! It felt so good at last to empty my distended bladder — full of my piss and his, too, recycled — almost as good as coming. There's nothing like a little delay to make the eventual release all the sweeter! (Is that the whole secret of erotic slavery in a nutshell?)

"Sir, thank you, Master, for allowing your slave to piss!" I said in case he was listening (I knew he had the room wired for sound, and he probably had a "slavecam" video hookup as well). Besides, it felt good just to say it — by then every affirmation of my status as his property felt good. I was where I needed to be, and wanted to be, in my life, so why shouldn't I enjoy it?

Shuffling back to my "bed" and lying down on my stomach with my face cradled on his boots, I felt more completely satisfied — or just more complete — than I had in years. *What a day and night we've had! What a life together we have to look forward to!*

"Sir, thank you, Master! Good night, Master!"

There was no response, but as I drifted off to sleep, I imagined him smiling.

CHAPTER 36

Property rights

I slept deeply despite having to stay on my stomach — once I rolled onto my back and was startled awake by the sudden pain. But I fell asleep again easily after I turned over, and except for another visit to the piss pail, hours later I guess, I stayed that way. In fact, I was snoring when Terry came back into the dungeon.

"On your knees, slave," he said brusquely after he woke me by turning on all the lights at once.

Groggily, I struggled into position, only to have my head pushed down onto his boots as soon as he came around in front of me. I kissed and licked them before registering which pair they were — the brown work boots that I'd cleaned the caked mud from two nights before but hadn't polished yet.

"That's enough, dickhead," he said once I had the front of the boots glistening with eager spit, pulling me erect again with the chain attached between my collar and his chair. "I have a nice fresh load of piss for you, hot from the tap."

I stared at the crotch of his faded blue jeans, which clearly showed his piss boner snaking down toward the left. I wasn't sure if I was supposed to get it out or let him do it until his hand on the back of my head mashed my face into the soft, worn denim. I found the buttons with my teeth and worked them loose, then used my tongue to free his cock.

"No fancy stuff, boy," he warned as he pushed his meat past my lips, letting it lay there on my tongue. "Just drink it down."

His cock tasted clean, with just a trace of soap, and I was almost disappointed to find that his crotch smelled the same way. The hot piss started to flow quickly, though, and I was too busy swallowing for any more piggy regrets. The taste was bittersweet,

probably from his morning dose of sugared coffee. He eased the flow a couple of times when my cheeks bulged, but I was getting better at this and didn't need much help. My belly filled with a satisfying warmth.

"Ahh! That's nice," he said, and ran his fingers through my hair. "Good boy," he said when he was through, pulling his cock out of my mouth and putting it away.

A hell of a way to wake up! I thought, and then realized that my own cock was rock-hard and pointing upward, with a bead of precum oozing from the slit. *I guess I like it!*

"What do you say, dickhead?" he asked sharply, breaking my self-absorption.

"Sir, thank you, Master!"

"You shouldn't need prompting by now, boy."

"Sir, no, Master. Your slave regrets the lapse, Master, and he promises to do better next time, Sir."

"See that you do, boy."

"Sir, yes, Master. Thank you, Master!"

"Good boy. Now stand up and turn around so I can look at your back. This has told me all I need to know about your front side for now," he said with a chuckle, grabbing my hard, drippy cock and pumping it in his hand. I moaned at the exquisite pleasure and hated to end it by turning around, but orders were orders.

He examined me silently for a few moments, and then I felt his fingers tracing the cuts and bruises he'd given me. It was painful and pleasant at the same time, and several more soft moans escaped me as he pressed more firmly here and there, palpating the injured flesh. I yelped less softly when he ripped off the bandages he'd placed over several of the cuts.

"Looking good," he said. "No new bleeding, clean scabbing. There are some lovely bruises, but except for the last three whip cuts it'll all fade in a week or so. How's it feel, Matt?"

I was awake enough by then to notice the shift in names and respond accordingly.

"Good, Sir. But I don't know if I can wear clothes over it."

"You won't have to for the rest of today, until we drive into the city for dinner. Turn around and kneel beside me."

He seated himself in his chair. Besides the jeans and work boots, he wore a blue shirt with his name embroidered over the pocket, like a factory worker. No fetish gear at all — unless you

have a fetish, as I do, for just about any kind of masculine uniform. And then, of course, there was his flattop haircut, straight out of the 1950s.

"What are you grinning at, boy?" he demanded.

"Just you, Sir — you look so hot!"

"Are you nuts?" he asked. "Here you are, chained naked in a dungeon after being whipped bloody last night, you've just taken a load of my piss, and all you can think about is how *sexy* I look? Don't you know you're supposed to be scared and humiliated, trembling in awe before your mighty Master?"

"Is that what you want, Sir?"

"Nahh . . . I like you the way you are. It's nice being considered sexy at my advanced age."

He grinned down at me, then glanced at the tray he'd set on the table at the other side of his chair.

"Time for your breakfast, boy. The oatmeal is probably cold by now. Maybe I should mix it with hot coffee, or more piss?"

"Thank you, Sir, but the only thing I want to eat first thing in the morning is you!"

"Very flattering, boy, but not smart. You need a good breakfast to start the day right."

He took the cover off the bowl and added some milk and sugar, then stirred it around. I stared at him, devoid of appetite. *Oatmeal? I hate oatmeal!*

"Let me see," he said, "I can take off your cuffs and let you eat it yourself, or I can put the bowl on the floor and make you eat without hands, or I can feed it to you myself. Hmm . . . I prefer your hands in cuffs, and if you slop it up I'll have to clean your face. Guess it's option No. 3. Open wide."

He extended the spoon filled with oatmeal toward my face. I sighed and opened my mouth, taking it in. *I'd rather have more of his piss*, I told myself — *or his cum!*

"This is the part the porn stories never talk about," Terry said as he fed me, spoon by spoon. "A Top who lives alone and makes another guy his prisoner ends up playing nursemaid, waiter, and valet as well as guard. It'll be nice when Philip moves back in. Then I can lock you up and send *him* down to take care of you. I won't have to show up at all except when I want to have fun!"

I must have looked worried, because he laughed.

"Eat up, boy!" he said with a grin, stuffing another spoonful

of tepid, congealed oatmeal into my mouth. "If I take the trouble to make food for you, you'd better appreciate it. I could always exchange this cereal for stale bread in dishwater, or dog food."

"Yesh, Shir," I mumbled.

"I'm serious about this, boy," he went on as he held a glass of orange juice to my face. "I expect you to eat breakfast every day from now on. It can be as simple as this, and if you use instant oatmeal or cold cereal you won't even have to cook it. Understand? That's an order from Master to slave, not just friendly advice you can ignore."

"Yes, Sir, thank you, Sir," I said.

"Good boy. Now here's the drill for today. After you finish breakfast, you'll polish these boots I'm wearing, and then I'll leave you to do your meditation. After that you'll clean those boots you used for a pillow and the other pair you didn't finish Saturday night. Shouldn't take more than a couple of hours. Then you can shower, and I'll bring you upstairs for some lunch — something you'll like better than oatmeal. When we're finished, you'll clean the kitchen, and then Mutt and I'll play in the back yard for the rest of the afternoon. We'll have dinner in the city as I said, and then go back to your place. I need to check out your apartment more carefully and give you a list of changes to make. I won't stay the night with you, because tomorrow I have to get back to the project in Vermont. In fact, I'll be in Vermont or else upstate for the next two weeks, which is one reason I wanted to make the most of these three days."

"Yes, Sir," I said, thinking furiously as he fed me the rest of the oatmeal. *Changes in my apartment?* Terry laughed again.

"You're so transparent, Matt! It doesn't take a mind reader to hear the wheels turning under those blond curls! You're worried about those changes I mentioned. Is it finally sinking in that being owned isn't just a weekend thing? Are you having second thoughts?"

"No, Sir! . . . Well, maybe, Sir," I said with a rueful grin. "It's just that after what you said last night . . ."

"Look, I said I wouldn't micromanage your life and that when I'm away you'll make your own decisions. And that's true. But as your Master, it's my right — and my responsibility! — to give you guidelines and limits. I won't tell you what shirt to put on each day, for instance, but I *will* go through your closet and

pick out any clothes I don't like so you can get rid of them. And since you don't cook, you shouldn't mind if I replace your pathetic kitchen equipment with gear that I can use without cursing when I'm there, right?"

"Yes, Sir! Anything that makes it easier for you to cook, Sir, is all right by me!" *But please, no more oatmeal!*

"So we're in sync on that much, at least," he said drily, the corner of his mouth doing its little dance.

He poured me a mug of coffee and added two sugars, no milk. *He's even noticed how I like my coffee!* He stirred the coffee and let me hold the warm mug in my cuffed hands. I sipped at it gratefully as he continued laying out my future.

"The other changes may seem harder, boy, but they're nothing you won't get used to quickly. For instance, you're not going to be using most of the furniture. I want you to buy a futon to sleep on; the bed is off limits unless I'm there and invite you in. And that nice leather chair of yours — it's mine now, boy. You stay off it, understand?"

"Yes, Sir," I said, less enthusiastically.

"No moping and pouting! These aren't punishments, Matt! You just need some regular reminders of what you are, and staying off the bed and that chair will help. The sofa, too. You can still use the chairs at the dining table when you need to write in your journal — yes, I want you to keep a journal — or pay bills. You'll continue to pay your own bills out of your own salary, and the apartment will stay in your name, but I'll need a set of keys so I can come and go as I please.

"We'll go over those details later. Anyway, the floor is good enough for you to sit on to read or watch TV. You can buy some big throw pillows if you like — as long as they're covered in plain black, gray, or blue. Is that clear?"

"Yes, Sir. No wild patterns or colors, Sir. Anything else, Sir?"

"Plenty, boy! And no lip! This isn't a joke. Here's another rule: your cock is totally off limits, all the time, except to clean it or when I tell you to touch it. Understand?"

"Yes, Sir. You mean I can't jerk off unless you tell me to, even when I'm home alone?"

"That's right, boy. That's one of the most basic rules for any slave. You don't come, *ever*, except by my permission or order, and you don't handle yourself, either. Any pleasure you get from your

dick from now on will depend on me. And I'm going to keep you horny and hard most of the time, because slaves serve better that way. You told me so yourself last night! You got a problem with it, boy?"

"Maybe, Sir. I'm used to jerking off pretty often, Sir."

"And did you think you would just keep that up after becoming my slave? C'mon, boy — you're not that naive!"

"I guess I didn't think much about that part of it, Sir. I wanted you — I *want* you, Sir — on any terms you'll have me. I don't mean I *can't* keep my hands off my cock, Sir, just that it'll be hard, especially with you away a lot of the time."

"Should I measure you for a chastity belt, boy?"

"Maybe so, Sir," I said with a good imitation of his crooked grin. "But can we please try the honor system first?"

"We'll see," he said, sighing and shaking his head. "Now, another rule: no more standing up to piss or using the toilet seat when you shit. Like I told you yesterday morning, sit on the rim of the bowl every time, even when you only have to piss. The same goes when you're outside your apartment. No more standing at urinals, no more sitting on the toilet seat. Anytime you have to piss or shit, sit on the bowl. That way you won't have to touch your dick to aim it. And whenever I'm around, ask permission first before you use the toilet at all, just as you do down here. Understand?"

"Yes, Sir. I mean, Sir, I understand what the rule says, but not the reason for it. Does this mean you want me to be dickhead all the time, Sir?"

"No! Why would you think that?"

"These new rules, Sir, are pretty strict and rigid, more like the way you treat dickhead."

"They're really minimal, boy, and except for keeping your hands off your dick, which I know will be a struggle for you, pretty soon you won't even remember you ever did things differently. It's like calling me 'Sir.' Originally I didn't ask you to do it all the time; that was your idea. But I'll bet by now you don't even have to think about it. It just comes out automatically, right?"

"Yes, Sir," I said, smiling. "But Sir, it *feels good* to call you that. Even after all this time, Sir, saying it's still like feeling your hand on my cock or your dick rubbing my prostate."

Terry laughed and shook his head again. "What *am* I going

to do with you, boy? You're too much sometimes. I may have to enlist Master Jake's help in training you."

"As you wish, Sir. But is it so terrible, Sir, if I don't feel the same way about *avoiding* things, like the furniture or my cock?"

"Look, Matt — the reason I have to deny you things is so you won't take anything for granted. These new rules are for your sake, not mine. I won't be there to see you sleep on the floor most nights, or sit down to pee, and even when I am, I won't especially get off on it. Some Masters do, but not me. Enforcing rules isn't what excites me about owning a slave — about owning *you*.

"It's like architecture: I have to follow a lot of rules when I design a building, but the designing is more than merely following rules. Creativity starts where the rules leave off. The rules I'm giving you are simply the basics of how I'd expect any slave to behave. It's how Master Jake trained me, and it's second nature now. These little disciplines will help keep you focused and centered."

"It sounds like they're meant to humiliate me, Sir."

"Humiliate you? Don't make me laugh. You're impossible to humiliate . . . don't be proud of it! Someday your vanity will be your undoing. Eating some humble pie would improve you."

"Yes, Sir. Sorry, Sir."

I tried to look contrite, but it kept turning into a smirk. I couldn't shake the association in my mind between humiliation and shame. I couldn't imagine anything Terry might do to me, or order me to do, that would make me feel ashamed. *The only thing I'd be ashamed of would be if I failed him somehow, and how could he want me to do that?*

"The odd thing," he went on, "is that you're easy to embarrass — or maybe it's not so odd. It's probably related to your vanity. I enjoy teasing you because you let down your guard when you're red-faced — once I shake your composure, you give up immediately. You lie on your back and expose your vitals. I think you get off on it, too! Don't pretend that you don't."

"It's true, Sir. I do like it when you tease me, Sir. It makes me feel . . . oh, younger somehow, less responsible . . . looser."

He just grinned at me.

"But isn't it enough, Sir," I went on, "if I'm naked when you're dressed, in chains when you're free, on the floor when you're sitting in a chair? Do you need all those other rules, too?"

"What about when I'm not there? You're not going to be

wearing chains around the house when I'm in Vermont! You're not going to be naked in front of your friends when they visit, or at work. You need these rules to reinforce your status — hell, your identity! — as my slave when I'm not around to do it myself."

"I don't understand, Sir."

"Look, Matt, we don't have a lot of ways to indicate that a slave is owned by someone, and those we do have are just about all connected with status. That's okay, because a slave needs to free himself of vanity and not worry about protecting his turf or perquisites. But the difference in status doesn't mean a difference in worth. A good slave is worth a lot more than a neurotic, un-productive free man. It's because I want you to be a good slave — *and* a happy slave — that I care about things like whether you eat breakfast or do your meditation or stay off the furniture. If our time together is too different from your life apart from me, you'll get confused and discontented. Even though we're not together full time, I *own* you full time, and I don't want you to forget it."

"Yes, Sir, but if I'm your slave all the time, what's the differ-ence between me and dickhead?"

"You seem to understand it well enough in practice, Matt. You handle the transitions very naturally."

"Thank you, Sir, but I don't know what dickhead means to you, really — how you see him as opposed to me." *Anymore than I understand what Mutt means to you*, but I didn't say that aloud.

"Hmm . . . well, you're both my slave, but dickhead is a kind of idealization that I know isn't possible for you to achieve all of the time."

"But you'd like me to, Sir?"

"Hell, no! Then *I'd* have to be 'Master Terry, the Great and Powerful' all of the time, and that's too hard! For instance, you know very well that dickhead would never ask that kind of ques-tion, and if he did, Master Terry would just slap his face and tell him to keep it buttoned until it's wanted."

He grinned at me, and I grinned back.

"Nonetheless," he went on, "it's important to me that *you* — Matt — understand everything about what we're doing — and why. If I can't explain something right at the moment you ask, I will as soon as I can."

"Thank you, Sir."

"It's not just for your sake. That's another lesson I learned

from my failure with Philip — I never told him the reasons for anything I did. I had this stupid idea that it was beneath a Master's dignity to explain himself. I thought my slave should just accept whatever I did without question, and up to a point he did. But the questions were still there, simmering inside him, and finally he exploded.

"With you I know that'll never happen — as Matt you can always ask questions, and if something bothers dickhead so much that you can't hold it in, you'll break character and tell me before doing anything foolish. And that's okay. It's my job to make dickhead feel so safe and secure he doesn't *need* to ask questions."

"Are Master Terry and dickhead just games we play, Sir?"

"No! They *are* unreal in a way, but that's because they're both perfect — something you and I can never be. I can only be dickhead's Master when I've set up a situation that's very simple, with no complications or shades of gray, like when I had you drink my piss this morning. There aren't a lot of ways to do that wrong, on your part *or* mine, and the proper responses to errors are just as limited and ritualized. But feeding you breakfast had way too many variables for dickhead to handle, and a conversation like this'd be impossible."

It's starting to come clear! I thought. But Terry went on, as if for his own benefit as much as for mine.

"Try this: dickhead is three-dimensional — he's not a cartoon. He has a real body and a good brain. If I smash him, he won't spring back to life. If I hang him up by his thumbs, he'll be damaged, just as you would be. But what's different is that he lives in the moment — he isn't *four*-dimensional the way you are, Matt. He doesn't have much history yet, and his future is a blank slate. That's how he's able to be such a perfectly compliant slave, because he's not influenced by years of past experiences or worried about getting old. He can do just what I tell him, without questioning it, because he only exists in my presence or following my orders. So you see, the *last* thing I'd ever do is give him orders to follow for an extended time alone in the city."

"And me, Sir?"

"You're four-dimensional, Matt, as I said, with 33 years of history, which sometimes weigh heavily on you, and a long future to look forward to — most or all of which I hope you'll spend with me. dickhead is you when you're able to put your past and

future aside and be *nothing but* my slave, in a timeless state of perfect submission and obedience. I don't expect you to exist there all the time. You couldn't be all the other things you are if you did: my boy who makes me explain everything, my sexy lover, my dog Mutt, a great bookstore manager, a good friend to Stan and many other people, and so on."

"I understand, Sir. Thank you, Sir."

"Okay, enough talk for now. Here, finish your coffee."

He refilled my mug and sat there silently as I drank it. I was silent, too, mulling over all he'd told me. *I never knew being a slave was so complicated!*

Terry took the mug from me, removed my handcuffs, and rubbed my wrists briskly to smooth out the indentations from the cuff bows. Then he unlocked my steel collar from the ring-bolt on his chair and stood up.

"Drag the leather mat down there," he ordered, pointing to the area on the main floor directly in front of his oasis. "You can kneel or sit on it as you work. See how kind I am, slaveboy?"

"Sir, yes, Sir, thank you, Master."

I wasn't quite sure if I was supposed to be dickhead or Matt at that moment, but it was safer to assume the stricter role until told otherwise — and, as he'd said, it was getting easier to move between them.

He followed me down, carrying the crotch-high loggers I'd used as a pillow, and when I'd wrestled the heavy mat into position, he told me to fetch my piss bucket from the platform, empty it in the toilet, and bring it back filled with clean water for boot washing. Then he walked off.

When I returned with the bucket of water, Terry was already back, sitting on the edge of the platform and dangling the familiar set of work-length manacles in one hand. On the mat below him were the bootblack kit and his alternate pair of cop boots — not the Dehners but the ones he'd worn the first time we played. I knelt at his feet, his work boots right in front of my face, holding my back straight so my ass wasn't touching my heels, and raised my hands to be manacled. He locked the British cuffs on my wrists but didn't lock the chain to my collar. Instead, he padlocked my collar chain to a ringbolt on the front of the platform.

"Polish these first," he said, scraping my chest with his left boot, "and then I'll leave you to meditate and do the others."

"Sir, yes, Sir. Thank you, Sir."

I rolled up his jeans and licked the left boot all over, tasting the remnants of the saddle soap I'd used on it two nights before. Then I applied tan wax polish, lifting and turning his foot with my hands. Terry cooperated but added his own little touches to the operation, like pressing the Vibram sole against my right pec as I waxed the upper or propping his left boot on my shoulder when I shifted my attentions to his right boot while the left one absorbed its polish.

When the right boot was fully licked and covered with polish, he rested it on my shoulder in turn, and I took the left one again in my hands. I wiped off the excess polish with paper towels and then brushed and buffed it — this was an even noisier process than the initial polishing, but I think Terry liked hearing the jangle and clash of my chains as I labored. Whenever I snuck a glance up at him, he was grinning. *"Music to my ears," indeed!*

He kept pushing the boot toward my mouth, and as my hands worked over the leather, my lips and tongue worshipped the rubber sole — I was glad I'd done such a good job washing off the dried mud earlier! The whole time I worked, my dick was hard and dribbling precum onto the leather mat. Although I'd licked my Master's boots many times, and cleaned a lot of them, too, this was the first time he'd let me combine boot service with boot worship. I was completely focused on my task — making his boots look good — and at the same time totally turned on by the way he made my whole body an accessory for his boots.

The boots were too worn to hold much of a shine, but by the time I finished with them, they looked more presentable than they probably had in a long while. I rolled Master's jeans back down, touched my lips to each boot toe once more, first the left and then the right as always, and returned his booted feet to their original positions against the side of the platform. Smears of polish on my face, hands, arms, and chest were evidence of how unsparingly I'd thrown myself into my work. I sat back on my heels then, wincing a little, and bowed my head, resting my chained hands on my thighs as I awaited his judgment. My cock, still hard, pointed proudly up toward him between my legs.

"Good job, boy . . . *damn* good job," he said, extending his legs and turning them from side to side to look the boots over. "Good boy, Matt. You're the best bootwipe I've ever had."

"Thank you, Sir. It was a pleasure, Sir."

"I want you to meditate for ten minutes, slaveboy. Kneel and stare at the wood, right here," he thumped the side of the platform with his boot, "and let your thoughts drift. Don't try to control them. Don't try to control anything! You'll know when it's time to stop and get to work. I'll see you in a couple of hours. After you've cleaned both pairs of boots, you can sit on the bucket to piss if you need to."

"Yes, Sir."

"Matt can say, 'Thank you, Sir,' too, you know. You don't have to be dickhead to be grateful for my direction."

"Yes, Sir, thank you, Sir!" I said, reddening in chagrin at the lapse. "Sorry, Sir."

"On second thought," Master said, "I *will* give you a theme for your meditation. Thankfulness. Slaveboy, I want you to meditate on how thankful you are to me for owning you and training you and giving you what you need. You're a slave now, and slaves are grateful for whatever they get. Happy slaves learn always to be thankful, because being bitter and resentful doesn't improve anything and just makes *them* feel bad."

He put his boot soles on my shoulders and pushed me down flat on the floor.

"Remember, boy," he said from above me, "I *own* you now. You're not a freelance bottom playing out a scene. Every joy or comfort in your life from now on is ultimately a gift from me, because I can take it away if I want to. Stop taking so much for granted. It's all changed now. We're starting fresh. Think about that. Think *hard*, slaveboy."

Even after the pressure of his boots on my shoulders vanished, I stayed just as I was, with my face pressed to the floor and my heart racing, until I heard the dungeon door close and lock behind him.

Slowly, I straightened up and sat back on my heels, wincing again at the pressure on my bruised ass. I was supposed to meditate on "thankfulness," and all I could think about was the changes Terry had said he wanted to make in my apartment! Somehow it bothered me less to put my body at his disposal than my "stuff" — all those books, pictures, and bric-a-brac acquired over the years that made my home a reflection of me, and of Greg.

Like most architects, Terry had a passion for order, and while

his house was both beautiful and comfortable, it had little of the random clutter that makes a place look "lived in." Kneeling there naked in his high-tech, spic-and-span "dungeon," wearing shiny, rust-free chains, I shivered at the idea of his going through my home and discarding whatever he didn't approve of.

I could just picture him holding one of my precious mementos poised over the waistbacket as he checked my reaction. *Would he spare it in deference to my look of horror? Or make me beg him to keep it? Or toss it in just to see my anguish?* It was hard to imagine Terry making any malicious decisions, thowing away one of my treasures simply to be mean. And yet, whatever remained after his "inspection" would do so only at his pleasure.

And that's the whole point, isn't it? I've put myself and all I have in his hands. How can I do that unless I trust him? And if I don't trust him, what am I doing here at all?

I cast my mind back over all of our encounters, searching for instances where he'd deceived me, or harmed me, in any significant way. There were none — quite the reverse: his acts of kindness far outweighed his sadism. The brief periods of intense pain he'd given me were always more than balanced by his loving care before and afterward, and the pain itself was always delivered with skill and intense watchfulness. The more I surrendered to his control, I realized, the more freely he'd exercise it for my benefit.

He'll take better care of me as his slave than I ever took care of myself, so how can I worry about my stuff? I scanned the apartment in my mind, subtracting whatever I was sure Terry would want to dump — nothing I truly cared about, just a lot of pack-rat accumulations I'd be well rid of. *As he said, I won't be able to take anything for granted. Whenever I touch that funny old boot-shaped beer stein I bought for Greg, or look at the Tom of Finland he gave me still hanging over the bed, instead of being sold or moved to Terry's house, I'll know, just from their continued presence, that Terry left them there for my sake. Every concession to my memories, or my bad taste, will be an act of love — a gift. How could I not feel thankful?*

I stared at the spot on the platform side that Terry had indicated. Instead of thinking *about* being thankful, I tried to *be* thankful, to let myself be filled with gratitude at his generous and kindly treatment. I tried to recall how I'd felt all those times when I'd said, "Thank you, Sir," over the past couple of days. I rehearsed the occasions in my mind and let the words resonate.

"Thank you, Sir!"
"Sir, thank you, Master!"
"Yes, Sir, thank you, Master."

Sometimes the recitation had been mere formula, of course, and sometimes I had felt anything but thankful inside, even rebellious. But more often it'd been sincere, if not deeply felt. I tried to focus on the occasions when my thanks had been especially sincere, when the words had bubbled up on a swell of deep emotion. *What was that emotion? Wasn't it . . . joy? Mixed with surprise? Is that it, then? Joyous surprise? And isn't that precisely how we receive any welcome but unexpected gift? And doesn't it feel good, like seeing the sun come out after a thunderstorm, or getting a letter from a friend you'd despaired of hearing from again?*

Staring at the wood in front of me, I let my eyes unfocus and concentrated on my breathing. *Becoming his slave was certainly unexpected! And welcome!* [Breathe in, breathe out.] *So many of the loose ends in my life come together neatly and beautifully in bondage to him.* [Breathe in, breathe out.] *His ownership might not always be comfortable or easy, but it gives me a purpose and direction.* [Breathe in, breathe out.] *His discipline makes me feel wanted and cared for.* [Breathe in, breathe out.] *Serving him gives me more joy than anything else I've ever done.* [Breathe in, breathe out.] *Sir, thank you, Sir! Thank you, Master!* [Breathe in, breathe out.] *Now back to work!*

I focused my eyes and shook my head to clear it. Whatever Terry had intended by the meditation assignment, I felt at peace again, contented, free of doubts or fear. *And now I have more of his boots to put to rights! What more could a bootslave want?*

I pulled over the crotch-high loggers and laid them out full length. The uppers weren't especially dirty, with just a few grass stains around the knees and some streaks from my precum, or my piss, lower down. But they had so much leather in them that even a basic clean-and-buff would take a lot of time — especially if I licked them all over, as I fully intended to do! The Vibram soles, however, had plenty of caked soil between the treads, and I used a damp sponge and a brush there, not my mouth. Since dickhead had licked at the soles the night before, during Terry's little "demonstration," I figured I'd had my quota of dirt for the weekend.

Alone in the dungeon, which was dead quiet except for the jangle of my wrist and collar chains, I found another kind of med-

itation in the long process of licking the leather uppers, one patch at a time, rubbing in dubbin, and buffing the oil-tanned surface till it gleamed. I tried not to think of other matters as I worked, concentrating on the boot leather under my hands or tongue. Of course, I was often distracted by stray thoughts or memories, but most of the time I was able to lose myself in my meticulous service to Master's boots. It was both relaxing and pleasant, and I felt grateful to him for giving me the opportunity.

"Sir, thank you, Sir!" I suddenly shouted. I grinned impishly as I imagined him, somewhere upstairs, hearing my shout and being so startled he dropped something. "Thank you for letting me service your boots, Sir!"

Threading the laces back into the finished boots, I had no idea how much time had passed. I might have used up the whole two hours Terry had allotted, and there was still one more pair of boots to do. Nonetheless, I needed a break. I stood and stretched as much as the chains would allow. I was smeared with polish all the way to my elbows, and I stank of sweat, cum, and piss, but I felt wonderful! I started to jog in place, but the echoing clangor from my chains was too much, so instead I slowly twisted and bent my body this way and that to loosen my tight muscles.

When I had all the kinks out — out of my body, anyway! — I sat down to tackle the police boots. I stared fondly at them and smiled, remembering our first night, less than five weeks before, when we'd met at the Spike. He was in his NYPD Highway Patrol uniform, and I'd gone down on his boots — *these boots!* — right there, with my arms cuffed behind me, scandalizing the crowd. *He said that's when he decided to take me home for some private cop discipline. Good thing he liked how I chowed down on his boots!*

Like the lace-ups, the cop boots weren't especially dirty, but their high-gloss shine had faded. Not thinking about the time, only the job I needed to do, I gave them the works: tonguewash, saddle soap, hot liquid polish (using matches from the bootblack kit), more tongue, brushing, polishing cloth, and finally buffing. I must have run over the two hours, in fact, for Terry came in while I was still finishing up the right boot.

He was very quiet. Suddenly I looked up, and he was standing at the edge of the platform. Automatically, I got up onto my knees and bowed my head.

"Continue, slaveboy," he said. "Finish those boots. I'll wear

them tonight, along with my uniform. Sort of rounding the circle. We might even stop in at the Spike after dinner instead of going straight to your apartment. I mean — *my* apartment," he said with a half grin.

"Yes, Sir. Thank you, Sir," I said, looking up at him towering over me. He was dressed the same as when he'd fed me breakfast, except the boots he was wearing looked a lot better than before!

I hunkered down and went back to work. A few minutes more buffing, and they were done. I set the tall police boots side by side on the front of the platform — Terry had retreated to his chair — and then laid the crotch-high loggers, which were much too tall to stand up without support, beside them.

Terry got up and came forward to check my work, crouching down to examine the boots carefully. He found no fault — there was none to be found! But when he said, "Good boy! These look real nice," I still felt honored and pleased.

"Thank you, Sir. It was a pleasure to do them, Sir."

"And how did your meditation go, boy? Still full of doubts, or do you see that the changes in your life are all for the better?"

"No more doubts, Sir. I never doubted, Sir, that belonging to you would be good for me. But some of the ramifications scared me a bit. I'm okay with them now, Sir."

"Good. I expect you'll do some backsliding, but I'll keep you on the path, with my hand and belt if necessary, as well as all the explanations and talk you need. Now, though, one more little chore before we get you cleaned up."

He reached behind his back, then handed down to me the studded leather collar he'd first put on me at the Bondage Club.

"This has had some wear and tear this weekend, boy, and needs a good scrub with saddle soap, then a little of that dubbin you used on these loggers. Be sure you clean any stray blacking off the metal studs. This is going to be your regular dress collar, so make it look good, slaveboy."

"Yes, Sir! Thank you, Sir!"

It took me only three or four minutes to freshen up the collar — and in the process get several more streaks of black on myself. Terry came down off the platform as I was finishing and unlocked the chain attaching me to it, after I gave him a proper greeting by kissing his boots and hand. He pulled me up and hugged me, heedless of my dirtiness, and then we kissed for a

long time. My cock was hard and dripping as his tongue probed my mouth and his moustache tickled my lip. *I love him so much!* I said to myself, but only because he didn't need to hear it — he could feel it.

He released me finally, and tousled my hair.

"Never forget that I love you, Matt," he told me, and my eyes filled. "No matter how hard I use you or push your limits of obedience, I love you and care about you. I would want you even if you weren't a slave. Fortunately, you *need* to be owned and controlled as much as I need to do it to you. We're a matched set, boy, and we're going to be great together."

"Yes, Sir! Thank you, Sir — for everything!"

"Okay, now march!"

He put his hand on my arm and walked me over to the shower cage. With an air of regret, he removed all of the restraints I'd been wearing — collar, manacles, and leg irons — and shoved me inside, then locked the mesh-reinforced door behind me.

I stood just inside, away from the shower head at the back, and watched through the glass-brick wall between us — which rose only about half a foot above my head — as he turned on the water and set the temperature. The obsessive control the arrangement represented suddenly struck me as funny, and I giggled.

"What's so funny, boy?" he shouted and twisted the water all the way off again.

"Sorry, Sir," I said as he glared at me through the wavy glass, "but it struck me as comical how much trouble you went to just to prevent a prisoner from setting the shower temperature."

"It wasn't any trouble. Remember, boy, I design prisons for a living! This setup uses standard equipment for maximum-security prisons. The guards always control the showers because a con might use scalding water as a weapon, either against a guard or another prisoner."

"Yes, Sir, of course, Sir," I said, stifling more giggles. The image of one of Terry's tricks attacking him with hot shower water *was* pretty ridiculous! Apparently he saw the humor in it, too, because he stopped glaring and gave me one of his half-grins.

"Well, I never denied I'm a control freak, boy!"

"Yes, Sir. Never met a Master who wasn't one, Sir!"

"Hmph! And how many Masters do you think you've met, boy? Don't answer that! I'll be back in 15 minutes. . . . Exactly,"

he said with an all-out grin as he turned on the water again. "Enjoy your shower, slaveboy."

"Thank you, Sir!" I said to his back as he walked away.

Terry had set the shower temperature moderately hot, and with my back and ass still sensitive, I eased into it. The water felt great on the front of my body, so I moved forward slowly and let it flow over my shoulders and down my back. It stung for the first few seconds, and then it felt good, so I let it soak me completely. I rubbed my wrists, ankles, and neck, free of steel cuffs and chains for the first time in many hours. It's not that I hadn't liked wearing them, but it was good to have a rest from their weight and unyielding grip.

Suddenly needing to piss, I shrugged and let it rip before I remembered Terry's new rule: never piss standing up. With difficulty, I cut off the flow. There was nothing to sit on, so I crouched over the drain and tried again. I overshot and duck-walked backwards until I was hitting in the gold. I felt silly crouching there like that, but it also felt good to obey his order, so I guess this one was a draw. *So I'll never use a urinal again — so what? It doesn't matter. Obeying him is what matters!*

My bladder empty, I stood again under the deliciously hot water. Soaping myself all over, I wondered briefly if Terry would still let me take baths at home — or keep the rubber duckie that held the soap in my tub . . . *his* tub! His *city* tub, as opposed to the one here in the house, which was now my home as well! I was too happy to worry about it, though.

A scrap of doggerel from *The Lord of the Rings* popped into my mind, and I recited it at the top of my lungs so that Terry, if he was listening, could hear it over the noise of the shower:

> Oh, Water Cold we may pour at need
> Down thirsty throats and be glad indeed.
> But Beer is better if drink we lack
> And Water Hot poured down the back!

Tolkien's epic was Greg's favorite book, and he often quoted that bit when we showered together, though he usually preferred wine to beer. A shared passion for heroic fantasy was one of the things that had brought us together, but I hadn't thought about hobbits and elves in years, or reread the trilogy since he'd

died. I suddenly realized I had no idea what kind of books Terry liked to read.

He does read, I'm sure of it! He'd just never given me any chance to look over his bookshelves, which were hidden away in his study. I filed it away as one of those questions I'd have to ask when the time was right.

I washed my hair and carefully rinsed out all the soap (there being a distinct lack of no-more-tears shampoo in this lockup). Terry still wasn't back, so I closed my eyes and luxuriated under the spray, pretending I was basking under a sylvan waterfall instead of in a maximum-security personal-hygiene unit.

He can be as obsessive as he likes, I told myself. *He can't limit my imagination.*

CHAPTER 37

Homeward bound

The rest of the day went exactly as Terry had said it would. After my shower, he put me in chains again and took me upstairs, where he prepared a delicious light lunch of grilled-cheese sandwiches and fresh fruit salad that we ate outdoors on the lawn. I cleaned up the kitchen, still in chains, while he busied himself elsewhere. By the time I finished, he was back outside, relaxing on the chaise. I went to him, and he took off the chains and installed Mutt's tailed butt plug and a wide dog collar with spiked studs. He had me put on kneepads, thick socks, and my Army boots, and then he inserted my arms into a pair of knee-high logger boots and laced them tight. He'd previously inserted a rolled pair of socks into each boot to cushion the base of my hand — my fingers didn't quite reach the toes.

Mutt and Terry romped on the lawn for two or three hours — I wasn't in a position to check the time! The kneepads and the boots, and especially the grass, made staying on my hands and knees much easier than it had been on the floor inside the house, but it took awhile before I got the knack of moving gracefully. He threw a ball and stick for me to fetch, led me all around his property on a leash, and taught me to heel, sit, roll over, beg, and other standard doggy tricks, interspersed with rest periods when he'd sit on the grass or a bench and let me lie at his feet or with my head in his lap.

I was rewarded with a pat on the head, a "Good boy!," or a small dog biscuit when I performed satisfactorily — I didn't learn too quickly, as it would spoil the illusion. He never punished me for my "mistakes," just patiently went over it all again. When I had to piss, I lifted one leg and sprayed it against a tree, just like

a real dog, and when he hadn't commanded me to heel, I'd run ahead, pulling at my leash, and sniff out the territory. Terry's delighted expression at these antics was all the reward I needed.

It was great fun, and I enjoyed giving free rein to the animal persona Terry had brought out in me. Nonetheless, I was exhausted and aching, and the afternoon sun was low, when he decided we'd had enough play and led me back into his bedroom through the outside door. He sat in his armchair, and I scampered toward him, ducking my head and slurping at each of his boots (instead of kissing them in human slave fashion) before sitting up, doggy-style, between his legs.

"Time to clean up and change for the city, Matt," he said as he pulled my booted arms onto his thighs.

I cocked my head, let my tongue loll out of my mouth, and gave him my best hangdog expression as he began unlacing the boots. Despite being tired and sore, Mutt didn't want to leave — and neither did Matt! Terry laughed.

"No begging, boy! I know you'd like to play some more, but there's more to life than play."

"*Rowrff!*"

"Enough, Matt. Behave."

"Yes, Sir. Sorry, Sir."

"I'm glad you enjoyed our romp, but I want you to be yourself the rest of today — no more Mutt or dickhead for a while, understand?"

"Sure thing, Sir. Thanks."

He pulled the boots off my arms and set them aside, then unbuckled the dog collar.

"Turn around and bend over," he ordered, and after I complied he pulled out Mutt's tail. "Now take off my boots."

I turned around again and reached toward the laces with my hands, looking up to check if that was okay or if he wanted me to use my teeth. He nodded, so I got them off quickly and efficiently, and the socks, too, after another nod.

He stood up and started unbuttoning his shirt.

"Take off the kneepads and your boots, and join me in the shower," he said. "You look like half my lawn is sticking to you."

Of course, cleansing his body came first, and he let me give him a leisurely soaping and scrubbing. He gave *me* a few playful kisses and nips along the way, then washed me briskly — except

for my asshole, which he soaped *very* thoroughly before shoving his cock inside and fucking me hard, almost brutally, not even pausing to push me against the wall but holding me in place with his arms, rolling and pinching my nipples as he fucked. After hours of wearing a butt plug, I was wide open, so I clenched my ass muscles to give him a good ride.

It turned out to be a short one, whether by design or because he was so turned on, I couldn't be sure. Not having a condom, he pulled out before coming, spun me around, pushed me to my knees, and shot in my face with a yell that rattled the glass door of the shower. Finally he had me kneel over the drain with my hands behind my back and took a long piss on me and in me, first washing off his cum, then finishing in my mouth. He let me relieve myself as well, once I got soft enough — it was as satisfying as coming, especially because I'd already shared in the pleasure of *his* release. I got rinsed off with a blast of cool water, and we were done.

After I dried him and then myself, I joined him in the bedroom. He was assembling his NYC Highway Patrol uniform, laying it out on the big, leather-covered bed. The clothes I'd worn to Altar Friday night — it seemed like a year ago! — were piled on the floor next to my boots. The black-leather chastity shorts and a jumbo solid steel butt plug lay on top of my ripped jeans.

Terry had me kneel on the bed with my ass in the air so he could install the plug, and then he told me to put on the shorts. My asshole quivered around the wide plug, which had felt cold going in, though it soon warmed up, and my cock was so stiff again that he had a hard time pulling it and my balls through the hole in the front of the shorts. But he finally strapped it in place, zipped the steel-reinforced leather shield over my harnessed equipment, and locked all five small padlocks.

"This'll keep you out of trouble, boy — and street-legal, too!" he said with a crooked grin. "Get dressed, and don't worry about helping me. I'll let you know if you can do anything."

I put my socks and boots back on, then the jeans — which barely fit over the bulky shorts — and my T-shirt, and finally my chaps. I held up my leather jacket and looked inquiringly at Terry, who was sitting on the bed and buttoning his uniform shirt.

"That too, boy. We're riding the Harley. Put it on and then help me with these boots."

I knelt in front of him and pulled the gleaming police boots onto his legs, over the snug, blue-striped navy breeches, and laced the instep and top of each boot. He stood and stamped each leg to settle in, and then I kissed the boots, first the left and then the right.

"Good boy," he said. "These look good. You look good. We make a good-looking pair. Shall we give the guys at the Spike a thrill, or just do a private show at the apartment for ourselves?"

"Whatever you wish, Sir," I said, grinning up at him.

"Ma-a-tt," he drawled warningly, "remember what I said about answering me when I ask about your preferences?"

"Yes, Sir, sorry, Sir — I was just embarrassed to admit how much of an exhibitionist I am!"

"Bullshit, boy — everyone knows you are! So you'd like to make another scene at the Spike?"

"Love to, Sir!"

"Let me think about it. I'll see how I feel after the ride and dinner. Now stand up, boy."

He hugged me tight, and we kissed deeply. But while his tongue was still in my mouth, he pulled my arms behind me and cuffed them. I was only surprised it had taken him so long! My cock strained against the leather confining it.

He pushed me to my knees and looked at me appraisingly for a long moment.

"You'll do, boy," he said finally. "You'll do fine."

"Thank you, Sir," I said, my eyes focused on his boots. He sat down again on the bed.

"Matt, look at me, and listen carefully. Now that you have a more complete idea of what's involved, do you still want to be my slave?"

"Yes, Sir, with all my heart!"

"Do you trust me?"

"Completely, Sir."

"Are you willing to let me make decisions for you and about you, even if you don't understand the reasons for them?"

"Yes, Sir."

"Even if you don't *like* what I decide?"

I paused — that was harder. But what was the point otherwise? If he did only what I wanted him to do, who was Master?

"Yes, Sir," I said firmly, committing myself to the unknown.

"Good boy," he said with a smile, recognizing what it had cost me.

"Matt, if someone had asked me a couple of months ago if it made sense for a Master and slave to commit to each other after only a few sessions over five weeks, I'd have said no. And when I collared you at Altar on Friday evening, I described you as a 'probationary slave' — I almost said, 'slave in training.' Trouble is, that implies there's a time when training is over, and I don't believe there is. Like an athlete or a soldier, a slave is *always* 'in training'."

He paused, and I held my tongue, unsure where he was going but content to wait. Even though I was handcuffed and on my knees, as instructed I looked into his face, man to man.

"If all went well this weekend," he said finally, "I intended to offer you a six-month extension of your probation. . . . I don't want you to feel railroaded. After last night I think I know the answer, but I have to ask: do you need another six months to be sure about me?"

"No, Sir!"

"Would your answer be any different if I took those cuffs off, and the jock and butt plug?"

"Are you kidding, Sir? I've started to feel there must be something wrong if I'm *not* cuffed and plugged!"

Terry grinned back at me.

"Do you have any doubts about me, Sir?" I asked him.

"God help me, boy, I don't! I must have rocks in my head, but I actually think we can make a go of this! The very first time I slapped cuffs on you and felt your tongue on my boots, that night at the Spike, I had the feeling you were right for me. All we've gone through together over the last five weeks has only strengthened that impression."

"Thank you, Sir. I've felt the same way."

"We don't have to abandon all caution, though. You know that Master Jake is my mentor and trainer. Would you accept him as your godfather or guardian? You could seek his help if I ever give you cause to think serving me is no longer in your best interest. Or would you be more comfortable with someone else?"

"Sir, it would be an honor, if Master Jake is willing."

"Oh, he will be, boy. He doesn't know it yet," he said with a grin, "but I very much doubt if the request will surprise him."

"Not much seems to surprise him, or escape him, Sir."

We shared a smile. Our respective experiences with Master Jake had been very different but equally critical in bringing us to this point.

"Well," Terry said then, "since neither of us wants to hold off or to fashion any loopholes, it's time for a formal commitment. I don't believe in written contracts for my slaves..."

Slaves? He's planning to have more than me? Terry noticed my puzzled look and immediately intuited the reason.

"Yes, boy, I may have others in the future besides you. You woke a dragon when you challenged me to be a Master again!" he said with a laugh. "I don't have any definite plans to take another slave, but I'm not going to rule it out, either. And you'll be part of the decision in any case. Why would I want the grief of having two slaveboys who don't like each other? But right now we're only talking about you and me."

"Yes, Sir. I understand, Sir." *Well, I did ask him once if I could join his "stable"! Could be fun to have a slavebrother — not counting Philip...*

"Hel-ll-o? Are you with me, boy?"

"Yes, Sir, sorry, Sir. Just thinking again, Sir."

"Sure you were, but right now I want you to *listen*."

"Yes, Sir." I knelt up straighter and looked at him expectantly. He snorted, unimpressed.

"I was explaining my feelings about contracts.... I don't say other Masters and slaves shouldn't use them if they want to, but to me written contracts are designed to protect strangers or people who have a reason not to trust each other. A partnership like ours isn't a business deal. It has to be based on a profound trust and mutual respect. I think we've developed that in even this short time, and it will only deepen as we get more used to each other. Right, Matt?"

"Yes, Sir! You've been extremely patient with my doubts and hesitations, Sir. And I've been learning that the more I trust you, the better it all works out, Sir."

"Good boy! Now, are you willing to swear an oath of service and obedience to me?"

"Yes, Sir, I am."

"You understand that it involves no legal constraint, that only your own honor makes it binding?"

"Yes, Sir." *And your skill at bondage!* I thought, struck by the irony of being asked to swear an oath while I was already bound.

Terry seemed to have the same thought, because he bent my head down toward the floor, then reached over and unlocked the cuffs holding my arms behind my back.

"Much as I prefer to see you in bondage, boy," he said as I straightened up, rubbing my wrists, "I don't want to leave any doubt in your mind — or mine — that you're entering slavery of your own free choice. Here's the key to the locks on your jock — you decide if you want to take it off for now."

"Please leave it on, Sir," I said, handing the key back to him.

"As you will." He smiled. "Symbolism like this is important, Matt, because the oath you're about to take is *much* more important than any of those rules I gave you earlier. Those are simply conventions — they don't mean anything in themselves, and I might change them at any time. Which doesn't mean you don't have to obey them!" He gave me a sharp look.

"Yes, Sir, I understand."

"All right then. This oath defines how we're going to relate to each other for a long time, maybe the rest of our lives. I've had the words in my mind for years, but until you came along, I figured I'd never actually have any use for them."

His wistful expression touched my heart, but instead of saying anything, I bent down and kissed his boots. It seemed to be the right thing to do, because when I straightened up and looked him in the eyes again, he was smiling broadly.

"*Good boy,*" he said. "I'll say each part first, and then you'll repeat it. If anything is unclear, or you feel you cannot say it sincerely, stop and we'll talk about it. But I don't think it'll give you a problem. Unless you've been doing a bang-up job of deceiving me, you've already accepted in your heart everything I'll ask you to swear to."

"I've never tried to deceive you, Sir."

"That's good, boy — see that you never do!"

"I won't, Sir."

"Okay, Matt, repeat after me: 'Sir, I solemnly swear that this body, mind, and whatever talents pertain to them'"

Whew! That sure covers it all, doesn't it? I took a deep breath, then repeated his words in a measured tone: "Sir, I solemnly swear that this body, mind, and whatever talents pertain to them . . ."

"'... belong to you, to be used however you desire.'"

"... belong to you, to be used however you desire."

"'Sir,'" he continued, "'from here on, unless you release me, my only purpose is to serve you, ...'"

"Question, Sir?"

"Yes, boy?"

"Do you mean, Sir, that everything I do, all the time, has to be devoted to your needs and desires? Sir, how can I do that without being your full-time, live-in servant?"

"Haven't you been *listening*, Matt? I told you I don't want that from you. You *can't* serve me the way I want by becoming my house boy or shadow. You need plenty of time on your own to stay as interesting and challenging as I expect you to be. Service takes many forms, not only the obvious ones. But if that's too confusing, focus on obedience instead! As long as you obey me, you're serving me."

"Yes, Sir. Thank you, Sir, for explaining it again to me."

"Now can you say the words, and mean them?"

"Yes, Sir, if you'll repeat them for me, please?"

"Of course. 'Sir, from here on, unless you release me, my only purpose is to serve you, ...'"

"Sir, from here on, unless you release me, my only purpose is to serve you, ..."

"'... my only duty to obey you.'"

"... my only duty to obey you."

"Good boy," he said. "Let's continue. 'Sir, my ambition is to please you and to bring ...'"

"Sir, my ambition is to please you and to bring ..."

"'... as much joy into your life as your ownership has brought into mine.' I hope you feel that's true, Matt."

"Sir, I've never been happier!" We shared a smile before I repeated his words with complete sincerity: "... as much joy into your life as your ownership has brought into mine."

"And the last clause, boy: 'Sir, I am your slave, your property, and you are my Master.'"

"Sir, I am your slave, your property, and you are my Master." That sounded like the end, but there was still more.

"'Your will is my will, Sir.'"

"Your will is my will, Sir."

God help me! I thought, but still meant every word. My heart

was pounding, and my dick was hard. So was his — or else he had a rubber hose stuffed in his breeches!

"*Good boy!*" he said. "Now it's my turn, because commitment goes both ways. I accept you, Matt Stone, a.k.a. dickhead, a.k.a. Mutt, as my slave, and I solemnly swear to give you clear direction and firm discipline, holding you to a high but not impossible standard, to enable you to fulfill your nature by serving me and others of my choosing, to use you hard but responsibly, to protect you, to love you, and to enjoy owning you for as long as this relationship meets both our needs. Stop crying and kiss my boots, slaveboy."

I bent my face to the gleaming leather and kissed it, then licked up the happy tears that fell from my eyes. When I sat back on my heels again, Terry slipped a medium-weight steel chain around my neck and padlocked it. The chunky brass lock lay on my breastbone, a solid reminder of his ownership — but a discreet one, as it could be covered by a T-shirt or buttoned shirt if needed.

"This is your collar, boy, until I replace it with something even more permanent. It's stainless and nonallergenic, so you can wear it all the time, whether I'm with you or not — even at work and at the gym. I'll keep the key."

"Yes, Sir! *Thank* you, Sir!" *First the leather dress collar, and now this! He's finally collared me for keeps! I'm really his now!*

I was grinning and crying and covering his hand with kisses. He'd collared me before, of course, but it had always been temporary, only for the course of a scene or a visit. He'd made it clear that he wouldn't give me a full-time collar until he was ready to make a full-time commitment, and now he had — and so had I.

"Time to get going, sport. Stand up."

He cuffed me again, and I waited there, fully dressed, my ass stuffed and my genitals strapped down, as he put on his CHP-style motorcycle jacket, then draped his NYPD gunbelt around my neck, plopped the squashed Highway Patrol cap on my head, and put the three-quarter-length NYPD jacket under his arm.

"I can't wear this jacket on the road because of the insignia," he explained, "so I'll stow it on the bike along with the gunbelt and cap. March, boy, down to the garage. Git."

He swatted my ass when I didn't move fast enough for him, but he was the one who slowed us down. Instead of taking the hidden stairs down to the lower level from the bedroom, he went by way of the kitchen, stopping there and in the living room to make sure the lights and the security system were properly set.

"Ever buddy-ride, Matt?" he asked when we finally reached the Harley.

"No, Sir," I admitted.

"It's easy, boy. You just hold on tight for dear life and move any way I do. If you don't fall off in the first mile, you'll be fine the rest of the way." I had to look carefully to be sure he was joking. "It'll be too noisy to talk, so I may as well gag you."

He rummaged in the bike's saddlebags until he pulled out a gag — a thick rubber plug attached to a leather mouth shield and chin cup, like a dog's muzzle, with air holes on either side of the plug. He fastened it snugly, his eyes sparkling with pleasure, and then found a spare helmet and put it on me. The helmet's own chin strap and smoked-plexiglass face shield would make it hard for a casual observer to realize that I was muzzled.

After stowing the police gear he couldn't wear, Terry took off the handcuffs again — but not for long. He gave me gauntlets to put on, and once he had his own helmet in place and was seated in front of me on the bike, he pulled my arms around his waist and locked the cuffs on over the gloves. I copped a feel of his crotch — he was hard! — and hooked my thumbs in his belt.

"The cuffs'll help keep you from falling off," he said with a barely suppressed chuckle, "and you'll enjoy the ride more, too."

You mean you'll *enjoy it more*, I thought. But that was okay — I'd just sworn to make *his* enjoyment my goal.

Terry opened the garage door with the remote control he carried, started the motor, and we cruised out the door. He paused to zap the door closed again, then revved the Harley to climb the drive out to the street. It was like turning on a vibrator in my butt! Every bump and pebble we rode over seemed to jiggle the plug against my prostate, and I worried that I'd come before we even reached the parkway. I hugged my Master tight and held on for dear life as he carried me home.

About the Author

Born in Pittsburgh in 1948, david stein grew up in Western Pennsylvania and went off to study philosophy at NYU in 1965 and later at Northwestern University, which awarded him a Master's degree (little did they know!). In the mid-1970s he came out and changed careers more or less simultaneously, and in 1977 he landed back in New York City, where he got a job as a magazine editor and has lived and overworked ever since.

In 1980 he co-founded Gay Male S/M Activists (GMSMA), today the world's largest and most respected gay s/m organization, and served it in many capacities, from president to newsletter editor and program chairman, for the next 11 years. It was for the GMSMA statement of purpose, back in 1983, that david coined "safe, sane, and consensual s/m," now a ubiquitous catch phrase he has mixed feelings about. Although still a member of GMSMA, he is retired from a leadership role. These days he is more active in the New York City men-only chapter of Masters And slaves Together (MAsT), which he also co-founded.

For six years he wrote the "Bond+Aid" safety column for *Bound & Gagged* magazine, and in 1996 he guest-edited issue #14 of *International Leatherman* magazine, which was devoted entirely to real-world gay Masters and slaves. Over the years, his fiction and nonfiction have appeared in *Drummer, DungeonMaster, International Leatherman, Mach, PowerPlay*, and other periodicals as well as the anthologies *Leatherfolk*, edited by Mark Thompson; *SM Classics*, edited by Susan Wright, and *Horsemen: Leathersex Short Fiction*, edited by Joseph W. Bean. Some of his writing is available online at www.lthredge.com/ds, as is a fuller biographical essay.

Having been involved in three Master/slave partnerships of various lengths, from two months to a year and a half, slave david is unowned but under the guardianship of Master Steve Sampson, the founder and director of BUTCHMANN'S S/M Academy (www.butchmanns.com) in Tucson, Arizona.

Learning the Ropes
A Basic Guide to Fun S/M Lovemaking
Curious about S/M? Perhaps you have always had an interest but did not know where to find reliable information. Or perhaps you just want to enhance your lovemaking with a spouse or partner. Whatever your reason, this book by S/M expert Race Bannon can help. Learn what S/M is, how to do it safely, and how to connect with partners, plus much more. Already a classic in its field. **$12.95**

My Private Life
Real Experiences of a Dominant Woman
Within these pages, the author, Mistress Nan, allows the reader a brief glimpse into the true private life of an erotically dominant woman. As you read each sexually charged chapter it is often hard to believe that what you are reading is true. But nothing in this book is fiction. Mistress Nan has beautifully recounted some of her more erotic and exciting encounters with the men and women in her life. Each scene is vividly detailed and reads like the finest erotica, but knowing that these scenes really occurred as written adds incredibly to the sexual excitement they elicit. Whether you wish to read for erotic stimulation or simply want to gain insight into the intimate life of a dominant woman, this book will not disappoint you. **$14.95**

Leathersex
A Guide for the Curious Outsider and the Serious Player
Everyone wants a more interesting and fulfilling erotic life. With that in mind, renowned author, editor, teacher, and leather historian Joseph W. Bean wrote this guide to the popular but often misunderstood form of erotic expression he calls "leathersex" — which may include S/M, bondage, dominance, submission, fantasy, role playing, sensual physical stimulation, and fetishes, among other aspects. Whether you're simply curious about leathersex or already enjoy its pleasures but want to learn more, this book is for you. **$16.95**

Leathersex Q&A
Questions About Leathersex and the Leather Lifestyle Answered
Author Joseph W. Bean answers a wide variety of questions about leathersex, including S/M, bondage, relationships, safety, spirituality, history, and much more, based on actual letters sent to him over several years of his career as a lecturer, columnist, and editor of a gay men's leather magazine. Although originating from a gay male forum, the information will be of value to any man or woman who wishes to venture into the world of leathersex. **$16.95**

Beneath the Skins
The New Spirit and Politics of the Kink Community
In recent years, large numbers of men and women have coalesced into a vibrant community defined by an interest in styles of sexuality broadly described by the terms "leather/SM/fetish." As with any other fledgling community, struggles to delineate common goals, definitions, and political agendas are inevitable. Author Ivo Dominguez, Jr., examines the issues that unite — and divide — people with a common interest in an uncommon sexuality. **$12.95**

Consensual Sadomasochism
How to Talk About It and How to Do It Safely
Easy to read, easy to follow, and easy to understand, this book by authors William A. Henkin, Ph.D., and Sybil Holiday, CCSSE, defines and demystifies the unique language of consensual sadomasochism, examines the psychological power of erotic dominance and submission, provides a carefully considered guide for safe S/M play, and explains how S/M can be an activity of intense intimacy and sophisticated erotic theater, as well as one of simple sexual pleasure. **$16.95**

Leather and Latex Care
How to Keep Your Leather and Latex Looking Great
Leather and latex clothing have been propelled to unprecedented popularity in recent years by both the mainstream fashion industry and alternative sexual subcultures. But these materials require special care if they are to maintain their beauty. This concise, easy-to-read book by Kelly J. Thibault tells you all you need to know to keep your leather and latex items in top shape and looking great, While clothing is the focus of this book, tips are also given about using leather and latex items in erotic play. A must-have for anyone investing in expensive leather or latex gear! **$10.95**

Between the Cracks
The Daedalus Anthology of Kinky Verse
Poets have always been kinky. Who are we? How did we get here? Where are we going? If the poets do not tell us, then how will we know? S&M, piercing, drag, dildos: is any of this really new? Or are we only revisiting Pandora's bountiful box? From the lascivious satire of Catullus to the obsessions of Michelangelo, the fetishes of Edna St. Vincent Millay to the faunal fantasies of D.H. Lawrence, the howling of Ginsberg and the beats to the sultry slammers of modern-day San Francisco, poet and photographer Gavin Geoffrey Dillard has collected the most exotic of the erotic of the poetic pantheon, lest any further clues be lost between the cracks. **$18.95**

The Leather Contest Guide
A Handbook for Promoters, Contestants, Judges and Titleholders
Ever thought about entering a leather contest? Wondered what it takes to win? Are you considering sponsoring a contestant — even organizing a contest event? Have you been asked to judge a contest? Written by Guy Baldwin, one of the most famous names in the leather community and a past winner of the International Mr. Leather and Mr. National Leather Association titles, this comprehensive and realistic guide is where you need to start. **$12.95**

How to Order

phone 323-666-2121

e-mail order@DaedalusPublishing.com

mail Daedalus Publishing Company
2140 Hyperion Ave.
Los Angeles, CA 90027

payment All major credit cards are accepted.
Via e-mail or regular mail, indicate type of card, card number, expiration date, name of cardholder as shown on card, and billing address of cardholder. Also include the mailing address where you wish your order to be sent. Orders via regular mail can include payment by money order or check, but may be held until the check clears. Make checks or money orders payable to "Daedalus Publishing Company." *Do not send cash.*

tax and shipping California residents, add 8.25% sales tax to the total price of the books you are ordering. All orders, add $4.25 shipping charge for the first book and $1.00 for each additional book to the order total.

over-21 statement Since many of our publications deal with sexuality issues, all mail orders must include a signed statement that you are at least 21 years of age. Also include such a statement in any e-mail order.